CROSSROADS
Constructions, Markings, and Structures

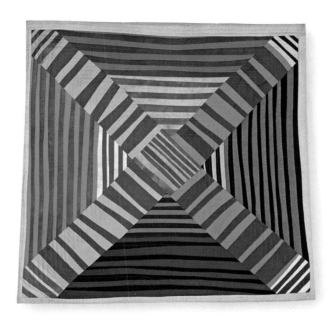

NANCY CROW
Foreword by David Hornung

Created to accompany a solo exhibition of the work of Nancy Crow
The Snyderman Gallery, Philadelphia, Pennsylvania
October 5 to November 17, 2007

Breckling Press

Library of Congress Cataloging-in-Publication Data

Crow, Nancy, 1943-
Crossroads : markings, structures, and constructions / Nancy Crow ; foreword by David Hornung.
p. cm.
Created to accompany a solo exhibition of the work of Nancy Crow at the Snyderman Gallery,
Philadelphia, Pennsylvania October 5 to November 17, 2007.
ISBN 978-1-933308-19-7
1. Crow, Nancy, 1943—Exhibitions. 2. Quilts–United States–History–21st century–Exhibitions. I.
Snyderman Gallery. II. Title.

NK9198.C76A4 2007
746.46092–dc22

2007034102

This catalog would not have been possible without the generous sponsorship of Bruce Hoffman,
The Snyderman Gallery, Philadelphia, Pennsylvania.

This catalog was set in Electra and Din Schrift
Editorial and production direction by Anne Knudsen
Art direction, cover and interior design by Maria Mann
Quilt photography by J. Kevin Fitzsimons unless otherwise credited

Published by Breckling Press
283 Michigan Ave., Elmhurst, IL 60126 USA

For an in-depth study of Nancy Crow's work from 1988 up to 2006, see NANCY CROW,
published by Breckling Press (2006). To view pages or order a copy, visit www.brecklingpress.com
or call 630 941 1179.

Acknowledgements

I am deeply indebted to many people for their help and assistance in making this exhibition and catalog possible. These include Emma Rees of Megalo Access Arts in Canberra, Australia, for reacquainting me with all the processes of screen-printing, including helping me to make huge screens and then assisting me in printing these screens, and then going on to print additional ideas and mark-makings as I sent them to her; Helen Grey for assisting Emma in printing many of these screens; Margaret Boys-Wolf for her assistance in this printing process; Claire Benn of Betchworth, Surrey, United Kingdom, for showing me how to create simple screens using painted pellon; Ann Johnston for inviting me to come work in her new studio, firing up my interest once again to paint directly onto fabric using fiber-reactive dyes; and likewise to Sue Benner for her encouragement.

I have only the most deep, heartfelt thanks to give my dear friend, Marla Hattabaugh, for her loyalty and patience as she hand-quilted top after top these past two years. Marla, you are just a superb hand-quilter and I love your work!

In addition, Kathleen Loomis stepped in to machine-quilt three pieces and Brenda Stultz hand-quilted two pieces; thank you both for your help and your wonderful work!

When David Hornung called to interview me for the Foreword, I was estatic at hearing his well-thought out questions which super-charged my imagination and forced me to think hard. What followed is a beautiful, articulate essay. Thank you, David!

Kevin, my dear Kevin Fitzsimons, you have been so loyal in coming to the farm to photograph my work in my studios. I really cannot imagine what I would have done without all your help over these past 20 years. Thank you!

Last I would like to thank Bruce Hoffman and Ruth and Rick Snyderman of The Snyderman Gallery for their long-time support and for offering me this solo exhibition.

I end with a HUGE KUDOS to you, Anne Knudsen, owner of Breckling Press, for sticking with me, believing in me and for putting out a gorgeous catalog in support of this exhibition.

Nancy Crow, Summer 2007

Nancy Crow at Crossroads

THIS EXHIBITION OF 25 RECENT QUILTS BY NANCY CROW captures one of America's premier textile artists at the height of her powers. Extending the boundaries of her visual language, these works represent three distinct modes of experimentation that the artist has titled *Constructions*, *Markings*, and *Structures*. With three exceptions, Crow completed all of these quilts over the past two years, developing them simultaneously and interchangeably.

Crow's quilts are distinctly contemporary, but with strong connections to the history of both fine art and textiles. Her designs are informed by a lifetime of looking; she is as familiar with the international history of textiles as she is with the work of Modernist masters. Widely acknowledged to be one of the seminal figures in the "art quilt" movement, Crow is also one of the most formally innovative. Her insistence upon machine-piecing, hand-quilting, and dyeing her own fabric imbues her inventive design work with a kind of historical ballast and a characteristic structural integrity.

Quiltmaking is an art form with roots in domestic utility; quilts were the ubiquitous bedcovering in nineteenth and early twentieth century homes. For some, it is surprising to find visual sophistication in such a familiar functional object. But, considering the history of women in visual art, it should not be. Throughout the eighteenth, nineteenth, and early twentieth centuries, women had limited access to professional careers in the fine arts of painting and sculpture. The pieced quilt, along with other domestic crafts, represented an avenue of expression for many self-taught and artistically gifted women. The "art quilt," the non-utilitarian descendent of the traditional quilt, retains some of its precursor's structural features, but exists solely to be regarded as a work of art.

In popular imagination, the idea of the domestic functional quilt retains powerful associations. Values like selflessness, resourcefulness, and frugality cling to it, provoking nostalgia for a time when those values were commonly celebrated as the basis of family survival. The

By David Hornung, chairman of the department of art and art history at Adelphi University in Garden City, New York. Mr. Hornung is a painter and former quiltmaker who lives and works in New York. He is also the author and designer of *Color: A Workshop for Artists and Designers*, a color textbook based on the class he taught for many years at the Rhode Island School of Design.

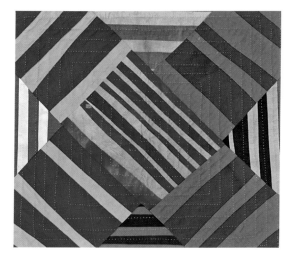

Detail of Constructions #61

wholesome associations we attach to quilts are reinforced by the pleasurable physical sensations they bring to mind: warmth, comfort, and intimacy. For many, the community event known as the quilting bee, although now a cultural memory, symbolizes the sacrifice of individual will to communal need.

Despite being non-utilitarian, the art quilt can evoke many of the values we associate with traditional quilts. Its very structure reminds the viewer of its pedigree and adds a layer of meaning that extends beyond the artist's immediate intent and concern. In a society where fewer and fewer people make things with their hands (most have even abandoned handwriting), a hand-sewn line of quilting can represent a painstaking gesture of commitment. Likewise, a design constructed through the cunning distribution of many small pieces of colored fabric can bring to mind the practical ingenuity of a woman recycling fabric scraps, even though the art quilt is unbound by such material constraints.

These historical associations can be circumvented by making the object less quilt-like. Many contemporary art quiltmakers do just that when they lead the viewer away from bed quilt references by printing photographic images on fabric, painting elaborate pictorials, minimizing the evidence of handcraft, or making their pieces in odd overall shapes. Art quiltmakers who distance themselves from the quilt tradition often do so to court a sense of contemporaneity within the art world, where current fashion favors concepts over objects and eschews recognizable links with historic artifacts except when viewed through the lens of irony. This reigning sensibility is usually called "Postmodernism."

Nancy Crow, on the other hand, maintains sincere connections to her artistic lineage. Her quilts, though contemporary in their use of color and design, are not Postmodern. They are predicated on long, and stubbornly held convictions about the integrity of material, process, and visual form. After 300 quilts and roughly 40 years of making art, she still maintains her faith in the power of form to embody important truths and to enrich a viewer's inner life. She cleaves to that belief because that is the way she, herself, experiences art.

Workspace

But, although Crow embraces quiltmaking with all its associations, her relationship to traditional quilts is not borne of nostalgia or sentimentality. She simply acknowledges the roots of her art and values the lessons she has learned from studying past masterpieces of her medium. Indeed, throughout her life she has refreshed her creative energies at the well of textile traditions in general, and those of quiltmaking in particular, whether Anglo-American, Amish, or African-American.

The visual connection between American vernacular design (as seen in traditional quilts, hooked and woven rugs, and coverlets) and both early and late Modernism has long been recognized. Galleries have occasionally shown nineteenth century Amish quilts alongside paintings by Kenneth Noland and other American abstractionists. The point of this exercise is to underscore the formal affinities between them and the essential Americaness of both. Crow's art has developed out of a dual awareness of vernacular design and modern art. In a real sense, she has married the two, albeit in a characteristically organic and intuitive way. She emerged as an artist at precisely the time that such a synthesis became possible.

By the 1970s, artists who were trained in university art departments and schooled in the formal innovations of Modernism began to look upon traditional textile arts, like weaving and quiltmaking, as an appealing and respectable alternative to the "high arts" of painting and sculpture. The pieced quilt, with its seductive combination of physical richness and visual surprise, cast a spell on those looking for a medium that had the graphic sophistication of advanced abstraction with none of its cultural pretense.

In graduate school, Crow pursued weaving and ceramics and earned an Masters in Fine Arts (MFA) at Ohio State in 1969. Her transition from weaver to quilter evolved gradually over the following decade. Open minded and visually adventurous, she absorbed the formal lessons of modern art along with those of traditional textiles. Crow was an art explorer, and one of the first to eventually settle on the quilt as a vehicle for personal expression.

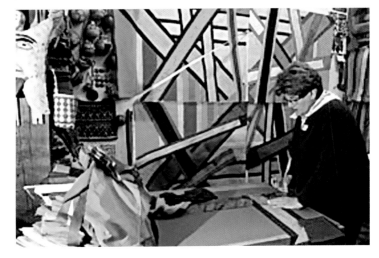

Nancy Crow at work

After receiving her MFA, Nancy Crow and her husband, John Stitzlein, lived for several years in Brazil. It was there, while pregnant with her son Nathaniel, that she pieced her first quilt for his bed. She moved to Athens, Ohio, in 1974 and joined a textile guild where she and several other weavers decided to start making quilts. By 1976 she was doing less and less weaving and, by 1979, she put her looms away for good.

For Crow, the advantages of quiltmaking over weaving lay in the relative ease with which shapes can be manufactured, positioned, and repositioned within the pattern. Indeed, her development over the years could be seen as driven, in part, by a search for ever increasing spontaneity. Quiltmaking is perfectly suited to her temperament. She is patient with the demands of the craft and possesses a quick visual intelligence. Quilts fuse her love of color and pattern with an innate respect for the physical imperatives of object making.

Crow's first 12 years of sustained quiltmaking brought her serious recognition and high regard within the textile community. The quilts of those years are densely worked engines of complexity. Typically, they combine numerous color progressions, aggressive edges, and strong value contrasts to create the sensation of layered planes of color and pattern. Her early work is formally inventive, varied, and energetic. The overall configurations are invariably symmetrical and grid based, reflecting her use of templates in their construction. Their emphatic symmetry sometimes lends her early quilts a somewhat kaleidoscopic appearance.

Crow worked with symmetrical design throughout the eighties and, in retrospect, her reliance on it seems wise. The complexity and aggressiveness of her work from that time is stabilized by the symmetry of the grid. The early quilts are suffused with youthful brio and unequivocally announced the arrival of an artist of power and conviction.

Around 1990, Crow began to lose interest in her way of working and yearned to open things up in some undefined way. That year she made almost nothing. She rejected the prospect of simply doing variations on her past successes, but was unsure of where to go. In a

Double Mexican Wedding Rings #4, © 1988-1990

2002 interview with Jean Robertson, Crow stated, "By 1990, I had had it with quiltmaking. I was sick of it. I hated it."

The dissatisfaction that gnawed at her was, in part, stimulated by something she had seen for the first time in 1988 when she encountered the quilts of Anna Williams of Baton Rouge, Louisiana. Williams made quilts directly, without rulers or templates. (Similarly spontaneous method of construction had been widely practiced by African American quiltmakers, as evidenced in the exhibition "Quilts from Gees Bend" at the Whitney in 2002, and in the work of artists like Lee Wanda Jones and Rosie Lee Tomkins. But the African American quiltmaking community was isolated and relatively unknown to art quiltmakers in the late eighties.)

For Crow, seeing William's work was an epiphany, but one that registered gradually over a period of several years. William's pieced quilts were liberated from the grid, the template, measurement, and the design constraints that all that implied. "What's wrong with me?" Crow later recalled thinking, "Why does everything have to be straight?"

A light went on in Crow's mind. Working with templates allows for freedom within the smaller design units, but not in the way they are fitted into the whole. For longer, more sensuous lines and curves, Anglo-American quilters traditionally turned to appliqué, which involves sewing additional shapes upon the surface of the pieced design. What impressed Crow in Anna William's work was the boldness of piecing shapes with wavering edges in a way that seemed to defy the logic of pieced construction. By not adding another physical layer to the quilt, as with appliqué, William's was able to maintain a unity of design and surface.

Although impressed with this more spontaneous approach to quilt top construction, Crow needed to make it her own. For one thing, the functional quilts made by Williams and other African American women were, when in use, physically supported by beds. Crow's art quilts, on the other hand, had to hang flat and straight on a gallery wall. Mastery of the new technique

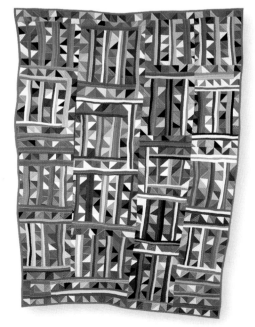

Monkey Wrench, © 1991 by Anna Williams

did not come easily. She substituted a rotary cutter in place of scissors. By her account, it took her two years to learn to use the rotary cutter with the level of skill that she demands.

Crow's process, as it has evolved, is to construct her quilts directly on the wall. She works with no preparation, except, perhaps, for a loose sketch from one of her notebooks. Her pieces are carefully improvised through a slow, but spontaneous series of numerous adjustments. Before she moves a shape, she sometimes takes a Polaroid photo as a memory aid for the purpose of comparison and in case she should decide to reconstruct the original design. When the design is finally arranged to her satisfaction, she sews it together. The process of machine piecing is, to Crow, a form of meditation that she relishes.

With large quilts, Crow needs a ladder to reach the higher parts of the piece in progress and considerable distance to see the whole design clearly. The work can be arduous. Absorbed in the creative act, one's mind can lose track of the number of adjustments one makes, but the body remembers every twist, turn, and step. Crow, who has already had knee-replacement surgery, talks about the physical demands of the larger quilts and the increasing challenge they present as she ages.

Once the top is completed, Crow indicates where the quilting lines should go and sends the piece out to a hand quilter to be finished. The quilting line is an essential part of the finished piece. Traditionally, its purpose was to hold the batting (the insulating material with which a quilt is stuffed) in place and to keep the layers of the "textile sandwich" from shifting. The tighter the pattern of the quilting line, the more durable the quilt.

Art quilts do not get the rough use that bed quilts endure. But the quilting line has an aesthetic purpose as well, which becomes evident when quilts are seen hanging on the wall. The pattern made by quilting lines can assert that of the top design, or have its own logic.

Additionally, the quilting line insistently locates what is referred to in painting as "the picture plane," meaning the physical surface of the object. Color relationships, the relative

Photographer J. Kevin Fitzsimons

scale of similar shapes, and shapes that appear to overlap each other can all be used to create spatial illusion in the overall design. Crow's quilts often emphasize the clear separation of overlapping planes, maximizing the illusion of depth. By asserting the physical surface, quilt stitches create a perceptual duality: that of the design as a series of multi-leveled planes and, in contradiction, the object itself with its own tactile presence and finite dimensions.

In a nonfunctional art quilt, batting primarily serves to increase the quilting line's visibility, especially when strafed with gallery lighting. The visual tension between the quilt and the spatial illusion of the top design is one of the great sensate pleasures of this art form. Crow understands this intuitively and usually prefers hand-quilting. The hand-sewn line, with its subtle irregularities and traces of human contact with the object, generates far more warmth than one sewn on a machine.

Hand-quilting an entire quilt is a journey that traverses only a few square feet, but can take weeks of the sewer's time. It is a mode of physical experience probably unsurpassed for sustained tactile intimacy. If there were 50 instead of 24 hours in a day, Crow would, no doubt, do the quilt stitching herself. Instead, she has been fortunate to find excellent collaborators over the years to take on the quilting as she has concentrated on the design and construction of her work.

Today, it is not uncommon for artists to have their work completely fabricated by other hands. For some, it simply underscores the current art world convention that, in art, ideas are what matters, not objects and certainly not craft. Once the piece is realized, the "fabricator" is never mentioned. In contrast, Crow accords the women who sew on her quilts a peer's respect, reflecting, among other things, her belief in the dignity of hand labor. Significantly, she credits them by name on the back of each finished piece.

Around 1990, Crow began to use custom hand-dyed fabrics in her work. A few years later, she was dyeing her own fabrics. Getting involved in the dye process has made her a

better colorist, with more refined expectations and greater control. When considering the work of the past 15 years, one is impressed with the sensitivity of her color and the range of her palette. Since she made her transition to more direct, essential designs and began dyeing her own fabric, Crow has made color a central issue in her work. Without a doubt, she has become one of the most accomplished colorists in contemporary art.

In the way they are made, quilts are often compared to collages, probably because both involve the juxtaposition of pre-fabricated visual elements. But the flexibility of collage is difficult to achieve in such a complex object, especially when it's a *pieced* quilt. In the 1990s, Crow succeeded in bringing that flexibility to her quiltmaking, and it opened the door to a world of possibility.

As the century turned, Crow mastered her own direct-cutting technique and attained the confidence to take increasing risks with design and color. This new, hard-won freedom gives her access to a greater variety of shapes and configurations, which, in turn, allows for a more complex range of expression to enter her work. Fully in command of her mature style, she is now able to improvise, like a jazz musician, on a broad range of visual themes.

Quilts Appearing in This Exhibition

NANCY CROW LIKES TO PRODUCE QUILTS IN A SERIES, each piece representing a facet of the extended exploration of an idea. In interview, she has said, "I have discovered that working in a series is important because there's a tendency on the part of an artist to want to resolve everything in one piece, and I think that's a grand mistake because it's biting off too much." In the same conversation, she alludes to the richness that comes from going ever deeper into an idea and its variations over the course of number of quilts.

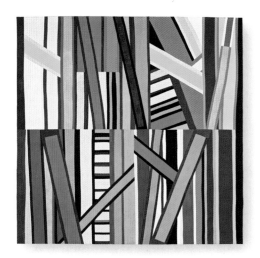

Constructions # 83: Anxiety!

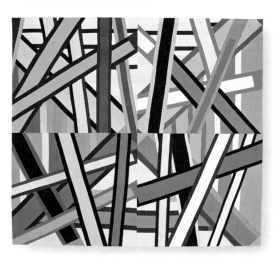

Constructions #84: No!

Crow tends to keep several pieces and, sometimes, several series going at one time. This exhibition consists of recent work from three separate series: *Constructions*, *Markings*, and *Structures*. Each is defined by some feature of its formal parameters or by specific aspects of its process.

Of the three series shown in this exhibition, *Constructions*, represented here by 13 works, is the oldest. It began in 1995 and has grown to over 90 quilts. Quilts from this series vary widely in their color and configuration. What they have in common is that they are all improvised and made without rulers or templates. In general, they seem to grow organically from shape to shape with only an informal plan in mind at the outset. All of the quilts that fall under this rubric have a strong architectural quality, but without the rigidity sometimes associated with the use of geometric shapes. Instead of perfect, measurable squares or rectangles, these quilts employ muscular approximations of those familiar shapes. Quilts in this series are characteristically robust with an engaging directness and simplicity.

Construction #83: Anxiety!, and *Construction #84: No!*, exemplify this series. Both are nearly square and are divided horizontally by a vector that visually divides the quilt into two long rectangles of equal size. In both the top and bottom rectangles, the spaces are jammed at different angles with straight (but not ruled) ribbons of color. These have been strip-pieced into three running stripes, often with a center hue edged on both sides by a narrower stripe of a second color. The overall palette shows strong contrast in hue, value, and saturation. The result, in both quilts, is striking, but there are important differences that distinguish them.

Despite its boldness, *Construction #83* is more restrained than *Constructions #84*. This is largely because its bands of color are often vertically aligned with the sides of the quilt while only a small percentage tilt from the vertical axis. Among the tilted bands, several share the same angle, further stabilizing the effect. The space in *Constructions #83* is layered, but relatively shallow, as many of the parallel verticals unite to form a single continuous plane.

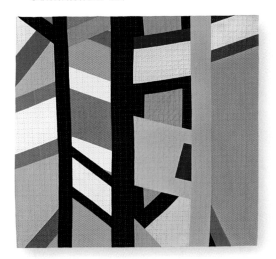

Constructions #87

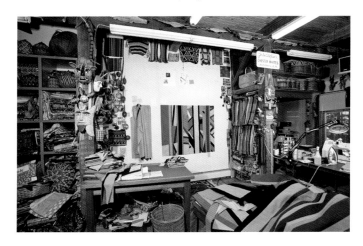

Constructions #88! Yes! in progress

It is when the edges are parallel that the subtle irregularities of free-hand cutting confound one's assumptions and reward the viewer with visual surprise. In both quilts, thrusting bands of color collide along the horizontal vector, infusing it with visual energy.

Construction #84: No! is a far more aggressive design. In addition to its horizontal vector, it has a weaker vertical axis that forms a subtle cross at the center of the piece. This creates four separate areas within which a tangle of girder-like ribbons of color is constrained. In contrast to *Construction #83*, the angled ribbons in this piece overwhelm those few that are perpendicular. The space is much deeper here, with pale yellow-grays linking up in the background to form a receding back plane. To make *Constructions #84* even wilder, Crow sometimes interrupts the continuity of a band when it reappears from behind another. The effect is like that of a straw standing in a glass of water appearing to bend as it penetrates the surface of the clear liquid.

Another important series, represented here by nine works, is *Markings*, an exploration of calligraphic mark making applied to quilt construction. Crow has written, "I began making *Markings* using paintbrush and screens. I have always loved screen-printing but never learned how to do it. So I started very informally and went at it in my own way."

In this series, Crow applies dye to fabric indirectly (with the exception of *Markings #9*, which was painted directly in dye using a brush and squeeze bottle). In *Markings #1: The Known and the Unknown*, she has screen-printing the image. (She later returned to screen-printing in *Markings #7* and *Markings #8*.) The color is almost monochromatic: a moody red with some red-orange for relief.

In *Markings #2: Inner Turmoil*, Crow began to experiment with an improvised "monoprinting" technique. She spreads the black dye with her fingers on an "Abitibi" board (a type of fiber board coated with a smooth, non-porous white enamel). After spreading the dye, she carefully lays the fabric over it to allow it to pick up the dye from the surface of the board. When the fabric is lifted and the image dry, Crow can add additional color. In this way, she creates panels that are packed with gestural energy, which can then be pieced together to make a larger whole.

Markings #1

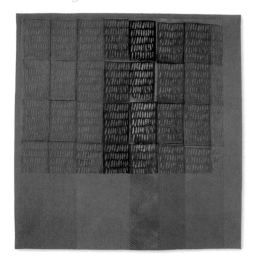

Markings #2

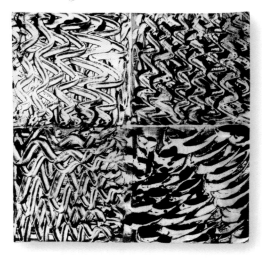

As different as *Construction #84: No!* and *Markings #2: Inner Turmoil* appear at first glance, it is noteworthy that, central to each of them, is the idea of powerful energy constrained by sudden termination at the edge of a rectangle. In both designs, an implied cross at the center occasions abrupt shifts in the action.

A much larger piece, *Markings #4: Trying to Control Anxiety*, uses the same technique, but the increase in the numbers of panels and the scale of the whole adds energy through sheer accumulation. The over-printed color in these two quilts is restrained and lyrical. It serves mainly to soften the starkness of the black dye against white cotton.

The quilting in *Marking #2* and *Markings #4* is distinctive. The quilting line takes it cue from the swirling black marks and literally traces some of them. By reinforcing the gesture in this way, the sewn line tends to stabilize it, but only if viewed closely. At a distance, the movement of the gestures appears unrestrained.

Crow calls the third series, represented by three works in this exhibition, *Structures*. This is the most recent series and grows out of *Markings* in its use of screen-printing and the way in which the quilting echoes the printed image. In *Structures*, however, there is little or no piecing. Crow silk-screens her design on whole cloth, and then has it hand quilted. The repetition of the screen to build a grid or any other sequential motif echoes the pieced quilt in that a design is composed of "blocks" of visual information assembled to make a whole.

This exhibition demonstrates the continuing vitality of Nancy Crow's creative output. Her strengths as a colorist, designer, craftsperson, and visual thinker are in clear evidence here. But, beyond those abilities, it is Crow's willingness to take risks in the studio that has brought her to this compelling place in her career. She shows a kind of courage in her working procedures that few artists are able to sustain past youth or the first flush of recognition. That she still enters her workspace with her head full of questions and the nerve to keep experimenting and exposing herself to potential failure, marks her seriousness as an artist and her quality as an example.

Markings #4

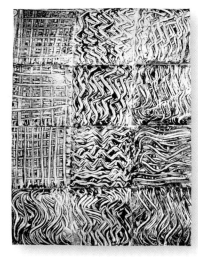

Structures #1

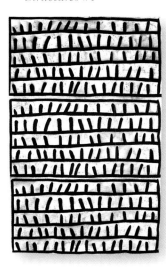

Constructions

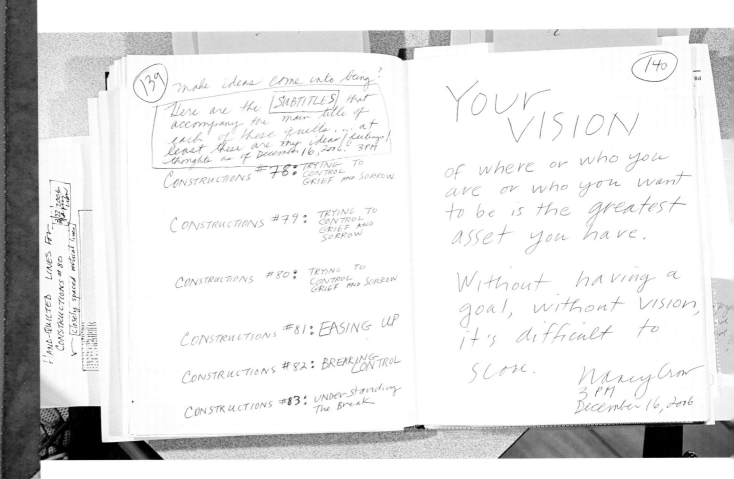

Quilts from the Constructions series vary widely in their COLOR AND CONFIGURATION. In general, they seem to grow ORGANICALLY from shape to shape with only an informal plan in mind at the outset. All of the quilts that fall under this rubric have a STRONG ARCHITECTURAL QUALITY, but without the rigidity sometimes associated with the use of geometric shapes. DAVID HORNUNG

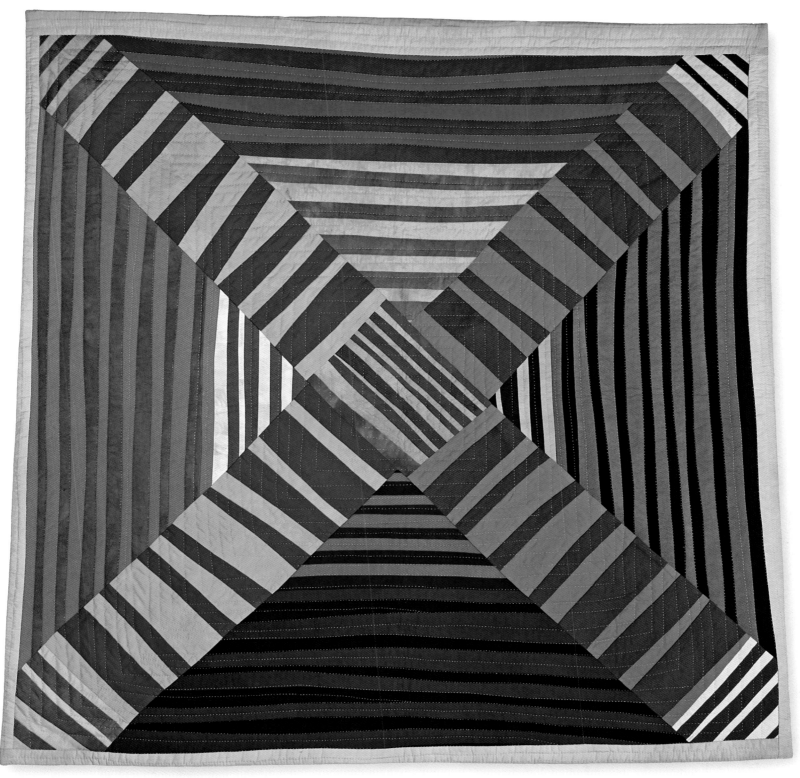

Constructions #61, ©2003.

39" × 39". 100 percent cottons. Hand-dyed, strip-pieced, restructered and then compositionally machine-pieced by Nancy Crow. Hand-quilted by Marla Hattabaugh with pattern denoted by Nancy Crow.

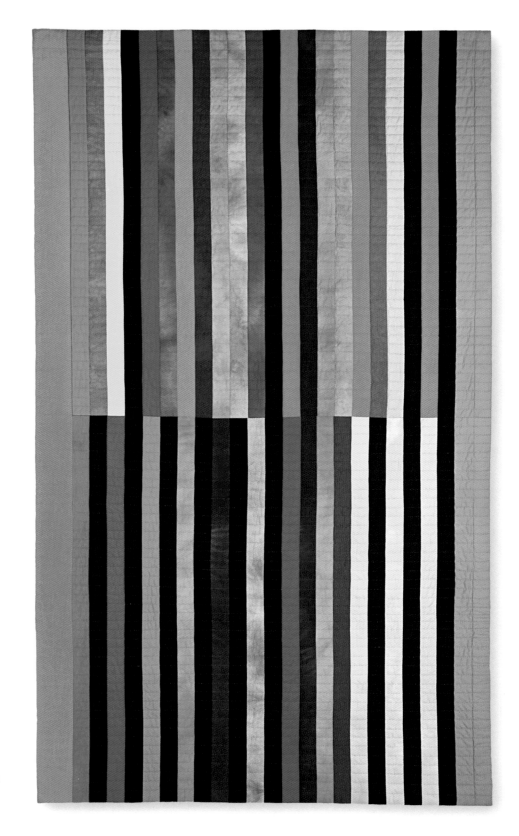

Constructions #71, ©2003. 37 ¾˝ × 65 ¾˝.
100 percent cottons. Hand-dyed, strip-pieced
and then compositionally machine-pieced by
Nancy Crow. Hand-quilted by Marla Hattabaugh
with pattern denoted by Nancy Crow.

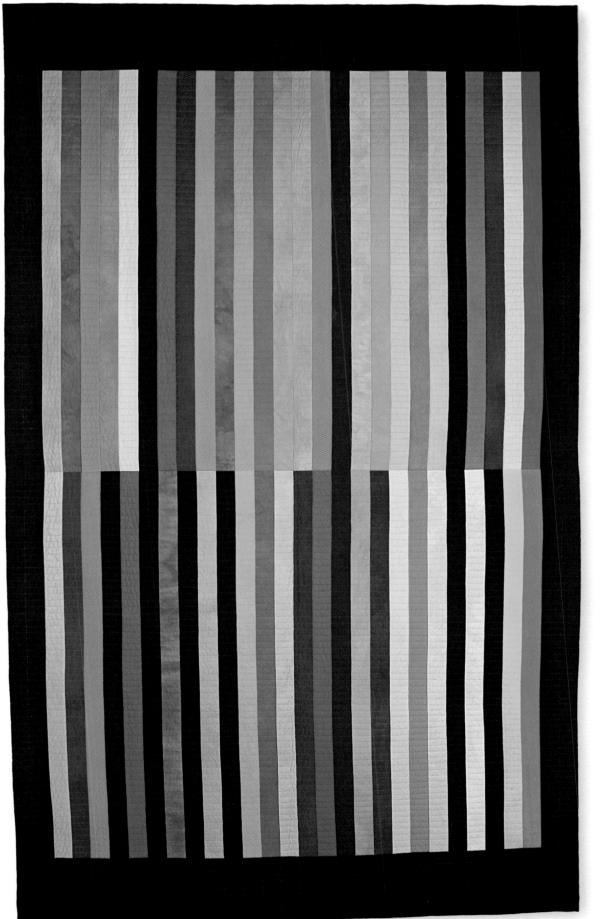

Constructions #72, ©2003.
58" × 96". 100 percent cottons. Hand-dyed,
strip-pieced and then compositionally
machine-pieced by Nancy Crow. Hand-
quilted by Marla Hattabaugh with pattern
denoted by Nancy Crow.

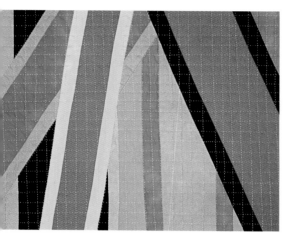

X IS DUPLICITOUS! X MEANS YES!

X MEANS NO!

X CAN BE A CROSSROADS IN ONE'S LIFE!

X CAN CLOSE DOORS! OR

X CAN CLOSE OUT DOUBT AND ALLOW DOORS TO BE OPENED!

X HAS ENORMOUS ENERGY AND INTENT!

X CAN BE A LINE OR A LONG NARROW SHAPE!

X CAN BE CONFIGURED OVER AND OVER!

X CAN BE A CROSSROADS IN ONE'S LIFE!

X CAN LEAD TO FREEDOM!

NANCY CROW AUGUST 20, 2007

October 6, 2006 *(revised December 16, 2006)* | SKETCHBOOK NOTES

*I awoke early this morning in an effort to unscramble all the hundreds of thoughts and notions swirling in my brain . . .
a condition that seems to get more extreme with age. I find it exhilarating but sometimes frightening in its intensity; all I
think about are images! I am trying to unscramble ideas and thoughts about WHO I WANT TO BE and WHAT I WANT FOR
MYSELF. I keep asking myself questions, trying to be as honeset and thorough as possible.*

Is it all about . . . STRUGGLING TO CHANGE?
Is it all about . . . STRUGGLING TO CONSTANTLY DIG DEEPER?
Is it all about . . . STRUGGLING TO KEEP BELIEVING ONE CAN DIG DEEPER?
Is it all about . . . STRUGGLING TO BE IN TOUCH WITH MY TRUE SELF?
Is it all about . . . STRUGGLING TO UNDERSTAND THE CONSTANT ANXIETY?
Is it all about . . . STRUGGLING TO UNDERSTAND THE VOLCANO OF ANGER INSIDE?
Is it all about . . . STRUGGLING TO ERUPT OR KEEP FROM ERUPTING?
Is it all about . . . STRUGGLING TO EXAMINE MY MOTIVES AND RESOURCEFULNESS?

Constructions #82: Breaking Control!.
©2006 (April to June). 75" × 83". 100 percent cottons.
Hand-dyed, strip-pieced, restructured, and then
compositionally machine-pieced by Nancy Crow.
Hand-quilted by Marla Hattabaugh with pattern
denoted by Nancy Crow.

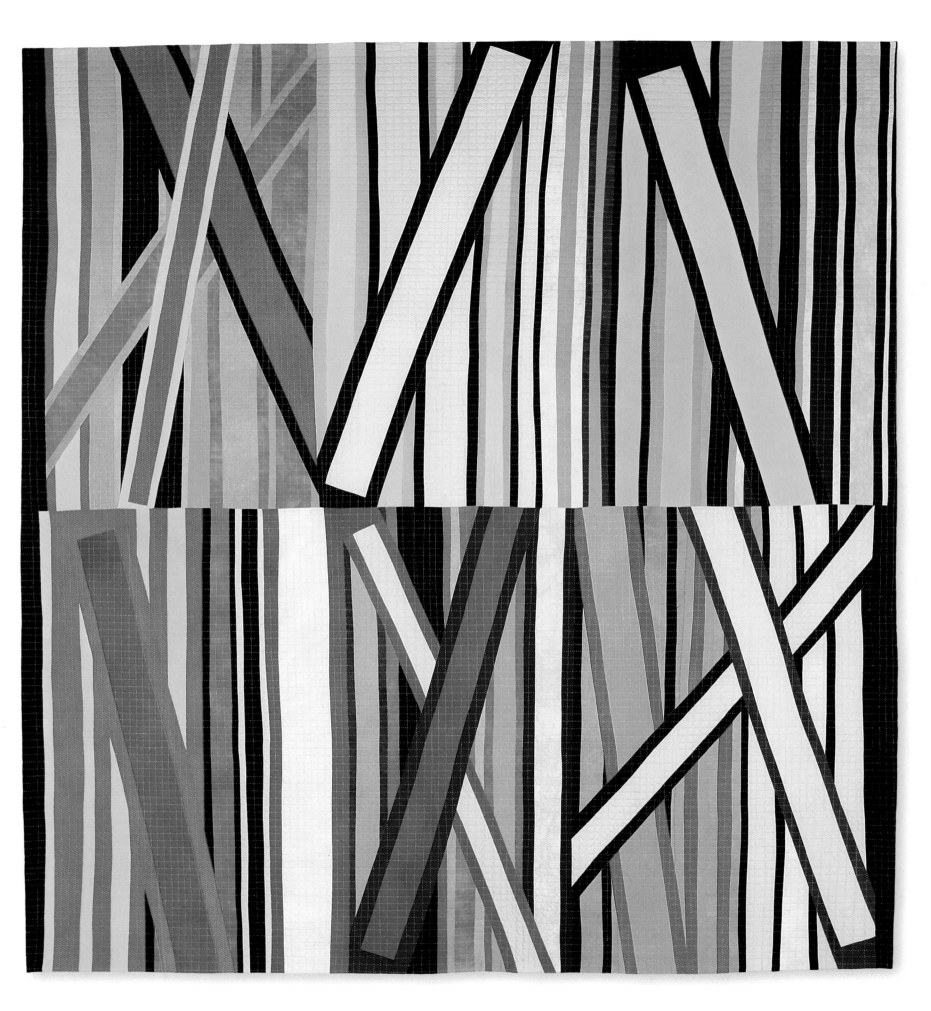

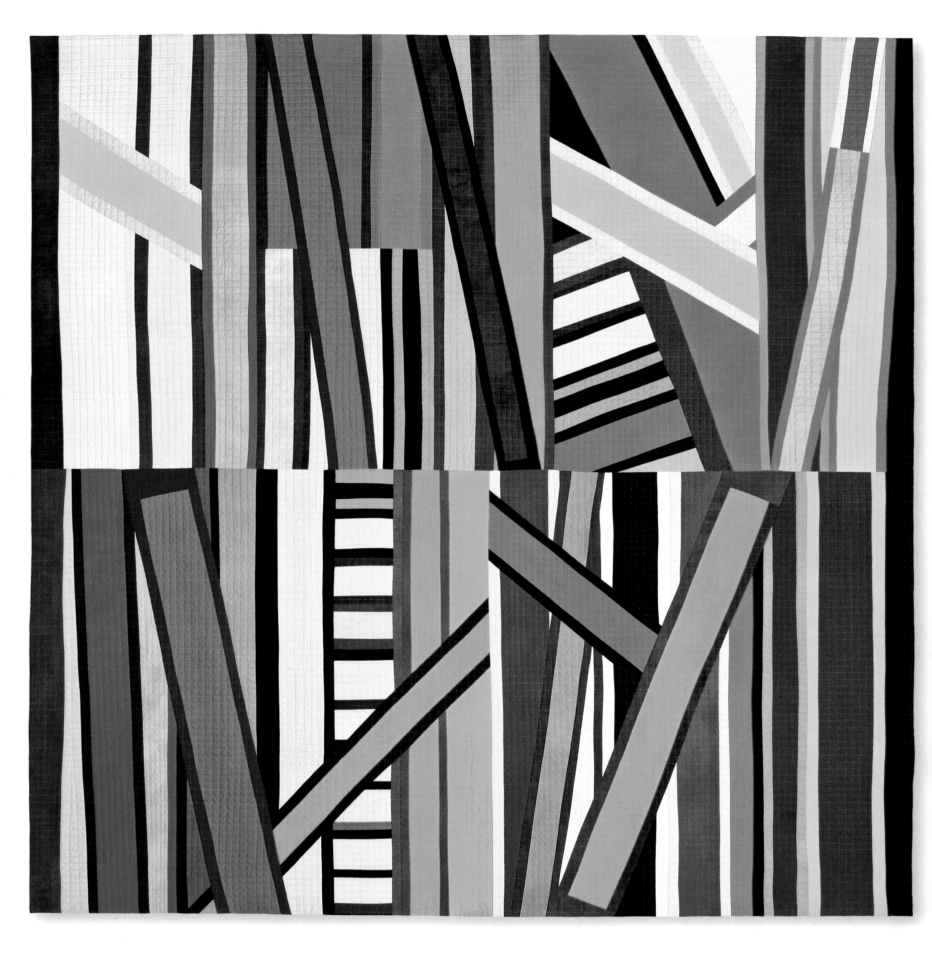

Crossroads: Constructions, Markings and Structures

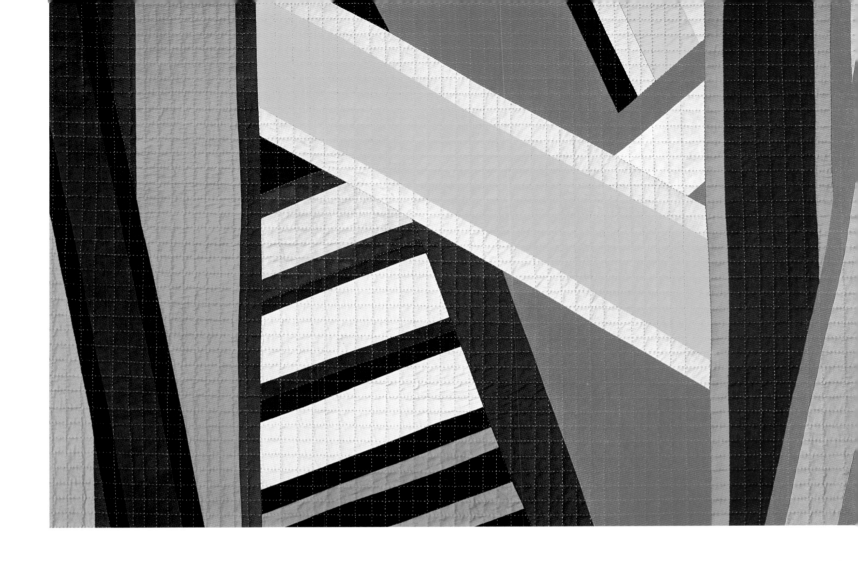

Constructions #83: Anxiety!, ©2006 to 2007.
79 ¼" × 81 ½". 100 percent cottons. Hand-dyed, strip-
pieced, restructured, and then compositionally machine-
pieced by Nancy Crow. Hand-quilted by Marla Hattabaugh
with pattern denoted by Nancy Crow.

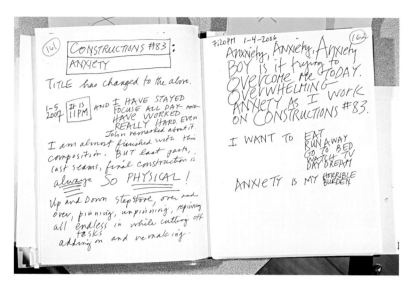

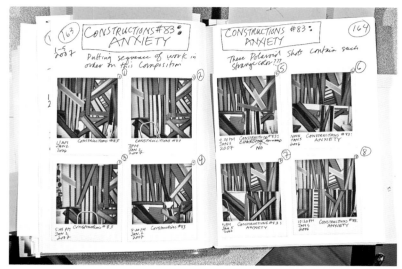

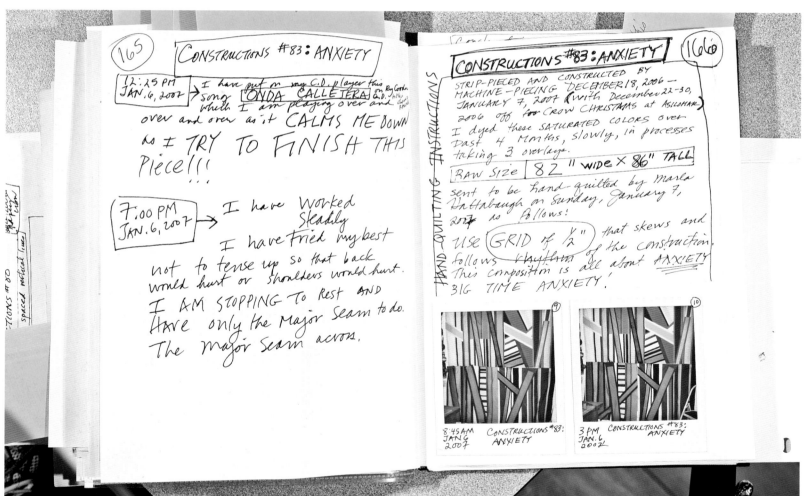

Pages from Nancy Crow's sketchbooks during the making of Constructions #83

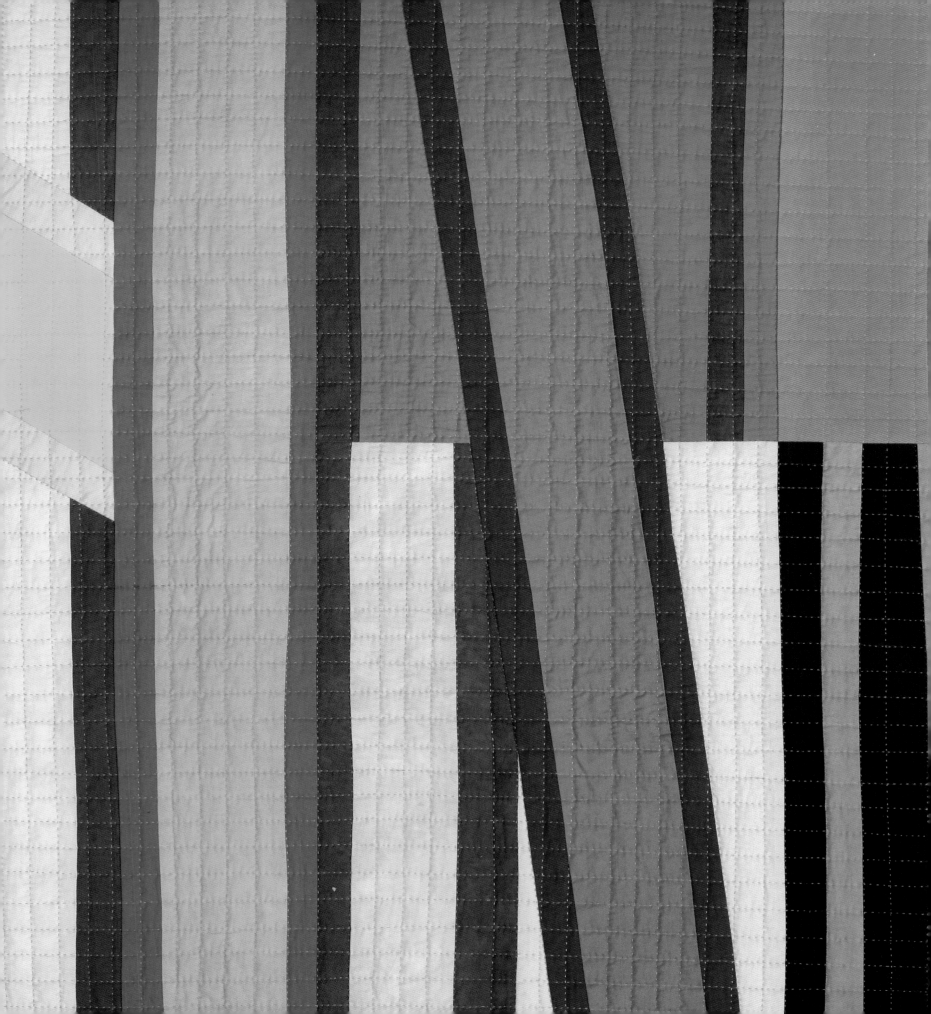

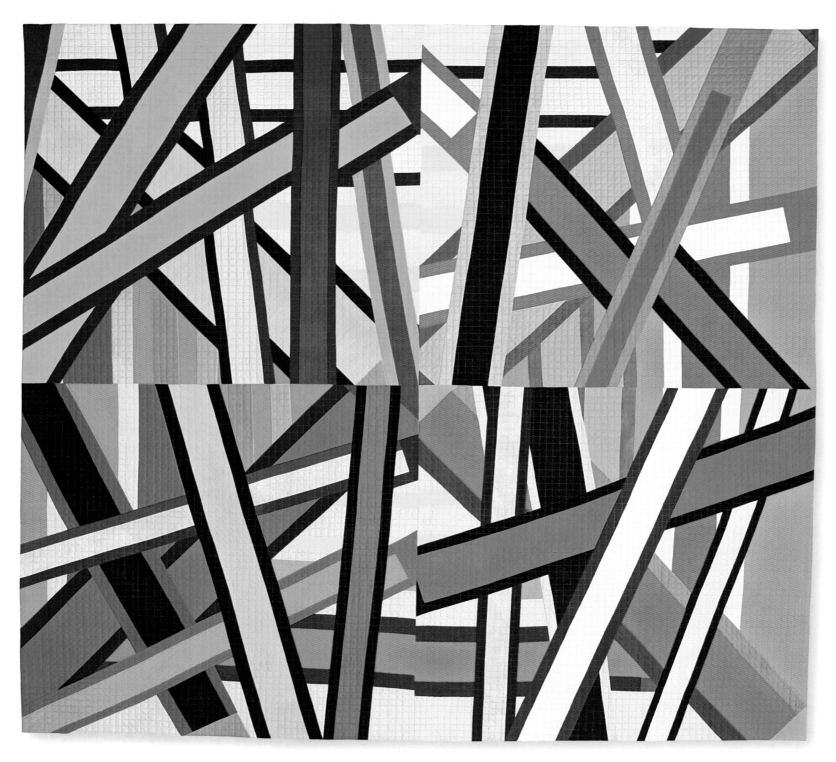

Constructions #84: No! ©2007.

75" × 70". 100 percent cottons. Hand-dyed, strip-pieced,
restructured, and then compositionally machine-pieced
by Nancy Crow. Hand-quilted by Marla Hattabaugh with
pattern denoted by Nancy Crow.

Close-ups of Constructions #84: No!
in the starting stages on the west wall
of Studio #1.

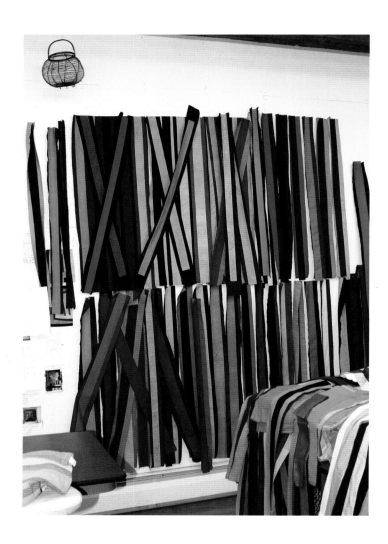

Constructions #85. This large work was incomplete at the time
of publication of the catalog. Like others in the series, the quilt is
made from 100 percent cottons, hand-dyed, strip-pieced, and then
compositionally machine-pieced by Nancy Crow. Here, the quilt
is shown as a work-in-progress on the north wall of Studio #1. The
smaller photograph was taken by Nancy Crow.

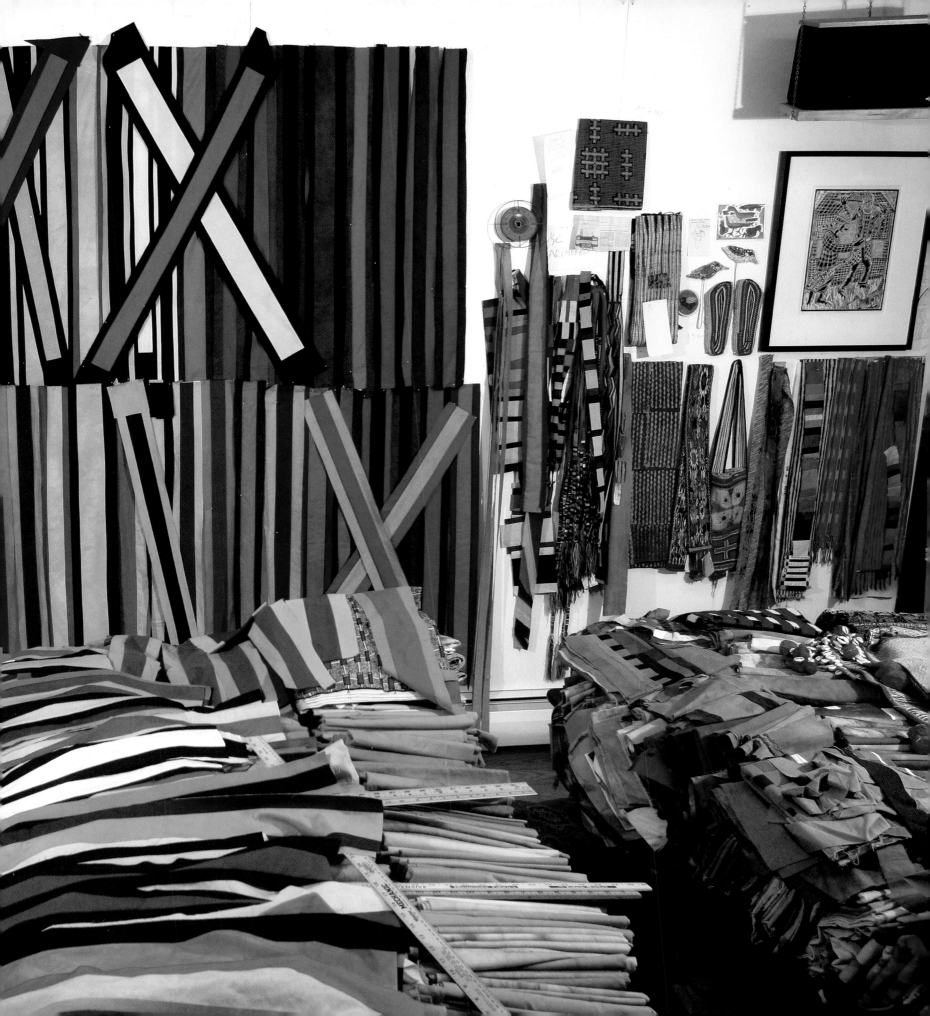

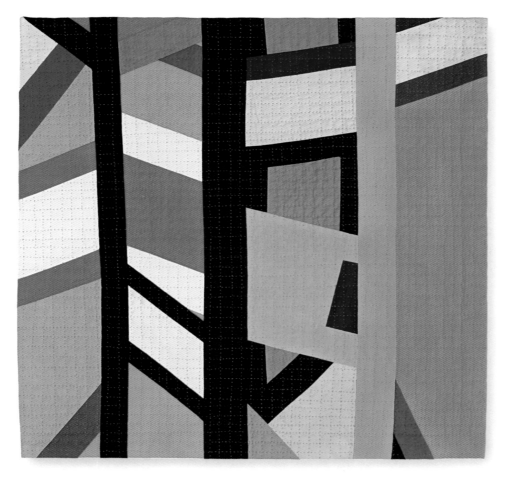

Constructions #87, ©2007.
21⅛" × 20⅝". 100 percent cottons. Hand-
dyed, strip-pieced, restructured, and then
compositionally machine-pieced by Nancy Crow.
Hand-quilted by Brenda Stultz with pattern
denoted by Nancy Crow.

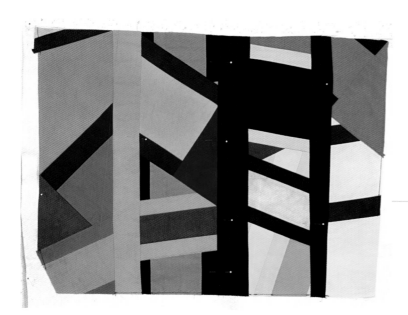

Constructions #89 in progress.

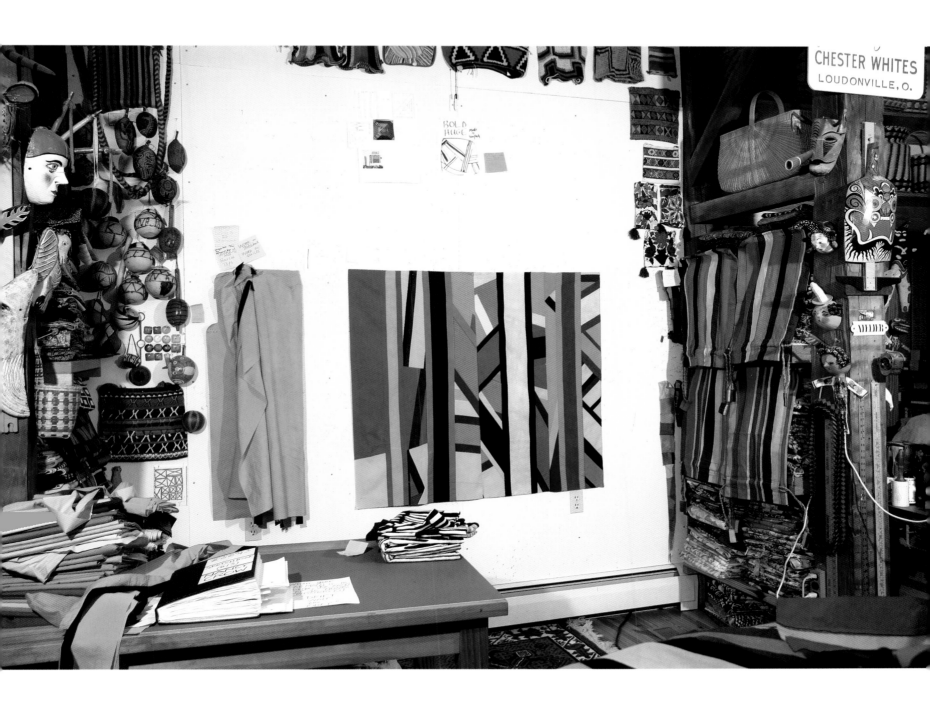

Constructions #88: YES! in progress on the west wall of Studio #1. The quilt was incomplete at the time of publication.

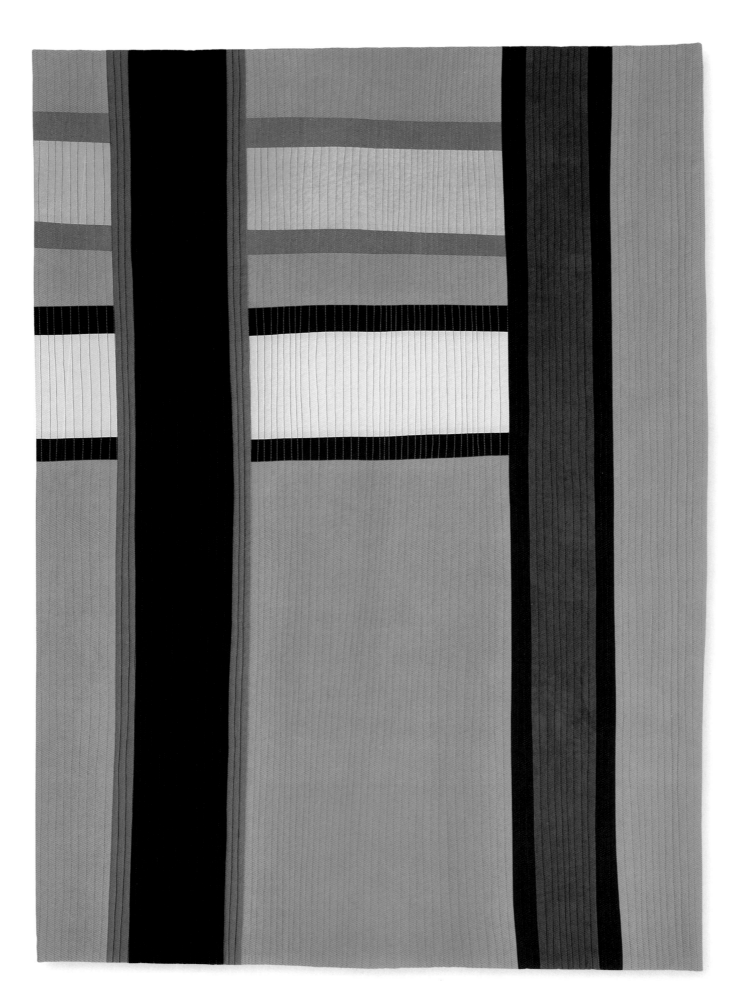

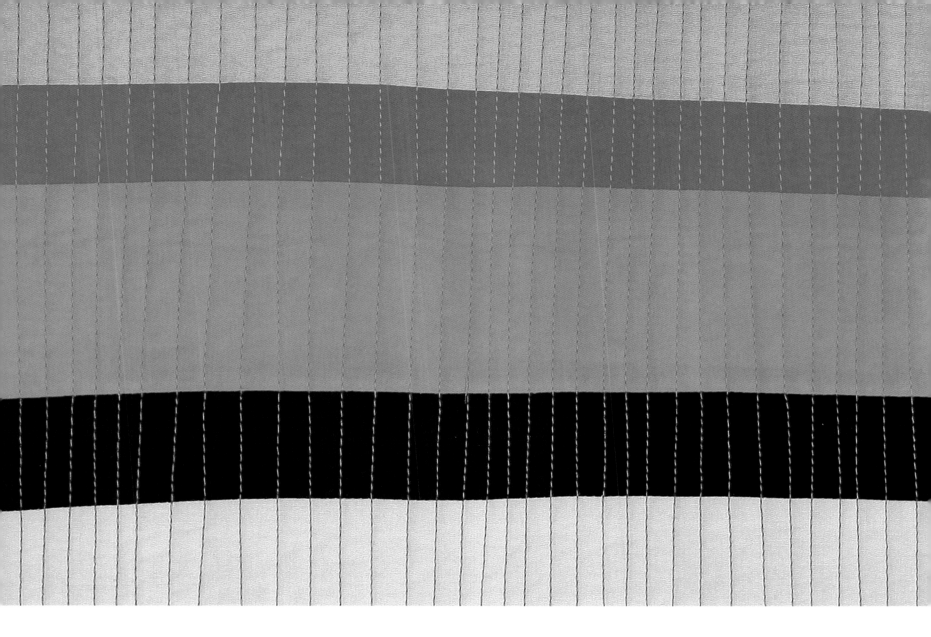

Constructions #90 , ©2007.

29 ¼" × 42". 100 percent cottons. Hand-dyed, strip-
pieced, restructured, and then compositionally
machine-pieced by Nancy Crow. Hand-quilted by
Kathleen Loomis with pattern denoted by Nancy Crow.

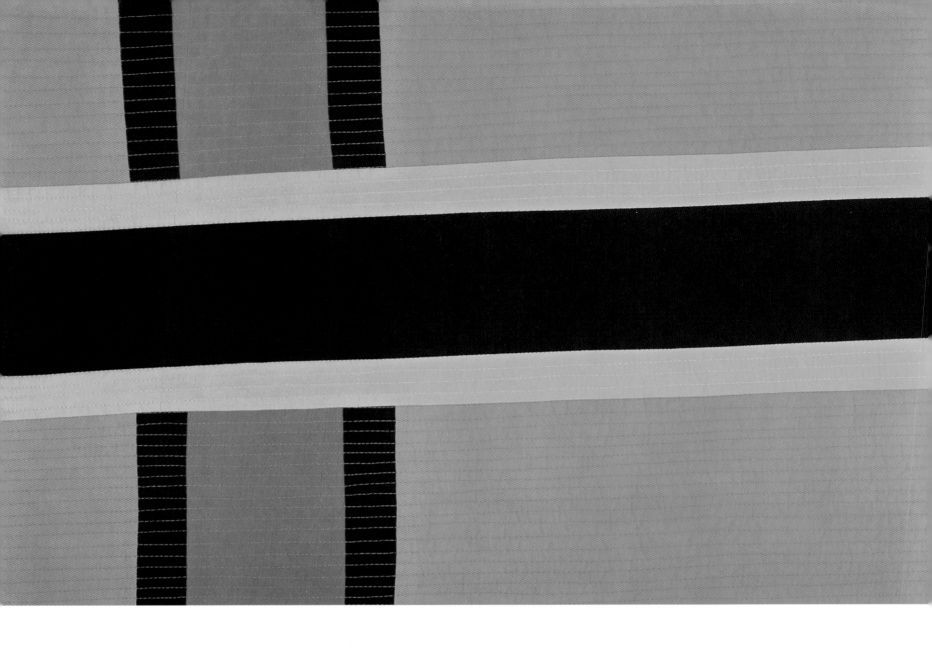

Constructions #91, © 2007.
41 ½" × 44". 100 percent cottons. Hand-dyed, strip-
pieced, restructured, and then compositionally machine-
pieced by Nancy Crow. Hand-quilted by Kathleen Loomis
with pattern denoted by Nancy Crow.

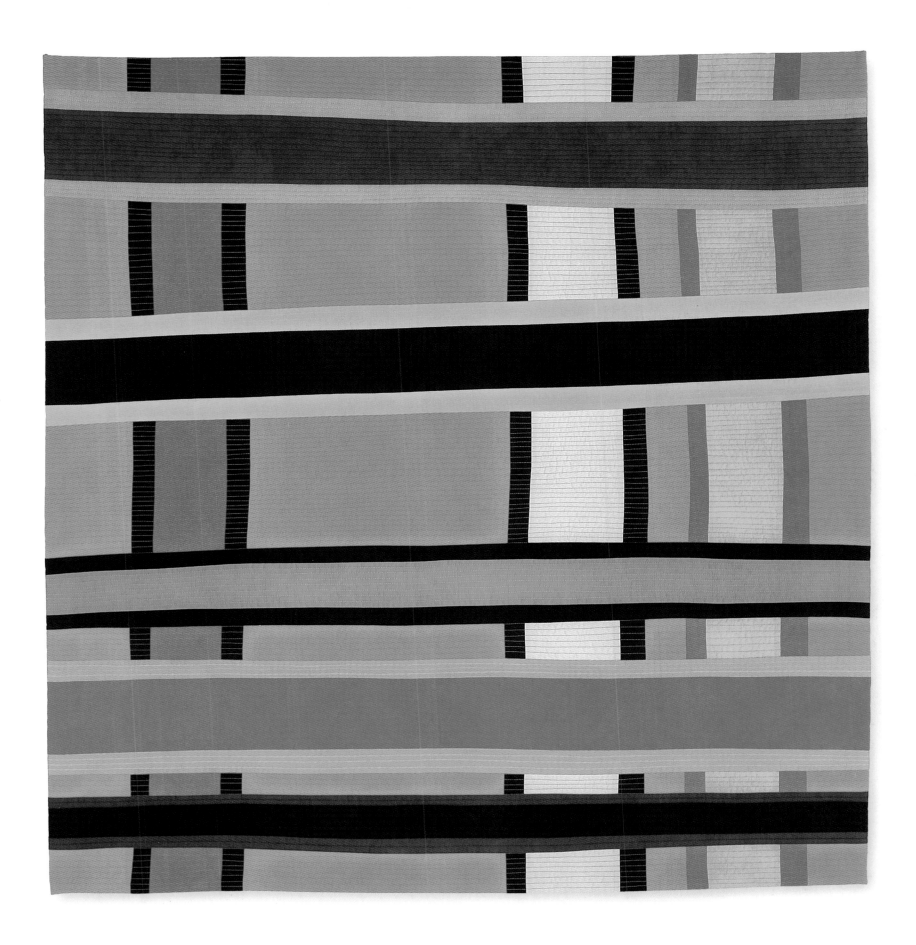

Constructions #92 , ©2007.

56" × 42 ¼". 100 percent cottons. Hand-dyed, strip-
pieced, restructured, and then compositionally machine-
pieced by Nancy Crow. Hand-quilted by Kathleen Loomis
with pattern denoted by Nancy Crow.

July 15, 2007 | SKETCHBOOK NOTES

*I do believe this body of work will look cohesive when all the parts are in place …
but the work will definitely swing over a wide, wide range of sensibility, from very
aggressive to very gentle, which is probably a true reflection of my personality and
feelings. I know this body of work is true of me and authentic.*

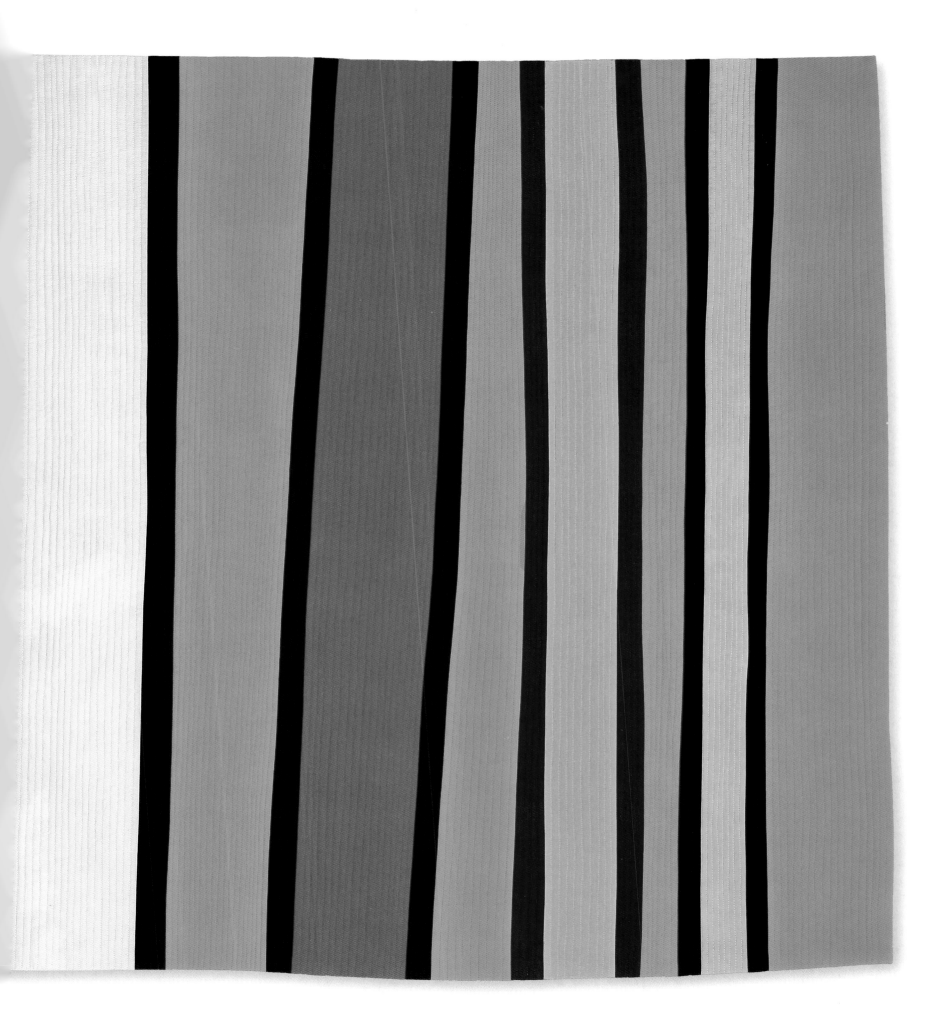

2006 to 2007
Markings

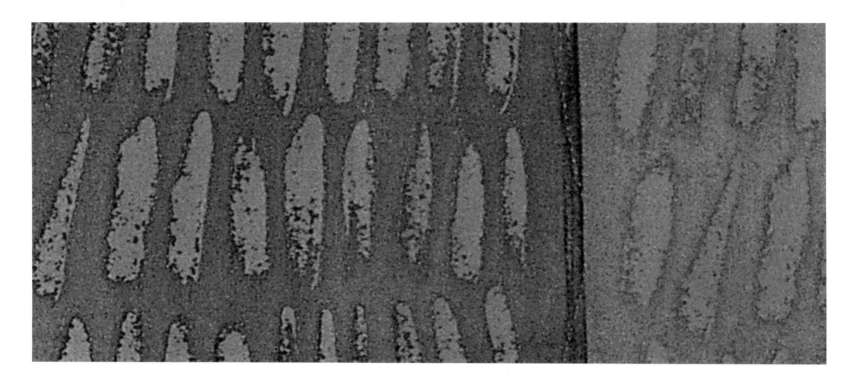

Markings #1: The Known and the Unknown,
©2006 (November to December).
72" × 77". 100 percent cottons. Screenprinted, hand-dyed,
and machine-pieced by Nancy Crow. Hand-quilted by
Marla Hattabaugh with pattern denoted by Nancy Crow.

Markings is an exploration of CALLIGRAPHIC MARK MAKING applied to quilt construction. Crow has written, 'I began making Markings using paintbrush and screens. I have always loved screen-painting but never learned how to do it. So I started very INFORMALLY and went at it in MY OWN WAY.'
DAVID HORNUNG

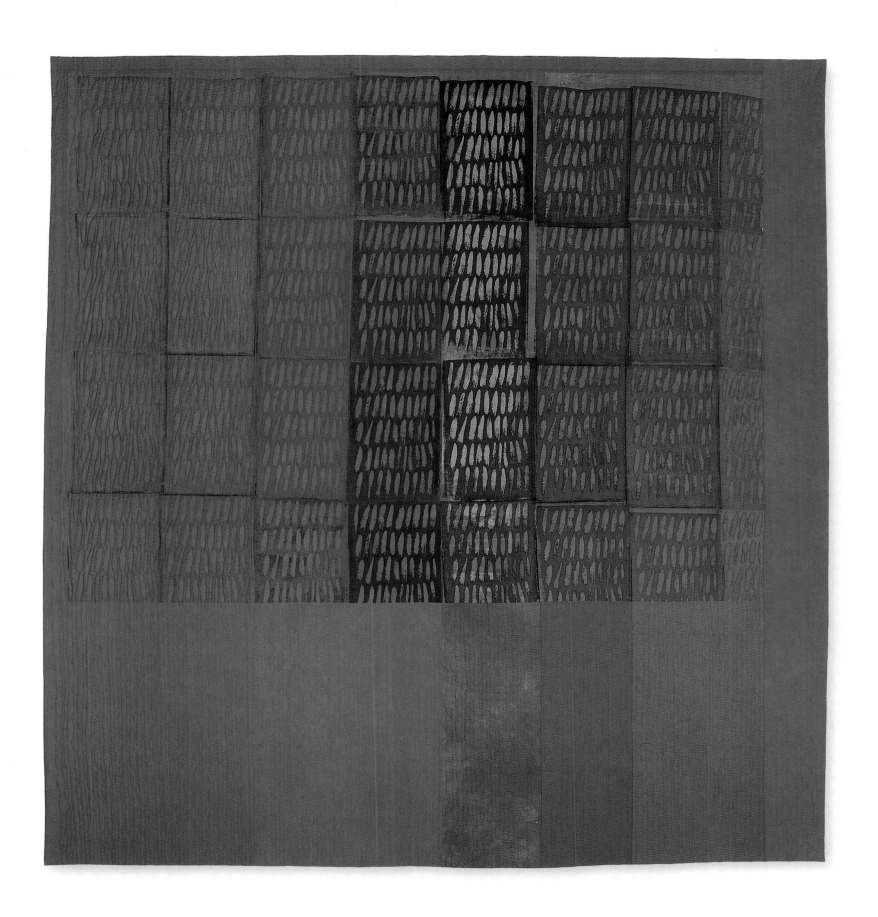

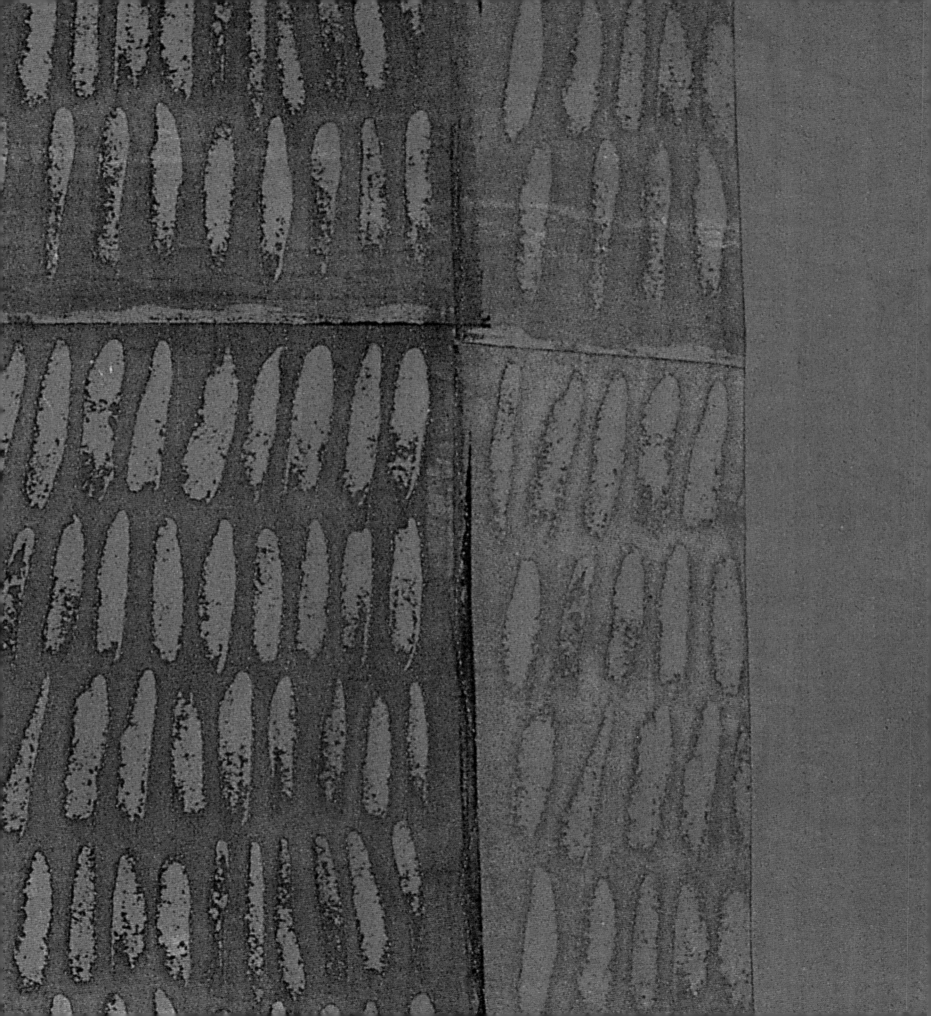

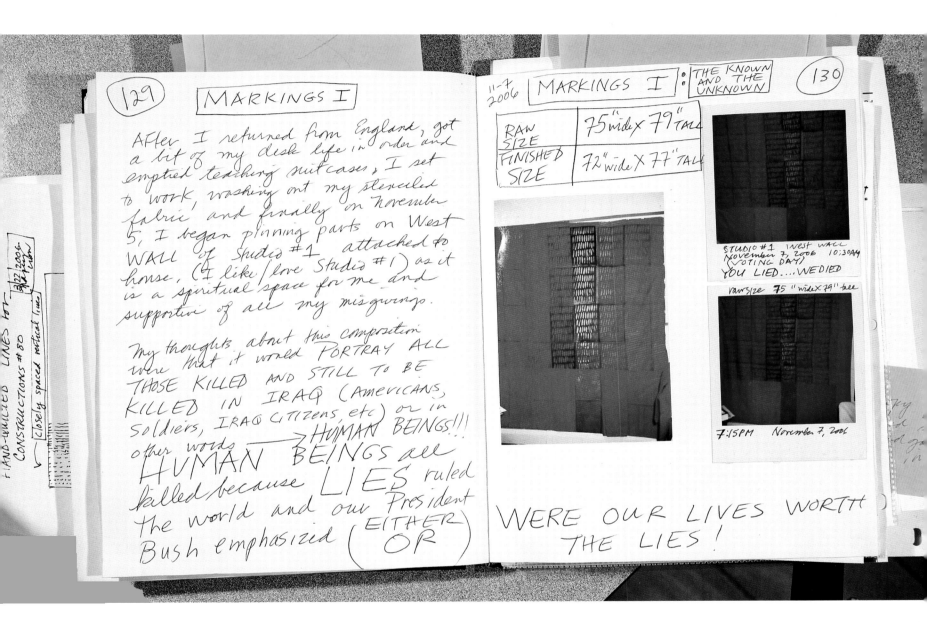

129 | MARKINGS I

After I returned from England, got a bit of my desk life in order and emptied teaching suitcases, I set to work, washing out my stenciled fabric and finally on November 5, I began pinning parts on West WALL of Studio #1 attached to house, (I like/love Studio #1) as it is a spiritual space for me and supportive of all my misgivings.

My thoughts about this composition were that it would PORTRAY ALL THOSE KILLED AND STILL TO BE KILLED IN IRAQ (AMERICANS, Soldiers, IRAQ CITIZENS, etc) or in other words → HUMAN BEINGS!!! HUMAN BEINGS all killed because LIES ruled the world and our President Bush emphasized (EITHER OR)

11-7 2006 | MARKINGS I : THE KNOWN AND THE UNKNOWN | **130**

| RAW SIZE | 75" wide X 79" TALL |
| FINISHED SIZE | 72" wide X 77" TALL |

STUDIO #1 WEST WALL
November 7, 2006 10:30AM
(VOTING DAY)
YOU LIED....WE DIED

raw size 75" wide X 79" tall

7:15PM November 7, 2006

WERE OUR LIVES WORTH THE LIES !

HAND-QUILTED LINES but → CONSTRUCTIONS #80 3/22/2006
closely spaced vertical lines

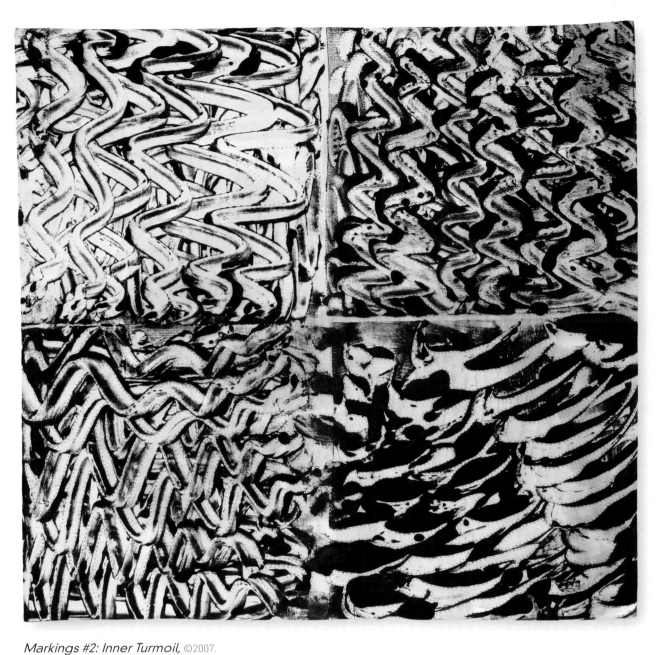

Markings #2: Inner Turmoil, ©2007.
20 ¾" × 20 ½". 100 percent cotton. Monoprinted and
hand-dyed by Nancy Crow. Hand-quilted by Marla
Hattabaugh with pattern denoted by Nancy Crow.

Markings #3: Inner Turmoil, ©2007.
20" × 21". 100 percent cotton. Monoprinted and hand-dyed
by Nancy Crow. Hand-quilted by Marla Hattabaugh with
pattern denoted by Nancy Crow.

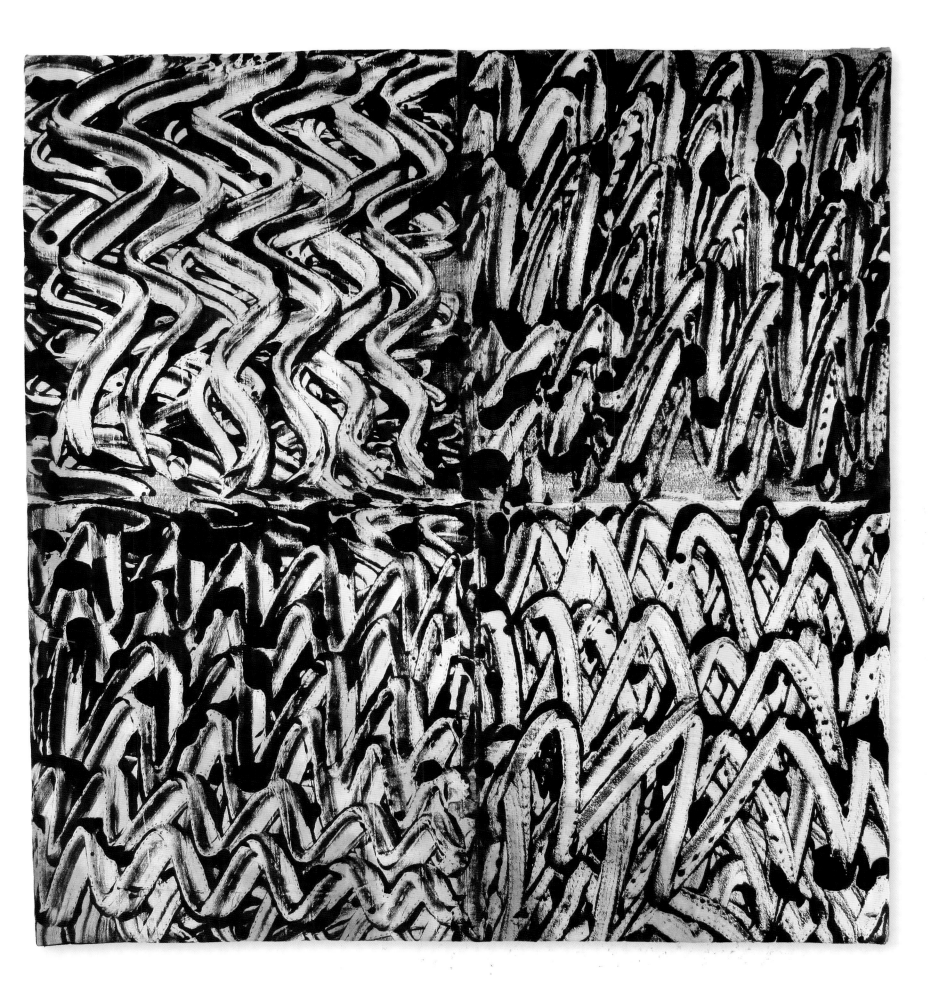

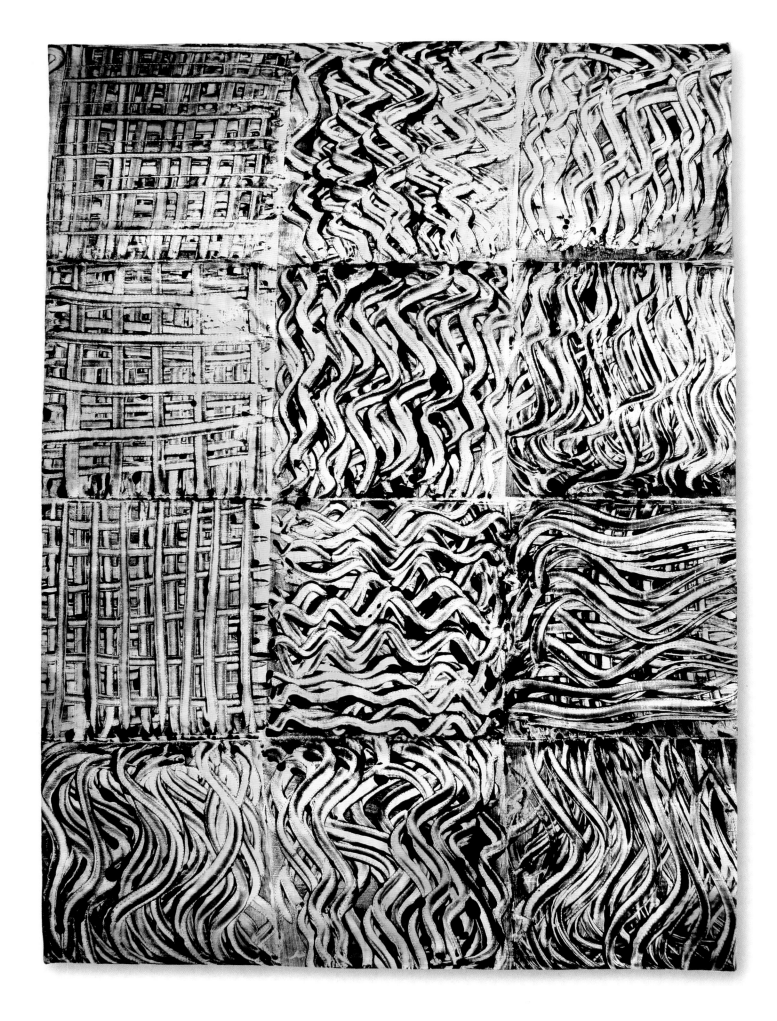

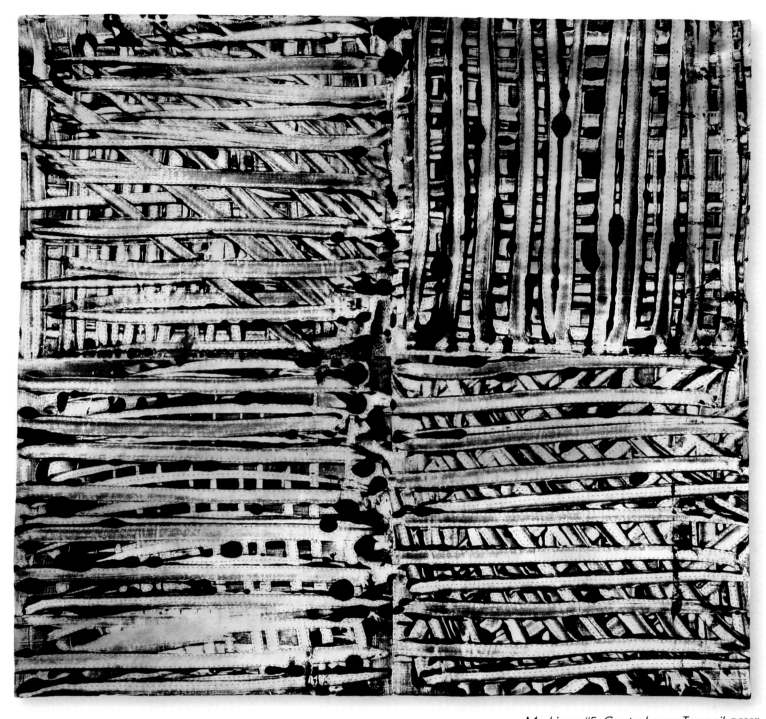

Markings #5: Control over Turmoil, ©2007. 21 ¾" × 20 ¾". 100 percent cotton. Monoprinted and hand-dyed by Nancy Crow. Hand-quilted by Marla Hattabaugh with pattern denoted by Nancy Crow.

Markings #4: Trying to Control Anxiety, ©2007. 30 ½" × 42". 100 percent cotton. Monoprinted and hand-dyed by Nancy Crow. Hand-quilted by Marla Hattabaugh with pattern denoted by Nancy Crow.

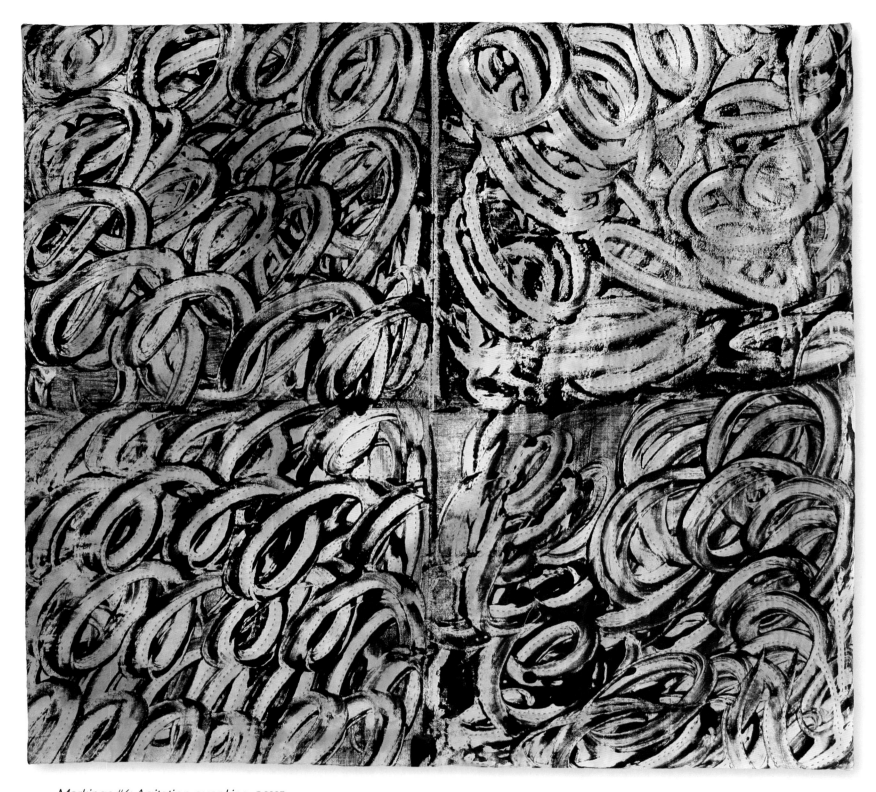

Markings #6: Agitation over Lies, ©2007.

20 ½" × 19". 100 percent cotton. Monoprinted and hand-
dyed by Nancy Crow. Hand-quilted by Marla Hattabaugh
with pattern denoted by Nancy Crow.

(143) december 16, 2006

I am always coming to Terms:

with [goals]
[needs]
→ especially needs ←

[anger]

(I AM incredibly angry today)

3:30 PM
Nancy Crow
Dec 16, 2006

such intense anger sometimes so focused it scares me

sometimes so vast that I do not know where it comes from

[sacrifices]

the sacrifices one will make to clear the road ahead aside from unforseen circumstances,

Coming to Terms with

- goals
- needs
- Sacrifices (?)
 another word
 one will make
 to clear the
 road ahead
 aside from
 unforseen
 circumstances

(144)

EARLIER THIS YEAR IN AUGUST 2006

I wrote: "I AM NOW IN A "STRUGGLE"= AN OVERWHELMING "STRUGGLE"= WITH PILES THAT OVERTAKE AND OBSTRUCT MY ABILITY TO WALK THROUGH

CLOGGED PATHWAYS AND PILES COVERING ALL WORK SURFACES AND THE FLOORS..... EVERYWHERE. NO QUIET SPACE LEFT! NO PLACE TO THINK!

PILES BLOCKING BOOKS THAT IN TURN BLOCK MORE BOOKS!

IS THIS SICK? NON- PRODUCTIVE WHY?"

Rewritten JANUARY 2, 2007
Nancy Crow

Pages in Nancy Crow's sketchbooks to which she returned several times during the period the quilts in the exhibition were made.

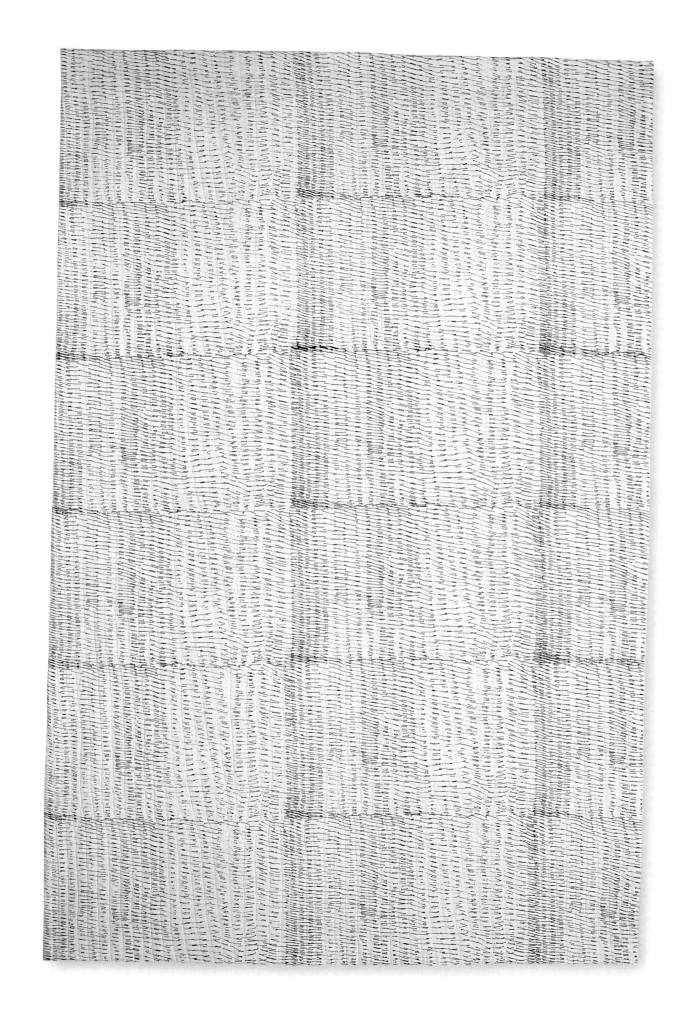

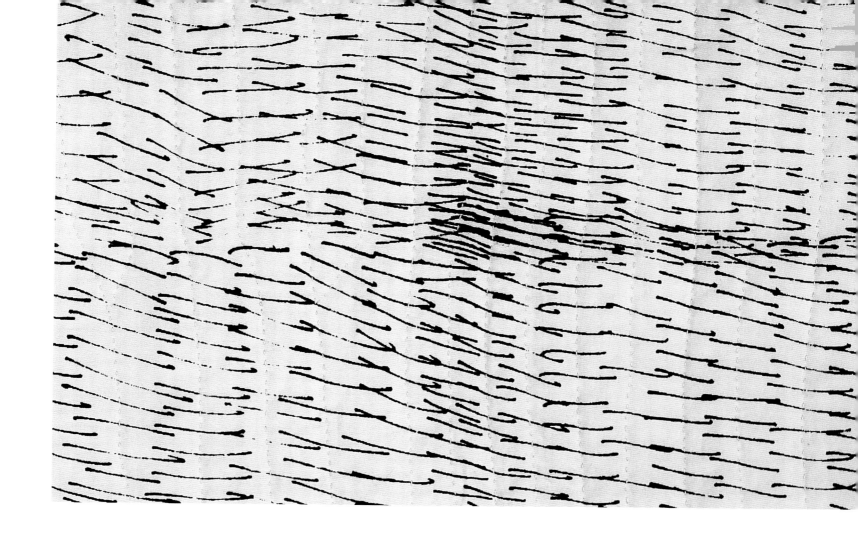

Markings #7: Quiet Beauty, ©2006-2007.
42" × 67". 100 percent cotton. Screenprinted by Nancy
Crow with assistance of Emma Rees. Hand-dyed by
Nancy Crow. Hand-quilted by Marla Hattabaugh with
pattern denoted by Nancy Crow.

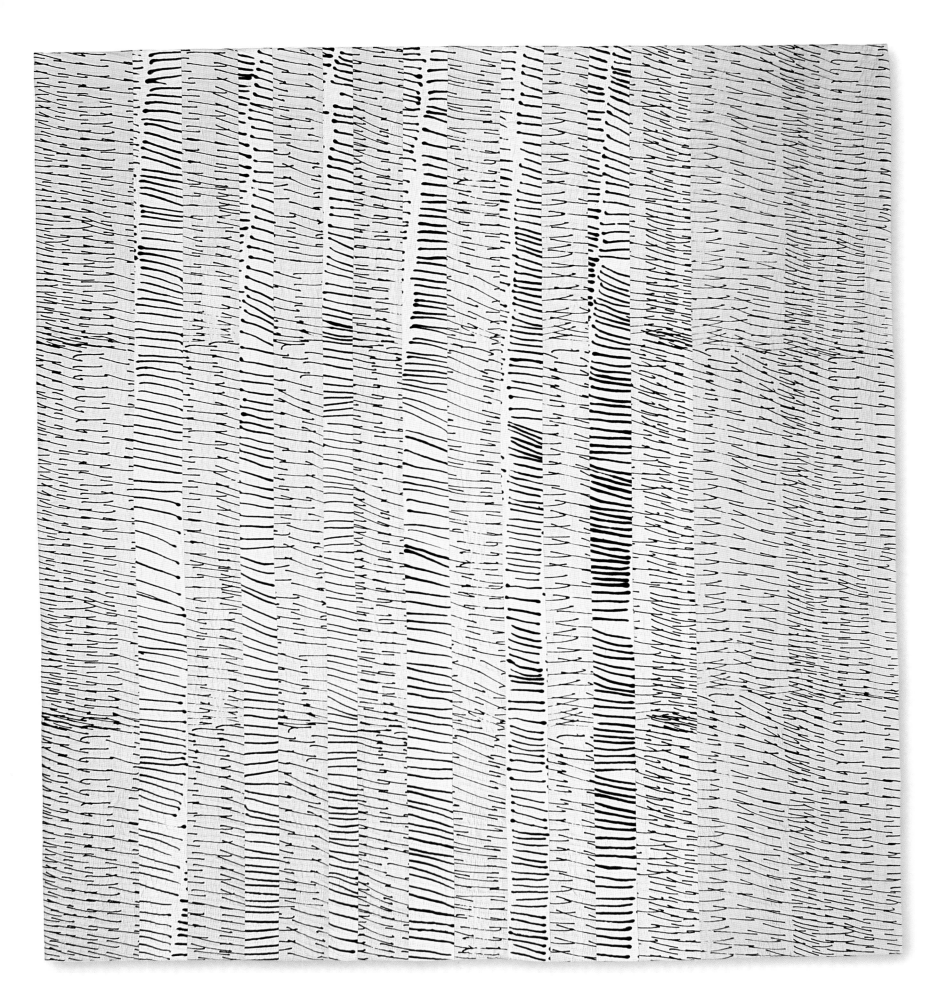

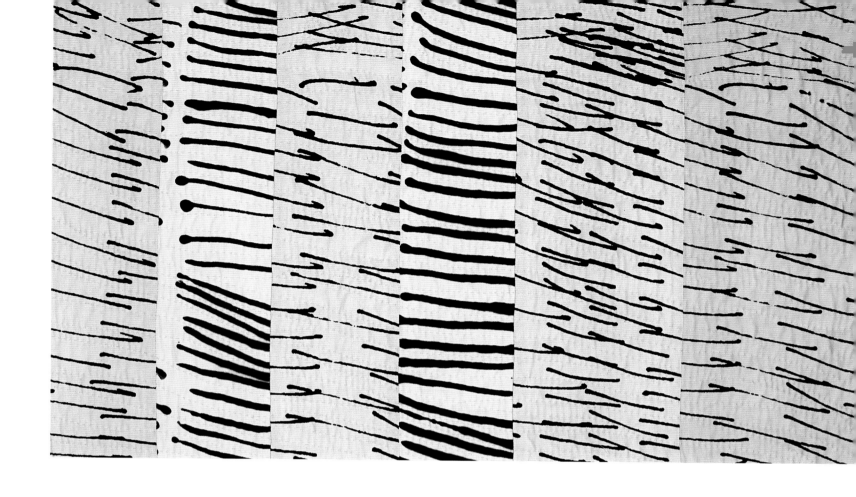

Markings #8: Broken Quiet, ©2006-2007.
55 ½" × 60 ¾". 100 percent cotton. Screenprinted by Nancy
Crow with assistance of Emma Rees. Painted, over-dyed,
and machine-pieced by Nancy Crow. Hand-quilted by
Marla Hattabaugh with pattern denoted by Nancy Crow.

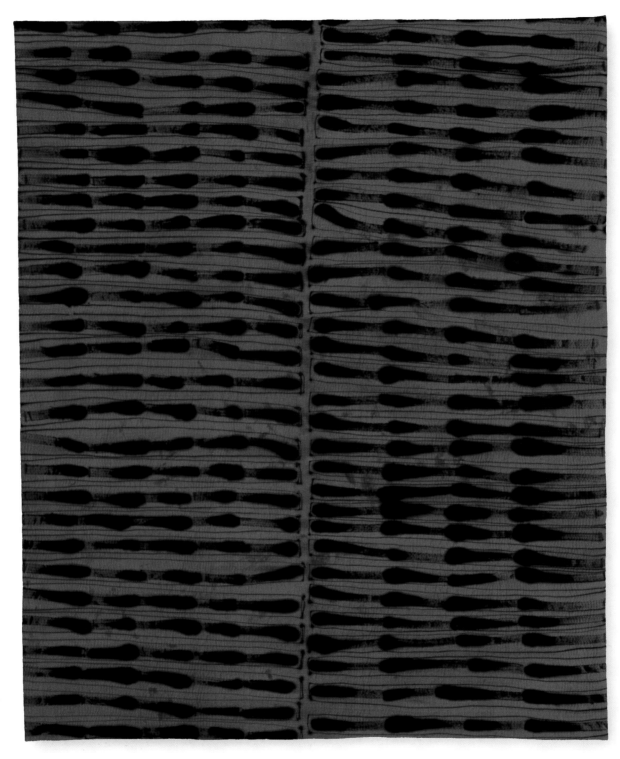

Markings #9: Compromise, ©2006-2007.

32" x 40 ½". 100 percent cotton. Hand-painted and over-

dyed by Nancy Crow. Hand-quilted by Marla Hattabaugh

with pattern denoted by Nancy Crow.

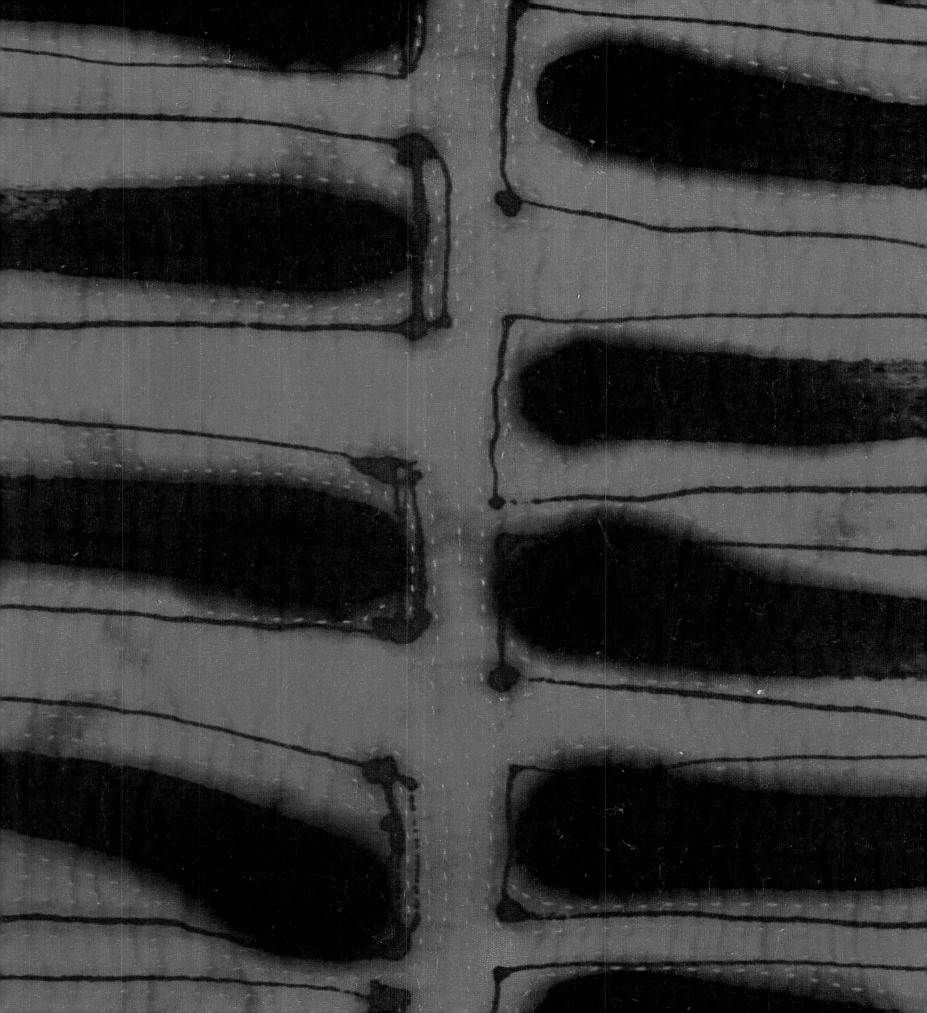

Structures

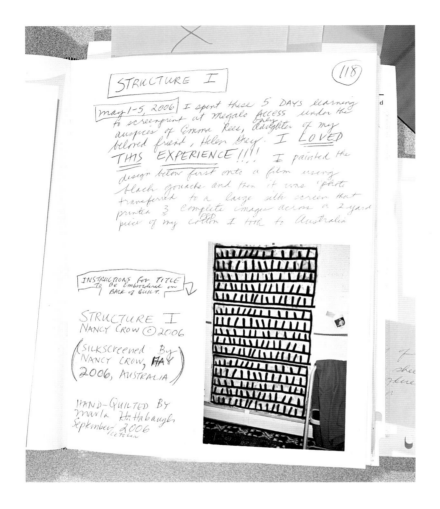

Structure #1, ©2006.
42" × 68 ½". 100 percent cottons. Hand-screened by
Nancy Crow with assistance of Emma Rees. Hand-quilted
by Marla Hattabaugh with pattern denoted by Nancy Crow.

Crow's Structure's series grows out of Markings in its use of screen-printing and the way in which the QUILTING ECHOES THE PRINTED IMAGE. *In Structures, however, there is little or no piecing. Crow silk-screens her design on whole cloth, and then has it hand-quilted. The* REPETITION *of the screen to build a grid or any other sequential motif echoes the pieced quilt in that a design is composed of* BLOCKS OF VISUAL INFORMATION *assembled to make a whole.* DAVID HORNUNG

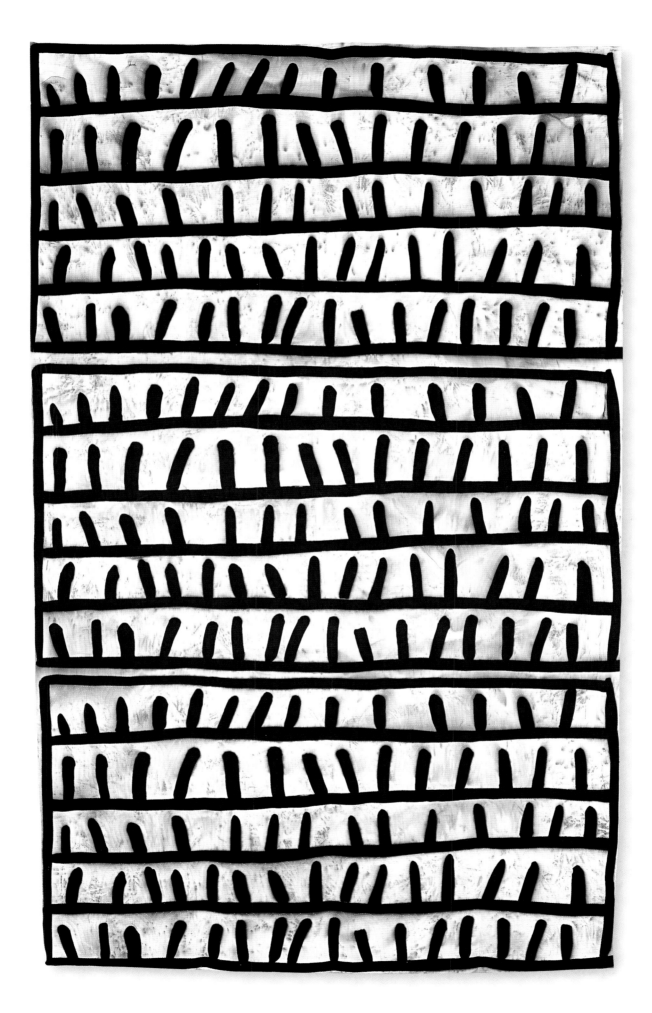

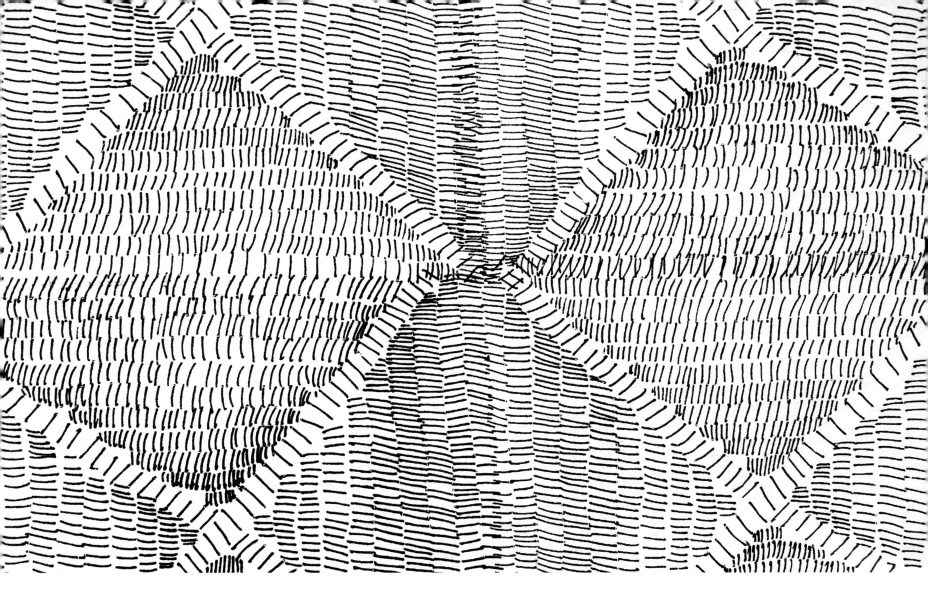

Structure #2, ©2006.

40 ½" × 67". 100 percent cotton. Hand-screened
by Nancy Crow with assistance of Emma Rees.
Hand-quilted by Marla Hattabaugh with pattern
denoted by Nancy Crow.

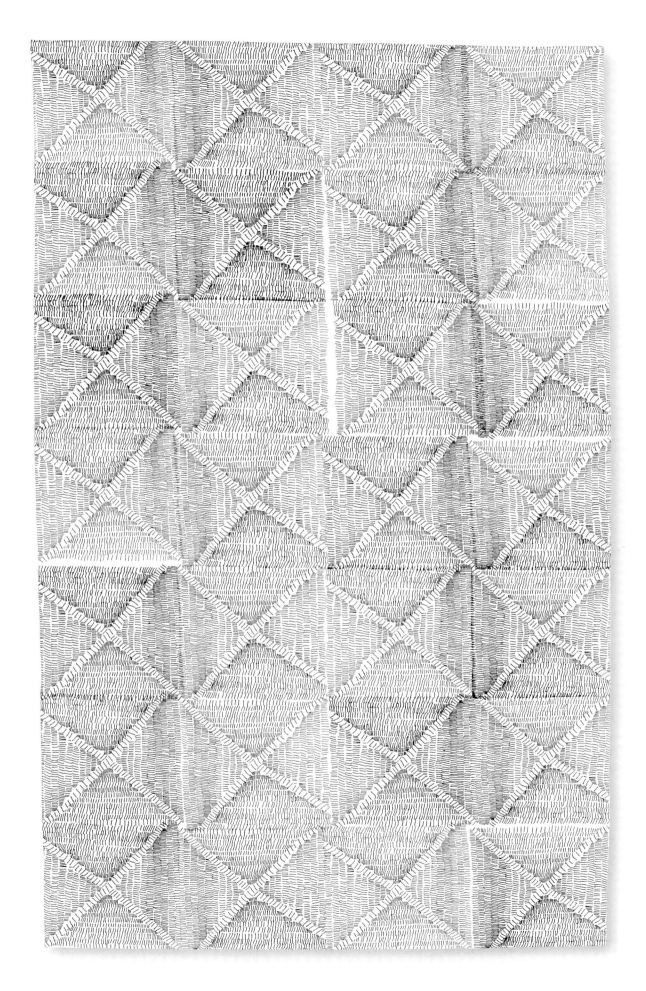

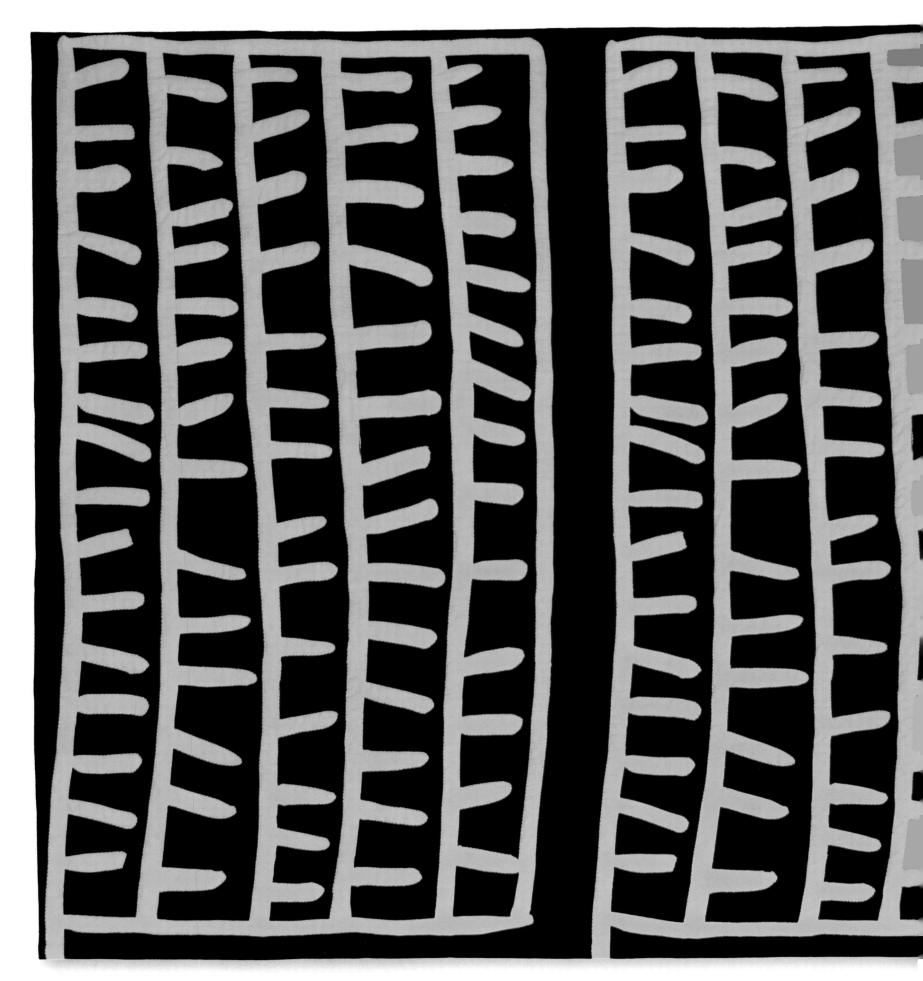

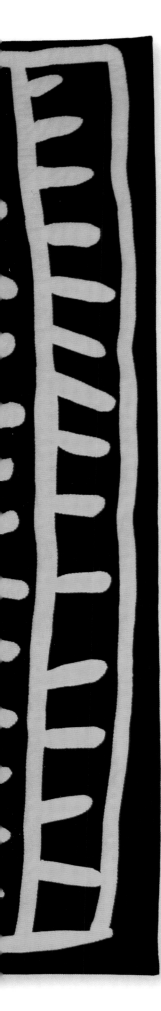

Structure #3, ©2007.

48 ½" × 42 ¾". 100 percent cotton. Hand-screened
by Nancy Crow with assistance of Emma Rees.
Hand-quilted by Marla Hattabaugh with pattern
denoted by Nancy Crow.

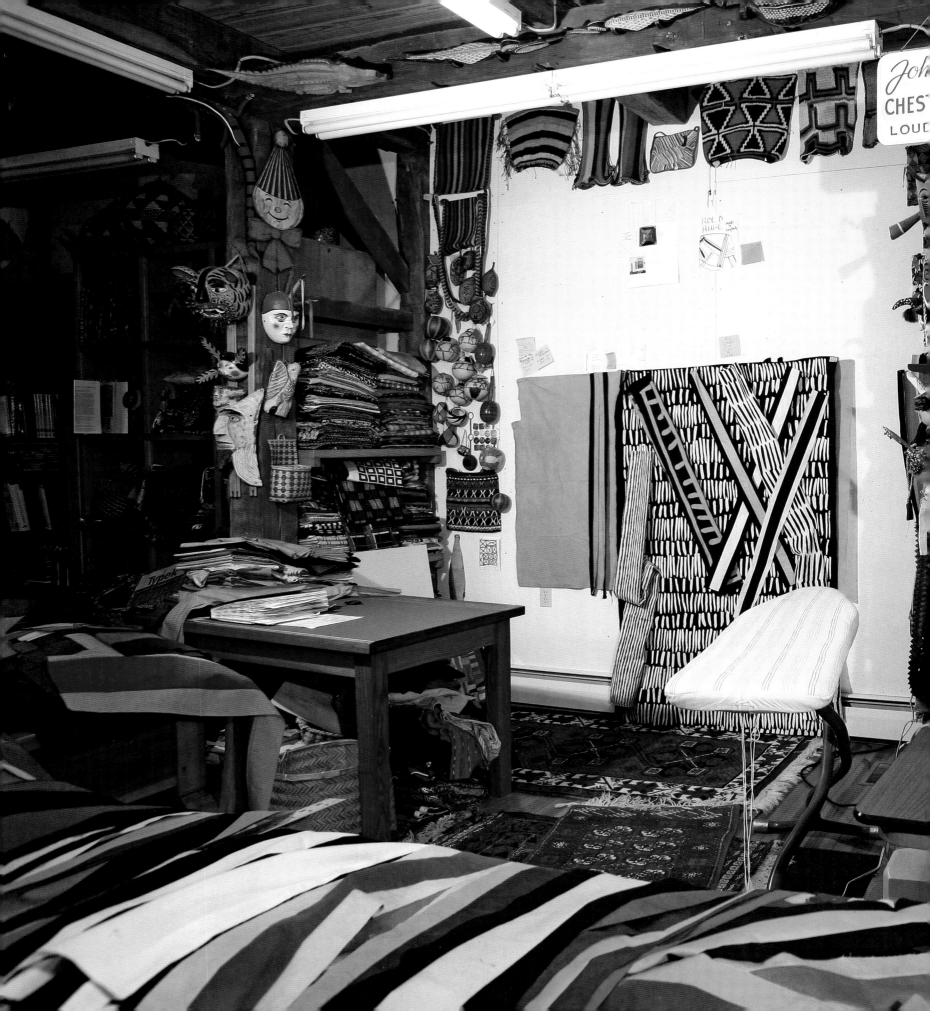

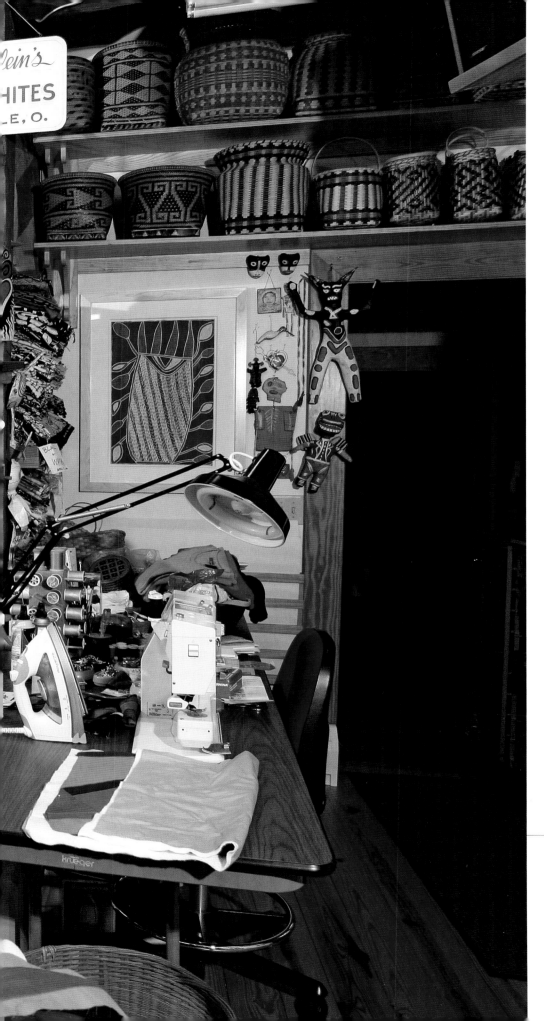

The west wall of Studio #1, with beginning ideas
for the start of a new pieced composition combining
screen-printed and solid fabrics (July 10, 2007)

BIOGRAPHY

OCCUPATION
Artist

MEDIUM
Quiltmaking

EDUCATION
Bachelor (1965) and Master (1969) of Fine Arts in Ceramics and Weaving from Ohio State University

PUBLISHED BOOKS
Nancy Crow. Elmhurst (Chicago), IL: Breckling Press, 2006
Nancy Crow: Improvisational Quilts. Concord, CA: C&T Publishing, 1995
Gradations: From the Studio of Nancy Crow. Saddlebrook, NJ: Quilt House Publishing, 1995
Nancy Crow: Work in Transition, Peducah, KY: American Quilters' Society, 1992
Nancy Crow: Quilts and Influences, Peducah, KY: American Quilters' Society, 1990

FABRIC DESIGN
Nancy Crow for Kent Avery, produced by Westwood, Inc., New York, NY

EXCHANGE ARTIST
Mainland China, Shaanxi Province, sponsored by The Ohio Arts Council, 1990

QUILT VENUE ORIGINATION
Quilt National
Quilt/Surface Design Symposium
Art Quilt Network

AWARDS
1999: Named a Fellow of the American Craft Council, New York, NY
1997: Inducted into the Quilters Hall of Fame, Marion, IN
1996: National Living Treasure Award, University of North Carolina at Wilmington

GRANTS
2002, 1996, 1988, 1985, 1982, and 1980: Individual Artist's Fellowships from The Ohio Arts Council
1990-1991: Major Fellowship from The Ohio Arts Council
1980: Craftsmen's Fellowship from The National Endowment for the Arts

MUSEUM COLLECTIONS
The Renwick Gallery, The Smithsonian Institution, Washington, D.C
The Museum of Arts & Design, New York, NY
The Museum of American Folk Art, New York, NY
Miami University Art Museum, Oxford, OH
Indianapolis Museum of Art, Indianapolis, IN

UPCOMING AND RECENT EXHIBITIONS

2008
Nancy Crow (Solo Exhibition), The Butler Institute of American Art, Youngstown/Trunbull, OH
Nancy Crow: Cloth, Culture, Context (Solo Exhibition), International Quilt Study Center, University of Nebraska, Lincoln, NE
Invitational—Saturn Returns: Back to the Future of Fabric Art, San Jose Museum of Quilts & Textiles, San Jose, CA

2007
Crossroads: Constructions, Markings, and Structures (Solo Exhibition), The Snyderman Gallery, Philadelphia, PA

2005
The Textural Revolution: Early & Recent Works by Dorothy Gill Barnes and Nancy Crow, Johnson Humrickhouse Museum, Coshocton, OH
Nancy Crow: Constructions—Color & Spatial Relationships, Auckland Museum, Auckland, New Zealand
High Fiber: Objects from the Renwick's Permanent Collection, Renwick Gallery of the Smithsonian American Art Museum, Washington, D.C.
Art Quilt Art, The Quiltfestival Höri 2005, Lake Constance, Germany
Magnificent Extravagance: Artists & Opulence, Racine Art Museum, Racine, WI
Nancy Crow: Constructions—Color & Spatial Relationships, Hawke's Bay Exhibition Centre, Hastings, New Zealand
Of Time and Place: Contemporary Layered and Stitched Textiles, Houston Center for Contemporary Craft, Houston, TX

2004
280/Parameters, Huntington Museum of Art, Huntington, WV
The Quilted Surface, Indiana University Southeast, New Albany, IN
Fourth Biennial Fiber Survey Exhibition, The Snyderman-Works Galleries, Philadelphia, PA
Textilekunst und Quilts, Hermann Hesse Museum & Höri Art Gallery, Lake Konstanz region, Germany
Artist as Quiltmaker, Oberlin, OH
Art-Quilt-Art, Indiana University of PA
The Textural Revolution: Early & Recent Works by Dorothy Gill Barnes and Nancy Crow, Johnson Humrickhouse Museum, Coshocton, OH

Constructions: Color & Spatial Relationships, Nancy Crow Retrospective, Auckland Museum, Auckland, New Zealand

2003
Invitational Exhibit, The Richard M. Ross Art Museum, Ohio Wesleyan University
Fiber Art Today: An Encore Presentation, Mobilia Gallery, Cambridge, MA
Fabric Constructions, Leedy-Voulkos Art Center, Kansas City, MS
Ohio Pioneers of the Art Quilt, Snowden Gallery, Ohio State University
280/Parameters, Huntington Museum of Art, Huntington, WV
Cheongju International Craft Biennale, Cheongju, Korea

2002
30 Distinguished Quiltmakers of the World, Tokyo Dome Stadium, Tokyo, Japan
Textiles Two Thousand Two, Center for Creative Studies, Detroit, MI
SOFA, New York, NY
Eloquent Threads: The Daphne Farago Fiber Art Collection, Museum of Fine Arts, Boston, MA
Mary Barringer and Nancy Crow, Snyderman Works Gallery, Philadelphia, PA

2001
Ground Cover: Contemporary Quilts, McIlroy Gallery, Niceville, FL
Crow Timber Frame Barn, Baltimore, OH
Quilt National, Athens, OH
Quilt Berlin Symposium, Berlin, Germany
Solo, Elzay Gallery, Ada, OH
Celebrating Contemporary Crafts, 2001, Providence Art Club, Providence, RI
SOFA, Chicago, IL
New Forms in Fiber: Trends and Traditions, Mobilia Gallery, Cambridge, MA

2000
Surface-Strength-Structure, Snyderman/Works Gallery, Philadelphia, PA
Nancy Crow: Quilts in Depth, Strasbourg, France
Small Works, The Gallery at Studio B, Lancaster, OH
Eclectic Energy, The Gallery at Studio B, Lancaster, OH
Visual Rhythms, Thirteen Moons Gallery, Santa Fe, NM

Nancy Crow maintains a large studio on her farm in Baltimore, Ohio. For more information, visit www.nancycrow.com.

THE WORLD OF THE

PARANORMAL

© Orbis Publishing Ltd 1995

Published By Grange Books
An Imprint of Grange Books PLC
The Grange
Grange Yard
London SE1 3AG

This edition published 1995

This material has previously appeared in the
partwork *The Unexplained*

Printed in the Republic of Slovakia
51631

ISBN 1 85627 720 8

THE WORLD OF THE

PARANORMAL

A UNIQUE INSIGHT INTO THE UNEXPLAINED

Grange
BOOKS

INTRODUCTION

An amazing new world is about to unfold before
your eyes. A world which baffles scientists and
sceptics alike. A world which intrigues every one of
us. A world which defies rational explanation.

The World of the Paranormal is the definitive work
on the spectrum of the Unexplained.
From the deepest recesses of the subconscious
mind to the infinity of outer space, this book will
introduce you to marvels and mysteries that will
haunt your imagination. With more than fifty
articles on Strange Phenomena, New Horizons,
Mindpower, Enigmas and matters Out of this
World, here is a book that could change your life...

Welcome to the World of the Paranormal...

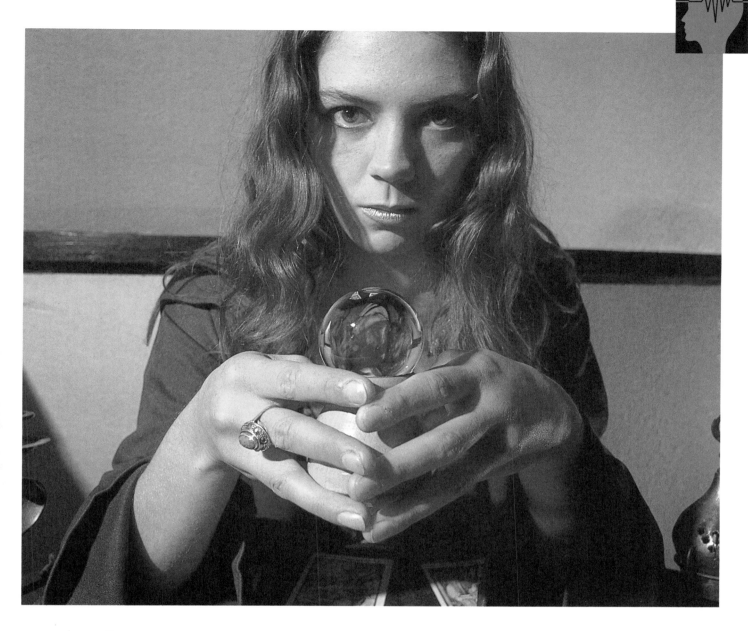

BORN TO BE PSYCHIC?

The clairvoyant will sometimes use a crystal ball as an aid to concentration. But the actual gift of extra-sensory perception is thought by some to be inborn, and even to be influenced by factors such as diet and sexuality.

ARE SOME PEOPLE MORE LIKELY TO BE PSYCHIC THAN OTHERS SIMPLY BECAUSE OF THEIR RACE OR EVEN THEIR BLOOD GROUP? A CONTROVERSIAL THEORY SUGGESTS THAT BEING PSYCHIC COULD BE A MATTER OF HEREDITY

A psychic is someone in whom extrasensory perception – telepathy, clairvoyance or precognition, for instance – shows itself at an unusually high level. A degree of *psi* (another term for psychic abilities) probably exists at some level in all humans, and is known to surface more easily in the young. Indeed, small children often have a telepathic link with a brother or sister, and almost always have such a bond with a parent, at least until more precise communication, through use of words, begins to develop. Psychiatrist Dr Berthold Schwarz even recorded 1,520 instances of *psi* among his own children up to the time they were 15 years old. Schwarz concluded that telepathy among family members is much more frequent than has often been supposed; but, because such telepathic

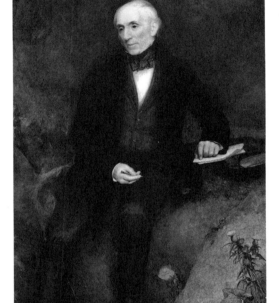

communication is rarely of a significant nature, it passes unrecorded and without comment.

Another reason why this form of *psi* may go unnoticed is that we are often unaware that we are receiving information telepathically. Some years ago, researchers at Newark College of Engineering in New Jersey, USA, set out to prove this in the laboratory. Two volunteers were seated in different rooms: one was given a list of names, some but not all of which were relevant to the other sitter, who was wired to a machine that plotted changes in blood pressure. When the experiment began, the person with the list was told to concentrate on the different names in random order. It was shown that whenever a name came up that was known to the other sitter, the machinery to which he was connected registered a slight change in blood pressure. Importantly, he must have been receiving information at a subliminal level: at no point did the sender announce that he was thinking of a specific name;

William Wordsworth (1770-1850), below left, the English Romantic poet, believed that children are born 'trailing clouds of glory' – that is, that they are still in touch with a spiritual realm. It is only the process of growing up, he held, that gradually ruins their innocent insight.

Research has indicated that environmental factors often influence psychic ability. Tibetans, such as the monks below, for instance, living almost in isolation from the rest of the world and traditionally leading a simple, spiritual life, are widely believed to possess particularly strong psychic powers.

Diet is also claimed by some to be a major factor in inducing psi. *In the West, vegetarianism is believed to make its adherents psychic. Yet some people who are almost exclusively carnivores, such as the Eskimo, below right, are legendary clairvoyants.*

rather, the telepathic interaction was played out subconsciously, measurable only by the physiological changes in blood pressure.

Psychic awareness probably diminishes as a child learns how to speak and concentrate on a task in hand. As he grows older, he no longer allows himself to be distracted by a ticking clock or passing traffic; and, in the process of blocking out such irrelevant data, he may also unwittingly shut out information he is receiving telepathically.

There are, however, various possible reasons why certain children seem able to retain psychic abilities into later life. A child who feels neglected or left out may, for instance, seek, cultivate and publicise *psi* as a way of attracting attention. He may also find that knowledge of some totally unexpected event can put him in the limelight in a most

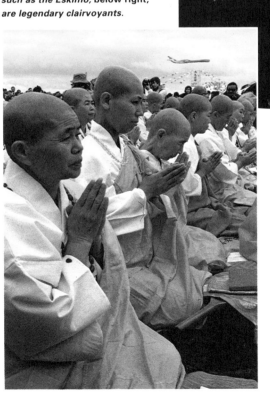

PSI

Michael Bentine, left, the versatile British comedian, is also a committed Spiritualist. Obviously extrovert, he seems living proof of the theory that outgoing and warm personalities are more receptive to psi. Some theorists go further, suggesting that physical type may make a person more or less psychic. Of W.H. Sheldon's three classic physical types, below right, it is the bony, introverted ectomorph who is generally less successful in ESP tests.

The scene, left, is from J. B. Priestley's play An Inspector Calls, about the cumulative guilt of a highly respectable family in bringing about the suicide of a young woman. Just as psychic abilities are believed to run in families, perhaps a group 'fate' can also be inherited.

to suffer from weak ligaments. American psychologist Dr W. H. Sheldon also investigated a possible link between physique and personality, but his theories have since been disputed.

Sheldon studied the physique of a vast number of subjects, and found that human body types can be described in terms of three main somatotypes – the endomorph, the mesomorph and the ectomorph. Some people, however, do not fall neatly into any of these categories but are a mixture of the three, to some degree.

The typical endomorph is physically plump and emotionally a good mixer; he enjoys comfort, food, drink and social events, and needs company when he is unhappy. Most significantly, the endomorph is predominantly extrovert, and extroverts tend to be more successful than introverts in parapsychological experiments. Other traits that appear to be associated with the high scorer in ESP tests include warmth, sociability, cheerfulness and enthusiasm. (Interestingly, this evidence seems to contradict that presented by mystics who claim that isolation and fasting heighten *psi*.)

The mesomorph, according to Sheldon, also tends to be extroverted, has an athletic, muscular build, and is tough, quick, alert and adventurous. Parapsychologists have discovered that people with these characteristics also seem to do remarkably well in ESP tests.

At the other end of the Sheldon scale are the ectomorphs – those with thin, bony physiques who tend to be tense, excitable, timid, withdrawn and prone to depression. They frequently do badly in laboratory tests of ESP. What remains unclear, however, is whether or not introverts have more spontaneous experiences of ESP.

Another characteristic of the psychic in both primitive and civilised cultures may possibly be disturbances in the electrical functioning of the brain, notably those brought about by epilepsy, once regarded as a 'sacred disease'. It is a belief that continues among certain peoples of the world. When anthropologist Adrian Boshier went to live among the primitive tribes of South Africa, for example, he was accepted by them largely because he had epileptic seizures. Interestingly, too, the

gratifying way. Certain factors, meanwhile, may influence the rate at which psychic awareness fades: its original intensity; the attitude towards psychic phenomena in the society to which the individual belongs; and the effects of climate, diet and day-to-day activity. Individual experiences may have a part to play, too. For example, someone who foresees an event in a dream may, thereafter, pay much more attention to all of his dreams, finding that nocturnal visions do indeed tally with subsequent events in the waking world.

Intriguingly, *psi* does occur much more often in some groups than in others – notably gypsies, Celts and Basques, among whom, oddly and perhaps significantly, Rhesus negative blood is found with unusual frequency.

An attempt to link *psi* with physiological characteristics was made by French researchers in the 1960s. They suggested that mediums tend to have a good deal of hair, to bruise and bleed easily, and

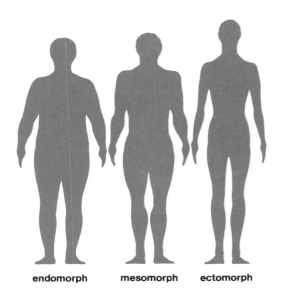

endomorph mesomorph ectomorph

well-known medium Leonora Piper (1857-1950) was also seen to be afflicted by 'small epileptiform seizures' just before going into a trance. Further evidence comes from a paper by the American parapsychologist William G. Roll that appeared in the *European Journal of Parapsychology* in 1978. Entitled *Towards a Theory of the Poltergeist,* it suggests that epilepsy may be connected with poltergeist activity, and that a particularly lively example of the phenomenon may be equivalent to a *grand mal* fit.

The ideas, customs, beliefs and assumptions of the particular social group into which a child is born and brought up will undoubtedly affect his development in every way. A marked degree of paranormal cognition may also be accepted and rationalised. In ancient Greece, for example, in Japan at one time (where there was an official Ministry of Divination

Vincent Van Gogh's **The Sower,** *below, although obviously non-representational, carries the conviction of true vision – as if Van Gogh actually saw the scene as he painted it. Mentally unstable for much of his adult life, it is possible that he shared the same neurological and emotional condition as some of the great mystics and saints.*

is more likely to occur in subjects who are relaxed, conscious attempts to induce it seemingly self-defeating.

This could be why certain subjects tend to perform badly under laboratory conditions. The controlled environment obviously puts a strain on the person under investigation, whether or not he is known to have psychic abilities, and may influence results. For example, subjects tend to perform best when they are in a happy mood. A good relationship with the parapsychologist, when a feeling of mutual trust exists, is also productive. In telepathy experiments, the relationship between the sender and the receiver would appear to be influential, too. Studies also suggest that subjects who go into the laboratory expecting to produce negative results usually do badly, while those with a positive attitude to *psi* tend to score more highly. One study has even concluded that telepathy may occur most frequently on nights of the full moon.

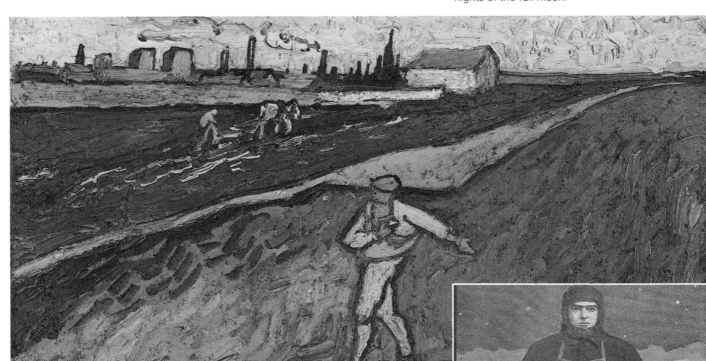

until the mid-19th century), and in Africa even today, a child's curious gift may be respected and cultivated. In a pre-eminently industrial civilisation, meanwhile, it may be rejected as fraud or lunacy. Elsewhere, opinion may be uncomfortably divided, especially where no distinction is made between psychical and spiritual activities, or the paranormal and the supernatural.

The part played by the physical environment in determining *psi* is difficult to pin-point. Psychic ability seems to emerge more often in nomads than among settled peoples, perhaps because the former tend to lead unstructured lives, free from bounds of order and routine, which makes them more relaxed and receptive. Certainly, studies since the turn of the century give the impression that *psi*

Sir Ernest Shackleton (1874-1922), right, leader of the 1914-1916 trans-Antarctic expedition, endured extreme physical hardship and a restricted diet, possibly as a result of which he, and at least two of his companions, hallucinated an extra crew member. Other explorers have had similar experiences. Some scientists believe that a diet lacking in calcium and sugar – and Shackleton's almost certainly was – can induce such visions.

orientation, which in turn makes him or her more sensitive and receptive to *psi*.

Different motives will, of course, fuel the desire to develop paranormal powers: scientific curiosity, a sense of vocation, a craving for fame, reverence, money or power. Some people, though, do not actively seek *psi*, they have it thrust upon them. Thus, the fasting hermit, seeking silence and solitude for prayer, may find himself distracted by telepathic impressions which he may not be able to ignore.

Whether *psi* is welcome or unwelcome, whether it is cultivated or repressed, and whatever are the many factors that may influence it, a lot more research needs to be carried out before firm conclusions can be drawn concerning either its nature or its source. But perhaps one of the most significant possibilities to have emerged so far is that, to varying degrees, we may all be capable of *psi*.

Spontaneous psychic experiences, as opposed to those that occur under laboratory conditions, are also influenced by state of mind, though since most accounts are anecdotal, the exact conditions that precipitate the phenomenon are more difficult to pin down. Someone who is rather tired, resigned, with low blood pressure and in the stage between waking and sleeping seems more prone to extrasensory impressions than someone who is awake, alert and concentrating on a particular matter. We also seem more likely to experience *psi* when we have just emerged from meditation – a fact that tallies both with clinical studies and personal experiences.

Those who both recognise and value extrasensory perception can, and often do, stimulate it by using meditation and other psychophysical techniques such as yoga exercises and deep breathing. Rhythmic singing, drumming, chanting and dancing may also be used, as they frequently were by those who were anxious to increase their psychic powers in ancient times.

FOOD FOR THOUGHT

Diet, too, may have a part to play. Vegetarianism is allegedly valuable in the cultivation of psychic powers, yet many groups in which *psi* seems to be unusually common – Eskimos, Bushmen, and Australian Aborigines – are hearty carnivores. In the 1950s, too, researchers discovered that a marked absence of calcium (and possibly of sugar) in a diet may cause the subject to become prone to visions.

Sex and sexuality may also influence psychic powers. Traditionally, the scryer – the young person employed to see visions in water or a crystal ball – had to be a virgin who had not yet reached puberty. In the same way, it was popularly believed that mediums lost their powers after marriage. However, this was certainly not the case with the great Victorian medium D. D. Home.

Another theory, put forward in 1914 by Edward Carpenter in *Intermediate Types Among Primitive Folk*, suggests that a homosexual temperament may be conducive to psychic development. It could indeed be that this kind of personality, sensitive to the feelings and problems of both sexes, experiences a profound uncertainty about his or her own

Parapsychological laboratory experiments suggest strongly that the more relaxed the subject, the more likely he or she is to be receptive to telepathic impressions. It also appears to be true that the more relaxed we are in everyday life – on holiday, as above, for example – the greater the chance of our experiencing spontaneous psi.

Hermits, such as the one shown right, at the mouth of his cave, have often sought solitude to pray and meditate, and may fast for long periods of time, thus creating ideal conditions for the creation of visions – and perhaps becoming especially receptive to telepathic impressions, too.

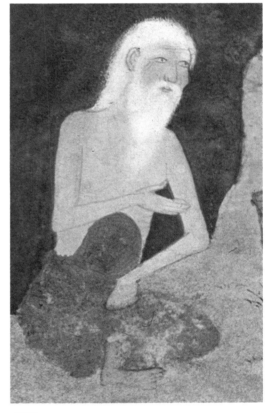

❚❚ INTRIGUINGLY, PSI DOES OCCUR MUCH MORE OFTEN IN SOME GROUPS THAN IN OTHERS – NOTABLY GYPSIES, CELTS AND BASQUES, AMONG WHOM, ODDLY AND PERHAPS SIGNIFICANTLY, RHESUS NEGATIVE BLOOD IS FOUND WITH UNUSUAL FREQUENCY. ❚❚

IT SEEMED THAT POPE JOHN WAS A POPE LIKE ANY OTHER – UNTIL, DURING AN OFFICIAL PROCESSION, 'HE' GAVE BIRTH TO A HEALTHY BABY. SUCH, AT ANY RATE, IS THE LEGEND. HERE, WE EXAMINE THE EVIDENCE FOR SUCH AN APPARENTLY OUTRAGEOUS AND EXTRAORDINARY STORY

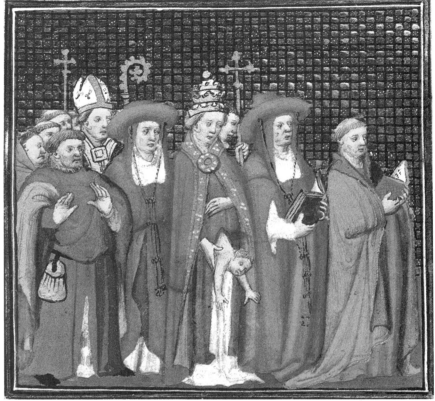

THE PETTICOAT POPE

Pope Joan, seen above, is delivered of a child in the midst of a papal procession in a 15th-century illustration from Boccaccio's Decameron. The Lives of the Popes, published in 1479 by the humanist scholar Bartolomeo Platina, seen left with Pope Sixtus IV in the Vatican Library, records that Joan dressed herself in a man's clothes and accompanied her lover to Athens, where she 'advanced in various sciences and none could be found to equal her'. On her return to Rome, she is said to have been unanimously elected pope.

The shocking and heretical story of Pope Joan, the female Vicar of Christ, who allegedly became pope by passing herself off as a man, (until nature caught her out and she delivered a child in the very midst of a papal procession), is one of the most scandalous rumours ever to concern the Vatican. Summing up one of the most extraordinary legends of the medieval period in his *Lives of the Popes*, published in 1479, the Italian historian Bartolomeo Platina wrote:

'Pope John VIII: John, of English extraction, was born at Metz and is said to have arrived at Popedom by evil art: for disguising herself like a man, whereas she was a woman, she went when young with her paramour, a learned man, to Athens, and made such progress in learning under the professors there that, coming to Rome, she met with few that could equal, much less go beyond her, even in the knowledge of the scriptures; and by her learned and ingenious readings and disputations, she acquired so great respect and authority that, upon the death of Leo, by common consent she was chosen Pope in his room. As she was going to the Lateran Church between the Colossean Theatre and St Clement's her travail came upon her, and she died upon the place, having sat two years, five months, and four days, and was buried there without any pomp. This story is vulgarly told, but by very uncertain and obscure authors...'

It is hardly surprising that the story should have gained such widespread acceptance: it is, after all, mentioned in a variety of contemporary documentary sources. The first of these is the writing of Anastasius Bibliothecarius, an educated Roman living in the 9th century, who made a brief reference to the story in a manuscript history. Anastasius was the custodian of the Vatican Library, and was

Pope Joan allegedly gave birth to her child while in papal procession between the Coliseum and St Clement's Church. The spot is said to have been marked by a large slab of stone – until Pope Pius, depicted right in a portrait by El Greco, evidently sensitive to the potential embarrassment of the story, had it removed.

involved in papal affairs to such an extent that, on the death of Leo IV in AD 855, he was put forward as his successor, until his personality proved unsuitable, and Pope Benedict III replaced him. Since Pope Joan's brief reign was supposed to have happened at about this time, Anastasius' commentary may be supposed to be of the greatest importance.

Certainly, his story seems to have proved popular with subsequent generations. Martinus Scotus, a monk from the Abbey of St Martin of Cologne in Germany, who died in 1086, wrote: 'A.D. 854, Lotharii 14, Joanna, a woman, succeeded Leo, and reigned two years, five months, and four days'. The Belgian chronicler Sigebert de Gembloux, who died in 1112, added some further information: 'It is reported that this John was a female, and that she conceived a child by one of her servants. The Pope, becoming pregnant, gave birth to a child, whereof some do not number her among the Pontiffs.' Stephen of Bourbon (who died in 1261), writing in *De Septem Donis Spiritu Sancti (Of the Seven Gifts of the Holy Spirit)*, confirmed the outline of the story, but was reticent about the details. According to him, the mysterious female pope was nameless, and her pregnancy was already well-advanced by the time she assumed the post. Indeed, her reign was so short that it was during the very inauguration ceremonies that he says she gave birth, and the irate crowd immediately dragged her out of the city and stoned her to death for her sacrilege.

In other medieval accounts, details of Joan's life differ slightly. In some, her name is given as Hagnes or Gilberta, and one source suggests she was Pope Leo IV's wife, who ruled in his place after his death. The most popular version of the story is given by the 13th-century Dominican monk, Martin of Troppau. In *Chronicron Pontificum et Imperatum (The Chronicle of the Popes and Emperors)*, he gives the following account:

> 'After Leo IV, John Anglus, a native of Metz, reigned two years, five months and four days. And the pontificate was vacant for a month. He died in Rome. He is related to have been a female and, when a girl, to have accompanied her sweetheart in male

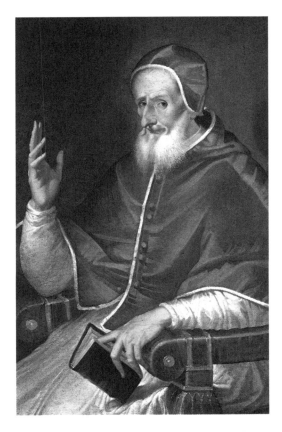

costume to Athens; there, she advanced in various sciences and none could be found to equal her. So, after having studied for three years in Rome, she had great masters for her pupils and hearers. And when there arose a high opinion in the city of her virtue and knowledge, she was unanimously elected Pope. But during her papacy, she became in the family way by a familiar. Not knowing the time of the birth, as she was on her way from St Peter's to the Lateran, she had a painful delivery, between the Coliseum and St.Clement's Church, in the street. Having died after, it is said that she was buried on the spot...'

P E R S P E C T I V E S

A FEMALE VAMPIRE?

All popes, by tradition, have been male; the exception is the legend of Pope Joan. Stories of human vampires have assumed they were all male as well, but there is another notorious exception. Elizabeth Bathory (1560-1614) was a member of a noble Hungarian family who became known in legend and history for her extreme cruelty. Called the Blood Countess, she married a soldier, Ferenc Nadasdy, at the age of 15. While he was away on military campaigns, Elizabeth enjoyed herself by torturing her maidservants - burning them with hot irons and cutting off their fingers. She also had a habit of biting them in rage if they dared to oppose her.

This may have given her a taste for blood. After her husband's death in 1604, Elizabeth is said to have lured unsuspecting girls from nearby villages to her castle where she beat, froze and starved them to death. It is said that she even bathed in their blood to rejuvenate her skin. Elizabeth's gory career seemed destined to go on forever, but in 1610 the king of Hungary heard rumours of her behaviour and her accomplices were put on trial. Although she herself was never tried, Elizabeth was condemned to life imprisonment and was walled up in a room of her castle. The number of her victims was estimated to be as high as 650.

The site of Joan's death was said to have been marked by a large slab of stone, with a classical inscription, until Pope St Pius V (1566-1572) had it destroyed. Thereafter, until the reign of Pope Leo X (1513-1521), it was customary for all papal candidates to undergo an inspection to prove their sex – an attempt, it seems, to prevent a woman from ever becoming pope again.

It is no coincidence that, in the 15th century, the papacy sought to eliminate references to Joan, for in Europe the Reformation was afoot, and Protestant pamphleteers had seized on the story, delightedly using it as a stick with which to beat the orthodox clergy. The story became more and more lurid with each telling. Anxious to prove the innate corruption of the Roman Catholic Church, the Protestants suggested that not only was Joan's first lover a Benedictine monk, but that her later seducer was a cardinal – or, on one occasion, the very Devil himself.

QUESTIONING SPIRIT

The secularisation of learning, one of the by-products of the Reformation, also brought about a new questioning spirit that was to knock the first serious holes in the story of Pope Joan. David Blondel (1590-1655) was a French country pastor and man of letters, inclined towards the Calvinist faith. Despite this, he was renowned for his liberal sympathies, and was something of an iconoclast. He took a long, hard look at the papal histories and published his conclusions in 1647 in his *Eclaircissement Familier de la Question: Si une Femme a été Assise au Siège Papal de Rome (Popular Solution of the Question: Whether a Woman had been Seated on the Papal Throne in Rome)*. This was to earn him the displeasure of his fellow Protestants.

The first thing that struck Blondel was that Anastasius' comment concerning Joan was clearly a later insertion, added in the margin. Furthermore, stylistically, it was reminiscent not so much of Anastasius, the supposed writer, but of Martin of Troppau, who was active some 400 hundred years later. Not only that, the insertion seemed to be in a different handwriting, and was totally at odds with the facts as given in the unadorned history. As

David Blondel (1590-1655), below, a French country pastor with Calvinist leanings, was the first to attempt an objective appraisal of the legend of Pope Joan. He published the result in 1647, below right. Analysing written sources of the legend, he found that the three earliest were contained in marginal additions, and that the original manuscripts made no mention of Pope Joan.

Accounts of Joan's end are various: in the 17th-century woodcut, bottom, she and her baby are shown hanging from a gallows like common thieves, while a dragon's mouth devours them and the flames of hell are seen to beckon.

Blondel put it: 'It is absolutely impossible that anyone could have been Pope between Leo IV and Benedict III, for he [Anastasius] says: "After the prelate Leo was withdrawn from this world, at once all the clergy, the nobles, and people of Rome hastened to elect Benedict; and at once they sought him, praying in the Titular Church of St. Callixtus, and having seated him on the pontifical throne, and signed the decree of his election, they sent him to the very-invincible Augusti Lothair and Louis, and the first of these died on the 29th September 855, just seventy-four days after the death of Pope Leo".'

Even allowing that Anastasius has discreetly drawn a veil over his own part in the papal election of 855, he is so specific on dates that he scarcely allows time for the very precisely recorded reign of 'two years, five months, four days' ascribed to Joan. With the severest of doubts thus thrown on his most contemporary source, Blondel moved forward with a thoroughness that a modern detective would envy.

Martinus Scotus was next on his list. Living in Germany, hundreds of miles from Rome, at a time when communications were notoriously poor, more than 200 years after the event, his account was immediately suspect. What is more, Blondel found

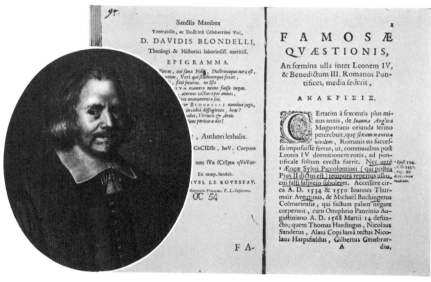

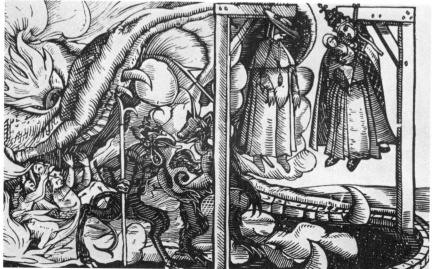

further signs of tampering. In some copies of the Scotus manuscript, the story of Pope Joan was told baldly, as a fact, but in others it was worded differently, implying that it was a matter of hearsay. In some, it was even left out completely. Then there was Sigebert de Gembloux, whose earliest manuscript, once again, did not refer to the legend. Neither does the *Chronicle of Guillaume de Nangiac*, written in 1302, incorporating and expanding much of Sigebert's work, contain any reference to a female pope.

In short, Blondel discovered that the three oldest accounts of Joan's life all showed signs of interference. In each case, the details of Joan's life appeared to have been added much later. Since the details of the story were all similar to that popularised by Martin of Troppau, Blondel considered that this worthy, or his followers, had been to blame, since they were 'much more given to all these kind of fables'.

The earliest genuine reference to a female pope therefore remains the 13th-century account by Stephen of Bourbon. But he did not name the lady, and credited her with far fewer adventures than do other accounts. Others gave her names as different as Margaret and Jutt, and her nationality as English or German. Martin of Troppau was the first to elaborate on the details of her early life, and to call her John or Joanna. So authoritatively does he relate the tale that few historians who came after him can have thought to challenge him.

The last hope of those who would seek to prove that there was a Pope Joan is that somehow the chronicles may be mistaken as to her dates. But alas, the reigns of the 9th-century popes are quite clearly delineated. Leo IV, Joan's supposed predecessor, reigned from 847 to 17 July 855; Benedict III succeeded him on 1 September of the same year. Benedict himself reigned for 2½ years, and was succeeded by Nicholas I within days of his death.

It is true that there was a Pope John VIII in the 9th century, and that he was in Rome in the 850s, as archdeacon of the Church of Rome. He did not, however, become pope until 20 years later, and his 10-year reign was primarily concerned with repulsing attacks by Muslims across the Mediterranean. To this end, he built a wall around the papal citadel, and encouraged religious and political unity in Europe in the face of outside heathen pressure. His reign is well-documented, and several of his letters survive. There is not the slightest hint that he was a closet transvestite, and quite how he became associated with the legend is not known.

Where, then, did the idea of a female pope start? Probably it originated in the 10th century. It was a miserable time, even by medieval standards.

La Papesse, or the Woman Pope, in the Tarot pack, right, is said to represent Pope Joan. In divination, the card stands for the qualities of intuition, inspiration and subconscious memory – and can also indicate lack of foresight.

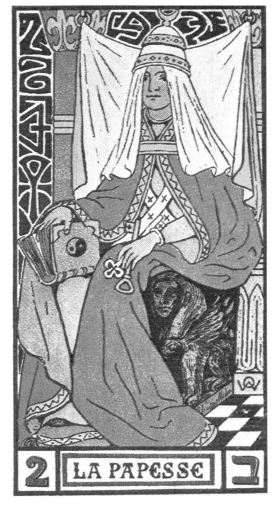

The Antichrist enters Rome dressed as a pope, left, in an illustration from a 15th-century French manuscript. Some of the wilder versions of the Pope Joan story suggest that Joan's lover was the Devil – and that her child was the Antichrist. Not surprisingly, critics of the Church found useful ammunition in this.

The Holy See was embroiled in various political wranglings involving European powers, and a succession of popes seemed to contrive to outdo each other in their amorality. The papacy was revered for the power it wielded, and the incumbents felt few scruples about killing or torturing to attain or retain it. Pope Stephen VII, who acquired the throne in 896, had his dead predecessor, Boniface VI, dug up, the corpse tried for misdemeanours, and then thrown into the Tiber. Stephen himself came to a sticky end shortly after, strangled by an irate mob, and the next two popes came and went so quickly that they are scarcely remembered. Leo V was imprisoned by a rival after only 30 days as pontiff and tortured to death. His rival succeeded him, but lasted only four months. He, too, was killed, by Sergius III, who was to reign from 904 to 911

Sergius was widely rumoured to be putty in the hands of his mistress, Theodora, the wife of an important Roman senator. When Sergius died, Theodora and her beautiful temptress daughter, Marozia, set about controlling his successors with a mixture of violence and debauchery that would have done the Borgias proud. For 20 years, Rome was dominated by this 'regiment of women', and the pious were wont to complain that 'We have women for Popes'. So perhaps it was rumours of this period that, distorted by time and distance, inspired Stephen of Bourbon to write his tale of a female pope.

SPANISH FLOOR SHOW

PORTRAITS THAT APPEARED MYSTERIOUSLY ON THE FLOOR OF A SPANISH KITCHEN SEEMED TO CHANGE AND DECAY OVER A PERIOD OF TIME, ATTRACTING THOUSANDS OF SIGHTSEERS AND BAFFLING PSYCHICAL INVESTIGATORS

On the morning of 23 August 1971, a housewife in the southern Spanish village of Belmez de la Moraleda went into her kitchen and was startled to find the likeness of a face apparently painted overnight on the floor. It was not an apparition, nor was it an hallucination: the housewife – a simple peasant woman named Maria Gómez Pereira – could only assume that a paranormal phenomenon had taken place in her home. The news spread quickly. Soon everyone in the village had heard about the strange happening and flocked to the house in Rodriguez Acosta Street in order to examine the face. It looked like a portrait in the expressionist style, and the features seemed to emerge quite naturally from the blend of colours in the floor cement.

In the end, the Pereira family tried to play down the extraordinary event that threatened to destroy their normally quiet everyday existence, and they decided to destroy the mysterious 'painting'. Six days after the appearance of the face, the Pereiras' son, Miguel, hacked up the kitchen floor and relaid it with fresh cement.

Nothing more happened for a week. Then, on 8 September, Maria Pereira again entered her kitchen, only to find a strange likeness of a human face in the process of manifesting itself in the concrete of the floor, in exactly the same place as the first one. This time, the delineation of a male face was even clearer than it had been before.

It was impossible now to keep the crowds of curious spectators at bay. Every day, hordes of people queued outside the house in order to look at the 'face from another world'. It remained on the floor for several weeks: and although it did not disappear, the features started to change slowly, as if the face were ageing or undergoing some other degenerative process.

Recognising the importance of the faces, the mayor of Belmez decided that the second one should not be destroyed, but preserved – rather like a valuable work of art. On 2 November 1971, a large crowd watched while the face was cut out of the ground, mounted behind glass and hung on the wall beside the fireplace. By this time, the story of the second Belmez face had spread far beyond the village, and photographs of it had appeared in the local press.

Maria Gómez Pereira, below, is seen at the door of her house in Rodriguez Acosta Street, right, in Belmez. When news spread of the paranormal portraits painted on her kitchen floor, a crowd of spectators became a permanent feature outside the house. Indeed, the family's life was so disrupted by the constant stream of visitors that they destroyed the first portrait.

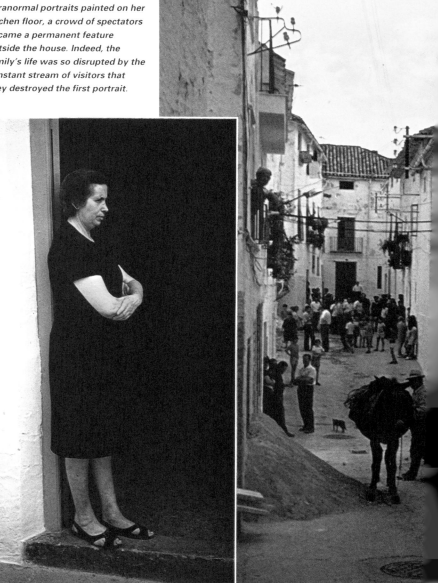

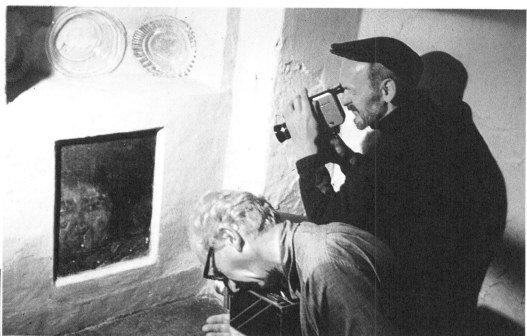

Psychical researchers, left, photographed the second face after it had been cut out of the floor and mounted on the wall. Over a period of several months, the expression on the face changed from awe to irony, and the delicate lines of the features started to degenerate. Witnesses were also able to watch other faces appear. These started as very crude lines, evolving into intricately drawn portraits.

The floor of the kitchen was then dug up to discover if there was anything buried there that might explain the mysterious appearance of the faces. At a depth of about 9 feet (2.7 metres), the diggers found a number of human bones. This discovery satisfied those Spiritists who were interested in the Belmez faces, since Spiritists believe that a restless spirit may haunt the place where its body is buried, or produce poltergeist phenomena there. Meanwhile, to the residents of Belmez, the discovery of the bones was not in the least surprising, since it was well-known that most of the houses in Rodriguez Acosta Street had been built on the site of a former graveyard.

CHANGING FEATURES

The face that had been put behind glass was scrutinised by an art expert, Professor Camón Aznar, who expressed surprise at the subtlety of the 'painting's' execution. He described it as the portrait of a startled or astonished man with slightly open lips. But during ensuing weeks, the lines of the face started to decay, and the expression changed to one of irony.

Two weeks after the kitchen floor had been excavated, and then replaced, a third face appeared very near the spot where the first two were discovered; and two weeks after this, yet a fourth face appeared, the first to have obviously female features. After examining these two latest faces, Professor Aznar expressed the opinion that they were examples of paintings in true expressionist style. Other observers, such as the painter Fernando Calderón and the parapsychologist Germán de Argumosa, considered them masterpieces of art, produced paranormally.

Stranger still, not long afterwards, around the fourth face, a quantity of smaller faces began to appear. Maria Pereira counted nine of them, while Professor Argumosa, who had taken up the case enthusiastically and become its principal investigator, was able to count 18.

At an international conference of parapsychology in Barcelona in 1977, Argumosa said that he inclined to the view that the faces were the result of some form of poltergeist-like activity produced by unquiet spirits. Although his ideas were not very clearly formulated, he admitted to being 'most surprised when I was able to witness the formation of some of the faces from very crude lines to meticulously drawn portraits'.

On 9 April 1972, Argumosa had watched the formation of one face over a protracted period of time. Other witnesses present were the journalists Rafael Alcala from the newspaper Jaén, and Pedro Sagrario from Patria. It was incredible, Argumosa wrote afterwards, 'how the face slowly assumed contours before our astonished eyes ... I must admit my heart was beating faster than usual'. Pedro Sagrario also described what he had seen: the gradual appearance on the brick-built part of the floor of seemingly unconnected lines, which eventually composed themselves into an impressive and attractive 'painting' of a face. This face was photographed several times; but it had virtually disappeared again by the end of the day.

CHAOTIC REACTIONS

Eventually, Argumosa invited his fellow parapyschologist Professor Hans Bender, of the Freiburg Institute in Germany, to help with the investigations. Professor Bender arrived in Belmez in May 1972, only to be met by a chaotic situation. Many people, including priests, painters, parapsychologists and journalists, had witnessed the phenomena, and everyone had a different theory as to what might be the cause.

After interviewing many of the local witnesses, Bender became convinced that the faces were genuinely paranormal in origin. However, Bender noted another dimension to the faces: they seemed to be perceived differently by different witnesses. The same face would appear to be that of a young man to one witness, and that of an old man to another.

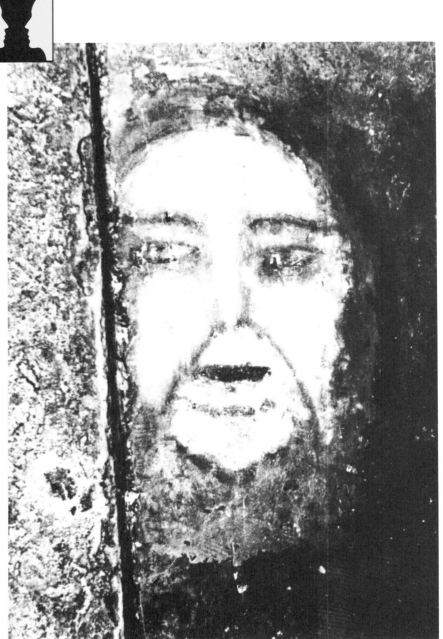

This method was intended to ensure that any faces that appeared had not been produced by any outside agency. But, unfortunately, water started to accumulate beneath the plastic, and the Pereira family decided to remove it before any faces became apparent. Although Argumosa and Bender paid several visits to Belmez during the next few months, their investigations produced no conclusive results. But the 'haunted house' had become a place of pilgrimage for those interested in the occult, and people came from Spain, France, England and Germany to look at the faces, which they interpreted variously as demonic or sacred. They also brought tape recorders to record sessions with the 'spirits' they expected to find lingering in the house. Quite a number of unusual recordings were obtained, including one made by Argumosa himself. On this can be heard loud cries, the noise of many voices talking all at once, and the sound of people crying. The tape was played in the Barcelona home of the psychical researcher Carole Ramis, and for her it certainly had an impressively eerie quality. Indeed, she was of the opinion that something very bad must have happened centuries ago at the house in Belmez – perhaps in some way connected with the graveyard beneath.

But no entirely satidfactory explanation for the faces has yet been given: indeed, chemists who examined the cement were quite unable to account for the appearance of the Belmez faces.

Some of the faces also seemed to be constructed like a jigsaw puzzle, or to 'interlock' with other, larger faces. (This quality of one line being perceived in different ways is also often observed in the work of mediumistic artists.)

Attempts had been made to clean off the faces with detergents, and by scrubbing. But they persisted, evolving and decaying, seemingly in accordance with some strange law of their own.

In an attempt to document the production of the faces under experimental conditions, Bender carried out a procedure that Argumosa had already tried without success. He and his team of investigators first photographed the kitchen floor in its normal state, and then covered it entirely with thick plastic sheeting. The sheeting extended right up to the walls, and was secured at 6-inch (15-centimetre) intervals. The original plan of also installing a camera to record the paranormal formation of faces proved impracticable, however, as the light in the room was too dim for filming, and additional lighting produced reflections on the plastic sheeting.

The second Belmez face was photographed on two occasions more than six months apart. On 10 September 1971, above, *the features were quite clear; but by 10 April 1972,* right, *they were starting to decay. Other portraits in the floor appeared, evolved, disintegrated and disappeared within one day. Both scientists and parapsychologists were utterly baffled by the phenomena.*

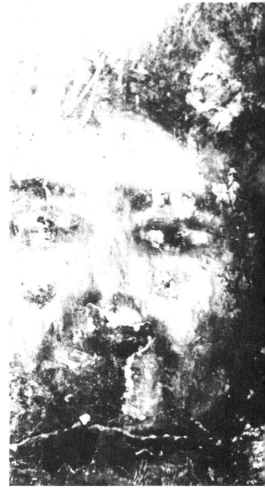

A TOPSY-TURVY WORLD

COULD THE EARTH TOPPLE OVER TOMORROW, TRIGGERING A CHAIN OF DISASTERS, BRINGING TROPICAL FORESTS TO GREENLAND AND BURYING INDIA UNDER POLAR SNOWS? MAVERICK POLE-SHIFT THEORIES CLAIM THAT THE GLOBE COULD TUMBLE IN SPACE LIKE A FLOATING BEACH BALL AT ANY TIME

The Earth turns steadily once a day, around the imaginary axis that punctures the surface at the North and South Poles – like the metal rod that passes through the old-fashioned schoolroom globe. One might think that it always has and always will. But a few independent thinkers dispute this claim. They believe our world is unstable, and could shift at any moment, so that those

In a vision of the globe according to pole-shift theorists, above, an ice-cap once covered Central and much of South America, while the Equator created a tropical zone running through Africa, Europe and on the far side of the Earth, Alaska, the Pacific and Antarctica.

areas of the surface that are now at the poles would find themselves at the equator. India could be covered by a polar ice cap, while Antarctica and Greenland would be basking in equatorial sunshine.

If the Earth were to tilt suddenly, the planet would be swept by hurricane winds and huge tidal waves, and racked by earthquakes and volcanic eruptions as the atmosphere, oceans and surface

rocks tried to catch up with the planet's new orientation. Indeed, believers in the pole-shift theory consider that our planet's tipping over accounts for a whole range of catastrophes in the Earth's history, from the extinction of the dinosaurs 65 million years ago to folk myths telling of the mysterious disappearance of Atlantis.

Pole-shift theorists are also often impressed by the fact that the climates of most countries have suffered dramatic changes in the past. During the Carboniferous era, for example, the British Isles were in a hot tropical region, with lush fern forests that have now been fossilised into coal. Such tropical forests also covered much of North America, right up to Greenland. At about the same time, India and the western parts of Australia were buried under thick sheets of ice.

SHIFTING THEORIES

In 1889, the American writer Marshal Wheeler concluded that this appears to prove that the Earth's axis can suddenly change its direction, in relation to features on the surface, by 90 degrees. This is due, he claimed, to a sudden shift in the orientation of the body of the Earth. The axis stays in roughly the same position (at 66° to the plane of the Earth's orbit about the Sun). The region then at the pole becomes cold and ice-covered. Wheeler's pamphlet *The Earth: its Third Motion*, sets out to show that our planet used to be orientated so that Sumatra and Ecuador lay at the two poles. The equator ran around the Earth through central Africa, Italy and Sweden to the present North Pole; then round through Alaska and the middle of the Pacific Ocean to Antarctica and back past Cape Town into Africa. Thus we had glaciation in India and Australia, near the Sumatran polar ice-cap, and tropical forest, according to his theory, in the equatorial regions running through northern Europe.

Wheeler believed that the shift of the poles from Sumatra and Ecuador was the Earth's 'third motion' (the other two being the daily rotation on its axis and the yearly revolution around the Sun). Clearly, a

lot of energy is needed to tilt the whole globe, and Wheeler thought that this came from 'encircling magnetic currents'.

Almost 80 years later, an electrical engineer, Hugh Auchincloss Brown, proposed a variant on this idea. Brown looked at evidence for the Earth having tilted in the much nearer past. His book *Cataclysms of the Earth* reached the conclusion that the Earth's axis tilted by 90° as recently as 7,000 years ago, and repeats the old idea that this shift caused Noah's flood. Other shifts, he said, occurred about 11,400, 18,400 and 41,800 years ago. Before the last shift, the poles were in central Africa and the mid-Pacific. The equator ran through Siberia, and here mammoths lived in tropical comfort – until the pole-shift, which had the effect of leaving them frozen solid.

Brown suggested an explanation for the rapid tilt of the Earth that is rather different from Wheeler's theory. After each pole-shift, ice and snow are thought to build up in the new polar regions until

300 million years ago, tropical forests such as that above, covered vast regions, including many that are now temperate in climate, such as northern Europe.

PERSPECTIVES

FLIP-SIDE EARTH

The paradoxical properties of fast-rotating bodies have been demonstrated to generations of children with the aid of the gyroscope. This is essentially a flywheel, mounted on a spindle. When it is set spinning, it seems to take on a life of its own, resisting attempts to twist its axis. The effect is shown dramatically if the device is supported at one end of its axis – as in the multiple-exposure photograph, *right*, in which a gyroscope is being held up by a loop of string. The gyroscope does not fall to the ground; instead its axis stays level but revolves – or precesses – around the point of support. If the flywheel is massive and spins very fast, the precession

the polar caps become so massive that the Earth is eventually in an unstable state. It then topples over by 90° so that the old polar caps now lie on the equator, and two opposite regions of the previous equator now become the Earth's North and South Poles respectively.

But there are, in fact, many reasons why 90° pole-shifts of this kind cannot have occurred. Firstly, the Earth's magnetic field is not strong enough to turn the planet over, even if something outside could twist over the field. What is more, although ice does accumulate at the poles, the Earth compensates for much of the extra weight. The weight of ice depresses the underlying land surface of Antarctica, while the northern polar ice displaces an exactly equal weight of water from the polar ocean beneath. In addition, the Earth's spin produces a bulge all round the equator, and the total mass in this bulge is far greater than that of the ice in the polar regions. The Earth already has the bulk of its asymmetrical mass at its equator, so it is extremely resistant to any supposed pole-shifting force.

The idea of pole-shifts every few thousand years is actually directly contradicted by the evidence.

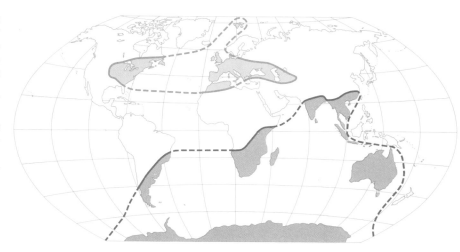

The map above shows how different world climate was 300 million years ago. In the green areas, tropical vegetation flourished; while in the blue land areas, the plants were of typical polar types.

The ice-caps in Greenland and Antarctica are millions of years old, not a few thousand; and there is no evidence for a polar ice-cap in central Africa as recently as 5000 BC. (The death of the mammoths is no longer the puzzle it seemed to be a few decades ago. We now know they were in fact arctic creatures, not tropical ones like the modern elephants, and that they died out gradually over tens of thousands of years, not as a result of one sudden catastrophe.)

Other evidence does not stand up either. Although India and parts of Australia were undoubtedly iced over some 300 million years ago, what is now the opposite side of the Earth was not under a polar ice-cap. In fact, Ecuador was then basking in the same kind of tropical paradise as northern Europe enjoyed.

After experimenting with gyroscopes, an American patent attorney, Adam Barber, decided that the spinning Earth sometimes flips over because it is following two orbits simultaneously through space. Barber agreed with orthodox scientists that the Earth follows an orbit 186 million miles (300 million kilometres) in diameter, which takes it around the Sun once a year. But he believed that, in addition, our planet has a smaller orbit, one-twentieth of this size, which it completes every 36,000 years. At intervals of 9,000 years, the Earth's axis is at right angles to both orbits. Barber concluded that, at this moment, gyroscopic forces would tip the Earth over by 135°. He published a pamphlet, entitled The Coming Disaster Worse than the H-Bomb, about the next pole-shift; and in 1955, he predicted its occurrence within the following 50 years.

is very slow and the device seems to hang motionless, defying gravity. The Earth itself, an enormous gyroscope, precesses very slowly – once every 26,000 years. Peter Warlow, an exponent of the pole-shift theory, believes that a hypothetical stray planet, passing sufficiently close, could exert a gravitational pull capable of twisting the Earth over. The axis of rotation would tend to resist any change, but the Earth itself could flip through 180°, perhaps in as little as a day. The magnetic field would not flip over. The oceans, the atmosphere and living creatures would not be thrown into space, but would probably share in the motion. But according to Warlow, earthquakes, triggered by crustal stresses, and the rapid redistribution of climates and ocean and air currents, would have disastrous effects on countless species.

If climates can be totally changed in a day by pole-shifts, then many parts of the world must often have seen newly-formed ice sheets encroaching on forests that only recently were flourishing in temperate or tropical zones. Such scenes are evoked by the view, above, of the Moreno glacier, flowing down from the Argentinian Andes.

EGYPTIAN MYTHS HAVE RECORDED FOUR REVERSALS IN THE DIRECTION OF THE SUN'S MOTION ACROSS THE SKY SINCE 9000 BC. WARLOW INTERPRETED THIS AS DUE TO THE EARTH SUDDENLY TURNING UPSIDE DOWN.

Fortunately, these gyroscope ideas can be dismissed. Astronomers could easily have detected any deviation of the Earth from its accepted orbit; and over the past 2,000 years of recorded observations, the effect of the Earth following a second orbit would have shown up readily as an unexplained apparent motion of all the other planets.

There is, however, another 'gyroscopic' theory that has been taken more seriously. In 1978, Peter Warlow published a paper on pole-shift in the learned and respected *Journal of Physics*. In this, he claimed that the Earth tips over not by 90° or 135°, but by 180°, so that the previous North Pole becomes the South Pole, and vice-versa. Warlow's experiments involved not an ordinary gyroscope but a particular type of spinning top, popular in Victorian times and now sometimes found in Christmas crackers. Such a 'tippe top' is a solid sphere from which the upper part, forming a cap, has been cut off and replaced by a short stem. If you spin the top with the stem uppermost and wait for it to slow down, the top will eventually flip over and stand on the stem, still spinning. The axis of spin is still vertical, and the direction of spin is the same: the solid body of the top has simply turned upside down relative to its spin.

Warlow compared the Earth to a tippe top, and backed up the analogy by exact calculation – unlike most writers on pole-shifts. Like the others, though, Warlow tried to confirm his theory with his own interpretation of the Earth's past. He took the evidence of myths very seriously. For example, he stated that Egyptian myths have recorded four reversals in the direction of the Sun's motion across the sky since 9000 BC – and interpreted this as due to the Earth suddenly turning upside down. The most recent shifts occurred in 700 BC and 1500 BC, he claimed, the latter producing the catastrophe that destroyed the Minoan civilisation in Crete. Before that, the Earth flipped over in about 3000 BC, 8000 BC, and 11,000 BC.

In a proven pole-shift, left, the position of the North Pole (the red circle) wanders erratically around its average position. This effect of the incessant movements of air, sea and crustal rocks is called the Chandler wobble after the scientist who discovered it.

Joshua is depicted, above, about to lead the Israelites against the Amorites. The Bible tells us that he ordered: 'Sun, stand thou still upon Gibeon; and thou, Moon, in the valley of Ajalon'. The obliging celestial bodies did so 'and hasted not to go down about a whole day', allowing the Israelites time to avenge themselves upon their enemies. This is one of many legendary accounts of the Sun standing still or rising in the west, said by Immanuel Velikovsky to support the notion that the Earth's rotation has changed both abruptly and frequently.

Looking to the more distant past, Warlow pointed out that the Earth's magnetic field, as recorded in rocks, has changed direction at least 20 times in the past 4½ million years. At these times, the magnetic pole in the Arctic changed from 'north' type to 'south' type, or vice versa. Warlow also contended that it is likely that the Earth's magnetic field is always the same way round, and that the Earth itself has tipped over.

But at times, it seems other planets are to blame. If a planet with a mass roughly equal to the Earth's were to pass by only about 30,000 miles (50,000 kilometres) from us (about four Earth-diameters away), its pull on the Earth's equatorial bulge would be strong enough to tip the Earth over. Warlow followed the unorthodox ideas of Immanuel Velikovsky in supposing that small planets are ejected from the cores of larger ones, and that Jupiter and Saturn have given birth to planets such

// TWENTIETH CENTURY ORTHODOX GEOLOGISTS BELIEVE THAT WHAT MOVE ARE NOT THE MAGNETIC POLES BUT THE CONTINENTS THEMSELVES. AND AS THEY HAVE DRIFTED ABOUT ... SO THEIR CLIMATES HAVE CHANGED. //

as Venus. He thus endorsed Velikovsky's proposal that the disasters of 1500 BC were due to the close passage of the newly formed planet Venus past the Earth.

Of all the pole-shifting ideas, Warlow's is the only one that can be taken at all seriously, simply because it is based on a sound physical foundation. But even so, the theory fails to stand up to scrutiny. It is just possible that a planet could pass the Earth closely enough to flip it over – but it would seriously affect the Earth's orbit about the Sun. Even a small change in the distance of the Earth from the Sun, or in the shape of the Earth's orbit, would alter our climate tremendously, and no such climatic changes are known to have occurred in the past few thousand years. Again, a planet with a mass similar to the Earth's, passing within the Moon's orbit, would have just as strong a gravitational pull on the Moon as the Earth does; and after a number of encounters, the Moon would have been torn away from the Earth and would have vanished into space.

Warlow had apparently not considered just how many planets would be needed to miss the Earth in this way. His evidence from myth supposedly shows that the Earth flips over every 2,000 years or so. This means a staggering 2 million reversals in our planet's history, requiring 2 million planets of about the Earth's mass to be ejected from other planets, and now lost from the solar system (except for Venus, and possibly Mars and Mercury). To put the matter into perspective, the amount of mass in the requisite 2 million planets would outweigh the Sun many times over!

Since these planets must also have passed only a few Earth-diameters away from our planet, it is amazing that not one of them actually collided with our planet. Although, of course, a single collision is not as likely as a near miss, the chance that all would just miss is extremely small – like throwing as many as 2 million darts at a board, getting close to the bull's-eye, yet never quite hitting it.

Warlow's ideas thus do not stand up to scrutiny, even as they are presented by him in his book *Reversing Earth*, published in 1982. Furthermore, the American physicist Victor Slabinski has pointed out that Warlow made three vital errors in his calculations. The effect of these errors, Slabinski found, was that the pull needed to turn the Earth over would have to be as much as 200 times greater than Warlow had calculated. So the passing planet would not be of approximately the Earth's mass, like Venus, but more like the giant planet Jupiter. The close passage of such a giant planet would also have thrown the Earth out of its orbit altogether.

After the debate stimulated by Warlow's investigation, no one can seriously consider that the Earth flips, tilts or shifts its axis dramatically to produce major catastrophes. Yet there are still two loose ends unaccounted for. The Earth's magnetic field undoubtedly does flip over. And, in the past, different parts of the Earth did have climates quite different from their present ones. Twentieth-century orthodox geologists have explained these vagaries of the Earth's climatic history by a different theory, however. What move are not the magnetic poles, they say, but the continents themselves. And as they have drifted about, from equatorial regions to polar zones, so their climates have changed.

The pictures, right, show the toppling of the Earth, according to Warlow. Tugged by a passing planet, the Earth begins to tilt, top. If the total shift takes a day, then this view shows it when the first 8 hours have passed. After 12 hours, centre, the poles are at the equator. After 16 hours, the Earth is actually 'upside down', bottom. To a surviving inhabitant, the Sun would now appear to rise in the West; and the Earth's magnetic field, in reality unchanged, would appear to have reversed.

CASEBOOK
GREEN-FINGERED ALIENS

VISITING HUMANOIDS ARE REPORTED TO HAVE TAKEN A KEEN INTEREST IN CULTIVATED PLANTS DURING SEPARATE INCIDENTS IN FRANCE AND IN SPAIN. WHAT COULD HAVE BEEN THEIR PURPOSE?

Ufologists often lament the fact that so few UFO sightings are made by people with 'trained minds' – by which they mean scientists and engineers. But this is not really surprising, since the 'trained mind' of a witness is likely to harbour prejudices that discourage him from reporting an extraordinary experience and, instead, encourage him to explain it away. On the other hand, unsophisticated observers, unacquainted with the UFO controversy, are often impressive witnesses, telling their stories without embroidering them. Indeed, the classic sightings of 'flying saucers' described here may have more value by virtue of coming from people of little formal education or technical training.

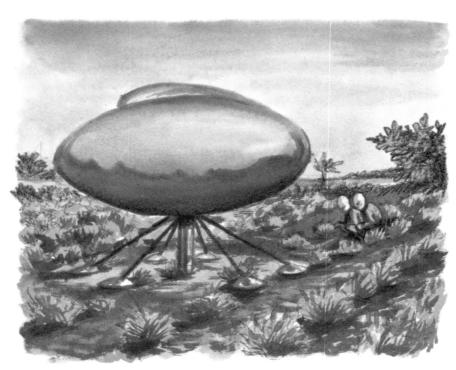

In the artist's impression, below, an oval UFO stands in a lavender field in south-east France, while two aliens examine plants that are growing close to their craft.

Just after 5 a.m. on 1 July 1965, Maurice Masse, a 41-year-old lavender grower, set to work in his fields situated on the Valensole plateau in the Basses Alpes of south-eastern France. At about 5.45 a.m., he stopped to have a cigarette, parking his tractor by a hillock at the end of a small vineyard that lay along the northern side of the field.

Suddenly, he heard a shrill whistling noise and glanced round the hillock, fully expecting to see a helicopter: instead, he saw a dull-coloured object the size of a Renault Dauphine car, and shaped like a rugby football, with a cupola on top. It was standing on six metallic legs, and there was also a central support, which appeared to be stuck into the ground. Close to the 'machine', Masse saw two boys, about eight years old, bending over a lavender plant.

Masse crossed the vineyard and approached the boys, believing them to be the vandals who had picked young shoots from a number of his lavender plants on several occasions during the preceding month. Then, to his surprise, he saw that he was not approaching boys at all, but two dwarf-like creatures with large bald heads. He was about 15 feet (5 metres) from the beings when one of them turned and pointed a pencil-like instrument at him.

Maurice Masse, below, owner of vast lavender fields in south-eastern France, stands on the area where a UFO stood while he watched, unable to move. Only weeds would grow in this patch of land after the incident.

One of the aliens, bottom, is depicted pointing some sort of weapon – perhaps an immobiliser – at the French farmer.

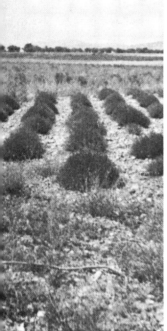

Immediately he was stopped in his tracks, unable to move any part of his body. (In the first reports of the case, it was stated that the witness was 'paralysed', but UFO investigator Aimé Michel suggested the term 'immobilised', perhaps by some form of hypnotic suggestion.)

According to Masse's description, the creatures were less than 4 feet (1.2 metres) tall, and were wearing close-fitting grey-green overalls. They had huge pumpkin-shaped heads, but no hair – only smooth white skin. Their cheeks were wide and fleshy, narrowing to very pointed chins; the eyes were large and slanting. The witness did not mention their noses, but he did describe the mouths, which were like thin slits and opened to form lipless holes. (It is rare in close encounters for humanoids to be reported as having their heads uncovered outside the craft, as in this case.)

BODY-TALK

The creatures appeared to communicate with each other, but not with their mouths, for inarticulate sounds seemed to come from the mid-body region. The hapless lavender grower thought they were mocking him, although he admitted that their glances were not hostile; indeed, he never had the impression he was face-to-face with monsters. Masse has never disclosed what took place during the rest of the time he was immobilised, 15 feet (5 metres) from the beings.

After a few minutes, the creatures returned to their machine, moving in a remarkable manner, 'falling and rising in space like bubbles in a bottle without apparent support . . . sliding along bands of light . . .', to enter the object through a sliding door. The witness said he could see them looking at him from inside the craft. Suddenly, there was a thump from the central support, which retracted, the six legs began to whirl, and the machine floated away

at an angle of 45°, making a shrill whistling sound. At 65 feet (20 metres), it just disappeared, although traces of its passage in the direction of Manosque were found on lavender plants for more than 100 yards (90 metres). (Mysteriously, these plants withered, then later recovered and grew taller and finer than those nearby.)

The farmer grew alarmed as the invisible bonds that held him failed to relax their grip, but after 15 minutes he slowly regained use of his limbs. He could see marks left by some of the legs of the craft, and almost liquid mud around the hole where the central support had entered the ground. (This was odd, since there had been no rain in the area for several weeks.)

Masse ran down to Valensole, on the outskirts of which is the *Café des Sports*. The proprietor, a friend, was just opening for the day, and Masse, shaken and as white as a sheet, told him part of his story. The café owner pressed Masse for further details of what had happened, but the farmer refused to say any more because he feared the rest of his story would not be believed. His friend advised him to report the incident to the police, but Masse would not. So the café proprietor rushed to the field, saw the marks and returned to tell Masse's story for himself.

That evening, Masse took his 18-year-old daughter to see the landing site: now they saw that only four of the craft's legs had left marks on the ground, and that the mud around the central hole had set like concrete.

THE WORLD'S REACTION

Soon after Masse's experience was made public, he was questioned by the chief of the local police. Crowds of sightseers visited the field, and Valensole was flooded with representatives of the press, radio and television. On 4 July, overwhelmed with interviews and questions, Masse collapsed, seized with an insuperable desire to sleep. It was reported that he would have slept for 24 hours a day had his wife not awakened him to make him eat.

The initial private investigation was conducted by a local magistrate, who handed his report to *Flying Saucer Review* in October 1965. He said that Masse had prevented his daughter approaching too close to the hole for he feared she might suffer some harmful effect from it: indeed, he was also worried about any possible genetic effects it might have on himself. In the end, he filled the hole, which was shaped like an inverted funnel.

Aimé Michel interviewed the witness twice at Valensole in 1965, and found him anxious and distressed, still worried about possible effects on his health. During his second visit, Michel showed Masse a photograph of a model based on a description of a UFO seen at Socorro, New Mexico, in 1964. Masse was staggered that someone should have photographed his machine; but when told that it was actually a picture of a craft that had been seen in the USA by a policeman, he sighed with relief: 'You see, then, that I wasn't dreaming, and that I'm not mad'.

Two years later, UFO investigators visited Maurice Masse again and he took them to see the landing site. It was 10 feet (3 metres) in diameter,

CASEBOOK

and still distinguishable because lavender plants around the perimeter were withered, and only weeds grew in the inner area, despite the fact that it had been ploughed and replanted since the time of the original incident.

Although Masse had recovered from his experience, he was anxious to avoid any more publicity. So, in an endeavour to hide the location of the landing site, he trimmed the mass of weeds to the shape of lavender plants. Eventually, he tore up the vineyard, ploughed the lavender field and then sowed it all with wheat.

THE ALFALFA FACTOR

In 1974, *Flying Saucer Review* received a report from the Charles Fort Group of Valladolid in Spain, who had investigated a UFO sighting that had been made some years earlier. The witness was a 22-year-old woman, a domestic employee in the house of a farmer at Puente de Herrera, close by the river Duero, south of Valladolid. The young woman's name was withheld, at her request, as she had received no primary education, and was illiterate.

On the night of 15 August 1970, the señorita had been watching television when she heard a piercing whistling noise. At the same time, the television picture was suddenly blotted out by a mass of lines. Playing with the controls had no effect, so she switched off the set and then went to the front door of the house to investigate the noise.

There, she was astounded to see a weird object with various lights standing on the drive. Nearby stood a strange-looking 'man' who seemed to be surveying a crop of alfalfa in an adjacent field. Very scared, the young woman went back inside the house and shut the door. Then the whistling sound began again; but, when she went to look out of the window, both machine and 'man' had gone.

The señorita told only her boyfriend of her experience at the time. Members of her family became aware of it only in March 1972 when, after her brother-in-law had made some observation about UFOs, she told them about what she had seen. It was her brother-in-law who passed the information to the Charles Fort Group.

During the investigation that followed, J. Macias and his fellow researchers learned that the period of time between the onset of the whistling noise and the witness first looking out of the window was about 5 minutes. The whistling noise persisted while she was peering through the door, but seemed a little less intense. She had switched off the porch lights as she usually did between 10.30 and 11.00 p.m., so she felt nobody could have seen her when she opened the door.

The UFO, which was balanced on several 'feet' on the road surface, was about 12 feet (4 metres) wide and 8 feet (2.5 metres) high. The upper part consisted of a hemispherical cupola, which seemed to be made of crystal. On top of this, a bluish-white light revolved erratically, the light dimming whenever it slowed down. The cupola was supported by a disc surrounded with a ring of coloured lights that constantly changed from white to purple and then again to yellow.

The occupant of the craft was about 5 feet 10 inches (1.8 metres) tall and was dressed in a dark, tight-fitting garment and a helmet. Around his ankles and wrists there were glowing white 'bracelets', and in the middle of his belt was a square 'buckle' of similar iridescent material. The señorita was not sure about the colour of his skin, and could not see any hair. She said the 'man' seemed to be interested in the alfalfa, and walked towards it with unusually long strides.

A PERSISTENT AFTERGLOW

According to the witness, physical vestiges of the craft were left at the landing site for, when she went to the window of her room, she saw a soft glow where the object had been standing. Intrigued by this, she inspected the ground. On the surface of the road there were black footprints, similar to those made by ordinary shoes, the heel mark narrower than that of the sole. The marks must have been seen by everybody coming to the house, but the señorita told no one of her experience at the time and therefore did not draw attention to them. While they remained, however, the area where the UFO had landed continued to glow at night.

The investigators considered that the señorita's illiteracy added to the authenticity of her account on the grounds that she could hardly have fabricated a story of such complexity. After speaking with members of her family, they realised that their knowledge of other UFO encounters was insufficient for her to have picked up such detailed data from them either. Furthermore, there seemed to be no motivation for a hoax, for it was only by chance that she mentioned her experience to her brother-in-law 18 months after the event. Other members of the family later told the investigators that, after their first interview with the señorita, she had wept hysterically and rounded on her brother-in-law for having given away her secret.

During a close encounter in northern Spain, an alien surveyed an alfalfa field while his craft flashed coloured lights, as shown in the illustration below.

There have been a number of ice ages, when great glacial sheets have grown to cover the Earth halfway from the poles to the equator, and even to blanket the highlands of tropical regions. During each of these ice ages – some of which spanned millions of years – the ice advanced and retreated, in fluctuations that created cold and warm periods, described as glacial and interglacial, respectively. We live in an interglacial period at present, but no one knows for certain when, or if, the ice age will return.

One school of thought, however, holds that ice ages are cyclic and predictable, and that we can expect a return in as little as 1,000 years. But if the ideas of one eminent dissenter are correct, the event is essentially unpredictable: and the disaster that triggers it could happen millennia hence ... or even as soon as tomorrow.

Mount McKinley, Alaska, is seen below, with its permanent covering of snow and ice. At the height of the last ice age, some 20,000 years ago, large areas of the globe displayed similar landscapes.

How do such widely differing theories come about? Geologists of the 19th century were staggered by the discovery of the very existence of ice ages. But the fact was incontrovertibly attested to by the evidence of widespread glaciation that they found throughout Europe and North America, and even in places that are now hot and arid, such as India and the Middle East. The problem of explaining their occurrence caught the imagination of scientists of many disciplines, and numerous theories were proposed.

One of the most obvious suggestions was that the Sun's temperature had fluctuated. Certainly, there has been a steady increase in the Sun's output of heat during the last 3,000 million years. The difficulty, however, lies in explaining relatively short-lived variations. One highly speculative idea is that the solar system frequently travels through dust

IN 1,000 YEARS' TIME, ACCORDING TO ONE THEORY, THE EARTH COULD BE IN THE GRIP OF A NEW ICE AGE. WHAT CAUSES THESE TERRIFYING AND LIFE-DESTROYING ERAS, AND IS THERE ANY WAY OF PREVENTING THEM? HOW CAN WE AVOID A FROZEN FUTURE?

TOMORROW'S ICE AGE

clouds in its 250-million-year orbit around the centre of the Galaxy, and that these clouds of interstellar dust reduce solar heat. Other astronomers have suggested that internal disturbances cause the Sun's radiant heat to vary. Ever since the 1930s, when the Sun's workings were explained in terms of nuclear reactions, it has seemed that there is no good reason why the Sun should not shine at a steady rate for thousands of millions of years. But there is now a theory that, at its centre, the Sun may currently be cooler than a calculation from its surface temperature would predict; and it is thought to be such

All theories that seek to explain the ice ages as consequences of a change in the Sun's temperature make them unpredictable. One model currently favoured, however, does purport to make it possible to predict the next ice age. Devised by a Yugoslav, Milutin Milankovich, in the 1920s, it states that the solution is to be found in tiny, regular variations

There are three major cycles in these variations. The first is that of the Earth's orbit. Over a period of 95,000 years or so, this changes its shape from circular to elliptical, and back again. When the orbit is elliptical, the distance between the Earth

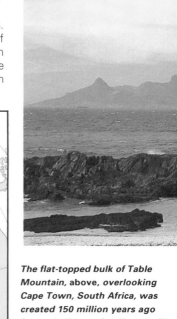

The flat-topped bulk of Table Mountain, above, overlooking Cape Town, South Africa, was created 150 million years ago from a build-up of sediments. The lowest layer contains striated and glacier-scarred pebbles from an ice age that once covered much of the southern hemisphere.

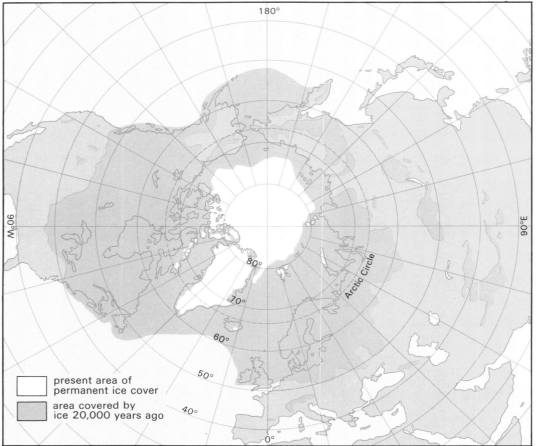

present area of permanent ice cover

area covered by ice 20,000 years ago

The birth of the island of Surtsey, in the North Atlantic, right, occurred on 14 November 1963, as the result of a submarine volcanic eruption. It has been suggested that huge clouds of dust ejected into the upper atmosphere by such large-scale volcanic eruptions may have been responsible in part for the occurrence of ice ages.

fluctuations that could well account for the occurrence of ice ages.

Most climatologists believe that a change of only a few per cent in the amount of sunlight falling on the Earth could trigger the onset of an ice age. But it is by no means clear whether it is an increase or a decrease in sunlight that is needed to cause an ice age. This may seem odd, but it has been suggested that an increase in the amount of sunlight falling on the Earth would increase evaporation of water, thereby increasing the amount of rain and snow worldwide. Extra cloud would prevent some proportion of sunlight ever reaching the Earth's surface; and increase in snowfall would increase the extent of the Earth's snow-covered areas and thus the amount of sunlight reflected back into space. All this would lower the world's average temperature which would, in turn, further increase snowfall – and so on.

The extent of ice at the height of the last ice age is shown in grey, above; and the extent of the permanent ice cover today, in white.

Estimated average summer temperatures in north-west Europe over the past three million years are recorded on the graph, right. An ice age occurs whenever the average summer temperature falls below 50°F (10°C). Oscillations in climate are becoming both faster and more severe.

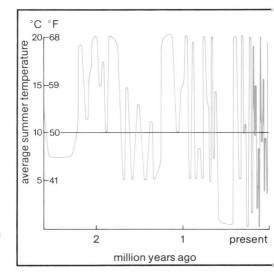

and the Sun varies throughout the year. The slight difference that this causes in the amount of heat reaching the Earth can accentuate or mitigate the seasonal difference between summer and winter temperatures in a particular hemisphere. At present, the Earth's orbit is only slightly elliptical and it is becoming more circular. Nevertheless, the variation in Sun-Earth distance tends to make northern summers and southern winters cooler, and northern winters and southern summers warmer than they would be if the orbit were perfectly circular.

The second cycle is that of the seasons, caused by the tilt of the Earth's axis. Currently, the tilt is about 23°27′, but is known to vary from 21°48′ to 24°24′. The Earth takes about 40,000 years to 'nod' once. At present, the tilt is decreasing as the Earth is becoming more 'upright' in its orbit and this has the effect of reducing the contrast between summer and winter.

The third of the cycles that are important in the Milankovich model is largely due to the Earth's precession, or 'wobble' – the change in direction of the Earth's axis. The effect is to change the season at which the Earth is closest to the Sun. The result,

once again, is to sharpen or soften the contrast between summer and winter, over a period of approximately 11,500 years.

Although the total amount of sunlight received in the course of a year is not altered by any of these effects, the mildness or severity of the seasons changes in a complex pattern. This pattern has been detected, so some scientists claim, in the geological record of ocean temperatures. This is obtained by studying the oxygen present in fossil marine organisms in rock cores drilled from the ocean bed. A complex statistical analysis of the graph of ocean temperature over time that is obtained in this way has revealed cyclic variations over periods of about 95,000 years, 40,000 years and 11,500 years.

But a major embarrassment for the Milankovich theory was that it seemed to suggest that ice ages should occur alternately in the Northern and

Southern Hemispheres. However, refinements of the theory, taking into account the distribution of the world's land masses, show how it is possible for ice ages to occur at roughly the same time in both hemispheres. This has, in fact, been proved by geological records.

Ice ages can only occur, it seems, when there is land at or near either or both of the poles, so that permanent ice caps can form. Since the continents drift slowly over the Earth's surface, there have been vast periods when there was only ocean in both polar regions. In such circumstances, it would not have been possible for ice ages to occur.

For many millions of years, however, Antarctica has been sited at the South Pole and the Arctic Ocean has been almost land-locked, so that it freezes easily. The requirements for an ice age in such conditions are sharp southern winters, so that large volumes of the Antarctic waters freeze. The Southern Hemisphere can then initiate the spread of ice, and cool northern summers, so that not too much of the snow and ice cover in the north melts. These conditions have been fulfilled by the Milankovich effect over the last 150,000 years. The advance and retreat of the ice in northern latitudes has also kept closely in step with the deficit or excess of solar radiation received in the Northern Hemisphere. Over the last 18,000 years, the Northern Hemisphere has been getting more heat than average, and the ice has retreated as a result. But from now on there will be less and less heating by the Sun in the north. It will reach a minimum in 10,000 years, but long before then a new ice age will have begun. By this reckoning, it will have reached its full intensity in 1,000 years; and it could endure for as long as 100,000 years.

DISSENTING VOICES

There are many scientists who have rejected the Milankovich theory, however, and the distinguished astrophysicist Sir Fred Hoyle was one of them. The Milankovich model shows, he said, that cyclic variations in the Earth's temperatures are to be expected; but it does nothing to show that ice ages would not occur even if all these variations were absent. Furthermore, he did not believe that variations of a few per cent are sufficient to plunge the Earth into an ice age, or to pull it out of one. As he put it:

'If I were to assert that a glacial condition could be induced in a room liberally supplied during winter with charged night-storage heaters simply by taking an ice cube into the room, the proposition would be no more unlikely than the Milankovich theory.'

Hoyle also believed that slow astronomical changes could never account for the suddenness of the onset of ice ages, which can develop in one or two centuries. They can end even more rapidly, in a matter of decades. Hoyle therefore believed that ice ages must have a sudden and violent cause, the only possible candidate being the impact of a large meteorite. Interestingly, bodies 1,000 feet (300 metres) or more in diameter hit the Earth about once in every 10,000 years – which is about as often as ice ages seem to occur.

So what would happen to us if such a body were to crash to Earth tomorrow? Assuming the object weighed around 50 million tonnes, it might throw 50,000 million tonnes of debris into the

stratosphere. The blanket of reflective particles thus produced would screen out enough of the Sun's light to lower the Earth's temperature significantly.

The land would cool faster than the ocean, and the temperature differences would cause the Earth's weather to become more violent, storms, rain and snow becoming more intense. The effect would be to drain the ocean of its stored heat, while slowing the cooling of the atmosphere. For 10 years, as the dust particles in the high atmosphere settled and the ocean's stored heat was used up, the Earth's temperature would drop. Snow would also fall in greater quantities and become permanent over ever-increasing areas.

The Earth's climate is governed to a great extent by its orientation in relation to the Sun, as shown below. Days are long in summer in the Northern Hemisphere because the North Pole of the Earth is tilted towards the Sun and short in winter because it is then tilted away. But the Earth also 'nods' – the tilt of its axis varying between 21° 48' and 24° 24', as illustrated, and the contrast between the seasons exaggerates or lessens as the angle changes.

At this point, a disaster would occur that would lock the Earth into a new ice age. The uppermost layers of water vapour in the atmosphere are warmed not by sunlight, which water vapour does not absorb well, but by heat radiation from the Earth. They would now cool to the point at which countless minute grains of ice ('diamond dust') suddenly form. Seen from space, they would look like a dazzling white blanket in the upper atmosphere, reflecting much of the Sun's heat back into space. The ice cover would also reflect a great deal of the heat penetrating to the Earth's surface. The world's temperature would then plunge further.

Once the sea's excess heat had been lost, and the temperatures of the oceans, air and land were

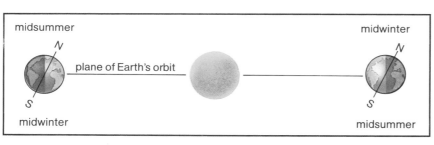

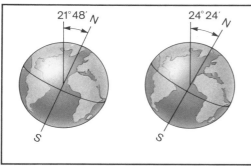

In addition to 'nodding', two other factors in the Earth's rotation affect the climate of the planet. Over a period of 95,000 years, the Earth's orbit changes from elliptical to circular and back again, as depicted. The slight differences in the amount of heat reaching the Earth that this causes can also emphasise or reduce the difference between the seasons. The Earth's precession, below, or 'wobble', with a period of 11,500 years, has the same effect. According to the Milankovich theory, these three cycles can coincide to produce an ice age.

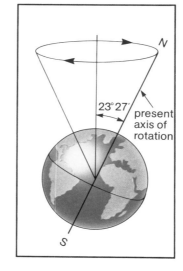

HOYLE SUGGESTED, IN ALL SERIOUSNESS, THAT THE HUMAN RACE SHOULD TAKE STEPS TO PREVENT THE RECURRENCE OF AN ICE AGE — A RECURRENCE THAT IS OTHERWISE INEVITABLE, AND WOULD BE SO RAPID THAT WE COULD NOT POSSIBLY COPE WITH THE DISRUPTION IT WOULD CAUSE. HIS PROPOSAL WAS THAT WE GO ALL OUT TO INCREASE THE STORE OF HEAT IN THE OCEAN.

in equilibrium, according to Hoyle's theory, winds would almost cease. There would be little rain or snow; but over the centuries, ice sheets – half-a-mile (800 metres) thick – would develop over Britain, northern Europe and much of North America. Even in tropical zones, the mountains would be capped with ice, from which huge glaciers would descend. A much reduced human population would live on, though millions would have starved as a result of the abrupt shifts in rainfall and vegetation patterns.

In Hoyle's view, only another meteor strike could reverse the effects of the one that brought on such an ice age. This time, a meteor with a high iron content would be required; but such bodies only represent between as few as one fifth and one tenth of all meteors.

If and when such an object struck, millions of tonnes of fine iron particles would be thrown into

the upper atmosphere. These would reduce the amount of direct sunlight getting through to the surface by perhaps 20 to 30 per cent. But the iron particles would absorb heat, rather than reflecting it back into space, and would cause the atmosphere to warm rapidly. The diamond dust would then vanish, turning into water vapour, and land and sea would warm up in their turn. The iron particles would take some decades to settle out of the atmosphere ; and when they had done so, the Earth would be able to complete its transition to a 'normal' state.

In fact, what we regard as a 'normal' climate has been the exception during the past two million years. Warm periods have been about 10,000 years

long, while ice ages have been about 100,000 years long. This is, in fact, consistent with the fact that stone meteorites strike the Earth between five and ten times more frequently than iron ones.

Hoyle suggested, in all seriousness, that the human race should take steps to prevent the recurrence of an ice age – a recurrence that is otherwise inevitable, and would be so rapid that we could not possibly cope with the disruption it would cause. His proposal was that we go all out to increase the store of heat in the oceans.

The depths of the oceans are cold, largely because of the existence of the Antarctic ice cap. Icebergs break away and slowly melt during the southern summer. The cold, dense sea water then sinks to the bottom where it is cut off from the warmth of the atmosphere and sunshine.

Hoyle proposed warming the ocean depths by pumping water from the depths to the surface. There the water would be warmed somewhat by the air; but it would still be colder and denser than the surface waters, and would sink again, being warmed by surrounding waters on its way down.

The warming must not be done too rapidly, for that would lead to a cooling of the surface waters, bringing on an ice age. In fact, the project is conceived on a grand scale. A century's pumping, Hoyle calculated, would be required to increase the heat stored in the oceans by a year's supply. (By

Admiralty Bay, King George Island, Antarctica, above, and the tundra of the Northern Hemisphere's Greenland, right, would both feel the effects of a future ice age. According to the Milankovich theory, the next ice age is likely to be initiated by a combination of factors: a series of sharp winters in the Southern Hemisphere, permanently freezing ever-larger areas of Antarctic waters, and cool summers in the Northern Hemisphere, permanently freezing the snow cover of land close to the North Pole.

this, he meant the amount of heat required to prevent the formation of diamond dust and hence the start of an ice age for a year.)

By such calculations, it would take a millennium to provide an extra 10 years' supply, which would double the world's present heat reserve. After a further 30-year supply had been established, the Earth would, Hoyle argued, be safe from the threat of a new ice age.

To achieve this cautious rate of warming, water would be pumped up in an area of the ocean about 2½ miles (4 kilometres) across. It would take just over an hour for the water to rise from the sea's average depth of 4,100 yards (3,800 metres). The system would be self-powered, using the temperature difference between surface waters and bottom waters to run the pumps.

The result would be to return the overall temperature of the oceans to its level of 20 million years ago when there were no ice ages. There would be some melting of the polar ice caps and a consequent rise in the world's sea level: but over a few thousand years, these could easily be dealt with. Hoyle envisaged that, during this time, we shall be pushing back the oceans from the continental shelves in order to exploit their rich mineral resources, so he was not worried by the prospect of having to build extra sea walls to provide a barrier against the oceans, since similar engineering projects would already have been accomplished.

Some have seen this visionary scheme as one of the most arrogant manifestations of mankind's technological conceit to date. But Hoyle insisted that it must be done. One day, another of those stony meteorites will strike and, said Hoyle, it is up to us whether disaster is prevented or sets in for a hundred millennia.

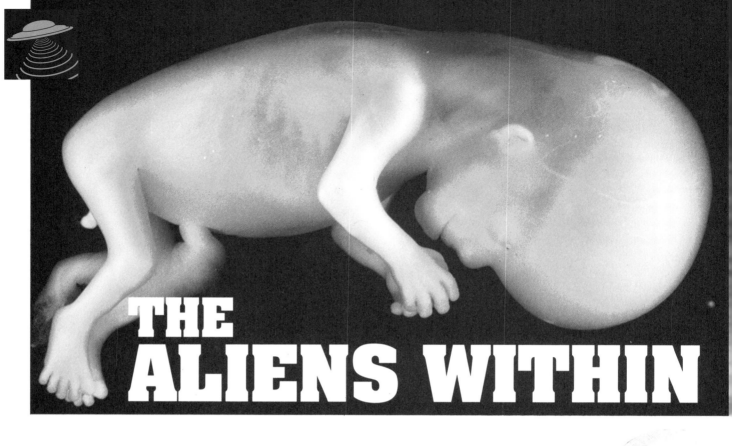

THE ALIENS WITHIN

STARTLING PARALLELS BETWEEN ABDUCTION REPORTS FROM ALL OVER THE WORLD SUGGEST THAT THESE EXPERIENCES COULD WELL BE LINKED IN SOME WAY. ACCORDING TO ONE ORIGINAL THEORY, THEY ALL STEM FROM THE VERY TRAUMA OF BEING BORN

Of all aliens reported by witnesses of close encounters of the third kind, by far most common are those of the humanoid type. Small, with disproportionately large heads and eyes, spindly-limbed, and clad in one-piece, tight-fitting suits, they often closely resemble nothing so much as a human foetus. Could this be mere coincidence – or might there be more to it?

The first striking feature is the general diminutive size of such humanoids – on average 3 – 5½ feet (90 centimetres – 1.7 metres). Humanoid reports also tell of creatures with disproportionately large heads and eyes. The foetal head size is also disproportionately large from the fourth week onwards; the eye sockets are large and, after the eyes form during the fourth week, they grow rapidly until at birth they are half the size of those of an adult – but in a body very much smaller. The bodily features of humanoids are generally reported to be rudimentary, or missing altogether. This is also true of the human foetus until very late in its development. The hands begin to form in the fifth week, and the feet in the sixth week; but fingers and toes remain webbed until around the eighth week. The underdeveloped ears, nose, mouth and shape of the face mean that the developing baby does not have a recognisably 'human' face until about the tenth week – it is, instead, very similar to what we might recognise as 'humanoid'. In most cases, humanoids are also reported as having no evident genitalia; and the genitalia of the human foetus also remain ambiguous or underdeveloped until the twelfth week.

The arms of humanoids are often described as longer than the legs; and the arms of the foetus are certainly longer than its legs until the fourth month. Humanoids walk clumsily, as if unaccustomed to such movements; the human foetus, meanwhile, does not make perceptible movements until the fifth month. Humanoids' skin is generally either pallid – grey or white – or reddish: foetal skin colour is pallid until the sixth month, and reddish in the seventh. Humanoids have wrinkled skins and hairless bodies; the human foetus has a wrinkled skin in the seventh month, and hair does not appear until the eighth month. Humanoids are often reported as having no eyebrows, and sometimes – when their skin is not wrinkled – it is said to be unnaturally smooth. Eyebrows only become visible in the unborn baby in the eighth month, and the skin becomes waxy and smooth just before birth, in the eighth and ninth months.

The similarities between humanoids reported in close encounter cases and those described in a hypnosis experiment, in which subjects were asked

o describe an imaginary close encounter and imagery from LSD-induced 'trips', suggest that early prenatal experiences may provide a rich store of imagery that comes to the fore when triggered in some way.

Psychiatrist Stanislav Grof, with years of experience in the therapeutic use of LSD, has expressed belief that many of his patients relive their own birth trauma during LSD sessions:

Indeed, these striking similarities suggest that the unborn child – particularly in the period of the first eight weeks from conception – may be the model for the humanoids reported in many close encounter cases.

The 10-week-old human embryo, left, and an artist's impression of one of the humanoids allegedly seen by Travis Walton during his five-day abduction from Heber Arizona, USA, on 5 November 1975, below left, bear striking similarities.

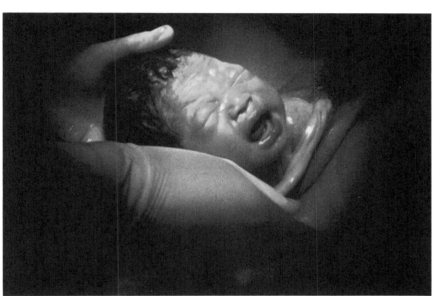

subcellular consciousness. Grof has said it is commonly reported by such subjects that they even identify with the sperm and ovum at the time of conception, and sometimes describe an accelerated process of foetal development.

One cellular component not mentioned in Grof's data, however, is potentially stunning in its implications for ufology. When the fertilised human ovum is six days old and attaches itself to the wall of the uterus, the distinctly embryonic tissue inside the ovum assumes an intriguing shape: it resembles a flattened, circular plate – the basic UFO pattern – and is then known as the embryonic disc. This stage of prenatal life is the first in which the fer-

'In a way that is not quite clear at the present stage of research, the subjects' experiences seem to be related to the circumstances of the biological birth. LSD subjects frequently refer to them quite explicitly as reliving their own birth trauma. Others quite regularly show the cluster of physical symptoms that can best be interpreted as a derivative of the biological birth. They also assume postures and move in complex sequences that bear a striking similarity to those of a child during the various stages of delivery.'

Grof has also described experiences in which LSD patients seem to 'tune in' to the 'consciousness' of a particular organ or tissue of their own body, and even regress, apparently, into a cellular or

It has been suggested that the travel through tunnels, frequently described in abduction reports, may well be reflections of the baby's passage down the vaginal canal, just prior to birth, above. The artist's impressions, above left, show a number of flying saucers from various UFO sightings. Six days after conception, the fertilised human egg also assumes a flattened, circular shape.

tilised tissues can be thought of as something integral, whole, or individual.

ARCHETYPAL SYMBOLS

The psychologist Carl Gustav Jung found an analogy between the shapes of 'flying saucers' and 'mandalas', which he defined as archetypal symbols of unity, wholeness, and individuation. If Grof's work is accurate, it could perhaps be interpreted as providing a physiological basis for Jung's theories about archetypal imagery and his related speculations as to the collective unconscious. At the very least, it is somewhat startling to realise that every human being who ever lived was – for a few hours – shaped very like a flying saucer. With that in mind, one can speculate that the embryonic disc may indeed manifest itself as a Jungian mandala or saucer archetype in everyone's sensibility, sometimes emerging as part of a witness's UFO-related imagery. Thus, UFO witnesses might sometimes be predisposed to perceive saucer-shaped craft in the presence of whatever psycho-physical stimulus triggers off the reaction – and what the witnesses think they perceive may be an archetypal echo of their own prenatal experiences.

One of the most difficult problems for ufology is the study of abduction cases. Often seemingly totally unsupported by reliable evidence, reports of abduction cases may seem pointless or even ridiculous; but they nevertheless present a coherent

> WITNESSES OFTEN REPORT BEING SUCKED UP IN A TUBE, APPARENTLY MADE OF LIGHT OR A LUMINOUS MATERIAL, INTO THE UFO. THESE MAY WELL BE MEMORIES OF THE BABY'S PASSAGE DOWN THE BIRTH CANAL.

body of evidence that deserves to be taken seriously. So how do abduction reports fare under an analysis of the subject's own prenatal experiences?

Stanislav Grof presents a useful breakdown of the birth process into four stages, each of which, he believes, has major implications for later personality development and behaviour. Stage one is of primal union with the mother, characterised for the foetus by nothing more than what Grof terms 'good' and 'bad' womb experiences – periods of disturbed or undisturbed life in the womb. Then, with the onset of the birth process, come contractions within the closed system of the womb – stage two. And next, in stage three, the foetus works together with the mother in its propulsion down the birth canal. Finally, there is stage four, birth – the termination of the foetus' union with its mother and the formation of a new relationship both with her and with the external world.

Grof found that many of his LSD patients relived their 'bad' womb experiences of foetal distress in feelings of sickness, nausea and mild paranoia, which may be traceable to any of several causes – such as the mother's physical or emotional health, her ingestion of noxious substances, or attempted abortion. Reliving 'good' womb experiences manifested itself in visions of prebirth bliss, including feelings of cosmic unity, transcendence of space

The Buddhist painting, below, shows a Buddha inside a mandala, surrounded by demons. Alvin Lawson suggested that the mandala may represent the womb – safe and secure within, but surrounded by all kinds of unknown dangers. The psychologist Carl Gustav Jung believed that flying saucers were a form of mandala – a fact that ties in very neatly with Lawson's contention that flying saucers can be regarded as representations of the womb.

and time, visions of paradise, 'oceanic' emotions, and other parallels with mystical or ecstatic experiences. Abduction reports are full of similar elements – cosmic vistas, feelings of harmony and peaceful self-awareness, and intuitive insights into the nature of the Universe, as well as reports of nausea after the event, discomfort, unpleasant tastes and odours.

The onset of the birth process – manifested, for the foetus, in the start of contractions in the wall of the womb – is reflected in repeated experiences during close encounters of being trapped, fixed, chained, or unable to escape an inevitable doom or unrelenting threat, or of 'cosmic engulfment', a gigantic whirlpool sucking the subject and his world relentlessly to its centre. Stage three, the passage through the birth canal, is reflected by great pressure and pain in the head and other parts of the body, and as a more general distress in which subjects experience sado-masochistic orgies, mutilations and self-mutilations, ritual sacrifices and other bloody events. Witnesses also often report hot flushes alternating with chills, and profuse sweating combined with shivering.

MEDICAL EXAMINATIONS

The final stage – separation from the mother and confrontation of a new world – is mirrored in the breathing difficulties that many witnesses report, and the severe pain in the umbilical region, often spreading to the pelvic area. There may also be a feeling that the victim's body is being cut open and his heart or other organs removed 'for medical examination'. Their eventual replacement brings a sense of rebirth and renewal.

It is easy to see how the immediate surroundings of the unborn foetus may also become reflected in 'close encounter' reports. Tubes and tunnels

became a necessary emergency – by which time the subject had experienced an hour or two in the birth canal, perhaps long enough to establish the tunnel and tube imagery in her subconscious mind.

UNORTHODOX DOORS

Images of doors or passageways are nearly as plentiful in abduction reports as tubes. Indeed, most witnesses describe unorthodox doors that appear suddenly in walls or on an object's exterior, disappearing without a trace soon afterwards. Such doors tend to open from the centre rather than on pivots, or have sliding panels. Some reports even tell of doors that disintegrate or 'explode' just before witnesses pass through them. All these unusual doorways and passages can be interpreted as suggesting another birth event – the opening of the cervix. Supporting this idea is the fact that a control subject, a normal birth, responded to a suggested situation of cervical dilation with the following comment: 'It's like a door opening'. Some have certainly agreed that the birth process is a more likely explanation of the many doors and tunnels in close encounter narratives than any attempt to make these descriptions plausible as realistic accounts of the interior design of alien spacecraft.

The placenta, too, may emerge symbolically in abduction narratives as a UFO shape and also as the rucksack often allegedly worn by aliens. The umbilical cord suggests the tube leading from the rucksack, and it may also take the form of the commonly seen retracting light beam. The amniotic sac, meanwhile, that surrounds the baby in the uterus may have an analogue in the 'bubbledome' headgear on reported aliens, as well as in the transparent UFOs that feature in many reports of close encounters of the third kind.

Such extraordinary parallels in many ways suggest that reported abduction experiences may indeed be no more than relivings of the birth trauma. Without more concrete evidence, it certainly remains a distinct possibility.

are frequent elements of these reports. Indeed, witnesses often report being 'sucked up' a tube, apparently made of light or a luminous material, into the UFO. These may well be memories of the baby's passage down the birth canal – a theory that was reinforced by a study of eight subjects who had all been born by Caesarian section. Interestingly, seven of these subjects used no tube or tunnel imagery in their accounts of how they boarded or left the UFO. The exception, however, had been treated as a normal birth until her mother had a haemorrhage and a Caesarian operation

At around 10 p.m. on 27 October 1974, the Day family, driving towards Aveley in Essex England, suddenly ran into a mysterious bank of green mist, as in the artist's impression, above. When hypnotically regressed, John Day described being drawn up a beam of white light into an alien craft. Alvin Lawson sees the light beam, a recurrent motif in close encounter reports, as a representation of the umbilical cord. He has also pointed out that the golden beam traditionally used to represent the impregnation of the Virgin Mary by the Holy Spirit – as in the painting of the annunciation, above left, by Carlo Crivelli – may have the same origin.

Alvin Lawson suggested that the placenta, seen left with the baby attached, may emerge in abduction accounts as a UFO shape. It may also be represented by the rucksacks often reportedly worn by aliens, such as the one, depicted right, seen at Vilvorde Belgium, in December 1973. The helmet, meanwhile, is said by some to represent the amniotic sac surrounding the foetus in the womb.

THE PHENOMENAL FEATS OF MENTAL COMPUTATION ACHIEVED BY A FEW REMARKABLE PEOPLE ARE CERTAINLY FAR BEYOND NORMAL HUMAN CAPABILITY. WHO ARE THESE SUPERNOVA PERFORMERS?

HUMAN CALCU

In today's age of cheap pocket calculators, many of us are in danger of losing whatever arithmetical skill we may once have possessed. In former times, a shop assistant, confronted with six similar items at 25p each, would make an instant mental calculation that 25p x 6 = £1.50 and would punch that figure on the cash register. Nowadays, in the same situation, a shop assistant will probably use the cash register as a calculator. Whereas children once mastered multiplication tables as a basic skill, they now tend to use their trusty calculator to discover, say, what 4 x 9 equals.

Compared with previous generations, many of us could be said to be arithmetically illiterate. But in past centuries there have been human beings whose calculating ability so far outshone that of their contemporaries and predecessors that mathematicians, scientists and psychologists alike have been astounded. Appearing at random like meteors,

such 'lightning calculators' demonstrate that the human brain is capable of feats that remain largely unexplained.

Some of these lightning calculators have been exceptionally gifted in other spheres of human activity, too; others, in contrast, have exhibited a stupidity that threw their strange mathematical talent into bizarre relief. The only thing common to most of them is that they demonstrated their extraordinary gift in early childhood. With some, it lasted throughout their lives; with others, it departed after a few years. Like the infant musical prodigies, Chopin and Mozart, who both played brilliantly and composed at an early age, the mathematical prodigies seem to have been either self-taught or somehow simply endowed with their ability.

The Irish mathematician Sir William Hamilton (1805-1865) is a good example of someone with exceptional all-round ability. He began to learn Hebrew at the age of three; and by the time he was seven, a fellow of Trinity College, Dublin, said that he showed a greater knowledge of the language than many candidates for a fellowship. By the age of 13, he knew at least 13 languages. Of his early mathematical ability, a relative said: 'I remember him a little boy of six, when he would answer a difficult mathematical question, and run off gaily to his little cart'.

The German mathematician and scientist, Carl Friedrich Gauss (1777-1855), also demonstrated an exceptional early ability to carry out mathematical calculations in his head. A story is told of the first day he attended the arithmetic class of his school, at the age of nine. Almost as soon as the teacher had finished dictating some problems, young Gauss threw down his slate with the remark, 'There it lies.' At the end of the hour, the slates were

Calculators, as above, are now widely used, even in schools. But skill in mental arithmetic was once vitally important to scientists. Sir William Hamilton, below left, and Carl Friedrich Gauss, right, were scientific geniuses, as well as mathematical prodigies. After the death of Gauss, anatomists pronounced his brain (as shown in figures 1 and 2, below), to be far more complex than that of a labourer, figures 3 and 4.

Fig. 1 — Gauss.

Fig. 2 — Gauss (lobe frontal)

checked: only Gauss' answers were correct. By the time he was 13, he was excused from further mathematics lessons; and many of his most important mathematical discoveries were made between the age of 14 and 17. He became the foremost mathematician of his age, publishing his book on the theory of numbers when he was 24. He also made notable contributions to astronomy. Throughout his life, he demonstrated an astounding ability to remember numbers and to carry out calculations in his head at uncanny speed.

MENTAL AGILITY

The multi-faceted brilliance of Hamilton and Gauss tends to obscure their extraordinary arithmetical skill. When we examine such people as Tom Fuller, Jedediah Buxton and Zacharias Dase, however, the real mystery of such strange abilities becomes evident.

Certain 18th-century African slave-dealers seem to have surprised Europeans with whom they traded by their mental agility in calculating intricate deals. However, Thomas Fuller outshone the best of them. Shipped as a slave to America, to the state of Virginia, he became known as 'the Virginia calculator'. In 1780, when he was 70, he was tested by William Hartshorne and Samuel Coates. Among the questions they asked him were the following:

'How many seconds are there in a year-and-a-half?' Fuller gave the answer in about two minutes.

'How many seconds has a man lived who is 70 years, 17 days and 12 hours old?' This time, Fuller supplied the answer in a minute-and-a-half. When his questioners told him he was wrong, he pointed out that they had not taken into account leap years. Fuller died in 1790. He had never even learned to read or write.

Another 18th-century illiterate who was nevertheless a mathematical prodigy was Jedediah Buxton, son of an English village schoolmaster. In spite of his father's occupation, Jedediah steadfastly refused to be educated, and as an adult could not even scrawl his own name. He seemed to have no interest in anything apart from calculating. In 1725, he remarked that he was drunk with reckoning. This was scarcely surprising for he had just answered, after a labour of one month (and without pen or paper) the following mammoth questions. How many barley corns, vetches, peas, beans, lentils and grains of wheat, oats and rye would fill a space of 202,680,000,360 cubic miles? And also how many hairs, each an inch long (and taking 48 hairs laid side by side to measure one inch across) would fill the same space?

His ability to solve this and similar problems earned him fame, and in 1754 he was taken to London to be examined by the Royal Society. He visited Drury Lane theatre to see Shakespeare's play *Richard III*, but his only response to this theatrical experience was to count the number of times

Fig. 3 — Ouvrier allemand.

— Ouvrier allemand (lobe frontal).

*In*FOCUS

TRICKS OF THE TRADE

Much of the labour of arithmetical calculations can be reduced by the use of a few simple tricks, and there can be little doubt that many of the famous lightning calculators used these. Those who professed not to know how they obtained their results may even have used such methods subconsciously.

The following are some examples. If you want to test how much trouble they save, try solving the problems the long way – and time yourself!

What is the square of 97?

Instead of multiplying 97 by 97 in the conventional way, proceed as follows:

$97 \times 97 = (100 - 3) \times (100 - 3)$
$= 10,000 - 300 - 300 + 9$
$= 9,409$

Multiply 197 by 104

$197 \times 104 = (200 - 3) \times (100 + 4)$
$= 20,000 - 300 + 800 - 12$
$= 20,488.$

What is the square root of 3,249?

Try approximate appropriate numbers:

$50^2 = 2,500$ (too small)
$60^2 = 3,600$ (too big)

Only 3^2 or 7^2 will give 9 in the last place.

Try: $53^2 = (50 + 3) \times (50 + 3)$
$= 2,500 + 150 + 150 + 9$
$= 2,809$ (wrong)

Therefore the answer must be 57.

What is the square root of 92,416?

The required number must lie between 300 and 310, since 300^2 (90,000) is too small, and 310^2 (96,100) is too big. Looking at the last two digits, we find the number that gives 16 when squared (4). So the square root must be 304.

What is the square root of 321,489?

To find the appropriate numbers (in hundreds) around which to test, look at the first two digits (32). The square of 5 is 25 and the square of 6 is 36, so the square root will lie between 500 and 600. Looking then at the last two digits, we ask what number squared ends in 89. The answer is 67. So the square root must be 567.

Mnemonic devices can also be used to remember numerical formulas that crop up frequently, such as the value of \prod (the ratio of the circumference of a circle to its diameter) to 12 figures. This is $\prod = 3.14159265359$.

The formula can be memorised by means of the following couplet, in which the number of letters in each word have to be counted up in order to give the number of each digit:

See, I have a rhyme assisting
My feeble brain its chore resisting.

The son of a village schoolmaster, *Jedediah Buxton, left, refused to learn to read and write but showed an extraordinary talent for mental computations. He excelled in very long problems that took weeks to solve, all without benefit of pen and paper. But to what extent could such an exceptional brain outdo a calculator, such as the one below?*

each actor appeared and left the stage, and the number of words each one spoke.

Another 19th-century mathematical wonder was Zacharias Dase, who was born in 1824. His extraordinary ability in mental arithmetic became evident quite early in his life; and as his fame grew, he travelled extensively throughout Europe, becoming acquainted with eminent scientists such as Gauss and the German astronomer Johann Encke. Dase seems to have had wider intellectual horizons than Buxton and Fuller, and wished to use his calculating genius in the service of mathematics and science. Since he was able to multiply and divide large numbers in his head, he was able to create mathematical tables at incredible speed. By 1847, he had calculated the natural logarithms for every number between 1 and 1,005,000 to seven figures. The length of time he required for any mental calculation was dictated by the size of the numbers involved. In one test, he multiplied together the numbers 79, 532, 853 and 93,758,479: it took him only 54 seconds. Multiplying two numbers, each of 20 figures, took him 6 minutes; two numbers, each of 40 figures, took 40 minutes; and two of 100 figures each took him 8¾ hours! All this was done without writing anything down.

A Singular Talent

Although he was anxious that his talent should be used to further the cause of science, he unfortunately had no ability beyond his gift. Many people even thought he was stupid. One teacher tried for six weeks without success to teach him the basics of mathematics. Geometry was a closed book to him. And yet in spite of all this, he did in some sense achieve his ambition. In 1849, on the recommendation of Gauss, the Hamburg Academy of Sciences gave Dase financial support to create tables of factors and prime numbers between 7 million and 10 million. He was still at this colossal task when he died in 1861.

Vito Mangiamele, son of a Sicilian shepherd, was aged 10 when he was tested by the astronomer François Arago before the French

Academy in 1837. To the question, 'What is the cubic root of 3,796,416?', the child gave the correct answer in half-a-minute. It took him less than a minute to provide the answer (which is 5) to the question, 'What satisfies the condition that its cube plus five times its square is equal to 42 times itself increased by 40?' On being asked to supply the 10th root of 282,475,249, the little boy gave the answer '7', which is correct.

The talent of an American boy, Zerah Colburn, seems to have appeared almost overnight. At first considered backward, he showed no sign of arithmetical ability at his village school. Then, one day, his father heard him reciting multiplication tables to himself without error. Soon his father was exhibiting young Colburn at various places in the United States, and took him to England in 1812. Now eight years old, Zerah was bombarded with questions such as: 'What is the square root of 106,929?' Without hesitation, he could answer '327'. To the question, 'What is the cube root of 268,336, 125?' he could give the answer '645' just as readily. He was also able to say whether a large number was a prime number. Given the number 4,294,967,297, he would even know that it was equal to 641 x 6,700,417.

Strangely, Zerah Colburn never seems to have excelled in any other activity at all; and he died at the early age of 35.

A study of such human calculators was made by an American psychologist, Dr E.W. Scripture

CASEBOOK

HUMAN SLIDE RULE

Born in 1806, George Bidder, *right,* was the son of an English stonemason. While still quite young, he was taken about the country by his father who wished to exhibit his son's most remarkable calculating prowess. People would test him with complicated questions such as: 'How many drops are there in a pipe of wine, if each cubic inch contains 4,685 drops and each gallon contains 231 cubic inches, and assuming there are 126 gallons in a pipe?'

Bidder was highly intelligent, and his fate was quite different from that of many other lightning calculators. He not only went to school but subsequently attended Edinburgh University, where he won the mathematical prize in 1822. Indeed, he became one of the foremost engineers in Britain, working for the Ordnance Survey and later for the Institution of Civil Engineers, of which he became president. He is regarded as the founder of the London telegraphic system and is credited with the design of the Victoria Docks in London. An expert in civil engineering in an era when England's railway system was being created, Bidder was highly sought after.

Unlike Archbishop Whately, who lost his outstanding calculating abilities at an early age, Bidder's powers actually improved as he grew older. According to a fellow of the Royal Society, he had 'an almost miraculous power of seeing, as it were; intuitively what factors would divide any large number . . . given the number 17,861, he would instantly remark it was 337 x 53.' He was not, however, able to explain how he did this.

Bidder passed on his gift to his son, George Bidder QC. Although not as brilliant a reckoner as his father, Bidder Junior became a noted mathematician who could multiply a 15 figure number by another 15 figure number in his head. Two of Bidder's granddaughters also showed considerable dexterity in mental arithmetic.

The theory that the right hemisphere of the brain (the one less used by most right-handed people) might be more active in lightning calculators was put forward in 1903 by the psychical researcher Frederic Myers. As evidence for this, he cited the fact that both Bidder QC and Edward Blyth, another 19th-century engineer and lightning calculator, were left-handed, indicating that their dominant hemisphere was the right one. However, it is not possible to determine now whether any of the earlier lightning calculators were left-handed; nor is it possible to say with certainty that the gift can be inherited.

1864-1943), who collected accounts of many more than those described here. As a psychologist, he was naturally interested in trying to discover how such arithmetical prodigies achieve their astounding results. While his studies do not clear up the mystery completely, they do, however, throw some light on the subject.

Scripture pointed out that in order to carry out their calculations and to store a multitude of numbers in their memories for long periods of time, the lightning calculators need to have exceptional memories. Indeed, Buxton, Fuller, Dase and Colburn all gave evidence of possessing remarkable memories, often in areas other than computation. Possession of total recall would also enable the results of past calculations to be available for future operations, in much the same way that a mathematical table, once learned, is available to the ordinary mortal. Various conversion constants, such as the number of seconds in a year, or the number of inches in a mile, once assimilated, were readily available to them for future calculations.

These were fairly obvious conclusions. But Dr Scripture also suggested that other characteristics of the lightning calculator were a facility for rapid recall, a love of arithmetical computations and short-cuts, mathematical precocity and an extremely good visual imagination.

Equally curious in many ways is that aspect of the brain that enables someone to talk backwards as readily as he or she can forwards, while keeping the words of a sentence in their correct order. This

In 1981, ten-year-old Ruth Lawrence, above, won an open scholarship to Oxford University in competition with over 500 students almost twice her age. She was assessed as possibly the most brilliant maths student ever seen in Britain.

is a talent possessed by Andrew Levine, of the Department of Political Philosophy at the University of Wisconsin. Give him any sentence by word of mouth in any one of several languages, and he will be able to repeat it to you, with each word in reverse order, at great speed. The French sentence 'Je vais visiter ma tante la semaine prochaine', (meaning 'I am going to visit my aunt next week') thus becomes 'Ej siav retisiv am etnat al eniames eniahcorp'. Scientists believe that study of the way in which Levine and others are able to play with words in this way, or calculate at an extraordinary rate, may reveal much about brain function. Meanwhile, it has to be conceded that this particular talent serves little purpose other than to entertain.

But it should not be thought that such prodigies are exclusively male, nor that 'lightning calculators' are confined to the past. In 1981, British student Ruth Lawrence, won an open scholarship to Oxford University – at the age of ten. Many consider her to be the brightest mathematician that Oxford has ever known.

What Dr Scripture and other investigators have not yet explained is why such characteristics are found in particular individuals. If it is a question of heredity, what special constellations of genes would be necessary to create such persons? How is it that a few brains can perform supernova feats of computation that make the ordinary person's mathematical skills appear primitive? These mysteries remain as facets of the larger mystery of the human brain.

...

THE CHINESE ORACLE

ONE OF THE OLDEST AND MOST FLEXIBLE OF DIVINATORY METHODS IS ALSO THE MOST FASCINATING. THE I CHING, DEVELOPED IN CHINA OVER 3,000 YEARS AGO, REMAINS A CONSTANT SOURCE OF INSPIRATION FOR THOSE WHO CAN INTERPRET ITS CRYPTIC MESSAGES

The great Chinese philosopher Confucius (c.551-479 BC) is reputed to have said: 'If some years were added to my life, I would give 50 to the study of the *I Ching*, and might then escape falling into great error.' That was in 481 BC, when he was already nearly 70 years old, and had written a series of commentaries on the text of the book that the Chinese call the *I Ching*, or *The Book of Changes*.

A romanticised Western view of the ceremony involved in consulting the I Ching, is shown below. The sticks are being passed through the smoke from an incense burner, while the enquirer makes his kowtows before them.

The *I Ching* is one of the oldest and most respected oracle books in the world. In its present form, it can be traced back at least 3,000 years – and even at that time, it was already considered venerable, since it was based upon more primitive forms of oracle.

The *I Ching* draws its basic philosophy from the ancient Chinese faith known as *Tao*. The word 'tao' is most usefully translated as 'way' – as in the Christian expression 'I am the Way, the Truth, the Life' – but no English word provides a really satisfactory equivalent, and even in Chinese it is susceptible to a variety of meanings. Indeed, as one Chinese inscription puts it: 'The Tao that can be put into words is not Everlasting Tao'.

To the Taoist sage, the world is not made up of separate particles of time and space: everything is part of everything else, and reality consists of ceaseless change. The river that one paddled in yesterday is not the river one swims in today; and so the Universe is seen as a moving pattern in which nothing is permanent. The *I Ching* is different from other oracle books in this respect: it does not regard the past, the present and the future as fixed. Instead, it treats time and fate as dynamic and flowing, never the same from one moment to the next. The advice that one obtains by consulting the *I Ching*, therefore, is of possibilities.

Essentially, consulting the *I Ching* requires the construction of one of 64 possible hexagrams –

blocks of six lines which, if properly understood and interpreted, are said to explain natural events and human existence. Each hexagram is made up of two three-line signs called 'trigrams'. There are eight different trigrams, and it is the arrangement of all possible combinations of these trigrams – lines that are either solid or broken – that makes up the 64 possible hexagrams, each of which has a significant Chinese name.

The lines of the trigrams are explained in terms of the two opposing, yet complementary, principles of Taoist philosophy, *yin* and *yang*. *Yin* is passive, watery, pertaining to the Moon, essentially female; *yang* is active, fiery, pertaining to the Sun, essentially male. A broken line represents *yin*; a continuous or solid line, *yang*. Indeed, it is the ceaseless interaction between these two as represented within the hexagram – reflecting constant changes in life itself – that has given this form of divination its very title, the *I Ching* or *The Book of Changes*.

The system of using broken and solid lines to represent *yin* and *yang* respectively, and the creation of the trigrams themselves, is said to have been the work of the legendary emperor Fu Hsi (pronounced 'foo she') in about 2800 BC. The formation of the hexagrams is ascribed to the Chinese ruler King Wen in the 12th century BC.

The texts that accompany the hexagrams in the *I Ching*, and which need to be consulted by the enquirer, are from several different historical periods and are divided into sections. The first section describes the hexagram in terms of the two trigrams; then comes the so-called 'Judgement', which is said to have been composed by King Wen. The third section, the 'Image', is succinct: it describes the kind of action that the sensible person – usually referred to as 'the superior man' – should take. This text has been attributed to Confucius.

The fourth section, the 'Lines' or 'Commentary', is also traditionally attributed to Confucius. This is generally longer than the 'Judgement', and takes note of the significance of the individual lines making up the whole hexagram.

Each of the eight trigrams – and consequently the hexagrams made up from them – have many levels of meaning. These include aspects of nature, such as earth or thunder; general qualities, such as creativity or stubbornness; seasons; times of the day; and parts of the body. For example, the trigram with three solid *(yang)* lines is called *Chi'en*, symbolising *The Creative*. The qualities it expresses are dynamic energy, masculine power; and it is associated with daytime, and late autumn to early winter.

The first of the 64 hexagrams is also called *Chi'en*, since its upper and lower trigrams are both *Chi'en*. This hexagram has the attributes of heaven, the king, the leader and the head of the family. According to one interpretation, it represents someone who uses his power and vitality constructively, but there is a warning of failure if the strength displayed is arrogant or excessive.

CREATING A HEXAGRAM

Although the hexagrams of the *I Ching* already exist, you cannot just choose one at will. Each person must build up his or her own hexagram in order to receive an answer to a specific question. This is done, line by line, from the bottom up, by casting successive lots.

There are two methods of casting the lots: by throwing three coins or, alternatively, using sticks

K'ung Fu-tzu, above, *is the great Chinese philosopher known to us as Confucius.*

The philosophy of Tao *contains a strong sexual element and intercourse is regarded as the interchange of* yin *and* yang *between the two partners, as shown below. The cup represents Autumn Days, the last of the Thirty Heaven and Earth postures: 'The lord Yang lies on his back, his hand at the back of his head, and lady Yin sits on his thighs but turning her face to his feet'.*

PERSPECTIVES

YARROW–MINDED

One traditional way of consulting the *I Ching* is based on the use of 50 dried yarrow stalks, a plant that once had certain holy significance to the Chinese. One of the stalks is set aside, and is not used in obtaining the hexagram, but the reason for this tradition is obscure.

The remaining 49 stalks are separated into two piles. After this, the procedure is as follows:

1. One stalk from the right-hand pile is placed between the little finger and the ring finger of your left hand.

2. Stalks are removed four at a time from the left-hand pile until four or less are left. These stalks are placed between the ring finger and the middle finger of the left hand.

3. Stalks are removed four at a time from the right-hand pile until four or less are left. These stalks are placed between the middle finger and the index finger of the left hand.

The stalks held between the fingers of the left hand will now total either 5 or 9:

$$1+1+3=5$$
$$or\ 1+3+1=5$$
$$or\ 1+2+2=5$$
$$or\ 1+4+4=9$$

4. These stalks are then put aside, and the process is repeated with the remaining 40 or 44 stalks. At the end, the stalks held between the fingers will total either 4 or 8:

$$1+1+2=4$$
$$or\ 1+2+1=4$$
$$or\ 1+4+3=8$$
$$or\ 1+3+4=8$$

5. This pile is also set aside, and the process repeated with the remaining stalks. Once more, the stalks held in the left hand will total either 4 or 8.

There are now three little piles: the first contains 5 or 9 stalks, the second and third each contain 4 or 8. There are therefore eight possible combinations of these three quantities. These provide a *yin* or *yang* line:

5+4+4 ——O——	*Old yang* line
9+8+8 ——X——	*Old yin* line
5+8+8	
9+8+4 } ————	*Young yang* line
9+4+8	
5+4+8	
5+8+4 } —— ——	*Young yin* line
9+4+4	

So far, only a single line has been generated; this is drawn as the bottom line of the hexagram. The procedure must then be repeated five times more, the lines being drawn in ascending order.

about eight inches (20 centimetres) long. (The traditional equivalents are old Chinese coins – round with square holes – or a number of dried yarrow stalks.) If coins are used, each side is given a value: the heads side of a modern coin is given the value three, the reverse side, two.

Before beginning, you need to ask a definite question of the oracle, preferably one that does not require a clear-cut 'Yes' or 'No'. The coins are then thrown six times. The first three throws give the lower trigram; the next three throws give the upper trigram. Each time the coins land, total their values – they should come to six, seven, eight or nine – and write them down, one figure atop the other.

In this way, every throw produces a line, and the hexagram is built from the bottom upwards. But to draw the lines correctly, you must know whether they are to be broken (yin) or solid (yang). Each total is, therefore, given a name according to its value: a six is equal to 'Old yin'; seven means 'Young yang', eight is 'Young yin'; nine, 'Old yang'. It is helpful to mark any 'Old yang' line with a circle in the middle, and the 'Old yin' with a cross.

The reference to 'Old' derives from the T'ai Chi, a philosophical concept first mentioned in the I Ching, which states that when a primary force, such as yang, reaches its maximum extent (becoming, in effect, 'Old'), it changes into its opposite, yin. This can be seen in the action of a wave, for instance, which builds into a crest (yang) and then, after crashing down, declines into yin, or the midday sun (yang) that sinks down into darkness (yin).

THE 64 HEXAGRAMS

THE 64 HEXAGRAMS SET OUT HERE FORM THE BASIS OF THE I CHING, OR THE BOOK OF CHANGES. EACH SIGN IS ACCOMPANIED BY A SIMPLIFIED INTERPRETATION, CONVEYING THE ESSENCE OF THE HEXAGRAM'S MEANING. FOR A COMPLETE UNDERSTANDING, YOU SHOULD CONSULT A TRANSLATION OF THE I CHING. WHERE HEXAGRAMS APPEAR TO SHARE THE SAME NAME, THERE IS A SLIGHT BUT IMPORTANT DIFFERENCE IN PRONUNCIATION.

1. CHI'EN *(The Creative)*
Use your strength correctly and success is yours, but beware of arrogance

2. K'UN *(The Receptive)*
Adaptability and yielding power of the feminine, plus perseverance, brings good fortune

3. CHUN *(Difficulty in the Beginning)*
A new situation struggles into being; do not force the issue and act carefully

4. MENG *(Youth)*
Inexperience leads to understanding only with a teacher's help. Be respectful and thoughtful

5. HSU *(Contemplation)*
In adversity, bide your time with positive ideas. Cultivate calmness, but be ready for action

6. SUNG *(Conflict)*
Internal or external disputes can be resolved only through compromise or outside advice

7. SHIH *(The Army)*
Massed forces need a strong leader who retains respect and can hold soldiers (power) in check

8. PI *(Union)*
True partnership and cooperation, based on mutual trust and commitment, lead to good fortune

9. HSIAO CH'U *(The Restraining)*
Great plans can be undermined by small things, forcing a compromise or rethink

10. LU *(Treading)*
Move cautiously in your dealings, respecting your inner nature or worth and that of others

11. T'AI *(Peace)*
When strength supports pliancy, harmony is created in personal relationships and circumstances

12. P'I *(Disharmony)*
When the creative and the receptive pull apart, there is lack of harmony and bitter feeling

13. T'UNG JEN *(Social Fellowship)*
The bonds of a community are retained by cooperation, acceptance of diversity and openness

14. TA YU *(Abundant Possessions)*
Great riches or glory in material possessions demand humility, correct behaviour and high principles

15. CH'IEN *(Modesty)*
Modesty of spirit and behaviour amid wealth and status maintain success; it is the greatest virtue

16. YU *(Enthusiasm)*
A time of energy and creativity, suitable for starting new projects and arranging one's affairs

17. SUI *(Adapting or Following)*
Submitting to the wishes of others, or adapting to the flow, can lead to contentment and saving of energy

18. KU *(Repair)*
After destruction and decay comes a time of rebuilding and repairing, the eternal cycle of nature

19. LIN *(Conduct)*
The proper conduct between a person in authority and the one below creates success for both

20. KUAN *(Meditation)*
Once work is done, spend time considering your affairs; contemplation brings clarity and understanding

21. SHIH HO *(Biting Through)*
Difficulties at the start must be 'bitten through', or overcome, by vigorous and just action

22. PI *(Grace)*
Qualities such as grace and youth are attractive and helpful, but one must remember deeper realities

23. PO *(Disintegration)*
Decay and disorder threaten to overwhelm the strong; keep your dignity by selfless behaviour

24. FU *(Returning)*
After bad fortune, your prospects are about to improve; this is the eternal cycle of Tao (The Way)

25. WU WANG *(Simplicity)*
Innocent simplicity and goodness of thoughts, if combined with perseverance, bring great benefit

26. TA CH'U *(Potential Energy)*
Spiritual or material reserves of energy are either being restrained or waiting to be tapped

27. I *(Nourishment)*
In seeking nourishment of mind and body, remember to distinguish between the wholesome and the impure

28. TA KUO *(Excess)*
In spite of your strength, too much of anything can be dangerous; the wise person, however, avoids excess

29. K'AN *(The Deep)*
Crisis doubled (thus deepened) may refer to a situation or mental attitude, but danger also strengthens resolve

30. LI *(Fire)*
The energies of a fiery, clinging person must be controlled; excessive energy can also destroy

31. HSIEN *(Stimulation)*
Quiet, persevering strength attracts the weak, stimulating them and bringing peace and joy

32. HENG *(Endurance)*
The partnership of an active, directing force with a gentle passive force will prove durable

The 'Old' lines, also known as 'moving' lines, reflect change. So when these lines occur, they indicate the need to form a new hexagram ('Old yang' becoming 'Young yin', and 'Old yin' becoming 'Young yang'). It is the text for this new, second hexagram that must be consulted for the answer to your questions.

The following example illustrates the way in which a hexagram is formed and the text consulted. You will, of course, need a good and full translation for this: there are many available from bookshops fairly inexpensively.

If, for instance, you build the hexagram 63, *Chi Chi (Completion)*, the upper trigram is *K'an*, symbolising danger, depth, water, the Moon, the winter season, the north, the middle son, an ear, the 'element' wood and the colour red. The lower trigram is *Li*, representing fire, the Sun, summer, the south, the middle daughter, the eye, and the colour yellow.

Although this is a very favourable hexagram, indicating a coming time of success and harmony, it still gives ground for caution to be exercised. The 'Judgement' on *Chi Chi* reads: 'After completion, there is success in small matters. Righteous persistence brings its reward. Good fortune in the beginning, but disorder in the end.'

Suppose, however, that the hexagram *Chi Chi* was obtained as shown *right*. The 'Old Yin' line – as marked X – was achieved from the number 6, and an 'Old yang' line – as marked O – was achieved from the number 9. When these two lines have changed to their opposites, this produces hexagram 31 or *Hsien (Stimulation)*, as shown *below right*, The 'Judgement', 'Image', and 'Lines' for this second hexagram should therefore be read for interpretation instead.

Exponents of the *I Ching* point out that the oracle is not to be treated lightly. Indeed, as hexagram 4 *(Meng, or Youth)* points out: 'I do not seek out the inexperienced; he comes to find me. When he first asks my advice, I instruct him. But if he persists, that is disrespectful and I give him no answer.'

CHI CHI

HSIEN

33. TUN *(Retreat)* Conserve your strength by withdrawing from a potentially harmful situation at the right moment	**34. TA CHUANG** *(Great Power)* Increasing personal energy leads to power, but be wary of excess and misuse of power
35. CHIN *(Progress)* Progress and prosperity occurs with a just ruler and an obedient, independent servant	**36. MING I** *(Darkening of the Light)* In dark times, the wise person yields on the outside, but hides his inner light or principles
37. CHIA JEN *(The Family)* Each person in the family plays an immutable role; thus, order at home and society is preserved	**38. K'UEI** *(Opposition)* Divergent thought and action can be counter-productive; but there may be progress in small matters
39. CHIEN *(Obstruction)* In facing obstacles, pause and prepare to overcome them by joining forces with others	**40. HSIEH** *(Liberation)* Problems are solved, and tensions and worry are eased; life returns to normality, bringing good fortune
41. SUN *(Decrease)* One person's loss is another's gain; but adjustment to changing fortune brings inner strength	**42. I** *(Increase)* Progress and success are brought about through self-sacrifice and service of the strong
43. KUAI *(Determination)* After a period of tension, accumulated energy breaks through to improve the current situation	**44. KOU** *(Tempting Encounter)* A strong force can be beguiled by apparent weakness; the male principle is seduced by the female
45. TS'UI *(Assembling)* Communities and families prosper when their members act in accord under a good leader	**46. SHENG** *(Pushing Upward)* Progress upward, such as towards power and influence, occurs by will-power and adaptability
47. K'UN *(Oppression)* A time of great adversity can be reversed if one remains cheerful and strong in heart	**48. CHING** *(The Well)* Depth of feeling and nourishment of soul and body, symbolised by the well, are indispensable
49. KO *(Revolution)* Social, political and personal change must be carried out only in the direst situation	**50. TING** *(The Cauldron)* Practical values (a cauldron for cooking) are dedicated to higher principles (nourishment of body or mind)
51. CHEN *(Shock)* A sudden, shocking event induces fear, but the wise person remains composed	**52. KEN** *(Keeping Still)* Complete stillness is acquired through meditation and distancing from the problems of others
53. CHIEN *(Development)* All progress follows a steady, ordained course; follow customs, not agitators	**54. KUEI MEI** *(The Marrying Maiden)* Informal relationships, such as that of a married man and his mistress, require tact and reserve
55. FENG *(Abundance)* A period of greatness, the zenith of achievement, has come about, even though it is brief	**56. LU** *(The Wanderer)* The wanderer must be cautious and obliging, as well as careful to preserve his inner dignity
57. SUN *(The Penetrating)* Like a soft wind that still penetrates, gentle influence can bring about enduring change	**58. TUI** *(The Joyous)* A time of success and prosperity, favourable for the start of new enterprises
59. HUAN *(Dispersion)* When rigid egotism is unblocked, or dispersed, by gentleness, wholeness is attained	**60. CHIEH** *(Limitation)* Fixing limitations upon oneself can be prudent, but too much restraint can be injurious
61. CHUNG FU *(Insight)* When learning and teaching is founded on what is right, great things can be achieved	**62. HSIAO KUA** *(Excess of the Small)* Do not overreach yourself. You can attain small successes by knowing your strengths
63. CHI CHI *(Completion)* Success and harmony have been achieved, but flux in life is always probable	**64. WEI CHI** *(Before Completion)* A time of transition is not yet over; be wary on your path and you will reach your goal

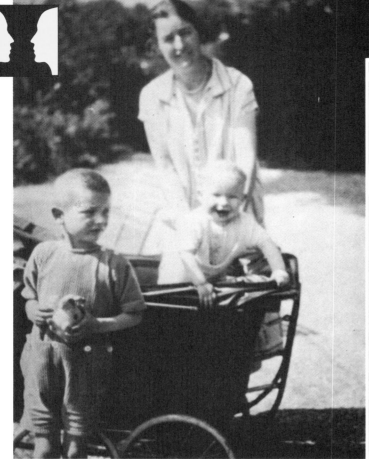

ANIMAL EXTRAS

SPIRIT PHOTOGRAPHY, WHETHER BY AMATEURS OR PROFESSIONALS, HAS ITS GALLERY OF GHOSTLY CATS, DOGS AND OTHER ANIMALS – USUALLY PETS – THAT APPEAR AS UNEXPECTED 'EXTRAS'

The majority of spirit photographs in which animal 'extras' appear have been taken unintentionally, generally by amateurs who have been most surprised to find these curious additional images on their films, but who have usually managed to recognise the identity of the unexpected ghostly forms.

An interesting example of this is a picture taken by Major Wilmot Allistone at Clarens, in Switzerland, in August 1925. At first glance, it seems a somewhat badly composed family snap, but on closer inspection it reveals itself as a remarkable psychic photograph. The Major was surprised and intrigued to discover that the developed print bore the faint image of a white semi-transparent kitten, nestling above the right hand of his son, alongside the furry toy animal that the child held in his left hand. The boy had held no such kitten when the picture was being taken. But what astonished the

The Allistone family are seen above, together with a surprising 'extra' in the form of a kitten. It showed up as though nestled in the boy's hand, along with the toy he held, seen clearly in the detail. The most astonishing thing about the spirit animal was that it resembled the child's recently killed pet.

Major was the fact that this ghostly kitten closely resembled the boy's pet, which had died a few days previously, having been mauled by a St Bernard dog.

The negative and prints of this fascinating photograph were later submitted to extensive investigation by experts, who even studied the negative under a stereoscopic microscope. The appearance of the dead pet was never explained.

Another example, in some respects even more peculiar, is a picture that was submitted to the British College of Psychic Science in 1927. This was a simple photograph of Lady Hehir and her Irish wolfhound Tara, taken by a Mrs Filson. The picture proved to be far from ordinary, however. The extra in this case is no semi-transparent wraith but a very substantial puppy head, curiously misplaced at the rear end of the wolfhound. Both Mrs Filson and Lady Hehir recognised this disjointed 'extra' as the

Cairn puppy, Kathal, which had been a close companion of the wolfhound. It had died in August 1926, about six weeks before the picture was actually taken.

In her signed declaration submitted to the college, Lady Hehir remarked: 'I feel convinced that he [the Cairn puppy] is often in the room with Tara and me, as she talks in a soft cooing way to something she evidently sees'.

INVISIBLE FORMS

One cannot have pets for very long without observing that they appear at times to see visitants invisible to the human eye – whether these are ghosts, elementals, or some other sort of being is open to discussion. However, one unusual photograph shows a pet actually watching a form that was invisible to the photographer at the time. It was intended to be an ordinary flash picture of Monet, a pet cat, taken by his owner Alfred Hollidge in 1974. The Hollidge family had only one cat, and there was certainly no other cat in the house when the picture was being taken. But the developed negatives showed a dark animal running in front of Monet – a small kitten, or a large rat, with a curiously long, tail-like attachment trailing behind. There is no way of being sure what Hollidge himself saw, for he left the negatives for some months before sending them off for processing, and he died before they were returned – so he never examined the final prints. But it is more than likely that he would have remarked on anything strange when taking the photograph, and would have been anxious to see the prints had he observed the dark intruder. Perhaps

The photograph, above, *shows a pet cat and a ghostly dark intruder that was unseen by the photographer – but the cat seems to be watching it with intense concentration.*

A Cairn puppy, below, *dead about six weeks, makes a curiously out-of-place appearance on this picture of its mistress and the wolfhound that was its close companion in life.*

the most interesting thing about this spirit photograph is that Monet does seem to be watching something in the area in which the extra appeared on the print.

But a number of spirit photographs with animal 'extras' have been taken by professionals. The well-established American psychic photographer Edward Wyllie, for instance, took a picture in which the spirits of both a woman and a dog appeared. It was taken in Los Angeles, California, in 1897 for J. Wade Cunningham, who later sent the English journalist and Spiritualist, William T. Stead, a long account of its making.

According to Cunningham, a female medium would often tell him of the beautiful woman who would sometimes appear when he was present. This spirit woman was frequently accompanied by a dog that barked and jumped with delight at the sound of Cunningham's voice. One day, the medium asked the spirit if she would be prepared to bring the dog and sit for a photograph. Wyllie, not knowing what was expected of him, was commissioned to make this spirit picture. The print he produced revealed both the beautiful woman and the dog, which Cunningham happily recognised as a pet he had owned many years before.

WISHFUL THINKING

The English medium and psychic photographer, William Hope, rarely took open-air pictures; but while on holiday in Exmouth, Devon, in 1924, he took some snapshots of his assistant, Mrs Buxton, and her family on the steps of their caravan. The print is badly faded now, but it is still possible to see a number of curious extras. Mrs Buxton herself is all but blotted out by an ectoplasmic cloud, and above her, swathed in this mist, is an image of the face of her son, who had died the previous year. She later said that, while the picture was being taken, she was 'wishing that he could have been one of the group'.

Alongside the son's head and to the right, there is also a form that clearly resembles the head of a horse or pony. In further tremendous excitement, the family recognised this as the son's white pony, called Tommy, which had died just a short time before the son. A third 'extra' is somewhat harder to see. This is superimposed over Mr Buxton's

A number of 'extras' crowd this picture, right, taken by the English medium William Hope. There is the woman's dead son (in the cloud of ectoplasm), a pony's head to the right of the boy's head (recognised as a dead pet), and the image of an old man to the left of the boy's head (recognised as the boy's dead uncle).

A strange animal form, obtained during a series of experimental seances in the studio of a photographer, can be seen below.

waistcoat, and is the image of an old man. Mr Buxton reported that it was a portrait of his brother, who had died some time previously.

The faded quality of this Hope picture provides a reminder that, for some mysterious reason, very few spirit photographs survive the ravages of time. It is a pity that the one made by the little-known psychic photographer Dr Stanbury in the 1880s could not be preserved.

PSYCHIC SNAPS

It seems that a certain Mrs Cabell had formerly owned two dogs – one, an old carriage dog with the fancy name of Secretary Stanton; the other, a small black-and-tan named Fanny. The two dogs were close friends, and they had died of old age within a few hours of each other. Some four years after their deaths, Mrs Cabell was spending the summer at Onset Bay in Massachusetts, USA, and was invited to a seance.

During the course of the evening, the medium observed on the psychic plane a 'little wee bit of a dog' jumping around Mrs Cabell, and when she examined the collar, she found the name 'Fanny' was inscribed upon it. Mrs Cabell was, of course, very excited, and took up with interest the suggestion that they should visit Dr Stanbury, who was nearby, to see if he could take a picture of her old pet. Mrs Cabell later told this story:

'Imagine my surprise at seeing my little pet cuddle up under my arm. And my surprise I cannot express at seeing the old coachdog, Stanton, also. He occupied the most prominent position, and had almost crowded out of sight his little friend in his eagerness to get there himself... The dogs' pictures have been recognised by hundreds of people who knew them when in life... It was four years after their death, or passing away, when this photograph was taken, which I prize beyond all price.' For Mrs Cabell, the reappearance of her pets – if only on

film – had clearly been most welcome.

Other animals also appear in the seance room at times. A sort of ape creature appeared on a photograph of the famous Polish medium, Franek Kluski, who was also photographed with an owl-like bird hovering over his back. This bird, which seems almost to be attacking Kluski, was not seen in the room before or after the seance. A totally unexplained image of a bat-like creature appeared above a cloud of ectoplasm in a picture taken by Staveley Bulford, a member of the British College of Psychic Science, in 1921. The cadaverous humanoid face of the bat appears to have been built out of a special kind of ectoplasm, which Bulford himself described as 'a quite different kind of ectoplasm, very dense and quite non-luminous'.

The series of seances that produced the ectoplasmic bat were conducted in the photographic studio of a certain Mr Scott between May and July 1921. He produced some extraordinary psychic pictures, as well as later 'communications' from the photographed spirits.

Further pictures that were obtained during these experimental seances were varied in subject matter, though they also included the 'standard' portrait of spirits, swathed in ectoplasmic cotton wool or other curiously unrelated ectoplasmic structures. One, however, was of a plant. It was extremely clear and detailed, in the form of a spray with thick velvety leaves, and flowers that were reminiscent of an edelweiss. The animal world was also represented in a photograph taken of Scott himself: above his head there appeared a quaint animal with a long, winding tail, again within a cloud of shiny ectoplasm.

While many psychic photographers tried deliberately to catch human spirits with the camera, few made a conscious effort to photograph animal spirits. Perhaps this is why such animal 'extras' occur comparatively rarely.

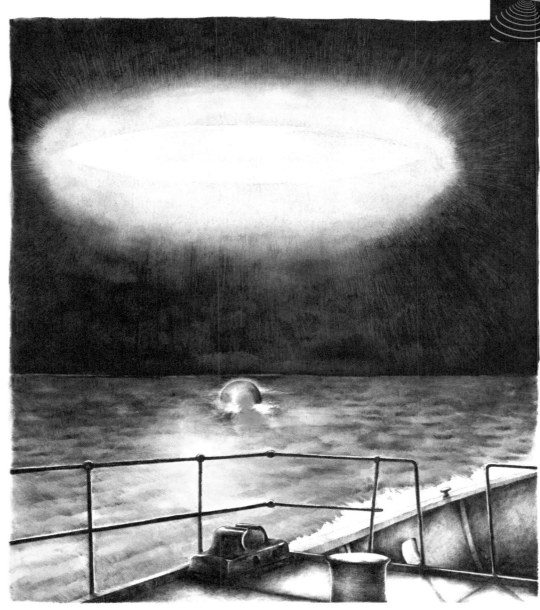

In the summer of 1980, the crew of the Caioba-Seahorse tugboat saw a mysterious object floating on the water off the coast of Brazil. It seemed to be signalling by turning on various coloured lights – as shown in the artist's impression, right – and, soon afterwards, a UFO descended. Slowly the two objects linked up and then, as one, rose and swept out to sea. According to one theory, the crew had witnessed the rescue operation of a USO.

AN UNFATHOMABLE MYSTERY

EVERYONE HAS HEARD OF UNIDENTIFIED FLYING OBJECTS; BUT WHAT ABOUT UNIDENTIFIED *SUBMARINE* OBJECTS? A GROWING NUMBER OF REPORTS ABOUT USOs HAS LED TO SIGNIFICANT INVESTIGATIONS AS TO THEIR ORIGIN

On the evening of 30 July 1967, Jorge Montoya was on duty on the Argentinian ship *Naviero* as it steamed in the South Atlantic, 120 miles (190 kilometres) off the Brazilian coast. The off-duty officers and crew, meanwhile, were below, having their evening meal. All was calm and as it should be when, glancing over to the starboard side, Montoya was suddenly startled to see a strange cigar-shaped craft gliding silently through the water 50 feet (15 metres) away. He stared in amazement for a moment and then alerted the captain on the intercom. When Captain Julian Ardanza arrived on deck, the mysterious vessel was still running alongside his ship. The two men studied it for some 15 minutes as it held its position. It glowed with a brilliant bluish-white light and left no wake. They estimated its length as about 105–110 feet (32–33.5 metres).

45

Then, without warning, the unidentified vessel turned towards the merchant ship and, glowing brilliantly as it accelerated, it dived beneath the ship and rapidly disappeared into the ocean depths. The officers and crew of the *Naviero* had just witnessed the appearance of an enigmatic unidentified submarine object (USO). In a subsequent press interview, the captain said that it was certainly no conventional submarine nor a whale; during 20 years at sea, he had never seen anything like it.

Reports collected suggest that USOs are almost as numerous in the waters of this planet as are UFOs in the skies. This is perhaps not surprising: after all, more than 70 per cent of the Earth's surface is covered with water. The average depth of the seas and oceans is 2 miles (3 kilometres), and Man has barely begun to explore the vast area that lies beneath the surface. Here, technologically advanced beings would – in theory – find an ideal place in which to pursue their activities well away from the sight of men.

What is more, just as diligent researchers have unearthed reports of UFOs that pre-date the well-known 1947 sightings – believed by many to be the first – so there are also reports of USOs from the past century. On the night of 24 February 1885, in the North Pacific, for instance, the crew of the ship *Innerwich* watched as a huge object, glowing with a brilliant red light, dived into the sea, throwing up a large volume of water as it sank below the waves. On 12 November 1887, near Cape Race, Newfoundland, Captain Moore of the British ship *Siberian* watched for five minutes as 'a large ball of fire' rose from the ocean to a height of 50 feet (15 metres). It moved towards his ship and against the prevailing wind before it departed. These and many

The object, left, was photographed in the ocean, west of the Cape of Good Hope in 1964 and has puzzled marine biologists ever since. The formation is suggestive of some kind of antenna. But is it anything other than a marine animal? Could it merely be an unusual form of the tall polyps, above, that live in the same waters?

other reports suggest that USOs can also sometimes become UFOs, and vice versa.

One of the most dramatic cases in the USO files occurred on the night of 26 July 1980. The tugboat *Caioba-Seahorse* was on a routine journey when, 60 miles (95 kilometres) from the Brazilian coast near Natal, the first mate was suddenly aware of a grey object 30 feet (10 metres) in diameter floating on the surface straight ahead. At the same time, a bright light could be seen rapidly approaching them over the sea. The first mate quickly changed direction to avoid a collision with the floating object, which then turned on various coloured lights – yellow, red, green and blue. The bright light had now reached them and could be seen as a glowing oval body, hovering silently about 200 feet (60 metres) above the floating USO. The tugboat's engines had stopped and the crew watched with fear and fascination as the UFO slowly descended on to the floating USO. A link-up took place, the USO lights went out, and the two bodies rose together. After hovering for some minutes in the area, the UFO swept rapidly out to sea with its load. This event naturally prompted a high-level investigation by the naval authorities, as well as much speculation from Brazilian civilian ufologists. Had the tugboat crew witnessed a rescue operation of one UFO by another? Or was it more of a routine pick-up, at a pre-arranged location? Whatever the naval authorities found out, they kept it to themselves.

A GREEN GLOW AT SEA

USOs have also been sighted off the North American coast, one witness being 19-year-old Wesley Gruman who was driving to Oak Bluff, Massachusetts, on the evening of 27 March 1979. Noticing a green glow over the top of some sand dunes, he looked towards the sea as soon as his view of it was unobstructed. Some 200 feet (60 metres) offshore, a 30-foot (9-metre) long luminous cylinder was floating on the water. Gruman stopped his car as the USO silently rose from the surface and he got out to watch its ascent. He decided to get his powerful hand lamp from the car, but found he could move only his head. This paralysis lasted until the USO had flown out of sight. Gruman also reported two other odd effects. The first was a low frequency hum that his AM car radio had emitted during the sighting, and the second was the behaviour of his wristwatch. This hand-wound calendar model had been three days ahead with the date before his experience, but the next day he noticed that the date it showed was now correct.

At Newport, Rhode Island, John Gallagher observed during daylight hours something unidentified that was lifted or propelled from the sea. In April 1961, he was working on a house by the beach and noticed a red sphere bobbing on the waves. Intrigued, he went to the second floor for a better view, and could see that it was about 200 yards (180 metres) offshore and drifting seawards. Suddenly, it rose steadily to a height of about 60 feet (18 metres), stopped and then, accelerating to about 100 miles per hour (160 km/h), moved with an undeviating flight out to sea. Gallagher was sure he had not seen a balloon, for its movements and speed had not been those of an object being blown by the wind, but of one under intelligent control.

Unidentified submarine objects also extend their activities to inland waters. Indeed, there are reports of them seen entering and leaving lakes and rivers, harbours, creeks and fjords. There was even a mass sighting on the Araguari River in Brazil in November 1980 when more than 70 people who were waiting for a ferry saw a solid object 15 feet (5 metres) in diameter rise from under the water. For some four minutes, it hovered at a height of 650 feet (200 metres), and then slowly moved out to sea. At one point, it moved to within 100 feet (30 metres) of the bank.

The man who saw a 'typical flying saucer' rise from the Thompson River near Kamloops, British Columbia, Canada, wished to remain anonymous, but he was known as a reliable individual to Dr. J. Allen Hynek, world-renowned UFO authority. On the sunny afternoon of 16 May 1981, the witness was quietly fishing when, with a noise 'like water being poured into a hot frying pan', the strange craft emerged from the frothing water about 100 yards (90 metres) offshore. Then, with a rapid acceleration, it zoomed up over his head and quickly flew away. While it did so, there was a pattering sound as pellets of something from the object rained down around him.

RIVER DIVE

The driver and passengers of a London bus could hardly believe their eyes when a silver cigar-shaped USO dived into the River Lea after cutting through telephone wires and gouging a scar in the concrete bank. Bob Fall was driving his number 123 bus towards Tottenham on 13 April 1964 when the USO dived across the road and landed in the river. The police, who found nothing when they dragged the 6-foot (2-metre) deep river, suggested that the witnesses may have seen a flight of ducks – but that still does not explain broken wires and damaged concrete.

Another 'impossible' USO was observed in the St Lawrence River near the city of Quebec, Canada, in March 1965. For four or five minutes, Captain Claude Laurin of *Quebecair* and his co-pilot could see the 'submarine' lying below the surface over 200 miles (320 kilometres) from the open sea, a situation that would be extremely hazardous for any ordinary submersible. On 23 May 1969, three eyewitnesses watched 'a round shining object with flashing red lights' dive into the St Lawrence. A police search found nothing, however.

The possibility that some UFOs, after a supersonic flight through the atmosphere, need to cool their overheated structures is persuasively supported by the following report. In the summer of 1967, a cub master and his assistant were camping with their pack on the shore of a quiet lake, 20 miles (32 kilometres) from St John, New Brunswick, Canada. The boys were asleep, and the two men had walked down to the lake to fetch water. Suddenly, down through the dusk came a UFO, shaped like two saucers – or plates placed face to face – with lights flashing red, orange, green and blue around its edge. As it touched the water and sank, there was a sizzling noise, reminiscent of the sound reported by the man who saw a UFO rise from the Kamloops River in 1981. The lake contained clear, cold water and was fed by mountain snows; but

when the men looked at it the next morning, it was quite muddy and felt lukewarm.

Not many people spend their nights outdoors on lakes, but those who do may see strange sights, as did a couple by the name of Bordes who, on the night of 16 September 1955, were fishing on the Titicus reservoir in New York state. By 1.30 a.m. they had had no luck. Then Mrs Bordes saw a pink luminous sphere rise from the water and splash back in again. A short while later, back on shore, they both saw a dark shape out on the water. It had two white horizontal streaks of light at its base, and a pale yellow revolving light above. Mr Bordes, more curious than afraid, rowed towards the lights, but the lights retreated at a faster rate. Then they came towards him and he, in turn, rowed away. His wife did not like the situation at all, so they rowed a good mile (1.6 kilometres) to the mooring stage, the lights now following at a distance. As they drove off in their car, the lights were still visible on the reservoir.

Reservoirs seem to be of particular interest to UFOs and USOs, and there are many reports of activity both over and in such waters. Speculation among researchers runs the gamut from the suggestion that they could perhaps be monitoring the pollution to which humanity regularly subjects itself to the belief that they are systematically doping our drinking water for reasons that are best known to themselves.

The power of these enigmatic machines – if machines they are – seems to be immense, as the following reports from the ice-clad waters of Sweden indicate. On 30 April 1976, between 5.15 and 5.30 p.m. three witnesses watched as a 30-foot (9-metre) long, dark grey object ploughed across lake Siljan in central Sweden, cutting a channel

Titicus reservoir in New York State, USA, below, *was the scene of a USO sighting by a couple called Bordes in 1955. They were followed by the lights of a floating object for a time, but came to no harm. Reports indicate that reservoirs seem to be of special interest to USOs.*

through the 8-inch (20-centimetre) thick ice. The channel was 10 – 12 feet (3 – 3.6 metres) wide and ran across the lake for more than half-a-mile (800 metres). As the USO ripped through the ice at about 60 miles per hour (95 km/h), ice blocks and water cascaded up on either side. Eight years earlier, on 5 April 1968, *The Times* reported that 'something incredibly powerful has smashed a huge hole through the ice covering a lake in Central Sweden, but scientists and military experts are uncertain about what it was'. Two local people had found the hole, which was 700 square yards (585 square metres) in an area near Malung. Leading the investigation was Colonel Curt Hermansson, who said that an aircraft crash was out of the question as there were no traces around the hole, 'only big blocks of ice which have been thrown up, indicating that whatever went into the lake was incredibly powerful'. The fact that the 3-foot (1-metre) thick ice had

Lake Siljan in Sweden is seen in the green lush of summer, above, and as it looked in the icy winter of 1976 when a USO ploughed across it, below. Three witnesses saw a big grey object cut a channel through the thick ice of the lake – an incident that has remained a mystery to this day. The way the ice was broken suggests that something extremely powerful may have pushed up from below rather than having fallen from the sky.

been thrown up suggests that, in view of the USO activity that has been logged, something 'incredibly powerful' may indeed have come up from below – but who can be certain? Divers who went down could find nothing on the muddy lake bottom to explain the mystery. A few days later, another large hole was discovered in the ice covering a lake at Serna, and that, too, proved a mystery.

It is not surprising that the authorities assumed that the holes had been made by falling objects. For years, the Scandinavians have been plagued by unidentified objects falling from the skies into their lakes. A great many of these occurred in 1946 and were at first thought to be meteors; but when reports of silver torpedo-shaped projectiles, emitting trails of smoke, continued to be made, very often several reports each day, they were termed 'ghost rockets'. The first assumption was that these were captured German V2 rockets being tested by the Russians, but such speculations were not borne out by facts. Although the German Peenemünde rocket development complex had been occupied by the Russians in May 1945, German scientists had already surrendered to the American forces, leaving testing facilities completely wrecked. It would not have been possible for Russian scientists to start assembling and firing V1s or V2s in the time available, let alone develop and build hundreds of new rockets with flight characteristics quite different from those of the V2.

A typical 'ghost rocket' report was made on 19 July 1946 by a family group who recounted that with a noise 'like a mighty wind', two rockets, 7 feet (2 metres) long and with stubby 3-foot (1 metre) wings halfway down their bodies, swept overhead and dived into Lake Mjøsa, 60 miles (96 kilometres) north of Oslo in Norway. A crater could be seen at the bottom of the lake, but dredging by the military authorities revealed nothing. The 'ghost rockets' were tracked on radar as they made abrupt changes of direction, yet they were rarely seen to crash. When they did crash, it was always into a lake – but no traces of wreckage were ever found despite intensive searches by troops.

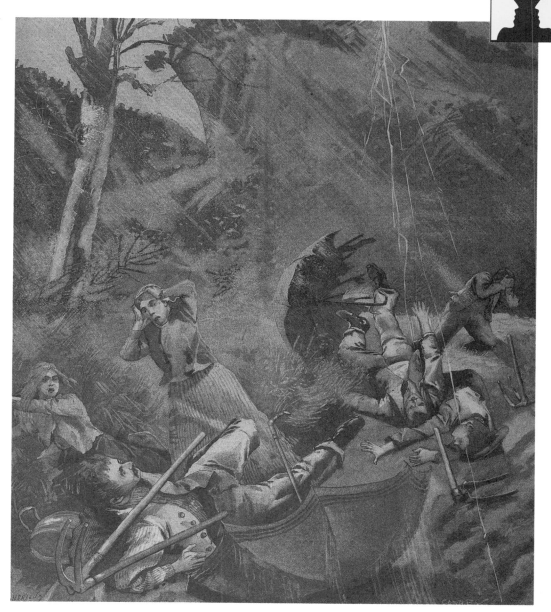

Lightning strikes a family in rural France, right – and leaves two dead, as illustrated in the Le Petit Parisien literary supplement of 1901. There are many instances of bizarre behaviour by lightning which sometimes even seems to choose whom or what it will suddenly strike.

NATURAL OR SUPERNATURAL?

NATURE PRODUCES A HOST OF ODDITIES THAT SCIENTISTS CANNOT – OR DO NOT TRY TO – EXPLAIN. WHAT IS THE ORIGIN OF SUCH MYSTIFYING PHENOMENA?

The world abounds in phenomena that are observed by hundreds of people, but that lack scientific explanations or are simply ignored by scientists. Among them are such obvious anomalies as UFOs and apparitions. But there are many more that, although not embarrassing to the scientific community in the same way, are equally extraordinary. One conspicuous example is ball lightning which, despite consistent reports by reliable witnesses, was not accepted as a genuine phenomenon until the late 19th century.

❜❜ LIGHTNING FELL INTO THE CATHEDRAL AT WELLS ... THE WONDERFUL PART WAS THIS ... THAT THE MARKS OF THE CROSS WERE FOUND TO BE IMPRINTED ON THE BODIES OF THOSE THEN AT DIVINE SERVICE. **❜❜**

to the unlikeliness of the event, this house was actually lower than the surrounding houses, and should therefore have been less vulnerable to being struck by lightning.

An example of similarly bizarre selection by lightning was reported in a 1902 issue of *Nature*. When a house in Jefferson, Iowa, USA, was struck by lightning, it was found that every other plate in a pile of 12 plates in the house was broken. Could this have been because the intense electric field of

In fact, the entire phenomenon of lightning is surrounded by mystery. Any school textbook will confirm that lightning is simply the rapid discharge of a large amount of electric charge to Earth. Generally, the charge builds up in clouds, and the lightning takes the shortest possible path to the Earth's surface. Occasionally, however, lightning is seen to strike *upwards*. Are we to assume that somewhere in the sky there exists an electrical terminal that is at times a stronger attraction than the Earth for both conventional lightning and slow, aurora-like discharges? And does the effectiveness of this high-altitude terminal vary with solar activity and possibly with meteor influx rates?

Sometimes, too, lightning strikes *horizontally*. Horizontal lightning passing between clouds is not difficult to explain – the clouds merely hold different concentrations of electrical charge, and the lightning passes from the one with the higher potential to that with the lower potential. But what of horizontal lightning that will travel great distances, apparently to strike some particular object?

An extraordinary example of this occurred on 16 July 1873 in Hereford, England, and was reported by W. Clement Ley to Symons's *Monthly Meteorological Magazine*. After a showery morning, stormclouds began to appear. At around 10 a.m., a large cumulus stormcloud arose in the west-south-west and, in a clear blue sky, it travelled steadily north-eastwards. A bolt of lightning emerged and, in Ley's words: 'The electric fluid travelled near the earth over high ground covered with trees, buildings, avoided All Saints' and St Peter's spires, very near which it must have passed, and singled out a house in the more eastern part of the city'. To add

the atmosphere was somehow intensified in every other plate, or was it the result of some purely mechanical action? The editors found themselves unable to comment on this odd occurrence.

So can lightning actually 'choose' what it will strike? The above examples demonstrate the difficulty of studying this kind of phenomenon scientifically. As is the case with ball lightning, reports are numerous enough to warrant being taken seriously – but such phenomena are not easily reproducible in the laboratory, and the presence of a competent scientist when such an event occurs is a matter of chance.

One aspect of lightning's apparent discernment in what it strikes has, however, been thoroughly researched. Studies carried out in 1898 and 1907 reveal that oaks are the trees most likely to be hit by lightning, while beeches are the least likely to be struck – so it is apparently safer to shelter from a thunderstorm under a beech tree. Unfortunately, though, these studies do not provide any information as to why this should be the case.

STRANGE TATTOOS

The subject of 'lightning pictures' – images allegedly 'photographed' on to living bodies or objects struck by lightning – was the cause of much scientific controversy during the 19th century. Indeed, the study of the subject was given its own name – keranography. The issue of the reality of such pictures is still undecided, however.

The first reliable report of the phenomenon was made by no less a person than the American diplomat and scientist Benjamin Franklin. In 1786, he wrote to the Meteorological Society of London about an incident that he remembered from 20 years before. A man who was standing close to a tree when it was struck by lightning was 'very much surprised to perceive on his breast a facsimile

Zuni Indians of New Mexico, above, are seen performing the rain dance. The ritual of cloud-summoning – in this case carried out by a group- has long been considered an important power of shamans and magicians.

The dendritic, or branching pattern, top left, made in a block of acrylic by the electrical discharge from a generator, closely resembles a lightning pattern, left. Images of trees made by lightning on living objects have been explained by scientists as no more than dendritic patterns. But does this explain those cases in which 'lightning pictures' are of crosses or of non-branching objects?

of that tree'. Similar incidents had been reported much earlier: in 1596, for example, during a summer storm, lightning 'fell' into the cathedral at Wells, Somerset. A report of this appeared in *Adversaria,* a book by the scholar Isaac Casaubon, who died in 1614. 'The wonderful part was this, which afterwards was taken notice of by many, that the marks of a cross were found to be imprinted on the bodies of those then at divine service.'

The classic explanation of lightning pictures is that the images arise from the well-known dendritic – or branching – patterns that electrical discharges are known to produce on the surfaces of many materials. This may explain cases where the images are of trees, but does it explain the strange images of the cross in the Wells case? And can it apply to the following extraordinary story, told by James Shaw at a meeting of the Meteorological Society held on 24 March 1857?

'About 4 miles [7 kilometres] from the city of Bath, near the village of Coombe Hay, was ... an extensive wood of hazel and detached oak-trees. In the centre of this wood was a field of about 50 yards [45 metres] square, in which were six sheep, all of which were struck dead by lightning. When the skins were taken from the animals, a facsimile of a portion of the surrounding scenery was visible on the inner surface of each skin...

'I remember that it caused a great sensation at the time ... the small field and its surrounding wood were so familiar to me and my schoolfellows that when the skins were shown to us we, at once, identified the local scenery... '

It could be argued that the picture was caused by random pigmentation and that it was the minds of the witnesses themselves that transformed the blotches into a recognisable pattern. The capacity of the human mind to impose order on what it sees is well-known. Indeed, it is widely utilised in

psychiatric 'ink blot' tests, for example, in which the subject is asked to interpret an image made by the totally random process of folding a piece of paper over wet ink. Whether or not the same process of pattern-making by the mind applies to lightning pictures, many would hold that it does apply when witnesses report seeing strangely shaped clouds. Some have even ventured to suggest that there may be something more to them.

Certainly, cloud-summoning has always been counted among the powers of magicians and shamans. On one level, cloud-summoning was merely rain-making, for clouds meant rain. But often – as among the ancient Chinese, the North American Indians and some of the practitioners of 'animal magnetism' of the 19th century – the shapes of the clouds summoned were equally important.

HOLY CLOUDS

One day in 1801, Clement Hofbauer, later canonised by the Roman Catholic Church, was at prayer before the altar of St Joseph in a Warsaw church. As Zsolt Aradi relates in his *Book of Miracles:*

'Hundreds of people saw a cloud forming above the altar, then enveloping the figure of the saint, who disappeared from their sight. In his place, they saw a celestial vision. A woman of great beauty, with radiant features, appeared and smiled at the worshippers... '

There are many such cases. On 3 October 1843, Charles Cooper, labouring in a field near Warwick, England, heard a rumbling in the sky. He looked up to see a strange cloud, below which hovered three 'perfectly white' figures, calling to him with 'loud and mournful' noises. Cooper assumed they were angels. Other witnesses, working in a field some 6 miles (9 kilometres) away, agreed that they had also seen the remarkable cloud reported by Cooper, although not all of them saw the 'angels'.

Another report concerns a sighting of an odd cloud that is at least as remarkable as those already described, and considerably better substantiated. It shows that clouds may assume very strange shapes under entirely natural conditions.

On 22 March 1870, the barque *Lady of the Lake* was cruising in the mid-Atlantic close to the equator when, around 7 p.m., a curiously-shaped cloud appeared towards the south-south-east. The sky was blue with patches of cirro-cumulus cloud. This particular cloud was circular and shaped like a wheel with four spokes, one much thicker than the rest. From the centre protruded a fifth spoke, broader and more distinct than the others, with a curved end. The cloud was light grey in colour and had a tail 'similar to that of a comet'. It was in sight for around 45 minutes.

Reports of such ring-shaped clouds, often rotating, are not uncommon and could have a logical scientific explanation based on the action of atmospheric vortices, or whirlwind effects. But the sight of one is a spectacular and disquieting experience.

A further bizarre phenomenon that occurs at sea and is believed to be entirely natural is that of oceanic phosphorescence. Ships that sail the Indian Ocean, particularly around the Persian Gulf, often encounter dazzlingly luminous waters. An anony-

THE COUNTENANCE DIVINE

Simulacra is the term given to the shadowy likenesses of natural objects that can be seen in fire, water, clouds, or damp patches on walls, floors or other surfaces. Among the most common are likenesses of Christ's face. Some of these are sometimes said to be more a testimony to people's capacity to see what they wish to see than truly anomalous phenomena, however.

mous report in a 1908 issue of the *Monthly Weather Review* told of a 'remarkable marine phenomenon', observed by the *SS Dover* as it steamed from Mobile, Alabama, to Tampa, Florida, USA. Some 35 miles (56 kilometres) from Mobile, at around 7 p.m., the ship's crew suddenly found themselves in water glowing with alternate blue and green light, the colours 'being so brilliant that the vessel was lighted up as if she were covered with arc lights with coloured globes'.

Half-a-mile (800 metres) further on, the ship ran into a second streak of light, which was the same width as the ship. Amazingly, the light was bright enough to read by. As the captain later testified: 'I grabbed a paper, and the finest print that I could find was easily discernible'.

MARINE BEAMS

A still more remarkable version of the same phenomenon was reported by Captain W. Rutherford of the *SS Stanvac Bangkok* on a voyage from the Pacific Ocean islands of Fiji to Indonesia on 27 September 1959. Around midnight, the vessel was passing through a fleet of fishing boats, and the captain and the officer on watch were keeping a sharp look-out for these small craft through binoculars. They noticed white caps forming on the surrounding waves, which made them think the wind must be freshening; but the steady breeze on their faces told them this was not so. Then flashing beams appeared in the water, and the officer on watch thought the fishing boats must be using flashlights. The beams soon became more intense

The *Houston Post* of 23 April 1977, for example, reported that a certain church in Shamokin, Pennsylvania, USA, had become a place of pilgrimage as the result of the appearance on the altar of an image of the face of Christ. Many of the people who went to see the phenomenon, however, found nothing but an ordinary altar cloth – and photographs taken at the time show nothing at all unusual.

An even more bizarre example was recorded in the *International Herald Tribune* of 25 July 1978. Maria Rubo, who lived in a farming hamlet in southern New Mexico, had been rolling out a tortilla – a kind of cornmeal flat bread – when she noticed that the dough contained a face. It looked like that of Christ. What made the event more remarkable was that this tortilla did not deteriorate after four or five days, as most do. Local people regarded the tortilla as a 'miracle' and their priest consented to give it his blessing, but the Archbishop of Santa Fe feared the start of a cult and advised extreme caution.

One of the best-known of the Christ simulacra, *above left,* is alleged to have appeared as shadows in the snow. It was once widely circulated by the media and is impressive, but of dubious provenance. The popular version of its origin is that someone took a photograph of the snow to use up a roll of film, and recognised the image of Christ only after the film was developed. Some stories say that the photograph was taken by a 12-year-old girl; others that it was made by some Californians who wanted to record an unusual snowfall. But perhaps the most poetic version has it that, in 1938, a Norwegian woman prayed to God to send her proof of his existence, that as a consequence she was divinely inspired to take an entirely random photograph in her garden, and that this picture resulted.

Another famous 'face of Christ' appeared as a cloud formation. A photograph of it was allegedly taken by a serviceman in the US Air Force during the Korean War. The photographer did not notice the image when he took the picture of American and Communist aeroplanes in action, however.

These examples have in common an almost complete lack of supporting evidence, making a rational evaluation of the pictures impossible. There is no information about prevailing weather conditions at the time, for instance, nor of any other relevant factors. Nonetheless, the images themselves are so compelling to most people that any explanation in terms of purely natural, random phenomena is bound to seem inadequate.

nd took the form of absolutely parallel beams of ght about 8 feet (2.5 metres) wide. They came owards the boat, passing under the prow at inter-als of about half a second. Captain Rutherford escribed the experience as being like a pedestrian tanding still on a 'huge zebra crossing' and seeing : pass underneath.

Suddenly, there was an alteration in the phe-omenon, as the pattern of the beams was seen to hange into giant radiating wheels slowly turning bout a centre, first to starboard and then to port, nd rotating anticlockwise and then clockwise. The eams next became parallel again and appeared to e following the exact course of the ship before radually fading from sight. Finally, there were ountless rings of light around 2 feet (60 centime-es) wide and 6 feet (2 metres) apart, seen to be ashing rhythmically.

Captain Rutherford commented that it reminded im of 'a treeful of glow-worms'. Although the light eams appeared to be above the surface of the vater, he believed that this was an illusion, and that he light actually originated beneath the surface of he water. He also reported a curious instinct he felt bout the phenomenon: 'The ship seemed to be in he centre of the disturbance, and at one time I had he feeling that she was actually causing it, and that I reduced speed or altered course, I would alter he pattern accordingly.'

Remarkable as this phenomenon seems, it has a erfectly natural cause: the glow is now known sim-ly to be the result of the luminescence of count-ss tiny marine organisms, as lowering a bucket into one of these phosphorescent seas will show. But what of the extraordinarily precise geometrical nature of such displays? Are we to assume that the marine creatures are putting on a show of 'forma-tion dancing' for our benefit? This can hardly be the case. One must assume, instead, that the creatures are influenced by forces – seismic waves, the pas-sage of the ship's wake, or something altogether more subtle perhaps – that cause them to react col-lectively in this beautiful and spectacular way.

In large numbers, the Noctiluca, *a marine animal and genus of the dinoflagellates, is said to cast enough light to read by – surely a prime natural oddity.*

The capacity of the human mind to create thoughts so powerful that their forms are visible has long been attested to by mystic religions. Here, we present a collection of pictures that suggest that this capacity indeed exists – casual photographs that include strange figures which no one saw at the time, and seemingly produced by mind-power alone

'Thoughts are things', insisted Annie Besant and C.W. Leadbeater in their book *Thought Forms.* The appearance of the thought form was believed to be the outcome of three factors: the quality of the thought determined the colour, the nature of the thought determined the shape, and the so-called 'definiteness' of the thought determined the clarity of the outline. The thought form of a person 'not terrified but seriously startled', for instance, was represented, as shown *above,* by an 'onrush' of crescent-shaped forms. The colours are the 'livid grey' of fear, which almost immediately becomes tinged with the red of anger as 'the man is already partially recovering from the shock, and beginning to be angry'. Another example, *right,* represents a conscious attempt to feel love and sympathy for mankind – and is the result of an attempt to imagine those feelings pouring forth 'in the six directions' of Hindu mystical thought. Everyone, Besant and Leadbeater believed, is sensitive to thought forms, even if not everyone can actually see them. In this way, one's thoughts, even those that remain unspoken, have a constant, if subtle, influence on other people. 'It is thus evident', Besant and Leadbeater concluded, 'that every man who thinks along high lines is doing missionary work, even though he may be entirely unconscious of it'.

The photograph, *above,* was taken by London medium Gladys Hayter, and is of her daughter, Dawn, driving the new car she had given her in March 1979. When the film was developed in September of the same year, both women were astonished to see on the print something that neither of them had been aware of at the time – the head of a small, blonde girl who was apparently sitting on the back seat of the car as evident in the enlargement, *right.* So who was the mystery girl? In a sitting with the direct voice medium Leslie Flint, Mrs Hayter's mother 'spoke', asking Gladys what she thought of the photograph and going on to observe that the girl, whose name was Sheila, was a happy little child who had attached herself to the direct voice medium's circle, of which Gladys herself was a member. 'Well, she's a nice little thing, of course,' commented Gladys' mother, 'but you know she's nothing to do with our family ... She's a little girl who's been coming round and playing, can you hear me?' In a later sitting, a spirit named Samantha Rigg-Milner revealed that the little girl's surname was Wilkins. 'I know the – I know who the little girl – I have seen her, you know ... Sheila – I have seen her in the car in your picture; I am very friendly with her.'

Mrs Hayter herself was convinced that the face of a Golden Labrador dog can be seen between Dawn and the ghostly child. This, she suggests, is Brandy, a dog that belonged to her daughter and was killed at the age of 18 months in 1974. The dog was also apparently a member of the medium's circle – and Gladys' mother confirmed that 'the dog is often around' in the afterworld.

The picture of a pleasant tea party on a summer lawn, *above,* was taken by Arthur Springer, a retired police inspector, in his own garden at Tingewick, Buckinghamshire, England, in 1916. Allegedly, no one was aware of the presence of the dog on the left-hand side of the picture until the film was developed.

Although, unlike human figures, spirit photographs of animals have proved remarkably difficult to capture in the studio, ghostly figures of animals do sometimes appear in photographs taken by amateurs – generally, as here, without having been seen by the photographer at the time. Often they are later recognised as dead pets of which the photographer, or someone else who was present when the picture was taken, was very fond. Indeed, it has been conjectured that these ghostly images on the film are actually conjured up by the intensity of emotion that was felt for the dead animal. The women at the tea table in this particular picture are clearly happily unaware of the presence of anything as weird or disarming as a phantom dog. But if the photographer was unaware that the ghostly dog was there, why would he have chosen to set his camera up in such a way as to frame it perfectly? If he did not see it, as he claimed, the shot is a curiously asymmetrical one, with the women unnaturally grouped to the right of the picture. Was the photographer perhaps surreptitiously leaving space to add a fake dog when he developed the film in his laboratory? The fact is that the original photograph was 'cropped' to give the picture, as reproduced *above,* and the group at the table was positioned centrally in the original composition.

The thoughtographic image, *above,* was produced under the supervision of Professor Fukurai on 10 May 1911 by the psychic Mrs Sadako Takahashi. Under hypnosis, a secondary personality emerged to give this information: 'The picture . . . was my thoughtography ... I wanted to give the warning that one should not be tempted by personal profit.' On 10 February 1917, Mr Kohichi Mita, a stage magician, produced the two plates, *below,* at a public experiment in the city of Nagoya. Separately, the two plates did not make any sense; but together, remarkably, they formed two Japanese characters.

Between 1910 and 1913, Professor T. Fukurai of the Imperial University, Tokyo, president of the Psychical Institute of Japan, conducted a remarkable series of experiments in clairvoyance and thoughtography with a number of Japanese psychics. Among those whom he investigated extensively was a Mrs Ikuko Nagao, who became aware of her psychic abilities after the death of her small son. Mrs Nagao was spectacularly successful in clairvoyance, as well as thoughtography experiments, which she was asked to produce images on sealed photographic plates. Like many psychics, she was able to produce impressions of objects. The picture, *left,* for instance, is a thoughtographic image of a figure from a Buddhist religious scroll. Even more remarkable, however, was her ability to produce accurate impressions of Japanese characters. Critics objected that the figures could be produced equally well by exposing the plate through a piece of pasteboard or similar material with the shape of the letter cut out of it. The example, *above,* of two particularly complex characters, was made to show how difficult such faking would have been. In any event, the phenomena were, of course, produced in the presence of expert witnesses.

THE COSMIC ORGASM

WILHELM REICH BELIEVED THAT THE SECRET OF PHYSICAL AND MENTAL HEALTH IS CONTAINED IN THE ORGASM, AND THAT SEXUAL ENERGY IS TANGIBLE AND CAN BE HARNESSED TO RID THE WORLD OF ALL ILLS

Wilhelm Reich (1897-1957), right, demonstarted bold theories about the importance of the orgasm in both individual and collective life. He believed that orgasm – and only heterosexual orgasm – could, if uninhibited enough, relieve men and women of all tensions and establish a total inner harmony. He even went further, claiming to have created 'bions', substances halfway between dead and living tissue, which could become living – albeit primitive – matter.

The quest to discover the secret of life, and to identify some force that distinguishes living protoplasm from inanimate matter, has obsessed occultists, alchemists and scientists alike for centuries. Although, in most cases, the investigator has pursued knowledge for its own sake, in others he has tried to usurp the divine prerogative and actually create life from inorganic material. Occasionally, he has even claimed to have succeeded in this.

As late as the 1930s, a London-based alchemist named Archibald Cockren, attempted to create life in the form of the 'alchemical tree': this was supposed to be a living mineral, described in the 16th century by Paracelsus as 'a wonderfull and pleasant shrub, which the Alchymists call their Golden hearb'. The poet C. R. Cammell said that he had seen this mineral 'hearb' in Cockren's laboratory and had watched it grow to a considerable size over a period of months.

But the claim to have created life has not been confined to eccentric occultists. The late Wilhelm Reich (1897-1957), a scientist with an impeccable academic background, asserted not only that he had created life but also that, by doing so, he had solved many mysteries of nature, from the causes of cancer to the significance of UFO sightings.

Reich was the son of prosperous Austrian-Jewish parents. After serving in the Austrian army during the First World War, he studied medicine at Vienna University and qualified as a doctor in 1922. While still a medical student, he studied the writings of Sigmund Freud (1856-1939) and other pioneer psychoanalysts, becoming convinced of the

PERSP
A WASTE OF ENERGY?

Reich's highly controversial claims, such as having created life from inorganic matter – the alchemists' obsession, as illustrated *below* –

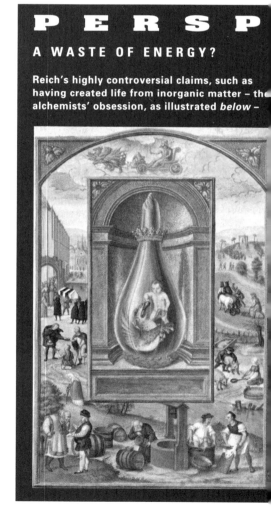

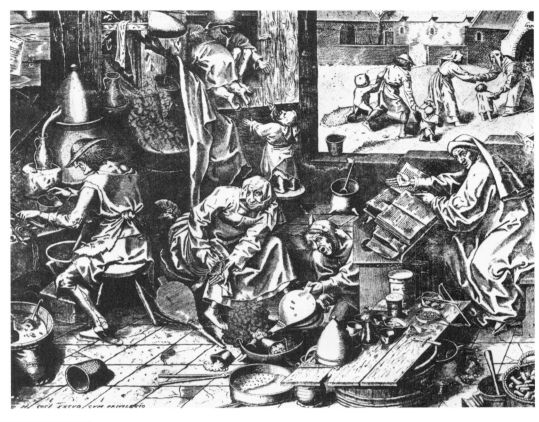

naturally gave his critics plenty of ammunition. An arch-sceptic of all matters paranormal, John Sladek certainly did not mince his words in the chapter on Reich in *The New Apocrypha*, particularly when describing Reich's 'disastrous ORANUR experiment'.

OR – Reichian shorthand for *'orgone radiation'* – was believed by his followers to be beneficial on a large scale. As his wife, Ilse Ollendorf Reich, explained: 'It was Reich's idea to help eradicate the terrible effects of the atom bomb through a three-fold attack: by using *orgone* energy to heal radiation sickness, to neutralize the effects of an atom bomb and . . . to immunize mankind against radiation'.

The ORANUR experiment consisted of exposing a large number of mice to radioactive material and then to beams of OR, which would, Reich and his research team were convinced, neutralize the harmful radioactivity. Very shortly, however, as Sladek describes, 'his assistants had noticed Geiger counters running wild, but of course they put it down to excesses of *orgone* energy. Forty test-animals died in one day, having all the symptoms of radiation poisoning. Then lab assistants began coming down with the same symptoms....' Reich's wife was similarly affected – so badly that she had to undergo surgery. But even so, Reich – with amazing obtuseness – consistently missed the point.

The hectic quest of the medieval alchemist for the secret of life – as depicted above, involved searching for an actual chemical or physical ingredient that could be isolated and used to create living tissue from dead or inorganic matter, Reich and his followers believed that he had succeeded in discovering radiating 'bions' – derived from sterilised sea sand – and that the radiations they gave off were the life-stuff of the Universe.

central importance of sexuality in human life. On 1 March 1919, he wrote in his diary: '. . . from my own experience, and from observation of myself and others, I have become convinced that sexuality is the centre around which revolves the whole of social life as well as the inner life of the individual'.

In 1920, Reich was accepted as a member of Freud's Vienna Psychoanalytical Society; and by 1922, as one of the co-founders of the Viennese Seminar for Psychoanalytic Therapy, he had become regarded by the elders of the analytical movement as an authority on therapeutic techniques.

But by 1927, Reich had begun to drift away from current Freudian orthodoxy. He was in fact developing a strand of early Freudian theory that Freud himself had neglected for over a quarter of a century: this concerned the *aktual* ('at the present time') neuroses.

In the formative period of psychoanalysis, Freud had classified neuroses into two groups: psychoneuroses that were caused by incidents that had happened long ago, particularly in early childhood; and *aktual* neuroses that were psychological illnesses, supposedly caused by current disturbances of healthy sexuality, such as premature ejaculation, or obsessive masturbation. Freud concentrated all his attention on the psychoneuroses and, after about 1900, scarcely ever mentioned the *aktual* neuroses.

❚❚ SEXUAL EXCITATION, REICH REPORTED, WAS ACCOMPANIED BY A SIGNIFICANT INCREASE IN THE BIO-ELECTRICAL CHARGE OF THE GENITALS. ❚❚

Reich, however, concluded that Freud was mistaken, and that almost all illness, including schizophrenia and manic depression, resulted from the failure to achieve 'true orgasm', which he defined as 'the capacity for complete discharge of all dammed-up sexual excitation through involuntary pleasurable contractions of the body'. The object of psychoanalytical therapy, Reich argued, was to establish 'orgastic potency' and to enable the individual to achieve a sexual climax that would be long-lasting, fully satisfying and unaccompanied by fantasies or fetishes. It would also be without subsequent feelings of guilt or inadequacy; and above all, it would be the result of a heterosexual relationship.

Reich also believed that the failure of dammed-up sexual energy to find release in the convulsions of orgasm resulted in 'muscular armouring' – muscular tension and rigidity. This armouring reinforced the original disturbance, which in turn led to

The Orgone Energy Observatory at Orgonon near Rangeley, Maine, USA, is shown below. *Reich and his supporters established this observatory in the hope that orgone energy could be detected and harnessed for the greater good of mankind. For a more detailed view of the effects of intensified orgone, the orgone energy accumulators,* left, *were used. Although quaintly resembling privies, they were believed to accumulate the orgone energy of anyone seated within. The energy thus collected and stored could, Reich believed, be used to treat virtually any kind of human ailment.*

more tension and rigidity – a self-perpetuating process of physical and mental degeneration.

Neither the traditional Freudian type of analysis (the unveiling of repressed memories) nor Reich's own practice, based on examining 'present-day character', was adequate to cope with such armouring. For this, Reich developed a new technique, which involved character analysis, deep massage, breathing exercises and violent physical manipulation of the patient's body to break down tension and release blocked-up sexual energy. Reich called this process *vegetotherapy*, because he believed that the energies trapped by muscular armouring were stored in the vegetative (otherwise known as the autonomic, or involuntary) nervous system.

Reich was also interested in the nature of sexual energy. He believed it to be a specific force, comparable to the forces of gravitation and electromagnetism, and that it could be accumulated in the same way that electricity is stored in a battery. To prove his point, he embarked on a series of experiments to ascertain 'whether the sexual organs, in a state of excitation . . . show an increase in their bio-electric charge'. Volunteers were wired up and the results of their sexual activity monitored: the results were spectacular. Sexual excitation, Reich reported, was accompanied by a significant increase in the bio-electrical charge of the genitals; anxiety, pain and guilt, by a reduction. The orgasm was a biological thunderstorm.

In 1935, Reich (who was now living in Norway as a refugee from the Nazis) began an even more ambitious series of biological experiments. He subsequently announced to his astonished scientific contemporaries that he had succeeded in producing, from substances such as sterilised coal and soot, what he termed *'bions'*. These, he claimed, were energy vesicles (sacs), halfway between dead

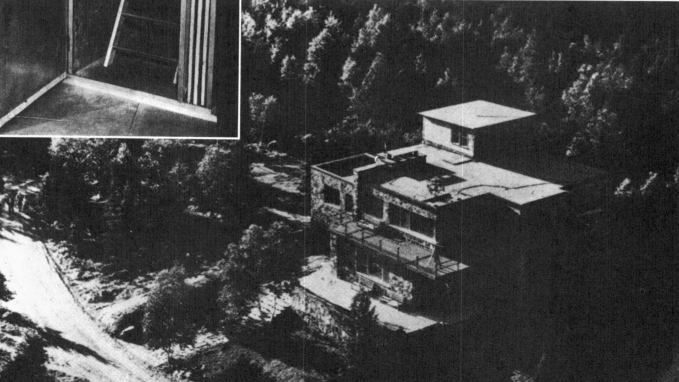

matter and living tissue, capable of developing into protozoa (single-cell organisms). One of Reich's assistants filmed these 'bions' through a microscope, but biologists were not impressed. The 'bions', they argued, were no more than tiny particles of non-living matter and their movements were the result of ordinary physical phenomena.

Undeterred by this criticism, Reich continued with his experiments. He concentrated his attention on a 'radiating bion' that he believed he had derived from sterilised sea sand; and, in 1939, he announced that the radiation given off by these sand-packet bions (which he named 'sapabions') was a hitherto unknown form of energy, the basic life-stuff of the Universe. He called it 'orgone', and devoted the rest of his life to studying it.

ORGONE ENERGY

In the same year that he claimed to have discovered orgone energy, Reich emigrated to the USA where he began to attract a small but enthusiastic following. He continued his research on orgone, which he maintained was identical with both the vis animalis ('animal force') of the ancient alchemists and the 'life force' – a mysterious quality distinguishing living from dead matter, as postulated by the philosopher Henri Bergson. Orgone was no metaphysical abstraction. It could not only be measured with an 'orgone energy field meter' (a modified electroscope of Reich's own devising) but could be seen by the naked eye in 'the blue coloration of sexually excited frogs', and also collected and stored in an 'orgone energy accumulator', another Reichian invention. These accumulators, said Reich, could be used in the treatment of every human ailment, from depression to cancer.

Orgone energy accumulators were (and are) boxes made of alternate layers of inorganic and organic material (usually metal and wood). The more layers there are, the more powerful the accumulator. Those intended for human use are large enough for the patient to sit inside; in appearance, they strongly resemble an old-fashioned privy.

As Reich grew older, his ideas about orgone grew stranger. He published an increasing number of pamphlets on how to trap and utilise this mysterious but basic energy, derived from the accumulator, below, and also attracted bizarre followers, such as the American architect Frank Lloyd Wright, above, who defended his hero through Reich's last harrowing trial. Another of Reich's faithful, if somewhat flamboyant, disciples was the beat poet Allen Ginsberg, above right, seen tangling with the British police. Ginsberg adapted Reich's theories to advocate collecting orgone through the use of hard drugs and homosexual practices – something of which Reich would never have approved.

Between 1939 and 1957, Reich published many articles and books, making increasingly astounding claims for orgone. Originally, he had regarded it as an energy exclusive to living organisms, but by 1951 he was asserting that it was the original building-matter of creation, the primal 'stuff' from which reality had evolved, and that physical matter was the offspring of the superimposition (the 'cosmic orgasm') of two streams of orgone. Everything from radio interference and the blueness of the sky (orgone was coloured blue) to hurricane formation and the force of gravity was a manifestation of orgone. The only exception was atomic radiation, which Reich saw as the antithesis of the life energy – a Satan to the Jehovah of orgone.

All this was strange enough, but even odder were Reich's writings on the subject of UFOs. Earth, Reich asserted, was the centre of an intergalactic conflict, and UFOs were the warships of the antagonists. One side was utterly evil, and extracted orgone from the Earth and its atmosphere with the intention of reducing the planet to a radioactive cinder; their opponents were allies of humanity and thus of Reich, and dedicated to replacing the stolen orgone.

Reich died in prison in 1957. He had been sentenced for defying a Federal injunction banning the sale of his accumulators on the grounds that they were fraudulent. For a time, it seemed that Reich and his theories would quickly be forgotten. Some of his followers became even odder than their teacher: one group, for instance, spent much time sitting in semi-darkness, clad in blue robes (in honour of orgone), attempting to communicate with their dead master through the ouija board. Other alleged Reichian groups, closely associated with the writers Allen Ginsberg and William Burroughs, combined Reichian theories with the advocacy of homosexuality and the use of psychedelic drugs, something that Reich would not himself have condoned.

However, some of Reich's writings have attracted more serious study, and a number of therapists, influenced by his ideas, now practise in major cities. But no one has yet attempted to repeat his laboratory work, with the object of establishing the extent to which his orgone experiments had any validity.

DEATH BY MAGIC?

ACCORDING TO ONE THEORY, TWO EXTRAORDINARY VICTORIAN WOMEN MAY HAVE STUMBLED UPON THE IDENTITY OF JACK THE RIPPER WHEN THEY OPENED A LOCKED TRUNK BELONGING TO THE MYSTERIOUS DR DONSTAN, WHO LIVED WITH THEM

The flamboyant occultist Aleister Crowley, below, inadvertently gave rise to the incredible theory that Jack the Ripper was no less than Madame Blavatsky, far right. The mistake arose from a misreading of Crowley's tortuous prose: 'It is hardly one's first, or even one's hundredth guess, that . . . Jack the Ripper was no less a person than Helena Petrovna Blavatsky'. Certainly, the idea of the overweight, ill and greatly revered founder of the Theosophical movement butchering prostitutes would have appealed to Crowley's sense of humour, but it hardly seems likely that she was the culprit.

THE FIFTH VICTIM

O ne biographer of occultist Aleister Crowley remarked that his subject was clearly at least half mad, for it seemed that he believed that Jack the Ripper was no less a person than Madame Blavatsky, revered founder of the Theosophical Society.

Crowley certainly believed many odd things – that, for example, he himself was the true Messiah, 'the Saviour of the World', and that brief details of his life were prophesied in the *Book of Revelations*. He did not, however, actually believe that the grossly overweight and terminally ill Madame Blavatsky was in the habit of disguising herself as a man and travelling halfway across London in order to murder Whitechapel prostitutes. Indeed, the biographer's attribution of this odd idea to Crowley seems to have arisen from a misreading of the second sentence of a document written by the magician: 'It is hardly one's first, or even one's hundredth guess, that the Victorian worthy in the case of Jack the Ripper was no less a person than Helena Petrovna Blavatsky.'

What Crowley *did* believe was that the mysterious killer was an advanced occultist in search of supreme magical power, a skilled astrologer, and a personal acquaintance of many of those active in the leading circles of the Theosophical Society. The man Crowley had in mind as the culprit used many names and, in the course of a long and adventurous life, had been in many strange situations and,

according to his own stories, had witnessed many remarkable things. The man – Crowley called him Dr Donstan – was first identified with the Ripper not by Crowley, but by a woman usually known simply as 'Cremers'.

Many strange people moved through the occult world of both Europe and North America between 1880 and 1940, but few can have been as mysterious as the woman whom some called 'the Baroness Vittoria Cremers'.

The exact date of her birth, which was probably about 1865, and the identity of both her parents are unknown. There were rumours that she was the illegitimate child of a member of the Rothschild family – but, then, similar stories have been told about a host of other men and women. She claimed to be the wife, or perhaps the widow, of a Russian baron, but no one ever encountered this elusive dignitary. Stories about her past were many and varied: she had been an undercover agent of the New York police, fearlessly investigating and exposing organised vice, or perhaps she had been a New York ponce, living on the immoral earnings of her lesbian lovers.

Even on such elementary matters as Cremers' physical appearance and manner of speaking, there was no agreement among those who knew her. Thus, one former close associate of Cremers described her head as grossly misshapen, her skin as resembling yellow parchment, her hair as 'dirty white', and her habitual facial expression as one of hatred and selfish envy. On the other hand, Jean Overton Fuller, the poet and astrologer, who met Cremers at a party in 1935, was impressed by her appearance, which had 'such an authority that all of

ECHAPEL FIEND.

The Ripper murders, left, attracted great media attention. As victim after victim was found butchered – in places such as Mitre Square, below – the police came in for heavy criticism for incompetence. But suddenly the murders stopped. Had the Ripper died – or had he himself been murdered?

us were awed . . . small talk foundered upon the power that was in Cremers and our awareness of it'. One person who clearly did not feel 'the power that was in Cremers', however, was a reporter from either the *Sunday Graphic* or the *Empire News* (accounts vary on this point) who forced his way into the party at which Miss Fuller was present and demanded of Cremers that she should 'tell him her Jack the Ripper story'. Whether or not she did so then is uncertain, but it is a fact that she told it to many of her friends.

OCCULT AFFAIRS

The story began in the middle years of the 1880s, when Cremers, who at the time could not have been much more than 20, first became acquainted with Mabel Collins, a leading member of the Theosophical Society and an associate of Madame Blavatsky. Acquaintance ripened into friendship and, after a few months, Cremers moved into Mabel Collins' home.

Exactly what form the friendship took, it is impossible to know. Perhaps the two ladies merely indulged in girlish chat, or carried out psychic experiments together – Mabel Collins was a gifted trance medium – and generally enjoyed one another's company. More probably, as was alleged by the late Gerard Heym, an authority on alchemy and modern occult history, they had a passionate love affair. If so, however, Mabel Collins must have been an active bisexual, for another guest in the house was her male lover, a hard-drinking astrologer and occultist who, at the time, was calling himself by the name of Dr Donstan.

'Donstan' was almost as mysterious as Cremers. He was a graduate of Trinity College Dublin, claimed to have acquired medical qualifications at various European universities, had served as a mercenary soldier in several minor wars and, at one time, under another name, was reported to have been court-martialled and cashiered from the British Army for cheating at cards. His behaviour was erratic, particularly when he had been drinking heavily, and by the autumn of 1889 – the time of the Ripper murders – Mabel Collins was anxious to be rid of him.

" DONSTAN WAS ALSO A SKILLED
AND PRACTISING ASTROLOGER,
AND THERE ARE INDICATIONS THAT
THE TIMES AND DATES OF THE
RIPPER MURDERS WERE NOT JUST
RANDOM BUT CHOSEN IN
ACCORDANCE WITH ASTROLOGICAL
CONSIDERATIONS. "

One of the most tantalising rumours about the Ripper's identity involved the Baroness Vittoria Cremers, whose forceful personality impressed the poet and astrologer Jean Overton Fuller, above left. 'Cremers' lived with the gifted medium Mabel Collins, above, but also with a certain Dr Donstan whose locked trunk held, so it was said, damning evidence that he was the Ripper.

One evening, shortly after the Ripper's fifth murder, the two ladies were discussing the case. One of them expressed her astonishment that the killer had not been detected within a few minutes of his first crime. He must, she said, have had bloodstains on the front of his shirt – for it was popularly believed that, while still at the scenes of his crimes, the Ripper was in the habit of eating parts of his victims' bodies.

This part of the conversation was overheard by Dr Donstan who, wearing full evening dress, had just returned from the theatre. He is said to have given a short laugh, turned up the collar of his opera cloak, pulled the cape across his shirtfront and remarked: 'You cannot have imagined that the man could be a gentleman, but there are many in evening dress going about the East End, what with opium smoking and one thing or another'. It was a remark that did not go unnoticed.

Something about Donstan's knowingness filled Mabel Collins with terror, and she became more determined than ever to get rid of her lover. She could, of course, simply have asked him to leave her house; but if she did this, she ran the risk of possibly being blackmailed by Donstan, a man totally devoid of scruples, for she had written him many compromising and sexually explicit love letters. These, so she believed, were still in his possession. Probably, she thought, he kept them in the large military-style leather trunk that he kept beneath his bed. It was guarded jealously, and never unlocked in her presence.

Cremers suggested an obvious solution. She and Mabel Collins should break into the trunk, regain and burn the letters; and then, free of any fear of blackmail, they could get rid of Donstan. The only obstacle was Donstan himself. His movements were irregular, following no timetable. He came and went as he pleased. And should he arrive home and find the two women rifling his trunk, his rage might be uncontrollable.

But Cremers solved the problem. She arranged for the delivery of a hoax telegram summoning Donstan to a meeting supposedly being held many miles away. As soon as he had gone, she and Mabel Collins broke open the trunk. There were no love letters inside. Its only contents were five ties stiff with dried blood.

And there Cremers's story ended. Neither woman reported the matter to the police, nor even consulted a solicitor for advice. But Donstan left Mabel Collins's home and, soon afterwards – so it is rumoured – died of alcoholic poisoning in a common lodging house.

BUTCHERY BY THE STARS

Perhaps Donstan was the Ripper – the magician-murderer who, so Crowley and others averred, stalked and murdered East End whores in a quest for occult power. He may certainly have possessed the anatomical knowledge that was demonstrated in the mutilations carried out by the Ripper on his victims. Donstan was also a skilled and practising astrologer, and there are indications that the times and dates of the Ripper murders were not just random but chosen in accordance with astrological considerations, either Saturn or Mercury being almost directly on the ascendant (the eastern horizon as drawn on a horoscope) when these horrendous killings took place.

Against this, it seems most improbable that, if Cremers and Mabel Collins seriously thought that Dr Donstan was the bloody menace whose murders had terrified the entire population of London, they would not have reported their suspicions to the appropriate authority. Even if Mabel Collins had been too strait-laced to make a full statement to the police – in which she would have had to confess that she, an unmarried lady of hitherto unblemished reputation, had not only had a lover but had also compromised herself by writing to him in sexually explicit terms – surely she could have denounced Donstan anonymously? But no such document survives in any of Scotland Yard's bulging 'Suspects' or 'Letters' files on the Ripper case.

Perhaps, however, one of the women did do something that materially altered the case. For the late Gerard Heym always affirmed that 'Cremers killed the Ripper' – and, what is more, that she did so by use of magic.

WHY DID THE MAMMOTHS DISAPPEAR?

EVER SINCE THE DISCOVERY OF THE FIRST COMPLETE MAMMOTH CARCASS, ONE QUESTION HAS HAUNTED THE MINDS OF SCIENTISTS: WHY, 12,000 YEARS AGO, DID THE ENTIRE SPECIES SUDDENLY BECOME EXTINCT?

It is in such areas as the typical tundra, below, that most mammoth remains have been found buried in the frozen layer or permafrost. Often they are astonishingly well-preserved – like the one, inset, found in 1860.

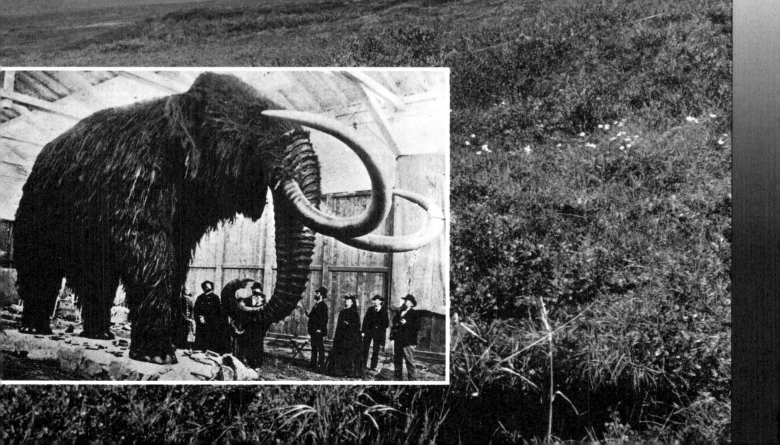

The Arctic, the frozen lid of the world, is one of the Earth's last truly mysterious places. Even today, oceanographers and geologists have barely begun to plumb its strange depths; and the ice, the sea and the coastlines that border it are still sources of controversy.

One of its more curious features is the 'permafrost' belt, which runs around the coastline of the Laptev Sea of northern Siberia to Alaska and then across Canada to the edge of Hudson's Bay. It has been described as 'frozen muck' – a kind of soup consisting of sand, pebbles, shells, vegetable matter and the semi-decomposed remains of millions of animals, ranging in size from small rodents through sabre-toothed tigers to musk oxen and, largest of all, mammoths – the elephants of the Arctic.

All these relics are of interest to zoologists, but it is the woolly mammoth – known to science as *Mammuthus primogenius* – that has caught the attention of laymen; for although it became extinct as a species at least 12,000 years ago, pieces of mammoth carcasses, largely preserved by the permafrost, have been uncovered at fairly regular intervals during the past two centuries. How these animals existed in these harsh regions, and exactly how and why they died, are questions that have caused violent altercations in the pages of scientific journals ever since the late 19th century.

Like many facts about these huge animals, the date of their appearance on Earth is uncertain, but it is known that they thrived during the Pleistocene epoch, which began about two-and-a-half million years ago and ended around 10,000 years before the birth of Christ. They formed one of at least three genera of the *Elephantidae* family (the present-day elephants of Africa and Asia are other members) that coexisted at this time.

Mammuthus meridionalis appears to have had his origins in Europe and Asia and may have evolved into the modern elephant, while *Mammuthus imperator* thrived for several thousands of years in Canada and Alaska before becoming extinct. The longest lasting pure genus was the woolly mammoth, whose fossilised bones have been found as far from its natural habitat as Wyoming and Lake Michigan. Despite these wanderings, however, it was mainly to be found in northern Russia, particularly in Siberia, where at any one time an estimated 50,000 mammoths roamed in herds, searching perpetually for the massive daily intake of food necessary to sustain them.

The few relics of the mammoth found in North America were of the 'normal' prehistoric type – incomplete skeletal remains in various states of fossilisation and deterioration. But the remains found in Siberia were in a different condition: they were frozen, so that the ivory of the giant tusks – some

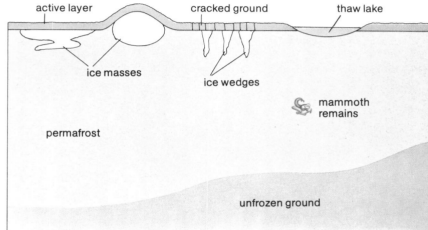

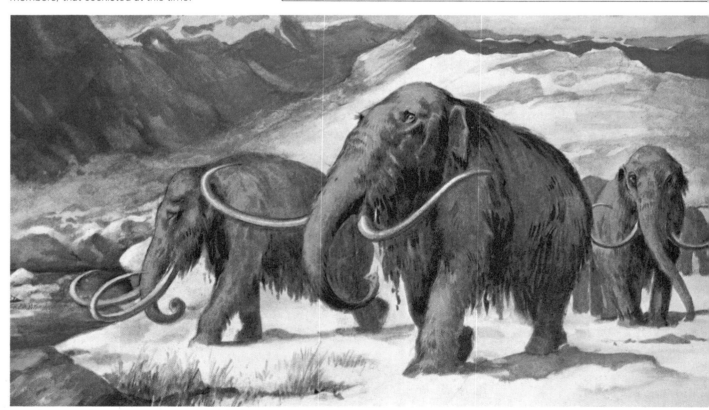

Mammoth ivory has been big business ever since the medieval period; and in the 19th century, there were regular shipments to the major European ports. The illustration, left, dated 1873, shows a consignment on the ivory floor of the London docks. Right up until the 1930s, Siberian tribesmen, as shown below, supplemented their living by excavating mammoth tusks.

The simplified diagram, left, shows the soil layers of the Siberian tundra. Beneath the so-called 'active layer', which is rarely more than 6 feet (2 metres) deep, freezing and thawing every year, is the permafrost. This can be anything up to 1,000 feet (300 metres) deep, and consists of shells, pebbles and sand, as well as the semi-decomposed carcasses of millions of animals – including mammoths.

Scientists believe that the curving tusks of Siberian or woolly mammoths – shown in an artist's impression, below left – were once used as snow-ploughs.

The Cro-Magnon drawing of a mammoth from the Rouffignac Cave, Dordogne, France, right, shows the massive forequarters and shaggy hide that are typical of those mammoth carcasses found in Siberia.

of them were up to 15 feet (5 metres) long – was in perfect condition to be worked into ornaments, sword handles, utensils and other artefacts.

There is evidence that the Chinese and Mongolians knew of these underground deposits of ivory at least 2,000 years ago. By the 13th and 14th centuries, Arab traders were converging on Russia to buy the huge tusks, and a thriving trade had developed within Russia itself. By the 16th century, with the spread of popularity of billiards, the raw material, which the Russians termed *mamontova-kosty*, or 'mammoth ivory', formed part of business deals between England, France, and St Petersburg, centre of such commerce.

DEATH CURSE

Interestingly, no one knows the origin of the word 'mammoth', although the Siberians themselves used the word *mammat* very early. Nor did its early discoverers question the origin of the strange and beautiful substance that they quarried from the permafrost, although the general belief was that it came from the teeth of a giant rat that lived deep underground and came to the surface to die. A considerable amount of superstition surrounded the creature, whatever it was, and most Russian traders went in fear of finding a live one, for to look upon it was said to bring a death curse upon oneself. The great skulls and long bones lent credence to the theory, prevalent throughout Christian Eurasia during the medieval period, that these were the remains of giants that had roamed the Earth before the Flood.

The first person to connect the Siberian mammoth with the modern elephant was a Dutch diplomat, named Evert Ysbrandt Ides, who in 1692 travelled to China on an errand for Peter the Great, Tsar of Russia. While there, he heard from the Chinese

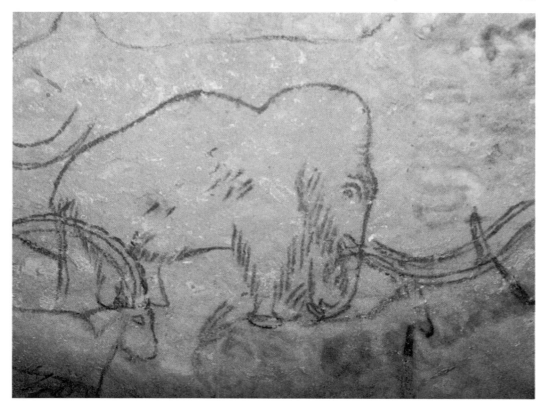

and Mongols stories of the mammoths, including tales of whole carcasses having been found frozen. As a result, he published a highly popular book that set out to prove that the remains were those of an elephant that had lived, as he put it, 'before the Deluge'.

Peter the Great was fascinated by the possibility that some of these great 'elephants' might still be alive in a remote part of his domain. The possibility seemed to be borne out by the story told to him by Michael Wolochowicz, a Siberian explorer who said that he had seen the body of one, thawing on the banks of the Indigirka River in eastern Siberia. Unfortunately, wolves had begun to eat the body, so that there was not much left, except for the skeleton. However, Wolochowicz averred: 'I saw a piece of putrefied skin, appearing out of a sand-hill, which was pretty large, thick-set and brown, somewhat resembling goat's hair; which skin I could not take for that of a goat, but of a behemoth, inasmuch as I could not appropriate it to any animal that I knew'.

It was left to a traveller, Khariton Laptev, writing in 1743, to suggest that the animals were ancient, preserved by a deepfreeze process. 'On the banks of several rivers in the tundra, whole mammoths with their tusks are dug out with hides on them. Their hair and bodies are, however, rotten, while the bones, except the tusks, are also decaying'.

Throughout the 18th century, zoologists speculated about the Siberian mammoths; and then, in August 1799, an almost complete specimen was found in the delta of the Lena River, the first to be studied scientifically. An ivory hunter named Shumakov, who was also a chief of the Tungus tribe, which held the mammoth in superstitious awe, saw a dark shape in a massive block of ice. The following year, he passed by again. The block had melted somewhat and he traced the outline of

Instead of the warm hair and tiny ears of the mammoth, designed to retain heat, today's African elephant, below, has a smooth skin and enormous ears, designed to disperse its body heat.

The map, bottom, shows the principal finds of mammoth remains since the late 18th century. The best-preserved examples were excavated in the permafrost region of Siberia, as shown in a paler shade on the map.

what looked like a huge animal. When he returned to the spot in 1801, the ice had melted, exposing one side of the animal. Shumakov was terrified: he had looked on a mammoth, and must surely die.

In fact, he did fall ill – but, to his astonishment, recovered. As he later explained, if he had survived a first sighting, why should he not go back and claim the tusks? His superstition cured, he returned to the site in 1803. This time, he found the beast fully exposed, with the surrounding ice completely melted. Again his nerve failed him, but he told his 'middle-man', an ivory dealer named Roman Boltunov, who persuaded him to show the carcass. Boltunov removed the tusks but made a detailed drawing, which he sent to Professor Ivanovich Adams at the Academy of Sciences in St Petersburg.

Realising the importance of the find, Professor Adams set out with an expedition to recover as much of the body as remained. The exposed side had largely been eaten by wolves, and the trunk and one foreleg were gone. But the skull was still intact and covered with skin, along with one ear and

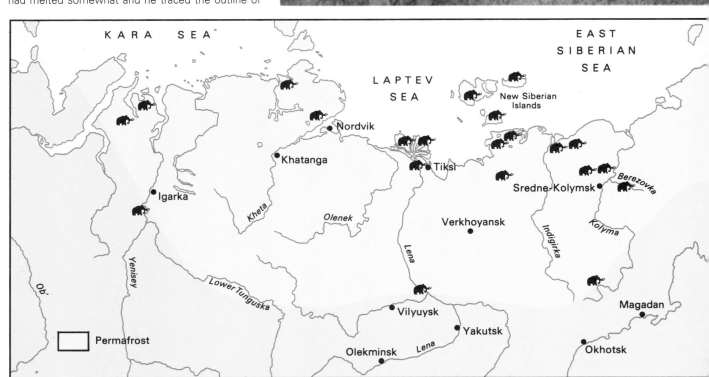

Permafrost

the left eye, plus much of the brain. The unexposed side was almost complete, with the shaggy hide lying under the body.

Carefully, Adams dismembered the corpse in order to send it back to St Petersburg. It took ten men to lift the hide alone: the reddish hair, which fell off and was gathered up separately for crating, weighed 3.7 pounds (1.7 kilograms). Adams finally bought back the mammoth's tusks from Boltunov, and the remains were sent back and reassembled in St Petersburg.

Adams' painstaking work had solved the problem of what, exactly, the animals in the ice were, but it raised other questions. Why had the creatures died out? Were they, in fact, extinct? It seemed unlikely that a body could be in such a relatively fresh-looking condition if it had indeed died 'before the Deluge'. Almost a century was to pass before the discovery of the most perfect specimen yet known indicated the probable cause of death of at least some of these mighty creatures.

PERFECT SPECIMEN

In August 1900, a party of hunters noticed that a landslip had occurred on the banks of the Berezovka River, a tributary of the Kolyma in the then Government (or province) of Yakutsk, northern Siberia. Protruding from the frozen gravel were the head and shoulders of a mammoth. The hunters took a tusk before reporting the find to the Governor of Yakutsk, who set a guard on the dead animal before informing the scientists in St Petersburg. An expedition under Professor Otto Hertz, head of the Department of Zoology of the Russian Academy of Sciences – although he himself was a specialist in insects – was soon under way. With him, Hertz brought a geologist and a leading taxidermist. After an epic journey on foot and horseback lasting several months, the party found the mammoth. Apart from some damage

An artist's highly romanticised impression of the discovery, in 1799, of a frozen woolly mammoth carcass by a Siberian ivory hunter is shown above. These remains later became the subject of the first scientific investigation of mammoths.

The Berezovka mammoth, below, was discovered in 1900. Its mouth was found to contain grass, unswallowed when sudden death overtook it. Exactly how it died, however, remains a mystery.

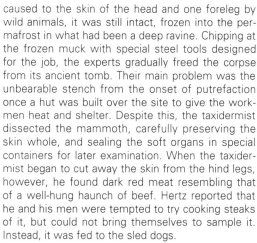

caused to the skin of the head and one foreleg by wild animals, it was still intact, frozen into the permafrost in what had been a deep ravine. Chipping at the frozen muck with special steel tools designed for the job, the experts gradually freed the corpse from its ancient tomb. Their main problem was the unbearable stench from the onset of putrefaction once a hut was built over the site to give the workmen heat and shelter. Despite this, the taxidermist dissected the mammoth, carefully preserving the skin whole, and sealing the soft organs in special containers for later examination. When the taxidermist began to cut away the skin from the hind legs, however, he found dark red meat resembling that of a well-hung haunch of beef. Hertz reported that he and his men were tempted to try cooking steaks of it, but could not bring themselves to sample it. Instead, it was fed to the sled dogs.

The body was that of a young male – 8 feet 10 inches (2.7 metres) tall at the shoulder, compared with the 10 feet 8 inches (3.2 metres) of Adams' specimen. Its hind legs were doubled under the body and the pelvis was broken, along with the right foreleg. The hide was nearly three-quarters of an inch (1 – 2 centimetres) thick, and covered with two layers of hair; the 'undercoat' was yellowish grey and about an inch (2.5 centimetres) long, and this was topped by a matted red coat between 4 and 6 inches (10 – 15 centimetres) long. Beneath the hide was a layer of fat, averaging 4 inches (10 centimetres) in depth, though a larger bulge of fat on the shoulders and head gave it a hump. Many years later, Carbon 14 dating processes were to indicate that both the Berezovka mammoth and that found by Adams died around 30,000 years ago.

A curious fact about the Berezovka mammoth was that its mouth contained buttercups and grass, which for some reason it had been unable to swallow. This indicated that the creature had met a sudden death. And an analysis of the contents of its stomach revealed that the mammoth's diet consisted of plants that still grow in the area. This raises a fascinating question: could perhaps mammoths still exist in deepest Siberia?

DREAMS THAT COME TRUE

Jacob's dream of a ladder, as recounted in **The Bible** *and depicted by William Blake,* **above,** *is one of the most important prophetic dreams in Jewish history*.

DO DREAMS SHOW US ASPECTS OF THE REAL WORLD THAT WE CANNOT SEE IN WAKING LIFE? WHAT IS MORE, CAN THEY REALLY REVEAL THE FUTURE?

Often our dreams take us to remote times and places: we find ourselves among people and things that are familiar, yet strangely transfigured. We do things that are impossible in waking life, or we find ourselves paralysed and unable to perform the simplest actions. Sometimes we have a sense that we possess profound knowledge that could give meaning to our whole lives – knowledge that is forgotten on waking, or seen to be nonsense. And sometimes, it seems, we are given real knowledge in dreams – a glimpse of the future as it will really happen.

The nature of dreaming has puzzled civilised mankind from earliest times, and countless strange beliefs and cults have grown up around the whole experience of dreaming. This need not surprise us when, even today, no single theory of sleep and dreaming is generally accepted.

Ancient beliefs about dreaming were usually based on the assumption that they predicted future events, and elaborate means of interpreting them were devised. Indeed, one of the oldest surviving manuscripts, an Egyptian papyrus 4,000 years old, is devoted to the complex art of dream interpretation.

A dream experienced by the Pharaoh Thutmose IV in about 1450 BC, for instance, was deemed sufficiently important to be engraved on a stone tablet that he erected in front of the Great Sphinx at Giza. It tells how, while he was still a prince, Thutmose took a midday nap and dreamed that the god Hormakhu spoke to him, saying: 'The sand in the district in which I have my existence has covered me up. Promise me that thou wilt do what I wish; then will I acknowledge that thou art my son, that thou art my helper...' When he became Pharaoh, Thutmose cleared the sand that had drifted over the Sphinx, which was sacred to Hormakhu, and his reign was long and fruitful, exactly as the god had promised in the dream.

DIVINE GUIDANCE

A dramatic story concerning a dream of Nebuchadnezzar, King of Babylon during the following century, is recounted in the *Book of Daniel*. The King awoke one morning, certain that he had had a dream, but unable to remember it. Sure that it was of divine origin, however, he called upon his wise men to tell him the dream and what it meant. They insisted that they could not tell what the dream had been, but Nebuchadnezzar imperiously threatened them with instant death if they failed to do so.

Daniel, already noted for his understanding of visions and dreams, saved the day. He prayed that God should reveal the dream to him, and that night he had a vision. He saw an image whose head was

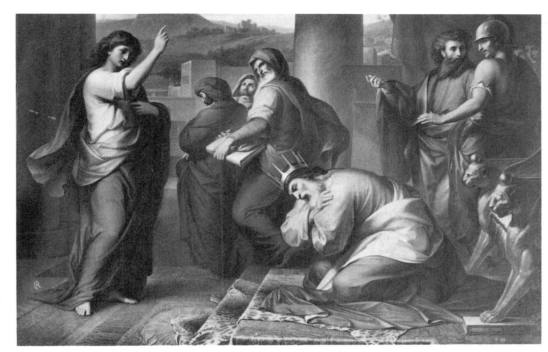

In another Old Testament account, illustrated right, Daniel reveals King Nebuchadnezzar's forgotten dream of an image with feet of clay and interprets it as a symbolic prophecy about the kingdom. Impressed, the King is shown paying homage to Daniel.

The Sphinx and stone tablet telling of Thutmose IV's dream of the god Hormakhu, who promised him a prosperous reign if he cleared away the sand from the Sphinx, are shown above left.

Alexander the Great, above, had a punning dream, correctly interpreted as a prophecy of victory by his official dream interpreter, Aristander.

❝ MUST NOT WE ADMIT ... THAT AMONG THE COUNTLESS MULTITUDES OF DREAMS, ONE HERE AND THERE IS LIKELY TO CORRESPOND ... WITH AN ACTUAL OCCURRENCE ... ? **❞**

PHANTASMS OF THE LIVING

GURNEY, MYERS AND PODMORE

of gold, and which had breasts and arms of silver, belly and thighs of bronze, calves of iron and feet partly of iron and partly of clay. The image was destroyed by a stone, which then grew into a mountain that filled the whole Earth. The King recognised this as his dream, and Daniel interpreted it. The gold head represented the King's rule, and the other parts of the image represented the decline of the kingdom under succeeding rulers, ending in its destruction. But the kingdom that followed would be set up by God and would last for ever. As a result, the King paid homage to Daniel, and raised him to high office.

Numerous other biblical examples of dream interpretation exist. The Old Testament patriarch, Jacob, for instance, while fleeing from his murderous brother Esau (whom he had tricked out of his birthright), slept in the wilderness; and while he slept, he had a dream. A ladder reached from Earth to Heaven, and the angels of the Lord ascended and descended it, while the Lord Himself stood at the top. God told Jacob that He would give him the land upon which he lay, and promised him 'in thee and in thy seed shall all the families of the Earth be blessed'. The dream, which inspired awe and terror in Jacob, it seems, came true, for he became the ancestor of all the tribes of Israel.

Generals, as well as patriarchs, often conducted their affairs according to the supposed meanings of dreams. Alexander the Great, while besieging the Phoenician city of Tyre in 332 BC, dreamed of a satyr dancing on a shield. His dream interpreter Aristander recognised it as a clever pun: *satyros*, the Greek for satyr, could be taken as *sa Tyros*, meaning 'Tyre is yours'. Alexander took heed, continued with the campaign and captured the city.

This early example of a dream containing a pun interestingly foreshadows Freud's theory that the unconscious mind is a master jester, expressing repressed impulses in multiple puns, and creating coded dream messages that can slip past the censorship of the conscious mind.

But among speculative thinkers of the ancient world, there were voices raised in opposition to the generally accepted views of dreams. Cicero, Rome's greatest orator, argued fiercely in the first century BC that those who claimed to be able to interpret dreams did so by conjecture. And though, among Moslems, dream divination was accepted as a genuine way of gaining knowledge of the future, Mohammed forbade it in the sixth century AD because it had reached excessive proportions.

It is now, of course, highly unorthodox to regard dreams as communications with the gods or spirits. But there is a split between those academic psychologists who believe that dreams are reflections of subconscious activity, expressing our hopes and fears, and those who believe that they merely embody the 'junk' that the brain has accumulated during the day and no longer needs.

Undoubtedly some dreams – especially nightmares – are caused by complex psychological influences with roots in the past rather than in immediate surroundings. But there is yet another class of dreams – those striking ones that seem to provide a preview of future events and that probably led to ancient beliefs about divination.

SHOT IN THE DARK

One often-quoted prophetic dream concerned the assassination of the British Prime Minister, Spencer Perceval, on 11 May 1812. Eight days earlier, a person living in Cornwall dreamed that he saw a small man enter the lobby of the House of Commons, dressed in a blue coat and white waistcoat. Then he saw another man draw a pistol from under his coat, which was brown with ornate yellow metal buttons. He fired at the first man, who fell to the ground with blood issuing from a wound just below his left breast. Certain other gentlemen who were present grabbed the assassin. When the dreamer asked who had been shot, he was told it was Mr Perceval.

The dreamer was so impressed that he wanted to warn the Prime Minister, but his friends dissuaded him, saying that he would be dismissed as a fanatic. Later, during a visit to London, he saw pictures of the assassination in print-shops, drawn from accounts by eyewitnesses. He recognised many details of his dream, including the very clothes the two men had been wearing.

Although that incident is said to have been carefully studied at the time and confirmed, it does not constitute good evidence, because the dreamer is not identified. By contrast, the following dream was described by a great writer, Charles Dickens:

'I dreamed that I saw a lady in a red shawl with her back towards me... On her turning round, I found that I didn't know her and she said "I am Miss Napier".

'All the time I was dressing next morning, I thought – what a preposterous thing to have so very distinct a dream about nothing! and why Miss Napier? For I have never heard of any Miss Napier. That same Friday night, I read. After the reading, came into my retiring-room Miss Boyle and her brother, and the lady in the red shawl whom they present as "Miss Napier"!'

Such dreams, as Dickens remarks, are usually very distinct, or have a special quality of their own.

Cicero, the famous Roman orator, below, was intensely sceptical about the claims of dream-interpreters, arguing that they relied on conjecture.

The British Prime Minister, Spencer Perceval, was assassinated by John Bellingham on 11 May 1812, as depicted above. Eight days before, an unknown Cornishman dreamed of the event in extraordinary detail – even down to the type of buttons on the assassin's sleeve.

Dr Walter Franklin Prince, an American clergyman and historian who became a noted psychical researcher, said that during his life he had experienced foul dreams compared with which all his other dreams were 'as the glow-worm to the lightning flash'. The imagery in these dreams was exceptionally vivid, and the emotions they aroused, usually intense. This is his account of one of those dreams:

'I dreamed that I was looking at a train, the rear end of which was protruding from a railway tunnel. Then, suddenly, to my horror, another train dashed into it. I saw cars crumple and pile up, and out of the mass of wreckage arose the cries, sharp and agonized, of wounded persons . . . And then what appeared to be clouds of steam or smoke burst forth, and still more agonizing cries followed. At about this point, I was awakened by my wife, since I was making noises indicative of distress.'

The following morning, a railway disaster occurred in New York. When Dr Prince read the newspaper accounts, he was struck by many 'coinciding particulars': the trains had collided at the entrance of a tunnel; in addition to those killed and injured by the impact, others perished or were severely wounded when steam pipes burst and the wreckage caught fire; and the disaster occurred no more than six hours after the dream and just 75 miles (125 kilometres) away from Dr Prince's home.

John W. Dunne, a British pioneer aeronautical engineer, was intrigued by his own dreams, which often seemed to glimpse future events. Dunne proposed theories of time that endeavoured to explain dream precognition. His book, *An Experiment With Time*, published in 1927, is one of the most famous studies of the subject.

Dunne made meticulous records of his dreams. The following, which occurred in the autumn of 1913, was a typical example:

'The scene I saw was a high railway embankment. I knew in that dream – knew without questioning, as anyone acquainted with the locality would have known – that the place was just north of the Firth of Forth Bridge, in Scotland. The terrain below the embankment was open grassland, with

people walking in small groups thereon. The scene came and went several times, but the last time I saw that a train going north had just fallen over the embankment. I saw several carriages lying towards the bottom of the slope, and I saw large blocks of stone rolling and sliding down.'

He tried to 'get' the date, but all he could gather was that it was the following spring. His own recollection is that he thought it was mid-April, though his sister believed he mentioned March when he told her of the dream next morning. They agreed, jokingly, to warn their friends against travelling by rail in Scotland during the next spring.

On 14 April 1914, the *Flying Scotsman* mail train jumped the parapet near Burntisland station, 15 miles (24 kilometres) north of the Forth Bridge, and fell on to the golf links, 20 feet (6 metres) below.

In recent years, several bureaux have been set up to collect premonitions from the public in an attempt to overcome the often-made objection that such reports surface only after an event. The Toronto Premonitions Bureau received the following account of a premonition, which, like so many others, came in a dream.

A Canadian woman, Mrs Zmenak, dreamed that police had telephoned her. They told her that her husband would not be home for a while because someone had been killed; then she saw a body without legs. When she woke she was sure her husband would not die, but that someone else would be killed if he went out next day. He ignored her warning. What happened next is described in the journal of the New Horizons Research Foundation, which ran the bureau:

'On the way home, his car failed electrically and came to a standstill; so he walked to a telephone to ask his wife to pick him up. A police car stopped to ask what he was doing; and as he was explaining, another car drew up on the other side of the road and the driver, who was lost, crossed over to ask his way. The police gave him directions, and as the driver went back to get into his car he walked into the path of another car and was killed instantly. His

The Archduke Ferdinand, above, was photographed just before his assassination by Serbian nationalists. The murder shattered the already fragile relations between the European powers and ushered in the carnage of the First World War.

CASEBOOK

A PORTENT OF WAR

During the night of 27 June 1914, a Balkan Bishop, Monseigneur Joseph de Lanyi, had a terrifying dream. In it, a black-edged letter lay on his study table, bearing the arms of Archduke Ferdinand (heir-presumptive to the Austro-Hungarian throne, and to whom the Bishop was tutor). When he opened the dream-letter, the Bishop saw a street scene at the head of the paper. The Archduke was seated in a motor car with his wife at his side, facing a general. Another officer sat at the side of the chauffeur. Suddenly, two men stepped forward and fired at the royal couple.

The text of the letter read: 'Your Eminence, Dear Dr Lanyi, My wife and I have been victims of a political crime at Sarajevo. We commend ourselves to your prayers. Sarajevo, 28 June 1914 4 a.m.'

The next day, the shaken Bishop received news of the assassination. And, within weeks, all Europe was at war.

legs were doubled up underneath him – they looked as if they were cut off. The police telephoned Mrs Zmenak . . . and told her that her husband would not be returning home yet because a man had been killed and her husband was needed to make a statement as a witness.'

When a prophetic dream coincides with reality to such a remarkable extent, it would seem to suggest that, in sleep, the usual barriers of time and space can be breached. And since we all sleep and dream, it would seem logical that we all have the opportunity to pass through these barriers on occasion in order to get a glimpse of the future.

John W. Dunne, below, dreamed vividly of a train falling over an embankment near the Forth Bridge. Some months later the Flying Scotsman crashed there, as shown bottom.

The Hindu deity, Vishnu, is depicted above, reincarnating for the second time – as a turtle. Belief in the transmigration of souls, or reincarnation as man or animal, is still common in most parts of the East.

DEATH'S GREAT ADVENTURE

SUPPOSED COMMUNICATIONS FROM BEYOND THE GRAVE SEEM TO SUGGEST THAT THE DEAD LEAD A STRENUOUS AND PURPOSEFUL EXISTENCE – IN FACT, SOME SAY THAT IN MANY WAYS THEY ARE MORE 'ALIVE' THAN WE ARE

If death is not the end of man's personality, but rather the beginning of a sort of 'pilgrim's progress', as many psychical researchers claim, what surely requires investigation is the nature of this adventure. According to one prevalent theory, the discarnate spirit, after meeting loved ones who have died before, is said to live first in a so-called 'summerland' or 'winterland', both of which are created from the individual's own habits of thought, good or bad. These are both on the ideo-plastic plane and seem to serve to break us of our earthly preoccupations and make us yearn for the benefits of higher, more spiritual faculties. But we must first undergo the judgement and the 'second death', processes that hold up a mirror to the people we were, mercilessly stripping us of any illusions about ourselves and making us realise – by momentarily becoming other people in our lives – what our actions and words had done to them.

Through experiencing the shattering but ultimately rewarding process of the 'second death', the spirit then 'earns' its entry into the second heaven. What has been shed in the trauma is only, we discover, our outer selves, or personality, which had seemed so essential previously. Personality (the word is derived from the Latin *persona*, meaning 'actor's mask') is cast away, so we now emerge as our real, 'undivided' selves.

The purpose of the second heaven is, apparently, to enable the questing spirit to grow and develop. The process takes place in what many accounts call 'the great silence'. During this period, former identity dissolves away and we experience a sense of great peace. We no longer know who or where we are, but this does not in any way prove distressing, any more than it is distressing for a butterfly to undergo the natural process of emerging from its cocoon.

At this point, the spirit loses contact with all those known during life. This is a temporary phase but said to be essential if we are to concentrate energies on coping with the new, immeasurably broader landscape we now face. There are now highly significant meetings with others – men and women with whom one feels a deep spiritual link

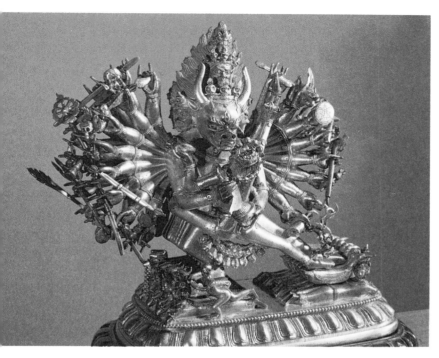

learn all the necessary lessons. All the opportunities will be there over the centuries for everyone. Not all of us will profit by experience or learn at the same rate, but there are many chances to put right mistakes made or opportunities lost. As Frances Banks said: 'It is still a continuation, a sequel. There is a definite continuing thread.'

This enrichment of the soul through the revelations of the past is the first step in the process of reassessment carried on in the second heaven. There are two other, equally important steps.

The first involves advice from wiser beings on how to deal with one's future earth life. The second step clarifies the true nature of the spirit's relationship with his peers, those 'old friends' with whom he has just been reunited. He now realises that they are all bound together for all eternity, united with the same overall purpose. Together, they form part of a highly important unit known as a group soul. It is said that to be with its members is to feel a deep spiritual homecoming.

The members of an earth family may be spiritually close or they may simply be genetically linked – effectively strangers on any deeper level. Their spiritual family is elsewhere. But, in the after-life, there

Most ancient cultures believed in a supernatural deity whose sole task was to preside over the dead. Part custodian and part judge, he is usually shown as a terrible figure, such as Yamantaka, Tibetan Lord of the Dead, above, or the Totonac god of ancient Mexico, Mictlantecuhtli, right.

The ninth hell, as described in Dante's Inferno and illustrated by Gustave Doré, is seen below. In this wasteland of ice and desolation, the damned soul is frozen forever, unless he confesses his sins to the superior souls who visit him.

and an intimate familiarity. This is reported as being like meeting old friends on earth with whom one has shared profound experiences. However, the spirits on this plane, although they are indeed old friends, belong to relationships formed over many lifetimes. This one fact is central to the understanding of the whole nature of the after-life. With those friends from long ago, the spirit relives ancient memories, to which his immediately previous personality had no access. Together, the members of the reunion relive past events they had shared; and as they do so, they begin to see a distinct purpose and meaning emerge from the apparently disparate and fragmentary personalities they had been in the past, for each soul has been reincarnated many times.

A CONTINUING THREAD

We now see that our lives are in no way arbitrary, but form part of a pattern and purpose that are still being worked out. Each is slowly awakening towards recognition of, and participating in, what is named his 'causal self'. This carries within it the seeds of each former life but also contains hints of what is to come in future incarnations. The second heaven is both retrospective and prospective – a plane of insight into both past and future. As the posthumous Frances Banks, a former Anglican nun, is claimed to have said: it is 'the initial stage of a journey into light, during which the surviving entity is gradually reunited with the whole soul'. We now see our past earth life in its true perspective – as a tiny fragment of a much larger prospect.

According to this theory, the past life is only the latest chapter in a long book, the 'story' of which can stretch back over many earth centuries. As the spirit begins to witness the unfolding panorama of his lives, he will inevitably realise that much in his past life was the direct consequence of actions from other, previous incarnations.

There are said to be many incarnations for most spirits, for almost everyone needs many chances to

75

In the statue over the Old Bailey, Britain's foremost criminal court, left, the scales and the sword carried represent two aspects of justice: mercy and retribution. According to one theory, however, absolute justice is said to be found only in the after-life – where motives are seen for what they really were in life. During the judgement, the soul suffers the pain and humiliation once inflicted on others. But kindness is also relived and rewarded.

are no such random or loose ties; the group soul comprises only members who are totally committed to their particular long-term spiritual assignment under the leadership of one who can perhaps best be likened to an elder brother. The individual members of each group are responsible to each other – and to the world – in order to fulfil the special task assigned when their group was created.

LIFE GOES ON

If such claims about conditions in the after-life – and, indeed, the purpose of life itself – are true, then our individual lives on earth can be seen in proper perspective, as part of a much greater plan. And although these accounts seem basically in harmony with the conventional Christian belief in heaven and hell, the approximately similar states exist not as final punishments or rewards for a single earth life, but as stages in a continuing education. Each has to redeem those parts of himself that are bound by the chains of his own creation. Even in the second heaven, the processes of self-cleansing and selfless service continue. Here, the spirit learns that there are further states of bliss, but these are too intense for it yet.

Here, it becomes plain that life on earth and life between incarnations simply provide different opportunities for 'growing up'. Each spirit will pass from hard work to refreshment and on to further tasks; and although the surroundings are said to be more pleasant than on earth, basically the work is just as strenuous. It takes enormous effort for each spirit to make any lasting progress, but we are not alone and can expect the kind of help, advice and inspiration that would have been impossible on earth. Encouraged and inspired, the individual can then progress towards his own ultimate maturity.

The destiny of each soul is said to be fulfilled only when that of the group soul is completed. This may take aeons. There are many group souls, said to range from comparatively few members to many hundreds. Frequently, a person's inner urge on earth is a reflection of the quest of his group soul, his equivalent of the Holy Grail. Everyone retains free will to depart from the group soul's set path, but the promptings of our own inner nature will, it is believed, eventually lead us back to it.

During its stay in the second heaven, the spirit learns from the 'replay' of his past lives to discover

PERSPECTIVES

THE MAN WHO WOULD BE KING

Death is said to be 'the great leveller', and nowhere is this shown more clearly than in *A Tudor Story* by the late Canon W. S. Pakenham-Walsh. This purports to tell the tale of the Canon's relationship – through several mediums – with various members of the Tudor court from the early 1920s to his death at the age of 92 in 1960. Pakenham-Walsh found that his main spiritual mission was to aid Henry VIII himself, who was angry, lost and clinging pathetically to a crown he no longer possessed, and could therefore

make no progress in the after-life. One medium had to remind 'Henry' that he was king no longer. He was furious, saying: 'I am a king. I carry royal birth and death in my hands... A king does not commit acts for which he is sorry.' The Canon enlisted the help of the 'spirits' of Anne Boleyn and Elizabeth I, among others, while also praying for the King's soul himself. For a time, Henry vacillated between apparent repentance and humility and outbursts of regal temperament. The breakthrough came when he was allowed to meet his sons – including the baby who had been stillborn, now grown up. Henry's last communication was: 'Know that Henry, once King of England, did repent'.

> *"*
> IT TAKES ENORMOUS EFFORT FOR EACH SPIRIT TO MAKE ANY LASTING PROGRESS, BUT WE ARE NOT ALONE... ENCOURAGED AND INSPIRED, THE INDIVIDUAL CAN THEN PROGRESS TOWARDS HIS ULTIMATE MATURITY. *"*

its true potential and what steps should be taken to fulfil it. Strengthened by the insight and love of our companions, we are now ready for a yet further expansion of consciousness, which takes place in the third heaven. This is, however, too intense an experience for many spirits to endure for very long, although it is open to us for precisely as long as we can sustain it. Although almost impossible for us to understand, communicators tell us that in the third heaven a spirit comes to the limits of its consciousness. After a brief glimpse of this plane, we find we cannot go further into it than our nature allows. Faced with such limitations, we have no choice but to return to earth.

OTHER LIVES, OTHER WORLDS

However, if our next incarnation goes well and we grow spiritually as a result, we will find that we can then proceed deeper into the third heaven. This, in turn, will enable us to make more of our succeeding earth life, for it is in the third heaven that the true nature of the group soul's task unfolds.

But what happens when a person has little more to learn from earth? Most accounts agree that a choice awaits us. We can take a leap into the great unknown, leaving this planet and its successive incarnations altogether, and begin again somewhere else. Communications are vague on this point, but they do seem to imply a new cycle of physical lives on another planet. Few, the posthumous F.W. H. Myers says, are sufficiently strong to go the first time the chance arises. Most spirits prefer to wait, helping others if needed, even if it means being reincarnated on earth yet again. A group soul will move on only when every member is ready to go. No one will be left behind.

People frequently deplore the injustices of 'life', meaning their earthly existence. But if the accounts of the after-life summarised above are substantially true, then there *is* such a thing as absolute justice; there is cause for hope, there is free will and ever-expanding consciousness. The narratives purporting to come from people in the after-life can be examined by anyone – religious beliefs and pious hopes aside – as evidence. According to certain Spiritualist beliefs, the last words of Mary, Queen of Scots – 'In my end is my beginning' – express the literal truth for everyone.

The bark painting by the Australian Aborigine artist Bunia, above, depicts aspects of the after-life.

In an early 15th-century representation, right, St Peter receives three souls at the gates of heaven. In the traditional Christian view, admission to heaven was in itself a kind of judgement, although the dreadful day of judgement was to come.

The wall painting at Tepantitla Mexico, below, dating back more than 1,000 years, is believed to show the rain god's paradise in the after-life.

ERICH VON DÄNIKEN
STARTLED THE
WORLD AND GAINED
INTERNATIONAL FAME BY
SUGGESTING THAT SUPERIOR
SPACE-BEINGS HAD VISITED
EARTH IN ANCIENT TIMES.
BUT HOW MUCH CREDENCE
DO SUCH STARTLING VIEWS
REALLY DESERVE?

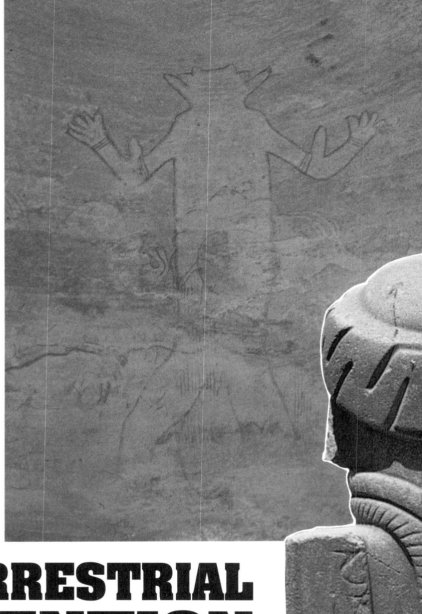

All myths contain a kernel of truth. It might be a human psychological yearning for some higher state, as in the myths of the 'Superman'. Or it might be an indication of the importance, no longer understood, once attached to some special place, such as a megalithic site. Other myths reflect memories of historical events and people – for instance, King Arthur or the Emperor Charlemagne. Some may even take us a surprisingly long way back into prehistory. Indeed, North American Indian stories, concerning the time when their world was dominated by the 'Big Snow', sound like a description of the last Ice Age, which ended 10,000 years ago.

But how do we understand those myths that read like pure fiction, yet occur in slightly different versions in the traditions of ancient peoples and tribal cultures from widely separated parts of the

EXTRA-TERRESTRIAL INTERVENTION

globe? Such stories frequently feature 'gods', or 'sky people', or beings from stars, who came down to Earth and civilised mankind. They flew, we are sometimes told, in winged or fiery chariots, and a few select mortals were given rides or carried off in them. These visitors from 'heaven' were even supposed to have taken human partners, breeding demigods who became kings and wise men. Where did these stories come from? Should we try to explain them in terms of Man's psychological needs? Or are we missing the point if we do not give these myths a chance and try to interpret them at their face value?

Many people believe that, with the benefit of 20th-century scientific knowledge, we can now understand such myths in ways that simply were not available. Today, the possibility (at least) of extra-terrestrial life-forms is one that most people are able to entertain. As Man begins the long trek into the solar system and the investigation of other worlds, the question of whether our own planet has already been visited by some intelligent life-forms has arisen quite naturally. Could the idea of the 'gods from heaven' perhaps be ancient Man's attempt to describe beings from other worlds, in the days before it was really known that such worlds existed? And might tales of fiery chariots that flew through the air be the only way that ancient Man could describe the kinds of air and space travel we now know to be possible?

For von Däniken, the intriguing figure from a rock painting in the Tassili mountains of Algeria, **left**, depicts a spaceman making a visit to Earth centuries ago. The ethereal form contrasts with the more solid drawings in the group.

At Tiahuanaco, Bolivia, impressive sculptures and monuments, **below** and **below right**, seem to suggest stupendous building feats by ancient Man – or were they perhaps the result of extra-terrestrial intervention?

This is the kind of reasoning – simplistic, yet appearing to smack of common sense – used by Erich von Däniken in his *Chariots of the Gods?* and sequel works. They all present the same theory: that the Earth was visited by intelligent beings from a distant galaxy in prehistoric and early historic times; that the human race was started by these aliens through genetic engineering on apes; and that Man, overawed by the technological wonders of the extra-terrestrials, worshipped them as gods. The essence of von Däniken's controversial theories is summed up in the sub-title of his first book: *Was God an Astronaut?*

SEARCH FOR PROOF

Although only one among many writers to argue along these lines, von Däniken had a meteoric rise to fame on the publication of his first book, which firmly established him as the leading proponent of extra-terrestrial intervention in Man's history. The staggering success of *Chariots of the Gods?*, chalking up well over 5 million sales in at least 26 languages, transformed a once bankrupt Swiss hotelier, with an ambition to travel, into the champion of the space gods, who went on to pursue his quest for 'final proof' around the globe with an almost messianic zeal. His success is particularly amazing as few thoughts contained in his books are original. Many links in the von Däniken argument can be found in the work of earlier, often far sounder, exponents of the 'ancient astronaut' theme. Archaeologists and theologians reacted with outrage, however, denouncing him as a fraud and a charlatan.

Von Däniken assured his public that he had plenty of hard proof that extra-terrestrials have visited and 'deposited physical signs of their presence on Earth'. Indeed, his books are full with details of ancient artifacts, which he claimed were representations of spacemen, rockets, aerials, and even

heart-transplants, and describes feats of engineering that he says could not possibly have been managed by ancient Man without some form of outside help. The technology, he explains, was simply not available.

But most of his evidence is a mish-mash of half-truths, cooked up with insinuations made in the form of questions. Indeed, the argument was sometimes so thin that von Däniken used the vagueness of his own question-without-answer style of writing to wriggle on the hook when critics caught him out. The famous ground drawings at Nazca in Peru, for example, were described by him in *Chariots of the Gods?* as follows: 'Seen from the air, the clear-cut impression that the . . . plain of Nazca made on me was that of an airfield!' At the mention of von Däniken's airstrips, German scientist Maria Reiche – who studied the lines at first hand over a number of years and did not find the slightest trace of extra-terrestrial landings – simply smiled and remarked: 'Once you remove the stones, the ground is quite soft. I'm afraid the spacemen would have gotten stuck'.

In a debate with author Colin Wilson in the magazine *Second Look,* von Däniken tried to soft-pedal on the question of the Nazca lines. 'I have not claimed that extra-terrestrials had built the lines at Nazca. I have only said these tracks were the result of some sort of cargo-cult of the natives there,' he said, and challenged Wilson to produce a statement from one of his books to the effect that the lines were built 'by or with the help of extra-terrestrials'. On Wilson's behalf, here is an extract from von Däniken's *Return to the Stars:*

'At some time in the past, unknown intelligences landed on the uninhabited plain near the present-day town of Nazca and built an improvised airfield for their spacecraft which were to operate in the vicinity of the earth. They laid down two runways on the ideal terrain.'

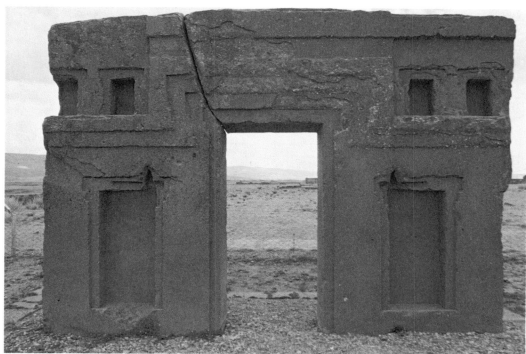

He claims to have explored this vast underground network with the help of Juan Moricz, self-styled discoverer and 'keeper' of the tunnels. 'We switched on our torches and the lamps on our helmets, and there in front of us was the gaping hole which led down into the depths... We slid down a rope to the first platform.'

As he marvelled at the wonders contained in the tunnels, such as the metal plates covered with a bizarre and unknown script, von Däniken said he 'felt tremendously happy', though he 'had the feeling of being constantly watched'.

But this 'expedition' to the Ecuadorean tunnels was to become the subject of a farcical controversy between von Däniken and Juan Moricz. Four months after the publication of *The Gold of the Gods*, von Däniken admitted to two editors of the German periodical *Der Spiegel* that he had never

And in *Chariots of the Gods?*, von Däniken claimed that the lines in general 'could also have been built according to instructions from an aircraft'.

He has been forced to back down on many other points, too. With regard to the non-rusting pillar at Meharauli, India, for example, which he misdated and wrongly described, he later admitted in an interview in *Playboy* magazine: 'When I wrote *Chariots of the Gods?*, the information I had concerning this iron column was as I presented it. Since then, I have found that investigations were made and they came to quite different results, so we can forget about this iron thing.'

Another classic case is the question of the secret systems of tunnels beneath the mountains of Ecuador, containing mysterious treasures of prehistoric artifacts and a 'library' of metal plates, inscribed with records of a visit by 'space gods'. A description of these supposed relics forms the centrepiece of von Däniken's *The Gold of the Gods*.

Erich von Däniken, top, is undoubtedly the most celebrated of all 'ancient astronaut' theorists.

The cave drawing from Soledad in the Baja peninsula of Mexico, above, is said to show a flying saucer, belching flames from its underside. Some believe it constitutes evidence of a visiting spacecraft in ancient times.

The candelabra 'tree of life', above Pisco in Peru, left, is a mysterious set of lines that some people say point towards Nazca about 120 miles (190 kilometres) away. One view, however, is that it is a 19th-century navigational aid.

even been to the part of Ecuador in question though he had done some underground exploring 60 miles (100 kilometres) away near the town of Cuenca. And in his *Playboy* interview, he admitted that the dramatic details of his adventures in the tunnels were largely imaginary, but excusable on grounds of 'author's licence'. Meanwhile, Moricz stated categorically in an interview that 'Däniken never set foot in the caves... If he says he personally saw the library and the other things, he's lying.' Moricz claims to have merely shown von Däniken a side-entrance to the tunnel network. 'You couldn't enter the cave . . . it's blocked', he said. As for the treasures, Moricz said these were photographed by von Däniken in a local museum, 'but most of the contents are junk'.

But though he stated he showed nothing of importance to von Däniken, Moricz actually began legal proceedings against him, demanding a percentage of von Däniken's royalties for illegally publicising his own discoveries.

Von Däniken still claimed in the *Second Look* article: 'What I have said in *The Gold of the Gods*

about these underground caves is all true'. He insisted that he saw the metal library with his own eyes and, according to his biographer Peter Krassa, he knew intuitively that the tunnels contain the proof of his theories.

PAUCITY OF EVIDENCE

Despite the claims put forward in *The Gold of the Gods*, and in numerous interviews and articles, no one has yet produced the slightest scrap of evidence that there is anything 'extra-terrestrial' about the supposed discoveries. Even if the tunnels are artificial – though a local geological authority thinks they are natural formations – and even if they do contain gold objects and a mysterious library with an undeciphered script, what does this prove? Von Däniken repeated Moricz's assertion that the library might contain a synopsis of the history of humanity, as well as an account of the origin of mankind on earth and information about a vanished civilisation'. But neither von Däniken nor Moricz claims to have deciphered a single letter of the script. And far from producing any relics manufactured by an unknown alien race, all the objects displayed as spoils of the caves are rather unsophisticated-looking objects of tin and brass (not gold) that could be made by any competent smith. Yet *The Gold of the Gods* announces the evidence from the tunnels as 'the most incredible, fantastic story of the century'.

Small wonder, then, that von Däniken's critics have often labelled him a fraud. But despite the numerous instances where von Däniken has been shown to have fudged his facts, sometimes on his own admission, millions of his readers still feel convinced by the bulk of the evidence in such books as *Chariots of the Gods?*, and the similar arguments put forward by other writers in books like it. What about incredible building feats, such as the pyramids of Egypt, Tiahuanaco in Bolivia, Sacsayhuaman in Peru, and the huge idols of Easter Island? Or the electric dry batteries and crystal lenses from ancient Mesopotamia, the intricate astronomical calculator found off the coast of Greece at Antikythera, or the massive stone spheres of

The Piri Re'is map, dated 1513, above, is said by von Däniken to show mountains in Antarctica – centuries before they were discovered by Europeans – buried deep under snow and ice. Von Däniken said the map is based on aerial photographs. But cartographers have pointed out that the map in fact holds few mysteries and is a noticeably inaccurate compilation of several different charts.

almost perfect construction, scattered in the jungle of Costa Rica? Von Däniken may have made crass mistakes, but it could be argued that the mythologies of the world suggest that 'gods' did once visit the Earth. Indeed, perhaps such technological feats prove that extra-terrestrial intelligence was once at work on our planet after all.

❚❚VON DÄNIKEN ASSURED HIS PUBLIC THAT HE HAD PLENTY OF HARD PROOF THAT EXTRA-TERRESTRIALS HAVE VISITED AND DEPOSITED PHYSICAL SIGNS OF THEIR PRESENCE ON EARTH ... REPRESENTATIONS OF SPACEMEN, ROCKETS, AERIALS, AND EVEN HEART TRANSPLANTS...❚❚

The lines at Nazca, Peru – such as those shown left – are still a focus of controversy in the debate about visitations to Earth by beings from outer space.

FOR MOST PEOPLE, A VISIT TO THE DENTIST MEANS STARK WAITING ROOMS, THE SOUND OF THE ELECTRIC DRILL AND THE TASTE OF ANTISEPTIC MOUTHWASH. BUT FOR PATIENTS ATTENDING FOR PSYCHIC DENTISTRY, THINGS COULD BE RATHER DIFFERENT

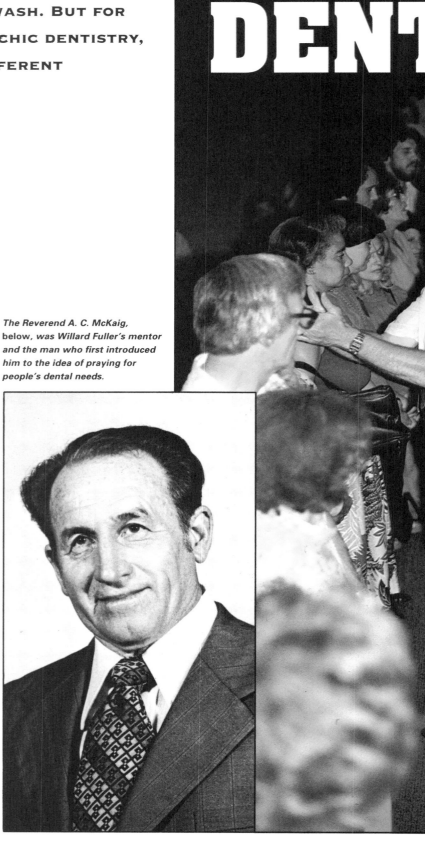

**PSY
DENT**

O f all the healing gifts, that of psychic dentistry is surely the most bizarre and the most difficult to explain. The few mediums who practise it are said to be able to mend bad teeth instantly with gold, silver or porcelain fillings that materialise in their patients' mouths. Sometimes, it is claimed, new teeth even grow where previously there had been only blackened stumps.

Such astonishing statements have their share of critics: even many believers in the paranormal treat psychic dentistry with some suspicion. But few who witnessed evangelist Willard Fuller at work remained sceptical. He is even said to have produced 'mouth miracles' in over 25,000 patients.

Fuller, an American, graduated in business administration and gained a degree in electrical engineering before the Baptist Church beckoned. Then, with another degree under his belt, this time in theology, he set out to travel across the United States. For 10 years, he preached as an evangelist for the Baptist Church.

Two things then happened that were to alter his life radically: he was excommunicated – he claimed, for asking too many questions – and, at about the same time, he went through what the old-time Pentacostalists called a 'baptism of the Holy Spirit'. Shortly afterwards, in response to his calling, he embarked on a healing mission.

To begin with, he practised spiritual healing that was no different from any other. But what started out as simply the laying on of hands was to develop into something quite extraordinary when Fuller met up with A. C. McKaig. Fuller already knew of this man who prayed for people's 'dental needs', with the frequent result that their cavities were miraculously filled. So, when he heard that McKaig was preaching in Shreveport, Louisiana, he had no hesitation in going along in order to witness the service for himself.

Fuller watched with growing excitement as the healer treated a variety of illnesses; but the best was yet to come, for McKaig had saved his dental treatments until last. One of those in the audience was a woman who had never visited a dentist in her life. She had a cavity that badly needed attention. Fuller watched as McKaig placed his hands on the woman's head and prayed for God to help her. The healer then gave her a torch and a hand-mirror so she could look inside her own mouth. As she examined her tooth, she gave a shriek of delight. 'It has silver in it!' she shouted. Fuller was standing nearby. He rushed over to the woman and peered at the filled tooth. 'It was bright, shiny and looking like a newly-minted coin,' he declared.

The Reverend A. C. McKaig, below, was Willard Fuller's mentor and the man who first introduced him to the idea of praying for people's dental needs.

HIC
STRY

The 18th-century drawing, below, shows a tooth being pulled and the patient's neck simultaneously being put out of joint. Fortunately, things have changed since then: but a visit to a conventional modern dentist's surgery, bottom, can still fill many people with undue terror.

Further such miracles were to follow as McKaig treated a stream of people, but one of the strangest happenings was reserved for Fuller himself. Abruptly, McKaig turned to him, pointed and announced: 'Now I am going to pray for you and ask God to bless you'. The healer was a small man and he had to mount a two-step platform in order to be at Fuller's height. The scene may have looked incongruous enough, but the results were apparently immediate and dramatic. God, says Fuller, spoke

to him in the following words, words he has never forgotten: 'Think it not strange, my son, all the things that thou has seen me do through him, this, my servant. For all the things that thou hast seen me do through him, I shall do through thee, and greater things I shall do through thee than thou hast seen me do through him.' It was enough to inspire Fuller and set him on the road to psychic dentistry.

Fuller admitted that it took some time before he found the courage to introduce it into his own healing services, since he was concerned as to whether it worked for him the way it had worked for his mentor. When he finally met the challenge, by treating a young man for a cavity, he was overjoyed to discover that he did indeed possess the power to heal. After that first tentative beginning, Fuller did not look back.

Bryce Bond, an American writer and healer, witnessed the psychic dentist at work. As he explained: 'Fuller's technique is simple. He gently smacks the person on both cheeks at the same time and says: "In the name of Jesus, be thou whole".' It is believed possible that the moment of intense belief is able to produce a spiritual alchemy in which gold, silver or porcelain take shape inside the patients' mouths. It may seem unlikely, but there are many prepared to testify that they have seen it taking place.

Those who have witnessed a filling form describe it as a small, bright spot that becomes larger until it fills the whole cavity, rather like a speeded-up picture of a rose blooming. The British psychic Matthew Manning endorses this description.

Patients would queue up to see Willard Fuller, shown left, in action. Techniques involved smacking the patient on both cheeks – the only painful part of an otherwise pain-free experience.

When he attended one of Fuller's healing sessions in New York, Manning was cynical to begin with; but, once he had witnessed the phenomenon at first-hand, he felt convinced enough to declare the treatment 'absolutely genuine'. He reported what he saw to *Psychic News:* 'One woman had at the back of her jaw a very decayed tooth which was black. I saw it fill with something white which appeared to be a kind of ceramic substance. When finished, she had a new white tooth. Several people were peering into the woman's mouth. The substance came from her gum. I saw this happen.'

Few doctors, however, were prepared to take Fuller's claims seriously, though some witnessed his sessions for themselves. Scientists employed by NASA at Cape Kennedy were among a group who received dental healings during a meeting in Miami, Florida, and doctors were present among the 400 witnesses who attended a demonstration at Wagner College, Staten Island, New York. One

substance; others talk of a platinum-coloured metal being used. But neither substance has been subjected to scientific analysis.

Fuller took time off from his ministry to train another psychic dentist, Paul Esch. Bryce Bond also investigated Esch's abilities and described his skills as nothing short of 'a miracle'. Of one meeting he attended in Woodstock, New York – a year before he encountered Fuller – Bond said: 'One of those present had a few empty spaces in her mouth, she tasted blood, then a tooth broke through the surface of the empty gum. Almost all those present noticed their teeth became whiter.'

Apparently, certain members of the group received two or three gold fillings. The sessions are very similar to Fuller's. Bond went on to say: 'The only way to believe it is to see it happen first-hand.' Perhaps he should have also added that the only way to see it happen is to *believe* it could happen, since faith is said to play a large part in both psychic dentistry and healing generally.

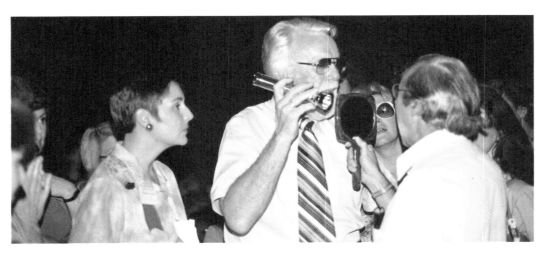

Fuller is shown, left, shining a torch into a patient's mouth, while the patient examines his new 'miracle' filling. Fuller's wife, looking on, seems as surprised as anyone.

Fuller would use none of the paraphernalia of the modern dentist, but carried the tools of his trade around with him. A look inside his briefcase, below, reveals that his only concession to technology is a battery for use in his torch.

Swedish doctor, however, was prepared to speak out. Dr Audrey Kargere from the Humanist College, Stockholm, was 'highly elated' when several of her silver fillings were transformed to gold. She also benefited from Fuller's more conventional healing, which resulted in her badly swollen leg returning to normal very rapidly. Peter Williams was another doctor at the same session. He was said to have been delighted, but baffled, when a blackened tooth was transformed to 'bright, shiny gold'.

MYSTERIOUS SUBSTANCES

According to Bryce Bond, it was not even necessary to ask for Fuller's help to benefit from the healing; it was enough to be present at one of the meetings. During the session he attended, he did not volunteer for psychic dentistry. Despite this, throughout the meeting, he was aware of a tingling in his gums, followed by numbness. Later, he discovered small pieces of tartar (the hard chalky deposit that the dentist scrapes off during a routine clean up) had become dislodged, and he was able to pick the small granules off his tongue.

Apart from claims that silver fillings have turned to gold, less conventional materials have sometimes been said to fill the cavities. Some witnesses claim seeing teeth filled with a translucent ruby-like

SEX, SIN AND SACRAMENT

THE SEX DRIVE HAS BEEN EXALTED BY SOME

OCCULTISTS, EVEN BECOMING THE INSTRUMENT

AND OBJECT OF CERTAIN MAGICAL PRACTICES

There has always been a curious ambivalence in occult attitudes towards physical sexuality. Thus some occultists and psychics have looked upon any and every sexual feeling or activity as pertaining to mankind's 'lower nature'. According to this school of thought, absolute chastity – purity

In the engraving above, a virgin is prepared for sacrifice during a black mass, with the goat-horned figure of the 'priest' representing the Devil in the background.

in thought, word and deed – is an essential prerequisite for spiritual advancement. Typical of those who hold this viewpoint was the medieval compiler of *The Sworn Book of Honorius*, a textbook of ritual magic, who solemnly advised his readers to 'be penitent and truly confessed of all sins, forbearing all female enticements . . . for it is better to live with a bear or a lion in its den than live with a woman'.

Other occultists and mystics have adopted a diametrically opposite point of view, regarding sexual activity as an authentic sacrament – 'the outward and visible sign of an inward and spiritual grace'. Such a sacramental use of sexual intercourse can supposedly be employed as a means of acquiring occult power and, at its highest, may lead to the ultimate goal of a mystic union with the divine, so it is said.

Among those mystics who have believed this are the 16th-century writers Cornelius Agrippa and Aratus. The former described copulation as 'full of magical endowment', while Aratus claimed that:

'As the physical union of man and woman leads to the fruit from the composition of each, in the same way the interior and secret association of man and woman is the copulation of the male and female soul, and is appointed for the production of fitting fruit of the divine life.'

ALCHEMICAL CONNECTIONS

Sexual symbolism was in common use among alchemists and some of them interpreted such symbolic phrases as 'the marriage of the Red King and the White Queen' not only chemically but also sexually. Some went so far as to attempt to manufacture the Philosopher's Stone – the mysterious substance that would transmute base metal into gold – from human semen. Thus 18th-century German records, quoted by Christopher McIntosh in his historical study of Rosicrucian societies, tell of an alchemical group that engaged in experiments of this sort. The leader of the group, an officer of high rank in the Austrian army, collected the raw material for this curious research by paying soldiers to masturbate.

The experiment ended in disaster. The soldiers under the officer's command were so enthusiastic to supplement their meagre pay that they neglected their military duties in order to engage in almost incessant masturbation. Eventually, the regimental surgeon became aware of what was going on. The alchemical officer was reported to his commanding general and dismissed from the service. And to add insult to injury, the alchemists failed in all their attempts at transmutation.

Neither a ludicrous episode such as this nor the occasional confidence trickster who uses mysticism and the occult as an excuse to engage in sexual fun and games should be taken as an indication that all who believe sex to be capable of leading to authentic religious experience are mad or perverted.

In the West, there has always been a complex inter-relationship between religion and magic on the one hand and human sexuality on the other. Almost all mystical symbol-systems, from astrology to the Tarot, have been given sexual interpretations. Even *The Bible* has been subjected to the same treatment by some commentators. Eliphas Lévi, for

other magicians. Those who hold this theory point out that poltergeist activity is usually associated with a disturbed adolescent who is unable to 'earth' his or her sexual energies with a partner of the opposite sex. The occult writer Benjamin Walker has gone so far as to claim that:

'Psychic researchers have repeatedly established that the centre of poltergeist activity is often a persistent masturbator, and they believe it possible that the biomagnetic energy drawn by the poltergeist is obtained during the release of sexual tension, when the masturbator reaches his or her climax. Excessive masturbation... has also been cited as the reason for other unexplained psychic occurrences... '

❚❚ SOME OF THOSE OCCULTISTS AND PSYCHICAL RESEARCHERS WHO ASSERT THAT THE SUBTLE FORCES OF THE SEANCE ROOM AND THE SEXUAL CURRENTS OF THE LIBIDO ARE MANIFESTATIONS OF ONE MYSTERIOUS ENERGY ALSO BELIEVE THAT IT CAN BE TRANSFERRED FROM ONE PERSON TO ANOTHER. ❚❚

instance, believed that the fall of Man, as described in *Genesis,* was sexual in nature: indeed, the 'original sin', which laid a perpetual curse on humanity, was seen as being Adam and Eve's first coupling. Madame Blavatsky, founder of the Theosophical Society, went even further: according to her, the first five books of *The Bible* are 'the symbolical narrative of the sexes, and an apotheosis of phallicism'. By 'phallicism', she meant the worship of the male sexual organ as a manifestation of the divine.

The potency of sex is the theme of Satana, above, engraved in 1896 by the artist Fidus who worked in Berlin. The woman is alluring, yet also strangely menacing, and the man seems to be in torment. His pose is somehow reminiscent of the crucifixion, and the title of the work makes an explicit link with magical sexual ritual.

UNMENTIONABLES

Unlikely as Madame Blavatsky's assertion may seem, there could be a modicum of truth in it. Some students of the *Talmud,* the lengthy compilation of ancient Jewish commentaries, would agree. According to them, the 'Ark of the Covenant', the holy chest made of acacia wood that the Israelites carried during their long wanderings and eventually placed in the Temple in Jerusalem, contained a sacred stone carved in the shape of the conjoined male and female sexual organs. There would be nothing particularly surprising in this, for similar objects have been venerated by many cults. The ancient Greek 'mysteries', or initiation rituals, carried out at Eleusis, for instance, involved a rite called 'carrying things not to be mentioned'. The unmentionable things in question seem to have been a stone model of an erect penis and a hollow stone, symbolising the womb of the goddess Demeter, who ruled over agriculture and fertility.

Some occultists believe that a mysterious psychic energy produces all the phenomena of the seance room, from table turning to spirit materialisation, and is, at root, identical with the energies that find their outlet in sex. It is the 'orgone' of Wilhelm Reich, the 'Od' of the 19th-century mesmerists, and the 'astral light' of Paracelsus and

The marriage of the Red King and the White Queen, right, from Splendor solis, a 16th-century manuscript by Salomon Trismosin, represents conventionally the combination of sulphur (male) and mercury (female). The Philosopher's Stone, which was believed to transmute base metals into gold, was said to be born of this union. Some alchemists interpreted such symbolism quite literally, and regarded sexual activity as necessary to the making of the elusive Stone.

Many occultists have interpreted the eating of the fruit of the Tree of Life – as depicted in an illustration from the Flemish Book of Hours, left, dating from around 1500 – as Adam and Eve's first sexual coupling.

17th-century poltergeist known as the drummer of Tedworth were on at least one occasion accompanied by a 'mysterious sulphurous smell', which 'those present found very offensive'. No such smells were reported by those who witnessed the Amherst hauntings: perhaps there were none or, more likely, Victorian sensibilities prevented them from being mentioned.

These allegedly paranormal happenings were almost certainly triggered by an experience undergone by Esther on 28 August 1878, exactly eight days before the supposed poltergeist first manifested itself. It involved Esther's boyfriend, a certain Bob McNeal.

It is probable that for some time Bob had been making overt sexual advances to Esther; for on the night of 27 August, she had a nightmare, replete with Freudian symbolism, clearly expressing the girl's fear of male sexuality. In this dream, all Esther's relatives had been magically transformed into huge bears with red eyes. When she opened the front door of her home, she was horrified to see hundreds of black bulls, blood dripping from their muzzles, converging on the house. She slammed the door shut and bolted it, but the bulls continued their advance, butting their huge horns against the house. The building shook under the concerted assault, and then Esther awoke.

On the evening of the day following this ominous dream, Bob McNeal took Esther for a drive in a two-seater buggy, which he had borrowed or hired. They drove together into the surrounding wooded countryside. Bob reined in the horse and began to make amorous advances to Esther, urging her to walk into the woods with him. When she consistently refused – it would seem that she was prepared to indulge in a little light petting in the

Whether or not excessive masturbation can be productive of psychic happenings, there seems little doubt that at least some outbreaks of poltergeist activity are triggered by sexual mishaps or unhappy and complex emotional involvements. Take, for example, the so-called 'great Amherst mystery' – the poltergeist haunting that astonished the inhabitants of Nova Scotia, Canada, in the autumn of 1878. It centred on 18-year-old Esther Cox. 'Esther Cox you are mine to kill', said writing that mysteriously appeared on the wall of the girl's bedroom. The haunting featured just about every type of poltergeist activity, from outbreaks of fire and stone-throwing to Esther's stomach swelling to enormous size. This last effect was presumably the result of swallowing air, or some internal fermentation, for she reverted to her normal shapeliness after 'a loud report, like a clap of thunder but without any characteristic rumble'. This must have been one of the noisiest poltergeist bangs ever, for Esther's mother leapt to the conclusion that her home had been struck by a meteorite and rushed to the bedroom of her youngest children to see if all was well with them. She found them sleeping peacefully and the house undamaged.

If, as seems likely, the poltergeist's 'thunderclap' was Esther breaking wind with immense vigour, one is forced to consider the possibility that the knocks, bangs and drummings associated with poltergeists sometimes have a similar origin. It is perhaps significant that the noises made by the

Ancient Greek mysteries involved the carrying of so-called unmentionable objects, such as the phallic figurine, above left, dating from before 2000 BC. The plaque, left, dates from the fourth century BC and depicts rites of initiation into the cult of Demeter, goddess of agriculture, and Persephone, her daughter. In the centre is an omphalos, a rounded rock representing the navel of the world; and below it are ritual objects, strongly suggestive of male and female sex organs.

buggy but nothing more – McNeal lost his temper. He pulled out a pistol, pointed it at the girl's head, and ordered her to accompany him into the woods. She still refused, and for a moment it seemed that McNeal would shoot her dead. Fortunately, however, another vehicle approached, the alarmed McNeal pocketed his pistol, snatched up the horse's reins, and drove Esther to her home. That night, he left Amherst, presumably in fear of being charged with attempted rape, and was never heard of again.

In a sense, however, he remained with Esther for many years. The sexual cravings and fears that McNeal had aroused seem to have built up in Esther a pressure of psychic energy – a sort of

Hereward Carrington, psychical researcher, right, traced and interviewed Esther Cox, a famous poltergeist victim who, many years before, had been plagued by disturbances at her home, below right, in Amherst, Nova Scotia. The house was almost wrecked by some of the outbreaks. Carrington found that the phenomena had not in fact recurred since Esther's marriage – possibly due to release of her sexual energies.

impending libidinal thunderstorm. Failing to find an outlet in the ecstasy of orgasm, it is thought to have powered the spontaneous combustions, levitations and other psychic wonders that astonished the citizens of Amherst.

Many years later, Hereward Carrington, the psychical investigator, traced and interviewed Esther, by then married and living in the United States. She was reluctant to talk about the past, but made a most significant admission. From the day of her wedding, she said, 'the power' had left her; she was again a stranger to the paranormal.

Some of those occultists and psychical researchers who assert that the 'subtle forces' of the seance room and the sexual currents of the libido are manifestations of one mysterious energy also believe that it can be transferred from one person to another. In this way, so it is suggested, the old can, accidentally or by design, draw in the life force from a younger person for their own benefit.

The use of this curious psychic technique has a long history. It is often called 'Shunamitism', a term that is derived from an incident recorded in the *Old Testament*:

'Now King David was old and stricken in years... he gat no heat. Wherefore his servants said unto him, "Let there be sought for my lord the king a young virgin... and let her lie in thy bosom, that my lord the king may get heat". So they sought for a fair damsel throughout all the coasts of Israel, and found Abishag, a Shunammite, and brought her to the king. And the damsel was very fair and cherished the king, and ministered to him... '

Abishag regularly slept with David, so it is said, but did not have sexual intercourse with him, for this would have 'earthed' the life force and frustrated their intention.

// LATIN HISTORIANS RECORD THE REMARKABLE CASE OF L. CLAUDIUS HERMIPPUS. WHEN HE REACHED THE AGE OF 70, HE BEGAN TO FEEL A WANING OF HIS PHYSICAL AND MENTAL POWERS. HE IMMEDIATELY BEGAN TO SLEEP WITH YOUNG VIRGINS – THOUGH WITHOUT SEXUAL ACTIVITY. HIS TOMBSTONE RECORDED THAT HE LIVED TO BE 115, OWING TO THE EMANATIONS OF YOUNG MAIDENS. //

Barbarossa (Frederick I of Germany), above, revived his failing energies by bodily contact with young boys. The cure may have been surprisingly successful: legend even has it that he did not die but merely sleeps. King David's tonic, right, meanwhile, is said to have been the embrace of Abishag.

The same technique was used in classical Greece and Rome, seemingly with considerable success. Latin historians record, for example, the remarkable case of a certain L. Claudius Hermippus. When he reached the age of 70, he began to feel a waning of his physical and mental powers. He immediately began to sleep with young virgins – though, like King David, without sexual activity. His tombstone recorded that he lived to the age of 115, owing to 'the emanations of young maidens, causing great wonder to all physicians'.

Many European rulers of the Middle Ages practised Shunamitism, sometimes in a homosexual variant. Thus, the Emperor Barbarossa held young boys against his stomach and genitals in order to 'savour and absorb their energy'; and Pope Innocent VIII, the immediate predecessor of the Borgia pope, Alexander VI, employed healthy young children to stroke him and thus transfer their more youthful energy to him.

Some physicians of the time held that this life energy was strongly concentrated in youthful blood; and Ficino, a Platonic philosopher who also practised medicine, even suggested that vampirism should be employed by those enfeebled by age. The old, he said, should drink fresh blood drawn from youthful veins 'after the manner of leeches'.

Shunamitism survived into the 18th century and, in both Paris and London, was practised on a commercial basis. For example, a certain Madame Janus of Paris owned a successful establishment that at one time was reputed to give employment to over 40 virgins. A client's course of treatment lasted for three weeks. Each night, he was given a 'magical bath' containing herbs, then massaged with aromatic oils, and finally tucked into bed between two virgins, one blonde and one brunette. The treatment was, of course, expensive and had to be paid for in advance. In addition, Madame Janus insisted that each client deposit a substantial sum of money with her. This was to be forfeited by any

man who was so rejuvenated that he deflowered one of his sleeping partners.

A similar establishment, the 'temple of Aurora', was conducted in London by Mrs Anna Fawkland, whose clients were reputed to include elderly aristocrats, such as Lords Buckingham and Cornwallis.

A belief in the efficacy of this almost vampire-like technique for acquiring psychosexual energy was also among the strangely assorted articles of faith of Heinrich Himmler, sinister chief of the Nazi SS. Himmler, as well as carrying out his unpleasant duties with dry efficiency, spent much time thinking about such unlikely problems as the mystic symbolism of Gothic architecture and 'the occult significance of the Etonian top hat'. In 1940, he became concerned about the number of Luftwaffe pilots who died from exposure after parachuting into the North Sea. He decided that, if such pilots were picked up while still alive, they would probably recover if they were placed between the bodies of naked girls. To test this hypothesis, SS physicians carried out a series of cruel experiments in which concentration camp inmates were placed in tanks of freezing water until they became unconscious and were then put to bed between naked girls.

The efforts of the women revived several victims to a point at which they achieved coitus. But this depraved parody of Shunamitism did not lead to a higher recovery rate overall than did orthodox methods of warming the experimental subjects.

COULD THE DISAPPEARANCE OF NUMEROUS SHIPS AND AIRCRAFT BE DUE TO A SINISTER FORCE IN THE WATERS OF THE GREAT LAKES OF NORTH AMERICA? OR IS THERE A MORE STRAIGHTFORWARD EXPLANATION?

Of all the mysterious paranormal – and generally elusive – phenomena that appear around the Great Lakes of North America, one curiosity appears regularly for all to see. It is the 'Three Sisters' – the trio of giant waves that travel with all-engulfing force, suddenly and without warning, across the tranquil surfaces. The local Chippewa Indians believed that this phenomenon was caused by the stirrings of a gigantic sturgeon; but modern locals call it the *Seiche* – pronounced 'sesh' and derived from Swiss French, for it also occurs on Lake Geneva.

On 26 June 1954, a *Seiche* wave struck the coastline of Lake Michigan between Whiting, Indiana, and Wakegan, Illinois, devastating property, sweeping 50 people into the water and drowning eight of them. Most of the victims were fishing on the shore, and survivors said that they had no inkling of disaster until the 10-foot (3-metre) roller appeared and crashed over them. In his book *The*

The freighter **Mataafa**, *bottom, sank in shallow waters within sight of the harbour of Duluth, Minnesota, USA, in the 'blow' of 1905; the wooden freight and passenger steamer* **Chicura**, *below right, disappeared on Lake Michigan on 21 January 1895; and the whaleback steamer* **Samuel Mather**, *below, was lost on Lake Huron on 22 September 1924.*

Great Lakes Triangle, author Jay Gourley describes how such a wave overtook and sank the *James E. Davidson*, a 6,000-tonne grain carrier on Lake Superior. Gourley asks: 'What force was behind the strange devastating wave? From where did it come? What power generated it? How could it be so accurately directed as to send a perfectly seaworthy ship to the bottom?'

These are fascinating questions indeed; but, apart from Gourley's implication that the wave was 'directed' by some intelligent power, they are readily answered by meteorologists, although even they seem uncertain as to the precise physical laws that govern the raising of *Seiche* waves. Generally speaking, they are long rollers that occur in the relatively shallow waters of a lake, bay or harbour, although they can sometimes travel across the Atlantic Ocean, building up in the relatively shallow areas of continental shelves. They vary in height from 3 or 4 inches (8 or 12 centimetres) to 30 feet (10 metres) and more, and they may be generated by a variety of atmospheric disturbances, high

GREAT LAKES MYSTERIES

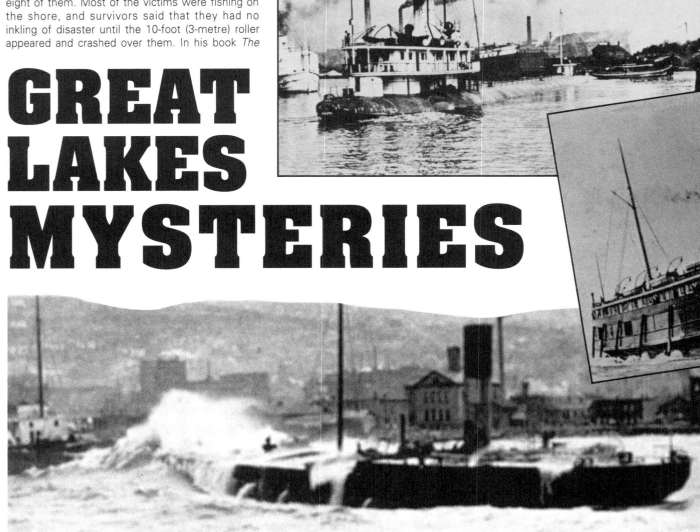

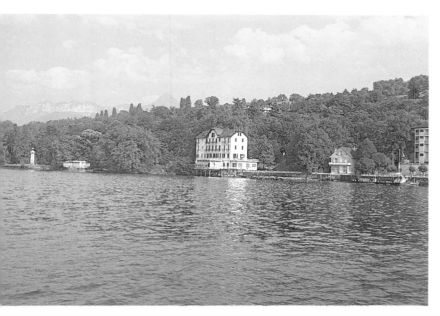

These are, of course, generalisations. Navigation is a complicated business, but these examples do give an indication of what may have happened to several of the vessels cited by Gourlay, and also by Hugh F. Cochrane in his *Gateway to Oblivion,* as having 'mysteriously' disappeared.

The two American sailing frigates, *Scourge* and *Hamilton,* that rolled over together on their way down Lake Ontario to Niagara in 1812 and sank, show all the signs of having being broached by a *Seiche* wave. They were sailing in calm weather and light airs, so they probably had topsails and royals – the uppermost square-sails on a sailing ship – set. Many a small boat has been rolled right over and set upright again by a beam sea – waves rolling against the vessel's side. The late Sir Francis Chichester reported that this happened to his *Gypsy Moth IV* on his voyage around Cape Horn. The spread of canvas on the upper masts of the two frigates, however, would prevent any tendency the ships had to right themselves, and they would sink.

BOW WAVE DISASTER

In the case of the tug *Sachem,* which sank in calm weather outward-bound from Buffalo in 1950, a bow wave would seem to be the likeliest cause of the disaster. She was found on the bottom of the lake with her engine controls in a 'stop' position and her bridge windows broken in. It seems likely that the officer on watch, seeing the 'Three Sisters' travelling head on towards him, rang up 'stop engines' on the engine-room telegraph before the wave engulfed the tug and drove her to the bottom, smashing the bridge windows in the process. It is possible that if he had rung up 'full ahead', the *Sachem* would have weathered the impact.

Strangely, Gourley makes a mystery of the case of the *Edmund Fitzgerald* when the facts show that there is little or none. A report in the *Buffalo Evening News* states that winds of over 90 miles per hour (140 km/h) were blowing, and the

It is from an all-engulfing trio of waves that occasionally appear on Lake Geneva, above, that the dreaded Seiche wave of the North American Great Lakes gets its name.

winds, or even small seismic stirrings in the bed of the lake itself.

Although the Great Lakes are vast in area, they are surprisingly shallow, varying in average depth between 200 and 600 feet (60 – 180 metres), with only Lake Superior plummeting to occasional depths of 1,300 feet (400 metres). This lack of depth means that strong winds can quickly whip up the lakes' surfaces to the violence and destructiveness of Atlantic storms. In summer, they are unpredictable. In winter, however, they conform to a pattern of behaviour that rarely varies. In November, they are lashed with violent winds and spume-topped waves before icing over, making shipping movement feasible only when the coastal regions are cleared by ice-breakers. And in April, as the ice melts, the storms rule the waves until the six-month season of deep-water navigation begins once more.

HAZARDOUS WATERS

In view of these *Seiche* waves and the regular storms on the Great Lakes, the occasional disappearance of shipping becomes somewhat easier to understand. In navigation of any kind, whether by sailing ship or by motor vessel, the ideal is to keep the ship's head into the wind and weather, 'beating to windward'. In foul weather, this is generally the safest course a sailing ship can pursue. The two most dangerous points of sailing are 'running' and 'reaching': in the former, the wind is 'abaft the beam' – that is to say, blowing from the direction of the stern – and in the latter, the wind is blowing against the side of the ship, tending to make her heel over. On enclosed waters, such as the Great Lakes, the waves tend to run in the same direction as the wind, making sailing doubly hazardous; for if a vessel presents her beam to the waves, she is likely to 'broach to' or roll dangerously in the trough of the seas between the waves, while if she is running before a following sea that is moving faster than she is, she may be 'pooped' – that is, the following sea will break over her stern, engulfing her. The same thing is likely to happen if she stops dead with her head to a breaking sea.

Sir Francis Chichester is seen right, aboard Gypsy Moth IV at the end of his epic 28,500-mile (48,000-kilometre) journey round the world in 1967. Near Cape Horn, Gypsy Moth IV was apparently turned right over and set upright again by waves rolling against her side. The same phenomenon may have scuppered many a heavier vessel on the Great Lakes.

November gales had raised waves of 25 feet (8 metres). The freighter was over 700 feet (210 metres) long, with a 26,000-tonne cargo of iron ore, and her captain reported that water had shipped into the hold amidships shortly before she 'disappeared'. If the labouring vessel had been caught with 25-foot (8-metre) waves at bow and stern and a trough in the middle, there is surely little wonder that she was sliced cleanly in two.

The disappearance of aircraft in the Great Lakes area becomes equally understandable when taken in conjunction with the freak weather conditions prevalent locally. Sudden fogs have always been a feature of the peculiar atmospheric conditions, and these may freeze very quickly in the bitter winter months. Paul Cena, a professional pilot who flies regularly in the Great Lakes area, reported in the US journal *Skeptical Inquirer* in the summer of 1982:

'It is foolish for a pilot to fly over a body of water as large as any of the Great Lakes [in a light aircraft] ... even though engine failure is rare, if it should occur, the pilot would have to make a water landing. In a plane not equipped with floats, this is dangerous to say the least. During my flight instruction, I was told to fly around a lake, not over it.'

NEAR-MISSES

In calm conditions, it has been estimated that a small, light aircraft will float on water for an average of 30 seconds; but in any kind of rough water, the sinking time is much reduced and a damaged aircraft, coming down in an uncontrolled dive, will of course sink on impact. Cochrane mentions at least two instances of light aircraft found with their wings 'sliced' off, but this may not, in fact, be so very sinister – nor even remarkable. Many Great Lakes pilots report near-misses with flocks of birds, particularly heavy birds such as the Canadian wild geese that inhabit the coastal zones; and a collision at full speed with one of these could cause extremely severe damage to the flimsy metal skin of a small aircraft.

Even if a pilot manages to bail out or make an emergency landing, the danger is not over. Much of the shoreline of the lakes is rough and wild. In one stretch of bushland on the north side of Lake

The bodies of sailors washed up on the shores of Lake Ontario are buried in the graveyard shown above in Prince Edward County, Ontario, Canada.

Aircraft pilots have often reported near-collisions with flying birds – such as those below – over the Great Lakes. It is easy to imagine how some of the mysterious accidents involving light aircraft in the area may actually have been caused by collisions with large birds like these Canada geese.

Superior, with an area of about 45,000 square miles (116,000 square kilometres), an average of 100 lives a year are lost. Most of the victims of this inhospitable terrain are hunters and fishermen, though small-boat sailors and pilots who have had to abandon their craft have swelled their numbers. In an interview with the *Toronto Sun*, Mac Nicholson, of a local search and rescue group of 250 volunteers, said: 'It causes a type of claustrophobia. Everything just closes in. Their minds go blank and they run themselves to exhaustion. They'll bull blindly through the thickest bush. The worst one I've seen, we had to put him into a straight jacket. He ran into the search line and we had to throw him down and hang on to him.'

Both Cochrane and Gourley mention cases of aircraft vanishing within minutes of reaching their destination without sending out a distress call of any kind. Again, a look at the facts offers a ready explanation for this. According to one issue of the US magazine *Plane and Pilot*, 'most... fatal stall/spins occur in the traffic pattern where chances of recovery are almost nil' – in other words, while the plane is circling the airport, awaiting permission to land. An inexperienced pilot may inadvertently let his air speed drop in such situations, thus precipitating a spin.

'Another cause of accidents,' writes Paul Cena, 'is simple pilot error. After a pilot has been flying for a while, he or she may become over-confident. Many accidents occur when a pilot doesn't... get a weather briefing or when a non-instrument-rated pilot is caught in instrument conditions. Pilot error leaves no evidence.'

Certainly, a pilot with instrument rating would not be unduly discomfited by fog.

Yet another regular mishap with aircraft around the Great Lakes is carburettor icing; the temperature of the carburettor can be as much as 70° F (21° C) colder than the outside air temperature, so that even on a warm day, carburettor heating has to be

So much for the most famous of the Great Lakes UFO stories. But what of the many other instances quoted by Gourley and Cochrane? Without examining each case in detail, it is fair to say that the majority have a number of factors in common: lights have been seen, usually alternately flashing red, green and white or golden. Sometimes, however, they take the form of red or white orbs that appear to wax and wane and, when viewed through binoculars, are seen to be in pairs. And the majority of instances have been seen in November, over water.

Every aircraft is required to carry navigation lights – a red light to port, a green light to starboard, and a white or golden light on the tail fin or on top of the fuselage. If a small aircraft is seen over the waters of a lake on a pitch black night with the possibility of reflections over the water, it needs little imagination to turn it into a UFO. But waxing and waning pairs of lights need a little more explanation: navigation lights do not vary in intensity.

switched on. In the winter over the Canadian border, delay can be instantly fatal.

Gourley, Cochrane, and J. Allen Hynek and Jacques Vallée, in their book *The Edge of Reality*, quote the case of the American F-94 Starfire jet, the pilot and radar operator of which were forced to bail out when their cockpit became 'superheated' while pursuing what they believed to be a UFO over New York State in July 1954. Donald Keyhoe, in his *Aliens from Space*, says: 'An F-94 Starfire was scrambled . . . when a gleaming, disc-shaped machine became visible, he started to close in . . . abruptly, a furnace-like heat filled both cockpits. . .'

The full story was told in dead-pan terms by the *Buffalo Courier-Express* two days after the incident. 'On a routine training mission . . . they were ordered by radio to investigate a third, unidentified airplane. They checked and found the plane to be friendly and started to return to their base... Fire broke out in the forward part . . . and the pilot and his radar operator parachuted from their red-hot cockpit at 7,000 feet [2,100 metres].'

" STRANGE OBJECTS CAPABLE OF SILENT YET INCREDIBLY POWERFUL ACCELERATION, MANOEUVRING HIGH ABOVE THE GREAT LAKES, HAVE BEEN WATCHED BY COMPETENT OBSERVERS. THEY OPERATE AS IF GUIDED BY AN INTELLIGENCE, RESEMBLE NO PUBLICLY KNOWN AIRCRAFT AND REMAIN UNIDENTIFIED. "

JAY GOURLEY, THE GREAT LAKES TRIANGLE

Vigorous UFO activity continues to be reported from the Great Lakes area. Many of the reports concern nocturnal lights – such as those, above, photographed in a time exposure over Toronto. They may be more easily explained, however, as aircraft navigation lights. But some are more difficult to account for: The picture, top, is said to be of light-absorbing UFOs, photographed over the western end of Lake Ontario.

In the early 1970s, a case of 'spook lights' was investigated near Joplin, Missouri, in the 'tri-state' area of the United States. Viewed through binoculars, the spooks appeared in pairs, seemed to bounce gently towards the observer before fading, and were often accompanied by smaller pairs of red lights. After careful investigation, they were proved to be the lights of traffic on the Creek River road, about 20 miles (33 kilometres) distant, refracted by freak conditions from the surface of the Spring River, a tributary of the Arkansas. There was, after all, nothing mysterious about them.

To be fair, each UFO case should be treated individually and investigated using the evidence available; but it seems reasonable to suppose that what happened in Joplin could – given the known eccentricity of the weather conditions – be duplicated over the Great Lakes. Sudden mists can play bizarre games with moonlight, which may account for certain 'sightings' made before the introduction of car headlights. Nature has certainly endowed Lakes Superior, Michigan, Erie, Huron and Ontario with a strange atmosphere. Meanwhile, the likelihood that they form a new mystery area with powers similar to those of the 'Bermuda Triangle' seems remote to some – to others, a distinct possibility.

IN TWO MINDS

SCIENCE HAS REVEALED THAT THE HUMAN BRAIN IS SPLIT INTO TWO – THAT, QUITE LITERALLY, WE ALL HAVE TWO INDEPENDENT BRAINS. WHAT ARE THE IMPLICATIONS OF THIS MOST EXTRAORDINARY DISCOVERY?

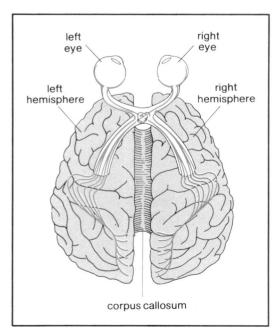

left eye

right eye

left hemisphere

right hemisphere

corpus callosum

One of the greatest achievements of the famous French mathematician Henri Poincaré (1854-1912) was the resolution of a difficult mathematical problem concerning what he called 'Fuchsian functions'. He says in his memoirs that he studied the problem diligently and logically for some time but failed to get a suitable answer. In the midst of intensive mathematical work on the problem, he took a short break to go on a geological excursion, where the excitement of the travel made him forget all about mathematics. So, with his mind full of geology rather than Fuchsian functions, he waited for the bus that was to take him on a field visit. The bus arrived – and suddenly, as he boarded it, the solution to his problem came to him in a kind of intuitive, unthinking flash. He was so confident that he had the right answer that he did not bother to verify his intuitive insight until he had returned from the excursion. His sudden insight, which turned out to be absolutely correct, had succeeded where logic previously had failed.

There are many instances in history of such 'flashes of insight' – many of them occurring in

SUBJECTIV

RESTORING THE BALANCE

Mysterious powers that lie hidden in our right brain may prove to be the origin of a whole range of experiences that defy rational explanation. Among them are a number of psychic abilities.

Water diviners, for instance, often dowse in a relaxed, almost trance-like state in which the left brain does not assert its dominance and the right brain can act freely. It is possible that the right brain even recognises the presence of water and causes the arm muscles to contract involuntarily, making the dowsing rod move. The involvement of the right brain in psychic abilities may explain, too, why phenomena

The abilities of the water diviner, left, and the subject of a Ganzfeld telepathy test, above, are thought to be controlled by the right brain.

like metal bending, telepathy and clairvoyance are so notoriously difficult to reproduce in the laboratory: the scientific environment of the laboratory may repress psychic abilities by actively accentuating the dominance of the left brain.

There is another startling possibility. Perhaps telepathy – apparently an elusive ability that surfaces only fitfully – is actually simply the way our right brains speak to each other. To restore the balance between left and right brains might therefore be to restore latent telepathic abilities.

PERSPECTIVES

ANALYTICAL

The brain, as shown far left, is made up of two distinct halves, linked by a 'bridge' of around 200 million nerve fibres that is called the corpus callosum. The left hemisphere controls most of the right-hand side of the body, while the right hemisphere controls most of the left-hand side. The two hemispheres have different cognitive functions: broadly, analytical functions occur in the left brain while intuitive functions occur in the right brain. The brain scans, left, were taken while the subject was listening to music. In the scan on the left, he is reacting intuitively and subjectively – and the neural activity is predominantly in the right brain. In the scan on the right, he is listening more analytically – and the main neural activity is seen to have shifted to the left hemisphere.

dreams – that suddenly provide a person who is worrying over some problem or other with the correct solution. What is especially interesting is that these insights often occur when the person concerned is not consciously thinking about the problem. It is as if, by 'letting go' and allowing itself to wander away from strictly logical thinking, the brain can somehow provide the answers.

So does Poincaré's experience, and others like it, mean that the brain can work in two distinct ways – either in a systematic, step-by-step way, or intuitively, without conscious control?

The answer, according to a growing number of physiologists and psychologists, appears to be 'yes': that is, our brain does seem to operate both logically and intuitively, and will oscillate between these two distinct forms of behaviour according to circumstances.

Work carried out by anatomists and neurophysiologists, who study the brain and its functions, supports this claim. Anatomically, we know that the human body is roughly bilaterally symmetrical. It is possible to draw an imaginary line through the middle of a person, bisecting the nose and ending between the feet and, with a few rather important exceptions – such as the heart – the right side of the body is seen as a mirror image of the left side. On a general anatomical level, this also holds true for the brain.

Looked at from above, the brain is made up of two cerebral hemispheres. Joining these two

hemispheres is a bridge that comprises about 200 million nerve fibres called the *corpus callosum*. This structure is one of several bundles of nerve fibres, linking equivalent centres on the two sides of the brain. Now, although each hemisphere of the brain appears to be the approximate mirror image of the other, this is not the case: when the hemispheres are examined more closely, profound differences emerge between the functions of the left and right sides.

There are, of course, other instances of seemingly symmetrical parts of the body that, although mirroring each other anatomically, are actually rather different functionally. The most obvious example is our hands: 90 per cent of people write using their right hand and are termed 'right-hand dominant'. In these people, the left hand is termed the 'minor' hand. The 10 per cent of people who write with their left hand are 'left-hand dominant'.

The two hemispheres of the brain also show this 'dominant-minor' distinction, but in this case, the left side of the brain is usually the dominant side (for 96 – 98 per cent of the population), the right hemisphere taking the 'minor' role.

It may seem curious at first that, although the left hemisphere of the brain is dominant, it is the right hand, in most people, that is dominant. But there is a straightforward anatomical explanation: in the hind-brain (the rearmost part of the brain, continuous with the upper end of the spinal cord), many bundles of nerve fibres 'decussate' (cross over) from right to left, and vice versa. This decussation of fibres is responsible for the fact that the left side of the brain generally controls the right side of the body, and vice versa. So it is that the dominant left hemisphere of the brain controls the dominant right hand.

ROOTS OF DEXTERITY

But what exactly does it mean to say that the left hemisphere of the brain is dominant? Dominance in a hand is quite clear. It is stronger and more dextrous. The brain, however, encased in its hard skull, is much more of an enigma. Perhaps not surprisingly, it was not until 1844 that it was proposed – by A. L. Wigan, in his book *The Duality of Mind* – that the fact that the brain has two hemispheres might mean that people have two separate minds. This extremely controversial idea was suggested to Wigan by a post-mortem examination he carried out on a man with no history of mental illness, whose brain turned out to have only one hemisphere. The fact that half his brain was missing had apparently produced no noticeable effect during his life.

This was the first recorded instance of extreme one-hemisphere dominance. Although more recent anatomical evidence has been less dramatic, neurophysiologists probing the brain have found many examples in which one hemisphere dominates the other in specific ranges of functions.

One important method of examining the functions of the two sides of the brain is 'split-brain' research. Splitting the brain means carrying out a commissurotomy – that is, cutting the *corpus callosum* which, as we have seen, is a thick bundle of nerve fibres connecting the two halves of the brain. Originally, this rather drastic-sounding treatment

was carried out, in the early 1960s, by Joseph Bogen of California to ease the pain of sufferers of extreme fits of epilepsy. By cutting the *corpus callosum* and the anterior commissure, another bunch of nerve fibres joining the two hemispheres of the brain, epileptic seizures were kept from spreading from one side to the other. The patients who underwent this surgery stopped having fits and in every respect appeared quite normal.

This fact was a source of puzzlement to neurophysiologists, because they could not understand why such major surgery apparently had no negative effects on the patients. Perhaps A. L. Wigan was right: perhaps, after all, humans did have two separate minds, and cutting the connecting links simply enhanced their independence.

However, it was not until R. W. Sperry and his colleagues at the California Institute of Technology started studying 'split-brain' effects in cats and monkeys and then extended their research to 'split-brain' humans that some curious anomalies in behaviour emerged. Sperry and his fellow researchers had reasoned that cutting the human *corpus callosum* meant that the speech and writing areas located in the dominant left hemisphere were no longer in contact with the right hemisphere that controlled the left side of the body. Therefore, they argued, if an object were presented in the left-hand side of the field of vision (which was perceived by the right hemisphere of the subject's brain), the 'split-brain' patients would be able to see the object, but could not explain what it was, nor write about it – these functions being a left-brain activity.

Sperry and his team set up a series of simple experiments to explore these ideas. In one such experiment, a split-brain patient sat on one side of a screen. Behind the screen, out of his view, was a collection of small, simple objects such as a hammer, a knife, a nut, a bolt, and so on. The name of

The 17th-century engraving, above, shows magicians in concert. Western society regards magic as 'sinister' – a word derived from the Latin for left-sided – perhaps because it apparently has no rational foundation.

In the carving below, the sacred boat of the Egyptian goddess Isis is seen sailing through the night. Processions in honour of Isis were traditionally led by priests bearing the image of a left hand.

The portrait by Jaco Bar, below right, is of Fra Luca Pacioli, one of the great Renaissance geometers. In the western tradition, the analytical has always been favoured at the expense of the intuitive. But intuition can sometimes aid in the most analytical thought processes. The famous 19th-century French mathematician Henri Poincaré, below, for instance, made an important mathematical discovery apparently almost by accident: it came to him in a flash of intuition while he was not consciously thinking of the problem.

one object was flashed for one-tenth of a second on to the screen in such a way that it was recognised only by the right hemisphere. When the patient was asked to name the object, he failed; but if he felt behind the screen with his left hand, he selected the correct object.

Many other controlled scientific experiments on this theme have been carried out, together with investigations of brain activity using electroencephalographs to compare neural activity in the two hemispheres when the subject is carrying out a number of varied tasks.

There are of course, the artists, sculptors, mystics and people who 'drop out' of the system and counter this left-brain domination by trying to assert the value of right-brain activity but they still remain, in general, a barely tolerated minority on the fringes of our society. Nonetheless, their presence may indicate that they are the vanguard of a new form of consciousness – a consciousness that embraces both right-brain and left-brain thought and behaviour. But this new form of consciousness will have a difficult struggle if it is to counter the powerful forces that favour left-brain dominance. Bearing

The left brain controls speech, writing and numerical abilities; its mode of thought is analytical, logical, and rational; and it proceeds by rigorous step-by-step analysis of the problems it is set. The right hemisphere, meanwhile, controls the ability to visualise in three dimensions, a 'sense of direction' and musical ability; it is perceptual, intuitive, imaginative, and discerns things as wholes or in terms of patterns rather than by analysing them logically in the manner of the left hemisphere.

Such findings lead us to interesting conclusions. The reason why, for most people, the left hemisphere of the brain appears to be dominant, for instance, is that its abilities in the verbal, analytical and logical areas are those that are the most highly regarded – in western culture, at least. The mathematician is trained so that his left-brain functions are developed to a high degree, whereas the value of his right brain can go unnoticed until the left brain relaxes its hold over thought processes. Poincaré's insights, remember, came to him in a flash, demonstrating that the processes of his right brain were largely unconscious, coming to the fore when not actively called upon.

in mind that the left brain controls the right side of the body, we would expect that, under the regime of the old consciousness, right-sidedness would be favoured, while in certain cultures the left side would have a flavour of disrepute about it.

Evidence confirms this: *The Bible*, for instance, indicates that God 'shall set the sheep on his right hand, but the goats on his left' (*Matthew* 25:33). The goats are not only placed on the left: they are ultimately destined to be thrown to the Devil.

In the Greek tradition of Pythagoras – a patriarchal tradition – the right side was associated with the light and the Sun, the straight, the good and the male, whereas the left corresponded to the dark and the Moon, the crooked, the evil and the female. In ancient Egypt, however – a matriarchal society – the Isis cult honoured the female, Isis, rather than the male, Osiris. Night was revered rather than day, and the Isis processions were led by priests holding an image of the left hand.

Western society, with its patriarchal, male-dominated view of the world, inherited from the Greeks, has suppressed the matriarchal view of the Egyptians – and there seems little alternative but to

conclude that this is because a rival order constitutes a threat to the dominance of the right side.

It is perhaps significant that western society sees as *sinister* (from the Latin for 'left-sided') such activities as magic and mysticism, because there appears to be no rational logic behind them. But activities such as transcendental meditation, yoga, faith healing, parapsychology, divining and achieving altered states of consciousness through the use of drugs all defy left-brain logic, and are practised by increasing numbers of people.

The growth in the pursuit of these 'sinister' activities has arisen, it seems, because more and more people are rebelling and reacting against the alienation, depersonalisation and rationalisation imposed by western technological existence, and are seeking to let their right brains come alive, thereby restoring the balance between left and right brains. The right brain can be seen to be reasserting itself in all aspects of life, ranging from

A medieval wall painting from St Thomas' church, Salisbury, England, above, shows the Last Judgement. Souls who are to go to heaven are sitting at God's right hand; those who are doomed to perdition are on his left.

The Tarot card designed for Aleister Crowley by Frieda Harris, right, features the interlocking symbols of yin and yang – the female and male principles, the integration of which represents the whole of existence. Yin and yang also broadly delineate the characteristics of the right and left brains respectively.

an increasing willingness to take paranormal occurrences seriously to an interest in mystical systems.

If this rebellion by the right brain is to generate a new consciousness of life, it is important to keep a sense of perspective. What is necessary is not left or right-brain dominance, but harmony between the two hemispheres of the brain. This harmony can arise only through an open dialogue between the halves of the brain, each contributing its own strengths and abilities. To this end, we may be able to train ourselves to use our right brains more consciously through, for example, biofeedback, giving time – from school age onwards – to 'right-brain' activities, and training ourselves to realise when to 'let go' or forget a problem so that the right brain can help to resolve it.

The renowned physicist Albert Einstein, it seems, was well practised in this. During his most enlightened moments, he seemed to relax and then allow his mind to wander, thinking in symbols rather than in words and sentences. Indeed, it is believed by some that the very use of language somehow imposes logic and thereby restricts potential creativity.

We may also be able to learn from the Chinese who have long held the view that all existence is represented by the integration of opposites known as *yin,* the female principle, and *yang,* the male principle – opposites that also, broadly, delineate the contrast between the right and left brains. The philosophers of ancient China, it seems, were wiser than we are: they knew – centuries before western neurophysiologists began to discover the same truth – that without this active union of opposites we are, to put it simply, but half-brained.

> ❚❚ INFORMATION COMES TO US SOMETIMES IN A FLASH, IN NO MORE TIME THAN IT TAKES TO DRAW A BREATH, TO HAVE AN INSPIRATION . . . IT CAN BE TRIGGERED BY MEDITATION, DEEP PRAYER, FASTING . . . BUT AT ITS BEST IT IS SPONTANEOUS. IT JUST ARRIVES OUT OF THE BLUE, SLIDING INTO CONSCIOUSNESS WHEN ONE LEAST EXPECTS IT. ❚❚
>
> **LYALL WATSON, SUPERNATURE II**

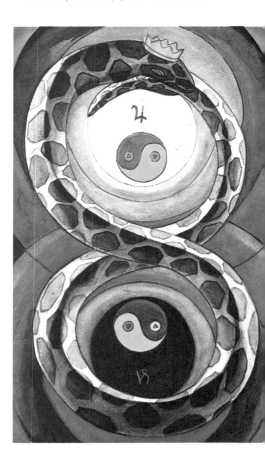

GLIMPSES OF THE FUTURE

Most precognitive experiences relate to events in the near future, while a minority seem to view the more distant future – years rather than weeks or months ahead. A very few, however, belong to a totally different category: they appear to take the subject to an era quite outside his own earthly lifetime, perhaps even to centuries ahead.

One such experience occurred to a British family when on holiday in Germany. They were travelling in their car on one of the motorways. There was nothing particularly noteworthy about the day nor the weather conditions; and as far as they could later judge, nothing had occurred beforehand to prepare them for the incident.

Presently, they became aware of a vehicle approaching them in the opposite carriageway, apparently travelling faster than they were. It was

Travelling on one of the motorways that criss-cross Germany, above, a family of British holidaymakers saw an extraordinary apparition – a silvery torpedo-shaped object, as depicted top, travelling fast in the opposite carriageway. Frightened faces peered at them through the vehicle's round windows.

not this that drew their attention, however, so much as the vehicle's shape. It was long and cylindrical, and there were what appeared to be round windows, or portholes, in the side. Out of those windows, looking straight at them, were four very frightened faces. Needless to say, the family presented equally alarmed faces.

Afterwards, the travellers were unable to liken the machine to anything they had seen before. They do not appear to have observed any wheels on the vehicle, nor were they aware of any engine noise. Had the object been seen in the sky, it might have been classified as a UFO. On the ground, it looked like a vision of the far-distant future – a machine that was the remote descendant of the modern car. The holidaymakers were, not surprisingly, unnerved.

Another remarkable experience occurred to a London man by the name of D'Alessio, when he

was taking a walk in the tree-lined street in which he lived. The evening was warm and pleasant, and he was walking slowly, enjoying the weather.

It was then that he began to feel, as he described it, 'strange, as if in a dream'. The sensation was not new to him, for he had had similar feelings in the past, and they had invariably preceded some form of time dislocation or out-of-the-body experience.

On this occasion, he continued to be perfectly aware of who and where he was, although he felt that his personality was somewhat different from usual: he was happier, more relaxed and less tense. He felt that he was in the same familiar location, but was also certain that the time was not the present. He seemed to be in the far future. A haze covered the entire scene 'and this haze trembled and stirred quite uniformly'.

D'Alessio was particularly impressed by the fact that everything was extremely quiet; the traffic in particular made no sound. The conviction then came to him that this traffic of the future could move not only in silence but also in complete safety. He felt that 'accidents are no longer possible, because vehicles cannot crash or collide any more'.

Another aspect of the scene struck the witness forcibly – the texture of the road surface and of the dwellings. They were made of the same synthetic substance, 'very smooth and silvery and beneficial to one's well-being'. It seemed to have qualities that no material in our own time has.

He continued to stroll along the street, enjoying the sensation and thinking: 'This is how it will be'. After a few minutes, the haze faded and both the scene and his sensations returned to normal. He was left with a feeling of considerable happiness.

D'Alessio regards his timeslips as involuntary and not capable of being produced to order in any

In Gilston Road, Fulham, London, above, a witness by the name of D'Alessio had the conviction that he had suddenly slipped into the future – into a time when the traffic was silent and vehicles could not collide. The road and buildings were made of a smooth and silvery substance. This was one of several time dislocations and out-of-the-body experiences that had occurred to this Londoner.

circumstances. They are always accompanied by the slightly dreamy, though not sleepy, sensation described. As he says: 'It is as if something strange and yet familiar is about to happen [but] at a different rate'.

This disjointed, 'out of phase' sensation is a common accompaniment of all timeslips, whether these take the subject into the past or the future. They are also frequently marked by a silvery or hazy light suddenly appearing over the scene and by a noticeable absence of sound.

TIMESLIP IN TOMBLAND

A similar incident occurred to an elderly man from Norfolk, in East Anglia. One day in early autumn, he and his wife made one of their rare visits to the county town of Norwich. They spent part of their visit in the central shopping area and then wandered into the district known as Tombland. This was the site of the city's market in medieval times, and is bounded by shops on one side and by the cathedral, and buildings fronting it, on the other. The main street through Tombland is usually crowded with cars and people.

The couple soon found themselves in a narrow side street. Here, the husband left his wife waiting on the pavement while he went to a nearby public lavatory. But instead of being away for a few minutes, as he had expected, he was away for an hour. His wife, meanwhile, grew increasingly anxious. At last, however, he returned and the story he told her was a strange and troubling one.

He had entered the lavatory, he thought, by a door opening directly from the street and that was at street level. When he wished to come out, he saw another door in a different position from the first, with steps that led upward – to the street. He took this exit, only to find himself in a street that

looked somewhat different from the one which he had left. It was like Tombland – but not the Tombland he had left.

Traffic was streaming along this street in a continuous, unbroken flow, moving so fast that it was quite impossible for a pedestrian to cross the road at any point. There seemed to be few people about, and the only form of traffic control was a set of lights, flashing alternately red and green without intermission. Warehouses and industrial buildings now stood where the cathedral and its associated buildings had been.

He stood in bewilderment for a long time, and then began to wander up and down the nearby streets, trying to find his wife. He was unable to say exactly how he did find her, but eventually he found himself in the narrow street that he had left, where he saw his wife, by now very anxious, still waiting for him.

Elements of Doubt

It is possible that he may have seen the distant future of Norwich. But there are certain elements in the story that throw doubt on this explanation. The first is that the single entrance to the only public lavatory in the Tombland area is not at ground level but is approached by descending steps. In the second place, red and green traffic lights do exist nearby today, in the form of the pedestrian crossing at the top of the hill, about 70 yards (64 metres) away. The traffic lights do not flash red and green but intermittently flash amber, and the pedestrian crossing light flashes green at times.

Nevertheless, the inexplicable fact is that the witness did not see the cathedral and its associated buildings, which are present in Tombland today, but instead was aware of industrial-style buildings, which are not. The missing hour is puzzling, too, for it would be difficult for him to be lost for that length of time in such a small area if he had merely become confused about his whereabouts. And the traffic, though it always moves fast in this area, does not maintain a smooth, unbroken flow. Furthermore, the place is usually crowded with pedestrians during the day.

The Erpingham Gate, below, of Norwich Cathedral is one of the conspicuous features of the city's Tombland district. Yet neither this nor any other recognisable landmark could be seen by a timeslip subject when, on leaving the public lavatory, bottom, he spent an hour wandering in the distant future. Warehouses stood where familiar buildings should have been; and instead of the clogged traffic of today, there was an unbroken, fast-moving stream of vehicles.

So how can such extensive timeslips occur? In cases where scenes from the past are witnessed by a present-day subject, it may be that some form of recording of an actual event is stored in the physical environment. Under the right conditions, it is then 'replayed' and 'picked up' by a witness whose brain is properly attuned. Or it may be that the memory of some former incarnation is evoked by the combination of, say, a particular place, temperature and state of the light.

Precognition does not fit into either of these models. But many scientists do not look on the idea with disfavour. 'In physics, everything that is not forbidden occurs. And physics does not forbid the transmission of information from the future to the present.' These are physicists speaking, the Americans Harold Puthoff and Russell Targ. Certainly, the behaviour of subatomic particles suggests that information travelling backwards in time is not unknown.

It could indeed be that all matter contains the 'blueprint' of its own future, and there are occasions when this pattern superimposes itself on our workaday present. But, in such cases, the 'blueprint' must lie in the surroundings and not in the subject, though it is the latter's brain that translates the information into experiences of sounds and images. Precisely how such information is stored and 'replayed' remains a mystery.

> **WHAT WOULD HAPPEN IF AND WHEN THE UNIVERSE STOPPED EXPANDING AND BEGAN TO CONTRACT? THIS WOULD LEAD TO ALL SORTS OF SCIENCE-FICTIONLIKE POSSIBILITIES FOR PEOPLE WHO SURVIVED . . . WOULD THEY BE ABLE TO REMEMBER TOMORROW'S PRICES AND MAKE A FORTUNE ON THE STOCK MARKET?**
>
> **PROFESSOR STEPHEN J. HAWKING**

THE VITAL KEY TO COMMUNICATING WITH ANY INTELLIGENT ALIEN RACES EXISTING IN SPACE IS LIKELY TO BE THE UNIVERSAL LANGUAGE OF MATHEMATICS, SCIENTISTS NOW SEEM TO AGREE

Many people have supposed that, even if signals that were obviously of artificial origin and therefore from intelligent beings, were picked up by a radio telescope on Earth, it would be impossible ever to enter into communication with alien species. How could we understand a language that no human being had ever spoken?

SIGNALS THROUGH SPACE

There are even some languages on Earth, still surviving in inscriptions, that no one understands. But it should be possible to solve the problem using basic mathematical and scientific facts.

The first task would be to design a radio message that was obviously artificial. A radio telescope can be used not only as a receiver but also as a transmitter. Thus the radio dish at Arecibo, Puerto Rico, has been used not only to pick up faint signals from distant radio sources in the heavens but also as a radar instrument, sending out powerful pulses of radiation to bounce off the planet Venus. In this way, rough maps of the solid surface of Venus were constructed even before a radar mapping instrument was put into orbit about the planet.

Suppose we used a powerful radio telescope to send out the following sequence of pulses: one pulse, gap, two pulses, gap, three pulses, gap, four pulses, gap, longer gap, six pulses. Suppose we then repeated this signal after an even longer gap and kept on doing this. Now it does not matter where in the Universe an intelligent species lives or what it is like: if it is to be regarded as intelligent, it is presumably capable of counting. And it does not

Hundreds of massed radio telescope dishes make up the proposed Cyclops system, as shown left. Equivalent to a single huge instrument, the array would be enormously sensitive and capable of locating the direction of a radio source with high accuracy. Cyclops could perform the most thorough search yet for weak signals from intelligences in space. First steps have been made with conventional radio telescopes, such as the instruments, below left, at Green Bank, West Virginia, USA. Messages have also been sent into space, though there is no hope of receiving an answer for millennia.

matter what its number scale is. Regardless of whether this consists only of one and zero, as does an electronic computer's, or contains 60 different numbers, like that of an ancient Babylonian, it will know that two is one more than one, that three is one more than two, and so on. It will realise that the signal it is picking up is simply the sequence of the first few numbers: one, two, three, four, . . ., six. It will recognise that this is an attempt to send out an obviously artificial signal, in the hope that if it is picked up by an intelligent race, it will send it back with the missing five inserted to show that the message has been understood. In order to ram home the artificiality of such a message, it could be varied from time to time with other sequences of numbers, perhaps bearing some arithmetical relationship.

Suppose now that an alien race has been contacted in this way and that they have replied, sending back the message with the missing set of pulses filled in, thus showing that they are interested in communicating. Could there be any wothwhile future in such a dialogue?

The problem would be to establish a common vocabulary of radio signals and gradually build up the number of 'words' until both races are proficient in the common 'language'. First steps would involve the transmission of simple sums.

It would be impossibly cumbersome to continue to transmit numbers in the form of simple sequences of pulses, of course. But we could easily teach the aliens our way of writing numbers more compactly in the decimal, or ten-based, system. A sequence of, say, six pulses could be transmitted, followed by a more compact signal pattern: this would correspond to showing a child a sequence of six pencil strokes followed by the written digit 6 in the course of teaching him the digits 0 to 9. When the aliens had learned the ten digits, we could send further sequences that would show how ten is represented as 10, eleven as 11, and so on.

We might then graduate to multiplications and divisions, sending such sums until the aliens realised that certain radio signals stood for the multiplication sign and the division sign. A little later, we could make it clear what symbols we were using for the ideas 'is greater than' and 'is less than'. Proceeding in this way, it is certain that an extensive set of mathematical symbols could be learned and used.

It might be thought that little progress could be made after this stage, but that is not the case. In the translation and understanding of ancient Egyptian hieroglyphics, a major breakthrough was achieved when the Rosetta Stone was discovered. This was a slab on which a single message was

*In*FOCUS

IN BLACK AND WHITE

A television picture could be transmitted to intelligent extra-terrestrials in binary code, as demonstrated *right*. Each symbol represents a single pixel (picture cell) — 0 for a white pixel, 1 for a black pixel. But how could we convey to listeners that we intend the sequence of digits to be interpreted as a television picture? A strong hint could be given by sending, say, 253 such symbols. Mathematically-inclined aliens would notice that this number is equal to 11 x 23 and that there are no other numbers that can be multiplied together to form it. This might suggest to them that the numbers refer to an array either of 23 columns of 11 elements, or to 11 columns of 23 elements. If they then tried to assemble the picture in the first of these ways, they would get a 'scrambled' result, as shown *right*. But when they tried it the other way, they would get the picture, *far right;* and if we were lucky, it would be intelligible to them.

Just such a message has already been beamed into space by the giant radio dish at Arecibo, and aimed at a tightly packed cluster of stars called M13. It therefore has a good chance of passing through a large number of planetary systems. A sequence of 1,679 digits was sent: this could be turned only into a 23 x 73 array, in which there was room for a wealth of information. The

atomic numbers of five elements important to life – oxygen, nitrogen, carbon, phosphorus and hydrogen – were given. Then formulae followed, showing how these are built up into DNA, the genetic material that governs our heredity. A small humanoid figure was included, too. Scientists who did not know the code proved able to 'crack' it – which encourages the hope that aliens might, too. Unfortunately, however, any reply from M13 will reach us no sooner than AD 50,000, because the cluster is at an immense distance.

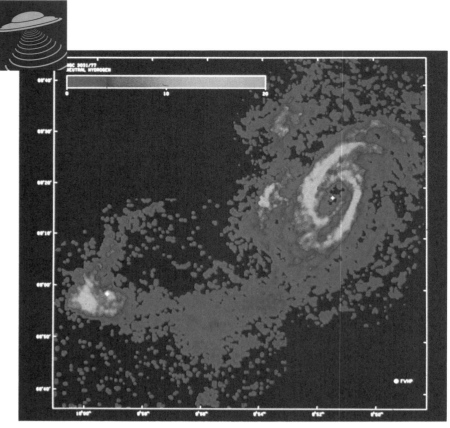

that the next thing to do would be to send out, suitably coded, the *Encyclopaedia Britannica*, thus presenting our alien friends with a comprehensive picture of Earth's civilisations. It would then probably only be a matter of time and patience before the ability to speak to each other had been achieved. From then on, progress would be limited only by the speed of radio.

For all but the nearest planetary systems, where the time between question and answer is much less than a century, interstellar conversations, however, would be between human race and alien race – not between individuals. One generation would ask its questions and hope that its descendants would think the answers worth having. For at least a percentage of questions, this would certainly be so. Aliens with other histories, and perhaps with other senses, would surely have perspectives on this mysterious Universe worth sharing. But another astronomical fact of life is the age of the Universe and our late arrival on the scene, making it probable that we are among the most primitive forms of intelligent life, with little to barter in exchange for information. To know that the human race is not alone in a huge Universe, however, would certainly remove the numbing suspicion that life on Earth is merely a highly improbable and purely temporary episode in the Universe's career.

engraved in three scripts: Egyptian hieroglyphics, Egyptian demotic script and ancient Greek. It was possible to match the Greek words with the Egyptian symbols, and from then on progress in deciphering ancient Egyptian inscriptions was rapid. The problem in enlarging our vocabulary of 'Extra-terrestrial' is to find one or more 'Rosetta Stones', that our alien friends also possess. Not only that, when we transmit our 'Rosetta Stones', the aliens must recognise what they are. There are several such 'Stones' which we might expect to be meaningful to any race that has reached our level of scientific and technological civilisation.

One of these is the periodic table of the elements. An astronomical fact of life, the sameness of the Universe, tells us that no matter where you go in the Universe, you find that all objects are made up of the same elements and in much the same relative proportions by mass.

The table of elements is a vast body of nuclear, chemical, electrical and numerical information. It can be used to define natural units for distance, mass, electrical charge and time; and with its aid, we should be able to teach the aliens our words 'hydrogen', 'helium', 'carbon', 'electron', 'proton', 'neutron' and so on. By sending symbolic descriptions of chemical reactions, we would be presenting our correspondents with easily understood lessons in our language. By this time, in addition, the mutual understanding of mathematics would also enable pictures to be sent in much the same way that thousands of pictures of Jupiter and Saturn were sent back to Earth from the Voyager spacecraft – namely, in digital form. The signal would consist of a stream of numbers, representing information about the brightness and colour of the picture at each point.

At international conferences devoted to the search for extra-terrestrial life, it is often suggested

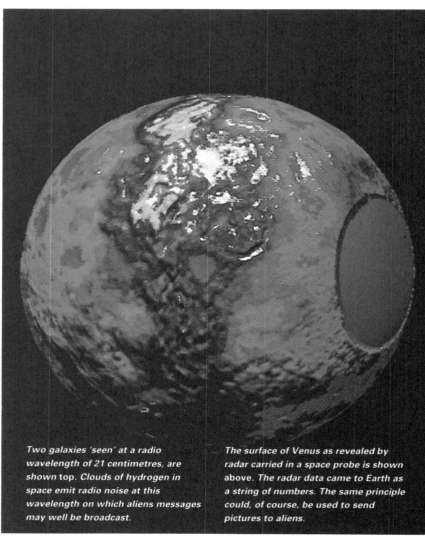

Two galaxies 'seen' at a radio wavelength of 21 centimetres, are shown top. Clouds of hydrogen in space emit radio noise at this wavelength on which aliens messages may well be broadcast.

The surface of Venus as revealed by radar carried in a space probe is shown above. The radar data came to Earth as a string of numbers. The same principle could, of course, be used to send pictures to aliens.

WHERE WAS ATLANTIS?

Santorini, or Thera, left, the southernmost island of the Greek Cyclades group, is thought by some to be the site of Atlantis.

The map, below, by Greek scholar Dr Angelos Galanopoulos, is of the Thera group of islands, where – according to his theory – a central crater was the site of Atlantis, destroyed in a volcanic eruption in around 1500 BC.

Many people believe that true paradise, as depicted below left, by the Dutch artist Hieronymus Bosch, was located on Atlantis.

DID THE MAGICAL ISLAND OF ATLANTIS EVER REALLY EXIST? MODERN RESEARCH SUGGESTS IT MAY WELL HAVE DONE – THOUGH PERHAPS NOT EXACTLY WHERE PLATO, ORIGINATOR OF THE STORY, CLAIMED

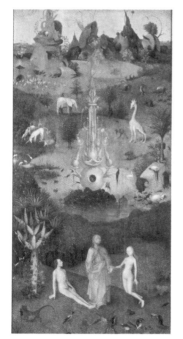

THE ISLAND OF SANTORIN and THE METROPOLIS OF ATLANTIS AFTER PLATO (KRITIAS, 430 VBC)

At a symposium organised by the Department of Classical Studies at Indiana University in April 1975, entitled *Atlantis: Fact or Fiction?*, experts in various fields of learning, from classics to geology, came together in the United States to attempt to settle the Atlantis question once and for all. In many people's minds they succeeded, proving Plato's 2,300-year-old story to be mere fiction.

Yet the final words by Professor Edwin Ramage, editor of the subsequent book, were far from conclusive. 'No-one,' he wrote, 'has yet offered a satisfactory solution to the problem – if, that is, there is a problem at all'. And, sure enough, new theories and new books have continued to appear.

Survival of interest in the lost continent certainly owes a great deal to Ignatius Donnelly's best-seller *Atlantis: The Antediluvian World*. At the start of the book, reprinted some 50 times before being revised in 1950, Donnelly listed what he called 'several distinct and novel propositions', summarising his extraordinary thesis as follows:

1. That there once existed in the Atlantic Ocean, opposite the mouth of the Mediterranean Sea, a large island, which was the remnant of an Atlantic continent, and known to the ancient world as Atlantis.

2. That the description of this island given by Plato is not, as has long been supposed, fable, but veritable history.

3. That Atlantis was the region where Man first rose from a state of barbarism to civilization.

4 That it became, in the course of the ages, a populous and mighty nation, from whose overflowings the shores of the Gulf of Mexico, the Mississippi river, the Amazon, the Pacific coast of South America, the Mediterranean, the west coast

ENIGMAS

of Europe and Africa, the Baltic, the Black Sea, and the Caspian were populated by civilized nations.

5. That it was the true Antediluvian world – the Garden of Eden; the Gardens of the Hesperides; the Elysian Fields; the Gardens of Alcinous; the Mesomphalos; the Mount Olympus of the Greeks; the Asgard, or Avalon, of the *Eddas* [medieval Icelandic poems]; the focus of the traditions of the ancient nations – representing a universal memory of a great land, where early mankind dwelt for ages in peace and happiness.

6. That the gods and goddesses of the ancient Greeks, the Phoenicians, the Hindus, and the Scandinavians were simply the kings, queens and heroes of Atlantis; and the acts attributed to them in mythology, a confused recollection of real historical events.

7. That the mythologies of Egypt and Peru represented the original religion of Atlantis, sun-worship.

8. That the oldest colony formed by the Atlanteans was probably in Egypt, whose civilisation was a reproduction of that of the Atlantic island.

9. That the implements of the Bronze Age of Europe were derived from Atlantis and that the Atlanteans were also the first manufacturers of iron.

10. That the Phoenician alphabet, parent of all the European alphabets, was derived from an Atlantean alphabet, which was also conveyed from Atlantis to the Mayas of Central America.

The distinguished Greek archaeologist Professor Spyridon Marinatos is seen above, inspecting ancient ruins on the island-volcano of Thera. This, he believed, was the site of Atlantis.

13. That a few people escaped in ships and on rafts, and carried to the nations east and west the tidings of the appalling catastrophe, which has survived to our own time in the Flood and Deluge legends of the Old and New Worlds.

BRAVE NEW VISION

What Donnelly had done was to take Plato's original 7,000-word story and extend it to offer a whole new version of Man's prehistory and solve many problems which now perplex mankind. Donnelly's 'brave new vision' is still the basis for the flood of books on Atlantis, from the occult to the 'rebel scientific', that continues to pour from the presses.

Donnelly's claims are often based on wrong or incomplete information, however, as scholars delight in pointing out. But their own claims are also often suspect – the moral for any would-be seeker after the truth of the Atlantis legend being to ignore both sides and to return directly to Plato's story. For, even if it is full of distortions and literary devices for the purpose of propaganda or instruction, as some academics claim, it may yet hide a lost truth somewhere.

By this criterion, two recent hot favourites for the 'Atlantis found' title are suspect: an eastern Mediterranean civilisation, centred on Crete or Thera; and northern Europe, including Scandinavia.

Dr James Mavor's book *Voyage to Atlantis* caused a minor sensation in 1969. It set out the

11. That Atlantis was the original seat of the Aryan or Indo-European family of nations, as well as of the Semitic peoples, and possibly also of the Turanian races.

12. That Atlantis perished in a terrible convulsion of nature, in which the whole island was submerged by the ocean, with nearly all its inhabitants.

Many people, inspired by Ignatius Donnelly's classic study Atlantis: The Antediluvian World, *believe that mankind first rose to a state of civilisation in Atlantis. They claim that the Sun-worship found throughout the world – for example, in the Sun-motifs of the mysterious carvings of the Nazca plane, above left, and the cult of Ra, the Sun god of ancient Egypt, above – is a relic of the original religion of Atlantis. The Christian legend of the Flood, meanwhile, shown in a Coptic manuscript from Ethiopia, right, is interpreted as a jumbled memory of the final submersion of Atlantis.*

❚❚ OTHERS THINK IT [ATLANTIS] IS UNDER LAND – THE SANDS OF THE SAHARA, ONCE AN INLAND SEA. SOME OTHERS THINK IT IS UNDER THE ARCTIC ICE. ❚❚

CHARLES BERLITZ,

THE MYSTERY OF ATLANTIS

claims, first made by the Greek scientists Dr Angelos Galanopoulos and Professor Spyridon Marinatos, that Atlantis was in fact the Minoan civilisation, and that this was destroyed by the eruption of the island-volcano Thera in about 1500 BC.

The name 'Minoan' was given to the ancient civilisation of Crete by the British archaeologist Sir Arthur Evans, who began to excavate its remains in 1900. He believed that shadowy memories of it had inspired the Greek myth of Minos, son of Zeus and king of Crete, who kept a bull-headed monster, the Minotaur, imprisoned in a labyrinth. At Knossos, Evans discovered the ruins of a splendid palace in which there was a bullring. In the reliefs and murals that adorned the palace, and in pictures painted on the large quantities of pottery that were found, there were also representations of bull-hunting and bull-fights, conducted by youths armed only with staves and nooses.

In Atlantis, there was also a cult of bulls, according to Plato: indeed, every four or five years, the 10 kings of the island had to face the bulls unarmed, capture one and sacrifice it.

DEATH OF PARADISE

By 1500 BC, Crete was the centre of a powerful seafaring empire. Yet within an extraordinarily short time, her power collapsed. There was widespread destruction of temples and other buildings throughout Crete, and the Minoan colonies and trading posts overseas were abandoned or destroyed. There was also an abrupt change in artistic styles, and the quantity of pottery made sharply decreased; a large proportion of the Cretan population migrated to the west of the island; and soon political power in the Aegean shifted to Mycenae, on the Greek mainland.

Marinatos and Galanopoulos claimed that the eruption of Thera, known to have occurred about 1500 BC, could have caused this collapse. The tidal

// THE FACT THAT THE STORY OF

ATLANTIS WAS FOR THOUSANDS

OF YEARS REGARDED AS A FABLE

PROVES NOTHING. THERE IS AN

UNBELIEF WHICH GROWS OUT

OF IGNORANCE, AS WELL AS

SCEPTICISM WHICH IS BORN OF

INTELLIGENCE. THE PEOPLE

NEAREST TO THE PAST ARE

NOT ALWAYS THOSE WHO ARE

BEST INFORMED CONCERNING

THE PAST. //

IGNATIUS DONNELLY, ATLANTIS:

THE ANTEDILUVIAN WORLD

The German scholar, Dr Jürgen Spanuth, above, has made out a fairly convincing case for his claim that Atlantis was located not in the Atlantic or Mediterranean, but on islands off the German coast.

A mural from the palace of Knossos on the island of Crete, above, depicts the ritual bull-leaping that was an integral part of Minoan culture. Plato, the originator of the Atlantis myth, wrote of a bull cult on Atlantis; and this has led some experts to suggest that Atlantis was in fact the ancient civilisation of Crete.

waves from the explosion would have drowned many of the inhabitants of coastal towns throughout the Aegean, and the volcanic ash and dust that would have been deposited, in layers perhaps 20 inches (50 centimetres) thick, would have ruined harvests for years. Marinatos and Galanopoulos also said that Thera was actually the metropolis of Minoan civilisation, rather than being an outpost, as is generally believed.

The claim that the Minoan civilisation was Atlantis is in many ways highly credible, and remains the most favoured by those few academics who still show any interest in the subject. Yet Mavor and his supporters have had to perform some deft twists of scholarship to prove their case.

So does the Minoan civilisation really match Plato's descriptions of Atlantis as closely as Mavor claims? An eloquent opponent of the claim for Crete or Thera is the German scholar Dr Jürgen Spanuth, who accuses its supporters of 'a gross logical error'. As he puts it:

'Neither Thera nor Crete lies in the Atlantic. . . neither island lies at the mouth of a great river, neither was swallowed up by the sea and vanished. . . In fact, this great breakthrough in archaeology is a bubble that burst long ago.'

Spanuth himself attempts to prove, in his book *Atlantis of the North*, that Atlantis was centred on the sunken islands near Heligoland, off the northwest German coast, and was in fact the Bronze Age forerunner of the Viking civilisation of northern Europe and Scandinavia, in an area that is known as Atland.

Spanuth, although presenting a highly convincing case, uses the same twists of scholarship that he so readily condemns in others – locating his version of the events in the North Sea instead of the Atlantic. Robert Scrutton does much the same thing in *The Other Atlantis* and *The Secrets of Lost Atland*, also promoting the case for a proto-Viking Atlantis.

All these recent attempts to locate and prove Atlantis deserve a certain respect for their openness to the idea that Plato's legend is a story based on fact – but they have then proceeded to alter the story to suit historical events at a different time in a different place. It may well be that the real story still lies hidden where Plato quite specifically put it – on a huge land-mass to the west of Gibraltar, an area which disappeared beneath the sea nearly 12,000 years ago as the result of a colossal natural disaster.

BATTLING AGAINST SCIENCE

OFTEN DEEMED THE ARCH-ENEMY OF SCIENCE, CHARLES FORT IS BELIEVED TO HAVE GAINED VALUABLE COSMIC UNDERSTANDING AS A RESULT OF COLLECTING ANOMALOUS PHENOMENA

Fort's interest in UFOs – such as the one, top – helped set the stage for the development of present-day ufology.

Galileo is depicted, above right, demonstrating his telescope to Florentine nobles. The first person to use a telescope for the study of the skies, Galileo made a series of important findings in the early 17th century but his work was rejected by hide-bound scholars and the then all-powerful Church.

The publication of *The Book of the Damned* by Charles Hoy Fort in 1919 undoubtedly changed the standard of reporting of anomalous phenomena in the American press for the better. Nonetheless, there was a sting in the tail. For whenever journalists reported a sighting of a sea serpent, or a home disrupted by a poltergeist, or a shower of frogs, they would comment to the effect that 'here is another datum for the arch-enemy of science, Charles Fort'.

The unfortunate reputation of Fort as an enemy of science still lingers. Anyone who has read his books, however, must disagree, for Fort was extremely well-versed and up-to-date in nearly all

branches of science for his day and understood the scientific method, the rules of evidence and proper scholarship. Indeed, he had looked closely at the great and impressive edifice of science and proclaimed it full of cracks. He found scientists who made pontifical pronouncements without bothering with the facts of the case, who substituted dogma for true scientific enquiry, and who suppressed, ignored or explained away any embarrassing data. For his part, he was convinced that anomalies could well hold significance for science and should be studied.

The history of science is not one of orderly progression; it resembles more a battle, full of seemingly chaotic advances, retreats and skirmishes. This view of disorder and accident in scientific progress has been endorsed in one of the essential works on the history of science, *The Structure of Scientific Revolutions,* by Thomas Kuhn. At any time in its history, says Kuhn, science is the prisoner of the 'basic preconceptions' of the day. These preconceptions are limiting factors, which he calls 'paradigms'. But paradigms are essential to the formal expression of a science because they serve as models or structures within which to organise whole areas of knowledge and to provide the context for explanations.

The illustration above is taken from Marco Polo's account of his Asian travels in the 13th century and shows the fantastic creatures that he had heard lived in India. Such travellers' tales are still part of the data-base of anomalous phenomena.

Kuhn shows that the rise of a new paradigm in science, and the demise of the outdated one, is not always the 'graceful surrender' by fair-minded individuals that science propagandists would have us believe. On the contrary, it is often as painful and protracted as any religious or political revolution, and for much the same reason. Scientists are human beings with innate weaknesses and worries. They have a great deal invested in their jobs, status and credibility – factors of more value to their security than the ideal of an open mind. Above all, they tend to be loyal to the familiar paradigm.

The classic example of reluctance to accept something new is that of the group of Italian scien-

Antoine Lavoisier, below, is known as the 'father of modern chemistry'. Despite his distinction as a scientist, he dismissed out of hand the existence of meteors – and thereby prevented their study for decades.

tists who refused to look through Galileo's telescope lest they, like the Jesuit Clavius, be tempted to abandon their comfortable view of a geocentric Universe on seeing Jupiter's satellites through the instrument. Indeed, the revolutions of moons about Jupiter, the model for the new idea of the solar system, remained in contention for many years after Galileo first proposed the idea.

NEW PARADIGMS

A new paradigm, or the data that leads to it, can seem threatening, even sinister. So the body of orthodox science behaves like an invaded organism and closes ranks against 'infectious' data. Eventually, anomalies mount up, and there comes a time when they can no longer be ignored. There ensues a crisis period during which whole fields of science are broken apart, the pieces reassembled to incorporate the new data. What was once anomalous is now accepted or explained as a self-evident fact. Recurrent crisis is not only typical of scientific progress, Kuhn says, it is essential to it. In his book *Lo!,* Fort called science 'the conventionalization of alleged knowledge', explaining: 'It acts to maintain itself against further enlightenment, but when giving in, there is not surrender but partnership, and something that had been bitterly fought then becomes another factor in its prestige'.

The main aim of orthodox science is to consolidate the field of knowledge, not to seek out oddities of fact or theory. Repeatability and regularity are preferred to anomaly.

The study of strange phenomena is clearly not at the same stage of development as mainstream science. In the field of 'anomalistics', as some American scholars call it, collections of oddities have long abounded, however. Indeed, many of the works of Greek philosophers such as Pliny, Pausanias and Athenaeus are rich in so-called Forteana. So are the writings of travellers such as

Ibn Batutah and Marco Polo, and of the compilers of early bestiaries and natural histories such as Olaus Magnus and Edward Topsell, their work forming a vast data base on subjects currently lumped under the heading of 'unexplained phenomena'.

AN UNBRIDGEABLE GAP

Fort also was convinced that orthodox science is, by its own definition, 'exclusionist'. A scientific experiment, for example, is an attempt to isolate something from the rest of the Universe. The flaw of orthodoxy lies in its attempts to put things into units or categories. Yet anyone who has seriously investigated strange data knows that they usually

Werner Heisenberg, left, won the Nobel prize for his work in nuclear physics. The quantum theory, to which he made a great contribution, was not taught at Britain's major universities for 30 years after its formulation – a striking example of how scientists will sometimes resist new ideas from even their most distinguished colleagues.

Spectra – as shown below – are bands of coloured light, formed when white light is broken up. The theory that light is made up of waves was accepted by scientists because of its success in explaining such phenomena. But, today, light is considered to behave either as a wave form or as a stream of particles (known as photons), depending on the experimental circumstances.

defy categorisation. Exclusionist science functions well enough, but bases its criteria on arbitrary decisions. As science progresses, such distinctions become obsolete and collapse. Thus, in the early 19th century, many biologists still regarded living things as essentially different from non-living things: for these 'vitalists' there was an unbridgeable gap between the animate and inanimate worlds.

" A NUMBER OF FORT'S SPECIAL CORRELATIONS – STRANGE LIGHTS ON THE MOON... LUNAR PERIODICIES IN BIOLOGICAL PROCESSES AND BEHAVIOUR, LAKE MONSTERS AND UFOS – ALL ARE MATTERS OF SERIOUS ACADEMIC STUDY TODAY. "

But from around 1828 onwards, as chemists learned to synthesise organic compounds (compounds such as urea or acetic acid, which are produced by living organisms), the distinction between the animate and the inanimate lost its fundamental importance. Today, there is a tendency to forget that many of the dividing lines drawn by contemporary science – such as that between mind and matter, for example – may be redrawn or abandoned; and scientists frequently slavishly accept or reject data by criteria that are, at best, transient. It is clear that this arbitrary structure predetermines how we interrogate the Universe and how we interpret its answers. The German physicist Werner K Heisenberg wrote: 'What we observe is not nature itself, but nature exposed to our method of questioning'. In other words, light will behave like a wave or a particle according to the context in which it is investigated.

The barriers between the acceptable and unacceptable in science are changing all the time: moreover, what is dismissed as magic or superstition by one era may even become the science of the next. The great French chemist Antoine Lavoisier told the Academy of Sciences in 1769 that only peasants could believe stones could fall from the sky, because 'there are no stones in the sky.' Indeed, it was his influence that prevented scientific study of meteorites – 'stones from the sky' – until 1803.

RADICAL PROGRESS

But some barriers are gradually breaking down. Today's life sciences contain much by way of rehabilitated folklore: old herbals have been used for new pharmaceuticals and the practices of shamans have been adapted for new treatments. Apparitional phenomena, once the preserve of theologians and demonologists, are now the subject of both psychical research and psychology. What is more, a number of Fort's special correlations – strange lights on the Moon, curious aerial lights, sounds that accompany earthquakes, lunar periodicities in biological processes and behaviour, lake monsters and UFOs – all are matters of serious academic study today.

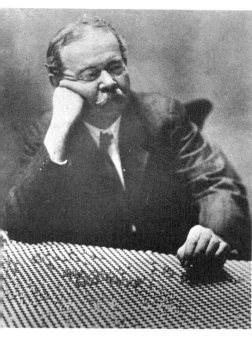

Charles Hoy Fort is seen left, at his super checkerboard. He invented a game called super-checkers, so complicated that it usually took all night to play it to the end.

Jesters – such as the one below – traditionally poked holes in the customs and beliefs of society . It is a role that Charles Fort played, too, by ridiculing the scientific establishment of his day.

In earlier times, most cultures had an appreciation of anomalies that we have lost. They also had some framework in which to study them, usually as omens or portents of social change. Priests in rural Scandinavia in the late medieval period were obliged to report to their bishops anything contrary to the 'natural order', and the chronicles that survive are treasure troves of sea serpent sightings, falls of mice and fish, animal battles and other strange phenomena.

Today, such stories are absent from the scientific journals, where Fort found them, and are used as small filler paragraphs in newspapers, often written up inaccurately and just for laughs. One day, when orthodox science widens its circle of attention, the task of assimilating Fortean phenomena will have been made easier by dedicated collectors of obscure and weird data. Their true function, in relation to mainstream science, is elegantly stated in a line from Enid Elsford's book on the medieval fool: 'The Fool does not lead a revolt against the Law; he lures us into a region of the spirit, where . . . the writ does not run'. In many ways, Charles Hoy Fort was certainly science's fool.

In answer to how strange phenomena could relate to the main body of science, Fort suggested that it was science that would eventually make the move to assimilate anomalous phenomena by adopting a more inclusive approach. Inclusionists would 'substitute acceptance for belief', he said, but only temporarily until better data or theories arose. This is exactly what true scientists do, of course – because, for them, enquiring after the truth is more important than being right or first. Inclusionism would recognise a state of existence in which all things, creatures, ideas and phenomena were interrelated and so 'of an underlying oneness'. From his thousands of notes, Fort saw that the Universe functioned more like an organism than a machine and that, while general principles applied universally, deviations and anomalies were the inevitable result of local expression of those principles. This almost mystical view anticipated C.G. Jung's notion of the collective unconscious and echoed similar beliefs that appear in the cosmologies of primitive and animistic religions. Yet another theory, in which the world is seen as functioning more like an organism than a machine, emerged in 1981 – Dr Rupert Sheldrake's principle of formative causation. This appears to offer philosophical tools for exploring continuity and synchronicity by postulating a resonance between forms of similar structure, whether living or not, that operates outside time and space.

The simply marked grave, right, at Albany, New York – where he was born – is that of Charles Fort.

❞ MOST SCIENTISTS SEEM TO HAVE A STRONG COMPULSION TO CLING TO OLD PARADIGMS. BY CONTRAST, PEOPLE LIKE FORT... TAKE PLEASURE IN THE FACT THAT THE WORLD IS BURSTING WITH ANOMALIES. ❞

COLIN WILSON, MYSTERIES

ENCOUNTERS OF THE MIND?

COULD IT BE THAT SOME ENCOUNTERS WITH ALIENS TAKE PLACE ONLY IN THE IMAGINATION, AND ARE 'REAL' ONLY IN WHAT IS A SUBJECTIVE SENSE?

Carol and Steve W., a young married couple from Gateshead in north-east England, had cause to become very worried in August 1979 when their home was suddenly invaded. This was no ordinary plague of mice or rats disturbing the normality of their lives: instead, it involved tiny UFOs and strange alien beings.

It began on 17 August. Carol was alone in the house with her three-year-old daughter as her husband was working on the night shift. She had been unable to sleep because of a searing toothache; the time was about 2 a.m. She went downstairs, made a cup of tea and sipped it while sitting on the bed. Suddenly, she noticed a red light shining in through the curtains. Puzzled, she got up and drew them

apart, to reveal a cymbal-shaped object above the rooftops opposite. The UFO hovered for a while displaying multicoloured lights, and then spiralled upwards into the sky.

Back in bed, Carol became distressed when a low rumble announced the return of what seemed to be the same object – this time in miniature – appearing on the curtains and flying into the room. In its wake was a trail of glittering specks. She felt a tingle on her body and heard a buzzing as the swarm of lights fell towards her. The specks then returned to the 18-inch (45-centimetre) disc and left the room through the open door.

The mini-UFO reappeared to Carol 13 nights later when she went into her daughter's bedroom to settle her back to sleep. The tingling returned and she screamed to her husband, who arrived just in time to see a flash of light outside the window. The disc had somehow flown out through the window, although it was shut at the time and remained undamaged.

Four nights later, Carol decided that her husband's next night shift could not be tolerated alone, so she went to stay with her mother, who lived nearby. At 4 a.m., she was again paralysed by buzzing and tingling as the mini-UFO entered the room. This time, it was accompanied by 12 weird human-like creatures, 2 feet 6 inches (76 centimetres) tall. They wore white suits and had pale, feminine features. Their hair looked unreal and reminded Carol of an *Action Man* doll. Some of the beings approached the bed, showed interest in her eyes and conversed in clicking sounds.

The invasions continued for over two months. Carol's family felt the tingle and paralysis at least once, and the dog was sent into a frenzy whenever the buzzing noises enveloped the house. Then, just as suddenly as they had begun, the experience mysteriously stopped.

2

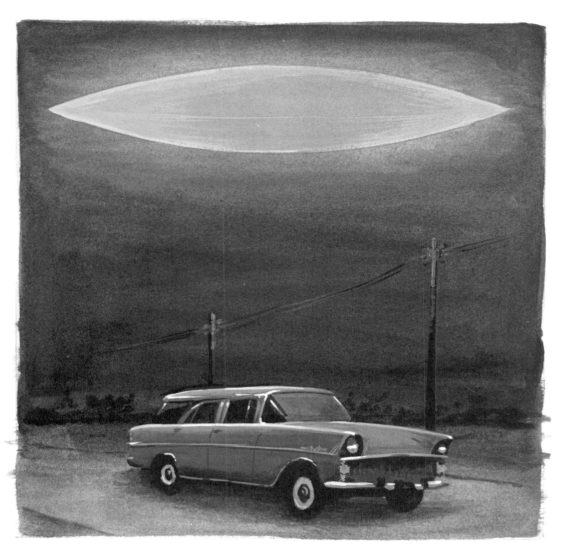

At 2 a.m., on 17 August 1979, Carol W. from Gateshead, England, was drinking a cup of tea to help her sleep when she became aware of a mysterious red light shining through her bedroom curtains. Drawing them back to investigate, she was startled to see a cymbal-shaped UFO hovering over the rooftops, as shown opposite, top. It flashed many-coloured lights before spiralling upwards and disappearing from sight. Back in bed, the witness was then alarmed to see what appeared to be the same UFO, but in miniature coming into her room through the curtains, trailing brilliant 'specks' behind it, as depicted opposite, bottom. She tingled all over her body and heard a buzzing sound as the tiny lights turned towards her. The specks then retreated into the disc which left through the closed window. Four nights later, although Carol was in a different house, the UFO visited her again – and this time brought along its crew as well.

This is an amazing story, which we must either accept or reject. There is no reason why the family should willingly have placed themselves under so much strain, and they continually asked for no publicity. But the events pose many more questions. How could a UFO appear inside a bedroom? How could a dozen figures, 2 feet 6 inches (76 centimetres) tall, come from a disc only 18 inches (45 centimetres) in diameter? And how could it fly through a closed window? The most obvious solution is that no object was ever physically present. What Carol observed was perhaps a projection, akin to a moving hologram or three-dimensional image.

All too often in UFO encounters, the unbending physical laws of nature are shattered beyond recognition. Solids cannot pass through solids without trace. Objects do not travel faster than sound without creating sonic booms. Yet these things, and many more, are described in UFO reports with a regularity that is remarkable. But if the UFO or entity were, in fact, just a film show, projected into our natural environment, then most of these 'problems' would not arise. Think of the movie we all star in at night, with its screen inside our heads. Dreams have no need to follow the laws of physics. Anything is possible for the imagination.

On 5 July 1972, 27-year-old Maureen Puddy saw a UFO on the Mooraduc Road near Frankston, in

On 5 July 1952, a huge blue UFO hovered over Maureen Puddy's car near Frankston in Victoria, Australia, as shown above. Twenty days later, it returned as she was driving past almost the same spot; this time, it stopped the car. She heard a voice in her head that urged her to make her story public and assured her that 'we mean no harm'. Six months passed, then Maureen Puddy heard the voice again. It told her to visit the scene of the sighting once more.

Victoria, Australia. The object was a huge blue disc, which hovered above her car as she returned from visiting her son in hospital. Twenty days later, at almost the same spot, it returned. This time, it seemed to drain power from the car, causing it to stop: indeed, the car appeared to steer itself to the roadside. A voice in her head told her: 'All your tests will be negative'. It then said: 'Tell media, do

❞ EXTRA-TERRESTRIAL CONTACT NOW CONSTITUTES A SUBCULTURE AS SIGNIFICANT AS THAT OF VISIONS OF THE VIRGIN MARY, AND THERE HAS BEEN TIME NOT ONLY FOR THE FABRICATION OF STEREOTYPES, BUT ALSO FOR THEM TO DEVELOP IN COMPLEXITY AND SOPHISTICATION. **❞**

HILARY EVANS,

GODS: SPIRITS: COSMIC GUARDIANS

not panic. We mean no harm.'

Judith Magee, a respected researcher, investigated the case. About six months later, she received a telephone call from Maureen, asking for an urgent meeting. She said that a voice had called her name and told her to return to Mooraduc Road. Judith Magee went with fellow investigator, Paul Norman, to meet Maureen Puddy at the scene of the sighting. On her way to meet the ufologists, Maureen told them, a figure in a golden suit had materialised in the car beside her.

As the investigators sat talking to Maureen at the site, she claimed that the entity had now returned and was standing in front of the car headlights. Neither researcher could see anything, however. Maureen meanwhile, began to describe the scene inside a UFO that she claimed was nearby. Over the next few minutes, she kept alternating between being 'here' (in the car) and 'there' (inside the UFO), although all the time she was physically with the investigators. Maureen Puddy claimed the being wanted her to go with it, but she violently opposed this. The researchers sensed the battle going on within her, and saw her tears as the situation got too much. Yet, if the testimony of the investigators is anything to go by, although Maureen felt

Every member of the Sunderland family of Oakenholt, North Wales, below, claims to have had some psychic experience since 1976. Three of the children, especially Gaynor (standing at the back), say they have met 'aliens' and have been taken by them to visit other realms of being. Author and UFO investigator Jenny Randles, centre left, believes that people with a psychic background are particularly likely to see UFOs and report close encounters.

An alleged alien footprint, bottom, was photographed in Florida, USA, by Ron Whritenour in 1966. If the print is authentic, then some extra-terrestrial beings would therefore seem real enough to leave physical traces and so cannot be 'all in the mind'.

she was 'inside' a UFO and 'observing an entity', this experience had no reality outside her mind.

The story of the Sunderland family from Oakenholt, North Wales, is an equally complex and incredible one, providing a neat encapsulation of the many difficulties there are in trying to suggest how such experiences occur.

Every member of the family (both parents and all five children) has claimed involvement in at least one paranormal event since 1976. On occasions, more than one person witnessed the same event; but most often it was a solitary experience. These events took many forms – most importantly, UFO sightings but also mild poltergeist outbreaks and a vast assortment of associated anomalies. Three of the children claim to have had independent contact with different alien races, including actual trips to other realms of being.

The principal focus was the eldest girl, Gaynor who has experienced direct contact, has visited an alien zoo, been taken for a ride on board a disc-like UFO, taken a guided tour of an alien city, suffered time dislocations and even produced apparently paranormal effects on photographic film. What is particularly interesting is that Gaynor says she has always been 'psychic'. Since a baby, she has seen what might be called UFOs or ghosts; and she claims to see the aura round the human body. At first, she assumed all these things were normal; she had no cause to suspect she was different.

It does seem that the alien contacts experienced by the Sunderlands have a direct relationship with the other paranormal events. Indeed, this is reinforced by the fact that, in an amazingly high percentage of UFO contacts, the central percipient has a history of claimed psychic experiences, which continue after the events that they initially report.

PSYCHIC CONTACTS

There seem to be two broad possibilities: either something external is trying to get in (perhaps aliens, who find psychic people the easiest channel of communication), or something internal is trying to get out.

Most of those who say they have seen aliens would have us believe that the first answer is correct, for that is what the aliens apparently tell them. George Adamski was advised in the 1950s that they 'come from Venus'; and in 1964, a Bolton woman met 'aliens from Pluto'. But now science has ruled out these planets as abodes of advanced forms of life, modern contactees have reported different origins for their aliens. All this sounds very suspicious. If there is no reason to trust the aliens when they tell us where they come from, what reason is there to trust them when they tell us they are aliens?

An internal origin for these contacts would explain – at least to some extent – the puzzling relationship between paranormal phenomena. All of them would be essentially a similar process clothed in terms to suit the personal beliefs and imagination of the witnesses. If they want aliens from zeta Reticuli, then they get them. If they are more inclined to believe in ghosts, then they get them instead (or even perhaps both things together). Such a concept would explain why contacts vary so widely from case to case, and yet remain

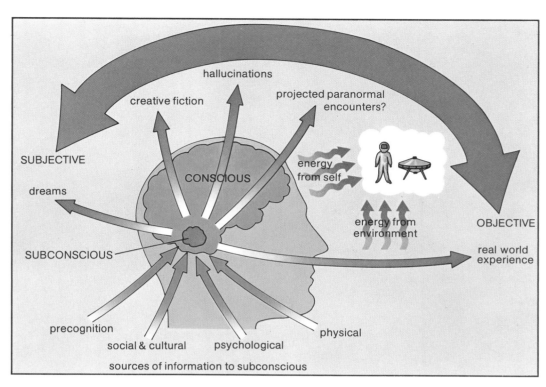

The diagram, right, explains the theory of subconscious projection. This relies on the idea that we all possess a store of subconscious archetypes that change only in context. For example, in the past these probably included angels and demons, whereas today they are replaced by benign or malevolent humanoids. According to this theory, something triggers off a projection of a paranormal encounter, peopled by archetypes and experienced as reality by the subject. This fits in well with the ideas of author and researcher Hilary Evans, who believes that paranormal experiences can be located on a continuous spectrum, with dreams at one end and solid, everyday reality at the other.

George King, shown together with his wife, above, founded the Aetherius Society in 1956, and claimed to have been called 'to become the voice of the Interplanetary Parliament'. The voice he heard was not psychic, he stressed, but 'completely physical'. It told him that spiritually advanced 'masters' live on other planets and are concerned about the welfare of mankind. King is seen here with the tape recorder he used to record the messages from the 'masters'.

❚❚ FOR ME, THE CONCLUSION IS INESCAPABLE: THEY ARE ALREADY HERE. THOUGH I DO NOT WANT TO BELIEVE THIS, AND FEEL DECIDEDLY UNNERVED BY IT, I BELIEVE IT IS TRUE. EXTRA-TERRESTRIALS HAVE BEEN OBSERVING US IN OUR INNOCENCE FOR MANY YEARS. ❚❚

BUDD HOPKINS, UFO INVESTIGATOR

within a basic pattern. It would also give us a means of understanding how a ghost can be created by rumour, and endowed with substance by those who perceive. It would also provide a reason for the obvious subjectivity of most of the contacts.

There are many comparisons between alien contacts, out-of-the-body experiences, and the hallucinations known to occur on the threshold of sleep and wakefulness. Time lapses, jumps from scene to scene, and certain internal features are found, for example, in all such phenomena. And there is also the peaking of experiences at 2 or 3 a.m., when the mind is most relaxed and brainwave patterns most receptive, a time when normally we dream our deepest dreams.

For this possibility to be accepted, two strong objections need to be overcome. What about the occasional physical evidence of UFOs, such as the stopping of car engines or marks on the ground? If we are willing to accept psychokinesis (the moving of objects without visible or known force) and we believe that Ted Serios and others can mentally impress images on to photographic film, then it is possible that the effects found in some UFO contact cases could be caused in a similar way, perhaps by psychics when their brainwaves are most receptive and powerful. The source of such productions could be deep and uncontrollable.

Just as dreams emerge from the depths of our subconscious, translated into images that have symbolic meaning to us personally, there seems justification for a belief that UFO contacts may work in a similar manner. Indeed, dreams, hallucinations, and possibly something just a little beyond may all be portions of a continual spectrum emerging from ourselves and our internal or collective needs. Thus, it may be that UFOs are images in our minds, not travellers from space. In some cases, these images may become so powerful that they are projected by the mind, to be seen as semi-material entities.

The four photographs on this page are stills that have been taken from a movie film made by an Associated Television camera team while working on the programme *Farming Today,* near Birmingham, England, in October 1972.

Cameraman Neil Stuart caught the brightly shining streak as it shot across the sky, *above.* It grew in length, as shown *above right* and *right,* and finally split into two barely visible 'blips', *below,* before vanishing.

The team reported the sighting to the authorities and to UFO investigators. Jenny Randles of Northern UFO Information Network watched the film and concluded that the 'UFO' was probably an F-111 tactical bomber from a nearby US Air Force base, jettisoning fuel. This was denied by a spokesman for the USAF – quite understandably, as offloading fuel is actually illegal over arable land. The case remains – rather unsatisfactorily – open to a number of interpretations.

The brilliant, gold-coloured UFO, *above,* was seen and photographed by Norman Vedaa and an anonymous friend near Denver, Colorado, USA, at 6.20 a.m. on 28 August 1969.

The solitary UFO was hovering over the highway when Vedaa saw it and grabbed his camera. He noted the object's 'extreme brilliance' and seemingly solid appearance, while his companion took the first of two photographs. They then drew in to the hard shoulder and took the second picture, remarking that the UFO was making no sound. While adjusting the camera, they saw, out of the corner of their eyes, the UFO turn and fly away at great speed, to 'disappear within seconds'. The pictures were subjected to the battery of computerised tests used by Ground Saucer Watch, Inc. These indicated that the object was dense, three-dimensional and distant from the camera – in short, a true UFO. GSW concluded: 'The images cannot be explained by any presently known natural or celestial phenomena.'

An alleged spacecraft is seen hovering over the Sixth Annual Spacecraft Convention, held at Giant Rock, in the Mojave desert, California, in the 1950s, *right.* That a UFO should put on such a display at such a gathering – and be photographed into the bargain – seems almost too good to be true. The most likely explanation is that the photograph in fact shows a 'dust devil', caused by a miniature whirlwind. But there is another possibility: that delegates to such a convention might, whether consciously or otherwise, wish to see a visiting alien spacecraft, projecting this wish on to the environment and thence on to film. If so, this is indeed a remarkable photograph.

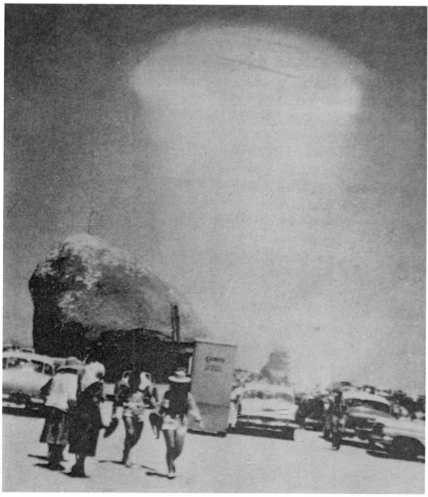

LEGIONS OF HELL

THE NAZI PARTY'S RISE TO POWER HAS OFTEN BEEN ATTRIBUTED TO OCCULT PRACTICE. ADOLF HITLER HIMSELF WAS UNDOUBTEDLY FASCINATED BY THE 'BLACK ARTS'. HOW AND WHY DID THIS SOMEWHAT BIZARRE ASSOCIATION DEVELOP?

The swastika became the official insignia of the Nazi Party, as shown below on banners at a rally at Nuremberg in 1933. Sitting on a white disc with a red background, it was a striking symbol which to Adolf Hitler, right, represented all the ideals of the Nationalist movement. Many have seen Hitler's decision to reverse the ancient symbol – to use a 'lefthanded' swastika rather than the traditional 'right-handed' one – as an indication of his sinister leanings. Once a symbol of good fortune, the swastika is now seen throughout the world as the embodiment of evil itself.

In the late summer of 1940, as the Battle of Britain was drawing to its close, Toby O'Brien, press secretary to Winston Churchill, suddenly had an inspiration. He was sitting in his bath one morning, when the words of a coarse comic song began to form, 'unbidden', in his mind. He repeated his composition over lunch later that day to a group of high-ranking British officers in Whitehall. They were convulsed with mirth. Some of them wrote it down, while others memorised it. Within weeks, it

had filtered through the ranks and was on the lips of squadron leaders, squaddies and admirals alike. Sung to the tune of *Colonel Bogey,* it went:

'Hitler, he only had one ball;
Goring had two but very small.
Himmler was very similar,
But poor old Goebbels
Had no balls at all.'

Toby O'Brien certainly did not believe his composition was accurate: precious little was known about the sexual endowments or habits of the Führer. But when Russian military surgeons examined Hitler's charred remains in the Berlin bunker in May 1945, they discovered that Hitler was indeed monorchid – that is, he possessed but one testicle. It was a bizarre and extreme coincidence.

Hitler's defect may indeed have had a profound significance for the development of his occult ideas. According to Dr Walter Stein, whose observations on personal conversations with Hitler in Vienna formed the basis of Trevor Ravenscroft's *The Spear of Destiny,* Hitler had formed, as early as 1912, a passion for the music of Richard Wagner – particularly for *Parsifal,* which praised Teutonic knighthood and exalted the Aryan race. Soon, Hitler discovered Wagner's source: the medieval poetry of Wolfram von Eschenbach. In fact, it was through buying a copy of Eschenbach's *Parsival* that had once belonged to Hitler that Stein met him. Dr Stein was impressed by the meticulousness of the marginal notes, though he was simultaneously appalled by

Toby O Brien, **below,** *penned an unwittingly accurate lampoon against Hitler in 1940.*

ong before Guido von List, **below,** *adopted the swastika as the emblem of his neo-pagan movement in Germany in the late 19th century, the 'crooked cross' was a widespread symbol of good luck, of life and of energy. The swastikas on the figure,* **right,** *part of the handle of a bucket found in the 9th-century ship-burial at Oseberg, Norway, represent the hammers of Thor, god of thunder and war. Those on the plinth of the statue of Kali,* **above right,** *meanwhile, signify a life-giving, regenerative force.*

the pathological race-hatred that they showed. Among them, there appeared numerous references to the character Klingsor, whom Hitler apparently identified with the notorious ninth-century tyrant, Landulph II of Capua.

Landulph's avaricious grasping for power had led him to study the black arts, and it was for these practices that he was excommunicated in AD 875. But one other fact must have given Hitler a sense of identity with the ninth-century 'Führer'. Landulph seems to have been either partly or totally castrated: Eschenbach described him as 'the man who was smooth between the legs'.

We know that Hitler was easily influenced as a youth, avidly soaking up the ideas of those –

Wagner and Nietzsche, for instance – who impressed him. Landulph's power mania and the unfortunate anatomical similarity to himself must have struck the young Adolf, and there is reason to suspect that Landulph's black magic did so, too. There is also evidence that Hitler was impressed by magical symbolism from the beginning of his political career.

PAGAN RITES

Throughout the latter half of the 19th century, German pseudo-intellectual circles had been obsessed with a movement compounded of pagan ritual and notions of Nordic purity, invented by a man named Guido von List. Born in 1848, the son of a rich trader in leather goods and boots – pointers, perhaps, to things to come – von List had renounced his Catholicism when he was 14 with a solemn oath that he would one day build a temple to Woden (or Odin), the war god of Scandinavian mythology.

By the 1870s, von List had a sizeable group of followers, dedicated to observing pagan feasts at the solstices and equinoxes. In 1875, they attracted attention to themselves by worshipping the Sun as Baldur, the Nordic god, slain in battle, who rose from the dead. The rite was held on a hilltop near Vienna, and concluded with von List burying eight wine bottles that were carefully laid out in the shape of a swastika.

The swastika had been a widespread symbol of good fortune from earliest times and among all nations: it had been found on Chinese, Mongolian and American Indian artifacts, was used by the ancient Greeks as a pottery decoration, and by medieval architects as a border design for stained

Hörbiger's belief that planets follow a spiral path led him to suggest that there were originally four moons orbiting the Earth, of which our present Moon is the only remaining one. The last collision of a moon with the Earth, some 13,000 years ago, he claimed, caused the disappearance of Atlantis – which the Nazis believed to be the original Aryan homeland.

Himmler was particularly impressed with Hörbiger's theories, and declared that he would build an observatory in Linz, his home town, dedicated to Copernicus, Kepler – and Hörbiger.

*In*FOCUS

A WORLD OF ICE

How did the cosmological theories of a blacksmith-turned-engineer become a mainstay of the Nazi world view?

The man in question was Hanns Hörbiger (1860-1931), *far right,* who believed that, among the 'cosmic building stuff' making up the Universe, there exists water in its 'cosmic form' – ice. This ice, he said, forms itself into large blocks that orbit young stars. Ignoring Kepler's laws of motion, which state that orbiting bodies travel in ellipses, Hörbiger argued that these blocks of ice follow a spiral path, so that they eventually collide with the star, *above,* causing an enormous explosion. The star then ejects a molten mass of rotating matter, *above right,* which forms a new solar system, *right.*

glass windows. Its name in Middle English, *fylfot,* means 'fill foot', since it was a device used for 'filling the foot' of windows. 'Swastika' stems from the Sanskrit *Su asti,* which means, literally translated, 'Good, he is'. In fact, the swastika, with its arms trailing as if the pattern were spinning clockwise, symbolised the Sun and the power of light.

In the 1920s, when the National Socialist movement was still in its infancy, Hitler asked for designs to be submitted for an easily recognisable symbol, akin to the hammer and sickle of the Russian communists. Friedrich Krohn, a dentist who was also an occultist, suggested a swastika on a white disc with a red background – red for blood and the social ideal, white for nationalism and purity of race, and the swastika for 'the struggle for victory of Aryan man'.

Hitler was delighted but for one detail – the traditional 'right-handed' swastika was to be reversed to form what the writer Francis King terms 'an evocation of evil, spiritual devolution and black magic'.

Dr Krohn fully realised Hitler's intention in changing the ancient sign, for he was a member of the *Germanenorden* – German Order – which, with the Thule Society, had taken over where von List's rather amateurish organisation had left off in the years before the First World War. Both societies which eventually became almost interchangeable in ideas and even membership, were originally composed of the German officer class and professions who were convinced of a massive international Jewish conspiracy, backed up by occult practices. To counter this, they established their own Nordic occult-based freemasonry, complete with elaborate

rituals and robes, Viking helmets and swords. More importantly, the Thule Society – which took its name from the fabled land of Ultima Thule, a sort of paradise on Earth – began to recruit new members from the lower classes and disseminated anti-Semitic material in its various newspapers. One of these, the *Völkischer Beobachter*, eventually became the official journal of the Nazi Party.

There is no doubt that Hitler, both in his down-and-out days in Vienna and later, as leader of the rising Nazi Party in the 1920s, was constantly fascinated by fringe occult theories. One of these was the lunatic 'World Ice Theory', a complicated set of ideas propagated by an Austrian engineer named Hanns Hörbiger (1860-1931). He held that the planets had been created by the collision of stars, such as our Sun, with huge chunks of ice. Hörbiger also held that his system enabled him to forecast the weather accurately. Some occult writers, notably Pauwels and Bergier in their *Dawn of Magic,* have even suggested that Hörbiger's forecasts influenced Hitler's disastrous Russian campaign.

Latterly, Hitler became obsessed with map dowsing – swinging a pendulum over a map to find hidden objects. The topic was brought to the attention of Hitler's aides by an architect named Ludwig Straniak, yet another amateur occultist. Straniak demonstrated to German naval officers his apparent ability to pinpoint the whereabouts of their ships at sea, simply by dangling a pendulum over an admiralty chart. They were particularly impressed when he located the pocket battleship *Prinz Eugen,* at that time on a secret mission.

THE BLACK MAGICIANS

Hitler's involvement with astrology, and prediction in general, has been much debated. It has even been claimed that he had powers of precognition, which allowed him to foresee the lack of opposition to his invasions of Austria and Czechoslovakia. But Hitler's real talent was as a masterly judge of the European political mood – an intuition that deserted him when he decided to invade Poland in 1939.

Josef Goebbels, propaganda minister, used astrology cleverly but cynically – quoting Nostradamus, for instance, in support of Nazi domination. Hitler and, in particular, SS chief Himmler took astrology seriously.

In view of this varied preoccupation with the occult, many have suggested that, among high-ranking Nazis, Hitler and Himmler at least were in a real sense 'black magicians'. However, one great question confronts those who claim this. Why,

> **" LIKE A SHAMAN, HE [HITLER] HAD EYES OF FIRE AND THE FACULTY OF CONJURING UP THE SPIRITS FROM WITHIN THE ABYSS OF HIS OWN SOUL. "**
>
> **CHRISTOPHER NUGENT,**
>
> **MASKS OF SATAN**

The German pocket battleship Prinz Eugen, top, was located by occultist Ludwig Straniak, simply by swinging a pendulum over a map. After hearing of Straniak's impressive demonstrations, Hitler himself became interested in – and then obsessed with – map dowsing.

Although no believer in the occult, Josef Goebbels, above, minister for propaganda and enlightenment, recognised Hitler's fascination for the subject and skilfully used it as a psychological weapon to further the Nazi cause among the German people.

when the Nazis rose to power, were occult writings and practices so rigorously stamped upon?

In 1934, a first move was made when the Berlin police issued a ban on all forms of fortune-telling, from fairground palmists to society astrologers. That the orders came from central headquarters is certain, and the officers who carried out the orders were very confused as to the intention behind them.

Next came a general suppression of all occult groups, even – to the chagrin and surprise of members – the German Order and the Thule Society. Both contained many Nazis, of course, but even for these there was no exemption. For instance, Jörg Lanz von Liebenfels, whose writings inspired much of the German racial mystique, and who boasted that by introducing Hitler to occult groups he had been his guru, was told that he must not publish occult works in future.

With the sole exceptions of 'inner party members', such as certain of Himmler's personal SS aides, occultists of all shades had been done away with or driven underground in German-occupied countries by 1940.

An answer to the enigma has been mooted by such writers as Francis King and J. H. Brennan. They argue that in regimes that in some ways are analogous with Hitler's – Mao's China, for instance, and Stalin's Russia – there was no such systematic weeding out of occultists. True, Stalin pounced on freemasons and the like, but only because they belonged to 'secret societies' *per se,* not because of their supposed magical activities. In China, even after the Cultural Revolution, seers and astrologers were frowned upon as superstitious, but nothing desperate was done against them. They were more mocked at than persecuted. Intriguingly, it seems authoritarian regimes do not usually fear magical practices as such.

But Nazi Germany had to trample down 'free-lance' occultists, because it was in effect trampling down its own rivals. There was, in fact, only one occult movement permissible under the Third Reich, and it was hidden deep in its coils. It was led by the supreme magus, Adolf Hitler, and his acolyte, Heinrich Himmler – both of them known to have been powerful black magicians.

VAMPIRES: MYTH AND REALITY

WHATEVER THE TRUTH OF THE VAMPIRE LEGEND, COUNT DRACULA CONTINUES TO HOLD HIS AUDIENCES IN A STATE OF HORRIFIED HALF-BELIEF

In Dracula AD 1972 – *a still from which is shown* above – *Christopher Lee, as the Count, attacks an innocent victim in a typical film interpretation of the vampire legend. The sado-masochistic overtones of the story, with its sexually irresistible attacker and willing victim, contribute to its overwhelming power to fascinate.*

In the illustration, **above right,** *three Brahmans make incantations, accompanied by vampires, in a story from Sir Richard Burton's* **Tales of Hindu Devilry.** *The tales are purportedly told by the Baital, Indian vampires.*

The Day of Judgement, as depicted **right,** *is symbolised by the the struggle to escape from the tomb. In the past, premature burial has all too often been a matter of grim reality.*

At the end of the first stage version of *Dracula* in 1924, the actor-manager Hamilton Deane (who played the part of Van Helsing) appeared before the curtain with a little reassurance for the audience:

'Just a moment, ladies and gentlemen! Just a word before you leave. We hope the memories of Dracula.. . won't give you bad dreams, so just a word of reassurance. When you get home tonight and the lights have been turned out and you are afraid to look behind the curtains and you dread to see a face appear at the window – why, pull yourself together! And remember that, after all, *there are such things!'*

It was a perfect exit line. The audience, primed to a fine degree by a background of vampire books, had spent the evening thrilling to the extraordinarily compelling tale of 'the greatest vampire of them all' – Dracula. His creator – the theatre manager, Bram Stoker – knew instinctively that his story would strike some chord deep in the collective subconscious of his audience.

As actor Christopher Lee explained, Dracula appeals partly because he is a superhuman figure, an immortal whose chilling presence is also sexually irresistible. Psychologists point to the clear difference between the sadistic, dominant vampire and the masochistic or subservient victim. But whatever the jargon used, Dracula is generally more fascinating than the atavistic werewolf (who is, after all, at least half animal, and certainly not an aristocrat) or the shadowy ghost.

The vampire is also rather different from 'the creature from the black lagoon' or Dr Who's enemies, the Daleks. Whereas such creatures as these can be dismissed as mere stagecraft, thrilling enough during the performance but forgotten soon after, the vampire is to be taken seriously. Indeed, there are masses of documents from 18th-century Eastern Europe presenting evidence for the existence of the 'undead'. Could it be, then, that there are actually such things?

As in many other aspects of the paranormal, all possible rational explanations must be thoroughly exhausted before a 'supernatural' explanation can even be considered. And in the case of the 'vampire epidemic' of 200 years ago, there are several

such rational explanations to choose from.

As the popular occult writer Dennis Wheatley has pointed out, in past times of great deprivation, beggars often broke into graveyards, sleeping in the shelter of mausoleums by day, and emerging at night to forage for food. Thin, pale and seen leaving tombs under cover of darkness, they were, perhaps not unnaturally, often taken for the legendary and terrifying vampires.

However, the mistaken identity of a few human scavengers does not explain those cases of corpses found to be incorrupt when their coffins were opened. This is a rare but by no means unknown phenomenon and various 'natural' explanations have been suggested as the cause of it. Certainly, the soil in which a body is buried can make an astonishing difference to the rate at which it decomposes. On the volcanic island of Santorini, Greece, for example, corpses are sometimes found so intact after a great number of years that the local people have a saying that speaks of 'sending a vampire to Santorini', just as the British might speak of 'sending coals to Newcastle' – that is, sending goods to a region where they are superfluous.

But by far the most convincing explanation is that of premature burial. Not all cataleptics were as fortunate as the Irish soldier, in the early 1800s, who 'came back to life' when being roughly handled prior to his burial. Coma, catalepsy and other death-like states are barely understood by the modern world, let alone by superstitious peasants from 'the land beyond the forests' in times gone by.

Indeeed, how many poor wretches may have awoken to discover themselves immured in a coffin with the heavy earth pressing down on them; or perhaps, having successfully fought their way out of the coffin, found themselves locked in the family mausoleum, there to die of hunger, thirst and inevitable horror?

TERROR BEYOND THE GRAVE

Premature burial was, in fact, common. It is even said that, when an 18th-century English graveyard was being demolished to make way for a car park, a third of the corpses turned up by the bulldozer showed signs of having struggled while in their coffins. The evidence included broken fingers from scratching at the coffin lid in their final death agony, hands protruding from the coffin, and blood upon the shroud where the 'corpse' had bitten his or her own flesh as suffocation, or madness, took its toll. Indeed, it was the presence of blood on an exhumed corpse that was frequently considered proof that the dead person was a vampire.

But if the newly dead was rumoured to be a vampire (perhaps feeble sounds may have been heard emanating from the grave), then the terrified 'witnesses' would take the time-honoured measures against it. And if the 'corpse's' heart was beating, that was, to them, a sure sign that it must be staked. No wonder there are so many accounts of alleged vampires screaming as the stake was plunged into their living hearts.

Charlotte Stoker used to tell the young Bram a grisly bedtime story concerning a local victim of the cholera epidemic. This woman, believed dead, was thrown on the heap of corpses in the lime pit. However, her grief-stricken husband, who went to

recover her body in order to give her a decent burial, discovered she was still breathing. She lived on happily for many years after that appalling experience. But what if she had recovered by herself and had been seen staggering out of the pit at night? It would have been easy to mistake her for one of the 'undead'.

From time to time, modern newspapers carry stories of people, certified dead, coming to life on the marble slab in the morgue or when being prepared for burial. In these days of 'spare part' surgery, controversy rages over the exact moment and true nature of death more than at any point in history. But the Victorians were at least aware of the possibility of premature burial; some even became obsessed with the idea. Edgar Allan Poe based several of his stories on the theme; and in both the United States and Europe, various patents were taken out on coffins with alarm bells or emergency air supplies incorporated into their design.

There is even a logical explanation for the widespread use of garlic as a vampire repellent. Plague was frequently carried by flies, and it was noticed that certain farms were spared if they hung out garlic. There was no magic involved; garlic bulbs exude drops of moisture that flies detest. Garlic, when eaten, is also believed to be a natural antiseptic, and a blood purifier.

Vampires were also a useful scapegoat in certain rural communities, if animals weakened and died. These days, the vet would no doubt administer a dose of antibiotics or special vitamin supplement and all would be well – in most cases. Mysterious sicknesses and mutilations of cattle and other animals do still sometimes occur; but in some regions, hostile ufonauts are now occasionally deemed to be the culprits.

DEMONIC BLOODSUCKERS

There may frequently be logical, even mundane, explanations for 99 out of every 100 cases of alleged vampirism, but it is the hundredth case that will set the researcher wondering. For many years, occultists have believed in the terrifying existence of demonic bloodsucking materialisations. One, the practising occultist Dion Fortune (whose real name was Violet Firth), believed that it is possible for the 'astral body' to escape from a person's living body and assume another form such as a bird, an animal – or a vampire.

Dion Fortune also cited the case of dead Hungarian soldiers who are believed to have become vampires during the First World War, maintaining themselves in the 'etheric double' – that is, halfway between this world and the next, or 'earthbound' – by vampirising the wounded. Vampirism is, indeed, believed to be contagious; and the person who is vampirised, being depleted of vitality, is thought to be a turned into a psychic vacuum, capable of absorbing the 'life force' from anyone unfortunate enough to fall prey to him.

Psychical research, on the other hand, deals not with beliefs but with observed facts. One of the most common of all phenomena investigated by the Society for Psychical Research in London, for example, is that of the poltergeist; and an allied phenomenon seems to be that of the invisible attacker. Raised scratch marks appeared on the face of poltergeist victim Eleonore Zugun of Rumania, during 1926, for example. And, in 1960, Jimmy de Bruin, a 20-year-old farm worker in South Africa, became the focus for a spate of poltergeist activity. On one occasion, an investigating police officer actually heard de Bruin scream with agony as cuts spontaneously appeared on his legs and chest.

Other areas of the paranormal also involve the spontaneous appearance of wounds or blood, such as images that are suddenly observed to bleed and individuals who produce stigmata. These, however, are commonly accepted as 'holy' phenomena, whereas vampirism is widely believed to be 'of the Devil'. It may indeed be true that they are opposite sides of the same coin, one good and the other evil. But perhaps all unexplained phenomena emanate from the same source, being neither moral nor immoral, just unusual. Meanwhile, we can continue to thrill to the latest vampire tale and ponder on the nature of its origin.

Premature burial may often have arisen because the various steps of *rigor mortis* are commonly misunderstood. The muscles of a corpse start to go rigid, beginning in the face and neck, about an hour-and-a-half after death. (This may set in sooner or later, depending on the temperature of the surroundings.) *Rigor mortis* passes off roughly 36 hours later – the muscles lose their extreme rigidity and the body becomes relatively pliable. This could well be the explanation for the 'vampire' story heard in 1974 in the valley of Curtea de Arges, Rumania. Here, a handsome gypsy woman described, through an interpreter, the shock of her family when they came to lay out her father's body for burial; for the limbs were pliable, not rigid. This news raced through the village, where this could mean only one thing – the old man had become a vampire. A stake was duly plunged through his heart, and the villagers were satisfied and relieved. But perhaps – if this was not simply a case of *rigor mortis* passing off prematurely – the old man was still alive.

*The vampire bat, **Desmodus rotundus**, above, is found in Mexico and South America. These creatures, only about 3 inches (8 centimetres) long, are able to feed on the blood of sleeping animals without awakening them.*

// VAMPIRISM IS BELIEVED TO BE CONTAGIOUS; AND THE PERSON WHO IS VAMPIRISED, BEING DEPLETED OF VITALITY, IS THOUGHT TO BE TURNED INTO A PSYCHIC VACUUM... //

THREE YOUNG FRENCHMEN HIT THE NEWS HEADLINES WITH AN AMAZING TALE ABOUT A UFO ABDUCTION IN THE REGION OF PARIS. WHAT HAPPENED DURING THIS CURIOUS TIMESLIP?

'Frenchman back to Earth with a bump' was the headline in the London *Times*. Across the world, the media reported the news to a public that remained unsure whether to take the story seriously or not. But this much was certain: Franck Fontaine, allegedly kidnapped by a UFO a week before, had been restored to friends, family and a wondering world in the early hours of Monday, 3 December 1979.

Where exactly had he spent those seven days? The world, hoping for a story that would make the Moon landing seem tame, was disappointed. Fontaine's recollections were few and confused. It seemed to him that he had simply dropped off to sleep for half-an-hour: indeed, he was astonished and dismayed to find he had been away for a week. He attributed the strange images in his mind to dreams, and was in fact bewildered to learn that he might have been abducted by extra-terrestrials.

Fontaine was equally dismayed to find himself the focus of the world's attention. During his seven-day absence, it had been his friends, Salomon N'Diaye and Jean-Pierre Prévost, witnesses of his abduction, who had been the objects of attention. Ever since their first startling telephone call to the police – 'A friend of mine's just been carried off by a UFO!' – they had been subjected to interrogation by the police, by the press, and by UFO investigative groups. But if Fontaine's return brought renewed publicity and fresh problems, at least it cleared them of the suspicion that they were responsible for their friend's disappearance – perhaps even his death.

The life-style of the three young men was not of a sort to dispel suspicion. All three – Prévost, aged 26, N'Diaye, 25, and Fontaine, 18 – scraped an uncertain living by selling jeans in street markets. They drove an old car that was uninsured, and none of them had a driving licence. Prévost was a self-declared anarchist. He and N'Diaye lived next door to each other in a modern block at Cergy-Pontoise on the outskirts of Paris. Fontaine lived 2 miles (3 kilometres) away.

According to their account, Fontaine had spent Sunday evening in Prévost's flat because they wanted to be up by 3.30 a.m. to travel the 35 miles (60 kilometres) to the street market at Gisors. The

Police search a field in Cergy-Pontoise, France, for clues to the disappearance of Franck Fontaine, reported as having been abducted by a UFO, below. Fontaine's two friends, Jean-Pierre Prévost and Salomon N'Diaye, said they had witnessed the kidnapping early one morning in late November 1979. In the background is the block of flats in which Prévost and N'Diaye lived and near which the event occurred.

MYSTERY OF THE LOST WEEK

market did not start until 8 a.m., but they wanted a good place. Besides, their Taunus estate car had been acting up lately, so they thought it prudent to allow extra time. After only about four hours' sleep, they were up and ready to load the car with clothes.

First, though, they gave the car a push-start to make sure the engine would function. Having got it going, they decided that Fontaine should stay in the car to make sure it would not stop again, while the other two got on with the loading. Fontaine had time to look about him, and so it was that he noticed a brilliant light in the sky some distance away. When his companions arrived with their next load, he pointed out the object. It was cylindrical in shape, but otherwise unidentifiable. When it moved behind the block of flats, N'Diaye rushed upstairs to fetch a camera, thinking he might take a photograph of the object to sell to the press. Prévost went in to

get another load of clothing while Fontaine, hoping for another view of the mysterious object, drove up to the main road that ran close by the flats.

BALLS OF LIGHT

Hearing the sound of the moving vehicle, his companions looked out of the windows of their respective flats. Both saw that Fontaine had stopped the car on the main road and noted that the engine was no longer running. Prévost, angry because they would probably have to push-start the car a second time, rushed downstairs again, and called to N'Diaye to forget about his camera because the UFO had now vanished. N'Diaye came after him, saying that in any case he had no film in his camera, and adding that from his window it had looked as though the car was surrounded by a great ball of light.

Outdoors again, the two young men stopped in amazement: the rear of their car was enveloped in a sharply defined sphere of glowing mist, near which a number of smaller balls of light were moving about. While they stood watching, they saw the larger globe absorb all but one of the smaller ones. Then a beam of light emerged, which grew in size until it was like the cylindrical shape they had seen

Franck Fontaine is seen, top, leaving the police station after being questioned upon his safe return. He said that his 'missing week' was a blank in his mind.

Salomon N'Diaye, above, and Jean-Pierre Prévost, right, reported the UFO incident to the police at once – a fact that convinced many that they must have been telling the truth.

earlier. The large sphere seemed to enter this cylinder, which shot up into the sky and disappeared from sight.

The two hurried to the car, but found no sign of Fontaine. He was not in the car, nor in the road adjacent, nor in the cabbage field. Prévost insisted on calling the police immediately and N'Diaye went off to do so. Prévost, remaining near the car, was the only witness to the last phase of the incident: a ball of light, like those previously moving about the car, suddenly seemed to push the car door shut. Then it, too, vanished.

Such was the account that the two young men gave to the police on their arrival a few minutes later. Because UFO sightings are a military matter in France, the police instructed Prévost and N'Diaye to inform the gendarmerie, which comes under the Ministry of National Defence. The two then spen

most of the day, telling and retelling the story. The interrogators stopped for lunch, during which time the witnesses telephoned the press with their story. Later, Commandant Courcoux of the Cergy gendarmerie told the press that there were no grounds for disbelieving the young men's story, that he had no doubt 'something' had occurred, but that at the present time he could give no indication of what that 'something' might possibly be. In a later interview, however, he admitted: 'We are swimming in fantasy'.

For a week, that was all the world knew. During that week, the young men were questioned over and over again. Some people accepted the UFO story as it stood. Others suspected it to be a smokescreen, perhaps a cunning plan to help Fontaine avoid doing his military service, or perhaps something more sinister. But one fact stood out clearly: Prévost and N'Diaye had informed the police promptly and voluntarily. Given their backgrounds, surely this was convincing proof of their sincerity?

When Fontaine gave his version of the story, there seemed no reason to question his sincerity either. He told how he had woken to find himself lying in the cabbage field. Getting to his feet, he realised he was just across the main road from the flats, close to where he had stopped the car to watch the UFO. But the car was no longer there. His first thought, as he hurried towards the darkened building, was that somebody had stolen their car and its valuable load of clothing. Neither Prévost nor N'Diaye was to be seen, so he rushed upstairs and rang the bell of Prévost's flat. When there was no reply, he went to N'Diaye's apartment. A sleepy N'Diaye appeared, gawped at him in amazement, then flung his arms round him in delighted welcome. Fontaine, already surprised to find his friend in his night-clothes, was even more amazed to learn that an entire week had gone by since the morning of the Gisors market.

Jimmy Guieu, well-known science fiction writer and founder of a UFO group, is seen above. The trio put themselves into his hands exclusively; but other UFO investigators found them to be very uncooperative.

He had little to tell the press or the police. The world's media reported his return but reserved judgement until they heard what the authorities had to say. But the police declared it was no longer their business: after all, no crime had been committed. Apart from the inherent improbability of Fontaine's story, they had no reason to doubt his word nor that of his friends.

Besieged by Ufologists

So now it was up to UFO investigators to see what further light could be thrown on the case. From the start, the witnesses had been besieged by various French groups, most of them fiercely independent and reluctant to cooperate with the others. One of the most reputable of all is called *Control,* to whom we owe most of what we now know of the inside story of the Cergy-Pontoise case.

But another group declared its interest before *Control,* while Fontaine was still missing: this was the *Institut Mondial des Sciences Avancés* (World Institute of Advanced Sciences). Its co-founder and spokesman was the well-known science fiction writer and author of two books about UFOs, Jimmy Guieu. Before he had carried out an investigation, Guieu affirmed his belief in the story: 'No question

> ❚❚ THE ALIENS EXPLAINED THAT FONTAINE HAD SIMPLY BEEN THE MEANS TO ESTABLISH COMMUNICATION: PRÉVOST WAS THE CHANNEL THROUGH WHOM THEY COULD COMMUNICATE TO HELP SAVE EARTH FROM IMPENDING DISASTER. ❚❚

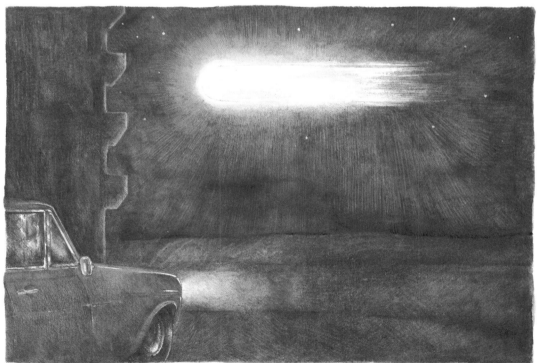

The cylinder-shaped UFO, right, depicted in an artist's impression, was seen by the three friends and appeared to have a diameter larger than that of the full Moon that night. It had a rounded front end and a tail that trailed off into a hazy cloud. It was when Fontaine went closer to the UFO, alone, that he disappeared.

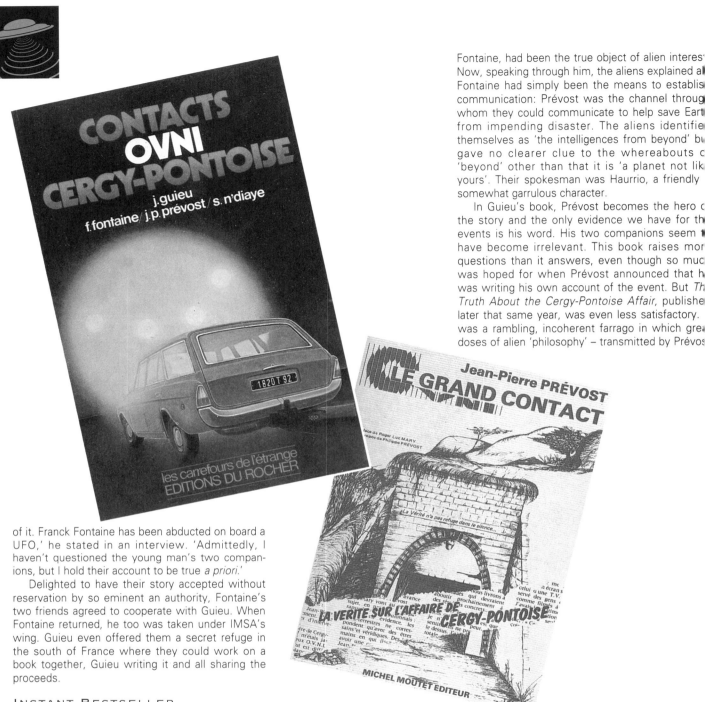

of it. Franck Fontaine has been abducted on board a UFO,' he stated in an interview. 'Admittedly, I haven't questioned the young man's two companions, but I hold their account to be true *a priori*.'

Delighted to have their story accepted without reservation by so eminent an authority, Fontaine's two friends agreed to cooperate with Guieu. When Fontaine returned, he too was taken under IMSA's wing. Guieu even offered them a secret refuge in the south of France where they could work on a book together, Guieu writing it and all sharing the proceeds.

INSTANT BESTSELLER

The resulting book, *Cergy-Pontoise UFO Contacts*, was rushed into print with astonishing speed, appearing a bare four months after Fontaine's return. Thanks to the combination of Guieu's name and the intense interest in the case, it was an instant bestseller. But readers hoping for a conclusive verdict were disappointed. The book was padded out by Guieu's journalistic style and digressive accounts of other cases, and there was an almost total absence of first-hand testimony from the principal witness – the abducted Fontaine – whose story the world wanted to hear. Such revelations as the book contained were of quite another nature.

Guieu had hoped that Fontaine would be able to recall more of his adventure if he were hypnotised, but the young man obstinately refused to submit to hypnosis. Then Prévost suggested that he should be hypnotised instead. What resulted was truly amazing. It now emerged that Prévost, not

Jimmy Guieu's book **Cergy-Pontoise UFO Contacts, top,** *and Jean-Pierre Prevost's book* **The Truth About the Cergy-Pontoise Affair, above,** *were published speedily after the alleged kidnapping of Franck Fontaine. Both turned out to be long on fantasy and short on facts, disappointing all who hoped for some clarification of what had really happened.*

Fontaine, had been the true object of alien interes' Now, speaking through him, the aliens explained a Fontaine had simply been the means to establis communication: Prévost was the channel throug whom they could communicate to help save Eart from impending disaster. The aliens identifie themselves as 'the intelligences from beyond' bu gave no clearer clue to the whereabouts c 'beyond' other than that it is 'a planet not lik yours'. Their spokesman was Haurrio, a friendly somewhat garrulous character.

In Guieu's book, Prévost becomes the hero c the story and the only evidence we have for th events is his word. His two companions seem 1 have become irrelevant. This book raises mor questions than it answers, even though so muc was hoped for when Prévost announced that h was writing his own account of the event. But *Th Truth About the Cergy-Pontoise Affair*, publishe later that same year, was even less satisfactory. was a rambling, incoherent farrago in which gre doses of alien 'philosophy' – transmitted by Prévos

– show that pious platitudes about the need f more love and less science are not necessarily co fined to planet Earth.

There is virtually no mention of Franc Fontaine's abduction: indeed, he and Salomo N'Diaye are scarcely referred to. But Prévost's vis to a secret alien base is described in some deta and this gives us a good yardstick for evaluating th rest of the material. It seems that one mornir soon after Fontaine's return, there was a ring Prévost's door. The caller was a travelling sale man, a total stranger who said he had to make a tr to Bourg-de-Sirod and invited Prévost to com along. Now, Bourg-de-Sirod is a small village ne the Swiss border some 225 miles (360 kilometre from Cergy. On the face of it, there is no concei able reason why a salesman should go there, n why he should think that Prévost might wish to g

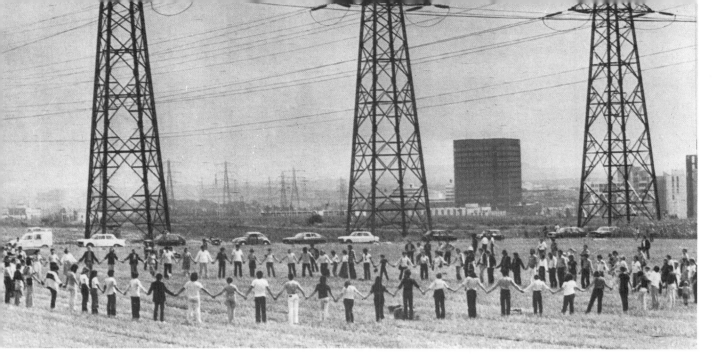

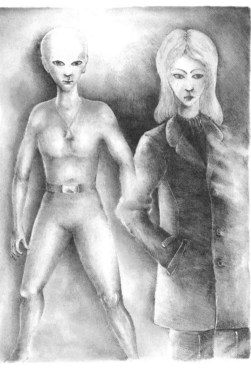

A group of people are shown above, anticipating a close encounter with aliens at Cergy-Pontoise on 15 August 1980. They gathered there when Fontaine revealed his arrangement to meet on that day with his abductors of the previous December.

A being named Haurrio, depicted left, allegedly contacted Prévost on behalf of intelligences from beyond . On one occasion, Haurrio was dressed in a one-piece silver garment, looking decidedly like an alien. On another, he had long blond hair and looked like a masculine woman in a suit. He was said to be friendly and very talkative.

here either, given that they were strangers in the first place.

However, there *was* a reason for interest by Prévost. Bourg-de-Sirod was a specially significant place for him because, as a child, he had gone to a summer camp nearby and had later worked there. More recently still, he and Fontaine had spent a camping holiday there. So Prévost, though surprised at the stranger's offer, cheerfully accepted it. The salesman dropped him off at the village and Prévost set off up the hill towards a particular site that had always fascinated him – a railway tunnel containing an abandoned train carriage from the Second World War.

Arriving at the tunnel in the late evening, Prévost found that other people were there before him – a group of young men gathered round a fire in the open. One of them called out his name: he was

from the Sahara and had recently written to Prévost. It turned out that he and the others had come there from many parts of the world, thanks to the 'intelligences from beyond'. Each spoke his own language – but was understood by the rest.

When Haurrio, the alien representative, arrived, he informed them that they had been chosen to spread the philosophy of the 'intelligences' on Earth. A beautiful female alien then took them on a tour of the tunnel, now being used as a UFO base. They saw several spacecraft, similar to ones that it seems Prévost had seen as a child. After their tour, the young men returned to their camp fire and went to sleep on the ground – which, on a December night in the mountains, must have been less than comfortable. Next morning, Prévost found his friendly salesman waiting to chauffeur him back to Cergy-Pontoise.

> **//** THE EVIDENCE AVAILABLE TO ME SUGGESTS THAT . . . WE ARE BEING VISITED BY A NUMBER OF EXTRA-TERRESTRIAL GROUPS . . . PARTLY PERHAPS TO LEND US A HELPING HAND AS WE REACH, FALTERINGLY, TOWARDS THE STARS. **//**
>
> **TIMOTHY GOOD, ALIEN LIAISON**

The more the men provided in the way of checkable statements, the harder it became to accept the original account of the alleged abduction. Doubts then increased when an investigative team from *Control* persisted in taking up the case without the cooperation of the witnesses – checking all the conflicting statements and fragmented testimony as best they could. Whether Jimmy Guieu and Jean-Pierre Prévost seriously expected their accounts to be believed, we may never know.

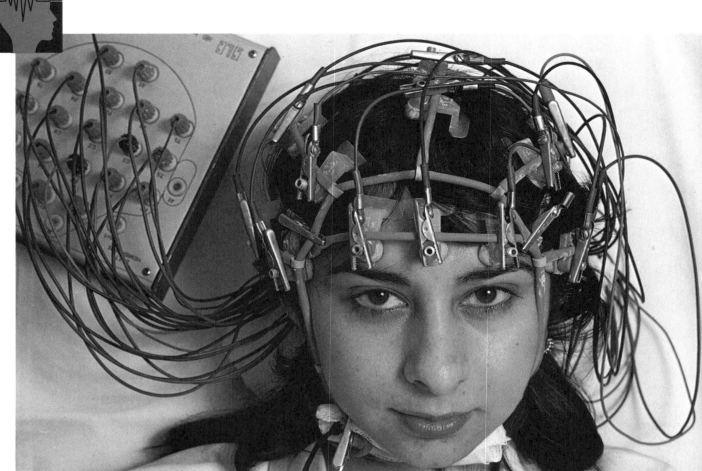

BEYOND THE BRAIN

MANY SCIENTISTS BELIEVE THAT THE MIND IS NOTHING BUT AN ASPECT OF THE ELECTRICAL AND CHEMICAL CHANGES THAT OCCUR IN THE BRAIN. IS THERE ANY EVIDENCE FOR THIS?

Our dreams, desires, memories, feelings and thoughts, our hopes and fears – even the way in which we experience the world around us – are nothing more than the product of chemical and electrical changes inside our brains. So when the brain stops functioning at the time of death, all mental activity ceases; and there is no possibility of our conscious survival of bodily death.

This, at any rate, is the belief that arises from the philosophy of materialism. According to this view, life arose purely by chance in a purposeless Universe, animals and plants evolved as the result of nothing more than chance genetic mutations and the blind forces of natural selection, and Man is

The subject, above, is wired up to an electroencephalograph machine (EEG), which monitors the electrical impulses produced by the brain. The typical EEG, above right, shows a read-out from a normal brain. EEG print-outs present the characteristic patterns associated with different states of brain activity – waking, deep sleep, dreaming and so on – but cannot reveal the actual thoughts passing through the mind of the patient at the time.

nothing more than a complicated machine. But this is not a theory that can ever be proven; what is more, in many respects, it is an atheistic creed.

Nevertheless, materialists often speak as if the success of science in dealing with the physical and chemical aspects of life supports the idea that life is nothing but a complicated set of chemical and physical mechanisms. The fact is, however, that many aspects of life have eluded explanation in purely mechanistic terms. The way in which trees grow from seeds and animal embryos from fertilised eggs, for example, clearly involves far more than the production of the right kinds of chemicals.

Scientist Rupert Sheldrake has proposed an alternative theory to account for the inherited abilities of animals and plants. According to this hypothesis, the form and behaviour of an organism is shaped by so-called 'morphogenetic fields', which impose order and pattern on physical processes within living tissues, including the brain. These

The photograph, top, is of hippuric acid, at a magnification of 150. The bright colours and abstract patterns are typical of certain types of drug-induced hallucination. Tiny amounts of lysergic acid diethylamide (LSD), for example, a colourless liquid that can be taken orally on small pieces of absorbent paper or bound with strychnine to form minute tablets or micro-dots, as shown top right, can produce hallucinations that go well beyond the normal range of activity of the human brain.

fields are built up by a process called 'morphic resonance' from past members of the species, and represent a kind of collective memory. Organisms 'tune in' to them, and through them, to both the form and the experiences of past members of their species. The genetic material, in the DNA of the genes, can affect the tuning system, but the shapes and instincts of the organism are not inherited *in* the DNA – just as people whose images appear on the screen of a television receiver are not carried *inside* the wires and transistors of the set. A correctly wired set is, of course, necessary for tuning in; but the factors that give rise to the pictures come from outside the set.

INFLUENCES FROM THE PAST

In a similar way, Sheldrake believes that the brain may be rather like a complicated tuning system. What is more, he believes, it is possible that it can be tuned to influences from its own past. This implies a theory of memory quite different from the conventional mechanistic theory, which assumes that all mental processes must depend on chemical or physical changes inside the brain. Perhaps memories are not, after all, stored as 'traces' in the nervous tissue, but are picked up by the brain as it tunes in to morphic resonance.

Materialists often argue that the fact that your state of mind can be influenced by physical and chemical changes in the brain shows that it is nothing but a product of brain activity. For example, consuming very small amounts of hallucinogenic drugs, such as LSD, can have dramatic subjective consequences. But this does not mean that conscious experience is nothing but an aspect of changes in the body. Take once again the analogy of a television set: the pictures on the screen can be affected by disturbing the wiring inside the set – or, for that matter, by pouring chemicals into it. But this does not mean that the pictures arise inside the set, or that the events shown on the screen are nothing but an aspect of what is happening within it. They do indeed depend on the set, but they also depend

on what the people are doing in the television studio, and on the electromagnetic waves by which the images are transmitted. If the set is badly damaged and the pictures on the screen disappear, the activity in the studio continues. In other words, the people whose pictures appeared on the screen have not been destroyed just because the set has 'gone dead'.

PATTERNS OF THE BRAIN

Measurements of electrical activity within the brain, using instruments such as the electroencephalograph (EEG), have shown that there are characteristic patterns associated with different states of consciousness – such as waking, deep sleep and dreaming. But while it is possible to tell from an EEG reading when someone is dreaming, for instance, we cannot identify what is actually going on in his or her dreams. It is rather like measuring the vibrations in a cinema projection room: they reveal whether the projector is projecting a film, rewinding, or switched off: but they cannot give any information about the subject matter of the film. Most of what is known about brain activity is as general as this. There is certainly no evidence that every image or thought that we experience is paralleled in detail by specific physical or chemical changes inside the brain.

Another analogy that can be used to help to demonstrate how states of mind depend on what happens in the brain, and vice versa, is provided by a pilot in an aeroplane. While the aeroplane is in flight, the pilot's actions are dictated by his interpretation of the readings on the many dials in the cockpit, wired up to instruments in various parts of the body of the aircraft. He also responds to what he sees in the sky around him and to radio messages from air traffic controllers on the ground. In turn, the actions of the pilot on the controls govern the thrust of the engine and the mechanisms that alter the direction and altitude of flight. But in spite of the fact that changes in the aeroplane influence the pilot, and changes in the pilot influence the

aeroplane, the two are obviously not the same. When he has landed the aircraft, the pilot can get out and leave; and if the aeroplane is badly damaged in flight and seems likely to crash, the pilot will be able to bale out and parachute to safety.

In a similar way, the conscious self can control the body in the waking state, and is in turn influenced both by what happens within the body and in the environment around it, and also by what other people say. But in sleep and in dreams, your mind may not be so closely linked to the body.

Renewing the analogy, sleep and dreaming correspond to the state of the aeroplane on the ground, with its engine ticking over or switched off: under these conditions, the pilot can either leave the controls and wander around within the aeroplane, or leave it altogether. But even when the aeroplane is in flight, the pilot's state need not always be closely linked to the state of the aircraft: he can opt to put it under the control of the autopilot mechanism, and then chat with other members of the crew or read a book, say. Similarly, in the waking state, the mind may sometimes be less

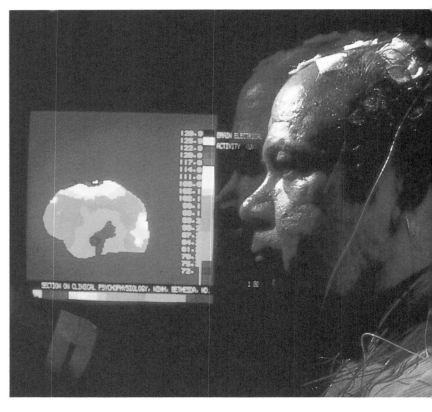

" THE CONSCIOUS SELF CAN BE THOUGHT OF AS INTERACTING NOT WITH A MACHINE, BUT WITH MOTOR FIELDS... IT 'ENTERS INTO' THE MOTOR FIELDS, BUT IT REMAINS OVER AND ABOVE THEM. "

RUPERT SHELDRAKE,

A NEW SCIENCE OF LIFE

The photograph, above, shows a demonstration of mapping of the brain's activity in response to an electric shock to the right arm. The mind, according to the argument of materialists, is nothing but a product of brain activity.
The actions of a pilot and his craft, below left, are closely linked, but the man and the machine are clearly not the same thing.

closely connected with the state of the body than usual – when daydreaming or lost in thought for instance.

One further analogy may also help to make the point that it is possible for the mind and the brain to be closely related without being one and the same thing. The brain may be compared with a complex computer. By itself, the computer 'hardware' can do nothing of significance. It is of use only when the right sort of programs are fed into it. These programs are not part of its wiring, but are created for particular purposes by a conscious

measured physically with scientific instruments. It eliminates the possibility of the existence of God and rejects all religious beliefs relating to life after death. But although this philosophy may have a certain intellectual appeal, does it in fact correspond to the way things really are? Or is it a gross over-simplification?

As to whether the mind and brain are identical, or that the mind is like a passive shadow of the brain, there is no evidence in favour of materialism that cannot be explained just as well, if not better, by the interactionist theory. There are even some very awkward facts that suggest the role of the brain may have been greatly overestimated in the past. It has, for instance, long been known that some people who have suffered from hydro-cephalus, or water on the brain, have greatly reduced amounts of brain tissue: the skull is mainly filled with fluid. In spite of this, they may be quite normal in their thought processes and behaviour.

DIMINISHED BRAINS

Studies on people of this type by Professor John Lorber, formerly of Sheffield University, using modern tissue-scanning techniques, have led him to ask, in a 1982 paper, *'Is Your Brain Really Necessary?'* He spoke of one case: 'There's a young student at this university who has an IQ of 126, has gained a first class degree in mathematics, and is socially completely normal. And yet the boy has virtually no brain.' The student's doctor at the university noticed that he had a slightly larger than normal head, and so referred him to Lorber, simply out of interest. 'When we did a brain scan on him,' Lorber continued, 'we saw that instead of the normal 4.5 centimetre [2-inch] thickness of brain tissue between the ventricles and the cortical surface, there was just a thin layer of mantle measuring a millimetre or so.'

Lorber's findings pose a dramatic challenge to conventional ideas about the role of the brain, and are a severe embarrassment to materialistic theories of the mind.

When it comes to the question of the possible personal survival of bodily death, the materialist theory again conflicts with other views – particularly the evidence from Spiritualist phenomena, memories of past lives in cases suggestive of reincarnation, and the apparent separability of the centre of consciousness from the body in out-of-the-body and near-death experiences. Even if some of this evidence can be explained in terms of telepathy, clairvoyance or precognition rather than in terms of the survival of the conscious self or soul, recognition of the existence of such parapsychological powers would mean that the mind has properties other than those explicable in terms of physics. Unfortunately, however, since all this evidence lies outside the scope of orthodox science, materialists can only ignore it or attempt to dismiss it.

There is, according to Sheldrake, no persuasive logical, philosophical or scientific reason why we should accept the materialist theory that the mind is nothing but an aspect of the functioning of the brain. The idea that the mind interacts with the body seems to make more sense of actual experience. What is more, it leaves open the possibility of a conscious survival of death.

ntelligent person – the computer programmer. The rogrammer's activities, meanwhile, are influenced y the way the computer performs, and the computer is in turn influenced by the programs; but the rogrammer and the computer can in no way be onsidered one and the same.

The idea that the conscious self and the body iteract with each other but not as aspects of the ame thing is known as 'dualism' or 'interaction-m'. It is the view taken by most of the greatest hilosophers from Plato onwards. Indeed, an uthoritative statement to this effect has been nade in a book called *The Self and its Brain*, written ointly by Sir Karl Popper, a distinguished – and ften controversial – philosopher of science, and Sir ohn Eccles, an eminent brain scientist. Meanwhile, ne theory that the mind is nothing but an aspect f the functioning of the brain continues to be efended by materialist philosophers, the debate eemingly never-ending.

What, then, is the main attraction of material-m? It seems to offer a relatively simple and traightforward view of the Universe in terms of atter and the laws of physics. It proclaims that ere is only one kind of reality – that which can be

The mind and brain interact but are not synonymous. The operator, above, is shown feeding a floppy disk – which stores information – into a microcomputer. Materialists like to point out that the brain itself may be compared with a giant computer – but a computer is nothing without its program, which has to be created by an intelligent human being.

The Roman mosaic, left, shows the nine muses, daughters of Zeus and Mnemosyne, who were considered to govern all aspects of the arts. The origin of creative inspiration, for the ancient Greeks and Romans, was to be found with these goddesses – not inside the head.

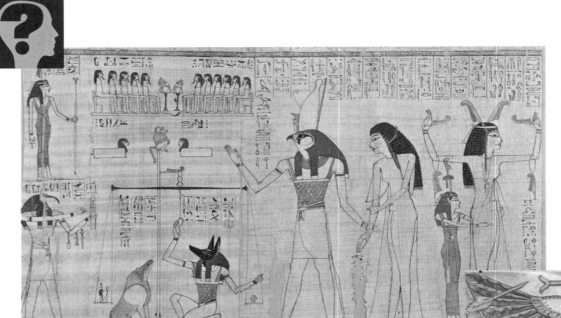

The Papyrus of the goddess Anha from one of the Egyptian Books o the Dead, left, shows Anhai's sou being weighed against truth and justice, represented as a feather. Horus, Anubis and Thoth are seer attending the weighing, in anima disguise.

The Magician from a Tarot pack, designed for Aleister Crowley by Frieda Harris, below, features Thoth in his guises as Hermes an as a baboon.

ECHOES OF ANCIENT EGYPT

A DISTANT CIVILISATION PERSISTS IN EXERTING A POTENT SPELL ON OUR IMAGINATION, INSPIRING MANY OCCULT SYSTEMS

W hen Aleister Crowley, the 'Beast of Revelation' and magus, published his commentary on the Tarot pack, he called it *The Book of Thoth* – proclaiming, as many other mystics and magicians have done, that it encapsulates the arcane wisdom of the ancient Egyptians.

Thoth was the scribe of the gods, who figured prominently in the ceremony of the 'weighing of the heart', the central ritual in the passage of a dead person's spirit from this world to the next. At this moment of trial, when Anubis, the jackal-headed god of the dead, laid the dead person's heart in one pan of a pair of scales to check that it balanced against a feather, representing justice and truth, Thoth stood by to record the result.

Thoth had another role, however, one more tantalising than the straightforward task of keeping the register of those who could enter into the realms of bliss. He was the god of knowledge and of wisdom. And by the easiest of extensions, he became the god of magic. The ancient Egyptians believed that Thoth had set down, in books written with his own hand , the most potent secrets of all. Indeed, Crowley and other modern necromancers have venerated Thoth as a continuing source of occult

Seth, below, *the renegade brother of the god Osiris, was jealous of his superior power, killed and then dismembered him, scattering the remains all over the land. Their confrontation continues to fascinate occult scholars as the archetypal battle between forces of good and evil.*

knowledge, thus enhancing the appeal of those rit als and magical systems that draw on Egyptia symbolism.

As long ago as 1781, a minor French schola named Antoine Court de Gébelin claimed, wit absolutely no foundation other than his imaginatio that the 22 trumps of the Tarot pack preserved th secret teachings of the Egyptians, deliberately di guised to prevent exploitation by the uninitiate The notion was happily accepted by later magician such as Eliphas Lévi in the 19th century. At aroun the same time, Count Cagliostro founded h Egyptian Rite of Masonry: for meetings, he used temple room in Paris, furnished with statues of Is and Anubis. Mozart, in his opera *The Magic Flut* had also linked freemasonry with ancient Egypt ar the mysteries of Isis and Osiris.

Ancient Egypt readily stimulates the occult imag ination. For a start, there are the remains of a ancient and mystifying civilisation whose grea works – the pyramids and temples ranged along th

Nile – suggest the use of powers and techniques that still amaze us in the technological late 20th century. There is, too, the accent on death, or rather on the hope of an afterlife, as recorded in tombs and mummies. There are also the hieroglyphs – pictorial writing that seems to promise so much more than a simple alphabet. And there is the ancient Egyptian religion itself, with its variety of transcendental beings, ranging from the mightiest of demiurges to the most localised of spirits.

Gods were closely allied to human life in ancient Egypt. The high gods, those with whom the kings identified themselves, represented just about every form of psychic power. The Sun-god Re ruled over the other gods and mankind, and the Egyptian king called himself 'Son of Re'. Other gods, who started as local deities, joined with Re in compromise rather than in struggle. So Amun of Thebes became Amun-Re, and the priests of Ptah of Memphis explained that Re was his father as he, in turn, was the father of other gods.

In myths telling of the creation, the sky and the Earth gave birth to other gods, namely Seth and Osiris, and to the goddesses Isis and Nephthys. Osiris, who was the god of fertility and of resurrection in the other world, became the most important god of all. His wife, Isis, gave birth to Horus; and with Nephthys, whose husband was supposed to

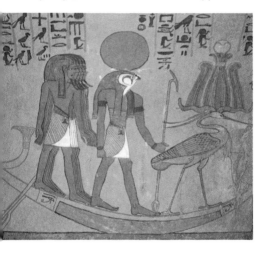

be Seth, Osiris went on to father Anubis, known as the god of death.

Osiris was good and bountiful. He taught the Egyptians to till and to cultivate the fields, also providing them with law and religion. Seth, however, succumbed to jealousy and laid plans to kill him. Seth tracked down and dismembered Osiris, scattering his body across Egypt, but Isis was able to collect the parts together, bandaging them into what is said to have been the first mummy, and breathing life into him once more. Horus, the child they then conceived, went on to contend with Seth. A memorial tablet left by one king of Egypt told of his knowledge of the god:

'Your nature, Osiris, is more secret than other gods. You become young according to your own wish. You appear in order to dispel darkness, for the gods and magic come into existence to illuminate your majesty and bring your enemies to shambles.'

Lower gods in ancient Egypt concerned themselves with everyday affairs, however. One of the

In the statue of Osiris, above, the crook and flail represent his role as inaugurator of Egyptian agriculture. These symbols are also used in today's occult regalia.

In the statue, right, Isis suckles Horus. The 'madonna-and-child' played an important part in the resurrection-based Osirian religion.

The Egyptian Sun-god Re, seen left with the head of a falcon, rides in his boat across the sky, bringing light to the world. On his head he carries a solar disk representing the Sun. Re was often identified with the falcon-headed sky god Horus, whose eyes, many believed, were the Sun and the Moon.

Thoueris (or Ta-urt), the Egyptian goddess of childbirth, below, was often represented as a hippopotamus standing on its hind legs.

oldest of the Egyptian deities, Thoueris or Ta-urt, was goddess of pregnancy and birth. Any woman in Egypt might pray to her statue or wear an amulet that showed the goddess as a hippopotamus standing on its hind legs. The god Bes became husband to Thoueris; and he, too, despite a fearsome appearance, was a friend to all.

HOLY CONSULTATIONS

People sought out 'consultations' with these gods in ways that link with forms of fortune-telling and dream interpretation in use today. Someone seeking advice might spend the night in a temple courtyard in the hope that the god would appear in a dream. Indeed, attendants, magicians and dream interpreters thronged the temples to offer their

help. One formula that was guaranteed to produce a vision of the god Bes involved, first, writing out a petition with an ink that included ingredients such as the blood of a white dove. Then:

'Make a drawing of the god on your left hand and wrap your hand in a strip of black cloth that has been consecrated to Isis and lie down to sleep without speaking a word, even in answer to a question.'

Much of the impact that ancient Egyptian society has had on the modern imagination stems from the massive accumulation of material associated with tombs and mummies. The ancient Egyptians believed that life could continue after death. To ensure that this would happen, they provided the dead person with an illustrated guide, the so-called *Book of the Dead*, which might be inscribed on a papyrus left with the body or painted on the coffin or a wall of the tomb. The *Book of the Dead* shows the tests through which a spirit must go before merging with Osiris in everlasting life. It gives, with detailed precision, the responses that a spirit must

The union of Geb, god of the Earth, with Nut, goddess of the sky, which is said to have resulted in the births of Osiris, Isis, Seth and Nephthys, is depicted left.

make to persuade the gods to give judgement in its favour. The drawings – of scenes such as the 'weighing of the heart', and of gods and of creatures, such as the dreadful beast Amemt, who waited to devour the heart that was found wanting – have provided a starting point from which many artists, among them Austin Osman Spare, painting earlier this century, have derived symbolic motifs.

Egyptian mummies have always fascinated travellers from other countries. In medieval times, Arab physicians decided that ground-down mummy made a useful remedy for many ills. This belief passed to Europe; and in the 16th and 17th centuries, speculators shipped out vast quantities of 'physic'. During the 19th century, public unwrappings of mummies became a popular entertainment – even an archbishop of Canterbury was once turned away from a lecture hall that was packed to capacity. In 1827, just 10 years after Mary Wollstonecraft Shelley had written *Frankenstein*, Jane Webb published *The Mummy*. At the high spot of the action, two of the characters climb into the Great Pyramid, carrying with them a galvanic battery, and literally shock the mummy of King Cheops back into life.

'A fearful peal of thunder rolled in lengthened vibrations as the mummy rose slowly from its tomb. Edric saw the mummy stretch out its withered hand as though to seize him. He felt its tremendous grip. Then all was darkness... '

This fantasy has become the source of many film plots, from *The Mummy*, with Boris Karloff, in 1932, to *The Awakening*, with Charlton Heston, in 1980 – to say nothing of *Abbott and Costello Meet the Mummy* in 1954.

Later ages made their own interpretations – and misinterpretations – of the realities of ancient Egypt. The Greeks and the Romans, who dominated the country in the few hundred years just before and after the time of Christ, already thought of Egypt as a land of inexplicable mysteries. When the Arabs conquered Egypt, they spun wondrous tales about the riches and powers that the ancient kings had once possessed. They told of caskets piled high with sacred symbols made of gold, weapons

fashioned out of iron that could not rust, glass that could be bent without breaking, books made of leaves of gold that contained the history of the past and prophecies of the future.

OBELISKS AND SPHINXES

As Europeans began to travel to Egypt, increasing amounts of titillating information trickled back to the West, and by the 18th century Egyptiana had been taken up by the fashionable as part of the general enchantment with Classicism. Artists inserted pyramids, obelisks and sphinxes into their fantastic landscapes. Sir Isaac Newton dreamed up a new chronology for Egyptian history while trying to synchronise the list of Egyptian kings with the eras of biblical history. A French writer, Jean Terrasson, collected together all the extant Greek and Roman descriptions of Egypt and turned them into a vast novel, *The Life of Sethos*. Others pondered on the significance of hieroglyphs, assigning meanings to them according to arbitrary whims. For instance, Thomas Greenhill, a London surgeon, confidently proclaimed in 1705, in a book subtitled *On the Art of Embalming*, that the crocodile was the emblem of malice; the eye, the preserver of

Fantastic stories of the resurrection of ancient Egyptian mummies all derive from Jane Webb's The Mummy *of 1827. The tale has since become a fertile source for horror films, offering title roles to numerous actors including Lon Chaney Jr in* The Mummy's Curse, *below left, and Christopher Lee in* The Mummy, *below.*

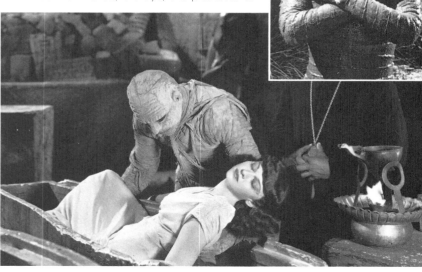

...ustice; and that the right hand, with its open fingers, signified plenty.

But such speculation was suddenly given a solid basis of fact after Napoleon invaded Egypt in 1798. A detachment of soldiers working on some fortifications near the coastal town of Rosetta turned up a slab of basalt carrying an inscription in Greek, as well as hieroglyphs and a demotic script that was a simplified form of Egyptian writing. Scholars could now work out how to read the hieroglyphs, although the task of deciphering them fully was to take another 20 years.

WIDESPREAD INFLUENCE

From then on, interest in Egypt grew and grew. Some travelled to Egypt to study its ancient civilisation. Others went to plunder as many antiquities as they could. Europe thus gradually became familiar with the temples and pyramids, the giant statues and the evocative script. The influence of ancient Egypt also showed up in areas such as furniture design: the Egyptian motif became part of both the Empire and the Regency styles, lingering on into Art Nouveau. Egyptian temples even provided the model for buildings, such as cotton mills in the north of England. Obelisks found their way to Europe and the United States. Organisations such as the Egypt Exploration Fund, founded in 1882, made Egyptological research generally available, and a burgeoning coterie of mystics incorporated all such information into their magical systems.

H. Rider Haggard, writing in the 1880s, also drew on the fashionable Egyptian hieroglyphs and burial places, embalmings and resurrections for his books *Cleopatra* and *She*, the story of Ayesha (She-who-must-be-obeyed), a doomed love affair spreading across millennia.

Aleister Crowley, meanwhile, reached the conclusion that the true source of all wisdom was Seth,

Two potent symbols used in Egyptian amulets as a protection against evil were the Eye of Horus, below, and the ankh, bottom, a key-like cross that represented life. Both of these symbols are incorporated into several modern occult ceremonials.

Leila Waddell, left, was one of Aleister Crowley's string of mistresses and magical assistants who were collectively known as the 'Apes of Thoth'. Crowley's burning ambition was to find one who was such an accomplished medium that he could contact his guardian angel through her.

later worshipped as Satan. Seth, he claimed, had appeared to him while he was in Cairo in 1904, in the form of a bodiless intelligence named Aiwass, and had dictated to him the three chapters that make up *The Book of the Law*. This is the book that expounds the basic Crowleyian principle. As Crowley put it: '"Do what thou wilt" shall be the whole of the Law.'

In Egypt, Aleister Crowley, who would later refer to his string of mistresses as the 'Apes of Thoth', looked for revelations in the Cairo Museum. He proudly regarded himself as the Beast of the Revelation, with the number 666 (see *The Book of Revelation* 13). Now, exhibit 666 in the Cairo museum happened to be a painted tablet commemorating an Egyptian priest, Ankh-f-nKhonsu. Crowley immediately decided that he had been Ankh-f-n-Khonsu in a previous life. He was also convinced

that a new Age of Horus was about to replace the passing Age of Osiris with its resurrection-based Christian faith.

Fascination with Ancient Egypt persists. To take just one example, the Egyptians were given to wearing protective amulets, the most symbolically impressive being the Eye of Horus; and even today, a bracelet of lucky charms may well carry a distant relation, a tiny symbol of an *ankh* (a key-like cross), the Egyptian sign for life.

> ▟▟ THE CROWLEYS TOOK A FLAT IN CAIRO AND CROWLEY TRIED TO CONJURE UP SYLPHS (SPIRITS OF THE AIR) . . . AT MIDNIGHT, HE MADE THE INVOCATION ACCORDING TO HIS WIFE'S INSTRUCTIONS... AND WAS TOLD THROUGH HER THAT... A NEW EPOCH IN HUMAN HISTORY HAD BEGUN AND THAT HE WAS TO FORM A LINK BETWEEN SOLAR-SPIRITUAL FORCES AND MANKIND. ▟▟
>
> COLIN WILSON, ALEISTER CROWLEY: THE NATURE OF THE BEAST

YOUNG VISIONARIES OF OUR LADY

THE VIRGIN MARY, IT IS CLAIMED, HAS APPEARED MANY TIMES IN THE 20TH CENTURY, MOSTLY TO CHILDREN – AND FREQUENTLY BEARING WARNINGS OF APOCALYPTIC DISASTERS

The visionary events at La Salette and Lourdes in France, at Knock in Ireland and at Llanthony in Wales, all happened in the 19th century. The first three sites have become major centres of pilgrimage, but Llanthony is nearly forgotten – perhaps because of inaccessibility, or because there is no Catholic tradition in Wales. In three of the reports, it was claimed that healing accompanied the visions. Three of the cases also prominently featured children. Two of the figures spoke and prophesied: two did not. But there are marked similarities among the descriptions of the figures in all these cases. And, in all of them, the experience is reported as having had a lasting effect on the witnesses .

The 20th century has seen no abatement in the frequency of visions, nor in their complexity.

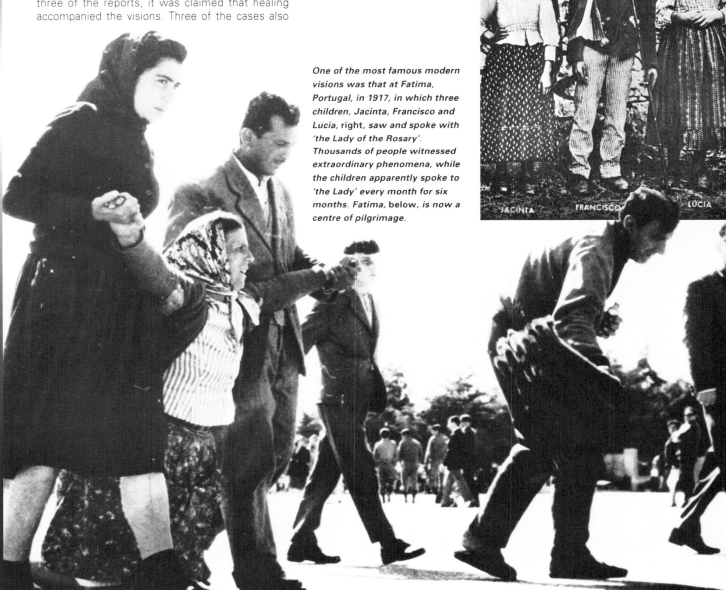

One of the most famous modern visions was that at Fatima, Portugal, in 1917, in which three children, Jacinta, Francisco and Lucia, right, saw and spoke with 'the Lady of the Rosary'. Thousands of people witnessed extraordinary phenomena, while the children apparently spoke to 'the Lady' every month for six months. Fatima, below, is now a centre of pilgrimage.

JACINTA FRANCISCO LUCIA

modern photographic and recording techniques have, in fact, enabled details to reach an eager audience of believers. A second group of cases is even more widespread – and, again, there are many features that resemble those in earlier reports. The visionary figure speaks; and, frequently, there is extensive prophecy. The figure seen is apparently much the same in all the cases, and subsequent healings are widely claimed. What is more, in the three major cases that follow, the original and prominent witnesses are again children.

The apparently miraculous events at Fatima, Portugal, in 1917, are well-known, particularly for the 'Dance of the Sun' that ended the last vision in the series of six, and for the mystery surrounding the prophecies said to have been given by the Virgin to the young witnesses – Lucia dos Santos, aged nine, Francisco Marto, aged eight, and his sister Jacinta, aged six. They were looking after sheep just outside Fatima when they saw the apparition of a boy, aged about 15, who exhorted them to pray. The 'angel', as they called him, appeared to them twice more that year, but it is the series of events that began on 13 May 1917 that has since made Fatima world-famous.

FROM OUT OF A CLEAR SKY

The three children were once again out tending their families' flocks when a sudden flash of lightning – in a clear sky – sent them scurrying for shelter. But no rain came; instead, they saw an apparition of a beautiful young woman, aged about 18. Lucia talked to her while Jacinta looked on. The vision said she had come from heaven and that she would reappear on the 13th of every month, for a period of six months.

The children agreed that they would keep the story of the vision to themselves, but when they got home, Jacinta blurted it out. The news, predictably, spread like wildfire, and soon crowds gathered outside Fatima on the 13th of every month.

The vision was seen – although only by the three children – every month from May to September, while the attendant crowds grew. On 13 October, some 70,000 people were present when the phenomenon that came to be known as the 'Dance of the Sun' took place – although by no means everyone saw it. It has been described thus in a Catholic pamphlet:

'The rain stopped suddenly, and through a rift, or hole, in the clouds, the sun was seen like a silvery disc. It then seemed to rotate, paused, and rotated a second or third time, emitting rays of various

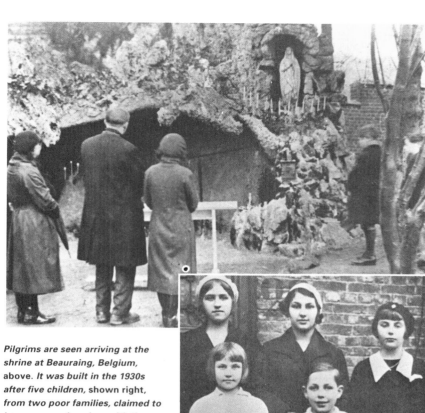

Pilgrims are seen arriving at the shrine at Beauraing, Belgium, above. It was built in the 1930s after five children, shown right, from two poor families, claimed to have seen and spoken with the Virgin over 30 times. Despite the number of alleged communications, the 'Lady' said little of any consequence. But even so, the story of the visions seems to have answered a deep need among Catholics, who still flock regularly to the shrine in great numbers.

colours. Then it seemed to approach the earth, radiating a red light, and an intense heat. The crowd fell into a panic, thinking the world was ending, and then into tumultuous devotion.'

It is unfortunate that the only photographs said to exist of this event appear to be fakes: certainly, they are less than convincing.

The figure itself was described as: 'A beautiful Lady, who seemed to be less than 18 years old. She wore a white robe, and her head was covered with a white veil. Her hands, clasped in prayer, held a rosary.'

The matter of the prophecies is most intriguing. The first two, supposedly given to Lucia in 1917, are less convincing for being revealed after their alleged fulfilment, in 1936 and 1941; but the third prophecy of Fatima remains one of the great mysteries. Said to have been given to Lucia on 13 July 1917, it was passed in secrecy to the Vatican, and is said to have been opened in secrecy by the Pope in either 1942 or 1960. Contrary to Lucia's apparent instructions, no official information has been given as to what it contains, but journalists and religious extremists have made a variety of guesses.

> THE FIGURE ITSELF WAS DESCRIBED
> AS A BEAUTIFUL LADY, WHO SEEMED
> TO BE LESS THAN 18 YEARS OLD.
> SHE WORE A WHITE ROBE, AND HER
> HEAD WAS COVERED WITH A WHITE
> VEIL. HER HANDS, CLASPED IN
> PRAYER, HELD A ROSARY. ▮▮

have demonstrated genuineness. Lengthy, learned and unconvinced accounts of the events were recorded by the Catholic historians, Herbert Thurston and Jean Helle. The visions were also used as propaganda in battles in national and Church politics.

Thurston and Helle's description of the Lady is quite standard. It runs as follows:

'They saw her shining form as she stood on what appeared to be a small cloud. Her white dress seemed to be touched with reflections of blue light, and her hair was covered by a white mantle. From her head came short rays of light, which gave the appearance of a crown. Her hands were joined, and she was looking towards heaven.'

One of the children claimed that the vision revealed her golden heart to her; but despite a continued stress on the significance of the Immaculate Conception, there was little meaning in what the figure had to say. Nonetheless, the huge crowds were prepared to accept the children's word about

Purportedly, it refers to appalling, worldwide war in the latter half of this century, to division within the Church, to the rise of Satan, and to the only gradual victory of Christ. There is a rumour that, in 1977, Christ himself appeared to an anonymous Catholic to state that the secret 'must be known by all by now', and clearly there is a widespread feeling that the facts – if facts there be – are being wilfully withheld.

THE BLESSED VIRGIN

The visions at Beauraing, Belgium, which lasted from November 1932 to January 1933, introduced a number of new elements to the subject of Marian visions. They were witnessed by, and only by, five children from two poor families, aged from 9 to 15. Thirty-three visions were said to have been seen and, although there was no independent verification, some of the visions were attended by very large crowds indeed. One fairly objective account tells of the first vision:

'On 29 November 1932, four children at Beauraing went to meet a friend from her convent school. After praying . . . in the garden of the convent, one of them rang the doorbell. They all waited, expecting one of the sisters to open the door. Suddenly, as Andrée was looking towards the viaduct, she cried out: "I see the light." "It must be the headlight of a car," answered one of the other children. All looked in the direction of the source of the light. "Something is moving there – is it a man or what?" they asked each other. Then Albert Voisin shouted: "This is the Blessed Virgin". All looked again, and all were convinced that it was the Blessed Virgin walking on the bridge... This was the beginning of the 33 apparitions... at one time, 30,000 people crowded around the site during the apparition, though only the children were favoured.'

One of the new elements at Beauraing was the depth of investigation relating to the claimed visions – including tests of the children's trance state, using lighted matches and a penknife, that seem to

In the Spanish village of Garabandal, that lies in the valley, top, four young children, above, began to see visions of angels – which, they were told, were to herald the vision of the Virgin herself. She is said to have appeared an astonishing 2,000 times over a four-year period. Sometimes, she was accompanied by angels and once by what the children described as 'the eye of God'. During their visions, they became entranced, parading about in 'ecstatic marches' or falling backwards in perfect synchronisation. Yet one of the children, Maria Cruz Gonzales, has since confessed that some of her 'trances' were fakes.

the vision, planted firmly as it was in the tradition of Lourdes. Though independent commentators had serious doubts, and there was little objective evidence, believers continued to flock to Beauraing.

A series of visions more plausible to both the serious researcher and the Church commenced at Garabandal, a small village in north-west Spain, on 18 June 1961. Again, four young children, all girls aged 11 and 12, were the only witnesses to the Lady herself. She spoke at length and in detail, with prophecy and admonition. Astonishingly, the figure is said to have appeared to the children some 2,000

 BEFORE THE CHILDREN . . .

THE VIRGIN APPEARED WITH

TWO ANGELS, ONE ON EACH SIDE.

ABOVE THE VIRGIN WAS A LARGE

EYE THAT SEEMED TO THE CHILDREN

TO BE THE EYE OF GOD. **//**

times in four years. Considerable evidence exists of related healings – including one restoration of sight – and the village has since become a major centre of pilgrimage.

The events commenced with nine appearances of an angel, warning the children that the Virgin would appear to them as 'Our Lady of Carmel'. Thus, even for the Virgin's first appearance, there were many witnesses present. 'Before the children . . . the Virgin appeared with two angels, one on each side. Above the Virgin was a large eye that seemed to the children to be the eye of God.' They later described her in these terms:

'She has a white dress, a blue cape, a crown of golden stars. She holds between her fine slender hands a brown scapular [cloak] except when she carries the Child in her arms. She has long chestnut hair with a parting in the middle. Her face is oval with a very delicate nose, a very pretty mouth with well-traced lips. She appears to be 18, and is on the tall side.'

The children, from their photographs, look cheerful and sensible enough. Yet while they saw the visions and spoke with the Lady, countless numbers of pilgrims and others watched them, and the doctors and investigators got on with their duties. The children seem to have been in genuine trances, and were oblivious to intrusions into their communication. Interestingly, they were apt to fall backwards (as do many subjects of conversion, faith healing and exorcism), sometimes together as if synchronised, or to link arms and parade backwards and forwards in 'ecstatic marches'.

The messages they received were similar to those given at Fatima. They consist mainly of warnings and expressions of concern. A sequence of events is outlined: that there will first be a warning, of which everyone on Earth will be aware, then a miracle will occur at the Spanish village of Garabandal – of which Conchita, one of the witnesses, now living in the USA, will give eight days' warning. As a result of this miracle, the USSR (as it then was) will be converted wholesale to Christianity, and a 'permanent supernatural sign will remain until the end of time'. If the world does not then repent, the chastisement will follow.

Veronica Leuken, the 'Bayside seeress' from New York, claimed she had visions of the Virgin, who blessed her Polaroid camera so that it would take pictures with strange effects, as shown bottom, *especially the appearance of the so-called 'Ball of Redemption',* below. *Critics, however, think it resembles a thumb over the lens. Veronica claims the Virgin imparts warnings concerned with the laxity of morals in the modern world and the threat of 'satanic' influence on the Church. But none of these prophecies seems to concern specific events.*

Unfortunately, one of the children, Maria Cruz Gonzales, has since told interviewers that some of their 'ecstasies' were certainly faked, adding that they used them as a ruse to get away from the town to play. The others, however, have always maintained that their visions and trances were indeed genuine.

UNIVERSAL SIGHTINGS

Children the world over attest to having seen Our Lady. In 1933, again in Belgium, eleven-year-old Mariette Beco saw the Virgin of the Poor on a white cloud some five feet [1.5 metres] away. More recently, too, in 1987, at Hrushiv in the Ukraine, a girl of eleven, Marina Kizyu, saw the Virgin Mary dressed in red and blue in a deserted church, dating from the 16th century, where a previous vision had occurred, and where many have since been witness to Our Lady, seen both weeping and in prayer.

The consistent, and yet inconstant, appearance of the Virgin herself – changing in age, perhaps according to the age of the witness, and changing in title and characteristics, seemingly according to the need and the situation – gives an impression that the visions may only be different versions of a similar psychological archetype, and that there may be no objective reality to all or any of the figures. But against this, we have to balance the fact that most of the visions have been seen by unsophisticated children, apparently unprompted. Can we really expect them to come up with such consistent stories? There is also the matter of the many healings and prophecies. Would a psychological illusion have such effects?

There are, of course, no simple answers. But the evidence of thousands of witnesses points to the fact that something unusual has indeed occurred at such places as Fatima and Lourdes. Certainly, until we have a great deal more evidence, we are in no position either to decry or dismiss any sincerely held belief based on these undoubtedly inspiring experiences.

SPIRITUAL JOURNEYS

DESCRIPTIONS OF DEATH IN MANY ANCIENT TEXTS READ VERY LIKE OUT-OF-THE-BODY EXPERIENCES – OTHERWISE KNOWN AS OOBEs. PROFESSOR ARTHUR ELLISON DESCRIBES HIS PERSONAL EXPERIMENTS IN ASTRAL TRAVEL

It is often thought that if one has an out-of-the-body experience – an OOBE – there remains no doubt about survival after death: that, in fact, an OOBE is a kind of mini-death, but with the option of returning to the body afterwards. Certain passages in religious literature certainly seem to confirm the similarity between death and OOBEs. Indeed, parts of *The Bible* can be interpreted to describe death as the breaking of a silver cord that joins the 'other' body to the physical body. 'Remember also your Creator in the days of your youth, before the evil days come... before the silver cord is snapped, or the golden bowl broken,' we find in *Ecclesiastes 12,* for instance.

The pioneering 'psychic' writers of the 19th and 20th centuries seized on such references, as well as similar passages in ancient Hindu scriptures such as the *Upanishads,* to lend weight to descriptions of their own OOBEs. These frequently involved the soul's existence in another body made of some subtle material as yet unknown to western science, moving out of coincidence with the physical body, and travelling away from it.

Until a few years ago, I myself thought that an OOBE would be an experience of great significance in which it would perhaps be possible to see dead relatives, converse with them, and bring back information that could be checked. All this would be of enormous help and significance in answering the ancient question of whether there is life after death.

With this in mind, I tried hard, with various methods, to experience an OOBE. A book by S. Muldoon and H Carrington, *The Projection of the Astral Body*, sets out a number of different methods of inducing an 'astral projection', as an OOBE was then called. All the procedures involved lying in bed on your back, and using the will and imagination in various ways. The principle was to loosen the grip of the physical body on the astral body by, for instance, imagining oneself in the astral body, consciously rotating about an axis from the head to feet, observing first the ceiling, then the wall, then the floor and the other wall. (Try it out, and you will find it is not at all easy.) Other methods involved

imagining yourself going up in a lift at the moment of sleep, and telling yourself that at a particular point in the dream you will wake up in a full astral projection. A third method involved going to bed very thirsty and imagining yourself going to the kitchen tap for a drink of water, pre-programming yourself to awaken, in an astral projection, on arrival at the tap.

For one hour every night for a month, I tried these methods on retiring to bed. At last, I had success! The first sign was that, in accordance with the book, I found myself in a cataleptic state – unable to move a muscle. This was stated by Muldoon and Carrington to be the normal precursor to the experience. I used my will – or perhaps it was my imagination – to make myself float upwards, and the experience was quite fascinating. I felt as though I was embedded in the mud at the bottom of a river, and the water was slowly seeping into the mud and reducing its viscosity, so that eventually I was borne upwards by the water. Slowly I floated upwards, still cataleptic, like an airship released from its moorings. I reached the ceiling and floated through it into the darkness of the roof space. Then I passed through the roof tiles, and the sky, clouds and Moon became visible. As

he Mourning, *by George Elgar
Hicks, left, shows parents grieving
over the body of their little girl,
while her soul – which looks very
similar to the 'astral body'
described by people who
experience OOBEs – flies
heavenwards. In William Blake's
illustration from Robert Blair's
poem* The Grave, *above, the soul
of the dying man is, intriguingly,
shown as a woman: 'How
wishfully she looks/ On all she's
leaving now no longer her's (sic)!'*

increased my 'willing' (or 'imagining'), my velocity of ascent up into the sky increased. To this day, I have the clear memory of the wind whistling through my hair. From the moment of getting into bed to this point in the sky, I had no break of consciousness. Eventually, it all died down, and I was back in bed. I immediately wrote full and detailed notes on my experience, and recollected that I had read an account by a French writer, Yram, of similar experiences involving travelling up into the sky.

THE SILVER CORD

Thinking it over, it seemed a quite useless experience. Any sensible person would say that I had dreamed the whole episode. So I resolved that next time would be different – and it certainly was! The book stated that the catalepsy would disappear when the projection from the body exceeded 'cord activity range', and the projector would be free to walk about. 'Cord activity range' meant, according to Muldoon, that the distance from the body was great enough to reduce the 'silver cord' connecting the astral and physical bodies of the experimenter to a fine thread. The 'vital forces' (whatever they were) flowing through it would then be reduced to a low level and the catalepsy would disappear. If this occurred, it would be possible to walk into town, examine a shop window never seen before, memorise the contents, return to the body, write it all down, and carefully check the description the following day. If this worked, surely no one would suggest that the whole experience had been a mere dream – especially if they were given the description before checking; and, even better, if they had themselves chosen the shop window to be 'astrally' visited!

So I tried again. This time, it took only three or four nights to repeat the projection. However, on this occasion, I stopped the vertical movement at ceiling height and changed direction. Still cataleptic, I floated horizontally, feet first, towards the

first-floor window of the room. Floating smoothly through the top of the window frame, I was aiming to describe a smooth parabola down on to the lawn. Here, I hoped, I should be outside 'cord activity range' and the real work of acquiring evidence could begin. It did not happen like that. As I cleared the window and started the descent to the lawn, I had one of the most intriguing experiences to date. I felt two hands take my head, one hand over each ear, move me (still cataleptic) back into the bedroom and down into the body. I heard no sound, and saw nothing.

The experiences I have described took place in the 1950s. Since then, I have learned a great deal. First, I would say that lying on your back in bed and concentrating on a particular idea is a recipe for producing an auto-hypnotic trance. I have no doubt that I put myself into trance. Secondly, as I was expecting – and therefore suggesting to myself – that my experience would be what the book described, I entered a cataleptic state. Had I not anticipated that, I believe it probably would not have occurred. Thirdly, as I was expecting to float vertically upwards, that is the experience I had. Other experimenters, with different ideas of what will happen to them, do not enter a cataleptic state, and sometimes 'leave the body' horizontally, through the head, or sideways. A suggestion, to a good enough subject in a deep enough trance, that he or she will move around in a subtle body to other parts of the physical world, near or at a distance, will often be enough to produce that effect. Many people are even capable of having an OOBE as a result of suggestion under hypnosis. So, do they see the ordinary physical world? They do not have their physical eyes with them and clearly cannot. So what do they experience? It would seem that they experience a dramatised reconstruction of a memory of the physical world: can it be anything else?

But, sometimes the physical world seen in an OOBE does not quite match reality. There may be

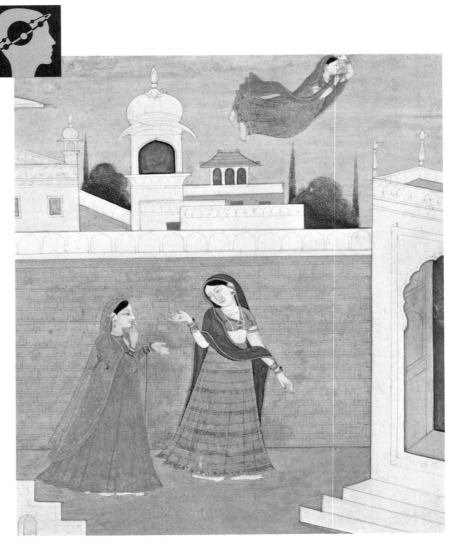

then read a paragraph, chosen by him at random silently. She received his impressions telepathically. So the experiment continued. All this was written down, she explains, in New York and sent by post that evening to Newfoundland.

Next morning, a telegram was received from the doctor in Newfoundland to describe the accident he had before the experiment, explaining the bandage. All this, says Eileen Garrett, was accurate.

Another person who experienced OOBEs regularly was Robert Monroe, an American business man. One particularly important experience he had involved his projection to the location (unknown to him) of a woman friend, whom he found talking to two girls. He could attract the attention only of the woman, he found, and she told him (mentally) that she knew of his presence – but continued talking. Though she stated that she would remember his visit, he nevertheless pinched her at about waist level, not expecting that she would feel anything. To his surprise, she cried out. After the experiment, when she returned to her home, Monroe asked her (normally) what she was doing at the time of his projection. She described exactly what he had observed, but remembered nothing of his 'visit'. Exasperated, he said: 'Did you not feel the pinch?' Very surprised indeed, she said that she had – and could not understand how this could have happened.

An interesting feature of some of Monroe's OOBEs was that he occasionally felt that he was partly or wholly 'someone else'. This is distinctly different from the reports of many other experimenters, who talk of having dual consciousness – that is, consciousness both in the projected form and in the reclining physical body – and sometimes even of discussions between the two.

symbolic additions, like bars on the windows to prevent escape. Objects may also have a kind of luminosity. Muldoon even suggests that it is possible to awaken, projected, from an ordinary dream when observing an incongruity in the surroundings – for example, by observing that the paving stones do not have their long edges in the correct direction.

DOUBLE PROJECTION

One of the best cases of a 'normal' projection into a 'duplicate physical world' involved Eileen Garrett, the famous psychic. She describes in her autobiography how she projected her 'double' from a room in New York to a place in Newfoundland, the home of the doctor who had designed the experiment. She could 'see', she wrote, the garden and the sea, the flowers and the house, smell the salt in the air and hear the birds. Entering the house, still quite conscious of her body lying in the room in New York, and able to speak to the experimenters there, she observed the doctor descending the stairs and entering his study. He, too, was psychic and appeared to be aware of her presence. She obeyed his instructions and described the objects on his table to the experimenters in New York. She also described a bandage on the Newfoundland doctor's head which, he told her out loud, was the result of an accident that morning. He then walked to the bookcase and she knew telepathically, she said, that he was thinking of a book about Einstein. He took it down, held it up for her to read the title and

The miniature from an early 19th-century Bhagavata Purana from India, above, tells the story of Usha, who experienced spontaneous 'dream flights'. The information she obtained on them could later be checked by visiting the places she described.

The image, right, is of 'the causal body of an Arhat', an illustration from C.W. Leadbeater's Man Visible and Invisible. Leadbeater believes that we have at least three bodies besides the physical – the emotional, the mental and the spiritual. The spiritual is seen here as it would, allegedly, appear to a trained seer.

CHRIST'S SUFFERING AND DEATH ARE AT THE VERY CENTRE OF CHRISTIAN BELIEF. BUT WHAT IF HE DID NOT DIE ON THE CROSS, INSTEAD MARRYING AND HAVING CHILDREN? COULD THERE PERHAPS BE DESCENDANTS WHO ARE ALIVE TODAY, AS SOME HAVE CLAIMED?

The discovery of secret documents, and possibly a hoard of treasure – even, some have suggested, mummified relics of Christ – in the small village of Rennes-le-Chateau in south-west France, turned a poor village priest into a millionaire. But it also set in motion a chain of events that led to a discovery that, if true, is undoubtedly the most disturbing revelation in the history of Christianity.

The crucifixion, here depicted by Giotto, has been a source of inspiration for countless artists. But did Christ actually die on the cross? The authors of a powerfully argued book, The Holy Blood and The Holy Grail, *believe he did not – and put forward a completely new interpretation.*

The story of the clues that led to this amazing discovery is related by Michael Baigent, Richard Leigh and Henry Lincoln, in their bestseller *The Holy Blood and The Holy Grail.* The book has aroused extremes of either instant enthusiasm or antagonism in its readers. Establishment critics, fairly predictably, have tended to dismiss the book as a wild romance based on the flimsiest of evidence. Nevertheless, such comment is both unfair and demonstrably untrue. No one can simply sweep aside the mass of evidence assembled by the authors and their cautious presentation. Indeed, many have seriously underestimated the implications of the substantial material gathered.

The authors of *The Holy Blood and The Holy Grail* present evidence of a powerful and ancient international mystery, and of a many-layered secret society with widespread influence, extending right to the present. The starting point of the authors' investigation concerns considerable buried treasure;

THE ROYAL HOUSE OF JESUS

145

their final conclusion, an astonishing claim that Jesus Christ married Mary Magdalene and produced children. Descendants of these children, they believe, intermarried with other kings and rulers of ancient times, notably with the Merovingians, the first dynasty of Frankish kings in Gaul. Direct descendants of these rulers, they hold, are alive and well, awaiting the call – or opportunity – to assume a leading role in the politics of Europe, and possibly of the world.

> ❚❚ IT WAS NOT OUR INTENTION TO DISCREDIT THE GOSPELS. WE SOUGHT ONLY TO WINNOW THROUGH THEM – TO LOCATE CERTAIN FRAGMENTS OF POSSIBLE OR PROBABLE TRUTH AND EXTRACT FROM THEM THE MATRIX OF EMBROIDERY SURROUNDING THEM. ❚❚
>
> BAIGENT, LEIGH AND LINCOLN,
>
> THE HOLY BLOOD AND THE HOLY GRAIL

The connection between such 'holy blood' and the Holy Grail in the title of this book is made through ingenious wordplay. The Holy Grail is a complex and mysterious concept. For some authors, it is a stone – for others, a repository for saintly relics. But, most often, it is the cup used by Jesus at the Last Supper, and in which his blood was caught as he hung upon the cross. In many of the early Grail manuscripts, it is referred to as the *Sangraal;* and in the later version by Malory, it is the *Sangreal.* Baigent, Leigh and Lincoln argue that some such form – *Sangraal* or *Sangreal* – must have been close to the original. And dividing this into two words in a way that seems entirely reasonable, they conclude that the word may not originally have been '*San Graal*' or '*San Greal*' – from which the English translation 'Holy Grail' comes – but '*Sang Raal*', '*Sang Réal*' or, as they triumphantly conclude, 'to employ the modern spelling, *Sang Royal*, Royal blood.' Thus, the legend of the transportation of the Holy Grail from Judea to Europe is not the legend of the bringing of an artefact – but the true history of the arrival in France of the descendants of Jesus and Mary Magdalene, carriers of the royal blood or '*Sang Réal*'.

The authors of The Holy Blood and The Holy Grail *argue that the Knights Templar (one is shown, right), an immensely powerful order of warrior monks, flourishing from 1124 to 1307, were only the military arm of a yet more powerful organisation, the Priory of Sion – guardians of the interests of Christ's descendants.*

It is, to say the least, an impressive hypothesis. But the claim for the existence of these living descendants of Christ is not a strong one, if only because it seems improbable that in all the dozens and dozens of generations that have elapsed since the time of Christ, one or other descendant would not have succumbed to the temptation to announce 'I am the lineal son of Christ'. Yet we find no whisper of any such announcement in the course of 2,000 years; nor, indeed, any really solid evidence of any actual progeny. Even if Baigent, Leigh and Lincoln are correct in their belief in the survival of descendants of Christ, the central mystery, on their own evidence, is something still wider and older. The Christ story and the events that surround it may well be, it seems, but one piece (an important piece, certainly) of a still larger mosaic.

Baigent, Leigh and Lincoln allege that the Knights Templar were among the major custodians of this secret. This band of warrior monks was formed around 1120 for the purpose of protecting pilgrims to the Holy Land. With astonishing rapidity, they became both a powerful military force and, effectively, the bankers of Europe. Their ascendancy came to an abrupt end, however, on the night of Friday, 13 October 1307, when, on the orders of King Philippe IV, all the Templars in France were arrested. Trials and punishments followed, and the order was finally suppressed, by edict of the Pope, in 1312.

> **IF JESUS WERE NOT MARRIED, THIS FACT WOULD HAVE BEEN GLARINGLY CONSPICUOUS. IT WOULD HAVE DRAWN ATTENTION TO ITSELF, AND BEEN USED TO CHARACTERISE AND IDENTIFY HIM... SURELY ONE AT LEAST OF THE GOSPELS WOULD MAKE SOME MENTION OF SO MARKED A DEVIATION FROM CUSTOM?**
>
> **BAIGENT, LEIGH AND LINCOLN, THE HOLY BLOOD AND THE HOLY GRAIL**

*In*Focus

MARY MAGDALENE – BRIDE OF CHRIST?

Was Jesus married? According to the book *The Holy Blood and The Holy Grail,* the *Gospels* themselves suggest he was.

The book's authors cite, in particular, Christ's first major miracle, the transmutation of water into wine at the wedding feast at Cana (*John 2:*1-13). According to the familiar story, Jesus and his mother, Mary, are invited – or 'called' – to a country wedding feast. For reasons not explained in the text of the *Gospel,* Mary calls on Jesus to replenish the wine, something that would normally be the responsibility of the host, or bridegroom's family. 'And when they wanted wine, the mother of Jesus saith unto him, They have no wine.' Why should she do this, they argue – unless the wedding was, in fact, Jesus' own?

More direct evidence comes immediately after the miracle has been performed when 'the governor of the feast called *the bridegroom,* and saith unto him, Every man at the beginning doth set forth good wine; and when men have well drunk, then that which is worse: but *thou* hast kept the good wine until now.' (Editorial italics.)

The implication is clear, some say: the wedding is Christ's own. If this surmise is correct, the obvious question is: who was Christ's wife? The two obvious candidates, from a reading of the synoptic gospels, would seem to be Mary Magdalene and Mary of Bethany, possible one and the same woman.

Christ is depicted meeting Mary Magdalene, above. Could this in fact have been a meeting between husband and wife?

Additional support for this theory comes from some of the apocryphal *Gospels,* suppressed early in the history of the Church. In the *Gospel of Mary,* for example, Peter speaks to Mary Magdalene in these words: 'Sister, we know that the Saviour loved you more than the rest of women. Tell us the words of the Saviour which you remember – which you know but we do not.'

Subsequently, Peter complains to the other disciples: 'Did he really speak privately with a woman and not openly to us? Are we to turn about and all listen to her? Did he prefer her to us?' Later, one of the other disciples consoles him: 'Surely the Saviour knows her very well. That is why he loved her more than us.'

The *Gospel of Philip* is still more emphatic about this: 'And the companion of the Saviour is Mary Magdalene. But Christ loved her more than all the disciples and used to kiss her often on her mouth. The rest of the disciples were offended by it and expressed disapproval. They said to him: "Why do you love her more than all of us?" The Saviour answered and said to them, "Why do I not love you like her?"'

Towards the end of the same *Gospel,* Baigent, Leigh and Lincoln point out, there is one more relevant passage which, to those prepared to take it literally and thereby admit it as valid evidence, clinches the argument: 'There is the Son of Man and there is the son of the Son of Man. The Lord is the Son of Man, and the son of the Son of Man is he who is created through the Son of Man.'

The authors of *The Holy Blood and The Holy Grail* have uncovered documents that suggest that the Templars were in fact the military wing of an older mystical alliance called the Priory of Sion – an alliance that, they claim, was created and still continues to exist for the specific purpose of protecting and promoting the interests of the direct descendants of Christ. The list of the leaders of the Priory of Sion through the ages is said to include Leonardo da Vinci, Sandro Filipepi (better known as Botticelli) Isaac Newton, Victor Hugo and Claude Debussy, as well as a number of seemingly unimportant French aristocratic figures.

REJECTION OF THE CROSS

During the trials of the French Templars in 1308, one member of the order testified that, on his induction, he was shown a crucifix and told: 'Set

The cup in the detail from an anonymous 15th-century painting of the Last Supper, below, from the monastery of St Neophytos in Cyprus, is thought to be the Holy Grail – a vessel that was also used, so the legend goes, to catch Christ's blood as he hung upon the cross. But the authors of The Holy Blood and The Holy Grail argue that the legends surrounding the Holy Grail refer to something quite different – the holy bloodline or family of Christ.

not much faith in this, for it is too young.' Another was told: 'Christ is a false prophet,' and a third: 'Do not believe that the man Jesus whom the Jews crucified in Outremer [Palestine] is God and that he can save you.' Apart from such specific charges, the Templars were also accused in general of denying, trampling and spitting on the cross. In the light of this, it is perhaps significant that, in his decorations of the church of Notre Dame de France in London, executed in 1960, the artist Jean Cocteau, who allegedly succeeded Debussy as the leader of the Priory of Sion, depicts himself standing with his back to the cross. What is more, at the foot of the cross, he paints a gigantic rose – an extremely ancient mystic symbol.

Baigent, Leigh and Lincoln admit that no satisfactory explanation has been advanced for the Templars' rejection of the crucifixion. Yet they fail to acknowledge the serious weakness this rejection creates in their own line of reasoning. If the Templars and their associates reject the crucifixion (for whatever reason), why should they be dedicated to preserving the secret of Jesus' physical descendants and restoring them to power? Here seems to lie a major anachronism. One possible

Pope John XXIII, right, used the same papal name as a 15th-century antipope. It has been argued that he was sympathetic to, or even perhaps a member of the Priory of Sion.

explanation, advanced later by the authors themselves, is that a fake Jesus died on the cross and that the real one escaped. Yet this does not at all seem to be the tenor of the Templars' remark that 'Christ is a false prophet' rather than that there was a false Christ. What, in any case, of the remark that the crucifix is 'too young' to be an object of veneration? There is, in fact, much other evidence to show that the Templar concerns were quite other, much older – and much more mysterious.

The Templars were also charged, both by the Catholic Church and also by persistent popular rumour, with believing that the bearded heads and skulls they worshipped in secret had the power to 'make the trees flower and the land germinate'. This last charge may seem innocuous enough on first consideration. But it clearly links Templar practice and tradition firmly with ancient and pre-Christian fertility religions – presumably not 'too young' to have real occult powers.

BETRAYAL AND DOWNFALL

The Knights Templar were betrayed to the Inquisition and all were simultaneously arrested on Friday 13th October 1307. Given the preoccupation of the medieval mind with numerology, this date may well be significant. But even if the attackers of the Templars took no account of such superstitious trifles, perhaps someone else did. For, according to Baigent, Leigh and Lincoln, someone not only engineered the Templars' downfall in this way but also gave them advance warning of it, thereby enabling them to destroy most of their records and remove to safety their vast treasure and their sacred relics (including, perhaps, as some believe, the shroud of Turin and even the mummified head of Christ).

The number 13 certainly plays a significant role in the mystery unfolded by Baigent, Leigh and Lincoln. Records state that the Grand Master of the Priory of Sion from 1637 to 1654 was J. Valentin Andrea. Around the beginning of the same century, the Rosicrucian movement – a mysterious fraternity

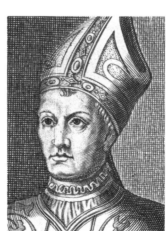

In his mural, right, for the church of Notre Dame de France in London, Jean Cocteau, above – allegedly Grand Master of the Priory of Sion from 1918 to 1963 – shows himself, significantly, looking away from the cross.

claiming to possess certain 'spiritual truths' – had announced its existence in Europe, and Andrea was himself a dedicated Rosicrucian. Despite his knowledge that all heresies had for some 200 years been strictly punished by the Church, Andrea set up in Europe a network of semi-secret societies, the Christian Unions, in order to preserve 'knowledge' that was bound to be regarded by the orthodox church as heretical. Each of these so-called unions was headed by an anonymous 'prince', who was assisted by 12 followers. This grouping is, of course, strongly reminiscent of witches' covens – the 12 men or women who are led by a familiar or initiate – or, of course, of the group formed by Jesus and his 12 disciples.

A further fascinating piece of evidence produced by Baigent, Leigh and Lincoln concerns Pope John XXIII. His choice, on his election in 1959, of the name John is a surprising one in view of the fact that a 15th-century antipope, or contestant for the papacy, had also carried the name John XXIII. After the modern Pope John's death, there were those who suggested that he was a member of the Rosicrucians and of the Priory of Sion. Had he adopted the name John because it was also the Christian name of Jean Cocteau, then the Grand Master of Sion?

The coincidence becomes potentially significant on consideration of a further fact: this modern Pope John decreed that Catholics now had permission to be Freemasons – a complete reversal of the Vatican's previous policy. Freemasons claim direct descent, ultimately, from the Knights Templar themselves, and also from such organisations as the Christian Unions. Moreover, Pope John proclaimed that the most important item of the whole crucifixion was not the resurrection, but the shedding of Christ's blood. This strange proclamation immediately turns our thoughts to the Holy Grail –

Pierre Plantard de Saint-Clair, below, was allegedly elected Grand Master of the Priory of Sion on 17 January 1981 – and is also said to be a direct descendant of Christ.

❝ IF JESUS WAS INDEED MARRIED TO THE MAGDALENE, MIGHT SUCH A MARRIAGE HAVE SERVED SOME SPECIFIC PURPOSE? ... MIGHT IT HAVE BEEN SOMETHING MORE THAN A CONVENTIONAL MARRIAGE? MIGHT IT HAVE BEEN A DYNASTIC ALLIANCE OF SOME KIND, WITH POLITICAL IMPLICATIONS AND REPERCUSSIONS? MIGHT A BLOODLINE RESULTING FROM A MARRIAGE, IN SHORT, HAVE FULLY WARRANTED THE APPELLATION 'BLOOD ROYAL'? ❞

BAIGENT, LEIGH AND LINCOLN, THE HOLY BLOOD AND THE HOLY GRAIL

the receptacle usually understood to have captured the blood that Christ shed while on the cross. For Baigent, Leigh and Lincoln, however, as we have seen, the blood of Christ means, more specifically, an actual bloodline – or descendants – of Christ. It is references such as this that make the whole question of the very existence of a 'royal house' of Jesus all the more thought-provoking.

COULD THE UFO PHENOMENON BE ROOTED IN THE TRAUMATIC EXPERIENCE OF HUMAN BIRTH, AND IS THIS A TESTABLE HYPOTHESIS?

ABDUCTIONS: THE INSIDE STORY

R ed Indian shamans – Black Elk of the Oglala Sioux, for instance – believed that they could travel from Earth to other worlds via a 'cosmic pillar', often symbolised by a pole or a tree. Black Elk often chose a spot beside a tree to begin his trances. Shortly, a spirit guide in the form of a bird would lead him upwards through a tunnel-like

The American Indian medicine man, below, is seen entering a trance-state. Shamans – as recent as Black Elk of the Oglala Sioux, above – regularly underwent experiences somewhat similar to UFO abduction reports.

aperture and then further upwards into a 'flaming rainbow tepee' where Black Elk met and communicated with a group of 'grandfathers'. At this point, in many accounts, the shaman would be forced to undergo painful bodily dismemberment – a demon supposedly removed every organ, bone and all the blood cells in his body. But everything would then be replaced, after being cleansed and purified, so that the shaman was spiritually and physically reborn, ready to return to his people with renewed spiritual energies. Sometimes Black Elk was returned on a 'little cloud'. 'Abduction' stories such as these, extraordinarily similar in many respects to UFO 'abduction' narratives with their echoes of the events that accompany birth, have been around for a very long time.

Those people who believe that UFO abductions relate to alien beings, parallel universes or other exotic origins will eventually have to explain – along with the lack of unambiguous physical evidence – why the incidents and images reported by abductees are so similar to those reported in a variety of obviously psychological processes, including drug-induced hallucinations, near-death experiences, religious and metaphysical ecstasies and, as we have seen, the trances of the shaman.

Every one of us has undergone a birth trauma. The universal phenomenon of birth is entirely free from ordinary cultural influences – for we experience it before we have undergone any kind of cultural conditioning – and it is, a far as we know, one of the first significant events consciously experienced by human beings. Although it is important to note that the causal link between specific events of biological birth and particular images has yet to be established, it seems that, in the birth trauma, we have a powerful experience that could well serve as the source of much imagery – including, perhaps, that reported by alleged victims of abductions by alien creatures. The fact that the experience of birth is more or less similar for everyone could indeed account for the similarity in abduction reports from all over the world; while the fact that no two births are absolutely identical could perhaps account for subtle differences.

When Betty Andreasson was abducted from her home in South Ashburnham, Massachusetts, on 25 January 1967, she found herself sitting in a clear plastic chair with a fitted cover filled with a grey liquid, as in the artist's impression, left. *Closing her eyes, she felt pleasant vibrations and was fed sweet fluid through a tube in her mouth. The whole experience seems to be a classic reflection of good experiences in the womb.*

" BETTY SPENT MUCH OF HER TIME ON BOARD THE UFO, FLOATING FROM ONE WOMBLIKE ROOM TO ANOTHER, THROUGH TUNNELS AND ON ELEVATORS OR OTHER COUNTER-PARTS OF THE BIRTH CANAL. *"*

A classic abduction case can be used to illustrate this hypothesis. At about 7 p.m. on 25 January 1967, Betty Andreasson, of South Ashburnham, Massachusetts, USA, was allegedly abducted from her living room by a group of alien beings. Her abduction began with a bright light that flashed outside her house, shortly after which a group of 4-foot (1.2-metre) beings appeared. They communicated with Betty, and floated her outside into a waiting craft where she was examined, immersed in a liquid. She was apparently then taken for a journey into alien realms. At the climax of her adventure, she witnessed a huge bird that spoke to her and that then, phoenix-like, was consumed in flames – an event that Betty, a devout Christian, interpreted in religious terms. She heard a voice that she thought was God's, saying: 'I have chosen to show you the world,' seemingly because of her sincere faith. After this, Betty's captors returned her safely home. The alleged abduction had lasted about 3 hours and 40 minutes.

The Andreasson case is useful because it has been extensively investigated by a group of dedicated ufologists. The main witness is also considered reliable, and the case details are representative of abduction narratives as a whole. What is more, as a competent artist, Betty was able to provide many sketches of her adventure. In short, the Andreasson close encounter of the third kind is about as reliable and detailed as any abduction case we are likely to find. At the same time, it has significant implications for UFO abduction research, for it contains a wealth of images and events relating to birth that also support a non-physical or psychological interpretation of UFO abduction mysteries in general. For example, Betty's humanoids were of the classic foetal variety: they had greyish skin, oversized heads, huge eyes, and underdeveloped noses, ears and mouths, although they behaved much like apparitions in being able, it seems, to pass through solid doors and to materialise at will. The leader even seemed to change his facial

The Garden of Delights by Hieronymus Bosch, below, *shows a kind of paradise and shares with many abduction cases the imagery of so-called 'good' womb experiences – a pleasant state of suspension within a transparent sac.*

features so that he became yet more foetal in appearance in his final meeting with Betty.

The event most obviously linked with perinatal imagery occurred in what Betty described as the cylindrical room, where she was enclosed in a clear plastic chair with a fitted cover, which her captors filled with a grey fluid. Here, she breathed through clear tubes that fitted into her nostrils and mouth. A telepathic voice then told her to close her eyes. Suddenly, she felt certain pleasing vibrations, the fluid whirled, and she was fed some sweet substance through the tube in her mouth. Floating and tranquil, she seemed to become one with the 'undulating fluid'. After a time, the fluid was drained, she was taken out, and she realised that her head hurt.

WOMB ANALOGIES

The cylindrical room is itself only one of several womb analogies in Betty's narrative; the transparent chair suggests the amniotic sac in which Betty floated in a foetal position; the grey liquid is the amniotic fluid; the breathing and feeding tubes are the umbilical cord. The tranquillising undulations and vibrations also suggest reference to 'good' womb experiences. Betty's headache may even be

around, feeling things... Feels like he's going right around my stuff inside – feeling it, or something with that needle.'

Betty was informed by the aliens that the navel probe was a test for 'procreation', and afterwards was told that there were 'some parts missing'. Betty had indeed undergone a hysterectomy some time previously, and was evidently reliving her own medical history; but the navel also commonly appears as an analogue of the umbilical cord in abduction reports. The aliens said they were 'awakening' something with their probing – a reference, perhaps, to death and rebirth that was articulated, in Betty's case, more clearly by the phoenix.

In Betty's vision, a worm was seen to emerge from the ashes of the phoenix. At the same time, two things seemed to be happening to her, both relating in a way to well-established perinatal events: she felt an intense, shivering chill when only a moment before she had been complaining of

a manifestation of the onset of another part of the remembered birth process – labour itself.

Betty spent much of her time on board the UFO, 'floating' from one womblike room to another, through tunnels and on elevators or other counterparts of the birth canal. The tunnels varied in length, but typically ended with doorways into brightly lit, dome-shaped rooms, where she was undressed, examined or 'cleansed'. The doorways suggest the cervical opening: usually a bare wall seemed to separate with a soft 'whoosh' on approach and unite again afterwards, leaving no trace. Other openings described include a circular membrane and mirror-like doors through which she crashed harmlessly.

During the medical examination that Betty alleges she underwent – in a big, bright room – the aliens inserted needle-tipped tubes into both her nasal cavities and her navel. In a hypnotic session conducted later by investigators, Betty recalled this experience in some detail as follows:

'I can feel them moving that thing . . . he's going to put it in my navel! O-h-h. I don't like this . . . I can feel them moving that thing around in my stomach or my body ... Oh! He's pushing that again . . .

Three Kentucky women, allegedly abducted by aliens, produced two sketches under hypnosis showing clear birth imagery. One depicts a woman on an observation table being examined by humanoids, top, a parallel with a baby's first moments. The other, a huge eye, above, is taken as a symbol of universal consciousness, often associated with tranquil periods within the womb.

intense heat, and also 'the worst thing I've ever experienced'.

It seems that the birth trauma hypothesis 'fits'. But is it correct to say that all abduction narratives are necessarily relivings of the subject's birth trauma? Even if this is the case, of course, it does not invalidate the experience nor in anyway prove that abduction experiences are all in the mind. What it does imply is that the UFO phenomenon may well stimulate a certain kind of hallucination in the human mind. The nature of the phenomenon itself, however, remains obscure.

P E R S P E C T I V E S

SPIN-OFF CASES

As Robert Sheaffer recounts in his book *The UFO Verdict*, accounts of abduction experiences have been known to flood in following publicity given to any one case. In particular, numerous reports were made following the showing, on 20 October 1975, of a film dramatization of the well-known Hill abduction case that had occurred near New Hampshire's White Mountains.

Interestingly, some of these concerned sightings and missing hours that were only recognised as such following this dramatization, screened under the title *The UFO Incident*. In one case, involving Mrs Sandra Larson of Fargo, North Dakota, her daughter and a friend, all three underwent dissection, like frogs in a laboratory, but were then put back

together again by the alien abductors – an experience remarkably similar to that of the Red Indian shaman, Black Elk, in his trances.

Certain subjects at first denied watching and therefore being influenced by the television dramatization, but subsequent questioning revealed otherwise. Indeed, details may have been unconsciously assimilated and worked into individual accounts, either genuine or fantasy, of experiences. A Defense Department memo, dated 11 November 1975, states: 'Since 28 October 1975, numerous reports of suspicious objects have been received at the NORAD COC' (Combat Operations Center). This was, of course, some eight days following the showing of the film.

AS A CHILD, RUTH HAD BEEN SEXUALLY ASSAULTED BY HER FATHER. BUT THE HORROR REALLY BEGAN WHEN, YEARS LATER, HALLUCINATIONS OF HIM STARTED TO PLAGUE HER. IT IS A CASE THAT PROVIDES UNIQUE INSIGHT INTO THE VERY NATURE OF REALITY

What is 'reality' and what are dreams? To the scientist, things are only real when they can be communicated by the senses by instruments that are extensions of the senses, when their measurements can be taken and their behaviour observed, when deductions can be made about them and scientific laws subsequently established. In the realms of thought, sane men also distinguish, mainly without difficulty, between fantasies and 'real' concepts.

But research has shown that there are, indeed, 'realities' beyond those generally perceived by our five senses, such as notes with a pitch too high to be heard by human ears. And there may be yet another form of 'reality', confirmed by the experiences

STALKED BY NIGHTMARES

Actress Connie Booth, above, played the principal role in the BBC's dramatised documentary The Story of Ruth *in 1982. Ruth, an American living in London with her husband Paul, was of average intelligence and perfectly normal – except for one thing: a three-dimensional hallucination of her father (who was still resident in the USA) followed and tormented her, reviving the hell she had been through when, as a 10-year-old, she had been sexually molested by him, as shown in the still,* **left.**

of mystics while in their ecstasies. But the fact remains that 'sanity' for most of us is the common ground of shared sensory perception: on the whole, the cat sits on the mat and not vice versa.

But what if our minds betray us, not in casual mistakes but by completely misinterpreting data supplied by our senses? What of Sybil Isabel Dorsett who, among her 16 personalities, saw herself in the mirror variously as a sophisticated blonde, brown-haired, a tall, willowy redhead, a dark, brown-eyed man, a blue-eyed man, a timid ash-blonde, a small, slim brunette – and with widely differing characters to match. She even bought clothes to suit one personality that would be utterly unsuitable for her 'real' physical self, the choice later utterly bewildering her other selves when they inhabited her body.

And what of Ruth, a 25-year-old American woman, married to Paul and living in London with their three children, the patient of Dr Morton Schatzman, psychiatrist? Her experiences are narrated in Schatzman's book, *The Story of Ruth*, dramatised on television by the BBC in 1982.

Ruth described her symptoms to Dr Schatzman: sex with Paul seemed 'dirty', she was scared of doors, avoided company, panicked in crowds and

hated going shopping; she had no appetite, felt negative towards her children, and sensed that her brain was going to explode. She had been the third in a family of four, the youngest being 10 years her junior. While her mother was having the last baby, Ruth's father attempted to rape her – and nearly succeeded. That the assault was likely to have been real, not imagined, is supported by the fact that the father was an habitual drunkard and regularly took drugs. He was also violent – once he actually fired a gun at Ruth (but missed); he had forged cheques; and he was a frequent inmate of mental homes and jails.

SICKENING HATRED

Ruth told her mother about her father's assault, but she professed not to believe her daughter, and packed her off immediately to the children's home where she had lived whenever her father deserted the family. Ruth married at 17, never lived with her parents again and felt a 'sickening hatred' towards her father.

What Ruth did not immediately tell Schatzman was that, almost every day, she had seen an hallucination of her father that appeared as real and solid as any living person. He had begun to appear a year after the birth of her youngest child. Sometimes she saw his face superimposed on Paul's or on her baby's; and even when she did not see him, she felt his presence in the house. She believed he wanted her dead and was prompting her to suicide. Once he sat with her at a friend's dining table, and looked so solid and ordinary that, if Ruth had been at home, she felt she would have offered him coffee. On another occasion, he occupied a chair between two visitors. She heard him speaking and watched him following their conversation – although he was invisible and inaudible to the others present.

Ruth became an in-patient at the Arbours Crisis Centre set up by Dr Schatzman and colleagues in London in 1971. There, she continued to see her

There are many legends in which hapless victims are pursued – and sometimes confronted – by paranormal beings, ghosts or, perhaps, hallucinations. The most famous of these were the Furies of Greek legend, who hounded Orestes, below. Ruth's 'father' pursued her as relentlessly as the Furies, mocking her terror, stalking her as she walked down the street, or suddenly appearing among a group of friends. He persecuted her in this way, she believed, because he thought that when she was a child he 'hadn't hurt her enough'.

> **▮▮** THAT FOURTH TIME – IT WAS ABOUT 12 NOON – SHE SAW A MAN SITTING IN FRONT OF HER ON THE TRAIN CHANGE INTO HER FATHER. SHE BECAME FRIGHTENED. WHEN SHE REACHED HER STOP AND GOT OFF THE TRAIN, THE MAN GOT OFF TOO, BEHIND HER. HE HAD HER FATHER'S FORM. SHE HOPED HE WOULD WALK IN A DIFFERENT DIRECTION, BUT HE DID NOT. SHE RAN TO A PHONE AT THE STATION TO CALL THE CRISIS CENTRE TO ASK SOMEONE TO MEET HER. **▮▮**

DR MORTON SCHATZMAN

father. She even felt her bed moved by his leg knocking against it (although it did not actual move). She saw him very clearly – 'I can see eac tooth' – heard him laughing and even smelt th sweat on him while in the doctor's presence.

Schatzman saw that Ruth thought rationally: h overall pattern of behaviour was not that of a ps chotic, and he knew that it was statistically cor mon for mentally healthy people in the West have some experience of hallucinations. Havir read that the Senoi, a Malayan tribe, thought drea life so important that they taught children to fac master and use whatever caused terror in the

ghtmares, he suggested to Ruth that she follow
eir example and confront her father's apparition.

The victory was not immediately, nor easily
on, however. Ruth continued to see her father,
ometimes superimposed even on to complete
rangers, and to hear and smell him. She also felt
at he read her thoughts and sensed that he was
ying to master her and take her over. The psychia-
st told her to send the apparition packing, which
e eventually did on occasions – but sometimes
s distinctive smell remained.

ATHER FIGURE

n her sixth day at the centre, Ruth saw Paul
nange into her father; and when he lightly touched
er hand, she felt it squeezed until it hurt. She
fused to sleep with her husband that night
ecause she felt he was her father. The next day,
e saw her father's face superimposed upon Dr
chatzman's. The doctor had suggested that she try
change him into her father because confronting
omething usually makes one fear it less and it
ould prove to Ruth that she had control: if she
ould summon the apparition at will, she could also

Guilt, in the form of the apparition of a 'wronged lady', is said to have warned Lord Lyttleton, as depicted left, *of his approaching death.*

In a scene from the television drama, below, *Ruth feels repelled by Paul's sexual advances – for it was not her husband (played by Colin Bruce) whom she saw lying beside her, but her father. Later in the course of her treatment, she found she could not only summon up an hallucination of Paul when he was absent, but actually make love with the hallucination – an experience she found to be sexually satisfying.*

will it away. This achieved, the next step was to create the illusion without using a real body as a 'model', and dismiss it: this she managed to do.

Further advance was made when Ruth again superimposed her father on to Schatzman, but he appeared to be wearing different clothes from the doctor. When Schatzman moved towards her, the apparition did so too; and when Schatzman lightly laid his hand upon Ruth's, she again felt her hand being painfully squeezed. She succeeded in dis-missing the appearance, but the experience left her very tired.

When Ruth left the centre after 11 days, Schatzman suggested that, far from being 'crazy', she was gifted in being able to summon and dis-miss apparitions at will. Her family history suggest-ed to him that the gift might be hereditary. At this point, the doctor had to go to New York for two-and-a-half weeks, during which time Ruth's father appeared to her at least eight times. She heard the rustle of his clothes and the popping of his cigarettes out of a packet, and was awoken once when he sat on her bed. She managed to send him away once, confused him on another occasion by casual reference to coffee and on a third, when he appeared while she was having a bath, asked him to pass her a towel. The apparition subsequently ceased for 19 days, its longest continuous absence, but then suddenly reappeared, superimposed upon Paul in bed.

On his return, Schatzman suggested that Ruth should try to create a friendlier apparition as an experiment in control. After some effort, she pro-jected a complete image of her best friend Becky, and held mental conversations with her. Ruth's apparitions usually behaved normally (although occasionally they walked through closed doors), but she also hallucinated the consequences of their actions, feeling a draught of air through a door opened by them and seeing Becky squeezing toothpaste on to a brush and handing it to her, though the door, paste and brush had not really moved. The duration of the appearances varied

> RUTH NEXT DOUBLED DR SCHATZMAN IN HIS PRESENCE – CREATING, IN EFFECT, HIS DOPPELGÄNGER SITTING IN A CHAIR ON HIS LEFT. WHEN SCHATZMAN WENT TO SIT IN HIS DOUBLE'S CHAIR, THE LATTER SAT IN HIS . . . SHE SAW BOTH MEN, REFLECTED SIMULTANEOUSLY IN A MIRROR.

from seconds to 15 or 20 minutes, and their creation both excited and drained her. She found that her apparitions also had personalities: although she could finally dismiss them, she could not always make them do what they did not want to do.

Ruth next 'doubled' Dr Schatzman in his presence – creating, in effect, his doppelgänger sitting in a chair on his left. When Schatzman went to sit in his double's chair, the latter sat in his, and when he passed in front of the apparition, he blocked it from Ruth's sight. She saw both men, reflected simultaneously in a mirror; and when Dr Schatzman held out his arms to thin air, Ruth saw him actually dance with his double!

Ruth made further progress when she produced an apparition of herself with which she established mental communication, although she found the experience exhausting. She repeated the experiment in Dr Schatzman's presence, her head hurting and heart pounding with all the effort this involved.

A Twilight World

By this time, in many respects Ruth had changed from patient to co-researcher with the psychiatrist. When she observed that an apparition's legs cast a shadow, experiments were carried out with light and darkness. Ruth could hallucinate the darkening and lighting-up of a room, yet failed to be able to make out the words on a bookcover in a room that was actually dark but which she 'saw' as lit. She could walk round an apparition, viewing it from every angle, could feel it (it was, she said, a little colder than a living being), and could see and feel it moving parts of her body, though these did not really move, or only very slightly. The apparitions could write messages that Ruth was also able to read, but the paper remained blank to everyone else, and they did not appear in photographs of chairs in which she saw them, nor did their voices

> ***... She sat on the floor and asked me to sit on a chair behind her and near her. That way, she could see my reflection in the mirror if she needed to. It was for her security, she said. If her father's face appeared to replace her face, then her father might take over her being, in which case she wanted me nearby.***

Dr Martin Schatzman

register on tape recorders – thus proving they h[ad] no objective reality.

Ruth next discovered she could create h[er] father's apparition superimposed upon her ow[n] reflection in a mirror, and did so with Dr Schatzma[n] sitting by to prevent her being 'taken over'. S[he] 'felt' her father's emotions and this frightened he[r] 'He', in reply to the psychiatrist's questions, ga[ve] information about himself. For Ruth, the experime[nt] resulted in considerable discomfort; but, althoug[h] she felt her father's fear, anger and sexual desir[e] she was not taken over by him. The experienc[e] involved similarities to mediumistic trance[.] However, whether the information that was give[n] by her 'father' was true – and whether Ruth h[ad] ever known it – could not be determined.

Dr Morton Schatzman, above left, the psychiatrist, had an imaginative and sympathetic approach to Ruth's distress and finally eradicated the nightmare element from the hallucinations she saw, actually helping her control and even create them at will.

Ruth is seen, left, confiding in Dr Schatzman, played by Peter Whitman, in the BBC television programme.

During several such sessions, a number of facts connected with her father's previous history and Ruth's childhood emerged. She seemed to feel his and her own emotions simultaneously, and the more she learned about him, the more she pitied him. She also found she could create him and merge with him without using the mirror, and still sense his feelings as before. 'The more I relaxed,' she said, 'the less I saw him and the more I became him.' Schatzman discovered that he could talk directly to the father through Ruth and found a plausible personality consistent with itself but not with Ruth's. Schatzman wondered whether this personality could have been a buried aspect of herself.

A startling development occurred when Ruth visited the USA and spent some time with her

faces of old ladies or babies

vagina

blood

her there. She created an apparition of Paul in her car – what is more, her father apparently also saw it. Perhaps even more startling was her success in twice making love with apparitions of Paul whom she 'created' on nights when he was absent. Both experiences were, she reported, sexually very satisfying.

Other experiments, however, failed. For example, Ruth tried to describe some new underpants Paul had bought by envisaging his apparition clad in them – but they were not the same as the real ones. And in an attempt to elicit information about Schatzman's life from his apparition, the 'misses' far outweighed the 'hits'.

Gradually, the limits of Ruth's strange ability were revealed. But she actually succeeded in making a double of herself. This doppelgänger – which brought to her recollection forgotten incidents from her youth – may simply have been a mechanism that enabled her to tap into subliminal memories. Whatever the explanation, Ruth recalled incidents from her past in great detail, many of which were later confirmed by her mother. Sometimes, she would even merge with her own apparition, so that she would enter 'memory trances', which in some respects were like those of spirit mediums and in others like hypnotic regression. In time, she learned

Psychiatrists frequently make use of Rorschach inkblot tests to gain some insight into the minds of their patients. The tests use randomly produced inkblots; and patients are asked what the shapes remind them of. Ruth, both as her adult self and when hypnotically regressed to her teens, was shown several such inkblots. One, left, was shown to the 'teenage' Ruth, who saw in it the heads of two babies, both of whom were bleeding. At another session, she saw two old women and a vagina in the same inkblot – an identification that anyone might make. The other blot reproduced, right, reminded the hypnotised Ruth of a vicious animal with pincers – or a penis. Asked if she had ever seen her father's penis, the 'teenage' Ruth replied primly: 'No, never. He was very careful never to do that sort of thing.' Yet when the notes of the session were read back to her 'normal' self, Ruth said that was a lie: 'He would wave it at you when he was drunk.' What seems to have emerged from these sessions was that the 'teenage' Ruth had disliked psychiatrists intensely and so said anything in order to be as uncooperative as possible. Her general level of association when faced with the inkblots was certainly not that of a psychotic.

a vicious animal

mouth

head or penis

pincers

to use this 'trance' technique without having to create her double, but did need someone else to be present in order to tell her what she had said, because she would not remember it.

In her regressions, Ruth talked and behaved like a child or an adolescent. Given a number of psychological tests while regressed to various ages, she performed in them as girls of those ages would be expected to do, thereby showing that she was reliving her past. Other tests proved that Ruth's apparitions affected her sight and hearing exactly as flesh and blood entities would have done. Dr Schatzman concluded that, far from being 'crazy' or having a damaged brain, Ruth showed evidence of an extraordinary capacity for creativity and projection.

Why, then, did the hallucinations come when they did? In 1976, when they began, her elder daughter was three years old – the age at which Ruth first entered the children's home – and her eldest child was seven, her age when her father returned to the family after his first period of desertion. These recollections of childhood traumas, perhaps subconscious, allied to the loneliness of living overseas in England – another Ruth amid the alien corn – could well have triggered her experiences.

And what of Ruth after the therapy? Her apparitions were to become pure entertainment. When driving alone, for instance, she found she could put one in the passenger seat for company, or converse with another, silently, at a boring party. The implications of her story for psychical research are far-reaching indeed.

// DR SCHATZMAN CONCLUDED THAT, FAR FROM BEING CRAZY OR HAVING A DAMAGED BRAIN, RUTH SHOWED EVIDENCE OF AN EXTRAORDINARY CAPACITY FOR CREATIVITY AND PROJECTION. //

STARS OF ILL OMEN

THE IDEA THAT THE DEVELOPMENT OF LIFE ON EARTH WAS DECISIVELY INFLUENCED BY COMETS IS REGARDED BY MANY AS CRACKPOT. BUT A THEORY NOW PROPOSED BY TWO SCIENTISTS GIVES IT A NEW PLAUSIBILITY

'I would rather believe that two Yankee professors would lie than that stones would fall from heaven,' exclaimed US president and scientist Thomas Jefferson (1748-1826). He had just heard a report from two Yale University scholars that over 300 pounds (130 kilograms) of meteorites had fallen at Weston, Connecticut, in December 1807. Jefferson was a victim of one of orthodox science's most persistent blind spots: for some 2,000 years, scientists had adhered to the word of Aristotle, who insisted that nothing solid could reach the world from beyond its atmosphere. His grounds for stating this were purely philosophical – beyond the Moon, everything was thought to be 'pure', made of matter finer than the Earth. How, then, could stones fall from the heavens?

This legacy crippled scientific research for centuries. As late as the 18th century, the Académie Française even persuaded several museums to throw away their meteorite collections on the grounds that these were of no interest to science. And although meteorite falls were frequently witnessed by peasants and others uneducated enough to believe their own eyes, science continued to maintain that meteorites did not exist – simply because, according to Aristotle, they could not.

Today, of course, scientists recognise the existence of meteorites. But the new theory of the origin of comets put forward some years ago by astronomers Victor Clube and Bill Napier of the Royal Observatory in Edinburgh (now at Oxford University) excited much the same reaction among modern scientists as did the idea of the existence of meteorites among their ancient counterparts.

Clube and Napier pointed out that, once in 50 million years, the solar system passes through one of the spiral arms of the Galaxy. The solar system is

The computer-enhanced photograph, above, is of Comet Bennett. Astronomers Dr Victor Clube and Dr Bill Napier, top, put forward the theory that comets have been responsible for many disasters in the Earth's history.

bound, according to Clube and Napier's model, collide with one of the immense icy clouds of du that are known to occupy the spaces between t stars. Mayhem results: the comets of the solar sy tem are hurled about in the resulting clash of gra tational fields, and a fresh influx of comets invad the solar system.

Proof for such a theory, according to Clube a Napier, has long been available. If the theory right, we would expect the solar system to awash with debris – which it is; and the plane should be pock-marked with craters – which th are. Clube and Napier's model may also be able explain one of the solar system's most mysterio anomalies, a ring of rubble that lies between t orbits of Mars and Jupiter – the asteroid belt. TI has long been the subject of speculative (a unworkable) theories about exploding planets – b according to Clube and Napier, the asteroid belt

...agon and serpent motifs – such ... in the ancient Egyptian painting ...m the tomb of Sennutem, top *– ...e, some have argued, stylised ...mets.*

a kind of dustbin of material left over from a previous influx of comets, now burnt out.

But what of the long-term effects of these periodic saturations of comets? The peak of comet activity would decay only slowly, and Earth would be under permanent threat of bombardment by further extraterrestrial missiles for many thousands of years. We last left part of the Galactic spiral system, the Gould belt, only 10 million years ago, at a point when our hominoid ancestors are thought to have been developing. True man-like beings were in existence a million years ago, and sophisticated prehistoric 'cave' cultures emerged 50,000 years ago. Well-established urban cultures, with written records, date back some 5,000 years. So might there be a possibility that Man experienced, and remembered, the long aftermath of an encounter with an interstellar cloud of debris?

Clube and Napier put forward the view that significant effects must have been felt well into historical times. As they have said: 'The current overabundance of interplanetary particles, fireball activity and meteor streams . . . all seem to bear witness to a sky that must have been exceedingly active within the past few thousand years.' Indeed, they calculated that, within the last 5,000 years, there must have been at least 50 impacts with cometary objects weighing between one and 1,000 megatonnes. The probabilities diminish, of course, as the size of the missiles increases; but there is an even chance that there was at least one encounter with cometary material weighing between 1,000 and 10,000 megatonnes within recorded history. The effect of such an encounter would be extreme: an impact of between 100 and 10,000 megatonnes, for instance, would cause blast and radiation damage over almost a million square miles (2.5 million square kilometres).

But Clube and Napier not only presented the mathematical probability of a close encounter with a comet. They attempted to identify the villain – or at least locate the remains of the body. By careful assessment of the remnants circling the skies today, they argued, we can reconstruct 'what must have been larger and most impressive pieces of cometary debris.' A large asteroid, called Hephaistos, discovered in 1978 – which, at a diameter of 6 miles (10 kilometres), could have wiped out the dinosaurs had it collided with Earth; a shower of rubble called the beta Taurid stream; and a decaying comet called Encke – all occupy almost exactly the same orbit, one that comes very close to Earth. According to Clube and Napier, it is difficult to avoid the conclusion that these objects are all fragments of one original body. Indeed, from the available evidence, Clube and Napier developed the theory that 'almost certainly a 12-mile (20-km) comet was in an Earth-crossing orbit and breaking up around about 2500 BC.'

What this huge comet must have looked like can be logically deduced. It would have had a magnitude of brightness, 'approaching that of the Moon, and sufficient to throw shadows at night. It would have appeared as an intense yellow spot of light surrounded by a circular coma probably larger than the full Moon, with a tail stretching across a large part of the sky.'

This prodigious sight, accompanied by a retinue of smaller comets as disintegration increased, would have been the dominant phenomenon in the sky for centuries.

MYTHOLOGICAL PARALLELS

It is easy to see why such a comet would have been universally feared. During its break-up, as it traversed the Earth's orbit, we would have encountered a regular stream of meteors. There would have been intense fireball activity and, at the closest approaches, a strong possibility of impacts from its fragments.

Such is the physical model for Clube and Napier's 'super-comet'. But do the records of ancient Man, who would have witnessed its deadly disintegration, provide any contemporary evidence for its existence? Clube and Napier put forward the view that we must look to mythology for such evidence, and that it is easy to see comets behind the sky-gods and celestial dragons of ancient myths. Practically every ancient culture has its version of a struggle for supremacy between the Sun or the reigning sky-god and an awesome primeval dragon. In Egypt, we have Ra and Apophis; in Greece, Zeus and Typhon; in Babylonia, Marduk and Tiamat; and in *The Bible,* Jehovah and Rahab. A physical reality behind such tales would explain the striking similarity that exists between so many Old and New World

soot that burnt the skin, a scorching wind, darkness for days, and fiery 'hailstones' that flattened trees as they fell. The parting of the Red Sea may even have been due to some seismic effect.

If all this sounds rather fanciful, it is worth noting that the Biblical narrative actually mentions something like a comet at just the point we would expect it. As the Israelites left Egypt, they were guided by a 'pillar of cloud' that rose in the sky before them and glowed like fire at night. Analysing details of its movements in the *Book of Exodus*, Clube and Napier concluded that we have here a plain description of an exceptional comet in a direct orbit of low inclination... If the passage is pure invention, one would have to congratulate the author on his powers of clairvoyance'.

The skilful blend of study of ancient sources and modern astronomical research employed by Clube and Napier makes a case that has had to be taken seriously by scholars in the many disciplines through which their theory ranges; and it is to be hoped that there will be no repetition of the excuses used to justify ignoring and deriding the work of another great rebel of 20th-century science, Immanuel Velikovsky. A hypothesis of a cometary cause for the plagues and other miracles of the exodus was popularised, and made slightly notorious in the 1950s by his book *Worlds in Collision*. Velikovsky's synthesis of events reads extravagantly: the 'comet' involved is a body of dimensions

> **// ANALYSING DETAILS OF ITS MOVEMENTS IN THE BOOK OF EXODUS, CLUBE AND NAPIER CONCLUDED THAT WE HAVE HERE A PLAIN DESCRIPTION OF AN EXCEPTIONAL COMET... IF THE PASSAGE IS PURE INVENTION, ONE WOULD HAVE TO CONGRATULATE THE AUTHOR ON HIS POWERS OF CLAIRVOYANCE. //**

legends, the dominant theme of all these mythologies being 'theomachy', or war of the gods, replete with descriptions of celestial battles, seismic action, raging seas, falls of stones, blood (possibly red dust, for instance), thunderbolts and other cataclysmic events.

Myths of world conflagrations and deluges take on a new meaning when reread in the light of the comet hypothesis. The *Old Testament*, in particular, has a framework of catastrophic episodes that could well describe the effects of cometary impacts, beginning with Noah's Flood and the blast of fire and brimstone that levelled Sodom and Gomorrah. Most striking of all are the events that preceded the exodus of the Israelites from Egypt around 1450 BC. Indeed, *The Bible* describes plagues that can easily be interpreted as the effect of passing through a stream of cometary dust and rubble – the poisoning and reddening of the Nile,

Noah and his ark are depicted, above, in a stained glass window from a church in Coignières, France. Clube and Napier have suggested that the Flood, among many other catastrophes described in **The Bible,** *was caused by the close approach of a comet.*

The Scottish stone carving, **left,** *shows – according to Clube and Napier – a long, curved comet tail and a huge halo surrounding a comet head that was probably as bright as the full moon.*

The destruction of the cities of Sodom and Gomorrah, **left,** *and the parting of the Red Sea to allow Moses and the Israelites to escape from the Egyptian army,* **below,** *could both have been the results of tectonic upheavals associated with the close approach of a comet to the Earth, according to the theory put forward by Clube and Napier.*

imilar to the Earth's that later settled down as the lanet Venus. A second round of catastrophes round 700 BC was, according to Velikovsky, aused by the planet Mars, whose orbit had been isrupted by the errant 'protoVenus'.

Self-appointed defenders of orthodoxy, including uch notable figures as Isaac Asimov and Carl agan, made a determined effort to ridicule – even uppress – Velikovsky's work, in one of the most candalous witch-hunts in the history of science. ut reasons for the hysterical reaction to *Worlds in ollision* were very often far from scientific: profesional jealousy (Velikovsky was not an astronomer y training, but a psychoanalyst); gross misrepreentations of his work carried in early reviews (it was claimed, for instance, that Velikovsky believed

that frogs fell from Venus); and perhaps also a deep-rooted fear of the concept that global catastrophes of the kind he described could have happened in the comparatively recent past.

This somewhat hysterical reaction took all of 30 years to die down. But calm, critical examination of Velikovsky's work was at last undertaken, notably by the Society for Interdisciplinary Studies in Britain. We can therefore begin to assess his contribution to science. Velikovsky's methodology, taking a bold global look at mythology to reflect the recent history of the Earth and the solar system, is invaluable. Indeed, his books contain a unique store of ancient cosmological myths to which many later researchers, including Clube and Napier, are indebted. Most of all, Velikovsky carried a lone – if colourful – flag for catastrophism through the 1950s.

In the 19th and early 20th centuries, most geologists had been catastrophists, accepting evidence that global disasters had shaped the Earth's history and altered the course of biological evolution. But then there was a lull in the popularity of catastrophism. The tide has now turned again, under the sheer weight of the evidence, and geologists are increasingly turning to 'neo-catastrophism'. As it is expressed by Derek Ager, professor emeritus at Swansea University: 'The history of any one part of the Earth, like the life of a soldier, consists of long periods of boredom and short periods of terror'.

TIME-SCALE PROBLEM

Looking back, we can see that Velikovsky's general case for a history of the Earth punctuated by extraterrestrial catastrophes was justified. But, from the extensive literature on Velikovsky's specific claims, one major scientific objection stands out – the problem of the time-scale involved. Velikovsky proposed that the comet that dominated the skies in the last few thousand years BC turned into the planet Venus. But, according to currently accepted laws of astrophysics, the transformation from an elliptical cometary orbit to a nearly circular one in such a short time would be impossible. Clube and Napier's theory avoids this problem: the remains of the body, they have suggested, are still on a cometary, Earth-crossing orbit. Thus the accepted laws of contemporary astrophysics are not flouted. They suggested – with complex arguments – that, as dangerous comets decayed, their names were transferred to planets. For them, Velikovsky's error was simply one of mistaken identity: 'He took the mythology of comets at its face value and, applying it to planets, came up with all sorts of impossible ideas.'

The other problem of time-scale is the basic reluctance of many scientists to accept the idea that catastrophes with extraterrestrial causes could have happened in the recent past. Scientists, as much as anyone else, are subject to the same desire for security – even if that means determining a safe history for the world in which nothing catastrophic has happened, except in the remotest past. The concept of a slow, uninterrupted progression of life, as envisaged by Darwin, is no longer tenable, as Clube and Napier realised: 'Darwin was allowed to imagine evolution without the devastating influence of comets. The resultant problems have been akin to explaining a game of football in which no one recognised the presence of the ball.'

POLTERGEIST PARADOXES

ARE THERE REAL, PHYSICAL POWERS THAT LIE BEHIND THE ACTIVITIES OF POLTERGEISTS, OR DO SUCH UNNERVING EFFECTS STEM SIMPLY FROM THE SUBCONSCIOUS MIND?

In 1952, researchers investigating poltergeist activity witnessed a remarkable incident. The heavy oak table around which they were sitting suddenly tilted slightly and rose – apparently of its own accord. It then moved forward over the floor, pushing ahead of it two of the men, both of whom were tall and well-built.

They were pushed into the fireplace behind them and, although unharmed, were considerably surprised. No external cause could be found for this incident, yet they noted that the temperature in the room had dropped dramatically, and one of the group (who was only later discovered to be a psychic) appeared to be in a trance-state. Such events have, it seems, been observed on countless other occasions, and in many parts of the world.

Certain physiological reactions to such phenomena have also been observed, recorded and measured. Loss of weight can sometimes occur, for instance. One medium, Eusapia Palladino (1854-1918), even claimed that she shed 20 pounds (9 kilograms) during a single seance. Experiments in Ireland with a table weighing 30 pounds (13.6 kilograms), wired up to equipment monitoring its weight, showed that when it was levitated, it somehow 'lost' 15 pounds. Unfortunately, a more thorough examination of weight-loss during such activities is extremely difficult, because there is usually no warning that an episode is about to occur.

The rapid drop in temperature that was noticed in the 1952 case also occurs in spontaneous phenomena of other sorts, records testifying to a fall of as much as 8°C (4.4°F) in 10 seconds. This sudden loss of heat apparently releases a great deal of energy, which may well account not only for the blue sparks that some witnesses claim to see, but also the malfunction of electrical equipment that is often observed. Lights, televisions and cookers are at times reported to turn themselves on and off as may, ironically, the monitoring equipment of researchers.

Electrical charges definitely seem to be a measurable by-product of psychokinesis. In an

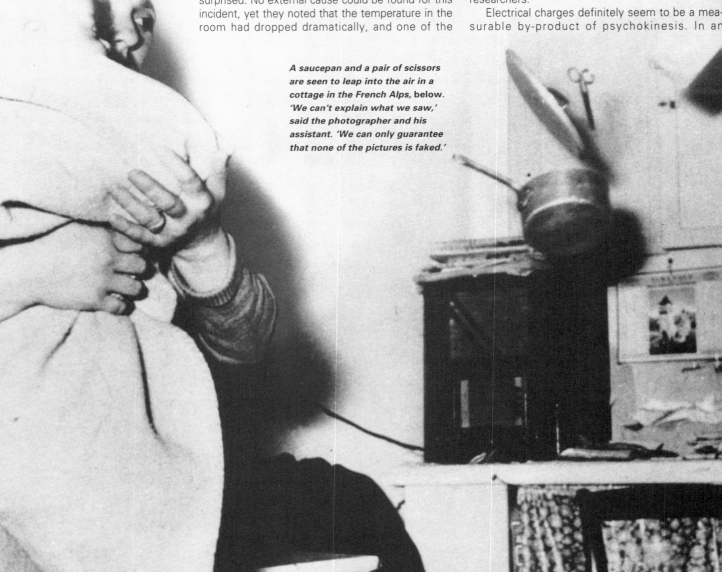

A saucepan and a pair of scissors are seen to leap into the air in a cottage in the French Alps, below. 'We can't explain what we saw,' said the photographer and his assistant. 'We can only guarantee that none of the pictures is faked.'

enced, the appearance of a 'ghost' may itself be a symptom of stress; and the shock caused by the appearance of such a mysterious figure may then trigger a series of inexplicable events for which the 'ghost' is blamed.

CONVERSION NEUROSIS

Neurosis is another psychological condition associated with psychokinesis. Indeed, Professor A. R. G. Owen suggested that 'poltergeistry' may actually be a conversion neurosis. In certain people, in other words, acute anxiety may be converted into noise and the movement of objects. But, if that is the case, why does poltergeist activity cease? 'Maybe', Professor Owen theorised, 'the activity eventually ends because it is not a disease but the cure.' Sleepwalking, another symptom of deep anxiety, is also associated with victims of poltergeist activity. It seems that the activity often continues while the victim is asleep, which supports the theory that the unconscious mind is the true source of the power. Mary Carrick, an Irish girl living in America in 1898, was 'pursued' by raps on the walls of rooms in which she worked, and heavy objects would move in her presence. She would often carry out housework while still asleep, and the knockings would continue unabated. Taps and scratchings have also been heard near beds in other cases, even when the victims were sound asleep.

A series of laboratory tests conducted on a housewife in the Soviet Union in the 1970 revealed the extent to which physiological and psychological factors collaborate to produce psychokinetic forces. Among other things, Nina Kulagina was able to separate the yolk of an egg from the white, and then reassemble the egg, without touching the container in which it had been placed. She was also able to arrest the heartbeat of a frog by suppressing an electric current. (She was not even told that the wires carrying the current were connected to a living creature.) In other tests, small electrodes were attached to her head and recording apparatus to her heart and wrists so that electrical pulses, generated during psychokinetic incidents, could be monitored.

Tests proved that the electrical activity of her brain rose to a very high level at such times, and that her pulse rate increased to an incredible 240

experiment carried out in Folkestone, Kent, for instance, it was established that a group of seven people, sitting at a table with hands joined, was able to generate a considerable electrical charge that lasted for three seconds. And in the case of 'Philip, the Imaginary Ghost', a group was able to produce recordable and apparently intelligent raps from the table, despite the fact that the entity was entirely 'fictional'. Hyperventilation is another phenomenon often encountered in such situations, mediums frequently seen to experience deep and rapid breathing as they enter a state of trance.

The psychological causes or effects of poltergeist activity are less easy to measure, though many victims display the same symptoms and have similar experiences. Many see apparitions, some of which are replicas of living people and some thought to be hallucinatory images – although they may be apparitions of unrecognised people. At the time when the Enfield poltergeist case was being investigated, the 'ghost' of Maurice Grosse, one of the researchers, was seen in the house at least twice. Dozens of other reports confirm that such an experience is not uncommon, though by no means all claims have been substantiated by evidence. But it does seem that it is often necessary for the poltergeist victim to create a visible form for the invisible agent of the disturbances, in order to be able to cope with the phenomenon. In other words, the 'ghost' provides an excuse for the disturbance, so that responsibility for damage can be placed on its phantom shoulders. In some instances, an apparition is seen even before a psychokinetic incident takes place, as though it were the catalyst or agent. As poltergeist activity frequently erupts when tension or trauma is experi-

The famous Italian medium, Eusapia Palladino, is shown above, raising a table about 10 inches (25 centimetres) above the floor. During a demonstration of this sort, she claimed that she would lose as much as 20 pounds (9 kilograms) in weight.

A table was seen to levitate in front of television cameras, below, during a seance in which 'Philip', the imaginary phantom, was 'contacted'.

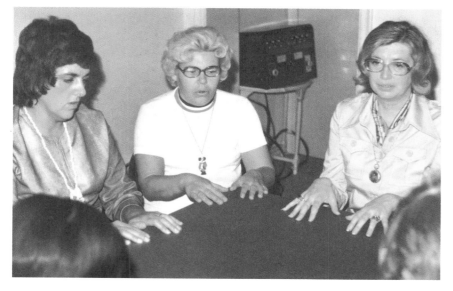

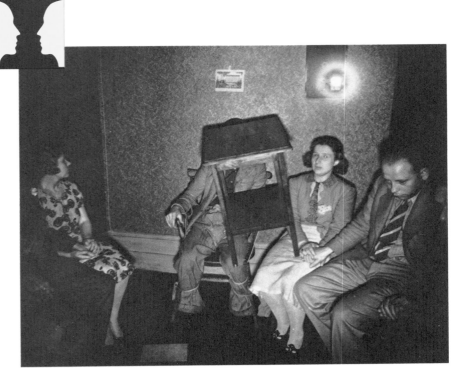

activity; she experienced slight dizziness; and her sleep pattern was disturbed. The sugar content of her blood increased, and her pulse rate became erratic. (Practically identical symptoms have been observed in people suffering from a mild form of epilepsy and also in certain women who are going through the menopause.)

LINGERING ENERGY

The generation of psychokinetic power thus appears to have its origins in certain psychological conditions, to which physiological symptoms bear witness. Yet the power seems to have an existence that is independent, to some extent, of those who generate it. A concentration of energy, once it is consciously created, also appears to linger in selected areas. In 1973, for example, it was discovered that a compass needle, deflected by psychokinetic force, would continue to oscillate if placed in the area in which a sensitive had originally projected the power, despite the fact that she was no longer present. One researcher, William Roll, even claimed that if one disturbance had taken place in a given area, another disturbance was likely to occur there.

beats a minute. (A rate of about 70 is considered normal.) The magnetic field around Kulagina also increased significantly; and when all the electrical and electromagnetic forces reached their peak, they merged in a single, fluctuating rhythm. At this point, she was able to move objects at some distance from her without touching them in any way. During each successful trial in which her psychokinetic power was evident, Kulagina is reported to have lost 4 pounds (1.8 kilograms).

The continuous monitoring of the woman's physical condition provided proof that Nina Kulagina was in a state of considerable nervous tension. An electroencephalograph registered intense brain

A table is levitated by English medium Jack Webber, during a seance, above.

The Polish medium Stanislawa Tomczyk demonstrates the levitation of small objects in full daylight, right. *After her marriage in 1919, she gave up all practices of this kind, and claimed that her 'act' had indeed been fraudulent – but she never explained how it was done.*

The idea that a 'cosmic force' lies behind those inexplicable incidents that are categorised as poltergeist activity is at least four centuries old. Paracelsus is believed to have proposed this explanation in the 16th century; and Mesmer, the celebrated hypnotist, promoted the belief some 300 years later. Today, experts in the field of parapsychology are extremely reluctant to concede any ground to the theory. Indeed, it is generally acknowledged that psychokinesis is a form of 'thought force', the origins of which are natural rather than supernatural. As Scott Rogo so neatly put it in a paper in the *Journal of the Society for Psychical Research:* 'Psychokinesis is a phenomenon of vast contradictions. It seems to be both a mental and a physical force at one and the same time.' At present, an explanation for the phenomenon lies beyond the boundaries of scientific theory. General acceptance and a deeper understanding of the force in the future will doubtless depend on strictly controlled investigation of psychokinesis in all its forms.

PERSPECTIVES
SUBSTANCE OF THE SPIRIT

Ectoplasm was originally a biological term, meaning the outer layer of the cell protoplasm. But in 1905, the French physiologist and psychical researcher Charles Richet lent the name to 'a kind of liquid paste or jelly [that] emerges from the mouth or breast...[and] organises itself by degrees, acquiring the shape of a face or limb.'

In the cases described by Juliette Bisson in her book *Phénomènes dits de Matérialisation,* the most stringent precautions produced no evidence of fraud, and investigators were unable to determine the nature of the substance. However, in the many instances of ectoplasmic materialisation that have been recorded since 1905, the phenomenon is generally suspect.

Mediums insist that ectoplasm is a living substance, which is destroyed by exposure to light; but interestingly, since the availability of infra-red film, there have been very few claims for the production of ectoplasm.

In photographs that were obtained during the 1920s and 30s, 'ectoplasm' bears a close resemblance to butter muslin – indeed, one of the only two specimens of ectoplasm ever obtained was found to be of this material: the other was of chewed lavatory paper. The fetid smell so often associated with ectoplasm also indicates, some believe, that it could have emerged from concealment within one of the body's orifices.

THE ONE GREAT CERTAINTY FOR EVERYONE IS DEATH. YET HOW MANY OF US BOTHER TO CONSIDER – LET ALONE PREPARE FOR – THIS HIGHLY SIGNIFICANT PART OF LIFE?

What happens when we die? Nothing? Complete bliss – 'eternal life'? Or a vague, insubstantial something? Materialists and atheists would, of course, answer 'nothing'. For them, life is a purely biological process; when the body dies, the personality dies with it, just as electricity stops being generated when a battery fails. To such people, life cannot 'go somewhere else'.

These rationalists frequently point out that the age-old belief in an afterlife is merely a reflection of Man's terror of death and personal oblivion. Throughout history, he has either avoided the unthinkable or surrounded it with ritual and a childish optimism. Materialists believe this to be craven and intellectually dishonest: we ought to face 'the

In his painting **The Plains of Heaven, below,** *the English painter John Martin presents a vision of the afterlife in which hosts of the blessed rejoice in a dramatic landscape worthy of the mid-Victorian Romantic poets. These angels, some of them winged, play the traditional harp.*

facts', they say – after all, it has to be admitted that the one sure fact of life for everyone is death.

So what of the concept of 'eternal life'? Nearly all religionists have preached that we survive bodily death in one form or another. It is probably also true to say that the more sophisticated the religion, the more certainly it envisages some form of life everlasting, whether in a kind of paradise or amid the torments of hell.

If the materialists are correct, no further enquiry need be made. But if the religionists are right, then it surely behoves each individual to look to his or her salvation. But any belief in an afterlife must remain a matter of faith, and only the experience of our own death can prove us either right or wrong.

But what if neither of these rigid concepts is correct? What if 'something' – some lifespark or vestige of the human personality – survives and enters a new kind of existence, not as a form of reward or punishment, but merely as part of some natural law? Today, many psychical researchers feel that the balance of evidence suggests that 'something' does survive, not necessarily for very long after

WHAT HAPPENS AFTER DEATH?

The building, far left, is a reconstruction of the Fox family's historic home in Hydesville, New York, where the modern Spiritualist movement was born.

The strange rappings and table-turnings that occurred in the presence of the Fox sisters, left, were taken by many to be the long-awaited proof of communications from the dead.

death, nor necessarily the whole personality. According to some, parts of an individual's memory-system and personality traits survive for a while, enabling the disembodied self to be recognised by the living who knew him or her, but later perhaps to disintegrate forever.

Objective analysis of purported evidence for human survival is a major concern of the Society for Psychical Research (SPR), founded in London in 1882. But the founding of the SPR would probably never have happened but for events of a generation earlier, which themselves might never have occurred but for the emancipation of Man's thought that began in the Renaissance.

As the horizons of knowledge expanded, the materialist position strengthened; and by the mid 19th century, a 'thinker' was generally reckoned to be someone who had freed himself from the trammels of 'superstition'. Religionists, feeling themselves under attack, tended to close their minds to any facts that undermined their position, ironically adopting much the same attitude that some scientists take even today when confronted with overwhelming evidence for certain paranormal events.

In the light of such hard rationalism, a faith with results that could be demonstrated was highly sought after. So when poltergeist activity occurred at the Fox family home in Hydesville, New York, in

// WE ENCOUNTER THE DEAD AT THE

MOMENT OF GOING TO SLEEP, AND

AGAIN AT THE MOMENT OF WAKING ...

THESE MOMENTS OF WAKING AND

GOING TO SLEEP ARE OF THE UTMOST

SIGNIFICANCE FOR INTERCOURSE

WITH THE SO-CALLED DEAD AND WITH

OTHER SPIRITUAL BEINGS OF THE

HIGHER WORLDS. //

DR RUDOLF STEINER,

THE DEAD ARE WITH US

1848, the public was tremendously excited. Here, at last, was 'proof' of the survival of the spirit; an antidote to the bleakness of materialism. Spiritualism was born and has since become a significant movement in the western world.

Spiritualists believe that their faith demonstrates incontrovertibly the existence of life after death. They point to seances where, it is said, spirits move heavy tables, play musical instruments and introduce apports; where dead relatives and friends speak recognisably in their own voices of events known only to themselves and one or more of the sitters, and sometimes even materialise in their own appearances before them.

But scientists of the time refused to investigate seance-room phenomena, while Spiritualists – and fundamentalist Christians – took refuge (though not as allies) in a simple faith that regarded any such discoveries as due to Devil-inspired cleverness.

OBJECTIVE ASSESSMENT

It was in this climate of extremes that the SPR was founded. Initial members included a group of British intellectuals who objected to the entrenched positions of 'believers' and 'sceptics' and who felt that objective assessment of unusual phenomena was long overdue. Since then, the material collected by the British SPR and similar societies in other countries provides the strongest clues for the serious enquirer into the nagging question: 'What happens when we die?'

The huge body of material collected since 1882 may be categorised as follows: phantasms; communications through mediums; cross-correspondences; 'drop-in' communicators; 'welcoming' phantasms, seen by the dying; experiences of patients during 'clinical death'; out-of-the-body experiences; cipher and combination lock tests; appearance pacts; evidence for reincarnation; and electronic voice phenomena.

In The Treasures of Satan *by the late 19th-century French symbolist Jean Delville,* left, *Satan is depicted flame-coloured as a sign of both his lust and his fiery destruction of souls through degradations of the flesh.*

Burial of the dead is not universal. In the artist's impression, below left, *a Red Indian brave visits the rotting corpses of members of his tribe, exposed to the elements and birds of prey on a hill set apart for this purpose. Their spirits were believed to spend eternity in the so-called Happy Hunting Ground.*

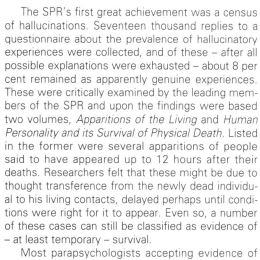

The SPR's first great achievement was a census of hallucinations. Seventeen thousand replies to a questionnaire about the prevalence of hallucinatory experiences were collected, and of these – after all possible explanations were exhausted – about 8 per cent remained as apparently genuine experiences. These were critically examined by the leading members of the SPR and upon the findings were based two volumes, *Apparitions of the Living* and *Human Personality and its Survival of Physical Death.* Listed in the former were several apparitions of people said to have appeared up to 12 hours after their deaths. Researchers felt that these might be due to thought transference from the newly dead individual to his living contacts, delayed perhaps until conditions were right for it to appear. Even so, a number of these cases can still be classified as evidence of – at least temporary – survival.

Most parapsychologists accepting evidence of phantasms agree that thought transference – which includes thoughts, feelings, and images both visual and auditory, and which would today be classified under the heading of extra-sensory perception (ESP) – is a faculty of some human minds and could be used to explain phantasms of the living. This also seems to be confirmed by the claims of certain individuals who say that they can 'think' themselves into paying 'astral visits' – travelling while out-of-the-body – to acquaintances. Claimants not only 'see' the rooms into which they project themselves mentally but report accurately such features as changes of furniture, of which their conscious selves were ignorant. Furthermore, they are often seen by the friends they 'visit', and are sometimes also accurately described by strangers who happen to be present.

However, some 6 or 7 per cent of the apparitions recorded in the SPR survey appeared too long after death for them to be explained as delayed telepathic communications. This small number of cases remained after all other explanations – hoaxing, exaggeration, mistaken identity, dreaming and so on – had been examined and found inadequate.

Intriguingly, those cases classified as genuine apparitions or phantasms of the dead showed certain common features. In some, the apparition conveyed information previously unknown to the percipient. In others, it seemed to have a clearly

According to various communicators, there are other planes that are inconceivable to us... but unless the evidence of physical research is an enormous confidence trick... the individual survives death in a form not unlike his present mode of being.

COLIN WILSON, AFTERLIFE

A 'mental' sensitive may go into a trance, in which a 'control' (otherwise known as a 'controlling spirit' or 'spirit guide') speaks through him or her, frequently in an entirely different voice, occasionally even giving her a different appearance, so that a European woman may temporarily take on the likeness and voice of, say, a Chinese man.

Through the sensitive, the control may also introduce other alleged spirits, recognisable by voice, gesture, or the nature of the private information given to one of the sitters at the seance. Such so-called spirits may seem extremely convincing, though it must be admitted that those who want to believe will probably believe anyway. However, sensitives often have striking gifts of clairaudience, clairvoyance and other forms of ESP. Sometimes, they will communicate through the planchette board, through automatic script, or through drawings in the style of recognised masters, or compositions in the manner of famous musicians.

Another type of sensitive is the 'direct voice' medium, who does not, as a rule, go into a trance but from whose vicinity voices of both sexes and different kinds speak in various accents, and sometimes even other, identifiable languages.

Communications from such sources vary enormously in quality, but much of it is trivial and curiously materialistic. It was even a frequent gibe in the early days of Spiritualism that spirits seemed to spend their afterlife smoking cigars and drinking whisky. Yet such 'materialistic' evidence would support the teaching of some Eastern religions that an early stage after death involves passing through

defined purpose. In yet others, it resembled a dead person unknown to the percipient who later recognised him from a portrait or photograph, or from some characteristic of the deceased unknown to him at the time. Sometimes, too, different people at different times – independently of each other – saw the same apparition.

CONTINUING DESIRES

Some psychical researchers think that only those cases in which apparitions indicate a specific purpose for their manifestation can be taken as significant evidence of survival and even then perhaps only as evidence of temporary survival. It could well be that, as a memory survives the event remembered, so a desire to communicate something urgently to the living might continue to exist after the thinker's death until its purpose is fulfilled: then it, too, might die.

Since the early days of the Society for Psychical Research, many astute minds have studied and recorded evidence of supposed survival provided by such apparitions. Some have believed that we live on, others not. But it is safe to say that none of the researchers involved has ever become convinced of survival on the evidence of apparitions alone.

While phantasms were being investigated by the SPR, so, too, were the activities of mediums – or, as they are better named, sensitives. These are people (more often women than men) who have unusual psychic talents, which they display in various ways. According to their specific gifts, they are generally classified as either 'mental' or 'physical' sensitives.

A representation of a Viking galley is shown, above, being burned at the climax of the annual Up Helly festival at Lerwick in the Shetland Isles. Ancient Viking funerals combined cremation with dramatic spectacle, the dead being placed in a burial ship which was set alight as it was pushed out to sea. It must have seemed to mourners on the shore that the journey to Valhalla (the Viking heaven) was a very real and even physical one.

Peruvian Incas, right, are seen burying a chief and preparing him for an afterlife just as stylish and prosperous as his earthly existence. Like many other pagan peoples, they buried treasure, food and weapons with their dead, believing these artefacts to be necessary if they were to survive in the next world in the manner to which they were accustomed. Others, however – such as the Balinese, seen in front of a pagoda-like cremation tower far right, top – do not hold possessions important for the life to come.

Very popular at Edwardian seances was the moulding of 'spirit' hands in paraffin wax. The hands were believed to dematerialise, leaving the moulds unbroken. But Harry Houdini, the great escape artist and scourge of fraudulent mediums, top left, proved that it was a relatively easy trick to learn.

a realm of illusion where the ego may indulge in anything and everything it wants.

Other communications, however, are of a highly ethical and literary standard. Yet, frequently, when challenged to give an unequivocal description of what awaits us on the other side of life, communicators reply (perhaps not unreasonably) that the spirit existence is indescribable. Some rare spirits are more forthcoming, though; and an uncannily consistent picture of the afterlife emerges through their communications.

'Physical' mediums are those in whose presence, whether they go into trances or not, physical phenomena occur, such as loud raps from the seance table or from various points around the room, perhaps. Sometimes these seem to be in an intelligent code, as if trying to convey some message. Also common are telekinetic phenomena (solid objects moving as if handled by an invisible person); levitation – of the sensitive or of objects; the playing of musical instruments by unseen hands; and actual materialisation of spirit forms.

Sadly, in the short history of Spiritualism, many of these phenomena have been faked, but there still remain many cases of genuine physical mediumship that defy 'rational' explanation. Many tests have been set up to try to trap the frauds, and, to a lesser extent, to determine the extent of the phenomena. One such test involved the provision of a dish of warm wax at a physical seance. The materialised 'spirit' hand dipped itself into the wax, which rapidly set. The hand then dematerialised, leaving the mould unbroken. Astonished witnesses took this as a certain sign of life after death.

169

HOMOEOPATHISTS BELIEVE THAT THEY CAN CURE ALL MANNER OF ILLNESSES BY TREATING LIKE WITH LIKE. BUT WHAT EVIDENCE IS THERE FOR SUCH APPARENTLY EXTRAVAGANT CLAIMS?

HOMOEOPATHY -A LIKELY CURE?

Many forms of unorthodox medicine seem to work in extraordinary ways, and pose a number of vital questions. Do they, in fact, have a direct physical effect on the body that can be measured and understood? Or are they sometimes merely placebos, depending on faith on the part of the patient for their efficacy – a faith that may also be enhanced by a good therapeutic relationship with the practitioner?

The problem is particularly acute in the case of homoeopathy, since exponents claim to deal with more than just the physical condition of the ailing person. Indeed, the selection of a correct remedy also takes into account the psychological make-up of the patient and his or her current emotional state, as well as the physical complaint.

Furthermore, the homoeopath does not send his or her patient off for numerous tests. Rather, he builds up a picture of the symptoms, derived from what can be observed, together with what the patient reports: how he feels at certain times of day, what aggravates or relieves his symptoms, and what his habits are. The homoeopath believes that all such details together constitute a meaningful pattern that can suggest the correct remedy. As James Tyler Kent, one of the 'fathers' of homoeopathy, put it:

'Homoeopathy is an exact science. It is based upon a natural law, and the true physician must prescribe in accordance with this law of nature. Homoeopathy has no specific for any disease by name, but it has a true specific for each individual case of disease.'

Homoeopathic treatment is based upon the successful application of the 'law of similars', and treats like with like. Samuel Hahnemann, an 18th-century German physician, came to believe that the appropriate medicine for the sick was one that, when given in small doses to a healthy individual, produced precisely the same set of symptoms presented by the ailing. Symptoms, he maintained, were actually the individual's own healing reaction to whatever disease was assailing him. The idea was not new: it had been presented before, notably in the writings of Hippocrates and in the *Medical Observations* of the English physician Thomas Sydenham, written in 1676.

So are the theories of homoeopathy really all that strange? There are in fact a number of drugs used in orthodox medicine that produce the very same symptoms, when administered to a healthy

Old tincture bottles line the shelves of A. Nelson and Co., the British makers of homoeopathic medicines, at their London premises, above. The pharmacy was begun by Ernest Louis Ambrecht, a fellow countryman and contemporary of Samuel Hahnemann, inset right, the founder of homoeopathy. Hahnemann taught three fundamental principles: that a disease can be cured by very small doses of a medicine that, in large doses, causes the symptoms of the disease; that extreme dilution enhances the medicine's curative properties and removes its harmful side-effects; and that a medicine must be prescribed only after study of the whole person, including his temperament.

person, that characterise the disorders for which they are prescribed. What is more, there are superficial resemblances between homoeopathic practice and orthodox vaccination. A vaccine will stimulate the body's defensive system so that it is able to deal with future attacks by particular disease-causing organisms. An individual may even develop mild symptoms of the disease immediately following vaccination. But the differences between the two procedures are also significant. Homoeopathy does not seek to immunise but to heal, and searches for the particular remedy that will produce the very symptoms displayed by the patient and so, in theory, trigger a healing response.

The feature that truly separates homoeopathy from present-day orthodox treatments, however, is that its medicines are administered in doses that are minute. In fact, they are so enormously diluted that some who doubt the efficacy of homoeopathy have even claimed that almost no traces of the original therapeutic substance remain once the extreme dilution has been prepared.

However, there is actually scientific evidence for the value of a certain degree of dilution. According to the so-called Arndt-Schulz 'law': 'Every drug has a stimulating effect in small doses, while larger doses inhibit, and much larger doses kill.' Although this dual action of drugs is well-established, orthodox medicine nonetheless balks at the extreme dilutions used in homoeopathy. A 'small' dose in ordinary medicine is massive by homoeopathic standards: while, according to orthodox medical opinion, drugs are meant to kill off diseases, rather than to help the body to heal itself.

The very preparation of homoeopathic medicines also adds to the mystique, therapeutic substances being converted by vigorous shaking, alternating with successive dilutions. This must be done in just the right way in order to 'potentise' the medicine.

Naturally enough, homoeopaths are concerned with producing scientific evidence and explanations for their treatments. A great deal of research has been undertaken, mainly in France, Germany, Switzerland, India, Britain and the United States, principally on plants, animals and micro-organisms.

But a study of the results may not readily reassure the sceptics. Indeed, an informal report made by Dr Jean Kollerstrom for the British-based Scientific and Medical Network was forced to conclude that very little published work in this field stands up to rigorous statistical analysis or meets the necessary standards of repeatability.

Between 1941 and 1954, Dr William Boyd of Glasgow University carried out research that had striking results. He measured the rate of chemical reactions involved in processes of growth, and the effect of mercuric chloride on that rate. Normally, mercuric chloride acts to inhibit growth. But his results showed that minute doses served to stimulate it. His work was analysed independently by four teams of statisticians, and they confirmed Boyd's conclusion. Unfortunately, however, this impressive result has never been repeated, and a fundamental demand of scientific research – that a claim cannot be regarded as substantiated until the same effect has been obtained by more than one researcher – remains unsatisfied.

In 1980, the Scientific and Medical Network also attempted to replicate the work of two Dutch

The beautiful structures, above right, were formed by crystallisation from a solution of chromium and nickel salts to which a small amount of a homoeopathic 'mother tincture' was added. The patterns depend on the chemical nature of this tincture which is a relatively concentrated homoeopathic solution from which highly diluted medicines are prepared.

*In*FOCUS

THE BACH FLOWER REMEDIES

Concocted specifically to reverse particular negative emotional states, these 38 different remedies, were first developed by Dr Edward Bach (1880-1936). According to Bach, who had worked as a homoeopath, a patient's physical symptoms can be alleviated by working on such mental conditions as depression, anxiety or even self-hatred.

According to Bach's exacting instructions, the flower heads have to be placed on the surface of water in sunlight for three hours. His theory was that that the flower remedies were effective because of the way in which they would attract spiritual power for cleansing and healing. There is little by way of clinical evidence for their efficacy: but even orthodox medical practitioners doubt that there is anything harmful about the remedies.

So it is that Bach prescribed cherry plum for uncontrollable temper; gentian for general pessimism; and wild rose for apathy. Pine, meanwhile, was recommended for self-reproach; willow for resentment; and oak for despondency. Chicory was believed to be helpful in overcoming self-pity; impatiens was suggested as a cure for irritability; and holly to combat jealousy. A special so-called Rescue Remedy combines five flowers for the treatment of shock or extreme panic.

scientists, Amons and Manavelt, carried out a few years previously. They had measured the effect of highly diluted mercuric chloride on the growth of cells known as lymphoblasts, produced by a mouse tissue culture in the laboratory. Once again, the Dutch workers found that the mercuric chloride affected the growth of the cells. But the Network team found no such effect in two series of their own experiments. In fact, there was neither stimulation nor inhibition of the growth of the lymphoblasts. As Dr Kollerstrom commented:

'Our results afford another example (of which there are several in the literature) of non-repeatability in this type of experiment. For the benefit of sceptical readers who would like to discard this tiresomely inexplicable phenomenon by assuming that it is due to sloppy experimentation or to inadequate experimental details having been given in the literature, I would like to state that in my opinion this is not often the case... The point I am making, hesitatingly and with reluctance, is that one may be forced to admit that non-repeatability, when one is working on the fringe of what one

The medicine cabinet, above, was used by Samuel Hahnemann, 'father of homoeopathy'. Since homoeopathic tinctures are used in extreme dilution, only a minute quantity of each is required. Hahnemann's own handwriting appears on the stoppers.

In a homoeopathic laboratory, below, the potency or power of a medicine is paradoxically increased by a sequence of dilutions, each followed by 'succussion', or vigorous shaking. A commonly used potency is '30c' – the result of 30 successive hundredfold dilutions.

hopes may be considered scientific, may have to be accepted as a 'fact' not due to human carelessness or to wishful thinking (in the first place), and presumably not due to bloody-mindedness on the part of the cell or organism. Thus we seem to be left only with the choice of 'experimenter effect' or other factors beyond our knowledge.'

The writer Fritjof Capra, formerly a physicist, has said that homoeopathy lacks any scientific explanation, but asks whether it should not be understood in terms of a 'resonance' or 'tuning' between the patient and the medicine. The metaphor suggests a strong response being called forth from the patient's own healing system by a relatively weak, but finely adjusted stimulus, the medicine – just as a loud note is given out by a piano string if it is precisely in harmony with some note played on another instrument. But Capra goes on to state that 'one is tempted to wonder whether the crucial resonance... is not the one between the patient and the homoeopath, with the remedy merely a crutch.'

It may be tempting to see homoeopathic approaches to medicine more in terms of psychotherapy or faith healing than as a form of drug treatment, but this is to ignore other aspects of the research literature and the more informal evidence from clinical case studies.

An important clinical trial was conducted in 1980 in Glasgow, Scotland, on the effect of homoeopathic therapy in rheumatoid arthritis. The results showed that those patients receiving orthodox drug treatment together with individually prescribed homoeopathic drugs showed greater improvement than those receiving orthodox treatment together with a placebo – some inert substance that they were led to believe was a medicine – and the difference was thought to be due to the drugs and not to the doctors involved.

One major breakthrough in replicating homoeopathic research was, however, achieved in 1981 Raynor Jones and Michael Jenkins, working at the Royal London Homoeopathic Hospital, successfully repeated experiments involving certain substances in extremely high dilutions that affected the growth of wheat seedlings.

The homoeopathic medicine made from monkshood, left, a poisonous plant, is used at the onset of certain acute conditions, such as fevers and colds, and also for treating chronic anxiety.

The Christmas rose, right, is used to make homoeopathic remedies for certain severe disturbances, involving unconsciousness, muscular weakness and grinding of the teeth, among other symptoms. An advantage of homoeopathic remedies in such cases is that only a little needs to be slipped into the mouth, where it can be absorbed even if not swallowed.

The Royal London Homoeopathic Hospital, below, was granted royal patronage in 1948, thereby raising significantly the status of this branch of unorthodox medicine.

Another impressive piece of evidence that has to be taken into account is the record of successful homoeopathic treatment given during the great cholera epidemic that swept Europe in the 1830s. The Royal London Homoeopathic Hospital also has well-documented evidence stretching over many years, which even seems to show the superiority of homoeopathy over orthodox medicine.

There is, too, a mass of anecdotal testimony that it is hard to dismiss. Just try telling a mother who has been desperately worried over a child with high fever that his temperature fell minutes after taking a homoeopathic drug simply because the child got on well with the doctor!

The problem is that homoeopathy does not fit in with current ways of scientific thinking: neither does another group of unorthodox treatments – the Bach flower remedies. To the conventional mind, their use as anything other than placebos is sheer lunacy. A flower head, from a wild plant, tree or bush, is placed in water in sunlight for a number of hours. The water then constitutes the remedy. Any matter that may have found its way into the water from the plant can only be minute in quantity: but certain commentators have speculated on some kind of 'energy' from the Sun that causes remarkable structural changes in the water, changes that happen to have beneficial effects upon the sick.

But we still have no real understanding of how these 'medicines' or those of the homoeopaths work, nor how they could provide valuable additions to the physician's traditional armoury of drugs. If they do not work by straightforward chemical action, the only alternative is to say that their beneficial effects must be imaginary, or that they are real, but work through the patient's confidence in the treatment; or even, perhaps, that they are real enough but should be classed under the heading of paranormal phenomena.

UNDERSTANDING GHOSTS

TROUBLED SPIRITS OF THE DEAD AND PHANTOM ANIMALS HAVE BOTH APPEARED AS GHOSTS. BUT ARE THEY, IN ESSENCE, THE SAME? WHAT DO VARIOUS TYPES OF HAUNTING HAVE IN COMMON?

The perennial question as to whether ghosts exist must, in view of various surveys carried out by societies for psychical research over the last 100 years or so, be answered in the affirmative – if only because to reject the testimony of the many hundreds of respectable people who claim to have experienced apparitions as wishful thinking, self-delusion or downright lying would clearly be sheer wilfulness.

The question now facing parapsychologists and researchers into the paranormal is: *how* do ghosts exist? Are they revenant spirits? Are they the result of telepathy? Or are they produced by mass hallucination or self-hypnosis? Advances in psychology over the last few decades have brought us nearer to understanding some aspects of apparitions, but the definitive truth still eludes us.

The most common form of 'ghost' appears to be the 'crisis apparition', which occurs when a person under great stress – sometimes on the point of death – appears to someone close, like a blood relation, as a 'vision' or, occasionally, as a disembodied voice. Indeed, the majority of crisis apparition cases have tragic overtones. For instance, soldiers have appeared to mothers or wives at the exact time of their own deaths on faraway battlefields. But not all apparitions are associated with unhappy events.

Victoria Branden, in her book *Understanding Ghosts,* quotes the case of a friend who was

The photograph, below, of the library at Combermere Abbey in Cheshire was taken on 5 December 1891 by Sybell Corbet, who had been staying at the house. When she developed the plate, she was startled to see the shape of an elderly gentleman sitting in a chair on the left of the picture. The figure was later identified as that of Lord Combermere himself: but at the time the photograph was taken, he was actually being buried a few miles away.

evacuated from England to Canada during the Second World War because of a health problem, leaving her husband behind in the Services. One evening, the children were busy with their homework, while their mother was ironing in what she admitted to Victoria Branden was 'a rather dream-like state'.

Suddenly, she saw the door of the room open and her uniformed husband came in. But before she could recover from her astonishment, he vanished. She put down the iron and sat, near to fainting, in a chair. The children clustered around her anxiously and when she told them what had happened, they said that they had not seen anything and the door certainly had not opened. The mother and the elder child had, however, read of crisis apparitions and became convinced that the vision meant that the husband had been killed or injured. They made a note of the time and circumstances, but agonisingly, that was all they could do.

Some days later, to what must have been the enormous relief, news came: the husband had been unexpectedly chosen to go on a training programme to Canada, and was to be stationed at a camp very near to his family. This meant, of course, that he could live with them while abroad. When the couple were finally reunited, the husband said that the news had come as a happy shock. He could not remember consciously 'projecting' any thought to his wife, but they worked out that he had probably opened his commanding officer's door after hearing the news at the moment when his wife had 'seen' her door open and the vision of her husband enter.

An interesting point about this incident is that the wife was 'rather dreamlike' at the time, with her mind in an open and receptive state. Meanwhile, the children, who saw nothing, were concentrating hard on their homework.

Exactly how such information is communicated remains a mystery, particularly in the case where an apparition appears solid and living. However, scientists point out that perception is a much more complex business than at first appears: vivid dreams, fo

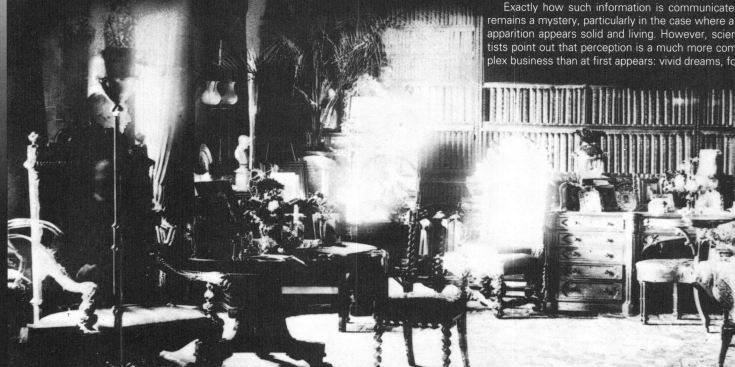

instance, often appear perfectly solid and physical, and in such cases the percipient is certainly not receiving information through his eyes. A hypnotist may tell a subject that, when he or she awakes, only the hypnotist will be in the room – even though other people may be present. Then, when the subject comes around, he will not see the others present until the hypnotist removes the suggestion. Something like this may also occur in cases of crisis apparition, although it seems remarkable that the agent – or person 'sending' the hallucination – can achieve at a distance, and in many cases while he is unconscious, what the hypnotist can only manage by giving specific instructions.

Evidence actually points to the fact that the agent's mind plays a smaller part in crisis apparitions than does that of the percipient. If we look at recorded cases, it becomes apparent that the agent rarely appears as he is at the moment of 'transmission' – the percipient does not see a mangled body in a motor car, or a dying wounded soldier in a trench, but what appears to be a normal image of the agent that, moreover, relates to the percipient's surroundings.

This point is stressed by G. N. M. Tyrrell in his book *Apparitions*. He points out that apparitions in crisis cases have even been guilty of such unghost-like phenomena as casting shadows or appearing reflected in a mirror. As he put it:

'[They] adapt themselves almost miraculously to the physical conditions of the percipient's surroundings, of which the agent as a rule can know little or nothing. These facts reveal the apparition to be a piece of stage machinery which the percipient must have a large hand in creating and some of the details for which he must supply – that is to say, an apparition cannot be merely a direct expression of the agent's idea; it must be a drama worked out with that idea as its motif.'

But telepathy can only partly explain cases of collective apparitions, where a group of people witness the same thing. What is more, by definition, the telepathic agent must be a sentient being; so it

Cases of crisis apparitions are most common in times of war, when a mother may see her son at the moment of his death on a battlefield, as below. It seems that the shock of death causes some kind of telepathic communication between son and mother. But rarely does the mother have a vision of a dying soldier; in most cases, she sees her son as he appeared in normal, everyday life.

is hard to see how any concrete object appearing as an apparition can do so as a result of telepathy. One of the most famous cases of a collective apparition was reported to the Society for Psychical Research in the late 19th century by Charles Lett, the son-in-law of a certain Captain Towns. One day at about 9 p.m., some six weeks after the Captain's death, his daughter, Mrs Lett, and a Miss Berthon entered a bedroom at his home. The gas light was burning:

'And they were amazed to see, reflected in the polished surface of the wardrobe, the image of Captain Towns. It was . . . like an ordinary medallion portrait, but life-size. The face appeared wan and pale . . . and he wore a kind of grey flannel jacket, in which he had been accustomed to sleep. Surprised and half alarmed at what they saw, their first idea was that a portrait had been hung in the room and that what they saw was its reflection – but there was no picture of the kind. Whilst they were looking and wondering, my wife's sister, Miss Towns, came into the room; and before any of the others

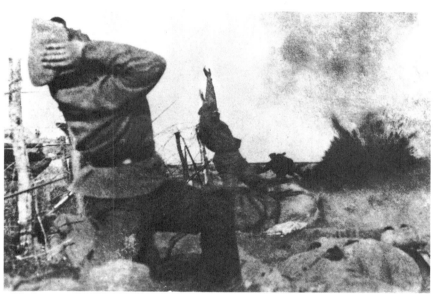

When apparitions not seen at the time – such as that shown left – turn up on photographic prints, some believe it may be due to the film being more sensitive to surroundings than the photographer. When the photographer sees something that the camera fails to capture, however, it may be because of human hypersensitivity.

// DO NOT LET US FEAR THE DEAD WHEN THEY COME TO US, BUT DO NOT LET US ALLOW A PANIC-STRICKEN DISEMBODIED ENTITY TO CLUTCH US ROUND THE NECK LIKE A DROWNING MAN, IN ITS EFFORTS TO REMAIN ON THE PLANE OF FORM... TO DO SO IS NOT TO HELP HIM, BUT TO CONDEMN HIM TO A TERRIBLE FATE, THE FATE OF THE EARTH-BOUND. **//**

DION FORTUNE, THROUGH THE GATES OF DEATH

had time to speak, she exclaimed: "Good gracious! Do you see Papa?"

'One of the housemaids passing by was called into the room. Immediately she cried:"Oh miss! The Master!" The captain's own servant, the butler, and the nurse were also called in and immediately recognised him. Finally, Mrs Towns was sent for and, seeing the apparition, advanced towards it with her arm extended as if to touch it. As she passed her hand over the panel of the wardrobe, the figure gradually faded away and never again appeared.'

Those parapsychologists who lean towards a telepathic origin for all apparitions would probably say that the vision was seen first by either Mrs Letts or Miss Berthon, who then passed it on by thought transference to each arrival. But where did the vision come from in the first place?

An early pioneer of psychical research, F. W. H. Myers, author of *Human Personality and its Survival of Bodily Death*, suggested that it was the revenant spirit or 'essence' of Captain Towns, taking a last look at his old home six weeks after death. Myers said that an apparition 'may be a manifestation of

THE GHOST THAT GREW AND GREW

One of the main problems facing the objective psychical researcher is that of sheer human gullibility. People like a good ghost story and tend to embellish any narrative – so that after a few retellings, the stark facts soon become wrapped up in a cocoon of invention.

In the summer of 1970, Frank Smyth, who was at that time an associate editor of the magazine *Man, Myth and Magic,* set out to examine the form taken by such gullibility. He therefore invented a ghost, complete with location, background and 'witnesses', and published the story in the magazine.

The invention was completely random. One Sunday morning, Smyth had gone down to London's Docklands to meet John Philby, son of super-spy 'Kim' Philby. Philby's building company was renovating a site at Ratcliffe Wharf, and Smyth decided that the deserted dock was sufficiently eerie to provide a location for his ghost. Hard by Ratcliffe Wharf was the semi-derelict church of St Anne; and this, plus the fact that it was a Sunday morning, influenced Smyth into making his 'ghost' that of a clergyman. Alongside the wharf runs Ratcliffe Highway, once – at least until the late 19th century – a thoroughfare of brothels, grog shops, and cheap boarding houses. The proximity of this old road suggested to Smyth that his vicar had been the owner of a sailors' rooming house, and that he had robbed 'homeward-bounders' (seamen newly paid off from ships in the Thames), had killed them in their lodgings, and disposed of their bodies in the river. Thus the background for the imaginary ghost was swiftly set up.

Philby, himself a former war correspondent, and Smyth then decided that witnesses were important. Together with one of Philby's employees, they lent their names to the fiction that they had seen the ghost – the figure of an old white-haired man with a walking stick. They also agreed that if anyone, either researcher or interested enquirer, asked about the 'phenomenon', they would immediately confess that it was invented.

Frank Smyth, inventor of the ghost of Ratcliffe Wharf, is seen below, in front of the church of St Anne.

Smyth then wrote up the story as a 'factual' article in *Man, Myth and Magic*. No one ever queried the credentials of the 'Phantom Vicar of Ratcliffe Wharf'; but over the next twelve months or so, eight books purporting to tell the stories of genuine ghosts appeared, each featuring the phantom vicar. Only one, by a London *Sunday Times* feature writer, treated the subject with some scepticism: the others not only recounted the tale without critical comment, but one, by a well-known writer on the supernatural, actually embellished it to a marked degree.

In 1973, Smyth wrote an article for the *Sunday Times,* telling of his experiment and subsequently appeared in a BBC2 film entitled *A Leap in the Dark.* This film, too, told the story of the invention, but it also featured a number of people who claimed actually to have seen the phantom vicar. One man said that he had witnessed an old man in 18th-century clerical garb walking in the roadway outside the 'Town of Ramsgate' pub, near St Katherine's Dock – a good half-mile from Ratcliffe Wharf. The writer Jilly Cooper told of interviewing a police superintendent who, on retirement from the River Branch of the Metropolitan force, had said that, as a young man, he had been unwilling to enter Ratcliffe Wharf for fear of the ghostly priest. And a Thames waterman claimed that he had seen the shadowy form of the vicar standing on Ratcliffe Wharf some months before the story appeared in the magazine. After the television programme, many other letters were sent to the BBC, most of them apparently sincere, telling of further sightings.

There is absolutely no foundation for the Ratcliffe Wharf story. Nowhere in the records of Wapping – nor indeed any other part of London's Docklands – does there feature any tale of a ghostly cleric. The fact is that apparently rational people still claim to see the apparition in the area – despite its widespread refutation. One psychical researcher, however, has since suggested that Smyth's ghost may well have existed after all, and that it somehow made itself known to him via what only seems to have been imagination.

CASEBOOK

persistent personal energy' and quoted several cases to illustrate his point.

In one, a travelling salesman arrived at a hotel in Boston, Massachusetts, and sat working in his room when he suddenly became aware of a presence and looked up to see his sister, who had died nine years previously. As he sprang delightedly to his feet and called her name, she vanished, and yet he had time to take in every detail. 'She appeared as if alive,' he said, but added that there was a small red scratch on her right cheek.

Disturbed, he made an unscheduled stop at his parents' home and told them of his experience. When he mentioned the scratch, his mother was overcome with emotion, and explained that she had made the scratch on the dead body of her daughter accidentally, as she was preparing her for burial. Two weeks later, the mother died.

Myers wrote that the figure was 'not the corpse with the dull mark on which the mother's regretful thoughts might dwell, but . . . the girl in health and happiness, with the symbolic red mark worn simply as a test of identity.' He also suggested that the

Unfortunately, unlike the ghosts of well-rounded fiction, these 'haunting' apparitions do not seem to make much sense in their actions: they carry on in a mundane fashion, either wandering about or simply staring out of windows.

By and large, parapsychologists tend to theorise that, in certain cases, a kind of psychic record may be imprinted on a location, perhaps because of some violence or strong emotion generated there. In these cases, the apparition would not be a sentient spirit, but merely a projection like a cinema film. This certainly seems to be a likely explanation. It also ties in with the telepathy theories: for, if a person can send an image of himself telepathically to a percipient, may he not also be able to send a sort of 'free floating' image that hangs, as it were, in the atmosphere to be picked up by anyone sensitive enough to receive it?

Such a concept would also explain the occasionally convincing 'photographs' of apparitions: in such cases, the photographic film may be more sensitive to the surroundings than its operator; conversely, where a photographer sees a ghost but his camera

apparition was the spirit of the dead girl inducing her brother to go home and see their mother before she died.

Where an apparition persistently 'haunts' a place or a house – or sometimes even a person – believers in an afterlife assert that the spirit is trapped in its earthly environment, perhaps because of some unfulfilled task, or for the purpose of punishment.

Ghost photographs often show images unseen by the human eye, as film is inherently more sensitive to certain light frequencies. The difference is rather like that between a picture shot with a standard film, above left, and one taken with infra-red equipment, above right. The infra-red photograph shows a tract of Australian desert more clearly and with much sharper detail, and provides information not otherwise available.

❝ IT IS POSSIBLE THAT SOME PEOPLE ARE ENDOWED WITH A PARTICULAR GHOST-SEEING FACULTY... AND THAT THE APPARITION IS VISIBLE ONLY... TO THOSE WHO ARE EQUIPPED WITH THE APPROPRIATE RECEIVER. ❞

HILARY EVANS,

GODS: SPIRITS: COSMIC GUARDIANS

fails to do so, with nothing showing up in the prints, it may be *he* who is hypersensitive.

If such phantom recordings are indeed possible, it may also be that they are not necessarily fixed for ever. Andrew Green, in his book *Ghost Hunting*, quotes an interesting case of a woman in a red shoes, a red dress and a black head-dress, reported to haunt a mansion in 18th-century England. In the early 19th century, it was reported that the apparition was that of a lady in pink shoes, a pink dress, and a grey head-dress. She was not witnessed again until the mid-19th century, by which time the figure had dwindled to 'a lady in a white gown and with grey hair'. Just before the Second World War, all that was reported was 'the sound of a woman walking along the corridor and the swish of her dress'. In 1971, shortly before the demolition of the property involved, workmen felt merely 'a presence in one of the old corridors'.

Modern scientific research – into, for instance, the baffling field of quantum physics – constantly produces new slants on old phenomena. Ghosts – whether human or non-human – may yet prove to belong to a sphere of reality so far undreamed of.

TUNING IN TO TELEPATHY

IT IS SAID WE ALL ONCE HAD TELEPATHIC ABILITIES WHICH HAVE BEEN LARGELY LOST. THE EXPERIMENTS DESCRIBED HERE ARE DESIGNED BY SERENA RONEY-DOUGAL AND TEST FOR THIS HIDDEN TALENT

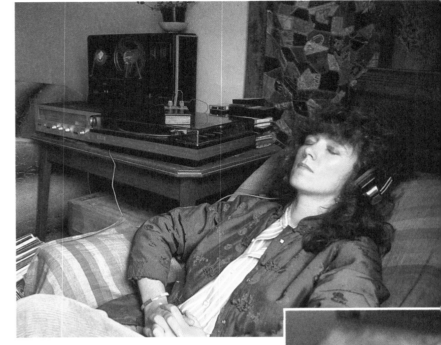

Imagine sitting in a comfortable chair in a darkened room, wearing headphones through which you can hear the roar of a waterfall cascading down a Welsh mountain. Your eyes are covered with halved ping-pong balls on which a red light shines, and all you can see, as you relax, is a diffuse red glow.

This extraordinary situation is part of an experiment designed to test for telepathy. As someone who has agreed to take part in the test, you are first welcomed by the experimenter, and then asked to fill in a 'mood report' describing your attitude to the experiment and your general emotional state. The experimenter then seats you in a comfortable chair, puts headphones over your ears, and adjusts the level of waterfall noise until it is comfortable. He or she next plays another sound at such a level that you can just hear it through the waterfall noise, and then drops the noise level by five decibels so that you cannot hear it at all. The experimenter now places palmar electrodes on your left hand so that any physiological response you may experience can be monitored. Then, halved ping-pong balls are placed over your eyes, and a red light is adjusted so that it is 18 inches (45 centimetres) from your face.

The gentle waterfall sound and ping-pong eye covers should block out all external conditions and visual distractions, relaxing you into what is known as the *Ganzfeld* state. (*Ganzfeld* – from the German for 'uniform field' – refers to the unchanging or uniform level of stimulation caused by blocking external sensation.)

Finally, the waterfall sound is switched off and you are next played a tape containing the suggestion that you will now become aware of subconscious information. The waterfall sound is then switched on again.

Deprived of outside sensory stimulation, you turn mentally inwards, becoming aware of thoughts, images and memories that are the expression of your subconscious mind. At the same time, another person – the sender – begins to pass information to you by playing a tape through your headphones, so quietly that it is impossible for you to hear it against the waterfall noise. This is known as subliminal stimulation: the stimulus is physically real, but is too quiet to be perceived consciously. Instead, it is picked up at the subconscious level. The target tape, in this experiment, carries five thematically related words, and is chosen at random from four by the sender after the beginning of the experiment. Thus no one knows, for the duration of the experiment, what the tape contains.

While in this state, you are asked to voice whatever comes into your mind. What you say is recorded and, after the experiment is over, you are asked to order the sets of target words according to which of them you feel corresponds most accurately with the impressions gained while in the *Ganzfeld* state.

WORD ASSOCIATION

You now complete another mood assessment form and undergo a word association test for each of the four target tapes, in which you are presented with the four sets of five words, including the set heard subliminally, and asked to think of the individual target words, saying whatever first comes into your head. The tape of your impressions is then submitted to three independent judges, who analyse it and estimate its correspondence with the four target tapes.

In the *Ganzfeld* state, it is also possible to perceive information that is not being transmitted mechanically through the headphones, but communicated telepathically by the sender. In a separate experimental session, the sender therefore selects a tape and plays it, not through your headphones, but through *his* – at an audible level. He then tries to visualise the image that the words on the tape create, and project them mentally to you.

In the experiment, the two means of transmission – telepathic and subliminal auditory – are varied

randomly. The subject therefore does not know how the information is being sent in any one session. Results show that those who are able to receive information that is transmitted subliminally are also sensitive to telepathically transmitted information; while those who find it difficult to pick up information one way generally find it equally difficult to do so in the other way. One objective of the experiments is to pinpoint the kind of psychological state – and the type of people – that make such information-transfer possible.

An analysis of one set of results showed that, out of a total of eight subjects, three consistently succeeded in identifying the target tape, placing it first or second. These three people show an awareness of the information, whether transmitted telepathically or mechanically, that is highly significant.

Transmission of information seems to require a two-stage process. The first stage involves the reception of the information in the subconscious, while the second involves forcing the subconscious knowledge into the conscious mind. Here, it seems that those who have some awareness of the way in which their subconscious minds work have an advantage: it is they who are able to translate the often quite complex and tortuous imagery of their subconscious minds into rational terms.

During one of Serena Roney-Dougal's ESP experiments, a sender, left, listens to a tape and tries to transmit the information to a subject. In another test, Serena Roney-Dougal, below, monitors the volume level of a tape while sending a subliminal message to her subject.

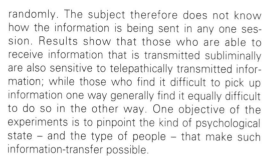

The subject of a telepathy test, above, sits in a state of sensory deprivation. Halved ping-pong balls cover his eyes as he listens through headphones to the sound of the Cenarth Falls in Dyfed, Wales, left. In this relaxed, so-called Ganzfeld state, he may become aware of subliminal messages transmitted to him by the sender.

In order to illustrate the complexities of translation and interpretation, we need to consider an actual example of a *Ganzfeld* session. Here, the target tape carried the five words 'sultan, Aladdin, harem, feasting, and dancing'. While in the *Ganzfeld* state, the subject made the following remarks:

'Seeing something, don't know what it is . . . crib or something – cradle, I mean; definitely a cradle in a sitting room – Middle Ages sitting room – somebody rocking this cradle dressed in Middle Ages clothes – tapestry in the back . . . mineral – either coal or some sort of stone, mineral . . . changing to pool or something . . . flashes of light . . . beansprouts . . . kitchen – copper utensils.'

The subject, in her own analysis of her impressions, understood the cradle images as being related to the harem; the flashes of light and mineral seemed related to Aladdin and his magic lamp; and the kitchen related to the feasting. Throughout the session, she felt preoccupied with food, and the

In Czechoslovakia, a series of tests was made between practising telepaths situated many kilometres apart. The receiver was not told when transmissions were to be attempted and yet, at the precise instant that the sender was asked to imagine that he had been buried alive, the receiver had a crippling attack of asthma.

Lyall Watson, The Romeo Error

179

cradle image occurred again later on. While there is no direct mention of an Arabian nights scene, the subject was able to tie in the thematic content of her image with the target so as to produce what is considered to be a 'hit'. Two of the three independent judges, incidentally, agreed with her analysis.

It is, of course, easy enough to see these connections when the person identifies the target. But when a person 'misses' the target, what then? Such 'misses' are generally not considered to be worthy of attention. But can we really say that telepathic or subliminal perception is operative only on those occasions when a person manages to identify the target?

Correct perception of the target, as we have seen, is a two-stage process; and one thing that has become apparent again and again during the experiments is that most 'misses' occur *not* because the information is not getting through to the subconscious, but as a result of incorrect evaluation of impressions gained while in the *Ganzfeld* state. Images that relate to the target are generally present, but the subject is unable to relate them to the words on the target tape.

PERCEPTUAL DEFENCE

On some occasions, there appears to be what might be called a low signal-to-noise ratio: the target-related imagery is present, but there is so much extraneous information – 'noise' – from the subconscious that it is extremely hard to identify subliminal or telepathic input. This 'noise' is perhaps one of the mind's principal methods of defending itself against unwanted input. The phenomenon is well-known in psychology, especially in subliminal perception research, where it is termed 'perceptual defence'. Obvious examples are simply not hearing what you do not want to hear – an ability that makes it possible for you to hold a conversation in a roomful of noisy people, or not to hear a publican calling 'time'. A further very clear example of this was provided by one subject who, in her *Ganzfeld* session, spent 10 minutes talking about how she had given up drinking. The target words were 'tavern, keg, barrel, tankard, goblet'; but she ranked this tape fourth – last – simply because, she said, it was 'too much of a coincidence'.

Most defences, however, are more subtle than this. Take a person who, according to his own estimations, scores only very slightly above chance in both telepathic and subliminal sessions. Yet his session transcripts were scored significantly *above* chance by all three independent judges. In other words, a logical, analytical assessment of his thoughts by independent observers gave statistically significant evidence of target-related imagery. During the sessions, he was 'aware' of the target inasmuch as he thought about things that were related to the target. Yet, on four occasions, he was unable, in the analysis that followed the *Ganzfeld* session, to identify the target, mainly because he chose not to use an analytical judging procedure, instead picking the target that he 'felt' was the right one. Such personal assessment proved inaccurate.

An even clearer example of the defensive process is provided by a subject whose attitude was one of disbelief in ESP. He did not believe that the

*In*FOCUS

GAMES OF TELEPATHY

The game described here is intended to reveal whether you can bring to the fore what some believe to be a natural telepathic ability, inherent in all of us, but usually lost following childhood.

It requires two players – a 'receiver' and a 'sender' – and an ordinary pack of playing cards. The aim is for the sender to look at each card, without showing it to the other player (the receiver), who has to identify whether the card is red or black. To play, proceed as follows:

1. Sit one behind the other, so that the receiver's back faces the sender.

2. The sender now shuffles the pack of cards and lifts up the top card, looking at its face. The sender should now signal that he or she is ready to transmit information by tapping the card, and then attempt mentally to send either 'red' or 'black' – depending on the colour of the card – to the receiver. One way of doing this is to close your eyes and imagine the word 'red' or

'black' somewhere around your forehead. Alternatively, try to visualise a red door, a fire engine or a British pillar-box.

3. The receiver then calls out the colour that he or she thinks the card is.

4. The sender places a tick (for a correct answer) or a cross (for a wrong one) on a sheet of paper.

A score of 26 correct answers out of 52 – the number of cards in the pack – is what you can expect according to the laws of chance. The player who scores consistently higher than the average 50/50 score is undoubtedly making use of some kind of telepathic power.

Yet, strange as it may seem, a low score is said by some also possibly to indicate the influence of the paranormal – but in a *negative* way, since the player may be unconsciously thwarting him or herself (a condition known as 'psi blocking'.) More advanced games can, of course, be attempted, and will involve the guessing of specific suits.

subjects, possibly to reduce any distress at the idea of being able to perceive a target using methods not believed in. Indeed, in the case of a person whose attitude to ESP is negative, distortions and symbolism become even more complex; but the fact that it is more difficult to unravel does not necessarily mean that the subliminal or telepathic information has not been received at a subconscious level. It means merely that the 'noise' level is higher and the 'signal' more distorted. With the 'hitters', the signal is clear and the extraneous noise, very low. Such people are familiar with their own mental processes, and can usually follow the indirect ways in which target words might influence their subconscious.

By examining the differences between those subjects who consistently hit the target and those who consistently miss, we can see that two factors emerge – factors that may account for these differences. The most important is that of attitude. Thus, someone who does not believe in his or her own capacity to become aware of subliminal and telepathic information and who claims to have had no personal experience of this sort of awareness, is very likely to miss the target. On the other hand, a person who has grown up in an atmosphere in which such things are accepted may be able to learn to hit the target much of the time.

From experimentation, it appears that we all have certain latent ESP ability. One way of becom-

Smugglers are seen being attacked by customs men in the 19th-century illustration, above. In one of Serena Roney-Dougal's sessions, the target words were 'smugglers, contraband, adventure, horses, moonlight'. The subject had impressions of ice, the Titanic, Alaskan permafrost and boys in prison, the sinister character of Steerpike from Mervyn Peake's Gormenghast trilogy, right, and Albert Pierrepoint, the last English state executioner, above left. These images may appear to have only a distant connection with the target words – but the subject's word association test later revealed that he did indeed link the word 'adventure' with 'cold', and 'smugglers' with 'gallows'.

images he saw while in the *Ganzfeld* state could bear any relationship at all to the target; yet, again and again, it did. The relationship was not patently clear, as in the case of the three 'hitters' – but it was very definitely there. Although he was himself unable to pick out the target, independent judges, with some understanding of the symbolic distortions and transformations that occur in the subconscious mind, were generally able to do so.

In one typical session, the target words were 'smugglers, contraband, adventure, horses, moonlight'. In this session, the subject talked several times about ice, icebergs, the Titanic, Alaskan permafrost and so on. After the *Ganzfeld* session, his word association with the target word 'adventure' was 'cold'; his word association with 'smugglers' was 'gallows'; and, during the session, he experienced images of boys in prison, Roman soldiers, Steerpike (a character from Mervyn Peake's Gothic novel *Gormenghast)*, with a knife in his hand, cannonballs and, most significant of all, Albert Pierrepoint, England's last state executioner.

Although there is no direct connection between these images and the target words, the word associations do provide a very revealing link. And it is important to remember that in free association work such as this, where a person is attempting to gain access to material from the subconscious, the mind works in distorted and essentially symbolic ways. Thus, we should not expect to get a direct representation of the target in the *Ganzfeld* images; rather, it is *connections* that we must look for.

Only around 10 per cent of subjects talk directly about the target theme, while transcripts frequently have many rich symbolic and associational connections that are easily recognised by the independent judges – even if they are vehemently denied by the

ing aware of this is to enter a passive and receptive state, such as that induced by the *Ganzfeld*, thereby learning by experience how to interpret the imagery received. In this sense, such experiments can be regarded as a kind of training programme in ESP. Through it, we may eventually come to greater understanding of the processes involved.

" A POSSIBLE VIEW IS THAT THE

MIND OF THE VERY YOUNG CHILD

IS OPEN TO TELEPATHIC AND

CLAIRVOYANT IMPRESSIONS IN A WAY

THAT THE ADULT MIND (WITH ITS

MEDDLING INTELLECT) SELDOM IS. **"**

STAN GOOCH,

CREATURES FROM INNER SPACE

GRAND UFO SPECTACULARS

WHAT IS IT THAT UFOS ARE TRYING TO TELL US? COULD IT BE THAT A KIND OF LIGHT SHOW IS OCCASIONALLY PUT ON FOR US BY THEIR ALIEN CONTROLLERS?

One recurrent feature of UFO reports is the seeming pointlessness of the incidents – lights that hover in the skies, that 'buzz' aircraft or frighten small groups of witnesses, all to no apparent purpose. Here we describe two extraordinary UFO events. The first is from the Canary Islands, where a UFO appeared before large numbers of people at a distance, as well as treating three terrified witnesses to a close-up display involving what seemed to be humanoid 'pilots'. The second story comes from Lot-et-Garonne in southwest France, where a UFO appeared silently above a field in which a farmer was working one night, frightening him out of his wits, and then simply, and silently, disappearing.

On the evening of 22 June 1976, an extremely active UFO visited the Canary Islands. It was witnessed by many people, and a number of reports found their way into the Spanish press. There the matter might have rested but – in a surprise turn of events – the Spanish Air Ministry released documentation concerning some 12 UFO incidents to journalist Juan José Benítez of the Bilbao newspaper *La Gaceta del Norte*. One of the cases listed in their dossier was the extraordinary Canary Islands spectacular.

A number of interesting facts emerged. A report by a doctor on the island of Gran Canaria had already achieved international publicity, and apparently the events had been confirmed – both by a Spanish warship and by photographs taken by a private citizen. (These were later impounded to be examined by the authorities.)

At 9.27 p.m. on 22 June 1976, the Captain, an ensign and several crewmen of the Spanish Navy corvette *Atrevida* spotted the UFO off the southeastern coast of the island of Fuerteventura. They saw a light, part yellowish and part blue, moving across the sea towards them, all the while gaining altitude. They thought at first that they were watching an aeroplane with its landing lights on, but then rapidly revised that opinion when the light stopped suddenly and was abruptly extinguished, only to be replaced by a rotating beam of light that shone downwards. Two minutes later, the light took the form of a giant halo that lasted for some 40 minutes, lighting up both land and sea. The original yellow-bluish light now reappeared, splitting into two parts, the bluish part remaining within the halo while the upper part began to climb in an irregular spiral before vanishing in the direction of the neighbouring island of Gran Canaria. It took only three minutes to get there, reaching the astonishing speed, over 85 nautical miles (158 kilometres), of some 1,900 miles per hour (3,060 km/h).

There were a number of witnesses to the UFO in the northern part of Gran Canaria; but the one with the best story to tell was the local doctor, Don Francisco-Julio Padrón Léon. He had been called out by a young man, Santiago del Pino, to attend his sick mother. The doctor and the young man were travelling in a taxi driven by Francisco Estévez, which had just negotiated a bend in the road at

The artist's impressions, right *and* opposite, *show the magnificent light displays that appeared over Gran Canaria and other nearby islands in 1976, as well as the two humanoids witnessed within a giant sphere.*

The impressive photograph of the Canary Islands UFO, below, was taken by a private citizen, but impounded for examination by the Spanish police and not released until some months after the incident had occurred.

place called Las Rosas (between Galdar and Agaete in the north-western corner of the island). Suddenly, they found themselves confronted by a giant sphere, hanging a few yards from the ground. The sphere was outlined in a pale greyish-blue. Almost instantly, the radio in the taxi cut out, and the three witnesses shivered as they began to feel a surging wave of cold.

The taxi driver stopped his vehicle, and was trembling with cold as all three men watched two enormous beings who were apparently inside the sphere (which was the size of a two-storey house and quite transparent – the stars behind it could be seen quite clearly).

The two ufonauts seemed to be clad in tight-fitting clothing in a deep shade of red, and wore black helmets. No features were described in the witnesses' statements, but the creatures were seen in profile. They stood facing one another on either side of an instrument console on a platform, manipulating levers and switches with hands that were enclosed in black cones. Dr Padrón was particularly impressed by the disproportionate size of the backs of their heads.

Suddenly, the taxi driver took it into his head to switch on the spotlight. At that instant, the sphere began to rise until the watchers could see a transparent tube inside it that emitted a blue gas or liquid. This gradually filled the sphere, which expanded until it was as big as a 30-storey building, although the beings and their console panels remained the same size.

Greatly alarmed, the driver turned round the car and back-tracked to some nearby houses where a resident family told the doctor that their television had blacked out. The witnesses joined the family in the house and, as they watched the extraordinary object from the windows, they saw the blue 'gas' stop swirling inside the sphere. Then the object emitted a high-pitched whistle and flashed away in

TWO MINUTES LATER, THE LIGHT TOOK THE FORM OF A GIANT HALO THAT LASTED FOR SOME 40 MINUTES, LIGHTING UP BOTH LAND AND SEA. THE ORIGINAL YELLOW-BLUISH LIGHT NOW REAPPEARED, SPLITTING INTO TWO PARTS.

183

the direction of Tenerife, changing as it went to a 'spindle' shape, surrounded by a halo.

It is now known that Dr Padrón was instructed by the Spanish Air Ministry investigators not to speak about his experience. Consequently, details of his statements were not known until the dossier was handed over to Juan Benítez. However, a sketchy outline of the story had leaked out before the restriction was applied. Some newspapers carried a story about a large spherical object that had been seen with control panels and 'pilots' inside it, hovering over an onion field where part of the crop was destroyed. Destruction of a circular area about 33 yards (30 metres) in diameter was even confirmed in the Ministry file.

The UFO was next seen by hundreds of people in Puerto de la Cruz as it passed over the island of Tenerife, and then by the crew and passengers of a ferry plying between Tenerife and La Palma – while many inhabitants of the outlying islands of Gomera and Hierro telephoned newspaper offices and local radio stations about their sightings of the object.

TRACED ON RADAR

The Ministry's dossier also contained a report that the object had been detected and followed on radar, along with prints from photographs of the UFO taken from the southern part of Gran Canaria. The photographer had been located by the police and his film had been impounded until release of the dossier some months later.

The doctor's testimony gives the impression that he witnessed a truly unique UFO 'display'. But was it an exhibition put on by remote control?

Over the years, there has been a great deal of speculation about the nature of objects seen by UFO witnesses. Are UFOs, in fact, some kind of projection from the controllers of the phenomenon? And if so, who – or what – are these controllers? What, if any, is their message? A report from France offers further intriguing evidence.

The five bright beams, below, were seen by farmer Angelo Cellot in the early hours of a November morning in south-western France.

The weather in Lot-et-Garonne in south-western France, 56 miles (90 kilometres) east of the city of Bordeaux, on the night of Saturday, 13 November 1971, was miserable. The sky was overcast and there was a drizzling rain. Nevertheless, farmer Angelo Cellot was out working, ploughing a field that adjoined the minor road between his house and that of his brothers. The tractor was fitted with headlights and a movable spotlight, for Cellot was accustomed to working late into the night.

At about 1.50 a.m., he suddenly became aware of a light that he first thought was coming from another farmer's tractor. However, as he turned his tractor at the road's edge and proceeded in the opposite direction towards the stream at the northern boundary, he realised that the light was in the air, and moving along the stream towards his field. He thought it was a helicopter; but as he turned again towards the road, Cellot realised the object had changed direction and was now following him up the field, preceded by a red light. The UFO, hovering at an estimated altitude of 130 feet (40 metres), had five bright lights underneath it, so bright that when he trained the spotlight on to it Angelo could not distinguish any shape behind them.

The farmer had reached the end of the furrow close to the road when he realised the aerial intruder was directly overhead. The area around him was bathed in light from the five beams, and puzzled concern now gave way to fear. Cellot saw that the UFO was descending and already only 50 to 70 feet (15 – 21.5 metres) above him. Fear quickly changed to panic. Cellot deserted his tractor, leaving the engine running and headlights on, and dashed away towards his brother Jean's house to raise the alarm. He had covered about 30 yards (28 metres) when he looked back and saw the UFO climbing and heading away to the north. So he ran back, and switched off both the lights and the engine. It was only then that he realised the object had been completely silent. As Angelo watched, he saw, to his relief, the UFO slowly disappearing from sight beyond a low ridge. Thoroughly shaken, and with no wish to finish his job, the farmer put the tractor in its barn and went to bed at 2 a.m.

This important story eventually reached the newspaper *La Dépêche du Midi*, and, thence, the French investigatory group GEPA, for whom Colonel Pierre Berton interviewed Angelo Cellot. He was accompanied at the interview by two police officers, and later made an official report.

As in many other experiences, the predominant feature of these two UFO sightings is light: glowing light, opalescent light, haloes of light, coloured light, revolving light, rays of light and mysterious solid beams of light. The precise purpose of such extraordinary spectaculars remains, however, utterly bewildering.

// CELLOT REALISED ... THE AREA

AROUND HIM WAS BATHED IN LIGHT

FROM THE FIVE BEAMS, AND PUZZLED

CONCERN NOW GAVE WAY TO FEAR. **//**

MOONSTRICKEN THEORIES?

THE MOON CONTINUES TO PUZZLE US. SOME EVEN SAY THAT SPACE RESEARCHERS ARE ATTEMPTING TO COVER UP A TERRIFYING FACT: THAT THE MOON, RIGHT ON OUR DOORSTEP IN SPACE, IS INHABITED BY ALIEN INTELLIGENCES. WHAT EVIDENCE IS THERE FOR THIS AMAZING CLAIM?

Despite the extensive and costly research carried out by American and Soviet space programmes, the Moon – for thousands of years, revered as the queen of the night – remains in many respects as mysterious as ever.

The Moon is a small world, about one quarter of the Earth's size, and one eightieth of the Earth's weight. It is a wilderness of barren rocks, piled up in circular rings called craters. Long, sinuous mountain ranges stand out like naked spines, many reaching greater heights than Mount Everest, despite the Moon's dimensions.

Between the mountains stretch huge, flat plains, hundreds of miles across. These dark, drab expanses are so vast that they can be seen from Earth even with the unaided eye. The first astronomers to view the Moon through telescopes thought their flatness showed them to be oceans: so it is that these dark areas still bear names like the Sea of Tranquillity (usually known by the Latin version *Mare Tranquillitatis*) and the Ocean of Storms (*Oceanus Procellarum*). But we now know that these 'seas' (*maria* in Latin) are actually smooth plains of dry rock, dust and volcanic ash. The Moon has no water or air. It therefore appears unlikely that life as we know it could survive there.

But astronomers had decided that the Moon is a hostile, barren, airless boneyard of a world even before the Apollo II astronauts reached it in July 1969, and saw at first hand the bare desolation of that world. Clad in tough spacesuits to ensure vital air supplies, they clambered down to the colourless, drab, grey surface under a black sky. Immediately, they felt the barren quality of their surroundings. The lunar rocks they brought back to Earth indeed showed that the Moon is a dead world that has remained unchanged for billions of years.

They also left instruments on the lunar surface to 'sniff' for any gases that might appear in the vacuum that takes the place of lunar atmosphere, and to 'feel' for shakes of the ground that would tell of moonquakes. Three Soviet spacecraft have also landed on the Moon, dug up its soil and returned small samples to Earth without the danger of a manned expedition.

These scientific undertakings should have solved the mysteries of our natural satellite once and for all. But in fact just as many many questions have been raised as answered. Even the Moon's origin is still in doubt. For over a century, some scientists have believed that the Moon was split off from our Earth in the early chaotic history of the solar system and flung out into space as our only natural satellite. Others have thought that the Moon formed close to our Earth, born out of the same cloud of whirling gases and dust. A. third school of thought sees the Moon as born elsewhere in the solar system. After wandering through space as a

On the floor of the crater Tycho, seen top, in an official NASA photograph, writer George H. Leonard claimed to see the letters PAF, written for extra-terrestrial communication. Leonard included an illustration of the crater with its cryptic message, above, in his book Someone Else is On Our Moon. *He also claimed to have seen structures on the crater floor that may be collectors of solar energy.*

planet in its own right, it was caught by Earth's gravitation and forced to be its satellite.

Among the huge amount of information about our satellite, independent thinkers have also found evidence to support a number of unorthodox opinions. The most common is the idea that the Moon is not in fact as dead as it seems. Perhaps, some claim, it did once support some kind of life; perhaps it still does. Perhaps alien life-forms live on our Moon, and may even have brought it within the Earth's orbit from the depths of space.

BILLION-DOLLAR COVER UP

American writer George H. Leonard is convinced that aliens are on our Moon. In his book *Someone Else is On Our Moon*, Leonard claimed that huge machines are excavating its surface, digging out craters. According to him, the lunar aliens have erected enormous living-domes and towers, and have driven huge screws, miles long, slantingly into the Moon's crust. They have even stitched together great rents in the lunar surface.

Leonard is convinced that the American space agency, NASA, is covering up its knowledge of these aliens, and that the Apollo astronauts took to using jargon terms to describe these artificial constructions so their radio transmissions would not give away the news of alien occupation. According to Leonard, the multi-billion-dollar Moon landings were not planned for any scientific purpose, nor even for the political prestige of winning the 'space race': both the US and USSR governments were acting together in clandestine agreement in order to discover just what the extra-terrestrials on our Moon are doing. And when they found huge,

powerful alien machines, but still could not discover their purpose, the governments clamped down on their results. NASA then told the world that it had 'finished with manned landings for the moment'.

Leonard bases this hypothesis on his own study of thousands of close-range photographs, many of them having been taken by the Apollo astronauts and by the earlier unmanned Orbiter probes of the 1960s. He claims that his interpretation is backed by 'Dr Sam Wittcomb', a pseudonym for someone once employed by NASA. All the evidence is from published NASA photographs, but Leonard's artefacts can be seen only on close examination with a magnifying glass. He says 'two square inches [12 square centimetres] of territory on the glossy photographs put out by NASA can keep one busy for weeks, and at the end of that period one may have only a glimmering of knowledge about half the area.'

Leonard claims the photographs show objects so regular that they must be artificial. In a mountainous region near the crater Bullialdus, he has picked

WILSON BELIEVES THAT THE MOON IS PARTIALLY HOLLOW: THAT IT IS, IN FACT, A SPACESHIP FROM THE REMOTE . . . UNIVERSE, FLOWN TO OUR SOLAR SYSTEM BY ITS ALIEN CREW.

The two tracks on the lunar surface, above, are claimed by writer George Leonard to have been caused by intelligent beings. The shorter track, resembling links in a chain, stretches 900 feet (275 metres); the thinner, fainter track on the extreme right of the picture, runs 1,200 feet (365 metres). According to Leonard, the objects producing them moved uphill out of their respective craters, and he concluded that the phenomenon could only have been produced artificially.

The faint, X-shaped images, encircled left, and drawn below, are, according to Leonard, 'X-drones' – alien machines up to 3 miles (5 kilometres) long, capable of pulverising rock.

out a huge set of gear wheels, the largest 5 miles (8 kilometres) across, and a 'generator' comparable in size. Within the prominent crater Tycho, he sees an artificial, covered region, octagonal in shape, with the letters *PAF* written in huge script on it. Other letter-like 'glyphs' appear elsewhere on the lunar surface, he says. The most common are *A*s, *X*s and *P*s. Leonard has also spotted letters from the ancient runic alphabet, and one that appears like 'an old Hindu *S* joined to a Semitic *S*. These letters, he has conjectured, act as location markers to identify particular craters to aliens flying over them in UFOs.

Inside one crater marked by such glyphs, Leonard claimed to have located half-a-dozen UFOs on the ground. They are, he said, ovals 150–200 feet (45–60 metres) across, and the one at the crater's centre is touching 'another glowing object, shaped like an electric light bulb. One could speculate with a fair amount of confidence that the oval object . . . is somehow being serviced by the other object.' The other UFOs are waiting their turn, like cars in a filling station, he has asserted. Each oval carries a *Y*-shaped marking, 'similar to an ancient Semitic *Z*, or to 'the tree of life'. Reversing the upward strokes on the *Y* produces a shape similar to a marking on the famous Socorro UFO, seen by a policeman in New Mexico.

Leonard's claims for alien excavators are even more startling. The most common are the so-called '*X*-drones'. These are constructed of two crossed tubes, making an *X* shape; the largest measure 3 miles (5 kilometres) across. Leonard has found *X*-

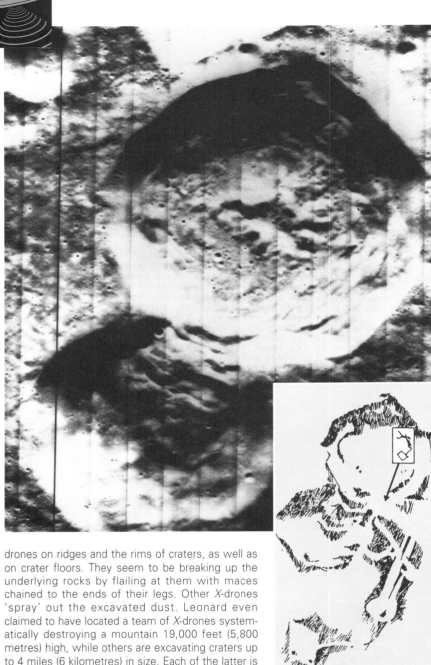

Alexander Shcherbakov – who were at the Soviet Academy of Sciences, and quotes their original article *'Is the Moon the Creation of Intelligence?'*, which first appeared in July 1970 in the magazine *Sputnik*. Vasin and Shcherbakov propose that the Moon was put there by aliens, whose spaceship it is. The surface we see is merely an outer skin, the true surface being 50 miles (80 kilometres) further down. The aliens left themselves headroom of 30 miles (50 kilometres) and constructed a continuous outer skin, 20 miles (30 kilometres) thick, to act as a screen against meteorites. On top of this tough shell is a layer of loose packing – the lunar surface – a few miles thick.

Wilson claims that this theory explains many of the 'mysteries' of the Moon. The craters are shallow compared with their width: meteorites hitting the Moon were unable to penetrate the tough shell, merely blasting away the thin, loose rock covering to make wide but shallow hollows. The smooth lava

> **The Moon has been rightly described as a stepping stone into outer space. But given the startling spaceship revelation ... it could well be a leaping-stone in the cosmic destiny of Man.**
>
> **Don Wilson,**
> **Our Mysterious Spaceship Moon**

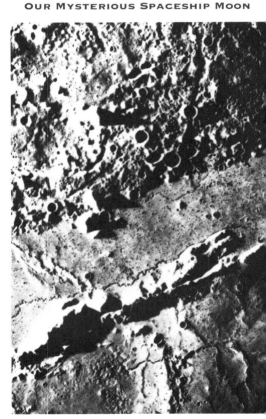

drones on ridges and the rims of craters, as well as on crater floors. They seem to be breaking up the underlying rocks by flailing at them with maces chained to the ends of their legs. Other *X*-drones 'spray' out the excavated dust. Leonard even claimed to have located a team of *X*-drones systematically destroying a mountain 19,000 feet (5,800 metres) high, while others are excavating craters up to 4 miles (6 kilometres) in size. Each of the latter is marked by a white cross which, he claimed, announces the presence of an *X*-drone.

There are other excavators, too, according to Leonard. He said that he spotted two 'super-rings', like human mechanical scoops, but several miles across, in pictures taken by the Apollo 14 crew, and was convinced that they must have seen it, intentionally keeping it quiet by using codewords such as 'Annbell' and 'Barbara'.

Another writer who believes that NASA is concealing information is Don Wilson, author of *Our Mysterious Spaceship Moon*. He too, notes strange structures on the Moon but pulls in a much wider range of Apollo discoveries to back his own hypothesis. Wilson believes that the Moon is partially hollow: that it is, in fact, a spaceship from the remote depths of the Universe, flown to our solar system by its alien crew.

Wilson claims a respectable source for this theory, two senior scientists – Mikhail Vasir and

The photograph of a double crater, top, taken by NASA's Lunar Orbiter 1 on 26 August 1966, was one of many studied by George Leonard, who claimed he could discern a huge machine – a 'super-rig' – at the top right-hand corner of the upper crater, depicted in the boxed sketch, above.

George Leonard claimed that a domed platform is casting the narrow triangular shadow in the photograph, right, of the Herodotus mountain range of the Moon.

plains are, meanwhile, 'cement-type material', pumped out by the aliens to patch up dents left by such impacts. According to the Russian scientists, the Moon has a lower density than the Earth because it is partially hollow.

ROCK OF AGES

Accepting these interpretations wholesale, Wilson adds his own interpretation of some of the 'surprises' revealed by the Apollo missions. These include discrepancies between the age of Moon rocks and Earth rocks, and between Moon rocks and the lunar soil on which they lie. Wilson concludes that the Moon is older than the Earth, but picked up 'younger' rocks as it travelled through 'differing cosmic time zones'. The Moon's chemical composition is not the same as the Earth's, and Wilson suggests that the surface layers were turned inside out when the aliens hollowed out the region below the outer shell to make their living space.

But is the Moon still inhabited? Wilson disinters the 70-year-old ideas of Austrian engineer Hans Hoerbiger – ideas, incidentally, that formed part of what little philosophical background there was to Nazism. Hoerbiger thought the Earth has had more than one moon, and that our present Moon appeared only 13,500 years ago. Wilson conjectures that the aliens turned up in their damaged spacecraft, converted Earth's previous moon into a new ship, and then departed in their new craft. (He does not, however, provide any sort of explanation for the previous moon's origin.)

Wilson put forward the belief that these aliens visited Earth while in our vicinity, and high in the Andes they founded the now deserted city of Tiahuanaco (translated by Wilson as 'the city of the doomed satellite'). He has also discussed evidence for the Moon still being under alien occupation. He

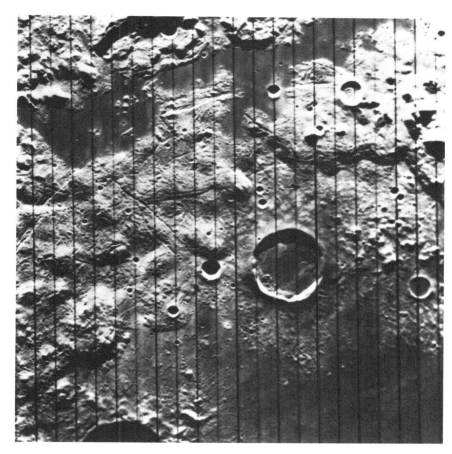

In the photograph, above, taken over the far side of the Moon, Leonard identified several structures as the work of intelligent beings. They include a dome on an 'architected' platform and parallel walls joined by an arch. The features shown include the flat, irregular-shaped Lacus Veris, *at the top of the picture, the large crater of* Maunder, *and part of the flat* Mare Orientale *in the lower third of the image.*

has not recognised Leonard's *X*-drones, super-rigs or letter-like glyphs, but he spotted high 'spires', 'blocks' and 'domes', relying more on the Apollo astronauts' comments and interpreting any departure from straightforward English as a cover-up code. Yet, even if one accepts Wilson's suspicions of dishonesty on NASA's part, this approach does not tell us what the astronauts actually did see.

Astronomers are convinced that our Moon is a dead world, for long inactive in a geological sense, and a satellite that has never harboured life. For a few independent thinkers, however, the silver orb of the night skies is a more frightening world. They see it as an abode of weird and possibly powerful aliens, right on our doorstep in space.

" WE FEEL THAT THE QUESTIONS WE HAVE RAISED IN CONNECTION WITH OUR MOON PROVIDE SUFFICIENT FOOD FOR SERIOUS THOUGHT ON THE MATTER... NOW, OF COURSE, WE HAVE TO WAIT FOR DIRECT EVIDENCE TO SUPPORT OUR IDEA, OR TO REFUTE IT. PROBABLY THERE WILL NOT BE LONG TO WAIT. *"*

M. VASIR AND A. SHCHERBAKOV

Illustrations from Don Wilson's book Our Mysterious Spaceship Moon, *left, attempt to prove that the geometrical arrangements of rocks in the area to the west of the Sea of Tranquillity are* menhirs *placed on the Moon by intelligent beings.*

CELTIC HARBINGERS OF DEATH

THE WAILING OF THE BANSHEE TO HERALD DEATH IS A WELL-KNOWN PART OF IRISH FOLKLORE. RECENT CASES SEEM TO INDICATE THE MOURNER MAY STILL BE ALIVE TODAY

One night early in 1979, Irene McCormack of Andover, Hampshire, England, was lying in bed when she heard what she later described as 'the most awful wailing noise'. She was alone in the house at the time and was deeply depressed, for her mother was close to death in Winchester Hospital.

When she heard the wailing, she nearly fell out of bed. 'I got up, shaking, and went downstairs; the dog was running round and round the living room, whimpering.' He would not settle, so Mrs McCormack took him upstairs to the bedroom where, after the wailing had died away, they both lay waiting for daybreak.

With the dawn came a police message for Mrs McCormack: she was asked to go to the bedside of her mother. When she arrived at the hospital, she found her in a coma. Irene McCormack stayed with her mother until the old lady's death a short time later. Once the funeral was over and the household had returned to normal, Mrs McCormack told the family about the wailing she had heard. Her Irish husband suggested that she had heard the banshee. 'Many of my family laughed at this,' Mrs McCormack said. 'They probably thought I was going mad... but I hope never to hear anything like that again.'

The word 'banshee' is derived from the Irish Gaelic term *bean sidhe,* which has the meaning 'woman of the fairies'. Her mournful cry is said to foretell death. According to Irish tradition, she has long red hair and combs it, mermaid-like, as she keens outside the family home of those who are about to die. She is rarely heard or seen by the doomed individual, however.

The banshee has her origins deep in Irish legend. She wailed for ancient heroes such as King Connor McNessa, Finn McCool, and the great Brian Boru, whose victory over the Vikings in 1014 broke their power in Ireland. More recently, residents of the Cork village of Sam's Cross claimed to have heard the eerie voice of the banshee when Michael Collins, commander-in-chief of the Irish Free State Army, was killed in an ambush in 1922 during the Irish Civil War.

'I saw the banshee flying wild in the wind of March': this is the title of the highly romantic interpretation of the banshee, by Florence Harrison, right.

In the late 1960s, the Irish psychical researcher Sheila St Clair produced a radio programme for the BBC on the banshee and, even allowing for Irish exaggeration, some of the accounts were chillingly convincing. A baker from Kerry told of an uncomfortable night that he and his colleagues had spent while baking bread ready for the morning delivery.

'It started low at first, then it mounted up into a crescendo; there was definitely some human element in the voice. . . the door to the bakery where I worked was open, too, and the men stopped to listen. Well, it rose as I told you, to a crescendo, and you could almost make out one or two Gaelic words in it; then gradually it went away slowly. Well, we talked about it for a few minutes and at last, coming on to morning, about five o'clock, one of the bread servers came in and he says to me, "I'm afraid

General Michael Collins, commander-in-chief of the Irish Free State Army, top right, was killed in an ambush at Beal-na-Blath – an event that the people of the Cork village of Sam's Cross claimed was foretold by the wailing of a banshee.

The assassination of John F Kennedy, whose funeral is shown right, is said to have been announced to an American businessman and close friend by the cry of the banshee.

they'll need you to take out the cart, for I just got word of the death of an aunt of mine." It was at his cart that the banshee had keened.'

On the same radio programme, an elderly man from County Down tried to describe the particular death cry he had heard in more detail. 'It was a mournful sound,' he said. 'It would have put ye in mind of them ould yard cats on the wall, but it wasn't cats, I know it meself; I thought it was a bird in torment or something. . . a mournful cry it was, and then it was going a wee bit further back, and further until it died away altogether.'

Although *bean sidhe* means literally 'fairy woman', most folklorists classify the banshee as a spirit rather than a 'fairy' or one of the Irish 'little people'; but according to mythology, the banshee will cry at the imminent deaths of fairy kings, too. Some of the older Irish families – the O'Briens and the O'Neils, for example – traditionally regarded the banshee almost as a personal guardian angel, silently watching over the fortunes of the family, guiding its members away from danger, and then performing the final service of 'keening' for their departing souls.

A County Antrim man, meanwhile, told Sheila St Clair, in that same radio programme, his interpretation of the banshee's role. He claimed that, centuries ago, certain of the more pious clans had been blessed with guardian spirits. Because these celestial beings were not able to express themselves in human terms, they were allowed to show their deep feelings only when one of their charges died: the result was the banshee howl. However, said the Antrim man, with the gradual fall from grace of

❚❚ I SAT BOLT UPRIGHT IN BED, AND THE HAIR ON THE BACK OF MY NECK PRICKLED. THE NOISE GOT LOUDER, RISING AND FALLING LIKE AN AIR RAID SIREN. THEN IT DIED AWAY AND I REALISED THAT I WAS TERRIBLY DEPRESSED. I KNEW MY FATHER WAS DEAD. ❚❚

the Irish over the years, only the most Godfearing families are privileged to have a death foretold by a personal banshee today.

This theory may please a businessman from Boston, USA, who some years ago claimed that the banshee, like other creatures of European folklore, had crossed the Atlantic. James O'Barry is descended from an Irish family that originally arrived in Massachusetts in 1848. It was as a very small boy that he first heard the banshee.

'I was lying in bed one morning when I heard a weird noise, like a demented woman crying. It was spring, and outside the window the birds were singing, the sun was shining, and the sky was blue. I thought for a moment or two that a wind had sprung up, but a glance at the barely stirring trees told me that this was not so. I went down to breakfast and there was my father sitting at the kitchen table with tears in his eyes. I had never seen him weep before. My mother told me that they had just heard, by telephone, that my grandfather had died in New York. Although he was an old man, he was as fit as a fiddle, and his death was unexpected.'

It was some years before O'Barry learned the legend of the banshee, and then he recalled the wailing noise on the death of his grandfather. In 1946, he heard it again, but in very different circumstances. He was an administrative officer serving with the United States Air Force in the Far East when, one day at 6 a.m., he was awakened by a low howl. He was terrified.

'That time, I was instantly aware of what it was. I sat bolt upright in bed, and the hair on the back of my neck prickled. The noise got louder, rising and falling like an air raid siren. Then it died away, and I realised that I was terribly depressed. I knew my father was dead. A few days later, I had notification that this was so.'

O'Barry was to hear the voice again 17 years later, on what he considers the most remarkable

occasion of all. He was in Toronto, Canada, by himself, enjoying a combined holiday and business trip.

'Again, I was in bed, reading the morning papers, when the dreadful noise was suddenly filling my ears. I thought of my wife, my young son, my two brothers, and I thought: 'Good God, don't let it be one of them.' But for some reason, I knew it wasn't.'

The date was 22 November 1963, the time shortly after noon, and the Irish banshee was bewailing the death of an acquaintance of O'Barry's – President John F. Kennedy.

If the Irish have their banshee, one might reasonably expect their close Celtic cousins, the Scots, to have a version of their own. It is not so, however, although most clans at one time or another have boasted a personal harbinger of death. The nearest thing to the banshee recorded in Scottish folklore are the 'death woman' who sits on westward running streams on the west coast of Scotland, washing the clothes of those about to die, and the Highland 'red fisherman', a robed and hooded apparition who sits angling for fish. To see him is, in itself, the warning of death.

THE DEATH WASH

But the MacLaines of the Isle of Mull, Argyllshire, preserve a curious legend concerning their own death spirit. In the 16th century, Eoghan a' Chin Bhig (Ewan of the Little Head) is said to have had a serious quarrel with his father, MacLaine of Loch Buie. In 1538, both sides collected for a showdown. The evening before the battle, Ewan was out walking when he met an old woman, who was washing a bundle of blood-stained shirts in a stream. Ewan knew that she was a death woman and that the shirts belonged to those who would die in the morning. Rather boldly, he asked if his own shirt

In the 16th century, the chieftain Eoghan (Ewan) a' Chin Bhig was given the island castle of Loch Sguabain, above, as a wedding gift by his father, who lived in Moy Castle, right. But Ewan, dissatisfied, asked his father for a better castle. A feud resulted, and Ewan was slain in battle. Ever since, the appearance of the headless Ewan has presaged death in the family.

A banshee appears in a cloud of smoke in the 19th-century illustration, below.

THE BANSHEE.

Awful Death warning by the appearance of an Apparition.

was among them, and she said that it was. She told him that if his wife offered him bread and cheese with her own hand, however, he would live and be victorious.

His wife failed to do so. Ewan, demoralised, rode to defeat and, at the height of the battle, a swinging Lochaber axe cut his head clean from his shoulders. His horse galloped off down Glen More, the headless rider still upright in the saddle. According to legend, the dead chief became his own clan's death warning, and his headless body on its galloping horse has been seen three times within living memory just before a family death. The vision is also still believed to herald serious illness whenever it occurs in the family.

Another celebrated Scottish death warning involves the phantom drummer of Cortachy Castle, Tayside, seat of the Earls of Airlie. One story says that he was a Leslie, come to intercede for a truce with his clan's enemies, the Ogilvies – the family name of Airlie – and that he was killed before he could deliver his message. A more romantic version, however, tells that he was a drummer with a Highland regiment and lover of a 15th-century Lady Airlie. He was caught by the Earl and thrown from a turret window.

Four well-attested accounts from the 19th century indicate that the phantom continued to carry

out its warning task efficiently. In the 1840s, the drummer was heard by members of the household before the death of the Countess of Airlie. The Earl married again shortly afterwards, and in 1848 had a house party, the guests including a Miss Margaret Dalrymple. During dinner on her first night, Miss Dalrymple remarked on the curious music she had heard coming from below her window as she dressed – the sound of a fife, followed by drumming. Both her host and hostess paled. After dinner, one of the other guests explained the legend.

GHOSTLY DRUMMING

The following morning, Miss Dalrymple's maid, Ann Day, was alone in the bedroom, attending to her mistress's clothes. She had heard nothing of the drummer story, and so was surprised when she heard a coach draw up in the yard below, accompanied by the sound of drumming. When she realised that the yard was empty though the drumming carried on, she became hysterical. The following day, her mistress heard the sound again, and decided that this was enough. Shortly afterwards, the new Lady Airlie died in Brighton, leaving a note stating that she was sure her death had been signalled by the drumming.

In 1853, several people heard and reported the drummer again, just before the death of the Earl;

Several accounts testify to the appearance of the phantom drummer of Cortachy Castle, Tayside, above, whenever one of the Ogilvy family is about to die. Two relatives heard the ghostly drumming before the death of David Ogilvy, 10th Earl of Airlie, above left, in 1881.

and in 1881, two relatives told of hearing the prophetic sound while staying at Cortachy during the then Lord Airlie's absence in America. Some days later, news of his death reached them.

In the case of both the Irish banshees and the Scottish death warnings, there are dozens who claim to have heard or seen these harbingers of disaster. Laying aside the unlikely possibility that all of them were either lying or exaggerating, is it possible to explain the phenomenon in any rational way?

Sheila St Clair has an interesting theory that closely relates to psychologist Carl Jung's collective unconscious – an inherited structure of memories passed on from psyche to psyche. 'I would suggest,' she says, 'that just as we inherit physical characteristics . . . we also inherit memory cells, and that those of us with strong tribal lineages riddled with intermarriage have the banshee as part of an inherited memory. The symbolic form of a weeping woman may well be stamped on our racial consciousness.... And just as our other levels of consciousness are not answerable to the limitations of time in our conscious mind, so a particular part of the mind throws up a symbolic hereditary pattern that has in the past been associated with tragedy in the tribe – be it woman, hare, or bird – as a kind of subliminal "four minute warning", so that we may prepare ourselves for that tragedy.'

> **▐▐ I WOULD SUGGEST THAT JUST AS WE INHERIT PHYSICAL CHARACTERISTICS . . . WE ALSO INHERIT MEMORY CELLS . . . AND THOSE OF US WITH STRONG TRIBAL LINEAGES RIDDLED WITH INTERMARRIAGE HAVE THE BANSHEE AS PART OF AN INHERITED MEMORY. ▐▐**
>
> **SHEILA ST CLAIR**

ASTROLOGERS HAVE ALWAYS HELD THAT THE CELESTIAL BODIES INFLUENCE HUMAN LIVES IN QUITE SPECIFIC WAYS. HERE, WE LOOK AT VARIOUS THEORIES CONCERNING HOW THE POWER OF THE SUN MAY AFFECT BOTH BEHAVIOUR AND CHARACTER

OUT OF THI

A strology is a very ancient science: its tenets and principles have come down to us over thousands of years, so that it is virtually impossible to separate original beliefs from those that have accrued over so many generations. Yet much of what is today considered traditional in astrology comes from no farther back than the end of the 19th century – a time when the study of astrology was suddenly revived in both England and France. The association of astrology with the Tarot cards, for instance, dates from this period. There is, however, no historical connection whatsoever between the two, except insofar as the 22 Tarot trumps are the remnants of a much larger set of cards that at one time included 12 that represented the signs of the zodiac, with another seven to represent the planets.

Some measure of the confusion as to the real purpose of astrology can be traced back to certain 19th-century astrologers, such as R.C. Smith, who claimed that the heavenly bodies influenced not only humans but animals, plants, precious stones and places. This linking of objects with things celestial according to an 'inner sympathy' lies behind the system of 'correspondences' that, for example, linked signs of the zodiac to parts of the human body. This theory inspired the English occultist Aleister Crowley (1875-1947) to compile his 'Tables of Correspondences', which he published in 1909 under the title *777*. Its 194 tables provide the equivalents of the letters of the Hebrew alphabet to the planets, the spheres and the elements; and to colours, Tarot cards, Egyptian, Roman and Hindu gods and goddesses, plants, precious stones, drugs and perfumes.

AS ABOVE, SO BELOW

Crowley invented much of this himself: parts he got from English occultists of the 1880s and 1890s, such as L. MacGregor Mathers; some can be traced back to medieval magical writers such as Cornelius Agrippa; while a few scraps can be attributed to Roman astrology and to beliefs associated with the Jewish Kabbalah. The system of 'correspondences' is very clearly a development of the 'as above, so below' principle designed to cover every contingency. Although it is regarded by many as completely

The giant solar flare, above, is perhaps as much as 100,000 miles (160,000 kilometres) in length. Whether or not we believe that it has an effect upon the destiny of those born at different stages of its annual cycle, observations made by John Nelson do seem to suggest that the relative positions of the planets affect activity on the surface of the Sun and, therefore, the amount of cosmic radiation falling upon the Earth.

artificial, this sort of thing is frequently made a essential part of what is widely taught in contempo rary courses in astrology.

The sceptic may be forgiven for finding some o the fundamental principles of astrology equall questionable. When one reads, for instance, tha the typical Pisces (the Fish) has unusually prom nent eyes and a fleshy body, with some kind o peculiarity about the feet, and that he or she is like ly to be a good swimmer, one is justified in sus pecting that the description is tailored to result i something that is essentially fishlike. Such anthro pomorphism turns up throughout astrology: th Cancerian (the Crab), for example, is said to wal with a peculiar sideways gait; the Sagittarian (th Archer, half man, half horse) is said to have a lon face with prominent front teeth, while femal

COSMIC STORM

Sagittarians often wear their hair in a pony-tail; and the Taurean (the Bull) is characteristically obstinate, with a broad face and thick-set body.

Characteristics are also supposedly exhibited by the planets, as well as the Sun and the Moon. Waite's *Compendium of Natal Astrology* lists some of them as follows:

Sun: pride, generosity, egotism, honour, loyalty, ardour, vitality

Moon: sensitivity, sentiment, maternal instinct, femininity, changeability

Mercury: quickness, sharpness, braininess, ready wit, flow of words

Venus: beauty, grace, charm, artistic tastes, affection, sociability

Mars: virility, energy, courage, initiative, impulsiveness, passion, aggression

Jupiter: optimism, cheer, generosity, joviality, sport, strength, nobility, ceremoniousness

Saturn: caution, taciturnity, pessimism, self-restraint, profundity, steadfastness

These are, of course, the characteristics that one would expect the individual gods of mythology to possess – but why has any particular god's name been given to any particular planet? Mars, by its red coloration, representing blood and passion, can be readily identified with the god of war and thereby with what are considered essentially masculine traits. But why should one small, bright planet be identified with ready wit and braininess, while another is identified with beauty and charm? Why should one distant and slow-moving body represent optimism and generosity, while another represents caution and pessimism?

It is when we come to look at the Sun that a possible explanation begins to emerge. There are those who believe that children born at midday in high summer tend to be very different in personality from those born at midnight in winter. Many who would not subscribe to any of astrology's beliefs nevertheless remain convinced that the season, the time of day and the weather prevailing at the moment a child is born can certainly affect his or her nature and behaviour.

Following this line of argument, consider the following: 'Recent investigations by a well-known market research bureau have revealed that a high proportion of children born at or near midday during the first two weeks of August are healthier than the national average, generally strong and tall, and fre-

quently blond. As they develop, they show good qualities of leadership, being both practical and kind-hearted.'

True or not, this is a plausible statement, and would be given due consideration by even the most sceptical of scientists. However, had it begun 'Leos tend to be... ', it would be likely to evoke cries of 'Nonsense!' and 'Superstition!' from even the most broad-minded of astronomers and other members of the scientific establishment, so nervous are they of the subject of astrology.

And yet, to say that the Sun is in Leo is actually to say no more than that the date is somewhere between 22 July and 21 August. However, that the part of the zodiac in which the Sun is found at this time of year has been named Leo may indeed be

*In*Focus

THE JUPITER EFFECT AND BEYOND

In 1974, a book entitled *The Jupiter Effect* caused widespread controversy among the scientific establishment. Written by John Gribbin and Stephen Plagemann, it developed the hypothesis that planetary alignments in relation to the Sun affect solar activity, and that an increase in this could trigger seismic activity on Earth.

Alone, this supposition would not have created too much fuss, but the authors also forecasted a particularly violent burst of solar activity for 1982, with what they said would be resultant earthquakes around the world, including California's notorious San Andreas Fault.

The authors chose 1982 because they believed that, in March of that year, the combined gravitational influence of the

The colour-enhanced image of Jupiter, above, taken by the Voyager 1 spacecraft in 1979, shows the cloud-enveloped planet and its Great Red Spot, thought to be an atmospheric disturbance that has persisted for at least 200 years.

planets on the Sun would provoke spectacular solar flares. Since Jupiter is the largest planet, with the greatest 'pull', the theory of such planetary influence was given the title 'the Jupiter effect'.

The forecast of massive earthquakes, however, proved to be wrong. The Sun's activity reached a peak in 1979; California was not devastated by earthquakes – then or in 1982 – and the authors publicly retracted their forecast. In their sequel *Beyond The Jupiter Effect* (1983), Gribbin and Plagemann admitted their mistake – but reasserted their belief that seismic activity on Earth is greatest in years of greater solar activity. They also repeated their arguments that gravitational interplay between cosmic bodies can influence Earth's climate with possible dramatic effects on world food production.

Gribbin and Plagemann also made another suggestion – that the world may get cooler before the end of the century, perhaps bringing about a minor Ice Age, similar to the one experienced in the 17th century – a forecast so far not fulfilled.

because the experience of centuries showed that those who are born in the period of the year that we call August tend to exhibit what are essentially leonine characteristics.

It is possible, then, that all the constellations of the zodiac were originally named for the characteristics exhibited by those born at that particular time of year. And it is possible that the names of the planets equally indicate the temperaments of those born when the particular planet was dominant in the horoscope. We are, it should be remembered, dealing with a mass of detailed information gathered over some 2,000 years.

The horoscope is a timemap of a particular moment. For a person born at that moment, it gives his or her 'Sun-sign' – it tells us in which twelfth of the year the birth took place: in other words, the position of the Sun in the horoscope circle and of the sign ascendant on the eastern horizon at birth. It also provides us with the relative positions in the heavens of up to nine other 'markers'.

The most important of these markers is the Moon, which moves right through each of the signs of the zodiac in less than three days. It is generally accepted that Sun and Moon exert a very great influence upon human lives: the Sun, because it provides light and heat, and is essential for the production of food; and the two together because they combine or oppose their gravitational forces to produce the tides. Since humans can be traced to an ancestry 600 million years back with an aquatic connection, there is no reason to suppose that we do not remain sensitive to tidal forces. Once this has been accepted as a possibility, we can consider the way in which the movement of the planets can affect the nature of gravitational and magnetic fields within the solar system.

THE SOLAR CONNECTION

In the mid-1940s, John Nelson, an engineer working with RCA Communications Inc., set up a telescope on the roof of the company's office building in central Manhattan, New York City, and began to study the Sun. Nelson knew that unusually violent solar activity was generally accompanied by serious interruption of radio communications, and his task was to find some way of predicting the occurrence of these 'cosmic storms'.

By 1967, Nelson found that he could claim a success rate of 93 per cent in his predictions of severe magnetic storms, out of a total of 1,460 specific forecasts. He had also learnt, over the years, which planetary groupings were good or bad for the transmission of radio signals. Disturbances, he had discovered, always occurred when two or more planets were spaced apart at 0°, 90° and 180° in relation to the Sun – and irrespective of whether there was solar activity or not. Moreover, greater disturbances occurred when one of the four inner planets (Mercury, Venus, Earth or Mars) was linked in this geometric arrangement with one of the giant outer planets, such as Jupiter and Saturn. Even worse storms took place, it became apparent, if five or six planets passed through these alignments with one another over a few days. Nelson also came to believe that the planet Mercury was responsible for triggering 90 per cent of magnetic storms.

In the 15th-century Italian manuscript, De sphaera, right, Jupiter is seen to represent physical well-being and material success.
Three of John Nelson's charts, below, show planetary positions relative to the Sun when severe magnetic storms took place on Earth. A key to the symbols shown is provided, bottom. The top chart, for 23 March 1940, anticipated a storm between 23 and 27 March when seven planets were either at right angles to each other or in opposition. The centre chart, for 12 November 1960, marked one of the worst storms in 20 years; the bottom chart, of 23 February 1956, was for the greatest ever recorded 'cosmic shower' – radiation from the Sun and from space.

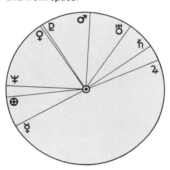

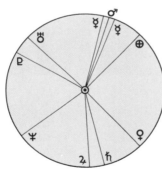

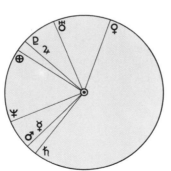

☿	*Mercury*	♄	*Saturn*
♀	*Venus*	♅	*Uranus*
⊕	*Earth*	♆	*Neptune*
♂	*Mars*	♇	*Pluto*
♃	*Jupiter*		

The nature of these terrestrial effects is so far undetermined: it may be no more than some kind of gravitational tide, or it may be the flood of cosmic radiation that accompanies a solar eruption. Some biologists believe that violent cosmic storms can have marked effects upon evolution, and meteorologists understand only too well their effect upon the weather. As for the cause of solar eruptions, it is hardly far-fetched to suggest that they could be the outcome of some kind of solar tidal surge due to the positions of the planets in relation to the Sun.

There are, then, at least two lines of enquiry that remain to be followed. Firstly, since Nelson's work has established a close connection between the positions of the planets relative to the Sun and the outbreak of unusual sunspot activity, is it possible to establish any similar kind of relationship between the aspects of the planets to the Earth and the birth of babies with particular kinds of personality? And secondly, if this kind of relationship can be proved – which would amount to substantial proof of the most fundamental beliefs of astrology – we next need to investigate whether the influence upon personality is due specifically to gravitational effects, or alternatively to the occurrence of different intensities of cosmic radiation.

> **"** NELSON'S WORK IS AN EXAMPLE OF WHAT ASTROLOGY MAY ONCE HAVE BEEN AND STILL COULD BE: THE STUDY OF THE CELESTIAL MOTIONS AND THE CORRECT INTERPRETATION OF THEIR TERRESTRIAL EFFECTS. **"**
>
> **GUY LYON PLAYFAIR AND SCOTT HILL,**
> **THE CYCLES OF HEAVEN**

HALF HUMAN AND HALF FISH, MERMAIDS HAVE FIGURED DOWN THE AGES IN FOLK TALES AND EVEN THE LOGBOOKS OF SOME OCEAN TRAVELLERS. BUT IS THERE ANY BASIS IN FACT FOR THESE COLOURFUL CREATURES?

Legends about mermaids and mermen stretch back into antiquity and can be found in the folklore of almost every nation in the world. Indeed, merfolk have been seen and vouched for down the ages by countless witnesses of attested integrity – and, it seems, they continue to be seen today.

According to the South African *Pretoria News* of 20 December 1977, for instance, a mermaid had been found in a storm sewer in the Limbala Stage III township of Lusaka. The reports were garbled

THE LURE OF THE MERMAID

and it was difficult to tell who saw what; but it seems that the 'mermaid' was first seen by children Then, as the news spread, so a crowd gathered. One reporter was told that the creature appeared to be a 'European woman from the waist up, whilst the rest of her body was shaped like the back end of a fish, and covered with scales.'

The earliest merman in recorded history was the fish-tailed god Ea, more familiarly known as Oannes, one of the three great gods of the Babylonians. He had dominion over the sea and was also the god of light and wisdom, bringer of civilisation to his people. Originally, Oannes had been the god of the Akkadians, a Semitic people of the northern part of Babylonia from whom the Babylonians derived their culture, and he was worshipped in Akkad as early as 5000 BC.

Almost all we know about the cult of Oannes is derived from surviving fragments of a three-volume history of Babylonia written by Berossus, a Chaldean priest of Bel in Babylon, in the third century BC. In the 19th century, Paul Emil Botta, the French vice-consul in Mosul, Iraq, and an enthusiastic archaeologist – albeit one whose primary concern was loot – discovered a remarkable sculpture

of Oannes (now in the Louvre, Paris) dating from the eighth century BC, in the palace of the Assyrian king, Sargon II, at Khorabad, near Mosul, together with reliefs showing people dressed in fish-like garments.

Another early fish-tailed god was Dagon of the Philistines who is mentioned in *The Bible: I Samuel 5: 1-4*. The Ark of the Covenant, we learn, was placed next to a statue of Dagon in a temple dedicated to him at Ashod, one of the five great Philistine city states. The following day, the statue was found to have 'fallen upon his face to the earth before the ark of the Lord'. Amid much consternation and, no doubt, great fear, the people of Ashod put the statue of Dagon back in its place again, but the following day it was again found fallen before the Ark of the Covenant: this time, the head and the hands had broken off.

It is also probable that the wife and daughters of Oannes were fish-tailed, but surviving representations of them are vague and it is impossible to be sure. However, no doubts surround Atargatis, sometimes known as Derceto, a Semitic Moon goddess. In his *De Dea Syria*, the Greek writer Lucian (c. AD 120 – c. 180) described her: 'Of this Derceto

The 'Fejee mermaid', top left, was the star attraction of Phineas T Barnum's touring show in 1842 and advertised with posters of voluptuous sea creatures, similar to that in the painting by John Waterhouse, top. But the creature is known to have been a fake, constructed from a female monkey torso that was joined to a large, stuffed fish tail.

likewise I saw in Phoenicia a drawing in which she is represented in a curious form; for in the upper half she is a woman, but from the waist to the lower extremities runs in the tail of a fish.'

Fish-tailed deities can be found in almost every culture of the ancient world; but by the Middle Ages, they had become thought of as humanoid sea-dwellers. One of the most important early scientific influences was Pliny the Elder (AD 23-79), a Roman administrator and encyclopedic writer who died in the eruption of Vesuvius that destroyed Pompeii. As far as medieval scholars were concerned, if Pliny had said that something was so, then it was undeniably so. They therefore accepted what he had to report about mermen:

'I have distinguished members of the Order of Knighthood [Roman soldiers] as authorities... that a man of the sea has been seen by them in the Gulf of Cadiz with complete resemblance to a human being in every part of his body...'

The mermaid, above, said to have abducted Mathy Trewhella, is carved for posterity on a pew in the church at Zennor, Cornwall. The carving is about 600 years old, but the legend may be considerably older.

Mermaids, mermen and merchildren are depicted disporting themselves in a turbulent sea, left.

Mermaids, such as the one, below, were widely seen as erotic fantasy figures, and were believed to prey on drowning sailors, turning them into sexual slaves.

Why, if the man so perfectly resembled a human, the 'distinguished members' thought they had seen a merman is not clear; but Pliny was convinced that merfolk were indeed real.

Tales of merfolk proliferated and were, oddly enough, openly encouraged by the Church, which found it politic to adapt ancient heathen legends to its own purpose. Mermaids were included in bestiaries, and carvings of them were featured in many churches and cathedrals. A particularly fine example of a mermaid carving can be seen in the church at Zennor, Cornwall, on a bench end. It is thought to be about 600 years old and is associated with the legend of Mathy Trewhella, the son of the church-warden, who one day inexplicably disappeared. Years later, a sea captain arrived at St Ives and told how he had anchored off Pendower Cave and seen a mermaid who had said to him: 'Your anchor is blocking our cave Mathy, and our children are trapped inside.' For the people of Zennor, the mystery of Mathy's disappearance was explained.

But, on the whole, mermaids were not a sight to be relished. Their beautiful song, it was said, had captivated many a ship's crew and, like the fabled sirens of Greek mythology, they lured vessels to grief on dangerous rocks.

LOGGED ENCOUNTERS

In the late Elizabethan and early Jacobean age, belief in the mermaid waxed and waned. Men such as the philosopher Frances Bacon and poet John Donne gave rational explanations for many natural phenomena, including the mermaid. Yet it was also a time of blossoming maritime travel, and certain great seamen of the age told of personal encounters with merfolk. In 1608, Henry Hudson, the navigator and explorer (after whom the Hudson Bay territories are named), made the following matter-of-fact entry in his log:

'This morning, one of our companie looking over boord saw a Mermaid, and calling up some of the companie to see her, one more came up, and by that time she was come close to the ship's side, looking earnestly on the men: a little after, a Sea came and overturned her: From the Navill upward, her back and breasts were like a woman's (as they say that saw her); her body as big as one of us; her skin very white; and long haire hanging down behinde, of colour blacke; in her going downe they saw her tayle, which was like the tayle of a Porposse, and speckled like a Macrell. Their names that saw her were Thomas Hilles and Robert Raynar.'

Hudson was a very experienced seaman who surely knew the calibre of his men and presumably would not have bothered to record a blatant hoax. What is more, the report itself shows that his men were familiar with the creatures of the sea; and they seemed to be of the opinion that this creature was exceptional. If their description is accurate, it certainly was.

But the great age for mermaids was the 19th century. More were faked and displayed to awed crowds at fairs and exhibitions than at any other time. It was also a period in which several remarkable sightings were reported, including two of the best authenticated on record. On 8 September 1809, *The Times* published the following letter from schoolmaster William Munro:

The mermaid, left, is from a cornice decoration in Sens Cathedral, France.

The sirens, below, attempt to lure Ulysses and his crew to doom with their irresistible singing. Seen here as mermaids, they are more often thought of as half-woman, half-bird, below right.

The predatory mermaid, bottom, is shown seizing a drowning sailor and carrying him off to her lair.

'About twelve years ago when I was Parochial Schoolmaster at Reay [Scotland], in the course of my walking on the shore at Sandside Bay, being a fine warm day in summer, I was induced to extend my walk towards Sandside Head, when my attention was arrested by the appearance of a figure resembling an unclothed human female, sitting on a rock extending into the sea, and apparently in the action of combing its hair, which flowed around its shoulders, and of a light brown colour. The resemblance which the figure bore to its prototype in all its visible parts was so striking, that had not the rock on which it was sitting been dangerous for bathing, I would have been constrained to have regarded it as really a human form, and to an eye unaccustomed to the situation, it most undoubtedly appeared as such. The head was covered with hair of the colour above mentioned and shaded on the crown, the forehead round, the face plump, the checks ruddy, the eyes blue, the mouth and lips of natural form. resembling those of a man; the teeth I could not discover, as the mouth was shut; the breasts and abdomen, the arms and fingers of the size of a fullgrown body of the human species; the fingers, from the action in which the hands were employed, did not appear to be webbed, but to this I am not positive. It remained on the rock three or four minutes after I observed it, and was exercised during that period in combing its hair, which was long and thick, and of which it appeared proud, and then dropped into the sea... '

Whatever it was that William Munro saw and described in such detail, he was not alone, for he adds that several people 'whose veracity I never heard disputed' had claimed to have seen the mermaid. But until he had seen it himself, he 'was not disposed to credit their testimony'.

> **THE UPPER PART OF THE CREATURE WAS ABOUT THE SIZE OF A WELL-FED CHILD OF THREE OR FOUR YEARS OF AGE, WITH AN ABNORMALLY DEVELOPED BREAST . . . THE LOWER PART OF THE BODY WAS LIKE A SALMON, BUT WITHOUT SCALES.**

In about 1830, inhabitants of Benbecula, in the Hebrides, claimed to have seen a young mermaid playing happily in the sea. A few men tried to swim out and capture her, but she easily outswam them. Then a little boy threw stones at her, one of which struck the mermaid and she swam away. A few days later, about 2 miles (3 kilometres) from where she was first seen, the corpse of the little mermaid was washed ashore. The tiny, forlorn body brought crowds to the beach; and after the corpse had been subjected to a detailed examination, it was said that:

'The upper part of the creature was about the size of a well-fed child of three or four years of age, with an abnormally developed breast. The hair was long, dark and glossy; while the skin was white, soft and tender. The lower part of the body was like a salmon, but without scales.'

Among the many people who viewed the tiny corpse was Duncan Shaw, factor (land agent) for Clanranald, and sheriff of the district. He ordered that a coffin and shroud be made for the mermaid and that she be peaceably laid to rest.

Of the' many faked merfolk of this period, only one or two need be mentioned to illustrate the ingenuity of the fakers. A famous example is

The Reverend Robert S. Hawker, below right, impersonated a mermaid and is known to have frolicked off the shore of Bude, Cornwall, by night in his youth.

recounted in *The Vicar of Morwenstow* by the English author Sabine Baring-Gould. The vicar in question was the eccentric Robert S. Hawker who, for reasons best known to himself, in July 1825 or 1826, impersonated a mermaid off the shore of Bude in Cornwall. On a night when the Moon was full, he swam or rowed to a rock not far from the shore and there donned a wig made from plaited seaweed, wrapped oilskins around his legs and, naked from the waist upwards, sang – far from melodiously – until observed from the shore. When news of the mermaid had spread throughout Bude, people flocked to see it, and Hawker repeated his performance. After several appearances, however, having tired of his joke – and his voice a little hoarse – Hawker gave an unmistakable rendition of *God*

Save the King and plunged into the sea – never to appear (as a mermaid) again.

Phineas T. Barnum (1810-1891), the great American showman to whom are attributed two telling statements – 'There's one [a sucker] born every minute' and 'Every crowd has a silver lining' – bought a 'mermaid' that he had seen being shown at a shilling a time in Watson's Coffee House in London. It was a dreadful, shrivelled-up thing – probably a freak fish – but Barnum added it to the curiosities he had gathered for his 'Greatest Show on Earth'. His trick, however, was to hang up outside his 'mermaid' sideshow an eye-catching picture of three beautiful women, frolicking in an underwater cavern. Under this, he had a notice that read: 'A Mermaid is added to the museum – no extra charge.' Drawn by the picture and the implication of what would be seen within, many thousands of people paid the admission fee in order to see this remarkable spectacle.

Mermaids have continued to appear in more recent years. One was sighted, for example, in 1947 by a fisherman on the Hebridean island of Muck. She was sitting on a floating herring box (used to preserve live lobsters), combing her hair. As soon as she realised she was being observed, she plunged into the sea. Until his death in the late 1950s, the fisherman could not be persuaded to

believe that he had not seen a mermaid.

In 1978, a Filipino fisherman, 41-year-old Jacinto Fatalvero, not only saw a mermaid one moonlit night but was helped by her to secure a bountiful catch. Little more is known, however, because having told his story, Fatalvero became the butt of jokes, the object of derision and, inevitably, was hounded by the media. Understandably, he refused to say another word.

It is widely accepted that the mermaid legend probably first arose from misidentification of two aquatic mammals, the manatee and dugong, and possibly seals. Obviously, many reports can be explained in this way; but surely this does not satisfactorily account for what was seen by Henry Hudson's sailors or the mermaid witnessed by

schoolmaster William Munro? Were these and other similar sightings merely sea-mammals?

Some believe that merfolk are indeed real, and descendants of our distant ancestors who came ashore from the sea. Whatever the truth, the romance and folkore of the sea would certainly be all the poorer without such creatures.

> **"** THE FEMALE MERROWS [THE IRISH EQUIVALENT OF MERMAIDS] ARE A LOVELY SIGHT, WITH THEIR FLOWING HAIR . . . BUT THE MALE MERROWS ARE NOTHING WORTH LOOKING AT, FOR THEY HAVE GREEN HAIR AND GREEN TEETH AND LITTLE PIG'S EYES AND LONG RED NOSES. **"**
>
> **CROFTON CROKER, FAIRY LEGENDS OF THE SOUTH OF IRELAND**

Young girls of the Temiar Senoi tribe, left, deck themselves with flowers before attending a trance ceremony during which the village shaman summons spirits to cure sickness. The shaman learns in his dreams of the special tune by which a particular good spirit can be summoned to overcome the bad influence responsible for someone's sickness.

If the young Senoi boy, below, prepared for the trance ceremony, wishes to become a shaman, he must have a dream in which he is 'adopted' by a spirit.

WORKING WITH DREAMS

WE GENERALLY ATTACH LITTLE IMPORTANCE TO OUR DREAMS. BUT, AS THE SENOI – A MALAYAN TRIBE – HAVE LONG KNOWN, DREAMS MAY WELL BE CHANNELS FOR EXTRA-SENSORY-PERCEPTION

In 1932, British anthropologist, Pat Noone, was exploring a remote area of the highlands of the Malay Peninsula. During his travels, he made a first-hand study of a tribe called the Temiar Senoi. In Noone's view, they were extremely contented – he even called them 'the happy people' in his letters. Their marriages were lasting, and there was no history of crime or violence within the tribe. Their children seemed wonderfully content, too. Noone wondered what it was that made this tribe

British anthropologist Pat Noone, above, devoted much of his career to investigating the dream life of the Temiar Senoi.

so different from the superstitious, fearful, and often violent tribes that inhabited the surrounding area. To discover this, he spent the rest of his life studying the Temiar Senoi, and invited an American psychologist, Kilton Stewart, to share this work and contribute his professional expertise.

Noone discovered that the Senoi culture was largely based on the sharing of dreams. Every morning, the extended family would meet over the first meal of the day to tell each other their dreams and then discuss them. As soon as a child was able to speak, he was encouraged to tell his dreams. As a result, he would gradually become more familiar with his inner world and that of others, too.

All children have frightening dreams and nightmares, but the Senoi society is unique, as far as we know, in the way they teach their children to deal

with them. If a Senoi child dreams he is being chased by a large animal and wakes up in terror, his father might urge him to turn and face his pursuer in another dream. But if the animal is too large to be confronted by the child himself, he is encouraged to call on his brothers or friends to help him outface the animal in a dream The nightmares will then decrease and eventually stop altogether. The Senoi children also strike up relationships with the figures who have previously frightened them in their dreams, and in time these dream characters become helpful advisers.

The Senoi believe that the inhabitants of their dreams are the spirits of animals, plants, trees, mountains and rivers. Through their friendship with these spirits, Noone found, they believe they can learn things that they could never know by means of the senses.

One man, for example, who had befriended the spirit of the river in his dreams, frequently had dreams telling him where he could catch large fish. When he went to this part of the river the following day, he caught the fish he had dreamed about. On another occasion, he dreamed about the design of a new fish trap. He actually built a trap based on the dream design and found it worked very well indeed. Other men, whose spirit friends were of the animal kingdom, frequently dreamed of the best places to go hunting in the forest. Meanwhile, an aspiring shaman, or healer-priest, Noone found, would acquire a guardian spirit whom he would meet in a dream. He would go into a trance and lead the village in dances taught by the spirit, thereby winning recognition as a shaman.

Stewart also recorded evidence of much more obvious and powerful psychic phenomena in the Senoi's lives. On one occasion, when there was an epidemic in the tribe, a shaman had a dream in which his dead wife visited him. She taught him a dance, which she said would heal those in the tribe who were ill. In the dream, the shaman demanded evidence that she was indeed his wife and not some other spirit impersonating her. She said that if the dance were performed correctly, she would

Members of a dream group, led by Joe Friedman, are shown above. They would meet regularly to discuss their dreams, just as the Temiar Senoi do each morning. The members of the group found themselves remembering their dreams much more fully as a result; and, most remarkable of all, began to find telepathic and clairvoyant links.

cause a wooden box that was buried with her to appear in the middle of the long hut.

That night, the tribe performed the dream-taught dance: at the end of it, a box appeared in the air and fell to the ground. A cold breeze swept through the hut. Those who were ill quickly recovered.

Stewart and Noone were sceptical of this account, and so decided to hypnotise the shaman in order to discover the underlying truth. Under hypnosis, he recalled the story with only a few minor changes. It therefore seemed to them that he was not guilty of any conscious sleight of hand: indeed, he had been as surprised as anyone else when the box appeared.

Whether we believe this extraordinary story or not – and the value of the evidence offered under hypnosis is probably highly questionable – it is just one of many from cultures that believe dreams can have a direct healing effect. So can such phenomena also occur in our own society? Do we, too, have a psychic component to our dream lives?

In an attempt to discover more about the dynamics of dreams, in 1972, dream investigator Joe Friedman began to lead groups using the Senoi approach. Each week, a number of London adults aged between 20 and 50, often complete strangers, would meet for one evening to share and discuss their dreams. Each week, everyone would tell one dream that he or she had experienced in the days since the group's last meeting. The group would then try to clarify the events of the dream and the accompanying feelings.

THE SHARED DREAM

Although the main purpose of these meetings was to help members come to understand their dreams, it was found during the very first session that various kinds of psychic phenomena seemed to be facilitated. The most obvious among these was the 'shared dream'.

One group member, Bill, for example, described a dream in which he was standing within a semicircle with a magician, who reminded him of Tom, another member of the group. From the point where Bill stood, lines led to the letters of the alphabet. The magician told Bill that he was an 'H' or a 'K'. On the same night, Tom had a dream in which he was working at a post office, sorting parcels alphabetically into different bags. The correspondence here involved a person in Bill's dream who resembled Tom, assigning letters of the alphabet to Bill, while on the very same night Tom had dreamt of sorting parcels according to the letters of the alphabet.

Sometimes, one person's dream was even found to correspond with an event in which another member of the group had been involved the previous week. The following is a striking example.

Another group member, Peter, dreamed he was engaged in, or witnessing, a struggle between a scientist and the Devil. The Moon, which Peter could see out of the window, turned blood-red, became full, and came speeding through the window, rushing with great force towards the man's face. To quote from Peter's dream diary:

'The Moon had entered the man's head. I knew the Moon was one of the Devil's minions and here was the agent of possession... I saw the man

knocked against the wall... Then a small patch of red light shone on the wall next to his right hand.'

At that time, a fourth group member, Ron, having had difficulty getting to sleep, had been reading a fantasy book entitled *The Illearth War* by Stephen Donaldson. The part in which he was engrossed concerned a certain Thomas Covenant who was making a final attempt to overthrow the power of the King of Evil, Lord Foul. The power of Lord Foul was evinced by the fact that the Moon became blood-red and served as one of Lord Foul's minions.

In his dream, Peter saw a patch of red light on the wall next to the scientist's right hand. In the book, Covenant wears a white gold ring on his left hand. This ring emits a red glow during the period of Lord Foul's ascendance. Peter had never read the book, nor had he any ordinary means of being aware that Ron was reading it at the time.

Electrode-connecting wires festoon the head of a sleeping subject, above, in a sleep research unit. Infra-red video cameras in the unit's special bedrooms allow continuous yet discreet surveillance, so that periods of REM (rapid eye movement) sleep – during which dreams occur – can be monitored, while print-outs provide data on electrical activity of the heart, brain and muscles of the face and neck.

On certain occasions, the kind of extra-sensory perception that emerges in a dream is not linked to the present but to a future event in the life of the dreamer or another member of the group. Such precognitive dreams are often specific and accurate, and foreshadow events that are outside the control of the dreamer.

Yet we are normally unaware of dream ESP. Even when we do remember our dreams, they are rarely recalled in much detail for a long period, and we rarely make a record of them. Finally, even when we do remember and record our dreams, we rarely discuss them with others. If Bill had not been participating in a dream group, he would not have told the dream to Tom, since they were not close friends, and so he would not have discovered that Tom had experienced a similar dream the same night. There is, it seems, far more to dream content that is immediately apparent, as the Temiar Senoi have clearly long realised.

Recordings of a subject's brain waves, right, are made while she is awake, to be compared with her sleeping brain activity. Such records show that certain types of brain activity are much the same during dreaming as during waking life. But dreams do seem more conducive to ESP – perhaps because, when we are awake, our awareness of ESP activity is swamped by a profusion of ordinary experiences.

ALEISTER CROWLEY, ONE OF THE MOST INFAMOUS ENGLISHMEN OF THE 20TH CENTURY, HAD MANY INTERESTS, AMONG THEM MOUNTAINEERING, DRUGS, PORNOGRAPHY – AND 'MAGICK'. HE EVEN BELIEVED THAT HE WAS THE 'BEAST' OF THE BOOK OF REVELATION

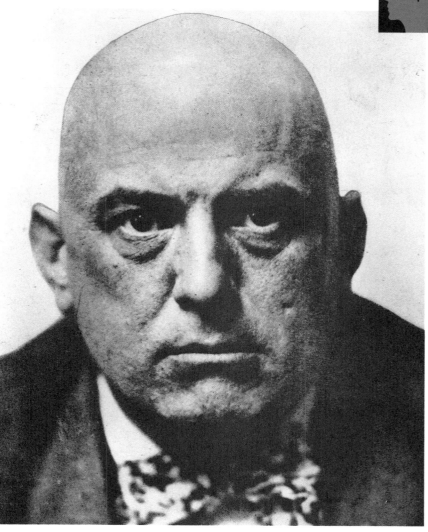

In the late 20th century, psychical researchers, also known as parapsychologists, largely concern themselves with mental phenomena, such as telepathy and precognition. But however important the scientific implications of such supposed phenomena, there can be no doubt that they are less spectacular than the alleged physical phenomena of mediumship – such things as levitation and materialisations of departed spirits – which were the main focus of psychic investigations during the period 1860 to 1930.

At that time, there were many physical mediums, among whom the most notable, apart from

'THE WICKEDEST MAN IN THE WORLD'

the great D.D. Home, was Eusapia Palladino, an Italian medium whose powers impressed such serious researchers as Everard Feilding and Hereward Carrington.

But one amateur investigator in particular was not at all impressed by her. After a sitting with Palladino, he even came to the conclusion that she was no more than a clever illusionist and that all those who had recorded her supernatural feats, notably the extrusion of a phantom 'ectoplasm' limb, had been duped.

The seance in question took place in 1913, and the researcher was trying to answer one crucial question that had presented itself to his mind: 'Feilding and the rest are clever, wary, experienced and critical, but even so, can I be sure that, when they describe what occurs, they are dependable witnesses?'

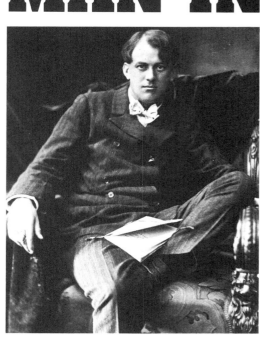

Aleister Crowley, above, had perfected his disarming hypnotic stare by middle age. Some – usually unbalanced – women found him irresistible. Even as an undergraduate at Trinity College, Cambridge, right, it was clear that Crowley had mapped out a future for himself that would be pure neither in mind nor in body.

205

Palladino sat at the end of a table – at her back, a curtained cabinet containing a stand on which were placed the various objects intended to be manipulated by her ghostly arm. Her right wrist was gripped by Mary d'Este Sturges; her left, by the investigator who had arranged the sitting.

The seance began in a way typical of many Palladino sittings: the curtain over the cabinet first bulged and then fell across the medium's left arm and hand and the investigator's right hand and arm. He reasoned to himself that this could not be the medium's left arm as he himself was holding it; but, as the mysterious arm disappeared from view, he suddenly felt Palladino's wrist slipping into his hand, although he had never been conscious of it ever leaving his grasp.

This minor but significant incident led the researcher to discount all the reports given by others who had attended Palladino's seances. 'If I,' he argued, '. . . cannot be relied upon to say whether I am or not holding a woman's wrist, is it not possible that even experts, admittedly excited by the rapidity with which one startling phenomenon succeeds another, may deceive themselves as to the conditions of the control?'

This investigator went on to have sittings with other mediums and to study the findings of other psychical researchers. As a result he became a complete sceptic, deciding that almost all the reported phenomena of the seance room were the outcome of fraud and self-deception.

DEDICATED OCCULTIST

Yet it is perhaps surprising that this particular investigator came to such negative conclusions. For, far from being a pure materialist, he was himself a dedicated occultist – none other, in fact, than Aleister Crowley, the practising ritual magician who, in the 1920s, was denounced as 'the wickedest man in the world'. His combination of total disbelief in

Jan: 10ᵗʰ 1910

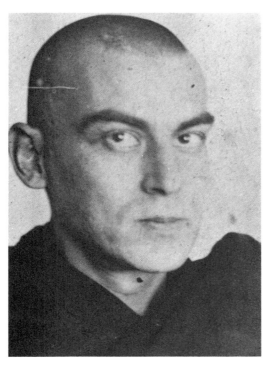

Crowley's marriage ('a detestable institution' he called it later) to Rose Kelly, a clergyman's daughter with whom he is seen above, was apparently perfectly happy until he discovered she was a dipsomaniac. After his divorce, he called all his mistresses 'Scarlet Women'.

Allan Bennett, left, was one of the few men whom Crowley revered, describing his mind as being 'pure, piercing and profound beyond any other'. Bennett taught Crowley magic when they were both members of the Order of the Golden Dawn. But they took different paths: Bennett went to Ceylon (now Sri Lanka) and became a Buddhist monk; Crowley became 'the Beast'.

Spiritualist mediumship with total belief in ritual magic was typical of the man: indeed, a thread of ambivalence and paradox ran right through his life, his teachings and his relationship with others.

Edward Alexander Crowley – later, he used only his middle name, and adapted it to the unusual spelling of 'Aleister' – was born in October 1875. His parents were members of the Plymouth Brethren, that most strict of Protestant sects, and they brought up their only son in all its rigid beliefs – that every word of *The Bible* was the literal truth, inspired by the Holy Spirit, that the Catholic and

> **" EVERY MAN SHOULD MAKE MAGICK THE KEYNOTE OF HIS LIFE. HE SHOULD LEARN ITS LAWS AND LIVE BY THEM. "**
>
> **ALEISTER CROWLEY,**
> **MAGICK IN THEORY AND PRACTICE**

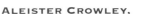

*In*FOCUS

SEX MAGICK

Crowley's pornographic treatise on mysticism, *The Scented Garden*, was an early reflection of what were to become his two principal obsessions in life: 'magick' and sexual indulgence.

It was in Paris, at the end of 1913, that he first experimented with a series of rituals that involved the painting of a pentacle (in the attempt to invoke the god Mercury), a ritual dance performed by neophyte Victor Benjamin Neuburg, whom he had met in Cambridge, and the scourging of Neuburg's buttocks, as well as the cutting of a cross on the skin above his heart. Finally, an act of buggery was committed by the two men.

On one occasion, Neuburg apparently became so possessed that he thought Mercury had told them they should perform the ultimate act of sex magick by raping and murdering a woman, subsequently cutting her corpse into pieces, and then offering them as sacrifices. The prospect of such behaviour was too much even for Crowley, and the ceremony is said never to have been performed.

Apologists for Crowley maintain, however, that magick was never an excuse for sexual activity as far as he was concerned. Rather, they say, Crowley seems to have reached the conclusion that, like magick, sex requires a great deal of discipline and experimentation if great heights are to be reached, and can be used in the practice of magick.

Magick, too, could be used to win a lover, according to Crowley. As he wrote in *Magic in Theory and Practice:* 'Suppose that I wish to win a woman who dislikes me and loves someone else. I have only to make my mind the master of hers... her mind will then present its recantation to her Will, her Will repeal its decision, and her body submit to mine as the seal of her surrender. Here the Magical Link exists... I may work naturally by wooing of course. But, magically, I may attack her astrally so that her aura becomes uneasy, responding no longer to her lover.'

Anglican Churches were 'synagogues of Satan', and that the overwhelming majority of mankind was doomed by a just God to roast in hellfire.

The elder Crowley died in 1887, and Aleister then became the object of his mother's fanatical venom. On more than one occasion, she accused him of being the actual 'Great Beast' of the *Book of Revelation*, whose number is said to be 666. To the end of his life, Crowley did everything he could to live up to this archetypal image. Some say he even came to believe he really was the biblical Beast.

Sent away to a school for the sons of Brethren, he had many experiences that made him lose his Christian faith. He even acquired a hatred of the Brethren and their beliefs that was to survive throughout his long and eventful life.

In October 1895, Crowley, in possession of a fortune of £30,000 that he had inherited on reaching the age of 21 – became a student of Trinity College, Cambridge. His three years at the university were happy ones: he collected rare books, wrote much poetry, spent his holidays climbing in the Alps and became interested in the occult.

This led him, in 1898, to become a neophyte – a student member – of the Hermetic Order of the Golden Dawn, a semi-secret society devoted to the study of the occult arts and sciences, including the invocation of spirits, divination, and alchemy.

Aleister Crowley considered most of his fellow members of the Golden Dawn to be 'absolute nonentities'; but he was impressed by the occult

Despite some of the more ludicrous poses he affected, such as the one right, the core of Crowley's 'magick' seemed to be genuine enough. His famous, and much misunderstood, 'Do what thou wilt shall be the whole of the law' was amplified by 'Love is the law; love under will'. He constantly urged his followers to seek their true selves. This, he believed, was the divine purpose of all human lives. He may have taken the idea from the Elizabethan magician, Dr Dee, who had written: 'Do that which most pleaseth you... ' The unenlightened took this to advocate moral laxity; and in his less noble moments, so did Aleister Crowley.

magical abilities of two of them, Cecil Jones and Allan Bennett. The latter took up residence with Crowley in his London flat, and together the two carried out many occult experiments. Among these was the 'consecration' – the charging with magical powers – of a talisman intended to cure a certain Lady Hall of a serious illness.

This was duly prepared and handed over. Unfortunately, however, neither Lady Hall nor her daughter followed Crowley's precise instructions; so that when the talisman was applied to the venerable old lady, she was seized with a violent series of fits and nearly died.

The consecration that produced these unpleasant effects was probably carried out in what Crowley called the White Temple, a room lined with mirrors and devoted to white magic. But his flat also included another room, the Black Temple, in which the altar was supported by the image of a black man standing on his hands and which contained a skeleton to which it is said that Crowley would sacrifice sparrows.

INVISIBLE VANDALS

There seems to have been a thoroughly sinister atmosphere about Crowley's flat. One evening in 1899, he and a friend, also an occultist, went out to dinner. On their return, they found that the locked door of the White Temple had been mysteriously opened, its furniture overturned, and the 'magical symbols' that it held scattered around the room. As Crowley and his friend restored the room to order, they claimed clairvoyantly to have observed 'semi-materialised beings... marching around the main room in almost unending procession'.

In 1900, the Golden Dawn split into two competing factions. Crowley managed to quarrel with both of them; and for the next three years or so, he lost interest in western occultism. Instead, he wrote poetry, travelled the world and got married to a lady whom he called 'Ouarda the Seer', although she

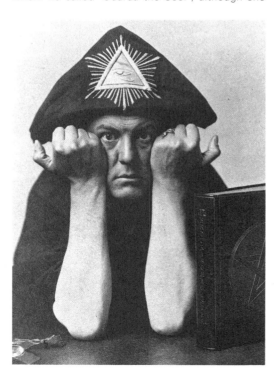

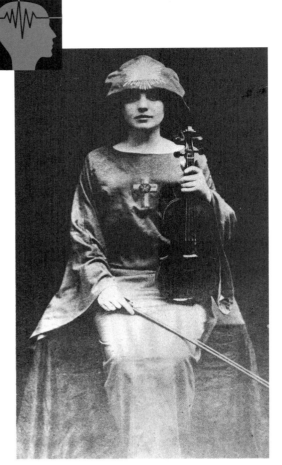

right to develop in his or her own way. 'Do what thou wilt shall be the whole of the law', said the new gospel, for 'Thou hast no right but to do thy will' and 'The word of sin is restriction'.

> **DO WHAT THOU WILT SHALL BE THE WHOLE OF THE LAW, SAID THE NEW GOSPEL, FOR THOU HAST NO RIGHT BUT TO DO THY WILL AND THE WORD OF SIN IS RESTRICTION.**

In fairness to Crowley and his followers, it has to be emphasised that he was always careful to point out that 'Do what thou wilt' is not quite the same as 'Do what you like'. When *The Book of the Law* says 'Do what thou wilt', claimed Crowley, it means 'Find the way of life that is in accordance with your inmost nature and then live it to the full.'

For some years, Crowley only half-believed in the truth and importance of *The Book of the Law*, but by 1910 it had mastered him, and he devoted the rest of his life to spreading its message and converting others to the belief that he, Aleister Crowley, was a new Messiah.

The methods he adopted to achieve these ends included the authorship of numerous books, most of them eventually published at the expense of himself and his followers, the setting up of two occult fraternities, the public performance of occult ceremonies at London's Caxton Hall, and even the establishment of an 'Abbey', situated in a derelict Sicilian farmhouse, the inmates of which devoted themselves to the practices of the new faith.

Leila Waddell, violinist and Crowley's magical assistant in London in 1910, is seen **left.** *She played the violin in Crowley's Rites of Eleusis at Caxton Hall, which was open to the public. Crowley claimed magically to have changed her from being 'a fifth-rate fiddler' to a musical genius – but just for the evening.*

Crowley and his 'Scarlet Woman' Leah Hirsig, pose, **right,** *with their baby, Poupée, outside the infamous Abbey of Thelema in Sicily in 1921. An experiment in communal living for students of 'magick', the Abbey was a disaster from the first, ending in 1923 with the death of one of its members.*

Jane Wolfe **(left** *in the picture, far* **right),** *a former stage and screen actress, is seen with Leah Hirsig outside the Abbey in 1921. The centre attracted many visitors from all over the world. Some were horrified (especially when Crowley offered them 'cakes of light', which were made of dung), and most went away utterly disappointed.*

actually knew little about the occult and probably cared even less about it.

In March 1904, the two were staying in Cairo. Crowley, wanting to demonstrate his occult abilities to his wife, carried out a number of magical rites. The results, if Crowley's written records are to be believed, were startling. He received a psychic message, flashed into his brain from some unknown source, which told him that a new epoch in history was about to begin. He, Crowley, had been chosen to be the prophet of this new age. Crowley's wife also received a message: that her husband was to sit down for one hour on three consecutive days with a pen and paper before him. The gods would then dictate to him, in voices audible only to their chosen prophet, the gospel of the new age that was about to dawn.

Crowley obeyed the directions. He heard a voice, presumably originating in the depths of his own mind, and wrote down the words dictated to him. The result was *The Book of the Law*, a prose poem which Crowley came to believe was inspired in precisely the same way that his parents had believed *The Bible* to be inspired.

The meaning of some parts of *The Book of the Law* is obscure. Even Crowley admitted that some passages were beyond his own comprehension. But the basic message was clear. Crowley was to be the prophet of a new era – the so-called Age of Horus. In the new age, all the old religions of mankind – Christianity, Islam and Buddhism, for instance – would pass away and be replaced by a new faith of 'Force and Fire', the basic moral principle of which would be complete self-fulfilment. 'Every man and woman is a star', Crowley was told – in other words, each individual has an absolute

A sketch by Crowley of a devouring demon is shown **above.**

XV

ℶ — The Devil ℸ

'The Devil', **right,** *is from a Tarot pack, designed by Crowley and painted by Lady Frieda Harris. The work on the cards was expected to take three months, but it eventually took all of five years.*

In the years before the outbreak of the First World War, Crowley and a few disciples carried out an intensive propaganda campaign in England. This, although it cost all of Crowley's money and much of that belonging to his friends, was notably unsuccessful. Few converts were made, and Crowley was subjected to much unfavourable publicity. In 1914, Crowley took himself and his new faith to the United States where, so he hoped, people would be more receptive to the new gospel and to his 'magick' – the occult system Crowley derived from his synthesis of western occultism, the teachings contained in *The Book of the Law,* and the tantrism (yogic theory and practice, largely concerned with sexuality) that he had learned from eastern sources.

But the New World proved even more resistant to Crowley's influence than the Old. The six years the self-proclaimed prophet spent in America were unhappy. He was perpetually short of money, made few converts, and was accused of being a traitor to his own country – reasonably enough for, until the United States' entry into the war in 1917, he earned a scanty living by editing a pro-German propaganda sheet.

In 1920, he returned to Europe along with two mistresses – Crowley always maintained a vigorous sex life – and established his 'Abbey of Thelema'

The pornographic wall painting, above, is from the Abbey of Thelema – one of the lesser of its evils, according to reports in the world's press.

(a magical word, implying 'New Aeon', though Crowley often translated it as 'will') in Sicily. For a time, this enjoyed a modest success. The Sicilians were surprisingly tolerant of Crowley and his 'magick', and a number of disciples, actual and potential, made their way to the Abbey. These included Jane Wolfe, a minor Hollywood star, Norman Mudd, a one-eyed professor of mathematics, and Raoul Loveday, a brilliant young Oxford graduate who had decided to devote his life to Crowley's new religion.

Loveday died while he was staying at the Abbey, probably of enteritis. His wife, who believed that her husband had been poisoned by blood that he had drunk in the course of an occult ceremony, returned to London and began a virulent newspaper campaign against Crowley. Eventually, this campaign, which included the denunciation of Crowley as 'a beast in human form', led to the closure of the Abbey. The Sicilian authorities then promptly deported him.

The remainder of Crowley's life was, in many ways, an anti-climax. He wandered through Europe, a lonely and increasingly unhappy man, and eventually died in 1947. At the time of his death, Crowley had only a handful of followers; today, however, he has many thousands. In some ways, his teachings seem more in tune with the present than they were with his own times.

THE BODILY GLOW GIVEN OFF BY CERTAIN HOLY PEOPLE, AS WELL AS THE SICK, HAS EXCITED WONDERMENT THROUGH THE AGES

A case of a glowing human who was otherwise healthy comes from a letter to the *English Mechanic* of 24 September 1869:

'An American lady, on going to bed, found that a light was issuing from the upper side of the fourth toe on her right foot. Rubbing increased the phosphorescent glow and it spread up her foot. Fumes were also given off, making the room disagreeable; and both light and fumes continued when the foot was held in a basin of water. Even washing with soap could not dim the toe. It lasted for three-quarters of an hour before fading away, and was witnessed by her husband.'

When it comes to luminescent animals, such as glow worms and fireflies, the scientific explanation is that they light up as a result of chemical reactions involving oxygen, luciferase, luciferin and adenosine triphosphate (ATP) within the body. But this kind of chemical reaction has not been offered as the reason for the human glow.

Many mystics and occultists maintain that every human being is surrounded by light – or an aura – of varying colours, which can be seen after occult training or by natural clairvoyance. The strength of this light is said to vary with each individual, but is supposed to be brightest around those whose spiritual nature is most developed, or those who are in

HUMAN GLOW-WORMS

A blue glow emanated from Anna Morana's breasts as she lay asleep. It happened regularly for several weeks, and each time the luminescence lasted for several seconds. No one could explain it.

An asthma sufferer, living in Italy, she first started to glow during an attack in 1934, and she became a news sensation for a time as the 'luminous woman of Pirano'. The blue light that she gave off was recorded on film, and was also witnessed by many doctors. One psychiatrist said that it was caused by 'electrical and magnetic organisms in the woman's body developed in eminent degree,' which did little to clarify the matter. Another doctor speculated that she had an abnormally high level of sulphides in her blood because of her weak condition and also because of her fasting, inspired by religious zeal. These sulphides, he said, were stimulated into luminescence by a natural process of ultraviolet radiation. Even if this were true, it did not explain why the glow came just from the breasts, and always only while the woman slept.

Data on 'glowing' humans is found in medical literature, as well as religious writings and folklore. Many toxicology textbooks discuss 'luminous wounds', for instance, and in their encyclopedic collection of *Anomalies and Curiosities of Medicine*, Dr George Gould and Dr Walter Pyle described a case of breast cancer that produced a light from the sore that was sufficiently strong to illuminate the hands of a watch which was lying several feet away. Hereward Carrington (1881-1958), an American psychical researcher, also told of a child whose body, after death from acute indigestion, was surrounded by a strange blue glow.

As she lay on her death-bed, above, a celestial light in the form of a cross and stars were seen to glow around the corpse of Jane Pallister, who died in 1833. Her son and other witnesses attributed this wonder to her extreme virtue.

Two wingless, female common European glow-worms, right, send out a cold, greenish-yellow light from an organ in the tail-end of their abdomens. These glow-worms (in fact, beetles of the family Lampyridae) produce light by means of a chemical reaction, and use it to attract males during the mating season.

During Christ's transfiguration on the mountain, depicted above right, his garments became white and shining as light – a phenomenon portrayed here by the round and angular shapes surrounding him. Light features again in the conversion of Paul on the road to Damascus, illustrated far right, when a brilliant flash seemed to knock him from his horse: we are told that it came from a vision of Jesus.

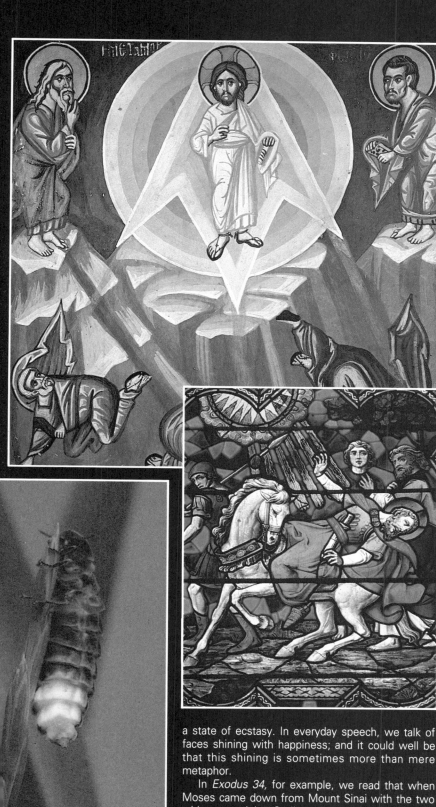

mystics distinguished four different types of aura: the nimbus, the halo, the aureola and the glory. The nimbus and halo stream from or surround the head, and the aureola emanates from the whole body. The glory, meanwhile, is an intensified form of the whole-body glow – a veritable flooding of light.

Theosophists speak of five auras: the health aura, the vital aura, the Karmic aura, the aura of character, and the aura of spiritual nature. Various colours of aural light are also said to indicate differing emotional states or character. Brilliant red means anger and force; dirty red, passion and sensuality; brown, avarice; rose, affection; yellow, intellectual activity; purple, spirituality; blue, religious devotion; green, deceit or, in a deeper shade, sympathy. The Polish medium Stefan Ossowiecki, in the early 1900s, occasionally saw a particularly dark aura that indicated the approach of death.

NATURAL FLAMES

Most people are familiar with the Christian representation of the halo. It is less known, however, that the original purpose of the crowns and distinctive head-dresses worn by kings and priests was to symbolise the halo. Representations of the aureola around great teachers and the holy are found in virtually every culture: they occur, for example, in places as far apart as Peru, Mexico, Egypt, Sri Lanka, India and Japan.

Pope Benedict XIV, in his great treatise on beatification and canonisation, wrote:

'It seems to be a fact that there are natural flames which at times visibly encircle the human head, and also that, from a man's whole person, fire may on occasion radiate naturally – not, however, like a flame which streams upwards, but rather in the form of sparks which are given off all round; further, that some people become resplendent with a blaze of light, though this is not inherent in themselves, but attaches rather to their clothes, or to the staff or to the spear they are carrying.'

Stories are legion in the hagiographical records of priests who illuminated dark cells and chapels with a light that emanated from their bodies or, conversely, seemed to stream upon them from some mysterious source. When the 14th-century Carthusian monk, John Tornerius, failed to appear in time to celebrate the first mass, the sacristan who went to fetch him found that his cell was radiant with light. Wondrously, this light seemed to be diffused like the midday sun all round the priest. In the process of beatification of the holy Franciscan Observant, Blessed Thomas of Cori, witnesses stated that on a dark morning the whole church had been lit up by the radiance that glowed in his face. And in what is apparently the earliest account of Blessed Giles of Assisi (d.1262), we are told that on one occasion in the night: 'so great a light shone round him that the light of the moon was wholly eclipsed thereby.'

Other accounts tell how the house of Blessed Aleidis of Scarbeke seemed to be on fire when she was praying within, the brightness coming from her radiant countenance; and how the cell of St Louis Bertran 'appeared as if the whole room was illuminated with the most powerful lamps.' The 15th-century German ecclesiastic Thomas à Kempis says of St Lydwina:

a state of ecstasy. In everyday speech, we talk of faces shining with happiness; and it could well be that this shining is sometimes more than mere metaphor.

In *Exodus 34*, for example, we read that when Moses came down from Mount Sinai with the two tablets containing God's commandments, 'the skin of his face shone.' This shining frightened everyone, so Moses put a veil over his face until he had finished speaking with his people. Similar glowings are described in *The Bible* with regard to St Paul's vision at the time of his conversion, and in the transfiguration of Christ, when his clothes became so shining that no 'fuller' or bleacher of cloth could equal its whiteness.

Nandor Fodor (1895-1964), the Hungarian writer on parapsychology, tells us that medieval saints and

Accounts of people who appear to glow, represented by the figure, above, often ascribe the phenomenon to their holiness or a higher spiritual nature. Indeed, in much religious art, the divine person is very often shown surrounded by a visible aura – for example, a halo around the head – that is taken to symbolise his or her sanctity.

'And although she always lay in darkness, and material light was unbearable to her eyes, nevertheless the divine light was very agreeable to her, whereby her cell was often so wondrously flooded by night that, to the beholders, the cell itself appeared full of material lamps or fires. Nor is it strange if she overflowed even in the body with divine brightness. '

SAINTLY LUMINESCENCE

Father Herbert Thurston, in his highly regarded book, *The Physical Phenomena of Mysticism,* wrote of these records of saintly luminescence:

'Although a great number of these rest upon quite insufficient testimony, there are others which cannot lightly be set aside... There can, therefore, be no adequate reason for refusing credence to the report of similar phenomena when they are recorded of those whose eminent holiness and marvellous gifts of grace are universally recognised.'

Father Thurston cites two striking cases from the 17th century concerning the Blessed Bernardino Realini and Father Francisco Suárez.

The process leading to the beatification of Father Bernardino, who died in Lecce in Italy in 1616, was begun in Naples in 1621. Among the witnesses examined was Tobias da Ponte, a gentleman of rank and good standing. He testified that, in about 1608, he had gone to consult the Father. Before entering the room, he noticed a powerful glow that streamed around the door, which was slightly ajar, and through chinks in the boards. Wondering what could have prompted the Father to light a fire at midday in April, he pushed the door a little further open. There, he saw the Father kneeling, rapt in ecstasy and elevated about 2 feet (more than half-a-metre) above the floor. Da Ponte was so dazed by the spectacle that he sat down for a while, and then returned home without even making himself known to the priest.

Other people also bore witness to the extraordinary radiance of Father Bernardino's countenance. They had not seen him levitate, but some declared that they had seen sparks coming from all over his body, and others asserted that the dazzling glow from his face on one or two occasions was such that they could not properly distinguish his features, but had to turn their eyes away.

CASEBOOK

A COLOURFUL TALENT

The famous American psychic and healer, Edgar Cayce (1877-1945), asserted that, right from a very early age, he had always seen colours in association with people. Indeed, he claimed always to see reds, greens or blues pouring from the heads and shoulders of those he met. As he put it: 'For me, the aura is the weathervane of the soul. It shows me the way the winds of destiny are blowing.'

It is, however, a talent that he believed could be developed by everyone. He was even convinced that the majority of us do see one another's aura but simply do not realise it. By taking note of the colours that people look best in and that they choose for their homes, Cayce held that we can begin to recognise the aura and the way in which it may change according to state of mind.

'All of you know what colours are helpful to your friends and bring out the best in them,' he wrote. 'They are the colours that beat with the same vibration as the aura, and thus strengthen and heighten it.' Thus, it seems, although the holy may 'glow' most of all, we are all surrounded by a degree of luminescence.

Mohammed, left, appears fully encircled by flames in this 16th-century painting from Turkey; Quetzalcoatl, below, the Aztec god, in his guise as the morning star is surrounded by fire on an ancient stele from Mexico; whilst the great Buddhist teacher Padmasambhava, below right, is haloed in an 18th-century painting from Tibet. Finally, the four kings of hell, bottom, on a Chinese hanging scroll, have crowned heads encircled by light.

Father Francisco Suárez, the subject of Father Thurston's second example, was a Spanish theologian who, from 1597 to 1617, taught at the Jesuit College at Coimbra in Portugal. One day at about 2 p.m., an elderly lay-brother, Jerome da Silva, came to tell the Father of the arrival of a visitor. A stick placed across the door indicated that the Father did not wish to be disturbed, but the lay-brother had received instructions to inform the Father at once, so he went in. He found the outer room in darkness, shuttered against the afternoon heat. Suárez's biographer, Father de Scorraille, records da Silva's account of the incident:

'I called the Father but he made no answer. As the curtain which shut off his working room was drawn, I saw, through the space between the jambs of the door and the curtain, a very great brightness. I pushed aside the curtain and entered the inner apartment. Then I noticed that the blinding light was coming from the crucifix, so intense that it was like the reflection of the sun from glass windows, and I felt that I could not have remained looking at it without being completely dazzled. This light streamed from the crucifix upon the face and breast of Father Suárez, and in the brightness I saw him in a kneeling position in front of the crucifix, his head uncovered, his hands joined, and his body in the air

> WITH MOST PEOPLE, AURIC VISION DOES NOT COME IN A FEW DAYS OR A FEW MONTHS. IT IS A LIFE-TIME STUDY AND ONE'S LIFE AND HABITS MUST BE ON A HIGH PLANE TO GET GOOD RESULTS.
>
> S.G OUSESLEY,
> THE SCIENCE OF THE AURA

five palms [about 3 feet or 1 metre] above the floor on a level with the table on which the crucifix stood. On seeing this, I withdrew . . . as it were beside myself... my hair standing on end... '

About a quarter of an hour later, Father Suárez came out and was surprised to see Brother da Silva waiting. The account continues: 'When the Father heard that I had entered the inner room, he seized me by the arm . . . then, clasping his hands and with his eyes full of tears, he implored me to say nothing of what I had seen . . . as long as he lived.'

Father Suárez and da Silva shared the same confessor, who suggested that da Silva should write his account and seal it with the endorsement that it should not be opened and read until after the death of Father Suárez. That, apparently was done. The account provides us with a particularly compelling story of human luminescence – in this case, the glow of holiness.

BETRAYED BY THE SENSES

CONCEPTIONS OF REALITY VARY CONSIDERABLY AMONG INDIVIDUALS. THE QUESTION INEVITABLY REMAINS, THEREFORE, AS TO WHO PERCEIVES WITH ACCURACY

I n psychiatric literature, there are numerous examples of quite well people who have, for a period, experienced hallucinations that they knew to be illusory yet behaved as if the experiences were genuine. These viewers seemed able to walk right around their hallucinations, which were apparently real enough to them to block out light and objects, to be reflected in mirrors and even appear in double images when the sides of

Our perception of the world is not always what it seems. The hologram of an apple, above, for instance, looks 'real' enough, yet it is only an image created by lasers. Some animals, meanwhile, see the world quite differently from the way we do. A bee might see the eye of a bird as huge and segmented, right. Dolphins, far right, however, use sonar with which to 'see' – and even, it is believed, possess a form of X-ray vision.

the viewers' eyeballs were pressed, just as real objects do. But since these images had no objective reality, there was no way in which light could possibly travel from the hallucinations and affect the eyes so as to register an image in the brain.

Yet, in such cases, the image is definitely there – for at least one person. This must mean that, instead of light travelling from a real object, registering on and being interpreted by the viewer's brain, the brain itself must create an image and in some way 'project' it to the spot where it is seen. Similar processes must also occur in hallucinations affecting the other senses – hearing, for instance.

There are, certainly, many types of hallucination that occur when the subject is awake, sleeping, in a trance, under hypnosis or only semi-awake.

PERCHANCE TO DREAM

Everyone, to be sure, experiences the hallucinations of dreams. Much of what we dream consists of unimportant fragments of memory, dramatisations of anxieties or desires escaping from subconscious repression, or sometimes simply the communication of physical discomfort – such as a dream of being suffocated when a pillow has slipped across one's face. Some extraordinary dreams, with startling vividness and impact on the dreamer, may also be significantly precognitive. These are, in many ways, picture-shows inside the dreamer's mind and correspond to no external reality that his or anyone else's physical senses can appreciate at the time. Yet, if they do prove precognitive, they are the shadows of coming events, and as real as the shadow of a man overtaking you when the evening sun is at your back.

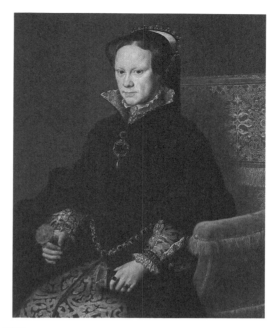

Queen Mary I (1516-1558), whose marriage to Philip II of Spain resulted in a phantom pregnancy, is seen, right, in a detail from a painting on wood by Sir Anthony Moore that is exhibited in The Prado, Madrid. In such cases, all outward appearances indicate the progress of pregnancy: the woman ceases to menstruate and may suffer from morning sickness and other allied conditions – but there is no baby. It seems that it is the intense desire of the frustrated mother that creates the cruel illusion of motherhood.

" **MANY CASES HAVE BEEN REPORTED WHERE A FIGURE OR AN OBJECT IN A DREAM HAS BEEN PROLONGED INTO A VIVID WAKING HALLUCINATION.** *"*

D.H. RAWCLIFFE, OCCULT AND SUPERNATURAL PHENOMENA

A TRICK OF THE MIND?

Some years ago, author David Christie-Murray was invited to lecture on psychical research at a school. He was given dinner before the talk by the housemaster who had arranged the lecture. Another guest was the mother of two boys at the school, who told Christie-Murray the following story.

The woman had always longed for a daughter and, when her two sons were in their teens, she adopted a baby girl whom she came to adore. But, sadly, when the girl was still only a toddler, she was killed in a car crash. What was worse, the woman said, she herself had been driving the car at the time, and the accident had been entirely her fault. The loss of the child and the sense of crushing guilt made life doubly agonising for the grieving mother.

One night, some time after the tragedy, she suddenly woke up and, overwhelmed by sorrow and feeling the need of comfort and companionship, tried to wake her husband. But it was impossible: he seemed to be in some kind of coma. In the end, she gave up and, in utter desolation, went into what had been the child's bedroom and sat on her bed.

Quite suddenly, she realised that the little girl was standing in front of her. She held out her hands and said 'Mummy'. The mother spontaneously opened her arms to

CASEBOOK

the child, who climbed on to her lap and laid her head on her shoulder. It seemed miraculous: her daughter had died but here she was, solid and warm, flesh and blood – a 'living' child whose hair could be felt against the breast. They sat in their joyful embrace for a short time. Then the little girl clambered down from her mother's lap, said 'Mummy, I have to go now,' and promptly vanished just as mysteriously as she had appeared.

The experience left the mother with a great sense of joy – an emotion as intense, in fact, as her previous desolation – and a total conviction of the survival of bodily death and some sort of after-life.

David Christie-Murray said of this quite extraordinary experience: 'There was no doubt about the emotion and sincerity with which she told her story and, if she was a pretender trying to hoodwink a psychical researcher of long standing, she was a very convincing actress. If the experience was genuine, as I do not doubt it was, at least it shows that not all "otherworldly" encounters are hostile, sinister or sick.'

This story seems to confirm the Spiritualist belief that departed souls can materialise in some sort of solid form. But others may well dismiss such an experience as a mere trick of the mind – the nature of this, in itself, being very much a mystery.

PERCEPTION

or perhaps even visitations from another dimension. Some of the images experienced at these times seem so overwhelmingly vivid that even the most hardened sceptic experiencing them finds it impossible to believe that they do not correspond to some reality.

Cultural expectations, researchers have found, often dictate the content of such hallucinations. Indeed, in ages of greater superstition – or faith – assisted by drugs, fasting, mortification of the flesh and meditation, individuals have often experienced either the orgies of the witches' sabbats, or visions and communications from angels, the Virgin and Christ. In our age, a similar kind of cultural conditioning may also explain the experience of the woman who, while seated beside her friends in a car, gave a running commentary that described how she was being taken on board a UFO.

This experience is in many respects akin to the hallucinations of hypnosis, in which especially receptive subjects can be made to see people and

In medieval times, there was great fear of incubi and succubi – respectively male and female demons who would have sex with sleeping women and men. They were often blamed for the sexual dreams that people had from time to time. But modern psychiatry has in fact discovered that some somnambules (sleep-walkers) can have such vivid sexual fantasies in dreams that they reach orgasm. A further remarkable hallucination is that of the phantom pregnancy: one famous historical example is that of Mary I of England (who ruled from 1553-58). She so yearned for a child that, for a full nine months, she showed all the signs of imminent motherhood.

Even more astonishing are reported accounts of spectral rape. A significant number of women have reported this experience, both while sleeping and while awake – developing, during the ghostly assault, all manner of bruises, scratches and bites that could not possibly have been self-inflicted, even as a result of the hysteria induced by sexual repression and guilt – the usual medical explanation for such experiences. There are even instances where members of the victim's family claim to have seen a ghostly attacker dissolving before their eyes.

STIGMATA OF THE MIND

In spectral rape, it is most likely, however, that the explanation is a psychological one. Other related phenomena, too, seem to originate in the mind. A knife-slash, for instance, has been known to appear on the face of a man reliving a brawl under the influence of drugs or hypnosis. A girl, believing herself to be the reincarnation of a slave flogged to extinction, collapsed on what she thought was the place of her death, whiplashes appearing spontaneously across her back. Such wounds are patently not self-inflicted physically, yet may be brought about mentally. As for the shadowy rapist seen by others, he could be, of course, an hysteric vision, created and then communicated by the victim to others.

Some of these phenomena are experienced while falling asleep (when they are termed hypnagogic), and some during the process of waking. These are the two twilight times in everyone's day, when we are all particularly open to hallucinations

It is said that what mystics see and feel while in their ecstasies is so different from everyday reality that there are no words to describe their experiences. The fourth-century St Anthony, having cut himself off from the world, was constantly beset by demons, as shown, above, in a painting by Bosch. He believed them to be 'real' enough to see and communicate with but, drawing on his faith, he could also dismiss them at will. A more modern mystic was the 19th-century writer Emily Brontë, right, whose ecstatic trances contrasted sharply with her everyday world of baking bread and supervision of her Yorkshire household.

objects that are not actually there, and not to see others that are. So how 'real' is the mustard that is tasted by both subject and hypnotist – although only the hypnotist has put it in his mouth? Or the pinprick or pinch felt by the subject but inflicted on the hypnotist?

Evidence points to the existence of many kinds of reality. One that is quite different from our workaday world, for instance, is that of the mystic or visionary who, when in an altered state of consciousness, suddenly becomes at one with the whole of the Universe and its source. He or she may even remember this moment of insight with a clarity that makes day-to-day reality seem as nebulous and insignificant as a dream. But whether other levels of reality are halfway houses between the commonplace world and the mystics' ultimate reality, or whether some manifestations of them – such as hallucinations – are merely the aberrations of disturbed minds is a matter that, for the present, remains to be determined.

217

CASEBOOK

A GIANT, FACELESS HUMANOID, THE STRANGE TELEPORTATION OF CATTLE, AND A CAR-CHASING UFO – JUST SOME OF THE MANY PHENOMENA ALLEGEDLY EXPERIENCED BY THE COOMBS FAMILY AT RIPPERSTON FARM, WALES

During the autumn of 1977, an enterprising hotelier in west Wales began to offer special weekend breaks for UFO investigators. Enthusiasts would be free to use the hotel facilities all night long, and an expert would guide them to the most favourable locations for UFO spotting, though sighting was, of course, not guaranteed. 'Pembrokeshire is quite a way ahead in this sort of thing,' the hotelier observed at the time; and she professed herself flabbergasted at the number of

UNRAVELLING THE RIPPERSTON RIDDLE

people who had written or telephoned in order to make enquiries.

What was drawing the attention of UFO enthusiasts, not only from Britain but also from abroad, was the continuous flow of remarkable reports from what the press now called 'the Broad Haven triangle'. Serious ufologists have learned to be cautious about 'flaps'. Periods when more than the usual number of reports come in may genuinely represent an increased level of activity, but it may simply be that the publication of reports encourages witnesses to come forward when otherwise they would have kept their experiences quiet. No more incidents may have occurred: it is just that more are disclosed. There is, of course, the further possibility that news about sightings may stimulate some people to have imaginary experiences.

Such possibilities are anathema, however, to those ufologists who are convinced that all UFO sightings are grounded in physical fact and who deny that there may be a psychological aspect to such experiences. But the possibility that some kind of 'contagion of ideas' was operating in west Wales during the spring and summer of 1977 is certainly suggested by many of the reports – most of all by the series of astonishing events that were alleged to have taken place at Ripperston Farm, and that focus on the Coombs family. So completely did these events capture the public imagination tha

Ripperston Farm, near St Brides Bay in west Wales, left, was the home of the Coombs family who reported many seemingly paranormal events in the spring and summer of 1977. One of the striking aspects of this case is that Brian and Caroline Klass, whose cottage adjoined that of the Coombs, did not see or hear anything unusual at this time – or at least chose not to publicise any experiences.

three books were wholly or in large part devoted to them. There was too, extensive coverage by press and television. Unfortunately, this resulted in so much contradiction and confusion that the true facts have been difficult to establish. In what follows, the most probable version of the truth has been selected; but frequently it has been a matter of choosing between contradictory accounts, and absolute accuracy cannot be guaranteed.

Billie Coombs was a herdsman, one of three men responsible for looking after the dairy herd at Ripperston Farm on behalf the farm manager, Richard Hewison, who lived at neighbouring Lower Broadmoor Farm and who was in turn responsible to the company that owned both farms. Billie and his wife Pauline lived with their five children in a cottage on Ripperston Farm. Immediately next door was another cottage, where Brian Klass, also a Ripperston employee, lived with his wife Caroline.

Although Pauline Coombs had reported some earlier UFO experiences, the first major event occurred on 16 April. She was driving home one evening after dark, together with three of her children, when her 10-year-old son Keiron, who was in the back seat, reported a strange light in the sky. It was about the shape and size of a rugby ball, luminous, yellowish, with a hazy, greyish light underneath and had a torch-like beam shining down from it. Keiron told his mother that the light had U-turned

Pauline Coombs was driving along the road leading to Ripperston Farm, above, when – she claimed – the car was chased by a UFO, shown in the artist's impression, left. She and the children were terrified; and their fear increased when, as they approached the house, the car engine and lights cut out completely so that they had to coast the rest of the way home.

and was following them. The object caught up with the car and travelled along beside it, at which point the car lights started to fade. Near the house, the engine cut out altogether, so that Pauline had to coast the rest of the way. She ran in to call her husband. He and their eldest son, Clinton, came out just in time to see the UFO heading out to sea. When Billie tried to start the car, he found that it now functioned perfectly.

A few weeks later, Pauline reported seeing another UFO from her kitchen window. It was apparently about 20 feet (6 metres) in diameter and rested about 3 feet (1 metre) off the ground. Silvery in colour, it had antennae and a tripod undercarriage.

It again took off towards the sea, leaving a circular 'burn mark'. On another occasion, two of the younger children claimed to have seen three UFOs in the sky, circular in shape and with domes. One was only about 50 feet (15 metres) above the ground, and from it a ladder was lowered, down which the children saw a silver-suited figure climb. The UFO also dropped a bright red, fluorescent box-like object into the grass of the field: later, the children looked for the box but it had disappeared.

On 22 April, Mr and Mrs Coombs were watching a late-night film on television, despite interference, which was particularly bad that evening. At about 11.30 p.m., Pauline became aware of a glow outside the uncurtained sitting-room window. An hour or so later, her husband saw a face at the window. 'It was a man – but a terrible size,' he later reported, estimating the height of the figure at nearly 7 feet (2 metres). The creature was wearing a white suit. Its face – if it had one – was concealed behind a kind of black visor.

Terrified, Coombs telephoned first the farm manager, Richard Hewison, and then Randall Jones Pugh, the local British UFO Research Association investigator. Pugh advised him to inform the police. Hewison came round at once, followed by the police, but they found no trace of the intruder. About three weeks later, a similar figure was sighted by the eight-year-old twins. They were out in the fields, 'playing roly-poly in the grass', when they saw an entity that they described in almost the same terms as their parents: again, it was dressed in silver, with a black head. It walked past them, about 50 feet (15 metres) away, and then it disappeared, apparently having walked straight through a barbed-wire fence.

A STRANGE DISAPPEARANCE

But of all the events that were reported from Ripperston Farm, certainly the most bizarre was the seemingly supernatural movement of cattle. On several occasions, Billie Coombs found that the cattle in his care – sometimes only one or two animals, but frequently the entire herd – had disappeared from the yard. On at least one occasion, he subsequently received an angry telephone call from a neighbouring farmer, asking him to come to collect his herd. Billie insisted that the animals had been properly fastened in, adding that he had even secured the bolt with binder twine as an extra precaution. To escape in the way indicated, the herd would have had to move directly past the cottage: yet neither Billie nor his wife had heard a sound. On one occasion, he reported, there simply had not been enough time between the moment at which the cattle had last been seen and the moment when they were reported to be at another farm for them to have traversed the distance in any natural way. The implication seemed to be that they had somehow been spirited from one place to the other. The cattle definitely appeared badly frightened, and next day the milk yield was down.

This extraordinary movement of cattle presents the toughest challenge to credulity. The UFO and entity sightings, remarkable as they are, fall within a commonly accepted range of phenomena; but teleportation of animals seems to belong to a completely different class.

CASEBOOK

This last case seems to point to poltergeist activity, which raises the question of whether a similar agency was at work at Ripperston. If so, it was a particularly powerful one: the teleportation of an entire herd of cattle definitely transcends any poltergeist phenomenon ever reported. Nonetheless, other events reported from Ripperston might be seen as supporting the poltergeist hypothesis. It is noteworthy, for example, that the place seemed to exert a highly malevolent influence on mechanical objects. Apart from the alarming failure of Pauline Coombs' car right at the climax of her frightening UFO chase, Billie Coombs reported that he had found it necessary to replace his car five times during 1977 alone and that they suffered an even higher accident rate with television sets. Again, the family's electricity bill was so extraordinarily high that they were forced to ask the Electricity Board to inspect the meters. Oddly, no fault was found.

The suggestion that psychic forces may have been at work is supported by details concerning the earlier history of Pauline Coombs, who was by faith a Roman Catholic. Some time before coming to Ripperston, the Coombs family had been living in a caravan at nearby Pembroke Dock. Here, strange

It is not, however, entirely without precedent. In his book *Haunted Houses*, John Ingrams describes a strange report from Birchen Bower, near Oldham in Lancashire. At this house, a macabre custom was observed. A former owner, terrified of being buried alive, had refused to allow her body to be buried. Instead, she left instructions that it should be embalmed and brought to the house every 21 years, where it was to be left in a granary for a week. This had a weird effect on the livestock:

'In the morning, when the corpse was fetched, the horses and cows were always found let loose, and sometimes a cow would be found up in the hay-loft, although how it came there was, indeed, a mystery, as there was no passage large enough to admit a beast of such magnitude... A few years ago, when a cow belonging to the farmer then tenanting the place was found in the hay-loft, it was the firm belief of many thereabouts that supernatural agency had been employed to place it there... How the cow was got up was a mystery to everyone, whilst that blocks had to be borrowed from Bower Mill to let it down through the hay-hole outside the barn was an equally well-known fact.'

The *Daily Mail* of 18 May 1906 also noted, in the course of a report on a disturbed house: 'A horse vanished from the barn and was found in the hay room. A partition had to be knocked down to get him out.' And in April 1936, the Italian journal *Ali del Pensiero* reported:

'Phenomena of incendiary infestation have been recently established on a farm in Prignano (Salerno); fires broke out spontaneously, destroyed household objects, and burned persons and animals. Bricks and stones fell in the rooms, although the windows were closed. There was spontaneous displacement of objects. A pair of oxen... were carried from one stall to another without human agency... A doctor and psychical researcher found a 16-year-old girl with strong mediumistic faculties who was the involuntary means of the striking phenomena.'

From her kitchen window, Pauline Coombs saw a UFO flying towards the sea, as depicted above.

The map, right, shows the position of Ripperston Farm in relation to that of Lower Broadmoor Farm. On several occasions, Billie Coombs reported that cattle had mysteriously disappeared from his yard – even though he had secured the gate – only to turn up at Broadmoor Farm, a half-mile (800 metres) away. Local BUFORA investigator Randall Jones Pugh, below, visited the farm but could find no explanation for the mystery.

" THE PROLIFERATION OF INCIDENTS AT RIPPERSTON FARM MADE IT A FOCUS OF INTEREST FOR REPORTERS AND INVESTIGATORS ALIKE... SO PERHAPS IT WAS ONLY TO BE EXPECTED THAT SOONER OR LATER FIGURES, VERY MUCH LIKE THE SINISTER MEN IN BLACK, SHOULD BE REPORTED AS TURNING UP. "

manifestations also began to occur. Every evening, from the inside of the caravan, Pauline would see a life-size apparition of the Virgin, wearing a white dress. She had a rosary tied round her waist and was holding the child Jesus. Later, the figure became that of Jesus on his own, and would remain for some half-an-hour. Word got around, and soon every evening a crowd of sightseers would turn up, hoping to catch sight of the phenomenon. Eventually, the owner of the caravan had it destroyed because he was annoyed by this constant flow of visitors. As reported, this incident is very unsatisfactory. Caravan owners do not usually resort to destroying their own property, even for such a reason. However, for our purpose, the suggestion is clear that there was already some quality about Pauline Coombs that might make her prone to strange experiences.

SINISTER VISITORS

The proliferation of incidents at Ripperston Farm made it a focus of interest for reporters and investigators alike, on and off throughout the spring and summer of 1977: so perhaps it was only to be expected that sooner or later figures, very much like the sinister men in black who so often visit witnesses to UFO landings, should be reported as turning up at the farm. One day, so the account alleges, an unusual car suddenly drove up, but silently, so that no one heard it approach. It contained two men who were remarkably similar to one another in appearance. One of them, immaculately dressed in a neat grey suit and gleaming shoes, got out. He was inspecting the cattle yard when Caroline Klass first saw him from her cottage next door – yet in some uncanny way, he was instantly beside her, asking where Pauline Coombs was, somehow knowing that she, Caroline, was not Pauline. Caroline described him as speaking with a foreign accent and as having something 'alien' about him. He possessed 'large, penetrating blue

Pauline Coombs is seen **above,** *at the window through which she and her husband saw a humanoid at about 1 a.m. on 23 April 1977. She had noticed a 'glow' at the window an hour or so beforehand, but decided not to mention it to her husband because she believed he would think she was 'suffering from nerves'. Then he saw a creature, a silver-suited man of 'a terrible size', pressed right up against the window, as in the illustration,* **right.** *The police were called, but they found no signs of an intruder.*

A strange entity, **below,** *dressed in silver and with a black head, was also seen at the time by two of the Coombs children.*

eyes which seemed to go right through her and examine her thoughts.'

The report alleges that the Coombs' eldest son, Clinton, was in the neighbouring cottage at the time but was too frightened by the sinister visitors to open the door to them. Instead, he bolted it and hid upstairs. Failing to get an answer to his knock, the man returned to Caroline Klass and pressed her for further information, though he seemed to know her answers before she had even uttered them. Then he asked her to show them how to reach their next destination, and the two men set off in the strange vehicle. A few seconds later, Pauline arrived home in her car. Investigators commented on the fact that, although there was no turning off the lane by which she had come, Pauline had not passed the two men. How could she have missed them?

If things had indeed taken place as this report suggests, we would have good reason to believe that something genuinely uncanny had occurred at Ripperston. However, certain investigators have said that their enquiries revealed the 'evidence' to be a hotch-potch of misleading statements and mischievous inventions. There is nothing to suggest that the two men were foreigners, they say. They were not uncannily identical either; and what is more, their questions were perfectly natural. Far from knowing that Caroline Klass was not Pauline Coombs, their first action was to ask if she was indeed Pauline. Clinton was not hiding in the house, terrified. And as for the question of why Pauline Coombs had not passed their car as she drove up, the explanation is perfectly simple – Caroline Klass had pointed out a short cut that would enable the men to reach their destination more quickly, and it led away from the farm by a different road.

In short, the whole episode, as reported, is held by these investigators to be an irresponsible distortion, designed to create a sensational story out of a simple and perfectly natural incident. Moreover, they add, this was far from being the only west Wales sighting in which the true facts were somewhat different from those originally reported.

A MIRACLE IN TIBET

experience a communication from Mohammed; a secular poet may find himself for an instant at one with the Universe and spend the rest of his life trying to express the glory of that moment's insight.

Such experiences can be used as propaganda for this or that form of belief. But the fact that they are shared by individuals of so many faiths and non-faiths surely means that they cannot be accepted as evidence for one particular form of truth.

The story of Peter's miraculous escape from prison, when chained between two guards (Acts 12), is one that even many Christians find difficult to accept. Yet a 20th-century Christian, Sadhu Sundar Singh, not only claimed to have had a similar experience but also spoke of witnessing an extraordinary vision, one that was to change his life.

Sundar Singh's story begins in India, in the early 1890s, when he was still a young boy growing up in a wealthy Sikh family. His mother, a deeply religious woman, had taker Sundar to visit a *sadhu*, a holy man who had chosen the life of a homeless wanderer in search of truth. The meeting between the young boy and the old mystic had a profound effect on Sundar, and he at once made it his resolve to search for God. When he was 14, his quest was intensified by the deaths of his mother and elder brother. A year later, possibly as a result of the missionary influences that were prevalent in India at the time, he struck out against western religion. Christianity was anathema to him; and to show his hatred, he stoned local Christian preachers and publicly burned *The Bible* in his village.

Three days after this denouncement, Sundar is said to have received the sign he had been so fervently looking for. After praying all night, he had a vision. In the vision, Jesus Christ appeared to him

IT SEEMED AS IF SADHU SUNDAR SINGH'S FATE WAS SEALED WHEN HE WAS SENTENCED TO DIE IN A DEEP, DRY WELL — BUT, MIRACULOUSLY, HE SURVIVED

All faiths have their saints, mystics and visionaries who have experiences expressed to them in the vocabulary of their own culture. A Roman Catholic may see a vision of the Virgin Mary; a Quaker may receive a revelation from the 'inner light'; a Muslim may

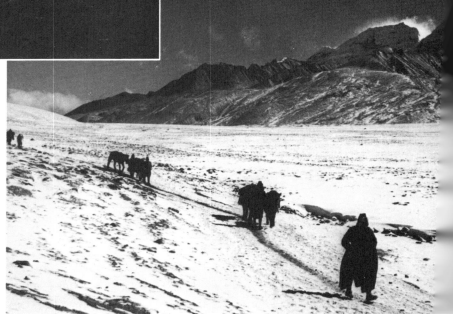

It was meeting a figure, such as the Indian holy man, right, that was to start the young Sundar Singh on his search for God.

Sadhu Sundar Singh, left, was undaunted by the bleak terrain of the Himalayas, below, and by the hostile reception committee he knew would be waiting for him when he crossed to Tibet.

and said in Hindustani: 'How long will you persecute me? I have come to save you. You pray to know the right way. Take it.'

Sundar's search had ended; and no one was more surprised than he that it should end with a revelation from a Christian God.

This was only the beginning of Sundar's story: with his personal quest now over, a new journey of evangelism had begun. He was baptised into the Christian Church in 1905; but, after taking an Anglican ordination course, he decided that the conventional priesthood was not for him. His newfound faith was not a fragile thing, but then neither was his sense of Indian culture and tradition. Sundar believed he could spread his own vision of Christ only if he remained unfettered by denominational bonds: not for him the dog-collars and suits that he had seen other converted Indian priests wearing. Nor was he willing to block out his awareness of the ever-present spirit world, a world also close to the hearts of some of the villagers among whom he lived and later preached.

To resolve his dilemma, he took the unique step of becoming a Christian *sadhu*, preaching the Gospel without material resources and relying on charity. As such, he was allowed access to areas

that would have otherwise been closed to him; and as an Indian holy man, albeit a Christian one, he was less likely to alienate the very people he was trying to convert.

Sadhu Sundar Singh made it his special business to evangelise in Tibet. And it was in that strange and mysterious country that the miracle is said to have taken place. He crossed the Himalayas several times on foot and, though it was not easy to make converts in a Buddhist country, his zeal remained undiminished. It was during one of these trips that he was arrested and condemned to death for preaching Christianity.

DEATH SENTENCE

Buddhist law forbids a true disciple to kill, so criminals are executed in ways that, by means of legal fictions, exonerate Buddhists from direct responsibility. Sundar's death sentence could have taken a variety of forms. One method was to sew the victim into a water-saturated bullock's skin: the skin would then be put out to dry, and as it slowly contracted, so the person within would gradually be smothered to death. Sundar's fate was to be just as unpleasant. He was beaten, stripped of his clothes and then violently thrown down a dry well, topped by a heavy iron lid. By his own account, the floor of the well was carpeted with the human bones and putrid flesh of previous victims.

It was only a question of time before either Sundar Singh would be suffocated by the terrible stench of death or he would die from starvation. One thing, however, sustained him. When he had first seen his vision of Christ, he reported experiencing a strong sense of peace and joy. This feeling, he claimed, remained with him always, even at times of distress and persecution. The effect of the vision – which, he maintained, was objective and entirely different from many other mystical experiences he was to have later on – was permanent; and that feeling of peace and joy stayed

*In*FOCUS

GOOD LORD DELIVER US

Acts 12: 1-17 relates a miracle that has no apparent rational explanation. Peter was imprisoned during one of Herod's anti-Christian purges. Chained between two soldiers, he was awoken in the night by a light in his cell. An angel appeared before him, struck off his chains and led him to freedom – bolts, bars and locks proving no obstacle.

'And the angel said unto him, Gird thyself, and bind on thy sandals. And so he did. And he saith unto him, Cast my garment about thee, and follow me.' Peter 'came to himself' in the city street. Until then, he thought he had been dreaming; but, finding his experience to be real, he went to the home of his friend where a girl, hearing his voice, reported that it was his spirit outside the house. When Peter's friends saw him, they were amazed by his account of his escape.

Nearly 2,000 years later, Sundar Singh's miraculous escape was to cause similar surprise and disbelief.

❝ ONE THING, HOWEVER, SUSTAINED HIM. WHEN HE HAD FIRST SEEN HIS VISION OF CHRIST, HE REPORTED EXPERIENCING A STRONG SENSE OF PEACE AND JOY . . . THAT FEELING STAYED WITH HIM THROUGHOUT THE DURATION OF HIS INCARCERATION IN THE WELL. ❞

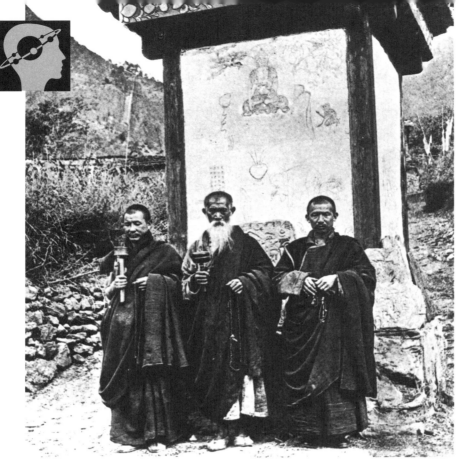

with him throughout the duration of his incarceration in the well.

Sundar passed the time in prayer until, on the third night, he heard a key grating in the lock above and the rattle of the withdrawn cover. He claimed that a voice now called to him to seize the rope that was lowered. His arm had been injured during the beating he had received, but fortunately there was a loop in the rope into which he placed his foot. He was then hauled up the well and was free. He claimed he then heard the lid being replaced and relocked. Once he was out in the fresh air, the pain in his injured arm simply disappeared and he is said to have rested until morning, then returning to the local caravanserai, an inn where groups of travellers would seek refreshment. He remained there for a short while before resuming preaching.

The reappearance of a man thought to be dead and safely entombed caused a furore. Sundar was arrested, brought before the head Lama and ordered to describe how his escape had taken place. His explanation of what had happened only enraged the Lama, however, who declared that someone must have stolen the key. But when he found it was still on his girdle, which never left him, he was said to have been terrified. The Lama, apparently cowed by the possibility that the escape was indeed a product of some kind of divine intervention, ordered Sundar to leave immediately and to go as far from the city as possible.

This, then, was the miracle in Tibet, when Sundar Singh was supposedly plucked from certain slow death. But was the hand that saved him divine or human? Certainly, Sundar's account has its weaknesses. How was it that, after his release, he was able to make it all the way back to the caravanserai without anyone commenting on his nakedness? In fact, such a sight was not as unusual in

The three lamas, above, posing in front of a pilgrimage shrine, are shown carrying traditional ritual objects – prayer wheels and rosaries. Buddhism, as practised in Tibet, is an amalgam of the Buddhism of India and indigenous religious beliefs.

Tibet as it would have been in Britain, say. There is, however, no getting away from the fact that someone could have stolen the key in order to secure Sundar's release, subsequently replacing it in the Lama's girdle, or there may have been a duplicate. Anyone who had been locked up for three days in the conditions he had to endure would, undoubtedly, feel confused and disorientated when eventually released. Perhaps this explains why he was unaware of any human presence when he finally gained his freedom. Another point to ponder is how, given the conditions of Sundar's entombment, he could have known he had been there for three days – although, of course, someone may have told him of this fact later.

A sceptic would have strong grounds, too, for pointing out that the tale rests on the unsupported witness of a single man. That man, besides being subject to a constant stream of mystical visions, had experienced many other wonders. He claimed to have made contact with a secret Indian Christian brotherhood whom he urged to declare themselves publicly; and to have met a *rishi* (hermit) of great age, the Maharishi of Kailash, in the Himalayas, who dwelt in a cave 13,000 feet (4,000 metres) above sea-level and imparted to him a series of apocalyptic visions. These, however, were never recorded; and the secret Christian brotherhood never declared themselves. Then again, the sceptic could also argue that, for all his concern with Christian truth, the *sadhu* was perhaps a bit of a romancer, given to flights of fantasy.

Of course, the sceptic should be left to believe what he wants to believe. But miracle or no miracle, the event cannot overshadow the fact that Sundar was a genuinely good man who, in his own lifetime, was revered by many as a saint.

HEAVENLY FORCES?

In fact, Sundar himself always tried to play down his psychic and mystical experiences, as well as his possession of a gift of healing. He found that a reputation for miracle-mongering pandered to the public's taste for the bizarre and that he thereby risked diverting attention to himself and away from Christ. His own view of the affair in Tibet was that it had been heavenly forces at work. However, he would probably have been the last person to have wanted to make a production out of the so-called miracle. Glorification of himself, or even the name of the God he served, was entirely foreign to him.

By the 1920s, Sadhu Sundar Singh had become something of a household name. He made many trips, financed by friends, to Ceylon, Burma, Malaysia, China, Japan, America, Australia and Europe. He preached wherever he went and met with many prominent churchmen, among whom he was to gain a high reputation. Through these trips, he also made a deep impression on thousands of ordinary people of many races. But there were just a few who regarded him with suspicion and branded him a confidence trickster who told lies to support a cause in which he had come to believe. He continued to visit Tibet, and the country that had been the source of his deepest revelation also turned out to be the place where he met his end. Sundar Singh finally disappeared, without trace, somewhere in the Himalayas, in 1929.

ALONGSIDE THE 'OFFICIAL' VIRGIN MARY EXISTS ANOTHER 'UNOFFICIAL' MADONNA – BLACK, MYSTERIOUS, ALL-POWERFUL AND POSSIBLY WITH RATHER DIFFERENT ORIGINS FROM HER CHASTE COUNTERPART

Until the late 18th century, pilgrims to Chartres, France, traditionally participated in a complex, intriguing and not unconventional Christian ritual. Having prayed in the abbey and heard mass in the cathedral, they would descend through a northern passageway to an ancient subterranean crypt beneath the church. Here, they would pay pious respects to *Notre Dame de Sous-Terre* (Our Lady of the Underworld) – a black ebony statue of a seated woman holding a child on her knees. On the statue's head, there was a crown: on its pedestal, a Roman inscription – *Virgini Paritures*

The Black Madonna, below, in the cathedral of Chartres, is the Virgin of the Pillar. The original stone column on which the figure stood is said to have been worn away by the bites and licks of its fervent worshippers.

(in translation, 'the Virgin who will give birth'). Having completed their devotions, pilgrims were then blessed with water drawn from a sacred well in the crypt. They were also permitted to drink of this water. Continuing their underground journey, they would at last emerge by a southern passage.

At the Benedictine monastery of Montserrat, in north-east Spain – where there is a particularly vigorous cult of the Virgin – a wooden statue of the Virgin and Child is also especially venerated. Indeed, Montserrat is a shrine for newly-weds, and the statue it contains is deemed to preside over marriage, sexuality and fertility. According to traditional legends, prayers to this statue are believed to ward off sterility.

Near Crotone, on a promontory overlooking the Gulf of Taranto in southern Italy, meanwhile, are the remains of a temple dedicated to Hera Lacinia, the Roman goddess of moonlight who protects women, especially in childbirth. She was believed to bring fertility and to govern the cycle of birth –

VIRGINS WITH A PAGAN PAST

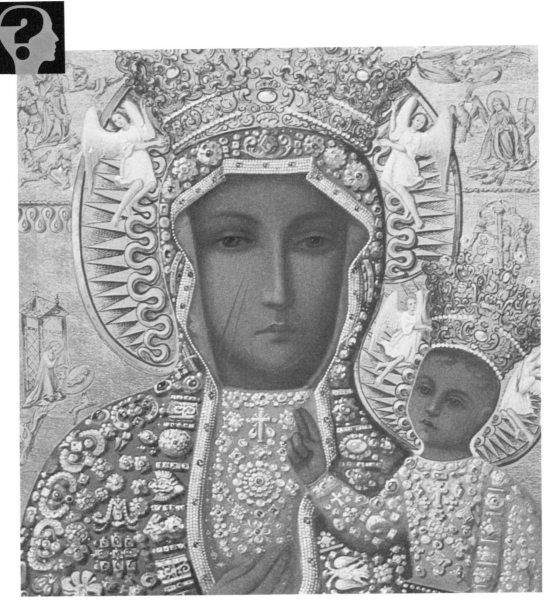

The Polish Black Madonna, left, is known as Our Lady of Czestochwa. Like all Black Madonnas, she is accredited with supernatural powers and has thousands of enthusiastic followers.

conception, pregnancy, labour and delivery. Crotone's church, like Chartres and the monastery at Montserrat, houses a black statue of a woman. This statue, too, has become a magnet for pilgrims. On the second Sunday of May, she is carried from the cathedral at Crotone to the Church of Our Lady of Capo Colonne on the promontory. Then, by night, she is returned by sea in a procession of torchlit fishing boats – whose crews hope thereby to earn the statue's protection.

// St Bernard... experienced his most dramatic religious illumination from the Black Madonna of Châtillon. While he was reciting the Ave Maria before her, she reportedly pressed her breast, whereupon milk fell into the monk's open mouth. //

To the Roman Catholic Church as a whole, these three statues are officially regarded as Madonnas like any other, and no special status or significance is accorded them. But to the local people, and to the pilgrims who visit them, they have a significance and power that goes far beyond that accorded by the Catholic Church.

These statues are generally known as 'Black Madonnas'. In addition to the three already mentioned, there are at least 35 others, scattered not only throughout Europe, but as far away as Mexico. Among the most important of all the Black Madonna sites are Einsiedeln in Switzerland; Rocamadour, Dijon, Avioth and Le Puy in France; Orval in southern Belgium; and Loreto, Florence, Venice and Rome in Italy.

The statues, as their name suggests, are all black and are made of stone, ebony or Lebanese cedar. They are robed in sumptuously rich apparel and, on festive occasions, are often decked with precious stones. All of them are crowned. To their worshippers, they are the 'Queen of Heaven' and are attended by an image of the moon and/or stars – a belief that pre-dates Christianity and goes back to the pagan worship of female deities. All are depicted holding a child, usually on the left

knee; all have become the object of pilgrimage; and all are believed to possess miraculous powers, especially of healing and fertility. The older ones have a curiously Middle-Eastern quality, possibly Byzantine or Egyptian. Many, like the one at Chartres, were destroyed during the French Revolution. Others, especially during the last 150 years, were officially replaced by more conventional statues of the Virgin – statues which are not black. Many of the original Black Madonnas have, over the centuries, even been purposely painted over with whitewash.

Black Madonnas are surrounded by legend and many are said to have appeared in miraculous circumstances. The Black Madonna at Tindari, Sicily, for example, is said to have been washed ashore in a casket. At Loreto, a 'strange building' containing the Black Madonna is said to have appeared suddenly, overnight, on 10 May 1291 – an event that the parish priest claimed to have been told of in the course of a dream.

The Black Madonna of Montserrat was supposedly discovered by shepherds in a cave in 880 AD, after they had been led to it by nocturnal celestial lights and angelic choirs. At Avioth, in north-east France, the Black Madonna is reputed suddenly to have materialised in a thorn bush. At Le Puy, she is said first to have appeared in a vision and to have commanded that a church be built on the site in her honour. The plan for the building is said to have been outlined by a fall of snow in midsummer; and its consecration, a century or so later, was allegedly attended by celestial lights and choirs.

HEAVENLY MILK

The Madonna, and the Black Madonna in particular, first assumed a crucial position in Christendom during the Middle Ages and the period of the Crusades. In large part, this was due to the influence of Saint Bernard (1090-1153), the famous abbot of Clairvaux in France, who probably did more than any other individual to propagate the cult of the Virgin. Saint Bernard himself is said to have experienced his most dramatic religious illumination from the Black Madonna of Châtillon. While he was reciting the Ave Marias before her, she reportedly pressed her breast, whereupon three drops of milk fell into the monk's open mouth.

The 'Queen of Heaven' also became the official patroness of the Knights Templar and, later, of their German equivalent, the Teutonic Order. She figured widely on chivalric banners and standards, and knights took the field in her honour, their battle cry often consisting solely of her name. In a sense, she absorbed the whole of the Christian Trinity – Father, Son and Holy Ghost. Indeed, as 'Bride of God', in many respects the Virgin effectively displaced the Trinity.

In the text of the *Mass of the Immaculate Conception of the Virgin*, there is even the following statement: 'The Lord possessed me at the beginning of His ways. I existed before He formed any creature. I existed from all eternity, before the earth was created... '

While the Virgin was sometimes referred to as the 'Bride of God', she was also known as the 'Mother of God'. For some medieval Catholic writers, it was even the Virgin, not God, who created

The Black Madonna at Einsiedeln, Switzerland, below, richly adorned as she is with gold and jewels, demonstrates the degree of veneration in which these unusual statues are held.

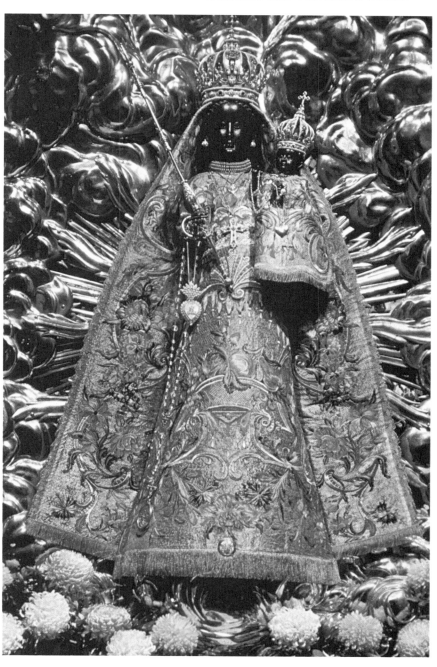

the world. The whole of existence was believed to have depended upon her. According to one writer: 'At the command of Mary, all obey, even God.' She was frequently equated with the Holy Ghost – who was often symbolised, like the Virgin, by a dove. Indeed, the Holy Ghost is regarded as feminine in Hebrew and was also considered to be such by the early Christian church.

HOLY MEDIATOR

During the Middle Ages, then, Christianity – particularly in the popular mind – centred primarily on the Virgin. It became, in effect, a matriarchal rather than a patriarchal religion – a religion orientated more around the feminine principle than the masculine. God, the Father, ceased to dominate the popular mind as He had previously. Jesus, the Son, became increasingly feminine in character, with emphasis placed upon his meekness, gentleness and passivity. And the Virgin became the mediator between God and Man – the guardian of all western Europe in many respects.

The great Gothic cathedrals of this time also became her temples and palaces. Indeed, between 1170 and 1270, no less than 80 cathedrals and 500 churches to 'Our Lady' were erected in France alone. A significant number of these edifices were constructed on sites already hallowed by the presence not merely of a Madonna statue, but of a Black Madonna. While it cannot be proved definitely, it has been argued that all the major cathedrals to Our Lady were actually built on former Black Madonna sites.

Yet the Church of Rome, as we have seen, appears at times to have been rather embarrassed by the Black Madonna statues. Officially, it refused to distinguish them from the more conventional 'white' Madonnas. At the same time, however, many of them were white-washed or, as in the case of the Black Madonna of Avioth, painted over in a flesh colour. Elaborate attempts were also made to rationalise the statues' blackness. Some of these rationalisations were plausible enough. The wood, in some cases, might well have been blackened by smoke or age. In some cases, the silver in which the statues were often swaddled might well have oxidised, thus darkening the wood. But the fact remains that most of the statues were carved originally from ebony – a black wood – or from black stone. In other words, it seems that they were intended to be black from the very beginning. This would also seem to be confirmed by the fact that Black Madonnas have been produced in relatively modern times and are almost certainly deliberately black – the Black Madonna installed at Orval, for example.

It has been suggested that the worship or devotion accorded the Black Madonnas was never strictly orthodox, nor truly in accord with established Catholic dogma. And indeed, many beliefs associated with Black Madonnas are not only non-Christian in both nature and origin – they are clearly pagan. Many of the Black Madonnas are associated with sexuality, procreation and fertility – hardly the traditional qualities attributed to the Virgin Mary. The Black Madonna of Montserrat is even honoured at festivals by a circular (orgiastic) ritual dance of unmistakably pagan derivation. Other Black Madonnas, like the one at Chartres, are identified as 'Queen of the Underworld'. Others still are explicitly associated with the moon, or with the planet Venus. Such associations do not seem to tally with the traditional image of Jesus' pure and immaculate virgin mother.

So it certainly seems that, if the Black Madonnas do represent the Virgin Mary, they must also, clearly, represent something else.

P E R S P E C T I V E S

THE CULT OF THE VIRGIN MARY

Mary, Mother of God, plays a key role in the Roman Catholic Church. She is believed to possess miraculous powers and to have ascended into Heaven without having suffered bodily corruption. She is also believed to be a living person who intervenes directly in the affairs of Man. While these beliefs are specifically Christian, they are also thought by some to have originated in pagan beliefs stretching back 10,000 years before the birth of Christ. It is these beliefs that are generally considered to mark the beginnings of the cult of the Virgin Mary and the origins of the Black Madonnas.

Long before the appearance of male gods, primitive Man is supposed to have worshipped a female Creator. This Goddess, because she came before the male, was believed to have been a virgin. The cycle of birth was shrouded in mystery. Since sex did not always lead to birth, it was believed that birth could occur without sex – by swallowing a blade of grass,

In the depiction of the Madonna and Child, above, the lilies in her hand symbolise purity.

for example, or standing against the wind. The Goddess alone controlled the mysterious cycle of fertility, conception and birth.

Originally, the Virgin was not accorded any greater honours than other saints. But to survive the shocks suffered after the sacking of Rome in 410 AD, the early Church, it has been suggested, grafted on to Mary, mother of Christ, attributes hitherto accorded to the Goddess. Both were known as the 'Queen of Heaven', as 'Protectress' and 'Virgin Mother'. In place of the Christian concept of the all-male Trinity – Father, Son and Holy Ghost – the Church now emphasised the place of Mary, the female principle. This struck a chord in the popular imagination which had always held the female, in some sense, to be higher than the male. Mary fulfilled this role in a way that the Trinity never could.

Within the Eastern Church, too, the role of the Virgin Mary, as evidenced by her presence on icons, is particularly significant.

HUMAN SALAMANDERS

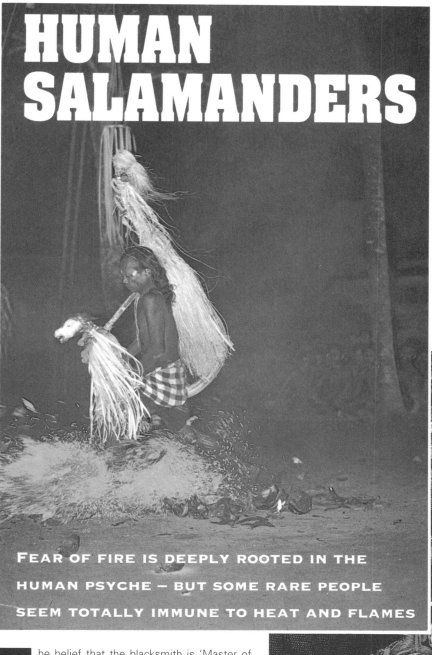

FEAR OF FIRE IS DEEPLY ROOTED IN THE HUMAN PSYCHE – BUT SOME RARE PEOPLE SEEM TOTALLY IMMUNE TO HEAT AND FLAMES

into the blazing forge and calmly picked out glowing coals, which he showed to the onlookers on his palms. As a finale, he casually handled a piece of red-hot iron.

'It don't burn,' he told the reporter. 'Since I was a little boy, I've never been afraid to handle fire.'

Coker was neither a showman nor a religious fanatic. To him, the startling phenomenon was simply a fact of life.

Another blacksmith was involved in a similar report made by New York physician Dr K. R. Wissen, in 1927. While on a hunting trip in the Tennessee mountains, the doctor met a shy country boy who could hold burning firebrands without feeling pain or suffering physical injury. The boy told Wissen that he had discovered his mysterious ability as a child, when he had picked up a red-hot horseshoe from a forge. Like Coker, he took his gift entirely for granted.

The Balinese trance-dancer, left, regularly escapes totally unscathed from fire. The Bible tells how King Nebuchadnezzar threw three men, as depicted below, into the fiery furnace. They, too, emerged unhurt.

The belief that the blacksmith is 'Master of Fire' is common in both ancient cultures and modern primitive societies, and at various times has been current in central Europe, Asia, Africa and North and South America. It is a credence which lends extra interest to an extraordinary story that was published in the *New York Herald* for 7 September 1871.

Nathan Coker was blacksmith in Easton, Maryland, and had long held the reputation of being immune to heat. A committee of local citizens and members of the press asked if they might put him to the test, and he agreed. First, a shovel was heated in his forge until it became white-hot and incandescent. Coker, we are told, pulled off his boots and placed the hot shovel on the soles of his feet, and kept it there until the shovel became black.

Next, lead shot was heated until molten. Coker swilled it around his teeth and tongue like a mouthwash, until it solidified. Then he plunged his hands

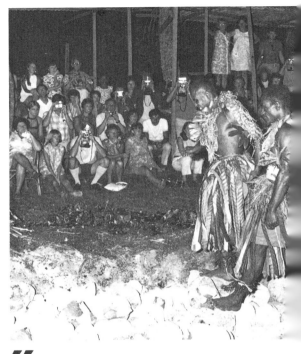

The immunity of certain people to extreme heat – whether cultivated, as in the case of shamanist societies, for instance, or apparently fortuitous, as in the case of such individuals as Nathan Coker – has been a source of wonder and bafflement to observers of the phenomenon for centuries. The very ubiquity, across ages and continents, of these 'human salamanders' adds to the mystery. The Biblical story of Nebuchadnezzar's burning fiery furnace and its three intended victims – Shadrach, Mesach and Abednego – for example, strikes a familiar chord when compared with modern firewalking in Trinidad or Polynesia. The fire was so hot that it killed the men who put Shadrach and company into it, yet we are told in *Daniel 3, 27*: 'The princes, governors and captains, and the king's counsellors, being gathered together, saw these men, upon whose bodies the fire had no power, nor was an hair of their head singed, neither were their coats changed, nor the smell of fire had passed on to them.'

Classical writers, such as Plato and Virgil, also recorded instances of people walking unscathed on hot coals; while, in the third century AD, the Neoplatonist Porphyry and his pupil lamblichus

The early 19th-century engraving, right, shows a traditional Thai firewalker, demonstrating his skills. It seems that only 'special' people, those few who are born incombustible, or others who undergo secret magical rites – perhaps involving auto-hypnosis – can expose their flesh to intense heat without feeling or showing any ill-effects.

" AMERICAN PHYSICIST JEARL WALKER DEMONSTRATES THE LEIDENFROST EFFECT BY WETTING HIS FINGERS AND THEN PLUNGING THEM INTO MOLTEN LEAD AT 500° CENTIGRADE. MEAT COOKS AT 100°, BUT THE WET FINGERS ARE PROTECTED, FOR A FEW SECONDS ANYWAY, BY A SHEATH OF WATER VAPOUR. AND HE SUGGESTS THAT THIS COULD BE THE SECRET OF FIRE-WALKING. "

LYALL WATSON, LIFETIDE

investigated the phenomenon as part of a thorough and objective survey of divination, spirit-raising and trance states. Certain 'possessed' mediums, they noted, felt no pain and suffered no injury when thrown into, or passed through, fire.

The annals of the early and medieval Church are littered with accounts of such saintly activities as levitation, miracle healing and teleportation, as well as immunity to fire. And though the majority of these are based on hearsay evidence, a handful do stand up to scrutiny. Among them are accounts of 'ordeal by fire', a favourite way of settling ecclesiastical differences. In 1062, the Bishop of Florence was accused by the saintly Peter Aldobrandini of having bribed his way into office. A long, narrow corridor was paved with red hot coals, with a bonfire at each end. Peter walked through one bonfire,

along the coals, and out through the further flames, his flesh and clothing remaining unburned. The Bishop declined to follow him, and resigned instead. Later, in the mid-13th century, another monk with a reputation for holiness, Giovanni Buono, made a habit of demonstrating his faith by shuffling his feet in burning coals 'as if washing them in a brook, for as long as it took to say half a *miserere*'.

In 1637, the French Jesuit, Father Paul Lejeune was very impressed – although at the same time considerably annoyed – by what he saw among the Huron Indians near Quebec. Lejeune was heading a mission to the Indians, but the tribal medicine men were in no mood to be converted and put on what appeared to be a special show for him – a sort of healing-by-fire ceremony. He wrote:

Firewalking becomes a tourist attraction, above, as holidaymakers eagerly photograph local volunteers stepping out casually over white-hot stones outside the Korolevu Beach Hotel in Fiji.

Saints Alexander and Eventius, right, are joined by Theodulus to celebrate their triumph over the flames into which they were thrown by Aurelius, persecutor of Christians.

An Indian fakir exhibits his technique of mind-over-matter, below, by hanging upside-down over a fire.

'You may believe me, since I speak of a thing that I saw with my own eyes, they [the medicine men] separated the brands, drew the stones from the midst of the fire, and holding their hands behind their back, took them between their teeth, carried them to the patients, and remained some time without loosening their hold . . . not only these persons but even the sick were not burned. They let their bodies be rubbed with glowing cinders without their skin appearing in the least affected.'

Even Lejeune's phlegmatic Jesuitry could not compete and he retired from the scene, temporarily defeated.

In 1731, lay authorities and the Catholic Church joined forces to examine an outbreak of hysterical possession that followed the death of the Jansenist heretic François de Paris four years previously. De Paris' followers, congregating around his grave at St Medard, were reported to have gone into convulsions, during which they spun like tops, twisting their limbs into impossible positions, and levitating. Louis XV ordered the cemetery closed, and appointed a magistrate, Carre de Montgeron (an agnostic), to head the examining board.

One meticulously detailed report compiled by Montgeron, two priests and eight court officials told of the incombustible Marie Souet. Naked, apart from a linen sheet, Marie had gone into a trance that rendered her body rigid. In this condition, she had been suspended over a blazing fire for 35 minutes; and although the flames actually lapped around her, neither she nor the sheet was damaged. The free-thinking Montgeron was so astounded by what he saw that he began a sympathetic examination of spiritism, annoying the authorities and landing himself in the Bastille for his pains.

AFTER-DINNER ENTERTAINMENT

The famous English diarist John Evelyn wrote of seeing 'Richardson the fire-eater' perform after dinner at Lady Sunderland's house in London on 8 October 1672. His account is all the more convincing for the slight note of scepticism at the end:

'He devoured brimstone on glowing coals before us, chewing and swallowing them; he melted a beer glass and ate it quite up; then taking a live coal on his tongue, he put on it a raw oyster, the coal was blown on with bellows till it flamed and sparkled in his mouth, and so remained until the oyster gaped and was quite boiled; then he melted pitch and wax with sulphur, which he drank down as it flamed; I saw it flaming in his mouth a good while. He also took up a thick piece of iron, such as laundresses use to put in their smoothing boxes, when it was fiery hot, held it between his teeth, then in his hand and threw it about like a stone, but this I observed he cared not to hold very long.'

Another celebrated 'after-dinner' performer, whose feats attracted considerable attention in Victorian society, was the medium Daniel Dunglas Home. Lord Adare, an army officer and war correspondent, and H. D. Jencken, a barrister, told how, at a seance in 1868, Home stirred up a glowing fire in the grate and 'placed his face right among the burning coals, moving it about as though bathing it in water'. It seems that Home could confer his immunity to onlookers, too: after making passes over their hands, he would hand them burning

embers without them suffering injury. More startlingly, at a seance at the home of Mr and Mrs S. C. Hall, a couple who combined prominence in the art world with membership of the Society for Psychical Research, Home took 'a huge lump of live burning coal, so large that he held it in both hands', and placed it on top of Hall's head. Hall said that the coal felt 'warm but not hot'. According to Mrs Hall, Home 'then proceeded to draw up Mr Hall's white hair over the red coal; Mr Home drew the hair into a sort of pyramid, the coal, still red, showing beneath the hair'.

FIRE-WALKING IN FIJI

Even while Home was startling such establishment figures as Lord Adare and Sir William Crookes, tales of firewalking and firehandling feats from far-flung corners of the Empire were becoming commonplace.

Basil Thompson, for instance, in his *South Sea Yarns*, related how he watched a group of Fijian islanders walking over a long pit of super-heated stones. Thompson put a pocket handkerchief to one of the nearer stones and it immediately scorched; yet not only did the near-naked Fijians walk over the

pit with impunity, but 'their ankle fillets of dry fern remained untouched.'

In 1904, members of Sir Francis Younghusband's expedition to Tibet told of Buddhist monks who could not only stand motionless and unharmed in the midst of blazing fires but sit for hours, clad only in thin saffron robes, in sub-zero temperatures. Over and over again, such stories were told, often by intelligent and unbiased witnesses – only, more often than not, to have them dismissed by the scientific establishment.

Professor E. R. Dodds, in his *Supernormal Phenomena in Classical Antiquity*, outlines the difficulty of collating ancient accounts of paranormal happenings. A useful purpose, he suggests, may be served by examining surviving evidence to see whether the phenomena described are consistent with those from other periods of history. If they are strikingly different, it could be argued that each age is the victim of its own superstitions.

In the case of 'human salamanders', the many similarities between accounts from all ages and countries must mean that the student of the paranormal has a sound basis from which to work.

THE ART OF LEVITATION

IT IS CLAIMED THAT MANY ANCIENT PEOPLES KNEW THE SECRETS OF HOW TO LEVITATE. BUT, APPARENTLY, IT IS NOT AN ART THAT HAS BEEN ENTIRELY LOST

A unique series of photographs appeared in the magazine *Illustrated London News* on 6 June 1936. They showed the successive stages in the levitation of an Indian yogi, Subbayah Pullavar – thus proving that, whatever else it was, this phenomenon was not a hypnotic illusion.

A European witness of the event, P.Y. Plunkett, sets the scene:

'The time was about 12.30 p.m. and the sun directly above us so that shadows played no part in the performance... Standing quietly by was Subbayah Pullavar, the performer, with long hair, a drooping moustache and a wild look in his eye. He salaamed to us and stood chatting for a while. He had been practising this particular branch of yoga for nearly 20 years (as had past generations of his family). We asked permission to take photographs of the performance and he gave it willingly...'

Plunkett gathered together about 150 witnesses while the performer began his ritual preparations. Water was poured around the tent in which the act of levitation was to take place. Leather-soled shoes were banned inside the circle, and the performer entered the tent alone. Some minutes later, helpers removed the tent; and there, inside the circle, was the fakir, floating on the air.

Plunkett and another witness came forward to investigate: the fakir was suspended in the air about a yard from the group. Although he held on to a cloth-covered stick, this seemed to be for purposes of balance only – not support. Plunkett and his friend examined the space around and under Subbayah Pullavar, and found it to be without any strings or other concealed apparatus. The yogi was in a trance and many witnesses believed that he

Photographs taken of a levitation performance, carried out by an Indian yogi, Subbayah Pullavar, before a large number of witnesses are shown right and below. They were taken by the Englishman P. Y. Plunkett and a friend, and published in the Illustrated London News of 6 June 1936. The first photograph, below, shows the yogi before levitation, lying inside a tent. He is grasping a clothwrapped stick, which he continues to hold throughout the performance. The tent is then closed, right, for some minutes during the mysterious act of levitation itself.

As the levitation performance continues, the curtains of the tent are drawn back and the yogi appears, floating in mid-air, as shown top right. Plunkett and his friend examined the space beneath and around the yogi, but were unable to find any evidence of strings or other supporting apparatus. Although some sceptics have claimed that the yogi was, in fact, not levitating but merely in a cataleptic trance, the relaxed position of the hand on the post suggests that the body of the yogi was indeed very nearly weightless during the performance. After levitation, above right, the yogi's body was so stiff that, try as they might, five men could not bend his limbs.

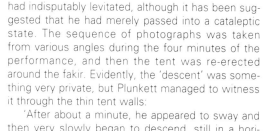

had indisputably levitated, although it has been suggested that he had merely passed into a cataleptic state. The sequence of photographs was taken from various angles during the four minutes of the performance, and then the tent was re-erected around the fakir. Evidently, the 'descent' was something very private, but Plunkett managed to witness it through the thin tent walls:

'After about a minute, he appeared to sway and then very slowly began to descend, still in a horizontal position. He took about five minutes to move from the top of the stick to the ground, a distance of about three feet [1 metre] . . . When Subbayah was back on the ground, his assistants carried him over to where we were sitting and asked if we would try to bend his limbs. Even with assistance, we were unable to do so.'

The yogi was rubbed and splashed with cold water for a further five minutes before he came out of his trance and regained full use of his limbs. Intriguingly, the swaying motion and horizontal position that Plunkett witnessed seem to be essential to true levitation.

Students of transcendental meditation (TM), at a centre in Switzerland, are sometimes taught to levitate. One student described this 'impossible' achievement as follows:

'People would rock gently, then more and more, and then start lifting off into the air. To begin with, it's like the Wright brothers' first flight, you come down with a bump. That's why we have to sit on foam rubber cushions. Then you learn to control it better, and it becomes totally exhilarating.'

So can anyone induce levitation? The TM students believe they can, after stringent mental training: the disciplines, both spiritual and physical, of the yogis seem to prepare them to defy gravity. It may even be fairly easy to induce a state of semi-weightlessness, as accounts of levitation performed almost as a 'party-trick' show.

If an individual sits on a chair, four people can then demonstrate the 'impossibility' of lifting him with their index fingers only, placed in his armpits and the crooks of his knees. They first put their

The Transcendental Meditation movement claims that the photograph, right, shows students levitating. It is alleged that, under the supervision of tutors, the students achieve weightlessness through meditation.

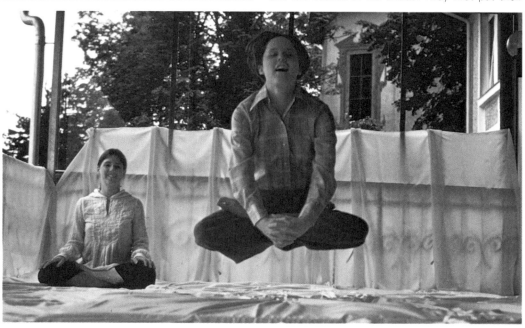

233

> **"** I FEEL NO HANDS SUPPORTING ME, AND SINCE THE FIRST TIME, I HAVE FELT NO FEAR; THOUGH SHOULD I HAVE FALLEN FROM THE CEILING OF SOME ROOMS IN WHICH I HAVE BEEN RAISED, I COULD NOT HAVE ESCAPED SERIOUS INJURY. **"**
>
> **D.D. HOME, 1833-1886**

using this strange form of locomotion, keeping his eyes fixed on some far-distant goal.

The Russian ballet dancer Nijinsky also had the extraordinary ability of appearing to be almost weightless. He would jump up high and fall lightly and gently in what was known as the 'slow vault'.

Like many inexplicable phenomena, levitation seems to be singularly useless. The distance covered is rarely more than a few feet or, at the most, the height of a room – purposeful only for dusting or decorating the home. But some people believe that the ancients could levitate quite easily, and did so to design certain enormous earthworks that can be appreciated only from the air, such as some of the white horses of the chalk downland in England and the desert patterns in Peru.

hands in a pile on top of his head, taking care to interleave their hands so that no one person's two hands are touching. The four concentrate deeply for about 15 seconds; then someone gives a signal, and quickly they replace their fingers in the subject's armpits and knees. The individual – at least in theory – will then be easily lifted into the air.

This phenomenon has been witnessed hundreds of times in pubs, homes, and school-yards. But how is it possible?

It is said that the sudden burst of concentration of four people with a single 'impossible' target could unlock the hidden magic of the human will. It has also been suggested that a little-known natural force, perhaps the same one that guides the dowser's rod, intervenes to achieve the miracle of nullifying the force of gravity.

It seems that religious fervour may have something to do with the phenomenon, too. There are certainly many reports of levitation by both Christian and Buddhist monks. In 1902, Aleister Crowley met his compatriot Alan Bennett, who had become a Buddhist monk, at his monastery in Burma: he, too, had once become so weightless that he was 'blown about like a leaf'.

Alexandra David-Neel, the French explorer of the early 20th century, describes witnessing an extraordinary kind of propulsion demonstrated by a Tibetan lama: 'The man did not run. He seemed to lift himself from the ground, proceeding by leaps. It looked as if he had been endowed with the elasticity of a ball and rebounded each time his feet touched the ground. His steps had the regularity of a pendulum.' The lama is said to have run hundreds of miles

The aerial view, left, is of the white horse at Uffington in Oxfordshire, England. The terrain on which it was carved, in around the first century AD, is so hilly that its true shape can only really be appreciated from the air – a fact that has led some to speculate that the people who carved it must have been able to levitate and inspect their work from above.

Objects, too, can be made to levitate, as shown in the photograph, above left, of a psychokinetic experiment in Missouri, USA.

Uri Geller and some friends are seen conducting a levitation session, left, with Colin Wilson as subject. First, the experimenters placed their hands on top of the subject head in such a way that no one person's two hands were touching. Then, on a command from Geller, they removed their hands from the subject's head and placed their index fingers under his arms and knees. The subject immediately rose into the air.

The limitations of modern levitation may not even have applied to the ancients: perhaps they had developed the art to such a high degree that they could soar into the sky at will. Like other psychic faculties, it appears that levitation is an art, once almost lost, that is now being re-learned by determined students. Perhaps one day, therefore, modern levitators will be able to 'fly' as the ancient Druids supposedly could.

But the reported 'flights' of the ancients suggest to some researchers that they were out-of-the-body-experiences or astral travel, rather than flesh-and-blood transportation. Certainly, many accounts of levitation or flying read like accounts of lucid dreams, and dreams of flying are in themselves very common experiences. Some dreamers wake up convinced they can fly; but fortunately, the sights and sounds of the real world generally bring them to their senses before they can experiment.

With a few exceptions, it seems that one can levitate only after long periods of training and discipline: in this way, the body is mysteriously 'given permission' to defy the law of gravity. Perhaps there is even a law of levitation with a secret formula – an 'Open, Sesame' – which the initiate uses before rising off the ground.

This theory would explain the unusual cases of spontaneous or random levitation that fascinated Charles Fort. One such case was that of 12-year-old Henry Jones from Shepton Mallet who, during the year 1657, was observed on several occasions rising into the air. Once he was able to put his hands flat against the ceiling, and on another occasion he took off and sailed 30 yards (27 metres) over the garden wall. The phenomenon lasted only a year – but this was long enough for the rumour that he was 'bewitched' to spread.

Certainly, levitation is a rare phenomenon; but when considered with other accounts of equally rare and bizarre human attributes, such as incombustibility, elongation and superhuman strength, it must be taken seriously. Mothers who lift cars off their trapped children, firewalkers and sleepwalkers who perform 'impossible' feats pose profound questions about the nature of Man's physical and psychical potential. Perhaps we are intended to be able to defy gravity at will. Until we understand more about the nature of the phenomenon of levitation, it certainly remains one of Man's more mysterious hidden powers.

❝ THE MASTER STOOD OVER HIM, HIS HAND ABOUT TWO FEET [60 CENTIMETRES] ABOVE HIS RECUMBENT BODY, THEN SLOWLY RAISED IT, AND ARKWRIGHT ROSE IN THE AIR, AS IF HE WERE BEING PULLED BY AN INVISIBLE CORD. ❞

CYRIL SCOTT,

THE INITIATE IN THE NEW WORLD

THE UFO AT WAR

FLYING DISCS WERE BUILT BY THE NAZIS AND LATER BY SOME OF THE VICTORIOUS ALLIED POWERS. COULD SOME SIGHTINGS OF UFOS BE EXPLAINED BY SUCH UNCONVENTIONAL CRAFT?

'The Nazis have thrown something new into the night skies over Germany. It is the weird, mysterious "foo fighter" balls which race alongside the wings of Beaufighters, flying intruder missions over Germany. Pilots have been encountering this eerie weapon for more than a month in their night flights. No one apparently

The rare photograph, above, shows 'foo fighters' – also known as 'kraut balls' – in company with Allied planes during the Second World War. Some aircrew described the mysterious spheres as being like silver Christmas tree decorations. The nickname came from the 'Smokey Stover' comic strip, popular at the time, in which the phrase 'where there's foo, there's fire' was often used.

The Chance-Vought Flying Flapjack, right, also known as the Navy Flounder, could take off nearly vertically and fly as slowly as 35 miles per hour (55 km/h), but was reported also to be capable of speeds greater than 400 miles per hour (640 km/h).

The Avro Car, left, was built for the US Air Force and Army by the Avro-Canada company, and was designed by an English engineer, John Frost. Officially, work on it was dropped in 1960, despite the early claim that the machine would reach twice the speed of sound.

knows what this sky weapon is. The "balls of fire" appear suddenly and accompany the planes for miles. They seem to be radio-controlled from the ground...'

The sightings referred to in this news story showed remarkable similarities. Lieutenant Schlueter of the 415th US Night Fighter Squadron, for example, reported being harassed by 'ten small balls of reddish fire' on the night of 23 November 1944 when flying over the Rhine; and pilots Henry Giblin and Walter Cleary reported that, on the night of 27 September 1944, they had been harassed in the vicinity of Speyer by 'an enormous burning light' that was flying above their aircraft at about 250 miles per hour (400 km/h). The mass of UFO reports agreed on two major points: the 'foo fighters' invariably appeared to ascend towards the aircraft from the ground; and they usually caused the aircraft's ignition systems to malfunction. Other reports, unconfirmed by the Allied forces, suggested that the malfunctioning of ignition systems had actually caused some aircraft to crash.

At first, the Allies thought that the 'foo fighters' were static electricity charges. But once this theory had been disproven, they then began to think that the balls of light were likely to be German or Japanese secret weapons, designed to upset the ignition systems of bombers. Another theory was

Canadian border over the Cascades, a mountain range in Washington State. There was much speculation that both the Soviets and the Americans, utilising men and materials taken from the captured secret research plants of Nazi Germany, were developing advanced disc-shaped aircraft.

FLYING PROTOTYPES

Speculation that there might be a connection between Nazi secret weapons and sightings of what seemed to be flying saucers increased when various West German newspapers and magazines began publishing articles during the mid-1950s about *Flugkapitan* Rudolph Schriever. According to these reports, this former Luftwaffe aeronautical engineer had designed, in the spring of 1941, the prototype for a 'flying top', which was test-flown in June 1942. With his colleagues Habermohl, Miethe and Bellonzo, he then went on to construct a larger version of the original 'flying disc' in the summer of 1944. At the BMW Plant near Prague, they then redesigned the larger model, replacing its former engines with advanced jets.

A brief description of Schriever's *Projekt Saucer* is given in Major Rudolf Lusar's book, *German Secret Weapons of the Second World War.*

'Habermohl and Schriever chose a wide-surface ring which rotated round a fixed, cupola-shaped

that the objects had been designed purely for psychological warfare, and sent aloft to confuse and unnerve Allied pilots. Finally, both the RAF and the US Eighth Army, unable to solve the mystery, reached the conclusion that the 'foo fighters' were probably the product of 'mass hallucination'.

The 'foo fighters' disappeared from the skies a few weeks before the end of the war. Interestingly, the next wave of UFO sightings occurred in Western Europe and Scandinavia, between 1946 and 1948, when many people, including airline pilots and radar operatives, reported seeing strange cigar- or disc-shaped objects in the skies. There were sightings in the USA, too. On 21 June 1947, Harold Dahl reported seeing saucer-shaped objects flying towards the Canadian border. Three days later, Kenneth Arnold made his famous sighting of saucer-shaped objects also flying towards the

cockpit. The ring consisted of adjustable wing-discs which could be brought into an appropriate position for take-off or horizontal flight, respectively. Miethe developed a discus-shaped plate of a diameter of 42 metres [138 feet], in which adjustable jets were inserted.'

Other reports, which sometimes conflict in their details of the overall project, agree on the 'flying saucer's' size, and that it had a height from base to canopy of 105 feet (32 metres), reached an altitude of approximately 40,000 feet (12,000 metres) and attained a horizontal flight speed of 1,250 miles per hour (2,000 km/h).

Rudolph Schriever himself claimed, in the late 1950s, that he had indeed worked on a wartime research programme called *Projekt Saucer*. His 'flying disc' had been ready for testing in early 1945, but with the advance of the Allies into Germany,

Blueprints for a 'flying saucer' are shown left. According to the obscure single-issue publication Brisant, in which these diagrams appeared in 1978, they are plans for a disc-shaped spaceship, modified by the West German government to make them 'safe' for publication. Although 'electromagnetic turbines', 'laser-radar' and computers are indicated, the design does not appear to be a practical one. The diagrams featured in an article on Rudolph Schriever's Second World War designs, and may have been inspired by them.

the test had been cancelled, the machine destroyed, and his complete papers mislaid or stolen in the chaos of the Nazi retreat.

Schriever died not long after these revelations, convinced to the end that UFO sightings since the end of the war were proof that his original ideas had been taken further with successful results.

But what were the 'foo fighters'? An identification was proposed by an Italian author, Renato Vesco, in a book first published in 1968. According to him the 'foo fighter' was actually the German *Feuerball* (Fireball), first constructed at an aeronautical establishment at Wiener Neustadt, Austria. The craft was a flat, circular flying machine, powered by a turbo-jet. It was used during the closing stages of the war, both as an anti-radar device and as a psychological weapon designed to disturb Allied pilots. Vesco says:

'The fiery halo around its perimeter – caused by a very rich fuel mixture – and the chemical additives that interrupted the flow of electricity by over-ionising the atmosphere in the vicinity of the plane, generally around the wing tips or tail surfaces,

> **//** CHARLES ODOM, FORMER B-17 PILOT... SAYS THEY [FOO FIGHTERS] LOOKED LIKE CRYSTAL BALLS, CLEAR, ABOUT THE SIZE OF BASKETBALLS, AND WERE OFTEN SEEN OVER VIENNA, MUNICH AND OTHER TARGET AREAS. **//**
>
> **HOUSTON POST, 7 JULY 1947**

subjected the H_2S radar on the plane to the action of powerful electrostatic fields and electromagnetic impulses.'

Vesco also claims that the basic principles of the *Feuerball* were later applied to a much larger 'symmetrical circular aircraft', known as the *Kugelblitz* (literally, ball lightning), which could rise vertically by 'jet lift'.

Since neither the British, the Americans nor the Russians are ever likely to reveal what they discovered in the secret factories of Nazi Germany, it is worth noting that, in 1945, Sir Roy Feddon, leader of a technical mission to Germany for the British Ministry of Aircraft Production, reported:

'I have seen enough of their designs and production plans to realise that, if they had managed to prolong the war some months longer, we would have been confronted with a set of entirely new and deadly developments in air warfare.'

In 1956, Captain Edward J. Ruppelt, then head of the US Air Force's *Project Blue Book*, was able to state:

'When World War II ended, the Germans had several radical types of aircraft and guided missiles under development. The majority of these were in the most preliminary stages, but they were the only known craft that could even approach the performances of the objects reported by UFO observers.'

The first concrete evidence for post-war 'flying saucer' construction projects came in 1954. The Canadian government announced that the enormous UFO seen over Albuquerque, New Mexico, in 1951 was similar to a craft that they had tried to build shortly after the war. Owing to lack of adequate technology, however, they had eventually passed the design over to the United States.

Further evidence for United States' involvement with saucer-shaped aircraft projects was to be found in the US Navy's so-called *Flying Flapjack*.

The US soldier, above, guards a V-2 rocket, still lacking its outer skin. This vast underground factory at Nordhausen in Germany was top secret during the Second World War, along with many others whose secrets may still not have been revealed by the Allied governments.

Wernher von Braun, creator of the V-2, is seen, above right, with senior military staff at the Peenemünde range.